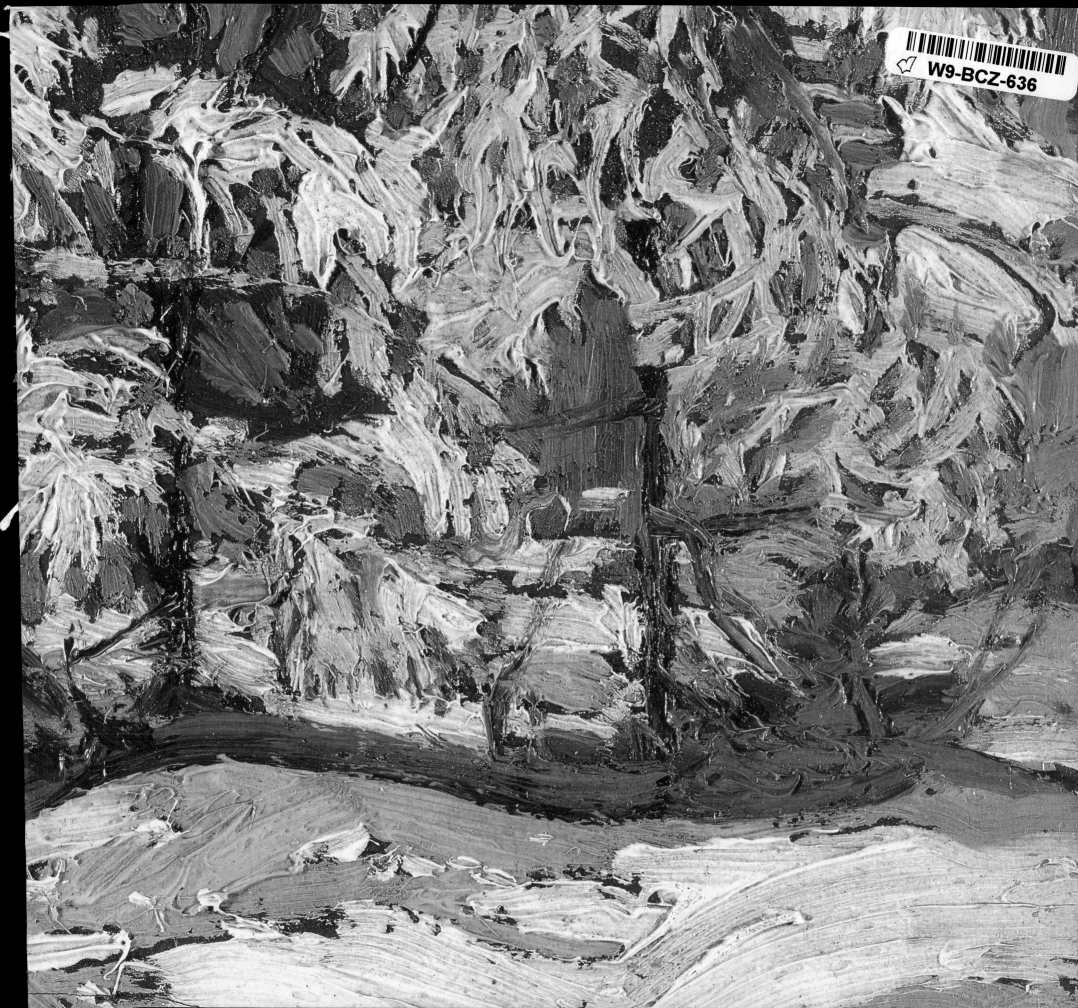

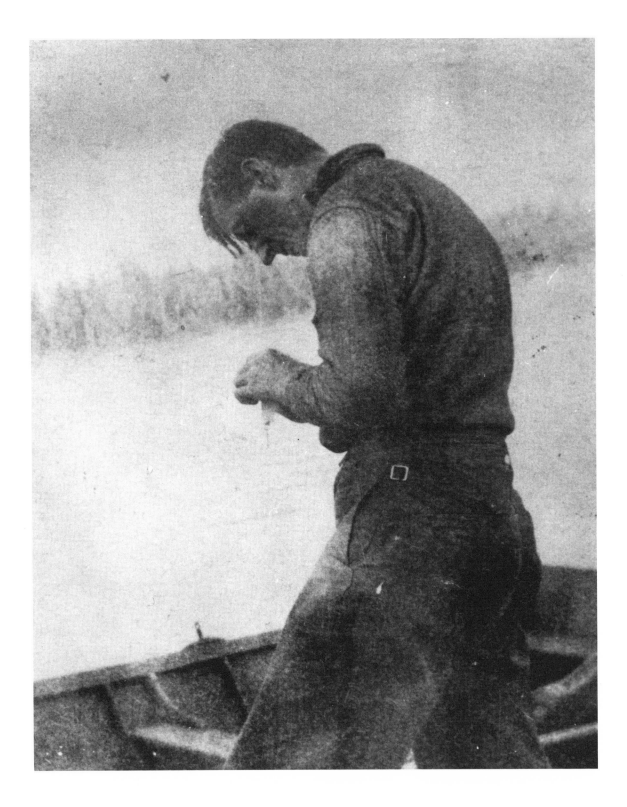

Edited by Dennis Reid

Essays by

Charles C. Hill, Andrew Hunter,

Dennis Reid, Robert Stacey

and John Wadland

Technical Studies by

Sandra Webster-Cook and Anne Ruggles

Chronology by

Joan Murray

Art Gallery of Ontario, Toronto

National Gallery of Canada, Ottawa

Douglas & McIntyre, Vancouver/Toronto

The Art Gallery of Ontario is funded by the Ontario Ministry of Citizenship, Culture, and Recreation. Additional operating support is received from the Volunteers of the Art Gallery of Ontario, Municipality of Metropolitan Toronto, the Department of Canadian Heritage, The Canada Council, and from gallery members and many corporations, foundations and individuals.

The exhibition and publication are supported at the Art Gallery of Ontario by the Department of Canadian Heritage Museums Assistance Program.

The National Gallery of Canada is funded by the Department of Canadian Heritage.

The national tour of the exhibition is supported by the Department of Canadian Heritage through the Canada Travelling Exhibitions Indemnification Program.

Canadian Heritage Patrimoine canadien

This book is published on the occasion of *Tom Thomson*, the exhibition organized by the Art Gallery of Ontario, Toronto, and the National Gallery of Canada, Ottawa, and circulated by the National Gallery of Canada.

Art Gallery of Ontario
317 Dundas Street West
Toronto, Ontario M5T 1G4

National Gallery of Canada
380 Sussex Drive, P.O. Box 427, Station A
Ottawa, Ontario K1N 9N4

Douglas & McIntyre
2323 Quebec Street, Suite 201
Vancouver, British Columbia V5T 4S7

Issued also in French under same title.

NATIONAL LIBRARY OF CANADA CATALOGUING IN PUBLICATION DATA

Main entry under title:
Thomson, Tom, 1877–1917.
Tom Thomson

Catalogue of a travelling exhibition first held at the National Gallery of Canada, June 7–Sept. 8, 2002. Co-published by: the Art Gallery of Ontario and the National Gallery of Canada. Includes bibliographical references and index.

ISBN 1-55054-898-0 (hardcover)

Thomson, Tom, 1877–1917—Exhibitions. I. Reid, Dennis. II. Hill, Charles C., 1945–. III. Art Gallery of Ontario. IV. National Gallery of Canada. V. Title.

ND249.T5A4 2002 759.11
C2002-910152-2

Frontispieces (in order of appearance):

Photograph of Tom Thomson, Canoe Lake, Algonquin Park (detail), likely photographed by Maud Varley, c. 1915–16, private collection.

Sketch for "The West Wind" (detail), spring 1916, oil on wood, 21.3 x 27.0 cm, Art Gallery of Ontario, Toronto, gift from the J.S. McLean Collection, Toronto, 1969, donated by the Ontario Heritage Foundation, 1988 (L69.49).

Photograph of Tom Thomson Sketching in Canoe, 1914, Arthur Lismer Papers, Edward P. Taylor Research Library and Archives, Art Gallery of Ontario, Toronto, gift of Marjorie Lismer Bridges (file 19).

Photograph of Tom Thomson at Lake Scugog, fall 1910, photographed by T.H. Marten, Tom Thomson Memorial Art Gallery, Owen Sound, Ontario, gift of Margaret Murch.

Design by Timmings & Debay
Editing by Alison Reid
Index by Heather Ebbs

Maps on pages 318 and 319 designed and created by James M. Britton, Peterborough, Ontario. Derived from original basemaps source © 2000. Government of Canada with permission from Natural Resources Canada.

Quotation beginning Andrew Hunter's essay written by The Tragically Hip, from Road Apples (Willowdale, Ontario: MCA, 1991) Copyright 1991 Roll Music/ Little Smoke Music (SOCAN).

Printed and bound in Canada by Friesens
Printed on acid-free paper

Douglas & McIntyre Ltd. acknowledges the assistance of The Canada Council and of the British Columbia Ministry of Tourism, Small Business and Culture. The publisher also acknowledges the financial support of the government of Canada through the Book Publishing Industry Development Program.

All dimensions of works of art are given in centimetres, height preceding width.

All plate numbers are catalogue numbers unless otherwise indicated.

Export Development Canada
Exportation et développement Canada

Simple and direct, yet powerfully evocative, Tom Thomson's artwork, like that of few other artists, captured the unique qualities of the Canadian landscape. He was Canada's most original painter during his lifetime, and his fresh, unique works are as captivating today as they were generations ago. Thomson's richly coloured interpretations of our northern landscapes — the sudden unfolding of spring, the dramatic sunsets of summer, the fiery hues of autumn, the cool light of early winter — continue to inspire us. His premature death in Algonquin Park cut short an astonishing and far too brief career.

Export Development Canada is proud to sponsor the Tom Thomson exhibition at the National Gallery of Canada, a major retrospective of his work. EDC has been helping Canadian exporters and investors successfully compete internationally for more than five decades by providing trade finance services and market information on some two hundred countries. We are dedicated to realizing the global visions of our customers and to enhancing prosperity for Canada. Our values uphold the importance of People, Excellence, Learning and Passion. Export Development Canada, sharing Thomson's commitment to this country, takes great pleasure in presenting the work of this legendary painter. His bold independence pointed Canadian artistic expression in innovative directions that to this day help define Canada on the world stage.

A. Ian Gillespie, President and Chief Executive Officer, Export Development Canada

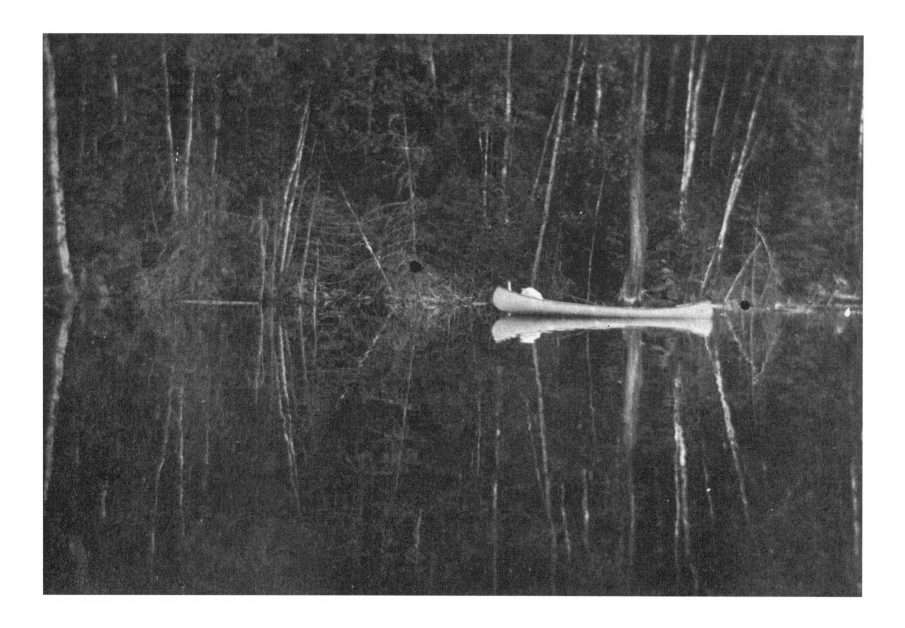

Contents

Directors' Foreword

The Art Gallery of Ontario and the National Gallery of Canada share a commitment to scholarship and research on the history of our Canadian traditions, but we have worked together to achieve this goal far too seldom. Our collaboration on this landmark Tom Thomson project, featuring a remarkable Canadian artist who is also a cultural icon, is particularly appropriate.

Thomson's first public exhibitions were at the Art Museum of Toronto (precursor of the Art Gallery of Ontario) and the National Gallery of Canada, which first purchased Thomson's work in 1914 and has long been its principal collection, as the recipient of the wonderful bequest of Dr. James MacCallum in 1944.

Our objective with this exhibition and accompanying publications is to take a fresh look at Thomson's life and times, to provide a perspective from the vantage point of new information, interpretations and methodologies.

Our joint project creates an image of a man more knowing, and more connected to his contemporaries, than we have thus far believed. It also links Thomson's art to the ideas and energies of his era in a way that deepens our understanding of the exalted position his works hold in the Canadian imagination. This is particularly gratifying to us.

Dennis Reid and Charles Hill, colleagues from our two institutions, have worked together to chronicle, document and analyze our heritage in this exhibition. It is our pleasure to warmly salute their contribution and that of their collaborators, Andrew Hunter, Joan Murray, Robert Stacey and John Wadland.

Thanks to the National Gallery's travelling exhibition program and to the Department of Canadian Heritage for its support through the Canada Travelling Exhibitions Indemnification Program, we are proud to share this signal exhibition with a broad national audience, at the Vancouver Art Gallery, the Musée du Québec and the Winnipeg Art Gallery. We are grateful for their involvement and assistance. We also wish to express our thanks to the many lenders, both public and private, whose generosity has made this exhibition possible.

The National Gallery of Canada especially thanks its presenting sponsor. Export Development Canada, a Crown corporation providing trade finance services that help Canadian firms compete internationally, is supporting the exhibition in Ottawa.

Matthew Teitelbaum, Director and CEO, Art Gallery of Ontario
Pierre Théberge, Director, National Gallery of Canada

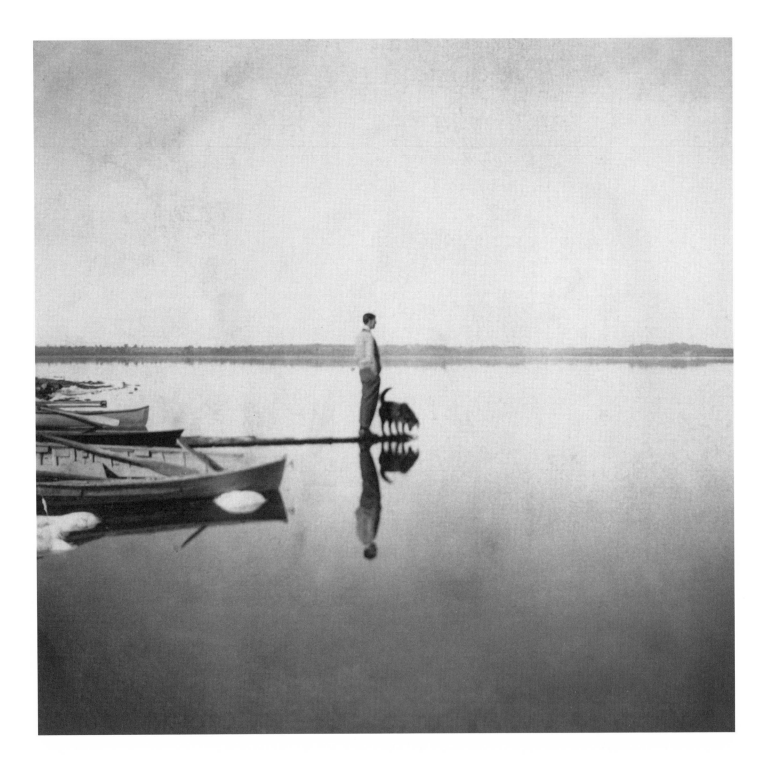

Acknowledgments

This book and the exhibition it accompanies are the two components of a joint project of the National Gallery of Canada and the Art Gallery of Ontario. Charles Hill took the lead on the exhibition, co-ordinated through the offices of the NGC, and Dennis Reid on the publication, which was the responsibility of the AGO. The selection of works for exhibition was made by a committee chaired by Hill, and all the paintings are reproduced in colour in this book. The selection committee comprised Hill, Reid, Andrew Hunter and Joan Murray. Hunter also contributed substantially to shaping the exhibition and this publication, and his focused research has been invaluable to the project's outcome.

Like all such research-based exhibition and publication projects, this one's core team owes a tremendous debt to numerous persons and organizations. Our first thanks must go to the private collectors, those who allowed us to see their paintings and those who generously agreed to lend, including Camp Tanamakoon Ltd., Alan O. Gibbons; and Phil Lind. Foremost is Kenneth Thomson, whose keen interest was central to the success of this undertaking. We must also thank those dealers who directed us to other private collections or who provided us with information on Tom Thomson works that had passed through their hands: Robert Heffel of Heffel Fine Art, and Peter Ohler, both of Vancouver; Doug Maclean of Canadian Art Gallery, Canmore, Alberta; Rod Green of Masters Gallery, Calgary; Douglas Udell of Douglas Udell Gallery, Edmonton; David Loch of Loch Mayberry, Winnipeg; John Morris, A.K. Prakash, Christopher Varley, Paul Wildridge of Roberts Gallery, Beverly Schaeffer of Sotheby's Canada, Erik J. Peters and Geoffrey Joyner of Joyner Fine Art, and Emmerich Kaspar of Kaspar Gallery, all in Toronto; and Eric Klinkhoff of Galerie Walter Klinkhoff, Montreal.

The staffs of the museums across Canada that are privileged to own works by Tom Thomson have been enormously supportive. We would like to thank Vincent Varga, Director, Sandra Cooke, former Registrar, Linda Morita, Librarian/Archivist, Catherine Stewart, Head of Collections, Megan Bice, former Curator, Harry Puno and Gary Kee, Technicians, at the McMichael Canadian Art Collection, Kleinburg; Stuart Reid, Director, and David Huff, Education Co-ordinator, Tom Thomson Memorial Art Gallery, Owen Sound; Kathleen Bartels, Director, Ian Thom, Senior Curator, Grant Arnold, Senior Curator, and Holli Facey and Danielle Currie, Rights and Reproductions, Vancouver Art Gallery; Virginia Stephen, Director, and Bruce Dunbar, Registrar, Edmonton Art Gallery; Dr. Patricia Bovey, Director, Mary Jo Hughes, Curator of Historical Art, Karen Kistiow, Registrar, and Anneke Shea Harrison, Assistant Collections Manager, Winnipeg Art Gallery; David Somers, Curator, Art Gallery of Peel, Brampton; Judith Nasby, Director, Verne Harrison, Registrar, and Dawn Owen,

Education and Collections Assistant, Macdonald Stewart Art Centre, Guelph; Louise Dompierre, Director, Tobi Bruce, Curator, and Christine Braun, Registrar, Art Gallery of Hamilton; Kim Ness, Director, McMaster Museum of Art, Hamilton; Clint Roenisch, formerly Curator, Kitchener-Waterloo Art Gallery; Brian Meehan, Director, and Barry Fair, Registrar, Museum London; James Campbell, Curator, The Weir Foundation, RiverBrink, Queenston; Laura Brandon, Curator of War Art, and Helen Holt, Manager, Art and Memorials, Canadian War Museum, Ottawa; Illi-Maria Tamplin, Director, Art Gallery of Peterborough; David Taylor, Curator, Gallery Lambton, Sarnia; Gillian Reddyhoff, Curator, Government of Ontario Art Collection, Ontario Archives, Toronto; Judith Schwartz, Director, The Justina M. Barnicke Gallery, Hart House, University of Toronto; Elizabeth Wylie, Curator, University of Toronto Art Centre; Janine Butler, Registrar/Librarian, Art Gallery of Windsor; and Jean-Pierre Labiau, former Curator, Montreal Museum of Fine Arts.

Numerous individuals have generously supplied information and photographs and responded to our requests. We would like to thank them all, but especially Anne Goddard, Jennifer Devine, Michael Eamon, Robert Fisher and Steve Moore, Archivists, National Archives of Canada, as well as the staff of the reference sections, circulation desks and photoduplication services at the Archives and National Library of Canada, Ottawa; Dr. Marie-Claude Corbeil of the Canadian Conservation Institute, Ottawa; Rick Stronks and Charlotte Woodley, Algonquin Park Museum and Archive; Christopher Laing, Seattle; Mary Mastin, Toronto; John F. Logan, Cobourg, Ontario; Paul Maréchal of Power Corporation, Montreal; Rachel Brodie of the Beaverbrook Art Gallery, Fredericton; Judy Dietz, Registrar, Art Gallery of Nova Scotia, Halifax; and Andrea Hines of Newport, Nova Scotia.

The staffs of the two organizing institutions have worked hard on this project, and at the National Gallery of Canada we are particularly grateful to Daniel Amadei, Deputy Director, Exhibitions and Installations; Karen Colby-Stothart, Chief of Exhibitions, and Diane Watier, Art Transit Officer; Marie Claire Morin, Director of Development and President and CEO, National Gallery of Canada Foundation; Jean Charles D'Amours, Chief, Corporate Giving; Serge Thériault, Head of Publications; Mark Paradis, Head of Multi-Media; Charles Hupé, Photographer; David Bosschaart, Designer; Cyndie Campbell, Archivist; Michael Williams, Photo Librarian; Steve McNeil of the National Gallery Library and Kathy Stone, Secretary to the Curator of Canadian Art. Beth Greenhorn, Curatorial Assistant, Canadian Art, has been an indefatigable researcher, her work crucial to the preparation of the exhibition and publication. At the Art Gallery of Ontario, our appreciation goes to Linda Milrod, Director of Exhibitions and Publications; Curtis Strilchuk, Exhibitions Registrar; Larry Pfaff, Deputy Librarian, and Randall Speller, Reference Librarian, Edward P. Taylor Research Library and Archives; Faye Van Horne, Head, Carlo Catenazzi and Sean Weaver, Photographers, Photographic Resources; Sherri Somerville, Assistant Manager, Design Studio; Sandra Webster-Cook, Paintings Conservator, and John O'Neill, Paper Conservator; George Bartosik, Manager, Exhibition Services, and his staff; and Akira Yoshikawa and Zbigniew Gorzelak, Art Storage Co-ordinators

in Registration. We are indebted as well to Heather McMichael and Vincent Stekly of Thomson Works of Art Limited. And many thanks, too, to Fred Schaeffer for his important contribution to the research.

Laura Brown, Curatorial Assistant to the Chief Curator, Art Gallery of Ontario, must be singled out for the immense care she brought to the co-ordination of the publication. And Yves Théoret, Exhibition Coordinator at the National Gallery of Canada, is to be congratulated for his superlative work.

We are also very grateful for the support of the institutions that will be receiving this major exhibition of paintings by Tom Thomson. Our thanks go to all the staff of the National Gallery of Canada, Vancouver Art Gallery, Musée du Québec, Art Gallery of Ontario and Winnipeg Art Gallery for the enthusiasm and professionalism with which they have undertaken the presentation, interpretation and promotion of the exhibition during its tour.

Our authors, as you will soon discover, have prepared provocative, informative essays, and our other contributors equally as useful and authoritative compilations of reference material,

which together reveal Tom Thomson in new ways and in unprecedented depth. This has been a truly co-operative project that has benefited greatly from the interaction and sharing of information among the participants. Our contributors have each added significantly to the outcome of both the exhibition and the book. Thank you, and congratulations, to Beth Greenhorn, Andrew Hunter, Joan Murray, Anne Ruggles, Robert Stacey, John Wadland and Sandra Webster-Cook.

We are grateful as well for the generous support of Scott McIntyre and Susan Rana of Douglas & McIntyre. Alison Reid, as editor, made countless improvements to the texts. Owing to the brilliant design by Mark Timmings and Emmeline Debay of Timmings & Debay, this is a visually splendid, easily accessible book that fully supports the project's goals of exploring both Thomson's art and the context of its production.

Finally, we thank each other. Earlier in our careers we worked together at the National Gallery for seven years (1972–79). It's a real pleasure to be collaborating again, and to have accomplished something that neither could have done as well alone.

Charles C. Hill, Curator of Canadian Art, National Gallery of Canada
Dennis Reid, Chief Curator, Art Gallery of Ontario

Mapping TOM

Andrew Hunter

Well, Tom Thomson came paddling past — I'm pretty
sure it was him. —The Tragically Hip, "Three Pistols"

He is a distant figure, moving past us, soon away from us. His features
are fading. His voice is faint. The cargo that weighs down his craft is
difficult to discern. What "baggage" does he carry on his journey? He
pushes across a deep pool of dark water that casts no reflection. It is a
dark void that begs to be filled. And it will be filled. Stories will be told.

—

Each time the song is sung, our notions of it change, and we are changed
by it. The words are old. They have been worn into shape by many ears

Figure 1 Tom Thomson, *Grey Day in the North* winter 1913 (detail),
oil on canvas, 22.0 x 71.3 cm, private collection.

and mouths and have been contemplated often. But every time is new because the time is new, and there is no time like now.

—Ciaran Carson, *Last Night's Fun: In and Out of Time with Irish Music*

⌐

Going North

⌐

Turn ye again, my people turn,
Enter my palace wild and rude,
And cheerily let your camp-fire burn
Throughout my scented solitude.

—Alan Sullivan, "The Call," 1912

⌐

When Tom Thomson arrived in Toronto from Seattle in 1905, going north was the thing to do. For health, leisure and character improvement, you followed "The Highway to Health and Happiness"[1] north, to the "highlands" of Ontario or Toronto, whether it meant a summer holiday or a move to the blossoming suburbs. Toronto was growing fast and, like most North American cities, swallowing up the surrounding countryside. A highly successful city of business and industry, it was an exciting place to live, but it was also becoming a dirty place, a place of fatigue, respiratory ailments and "brain fag." Toronto was no Dickensian London, but it was a place you needed to get away from to recover and rejuvenate.

If you could afford it, you joined "the movement NORTH"[2] to one of the new lush suburban developments "On the High-lands of Toronto."[3] England's City Beautiful Movement inspired the suburbs. The house designs reflected the æsthetics of the Arts and Crafts movement, and the California bungalow was extremely popular. The promotional literature for such housing developments was elegantly presented. In 1911 J.E.H. MacDonald of Grip Limited designed the printed material for Lawrence Park Estates. In 1912, while with the firm Rous and Mann, he designed a brochure for the Strathgowan suburb.[4] But the suburbs, for many, weren't far enough away from the city, so they summered on Georgian Bay or at Bala in the Muskokas or Kempenfelt Bay on Lake Simcoe, the "Summer Home of Leading Canadians."[5] Getting "Back to Nature"[6] was the emphasis in the marketing of both the suburbs and the northern holiday. In a promotion typical of the period, W.S. Davis, a real estate agent, stated, "Did you ever stop to think why it is that the man who has his little place in the country is a jolly, whole-souled, healthy, likeable chap, while his city-dwelling associate is, not infrequently, solemn, gruff and dyspeptic? Well, it is simply because the one has learned, direct from nature, her secret of perpetual youth, while the other has missed the real joy of living."[7]

Under the heading "Camping Out—Algonquin National Park" and featuring an image of campers and canoeists framed by birch trees, a Grand Trunk Railway advertisement encouraged northern holidays with anti-urbanism and the promise of rejuvenation: "Can you think of any better medicine for one worn out by excessive study, overwork or too close confinement to their business or profession, than a few weeks roughing it amid scenery and exhilarating air, where you may fish, canoe and bathe to your heart's content?"[8]

The key phrase here, *roughing it*, is misleading. The majority of the well-to-do who ventured north had summer homes or stayed at comfortable resorts like the Royal Hotel at Honey Harbour on Georgian Bay or the Highland Inn in Algonquin Park. Settled in for the summer, sojourners were catered to by hotel staff and hired guides, dined in fancy halls and attended lavish parties. Toronto society with all its trappings went north and was entertained.

Those who couldn't afford luxuries, or whose working hours made such extended escapes impossible, took day excursions—a steamer trip to Niagara Falls or Toronto Island, picnicking in High Park or fishing on the Don or Humber Rivers. Significant improvements were made to High Park, and in 1911 the Humber Valley from Lake Ontario to Dundas Street was the focus of a major park development that included boathouses, landscaping and pathways.

Many did make trips north, and advertising catered to this group as well. Primarily young men, but also young women, took up camping and fishing. Such activity could be transformative; it could build confidence and character. For women, being away from the dictates of Toronto society could be a liberating experience.[9] For men, it encouraged the development of the "manly" virtues. The cover of the August 7, 1909, issue of *Toronto Saturday Night*, showing a man patching his canoe on the shore of a northern lake, with the caption, "And He Was a Clerk Only Yesterday," says it all. The philosophy of the day was that people were getting soft (both physically and morally). Nature and the primal experience would ameliorate this condition.

For its attractions during the summer months, the North was heavily promoted. Not just the resorts and railway and steamer services, but fishing tackle and camping gear were marketed alongside the latest outdoor essentials: "The Victor-Victrola is an important part of the camping outfit . . . particularly enjoyable on the water."[10] Ganong's Chocolate advertised its products' "Delicious fruits, crisp, flavoury nuts, and delicate sweet meats," with a picture of a young couple picnicking on a shore, their canoe on a beach.[11] Eaton's was selling a new tent, "The Little Brown Bungalow of Your Dreams."[12] A Kodak camera was needed to "Keep the fun of vacation days."[13] The A.T. Reid Company of Toronto, a haberdashery, extolled a "New Pleasure this summer," their "Shure two Slip Cravat,"[14] which would go well with the "right" collar from "Challenge Brand Waterproof Collars & Cuffs."[15] Both ads showed young men canoeing in shirt and tie. Readers were encouraged to build their own cottages and to get "Back to Nature in a Russell. . . . When you hear the *call of the wild* you load yourself and your friends into the roomy tonneau, and rush away to the Northern Lakes."[16] In 1913 the Russell 38 touring car would set a buyer back $5,000.

Encouragement to discover nature was not new in the early 1900s. Outdoor activities had been widely advocated in the late 1800s in books like *Our Own Country Canada*[17] (fig. 2) and *Picturesque Spots of the North*.[18] The appeal of the North was certainly not new to Tom Thomson when he arrived in Toronto. The area around Owen Sound on Georgian Bay, where he grew up, had been a popular destination for sportsmen and boaters for many years. In Seattle, where he had just spent at least three years, the popular press proclaimed nature's allure with a vigour equal to that of their Toronto colleagues. The *Seattle Mail & Herald* regularly

Figure 2 "Bits in Muskoka," from W.H. Withrow, *Our Own Country Canada*, . . . (Toronto: William Briggs, 1889).

included material on camping and fishing. Calling itself "A Social and Critical Journal," the *Mail & Herald* also devoted a substantial amount of space to coverage of the arts. The photographer Edward S. Curtis would appear twice on its cover in 1904 — on July 30 after being "summoned" to photograph President Theodore Roosevelt,[19] and again on November 26, once he had become "famous the world over" for his "Indian pictures."[20] The success of Curtis's "Indian" photographs reflected the public's fascination with nature and the "primal," which they clearly associated with Native Americans. Curtis's portrait subject Teddy Roosevelt was a major proponent of America's National Parks (which predated and provided the model for Canada's National and Provincial Parks) and the wholesome pastimes of hunting, fishing and riding. Thomson's brother's Acme Business College was a regular advertiser in the *Mail & Herald*, as were his employers Maring and Blake and then the Seattle Engraving Company, the latter taking over the cover design of the *Mail & Herald* in 1904.

"They ain't no place this side of Nepigon [*sic*] in the backwoods of Canada for speckled trout like the Petawawa." That's what old Tom Salmon had told us, and a man with a name and a personality like Tom's ought to know something about fish.

—Sid Howard, "Down on the Petawawa," *Toronto Saturday Night*, June 25, 1904

In Toronto, the North was also promoted in the numerous fishing, hunting and travellers' tales printed. The northern experience

was extremely prominent in the newspapers' "women's sections." Articles such as "Housekeeping in the Forest"[21] were common, along with descriptions of the appropriate outdoor fashions and suggestions for dealing with the seasonal help, like fishing guides and hotel employees. Algonquin Park staff contributed regularly to *Toronto Saturday Night*. The park's superintendent, G.W. Bartlett, wrote a number of pieces, including "The Beaver in His Native Home"[22] and "The Menace of the Timber Wolf."[23]

Beginning in 1909, the park ranger Mark Robinson, who would become one of the most quoted sources on Tom Thomson, wrote often for the periodical about the park and its wildlife. Also typical were poems about fishing and the wilderness, romantic tales set in cottage country and wild adventure stories. Arthur Heming, an artist, writer and illustrator, was one of the most prominent creators of fiction. His stories like "Beyond Man"[24] are classic examples of the kind of adventures of derring-do in the wilderness that carried on the tradition of stories from Victorian *Boy's Own* annuals that the Monty Python alumnus Michael Palin would later refer to as "Ripping Yarns!" Heming was not alone in publishing his popular romantic visions of the wilderness, which are also found in the writings of Jack London, James Oliver Curwood and Robert Service, and by 1912, when Tom Thomson made his first trip north to Algonquin Park, Ernest Thompson Seton (1860–1946) was a widely read author and influential naturalist.[25]

Seton's animal "biographies" and woodland adventures, contained in his books *Wild Animals I Have Known*, *Lives of the Hunted* and *Two Little Savages*, defined, both in Canada and the United States, a new idea of the wilderness and humanity's relation-

ship to it. Seton's concept of conservation differed radically from that practised by Algonquin Park staff, engaged in the ongoing program of wolf extermination described by Bartlett in the article cited above. For Seton, humanity was part of nature, which was to be respected and learned from, and his ideas were strongly linked to romantic stereotypes of Native peoples. For Bartlett and his staff, "man" had the God-given right to modify and manage nature, and during Thomson's time, this philosophy prevailed. But while the messages were contradictory, both served to promote the North. Seton sold the idea of the wilderness as a physically, mentally and spiritually healthy place where important life lessons could be absorbed, primarily by young people. It was an attitude shared by the Boy Scouts[26] and the founders of Algonquin Park's Camp Northway for girls at Cache Lake (1908) and the Pathfinder Boys Camp at Source Lake (1914). Bartlett's message let people know that the North was safe and under control, and further, that they belonged there. Stories like one by J. Harry Smith served to reinforce this idea; it begins, "This is the uneventful tale of a canoeing jaunt through a few of the lakes that lie toward the south-west corner of Algonquin Park."[27] A year after its publication, Tom Thomson would step off the train at the same spot where Smith had started his "jaunt."

As a site of tourism, the "Highlands of Ontario" were becoming easily accessible, and not everyone was thrilled with this change. Ideological clashes became common between proponents of the new tourism of leisure, with its amenities, and those who wanted to maintain their North as a place for solitude and adventure. Sherwood Hart captures this friction well in his poem "That Old

Canoe." After reminiscing about his boyhood adventures in "the old birch bark," fishing and swimming by a secluded "log settlement school," Hart laments:

There's a summer hotel by the Settlement now,
with launches and gay canoes,
And the folks hang around in white, starched duds,
and Pipe-clayed canvas shoes,
And a guide takes you and your new steel rod,
and your fancy, high-priced bait,
And he shows you where to try your luck,
and you do as You're told — and wait![28]

Hart's poem reflects the attitude of writers like Heming and many sportsmen who felt that the North, at its best, was where man tested himself against the elements. It was not only a place to be isolated from the softness of civilization but also a place to find invigorating challenges and danger. The same sensibility is captured by the writer Aubrey Fullerton: "If half the things that men have gone through in the West and North were known — half the nightmares, and perilous journeys, and skin-of-the-teeth escapes — we would have the makings of a Library of Real Life Heroism and wonderful experiences surpassing fiction. For the West and the North are where strange things happen, the land of patient bravery and reckless bravado."[29]

For those who went north on holiday, the apparent adventure and risk-taking were in fact more often performance and play than reality. As at other tourist destinations in Canada, parties were chaperoned through the wilderness and catered to at evening camp, if

they hadn't simply returned to their hotels. Vacationers dressed the part, too, as was satirized in a 1906 cartoon showing a well-dressed guide (who looks remarkably like Mark Robinson) and his roughly dressed party (fig. 3).[30] In contrast to the majority of tourists, however, some few went north for the "real" experience and truly attempted to "rough it"; their interest in the wilderness tended to be philosophical. Tom Thomson certainly fitted this mould.

All up "The Northern" on a summer's day,
The artist may bright scenes in landscape take;
The busy Crescent on Kempenfelt Bay,
Barrie and Consort, Pride of Simcoe Lake.

— A Toronto Boy, from "Canada First:
An Appeal to All Canadians," 1880

By the time Thomson went north, the cultural community had been for a number of years looking for rejuvenation in the vast natural wilderness. This was, they believed, the landscape that distinguished Canada from the cultivated pastoral worlds of England and Europe. Canada would be defined as wild and rugged, reflecting the Victorian ideals of hearty confidence and vigour. Canada would be a strong, healthy nation, a world leader, well prepared for "arduous labours the future has in store."[31] The idea of Canadians at home in untamed nature became popular, as did embracing the country's vastness and resource potential. This idea of the North quickly evolved from the gentility of Hart's poem to something much hardier and more virile in tone. The scenes and

experiences artists went looking for after the turn of the century were not those described by "A Toronto Boy." Artists like Thomson's Grip colleague Tom McLean were searching for much more rugged places, the kinds depicted in the 1900 *Canadian Calendar* designed by the Toronto Art League.[32] The calendar included images of the North not only as a vast wilderness but also as a site of industry—mining, logging and hydroelectric development. Among its illustrators were league members David Thomson (no relation to Tom) and C.W. Jefferys. To find this North, one had to live it, had to "Hear the challenge, learn the lesson, pay the cost," as Robert Service had declared in his poem "The Call of the Wild,"[33] and Thomson would certainly "pay the cost."

Gone Fishing

I'm quite sure it was Tom's first visit to Algonquin Park. Tom McLean, a Toronto artist who was located with us at the Grip, gave us a letter of introduction to the elder Mr. Bartlett, who was superintendent of the park at the time. McLean told us of the beauty and fine fishing in that region and Tom and I thought we would try it.

—H.B. Jackson, in a letter to Blodwen Davies, May 25, 1930

When Tom Thomson arrived in Algonquin Park with his friend H.B. (Ben) Jackson in the spring of 1912, he was not heading north as a serious artist. Painting was an activity that Jackson felt Thomson did not think "would ever be taken seriously; in fact,

Figure 3 "Did You Ever Notice That on Fishing Trips, the Guide Tries to Dress like a City Chap, While the City Men Make Desperate Efforts to Look like Bushrangers?," cover, *Toronto Saturday Night*, July 28, 1906.

Figure 4 H.B. Jackson, *Tom Thomson, Rainy Day in Camp*, 1912, oil on canvasboard, 25.3 x 17.5 cm, National Gallery of Canada, Ottawa, purchase 1929 (3690).

he used to chuckle over the idea." According to Jackson, he and Thomson were "spending our holidays and weekends in the country sketching-fishing. . . .

"If it was a rainy day we would stay in camp, Tom would clean his pipes and read Walton's *Compleat Angler*."[34] It was on such a day that Jackson painted *Rainy Day in Camp* (fig. 4). Thomson sits still, quiet and contemplative, just as he should, according to Izaak Walton's instructions. Published in 1653, Walton's *Compleat Angler, or The Contemplative Man's Recreation* has become a bible for the fisherman. In it, one can study Walton's "Observations of the PERCH and how to fish for him" or get "Directions for making of a Line, and for the colouring of both Rod and Line." Early editions of the book include fine engravings by Lombart F. Vaughan, based on the works of a number of English artists, of individual fish and anglers at idyllic spots in rural England. Thomson's early ink drawings of anglers in the countryside are remarkably similar to these illustrations.

But Walton's book is more than just a field guide; it passes on a code for living, one distinctly at odds with the aggressive, survival-of-the-fittest attitude that was coming to dominate the modern world of Toronto. Walton's philosophy echoes down through Henry David Thoreau's *Walden, or Life in the Woods*, 1854, and the romantic ideals of a rural past that William Morris had propagated through the Arts and Crafts movement in England. It inspired books like *The Beech Woods* by Duncan Armbrest, published in Toronto in 1916, which encouraged the reader to be rejuvenated by the peaceful contemplation of nature. We can even hear Walton paraphrased in the language of the advertisements for the new suburbs quoted above. "It breathes the very

spirit of innocence, purity, and simplicity of heart," Charles Lamb told Samuel Taylor Coleridge. "It would sweeten a man's temper at any time to read it; it would Christianize every angry, discordant passion; pray make yourself acquainted with it."[35]

Until 1912 Thomson's excursions from the city seem little different from the day trips and holidays that many of his contemporaries were taking. Camping and fishing trips short distances from the city that included sketching or photographing of the scenes were certainly not new or remarkable pastimes. Thomson appears very much a working man of his day, enjoying nature and the countryside during his off hours. It is clear, however, that his trips throughout the North in the summer of 1912, first with Ben Jackson in the southwest corner of Algonquin Park and then, after being joined by Thomson's design studio colleague William Smithson Broadhead, through the Mississagi Forest Reserve west of the park, mark a turning point in his life, a life that previously seemed to lack focus. Very little of what we know of Thomson prior to 1912 would suggest the person who emerged in Algonquin Park, a man whose embrace of the North reads as a strong rejection of the urban culture of Toronto and an act of near communion with the bush. This is what makes his reading *The Compleat Angler* so fascinating. The details of Thomson's life over his final years seem to reflect a strong identification with Walton's message.

Tom Thomson had been fishing throughout the rural countryside around Leith since he was a young boy, and his skills as an angler made him comfortable in nature and clearly provided him with a valuable skill for surviving alone in Algonquin Park. Being in the North, away from the city, further provided Thomson with

the setting to lead Walton's "contemplative" life. This impression of Thomson as a "follower" of Walton's is reinforced by his sister Minnie Henry, who, in a letter to Blodwen Davies, quoted the following passage from *The Foot Path of Peace* by Henry Van Dyke, the poet and First World War U.S. naval chaplain, in an effort to define her brother's character. It was a passage that Thomson himself had quoted in a pen-and-ink work.

To be glad of life because it gives you the chance to love, and to work and to play, and to look up at the stars; to be satisfied with your possessions, but not content with yourself until you have made the best of them; to despise nothing in the world except falsehood and meanness, and to fear nothing except cowardice; to be governed by your admirations rather than your disgusts; to think seldom of enemies, often of your friends, and everyday of Christ, and to spend as much time as possible, with body and with spirit in God's out-of-doors — these are little guide-posts on the foot-path to peace."[36]

Ben Jackson confirms this image of Thomson. "Tom was never understood by lots of people, was very quiet, modest and, as a friend of mine spoke of him, a gentle soul. He cared nothing for social life, but with one or two companions on a sketching and fishing trip with his pipe and Hudson Bay tobacco going, he was a delightful companion. If a party or the boys got a little loud or rough Tom would get his sketching kit and wander off alone. At times he liked to be that way, wanted to be by himself commune with nature."[37]

Thomson affirmed the image of himself as a loner who disliked the social atmosphere that accompanied much of the northern

experience in a letter to Fred Varley sent from Go-Home Bay in the summer of 1914. He had been spending a few weeks at the cottage of his benefactor, Dr. James MacCallum, but he had clearly had enough. "I am leaving here about the end of the week and back to the woods for summer. Am sorry I did not take your advice and stick to camping. This place is getting too much like north Rosedale to suit me—all birthday cakes and water ice, etc."[38]

By the summer of 1914, Thomson's idea of the North was firmly established, and it was not the posh cottage life. His raw sketches, produced since the summer of 1912, including even those he painted while on Georgian Bay such as *Cottage on a Rocky Shore* (pl. 28) confirm his aversion. His letter to Varley is extremely valuable, as it contains one of the few firm statements by him about the northern experience, echoing the annoyance voiced in Sherwood Hart's poem above.

Although his painting came to define his life in the eyes of others, Thomson never abandoned his love of fishing. In fact, it seemed to be a primary determining factor in his movements throughout Algonquin Park, where he continues to be remembered equally as an artist and angler.[39] "It appears that Tom Thomson is some fisherman, quite noted round here," A.Y. Jackson claimed in a 1914 letter from Canoe Lake to J.E.H. MacDonald.[40] Thomson's skills as a fisherman, and as a cook of the catch, would be consistently commented on by friends and fellow artists in support of their position that he seemed completely at home in nature. Of the few known photographs of Thomson, the most often reproduced show him as a fisherman. Near Canoe Lake, he stands behind a line of trout hung from a wire fence (fig. 12, p. 39).

In another image he is hunched over, baiting his line (see frontispiece, p. 2). In the most often reproduced photo, he is perched in mid-cast atop a little rock in his signature "oil-tanned shoe-packs,"[41] which nobody else wore (see back of dust jacket).[42] There is only one known photograph of Thomson painting (p. 10). He did take some himself—two trout, a baking fish, and his close friend Winifred Trainor holding a catch. His love of fishing would be reflected in his work, not just in the paintings that depict fishing directly, such as *Little Cauchon Lake* (pl. 96) and *Autumn, Three Trout* (pl. 109), but in the sites he often chose to paint.

I care not, I, to fish in seas;
Fresh rivers best my mind do please,
Whose sweet calm course I contemplate,
And seek in life to imitate.

—Izaak Walton, from "The Angler's Song," *The Compleat Angler*

According to Walton, the trout "is a fish that feeds clean and purely in the swiftest streams." So, perhaps, it wasn't the society atmosphere that chased Thomson away from Go-Home Bay and back to Algonquin Park. Maybe the fishing just wasn't as good, or to his liking. But one thing is for certain: unless he was working as a guide, fishing was not a "party" experience for Thomson.

There are numerous photographs of groups fishing around Georgian Bay, throughout the Muskokas and in Algonquin Park that date from Thomson's time and the decades prior. Most depict

fishermen led by hired guides. In many of these images, the catches are phenomenal. Anglers were not practising the "catch-and-release" method; fish were a bountiful resource. A 1905 photograph of a party at Monteith House on Lake Rosseau proudly displays two strings of salmon, totalling twenty-eight fish. Closer to Thomson's base, a postcard shows tourists and a string of over thirty fish at Canoe Lake in the summer of 1916.[43] Thomson did not fish in such parties. He wasn't led around by guides and shown the best spots. He found them himself, and these places show up in his paintings[44] — rapidly moving streams, flooded shorelines and the foot of lumber dams. Early works like *Drowned Land* of 1912 (pl. 5) show ideal fishing territory, the edge of a lake where flooded trees have died and dropped over, providing good hiding and breeding places for fish. As can be seen in the photographs of the Hayes fishing party (fig. 5), the foot of a lumber dam was a prime fishing spot. Structures like this show up in numerous Thomson works, including *Old Lumber Dam, Algonquin Park* (pl. 3), *Tea Lake Dam* (pl. 60) and *Timber Chute* (pl. 61). Most of them were still in use during Thomson's time.

Industrial Park

Oh, come all you jolly shantyboys wherever that you be. . . .

—Opening line of "The Jam on Jerry's Rocks," from *Lumbering Songs from the Northern Woods*, 1985

In an hour or so we enter a little cove just beyond the burnt island seen from the camp. There, a short distance right ahead,

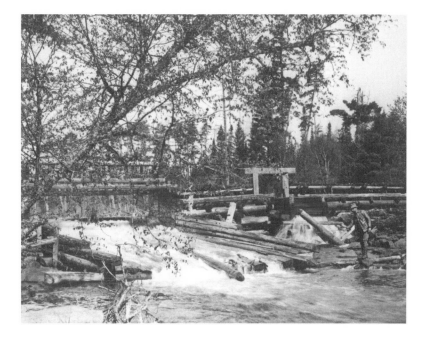

Figure 5 The Hayes Fishing Party, Algonquin Park, c.1897. Algonquin Park Museum and Archive (APM #63).

is a newly built timber dam and slide — another evidence that the axe of the lumberman will be heard in these woods during the approaching winter.

—James Dickson, *Camping in the Muskoka Region*, 1886

Images of lumbering are frightening, with huge tracts of land cleared by logging, then burned over. This was not a clean industry that saw timber as a "renewable resource" but one that literally slashed and burned its way across the landscape. White pine was the primary target on the east side of Algonquin Park, and there were still significant stands of old-growth forest in the park in

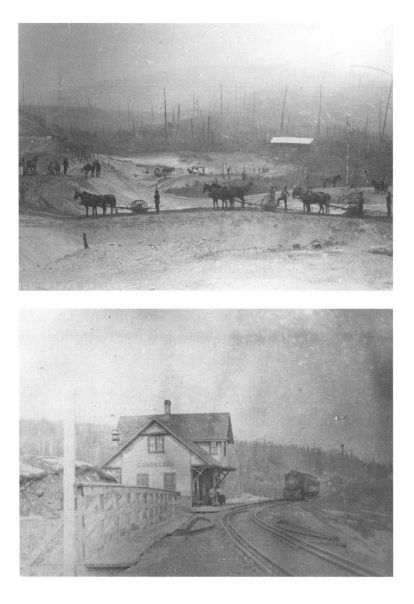

Figure 6 "Big Fill," building the Ottawa, Arnprior and Parry Sound Railway through the southeast section of Algonquin Park, 1894. Algonquin Park Museum and Archive (APM #128).

Figure 7 GTR passenger train pulling in to Canoe Lake Station, 1915. Algonquin Park Museum and Archive (APM #28).

Thomson's day. On the west, both pine and hardwood were harvested, but the trees weren't selectively culled; everything was taken out, leaving behind the dry "slash," which could be easily ignited by lightning or sparks from a passing train. The hill behind Canoe Lake Station fell victim to such a fire around 1916, when a Grand Trunk Railway engine ignited the recently logged hillside.

Contrary to the popular impression of Algonquin Park as a pristine wilderness, the landscape and waterways that Thomson navigated were part of a highly controlled space with a significant industrial history. The Grand Trunk Railway certainly tried to deny this history, describing the park as "an unspoiled territory."[45] A hand-annotated map, showing the patchwork of logging limits that completely covered the park in 1894–95, 1904–05 and 1912–13, gives ample evidence to the contrary (fig. 8). Logging was a constant presence during Thomson's years, and the lumber industry had done much to define Algonquin Park. J.R. Booth's company brought the railroad through. Lumber companies dammed rivers and lakes, dramatically changed the water levels and clear-cut much of the landscape. In his editorial notes to the republication of James Dickson's 1886 book *Camping in the Muskoka Region*, Gary Long states that "the modern canoe tripper will scarcely recognize Dickson's description"[46] of Canoe Lake, a place of "picturesque beauty" from which one could view "land high and mountainous, topped with a dense forest of pine."[47] In the 1890s, the logging firm Gilmour and Company had established a permanent settlement at Canoe Lake. The tourism industry followed the lumber companies and benefited from their infrastructure, taking over buildings and rail lines, and as noted above, some structures

built for logging created some very good fishing sites. Mowat Lodge and many of the summer cottages on Canoe Lake were the remnants of Gilmour's disastrous attempt to log the area and float their cull, via tramway, over the height of land and down the Trent watershed to a sawmill at Trenton.[48] Period photographs of the area, including one by Thomson (see fig. 54, p. 102), show that the remains of the Gilmour chipyard covered a huge area at the north end of Canoe Lake near Potter's Creek. According to Rose Thomas, who lived with her parents at the Canoe Lake Station, there were no trees in the area when they arrived in 1914.[49]

The lumber industry is present in Thomson's work both in what is obviously depicted, such as dams, pointers, alligators (see fig. 53, p. 102)[50] and drives, and, less obviously, in the landscape. Early sketches such as *Canoe Lake* (pl. 14) and *Red Forest* (pl. 15) show terrain above the shore that has been dramatically altered by logging. Even Thomson's many paintings of white birches are responses to a landscape influenced by the industry. White birch has always been present in Algonquin Park as a "fringe" species around lakeshores, but it does extremely well in "sunny, open areas whose previous tree cover had been removed."[51] It seems logging created much of the extensive stands of white birch that Thomson loved to paint.

The presence of logging is more obvious in works like *Canoe Lake, Mowat Lodge* (pl. 30), where the history of occupation and change has created a pattern across the landscape. Paintings like *Fire-Swept Hills* (pl. 59) and *Burnt Land at Sunset* (pl. 52) are incredibly intense responses to the ravaged earth. Thomson would have been quite familiar with the relationship between lumbering

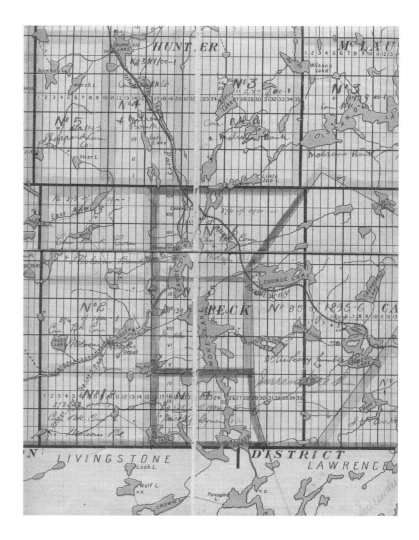

Figure 8 Hand-annotated map of Algonquin National Park of Ontario showing timber limits for 1894–95, 1904–05 and 1912–13, Copp Clark Litho map, c. 1900, pencil and red ink. Algonquin Park Museum and Archive (Q2.1.5).

and fire. He worked as a fire ranger in the summer of 1916, the year he produced *The Jack Pine* sketch (pl. 97), ironically another "fringe" tree that thrives following the major destruction of logging or forest fire.[52]

Intentionally or not, Thomson didn't paint just the aftermath of logging; he produced a number of powerful and poetic images of the industry in action, both in Algonquin Park and in the regions surrounding the park, like the Magnetawan River. Major canvases such as *The Drive* (pl. 130) and *The Pointers* (pl. 127), sketches like *Bateaux* (pl. 106), *Tea Lake Dam* and *The Alligator, Algonquin Park* (pl. 110) and the various views of lumber slides/chutes all testify to the artist's engagement with the industry. What Thomson's true feelings were is a mystery, but it seems unlikely that he held a present-day environmentalist's negative view of lumbering. He appears, on the other hand, to have seen the industry as a significant part of his environment. His images of the lumber trade are part of a range of imagery showing that his idea of the North was far more expansive than birch groves and lone pines. He appears to have accepted the complexity of the economy and culture, and it is reflected in his work.

On the Opeongo Line
I drove a span of bays
One summer once upon a time
For Hoolihan and Hayes.
Now that the bays are dead and gone
And grim old age is mine,

A phantom team and teamster start
From Renfrew, rain or shine —
Aye, dreaming, dreaming, I go teaming
On the Opeongo Line.

—From "The Opeongo Line,"
Lumbering Songs from the Northern Woods

Figures do not often appear in Thomson's paintings. There are a few sketches of specific people like *In the Sugar Bush* (pl. 45), a "portrait" of Shannon Fraser, who ran Mowat Lodge, but in most cases the figures are in the distance. The little fisherman at the bottom of *Little Cauchon Lake*, the tiny figures in the far pointer in *Bateaux* or the river drivers atop the dam in *The Drive* and *Tea Lake Dam* all tend to blend into the scene. Even in *The Pointers*, the line of red boats with their crews are not immediately visible, overwhelmed by the colourful autumn foliage on the far shore. The absence of people conforms with the common view of Thomson's northern experience as a man alone in the empty wilderness. But like the tourists he guided and the residents of the Canoe Lake area, Thomson would have had regular contact with the lumbermen. Certainly during his stint as a fire ranger, such contact was unavoidable.

While working on a drive for the J.R. Booth logging company in 1916, Peter Sauvé claimed to have met Tom Thomson at Achray on Grand Lake. At the time Thomson was a fire ranger stationed with Edward Godin. Sauvé described his brief contact with Thomson in an interview with Taylor Statten around 1970.

He went fishing with Thomson, said he was "nice" and "a perfect gentleman." He watched Thomson by the dam at the foot of Grand Lake paint what "we were told was a log drive."[53] When asked what the other river drivers thought of Thomson, Sauvé replied, "The other men thought the man was foolish . . . out of his head, all his thoughts and everything, when he was bored. They didn't know anything about a painter." He claimed that Thomson and Godin would sometimes "board with us" and that Thomson would "sit and talk with the men."[54] What Thomson talked about with the men Sauvé didn't say. It is, however, worth speculating.

When the lumbermen came up the Petawawa and into the Algonquin Park area, they didn't just bring the axes James Dickson mentioned in 1886. They also introduced a deep culture of songs that had spread west from the Maritimes, through Quebec, up the Ottawa Valley and throughout major American logging regions like Maine, Wisconsin and Minnesota. Documented in detail by the folk music specialist Edith Fowke in *Lumbering Songs from the Northern Woods*,[55] these songs tell a history of the lumbering experience from the workers' perspective. It is, like much of Thomson's history, an oral one. The songs tell of the hard life in the camps during the long winters when the cutting was done. They recount romantic tales of the shantyboy and his girl, and there are songs of tragedy, of death on the drives, an extremely common occurrence. The classic and best known of these songs are "The Jam on Gerry's Rocks" and "Johnny Murphy," which could be found from Prince Edward Island to Minnesota and beyond. In each of these examples, the death of one or many river drivers occurs

Figure 9 Two men breaking a log jam, Algonquin Park, Algonquin Park Museum and Archive (APM #383).

during the breaking of a log jam. "Lost Jimmy Whelan" also tells of a young river driver lost in a jam.[56] This ballad became widely popular, according to Fowke, with the name sometimes changing to Johnny Doyle or Jimmy Judge.[57] In folk music, an earlier narrative is often used as the framework for a new story. The folklorist A.P. Hudson termed this *rifacimento*.[58]

As he sat in the evening "talking to the men," I wonder if Thomson heard these songs. Apparently he liked music, so one can imagine his sticking around when the fiddling started and the songs began to flow. Did he hear "The Jam on Gerry's Rocks"? Did he know of poor Jimmy Whelan? Could he sing the song?

Just as he spoke the jam it broke
And let poor Whelan through.
The raging main it tossed and tore
Those logs from shore to shore,
And here and there his body went,
A tumbling o'er and o'er.

—From "Lost Jimmy Whelan"

Among Thomson's logging scenes, there is a rather strange and haunting sketch. In *Crib and Rapids* (pl. 62)[59] Thomson has positioned himself and the viewer as if we are hurtling down the chute, like a theme park waterslide, heading for the turbulence. At the foot of the chute, logs disappear into the froth of white water. Two have emerged, forming a perfect cross. The cross seems so obvious and perfectly positioned that it is hard to believe it wasn't intentional, a kind of message from Thomson, having listened to the songs and witnessed the wooden markers along the edges of rivers where lumbermen were "lost." But then again, maybe there is nothing unusual about this painting. Perhaps I am reading this scene through Jimmy Whelan's story or the one I've heard of a young river driver who tried to cool off one hot summer day by riding down the chute, only to die horribly by drowning or by vicious battering of the logs. After all, I wouldn't be the first to see the foreboding of tragedy in Thomson's work or read what I wanted to into his life.

Arthur Heming's painting *Canadian Jamcrackers* (fig. 10) gives us a scene consistent with the tragedy described in "Lost Jimmy Whelan." A lone river driver rides his last log into the abyss, watched over by the crosses of those who have gone before. It's pure melodrama. Heming even includes the giant hand of Death reaching up out of the dark waters from beneath the falling man. The image is in keeping with Heming's idea of the North that he had so successfully promoted, a place of macho risk-taking. "He used to mention a man named Heming," Edward Godin told Blodwen Davies in 1931, recalling Thomson.[60] That Thomson would have shown an interest in Heming is not surprising, as the latter was one of the original residents of the Studio Building and, as noted, an extremely successful writer. According to A.Y. Jackson, "[Lawren] Harris hoped he'd inspire a northern movement." But Jackson was dismissive of Heming, claiming his highly respected knowledge of the North was false. Jackson stated, "In his book, *The Drama of the Forest*, he writes that he made twenty-three trips into the north country. I do not remember

that he ever mentioned the north country or expressed a desire to go there."[61] Heming wasn't around to defend himself when Jackson published his claims in 1958. But if Jackson is right, Heming would not have been the first, or the last, to exaggerate or embellish their own, or another's, relationship to the North. Within the Thomson lore, Heming the artist would not be a factor to artists like Jackson. But the ideas of the North that Heming perpetuated would certainly have been echoed by many of Thomson's supporters, including Jackson and the Group of Seven.

He knew the woods as the Red Indian knew them before him. . . . He knew the craft of the woodsman. . . .

Never before had such knowledge and the feeling for such things been given expression in paint. Thomson's canvases are unique in the annals of all art especially when it is remembered that he was untrained as a painter. His master was Nature.

—F.B. Housser, *A Canadian Art Movement: The Story of the Group of Seven*, 1926

Tom Thomson is the manifestation of the Canadian character.

—Arthur Lismer, *The McMaster Monthly*, January 1934

An impression of Thomson quickly emerged after his "mysterious" death in the summer of 1917 and has had remarkable longevity; it is a portrait that could have been crafted by Arthur Heming. This idea of Thomson was fostered by the Group of Seven and in such publications as F.B. Housser's *Canadian Art*

Figure 10 Arthur Heming, *Canadian Jamcrackers* 1933, oil on canvas, 81.3 x 121.9 cm, Philip B. Lind.

Movement and Newton McTavish's *Fine Arts in Canada*. A.Y. Jackson, Arthur Lismer, J.E.H. MacDonald, Albert H. Robson, Barker Fairley, Harold Mortimer-Lamb and Dr. James MacCallum all published biographical portraits of Thomson, and almost all maintained the same basic details. Thomson was a "remote and mystical figure" whose career was "meteoric."[62] He was an untrained or minimally trained artist, with natural instincts, who did not rely on theory. "Neither theory nor any acquired opinion can have had any permanent place in Thomson's mind," claims Barker Fairley. "He was naïve throughout."[63] His paintings were a religious act. "With his equipment he went to Nature and communed with her in all her moods"[64] and created works out of "devotional meditative study."[65] He spent most of his life away from the city, "living in the woods and even when in town avoiding the haunts

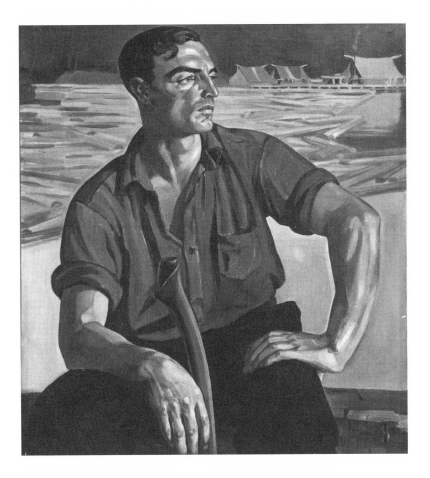

Figure 11 Yulia Biriukova, *The Riverman Frenchy Renaud* 1935, oil on canvas, 122.1 x 106.9 cm, Art Gallery of Hamilton, gift of Thoreau MacDonald, 1973 (74.43.2).

of artists."[66] He connected with nature in a way that no other artist had. "She sent him out from the woods only to show these revelations through his art."[67] "His "inherent honesty"[68] and lack of interest in money (a sign of his disregard for material things) were key to his aura of spiritual commitment. He was a true Canadian, of pioneer ancestry, who learned his lessons not from school or the academy but from the land. He was a "voyageur,"[69] more "Indian" than the "Red Man." "No trapper, or fisherman, or backwoodsman of the North Country excelled him in the lore of natural phenomena."[70] "He was an expert woodsman . . . ; and in the lore of the forest no half-breed or Indian could excel him."[71] In *Paddle and Palette*, Blodwen Davies brought all these romantic ideas together and solidified the Thomson myth. Thomson "was to become priest and prophet" of the North.[72]

Through the story of painting in Canada there stalks a tall, lean trailsman, with his sketch box and paddle, an artist and dreamer who made the wilderness his cloister and there worshipped Nature in her secret moods.

—Blodwen Davies, *Paddle and Palette: The Story of Tom Thomson*

In the creation of this picture of Thomson, much was exaggerated and more was stripped away. According to Housser, "For a dozen or more years he had lived in his north country being much alone, often spending the night in his drifting canoe."[73] Davies repeated this belief, and even A.Y. Jackson in his essay for the 1919 exhibition of Thomson's work at the Arts Club of

Montreal echoes the notion that Thomson had been spending time alone in the North before 1912. In "Out of the North Country," O.J. Stevenson implies that Thomson had been spending "eight months a year"[74] in the North for most of his life and, as the title of his piece suggests, that Thomson came down from the North. For Stevenson and others, the North is a wild and mysterious place, without industry or history. Davies asserts that the North was "where the land was vibrant with a life that had not yet been subdued to the needs of a mechanical age."[75] Remarkably, in many of these narratives, his painting *The Drive* is reproduced, a direct contradiction of the North described. The fictionalizing of Thomson, however, did not go unnoticed. A reviewer of Newton MacTavish's *Fine Arts in Canada* made the following "protest" about the "myth now developing" around the artist: "Instead of their daily comrade at the designing bench, working side by side, and going on week-end sketching trips together—a matured man leaning towards his forties, experienced in drawing and design, and influenced by reading and association with highly-trained prize-winning intimates—we have the young man suddenly appearing out of the northern woods with his wild art slung behind him."[76]

Both A.Y. Jackson and Barker Fairley acknowledge that there were fictions in the Thomson biography, and Albert H. Robson began his *Tom Thomson: Painter of the North Country*, "During the last decade his career has been wrapped in mists of mystery and half truths." But in each case they reiterated the standard details of the myth cited above—Thomson as untrained, one with nature, innocent. As late as 1944, Lawren S. Harris was repeating this

perception: "There was nothing that interfered with Tom's direct, primal vision of nature. He was completely innocent of any of the machinery of civilization and was happiest when away from it in the north."[77]

This portrait of the artist and the North was created largely from an urban perspective by Thomson's artistic circle, and it fitted their vision of Canada and the ideal artist. While Thomson may have been untainted by theory and philosophy, the academy and European ideas of art (which is unlikely), his early biographers certainly were not. A delicate balancing act was required in describing Thomson's paintings, and much effort was made to reassure viewers that though his works might appear modern and radical, they were not wild imaginings or the kind of pictorial experiments practised by the European moderns. In "Tom Thomson: Painter of the North," MacCallum repeatedly returns to the theme of "truthfulness." According to Fairley, "Whatever device he applied was either derived from or immediately corroborated by his apprehension of the landscape he knew so well."[78] Equally, there was the need to address the influence of his fellow artists, Jackson, Lismer and MacDonald in particular. An affiliation had to be established between Thomson and the new "school" of Canadian painting forming in Toronto, but care had to be taken not to suggest too much influence on Thomson the "pure" artist and equally to avoid the idea that mature artists like Jackson were disciples of Thomson.

The romantic picture of Thomson served to obscure the little-known facts about his life and to implant the idea that the landscape he inhabited was a primal, "virgin" wilderness. The stories

posited him as a man of nature, as opposed to acknowledging that the artist made an informed philosophical decision to move north. Common to much Thomson lore is the attempt to define his rural/agrarian past as a wilderness past. But this is not surprising because the distinction was regularly blurred, as can be seen in the defining and marketing of the suburbs, parts of a city, with all its amenities like running water, electricity and transportation, that were sold as if they were unspoiled countryside.

Thomson was not a man of the wilderness; rather, he appears to have taken to an extreme the philosophy of Izaak Walton and the back-to-nature call beckoning so many during his lifetime. I'm not suggesting that he went as far as Archie Belaney did in his transformation into Grey Owl, but Thomson does seem to have evolved into the northern woodsman. And while he may not have intentionally cultivated a connection to ideals of the noble savage, the inference that Thomson was "Indian" was certainly common. "Thomson's attitude to the north country was almost purely Indian in spirit," claims Blodwen Davies in *The Canadian Theosophist*, and she made the link to Grey Owl concrete: "Those who have read Grey Owl's *Tales of an Empty Cabin* will recognize there a spirit kindred to Thomson's."[79] Thomson apparently met Archie Belaney in 1912 at the Mississagi Forest Reserve, where the latter was working as a ranger. This meeting has been cited by numerous writers, including Albert H. Robson, who goes on to claim that Belaney visited Thomson in Toronto in 1912.[80] I'm not convinced that this apparent meeting was of any great significance to either man. Thomson was yet to become the "Painter of the Northern Woods" and Belaney was still Archie;

there was no Grey Owl until well after the war. And in 1937, when Sutherland and Robson connected Thomson and Grey Owl, there was no longer Archie Belaney. Ironically, he reappeared a year later. "Grey Owl Really an Englishman," the *Toronto Daily Star* declared on April 14, 1938.

Grey Owl is certainly a phenomenon worth considering in relation to Thomson, as the authenticity of both men of nature was clearly determined from an urban perspective. The significant difference is that Archie Belaney wilfully fabricated a persona and was fully exposed after he died. Thomson's character, on the other hand, was largely projected onto him after his death. Archie Belaney/Grey Owl conformed to popular period ideas of Native peoples and wilderness, just as Thomson's romantic/heroic character was determined by Canadian ideals of the time. Furthermore, associating Thomson with the environmentalist Grey Owl served to position the artist as an environmentalist also. Grey Owl ended up an employee of the National Parks Service, stationed at the Beaver Lodge in Saskatchewan's Prince Albert National Park. Visitors could hike out and meet him and his two pet beavers and hear his wilderness stories.[81] With the publication of Audrey Saunders's *Algonquin Story* in 1946, the Thomson legend was definitively connected to the woods too. Saunders devotes an entire chapter to Thomson, and he continues to be a staple of the park's mythology.[82]

Although a visitor couldn't meet Thomson, one could still hear about him from his "friend" the park ranger Mark Robinson, who became a popular figure throughout the park and at summer camps. Robinson's account is initially told via Blodwen Davies,

as she was the first to correspond with people in the park who knew Thomson. It is through Robinson that a number of stories originally emerged, to be repeated by other writers, including his daughter, Ottelyn Addison, who published *Early Days in Algonquin Park*[83] and *Tom Thomson: The Algonquin Years*.[84] The stories of Thomson's painting at night in a storm, Robinson's helping him in his search for a particular colour or type of tree and the idea that the artist was producing a sixty-day "record" of the "last" spring all come from Robinson. And it is he who is largely responsible for the suggestion that there was more to Thomson's death than accidental drowning, a suggestion that has now become the dominant popular narrative. It is one that I don't intend to address here, except to say I am convinced that people's desire to believe the Thomson murder mystery/soap opera is rooted in the firmly fixed idea that he was an expert woodsman, intimate with nature. Such figures aren't supposed to die by "accident." If they do, it is like Grey Owl's being exposed as an Englishman.

I am cautious about being too critical of Robinson, as he is, like Heming, not around to defend himself; however, as he has become the source of so much of what has been published as Thomson fact, I think it is important to qualify his usefulness as a source. When interviewed in 1979, Audrey Saunders stated clearly that Robinson was a storyteller, "and a good one." When asked, "So, did his information suffer from accuracy, then?" she emphatically replied, "Yes. Mark was a great guy, but if you listened to his stories as often as I did, you could see variations in them. He had certain fixed ideas which have gone into the history of the Tom Thomson story, which I don't think are necessarily

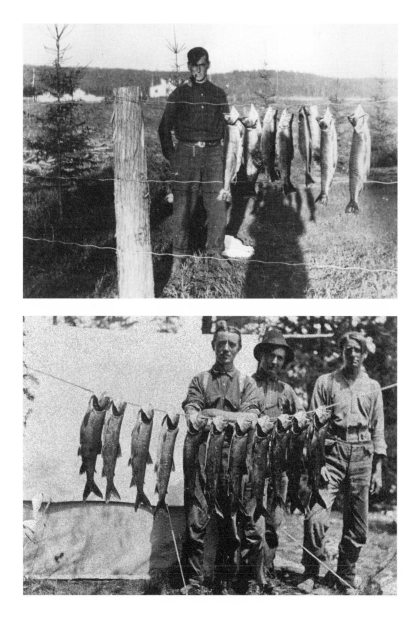

Figure 12 Tom Thomson at Canoe Lake with catch, c.1916. National Archives of Canada, Ottawa (PA 125106).

Figure 13 Archie Belaney (right) and friends with catch, c.1925. Don Smith Collection, Archives of Ontario, Toronto (C273-1-0-46-23).

so. And you see them repeated over and over again."[85] The two versions of his first meeting with Thomson are obvious examples of Robinson "variations." In one, Robinson meets Thomson coming off the train. In another, he comes upon Thomson painting and is suspicious that he may be a poacher posing as an artist. And there are the Robinson diaries.[86] Unlike the diaries of the park ranger Harry Callighen,[87] Robinson's never mention that Thomson was a painter until after the artist's death. None of his often-repeated stories are to be found. The famous lining-up of sixty sketches in Robinson's cabin and Thomson's declaration that he had produced a record of the spring is intriguingly absent — intriguing because Robinson has a habit throughout his journals of making comments that give a sense of his relationship with the people he makes note of. He comments on what was discussed during a visit, if there was tea or lunch or if he had enjoyed himself. With Thomson, there is none of this — the few references to him prior to his death include no such detail. They are short and matter-of-fact, more business than personal, not damning evidence of the fallacy of Robinson's stories but clearly worthy of note, considering the weight they have carried. This includes Thomson's relationship to the war.

The First World War is significant to any consideration of Thomson for various reasons. The most potent is defining him within the culture of mourning and an emerging national identity that became so powerful in the years following his death. But another important factor is that the war kept a number of the key Thomson "biographers" away from him during the critical years of 1914 to 1917. A.Y. Jackson did not see him after 1914. Mark Robinson was away from Algonquin Park from the fall of 1915 through the spring of 1917.[88] These absences clearly affected Thomson's development and equally contributed to the gaps in his story. Why Thomson himself did not serve is a question that Robinson and Thomson's family tried to answer by claiming that he had attempted to volunteer but was rejected (more than once) for medical reasons. Blodwen Davies concocted an elaborate scenario that his artist colleagues, believing he was a budding genius, persuaded him not to risk his life by joining the army but that he secretly tried to volunteer.[89] It is hard to imagine a confident and mature artist like Jackson volunteering to serve but telling Thomson he shouldn't because of his "genius." Thomson's sister suggested pacifism, stating that "he hated war and said simply in 1914 that he never would kill anyone but would like to help in a hospital, if accepted."[90] The writer William Colgate states that Thomson "brooded much upon" the war and that "he himself did not enlist. Rumour has it that he tried, and failed to pass the doctor. This is doubtful."[91] Colgate says that the war brought "only a vision of black gloom and stark desolation" to Thomson.[92] His companion at Achray in 1916, Edward Godin, claims: "We had many discussions on the war. As I remember it he did not think that Canada should be involved. He was very outspoken in his opposition to Government patronage. Especially in the Militia. I do not think that he would offer himself for service. I know up until that time he had not tried to enlist."[93]

In a letter to J.E.H. MacDonald from 1915, Thomson considers the subject of the war. Though hardly expressing a clear position on the conflict in Europe, his comment does seem more

in keeping with the ideas expressed by Godin and Colgate than the suggestion that he was trying to volunteer: "As with yourself, I can't get used to the idea of Jackson being in the machine and it is rotten that in this so-called civilized age that such things can exist, but since this war has started it will have to go on until one side wins out, and of course there is no doubt which side it will be, and we will see Jackson back on the job once more."[94]

In the end, there is no compelling evidence to support any version, as there are no military records for those who were "rejected." What the contradictions reflect, however, like so much of the Thomson record, are the perspectives of the speakers. For many Canadians, whether one served, or at least attempted to, was very important, so we can understand why it was important to some, particularly Mark Robinson, who was active in the militia, that this potentially problematic aspect of the Canadian "hero's" story be clarified. But whether he attempted to serve or not, the idea of Thomson as a heroic figure was very much in keeping with the language of the war.

From my nook beneath the pine
I can see the graceful line
Of the little brown canoe in the bay;
Bright and windy is the weather,
But there's no one to untether
And go speeding to the open far away,
Where the ragged clouds are flying
And the sunset gold is dying—
Empty, listless she is lying,

Idly rocking, idly rocking
In the bay.

—Helena Coleman,
from "Rocking in the Bay"

Helena Coleman is speaking of a young man lost overseas in France, but, like many Canadian war poets, she saw the empty North as a popular setting for mournful prose. Thomson's death left a similar sense of emptiness, and the language used to remember him echoes that for the fallen soldier: sacrifice, a noble death and a powerful connection to the land. Canadian soldiers were often represented as peaceful people who came from the backwoods or off the farm to fight the good fight in a war that was described with the same language of adventure that had typified the North. Robert Service's admonition to "hear the challenge, learn the lesson, pay the cost,"[95] while written about the wilderness, could as easily have been applied to the soldier and is reminiscent of the tone of aggressive recruitment drives. In death, soldiers made the land sacred, just as Thomson made Algonquin Park hallowed ground. Within the mythology of Canada, the sacrifices Canadian soldiers made on European battlefields like Vimy Ridge (figs. 14 and 15) and Passchendæle have been consistently seen as essential moments in Canadian history, events that served to clarify the nation's identity.[96] Thomson's artistic "battles" were seen in the same light.

For most Canadians, the Great War reflected nineteenth-century notions of struggle and sacrifice. This is most obvious in

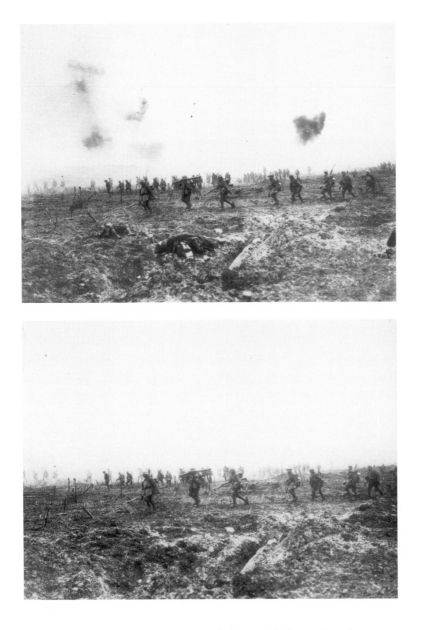

Figures 14 and 15 Two versions of the 29th Infantry Battalion advancing over "No-Man's Land," Vimy Ridge, April 1917. National Archives of Canada, Ottawa (PA 001020, PA 1086).

the designs of the many figurative memorials constructed after the war. The conflict, with its horrendous death toll, was understood through existing narrative models, and while many of the events don't seem to quite gel with their artistic representation, there was comfort in the familiar. Thomson died just three months after Vimy, and like the valiant soldiers in John McCrae's famous poem "In Flanders Fields," he would "throw the torch" to those who followed. Canadian artists were expected to "hold it high" and not "break faith" with Thomson.[97] To do so would be sacrilege. Thomson appears to be like the crucified soldier that adorns the war memorial in Preston, Ontario: soldier as Christ figure, making the supreme sacrifice (fig.16). Such a loaded, heroic narrative provided a rationale for the losses: to consider the death of a loved one as being without purpose or reason was, and is, difficult to accept. Thomson's death was no different. There had to be a "reason" for Thomson, and so the stories flowed, largely through the stories of others.

> To the memory of Tom Thomson, artist, woodsman and guide. . . .
>
> —J.E.H. MacDonald, from his "Thomson Cairn Poem"

It is remarkable how often texts on Thomson end by quoting J.E.H. MacDonald's poem. His words represent the unquestionable "truth" of the man, permanently affixed to that pile of stones overlooking Canoe Lake (fig. 17). MacDonald consistently gets the last word, and he does right here, but for a different reason.

We looked and felt that all things moved
Upbuilding to a blessed end,
And rarer every beauty seemed
With virtue of our friend.[98]

MacDonald wrote his poem "Red, Yellow and Blue (at Canoe Lake)," a portion of which is quoted above, around 1918, at the same time he was writing poetry about the war, dwelling on the loss of many lives and trying to resolve his feelings. Concurrently, he wrote "Below the Rapids," another poem of loss about a young artist who died in the North:

He'll follow no more the sun
Portage and rapid are one
Night brings no need of camping place
The end of the trail is run.

Take him not back to the town
Here where he died set him down
He'd scorn to lie in formal plot
Awaiting a harp and crown[99]

The poem is dedicated to Neil McKechnie. McKechnie was a member, with MacDonald, of the Mahlstick Club and Graphic Arts Club who drowned in 1904 on the Mattagami River following an "upset" while attempting to run the rapids. The main source of McKechnie's story is his travelling companion, Tom McLean, who stood on the shore and watched helplessly as his friend went down. Various articles tell us that he was an "experienced canoeist,"[100] and considering the circumstances of his death, there is one great contradiction. The Toronto *Globe* claimed he

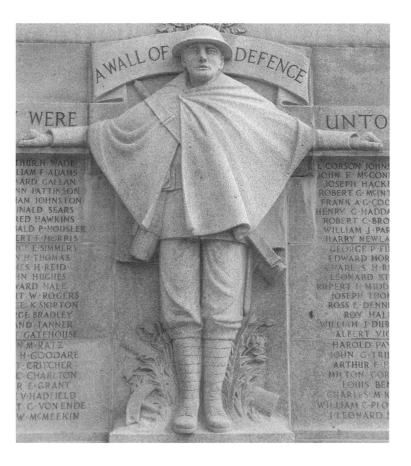

Figure 16 Preston War Memorial, Cambridge, Ontario, central section c. 1920.

43

Figure 17 Photograph taken by J.E.H. MacDonald, September 1917, of the cairn constructed to the memory of Tom Thomson at Hayhurst Point, Canoe Lake, Algonquin Park. Arthur Lismer Papers, Edward P. Taylor Research Library and Archives, Art Gallery of Ontario, Toronto, gift of Marjorie Lismer Bridges (file 19).

was an "excellent swimmer."[101] McLean, in a published letter, stated clearly, "You know, he could not swim."[102]

Thomson was eerily similar to McKechnie. They were born in the same year. Both were from working families of Scottish ancestry. Both trained at photo-engraving firms. Both would be remembered as "expert" canoeists and woodsmen. They shared some friends, including Tom McLean, who encouraged both to go north, and J.E.H. MacDonald.

It is curious that MacDonald wrote "Below the Rapids" so long after McKechnie's death and so soon after Thomson's. Per-

haps it was his way of saying politely that Thomson should not have been moved to Leith but belonged, like McKechnie, where he died. The idea that heroes should be laid to rest where they sacrificed themselves was certainly in keeping with Canada's attitude to its war dead, who were buried on the battlefield, in the earth they had sanctified with their blood.

I discovered McKechnie through an article MacDonald wrote in 1917 called "A Landmark of Canadian Art,"[103] in which he described the creation of the Thomson cairn and stated that "[s]uch a monument was almost unique in Canada. One similar in intention stands in the burying ground of Fort Mattagami far in the north of Algonquin, commemorating the death of Neil McKechnie, a young artist of promise who drowned in a rapid there some years ago."[104]

I'm telling you this story now because I want to give you a sense of how I first read it, not as a story logically placed in the chronology of events but found after the main narrative had been established. As I've tried to suggest here, I believe Thomson, in life and death, was/is the product of many narratives combined, the result of an ongoing process of *rifacimento*. McKechnie is a significant obliterated fragment of that process.

In the July 9, 1904, issue of *Toronto Saturday Night*, Sid Howard, a regular contributor, writes, "Somewhere in those dark spruce woods that called him every spring, by a tumbling rapid, will be by now, an axe-hewn cross. . . . They will call the place McKechnie's Falls, perhaps, and with time the thing will grow into a legend."[105] There is no McKechnie's Falls, and there is no legend. McKechnie's grave at Fort Mattagami is marked by a small granite rock and a

bronze plaque placed there by his "friends of the Graphic Arts Club" (fig. 18).[106] He has been all but forgotten. His tragic end in the North may have seemed the stuff of legend at the time to the small community of artists he associated with, but he represented only promise.

"Down at the Arts Club," Howard continues, "they say he was a Canadian, a real Canadian, of a type of which we have but few. Foreign-taught painters of Canadian landscape have we, Canadian-taught painters of foreign landscapes, but an artist with the spirit of Canada's youth in his heart—wild, free, strong, untrammeled of convention, where is he?"[107]

A few months after this memorial was published, Tom Thomson appeared in Toronto, as if called forth by Howard's pleading. Thomson would step into the void left by McKechnie's passing. It was a void that required more than great art to fill. It required a particular character and Thomson, in life and death, fitted the bill.

~

The mystery of the North got his heart—its wildness, its somberness, and most of all its strength. Strength itself was beauty, and the raw strength of the granite-ribbed wilderness best satisfied his taste.

—Sid Howard, *Toronto Saturday Night*, July 9, 1904

~

Figure 18 Grave of Neil McKechnie, Mattagami First Nation Cemetery, Lake Mattagami, near Gogama, Ontario.

TOM THOMSON
as Applied Artist

Robert Stacey

applied art: Art which is essentially functional, but which is also designed to be æsthetically pleasing. . . .
— *The Thames and Hudson Dictionary of Art Terms*

Past-Prologue

Sometime in 1911 or 1912, an unknown photographer captured a rare moment of repose in the hectic daily routine of a downtown Toronto engraving house (fig. 19). At least seven of the celluloid-collared, necktie-clad members of what was known as the Art Room of Toronto's Grip Limited can be identified with some certainty, thanks to the latter-day testimony of an alumnus of this illustrious company.[1] Standing together

Figure 19 The Art Room, Grip Limited, Toronto, 1911 or '12. National Gallery of Canada Archives, Ottawa, gift of Leonard Rossell. From left to right: Leonard Rossell (?) Stanley Kemp (?), Rowley Murphy (?), Tom Thomson, W.S. Broadhead (standing), Arthur Lismer, F.H. Varley (?), J.E.H. MacDonald, unknown.

at the back are three figures whom we can tentatively finger as follows, reading from left to right: William Smithson Broadhead (1889–1960), Arthur Lismer (1885–1969) and Frederick H. Varley (1881–1969). All graduates of the prestigious Sheffield School of Art, these recent immigrants had experienced difficulty finding full-time employment in Britain in graphic art, the craft they hoped would eventually float their careers as full-time painters. Broadhead, the first off the boat, had been drawn to the Ontario capital from South Yorkshire by the promise of well-paid work in the booming commercial art, printing and advertising industries. Lured by his enthusiastic letters home, trumpeting that a labour shortage made Toronto a job-hunter's market, Varley and Lismer had followed, Lismer in January 1911 and Varley in August of the following year.[2]

Seated directly in front of this triumvirate is a pipe-puffing, nattily suited Tom Thomson. By focusing on his handsome face — and thereby blurring those in front of him and to the sides — the photographer inadvertently made him the image's centre of attention. In so doing, he prophetically underlined Thomson's future status as the primary precursor and catalyst of the Group of Seven.

The photo also reveals the self-effacing yet canny nature of the artist regarded as the Group's "philosopher-poet." Unobtrusively overseeing the crowded studio from his cluttered back-corner drawing table (a position chosen as much out of modesty as to afford him a view of the entire workforce) is the department's apparently bemused head designer, J.E.H. MacDonald (1873–1932). (Years later, MacDonald looked back fondly to "those crazy old days at Grip.")

Out of the picture on the day of the photo shoot are a number of other key Grip artists, two of whom would join MacDonald, Lismer and Varley in co-forming, with Lawren Harris and A.Y. Jackson, the Group of Seven in 1920: Frank H. Johnston and Franklin Carmichael. Also conspicuously absent from the shop floor is Grip's art director, Albert H. Robson (1882–1939), who wisely left the management of the boisterous "Grip Gang" to his captain, MacDonald, and the latter's chief constable, Tom Thomson.

MacDonald had rejoined the firm in 1907 after two years at the prestigious Carlton Studios as a designer-illustrator specializing in book covers. Carlton had been established in London, England, in 1901 by T.G. Greene, Arthur Goode, Norman Price and William Wallace, all fellow alumni of the Central Ontario School of Art and Design and also, like MacDonald, former employees of Grip Printing and Publishing Company. Carlton would grow at such a pace that by the early 1920s, it could be described in print as the world's largest advertising agency. And yet it could honestly proclaim itself to be a practical application of the socialist theories of William Morris (1834–1896), on whose financially as well as æsthetically successful decorative arts business, Morris and Company, Carlton studios was modelled.

The Morris spirit flowed most directly to the firm's founders through the Toronto Art Students' League (TASL), established in 1886 as an evening life class and social club for daytime "artworkers" and as an outlet for creative exploration. Although disbanded in 1904, the league lived on in other artists' associations, notably the Graphic Arts Club (restricted to professionals), and in the determination of its former members to live and work

according to the tenets of Morris, John Ruskin, Walter Crane and other espousers of the Arts and Crafts ethos.[3]

The "Carlton Idea"—described by the founding business manager, William Wallace, as "an intelligent harmony of various specializations"—was then new to London. In the name of efficiency and customer convenience, such amenities as a design studio, print shop and bindery and advertising and ad placement departments (as well as a reference library for staff and a sample gallery for clients) were grouped together in centrally located premises. In essence, Carlton manifested a benign strain of the division of labour, as practised in Morris's workshops, where various crafts and trades toiled harmoniously together, rather than as alienated pieceworkers.

Much as they revered Morris, the Carlton founders would have cited as a more immediate source the "all under one roof" concept of the original Grip Printing and Publishing, whose design department MacDonald had joined in 1894. After two years at Carlton, "Jimmy" MacDonald returned to Toronto to assist "Ab" Robson in retransferring that "harmonious specialization" praxis to the recently renamed Grip Limited.

Called after the sardonic raven in Charles Dickens's *Barnaby Rudge*, Grip P. and P. was an outgrowth of the satirical illustrated weekly *Grip*, founded in 1882 by Canada's premier political cartoonist, J.W. Bengough. Like many others of the day, the magazine had its own engraving, lithography, platemaking, printing, binding, publishing and advertising departments; these continued to thrive without the parent publication after its demise in 1892. A mainstay of the establishment was A.H. Howard (1854–1916),

the best Canadian graphic designer before MacDonald. (A worshipper of Crane and Morris, Howard had co-founded the TASL as a means of educating and inspiriting the youthful workers in the city's printing and engraving establishments, many of whom nursed "legitimate" artistic ambitions but had little or no access to art schools or to older mentors.) Grip's chief competitors for high-end printing and graphics were the Toronto Engraving Company, which was renamed Brigden's in 1909, and the Toronto Lithography Company, which evolved into Stone and later Rolph-Clark-Stone.

Like many in Grip's art department, MacDonald dreamed of being free to paint full-time. But with virtually no commercial or public galleries in the city, and few private or corporate patrons for struggling talent, creative outlets had to be found in illustration and lettering assignments or all-too-rare freelance commissions (or perhaps a mural scheme, such as finally came his way with the MacCallum cottage decorations of 1915–16, in which he would be assisted by Tom Thomson).

The two major professional artists' societies of the day—the Ontario Society of Artists and the Royal Canadian Academy—required a substantial body of work before conferring membership and its privileges but offered non-members annual opportunities to exhibit juried submissions. MacDonald, for instance, first showed at the OSA in 1900; significantly, his name initially appears in the catalogue of the special *Applied Art Exhibition*, held at the society's King Street West premises, under the ægis of his then employer, listed as "Grip Printing & Publishing Co.," no. 41. "Catalogue covers. J.E.R. [*sic*] MacDonald"; then later on its own,

"MacDonald (James E.H.)" no. 108, "Three Designs for Book Plates."[4] Other Grip artists listed in the catalogue are Carl Beal, Fergus Kyle, Edgar McGuire, A. Goode, A.A. Brown, Norman Price, T.G. Greene and A.A. Martin (the latter soon to join his comrades as Carlton Studios' president). Most if not all these exhibitors were elsewhere employed by the time that Tom Thomson was taken on by Grip about December 1908, but management continued its practice of permitting employees of the art department to extend their expressive skills in drawing, lettering and design. This attitude was a reflection of the æstheticism of G.A. Howell, Grip's managing director from 1903 to 1906 and subsequently a director and secretary-treasurer of the firm.

Seattle, Here I Come

Unlike such older contemporaries as C.W. Jefferys (1869–1951) and J.E.H. MacDonald, who entered the field of commercial art as youths determined to graduate, one day, from lowly employees to freelancers to full-time painters, Thomas John Thomson seems to have drifted into the craft as insouciantly as he later paddled and portaged his way into the Ontario wilds. True, several members of his family showed an artistic bent, and growing up in the picturesque environs of Owen Sound undoubtedly inspired them to sketch out-of-doors. Tom, however, would not exhibit much real promise until his mid-twenties.

Having secured his first situation in the winter of 1899 as a machinist, he left after only eight months of apprenticeship. A foundry job failed to appeal to his romantic sensibilities (and

weak lungs), and he followed his brothers George and Henry to the Canada Business College, in Chatham, Ontario, to prepare himself for a white-collar office position. There he picked up the rudiments of penmanship; a good copperplate hand was still a requisite for a clerk, private secretary or bookkeeper, despite the growing dominance of the typewriter.

Graduating in 1901, he travelled first to Winnipeg, then to Seattle, where he was joined by Henry Thomson in January 1902. The practical attraction of this wet West Coast city was that his brother George — later to become a landscape painter — was associate proprietor of the Acme Business College, listed in 1904 as being the eleventh largest in the United States.[5] Tom Thomson's signature appears in the lower-right corner of a somewhat pretentious document (now unlocated) proclaiming that as a graduate of the college, "he takes pleasure endorsing the work of this institution." His use of at least four different letter forms suggests that during Acme's six-month course, he may have learned calligraphy and penmanship but not the basic tenets of typographic design.

Perhaps on the strength of this sample of his new skills, Thomson landed a job at Maring and Ladd of Seattle, which specialized in advertising and three-colour printing. (The proprietor, C.C. Maring, in whose home Thomson boarded, was himself a Canadian—likely a factor in his hiring.) There, Thomson's way was not made smoother by his independent spirit, otherwise known as stubbornness: Fraser Thomson, another brother, pointed out that instead "of his doing the work according to the instructions given by Mr. Maring he would invariably

work out the design to suit his own ideas which would make Mr. Maring angry. . . ."[6]

"Doubtless it was in Seattle," Joan Murray contends, "that Thomson came into his own. His work there seems to have authority and presence, qualities which were to mark him as a practising artist. This can be seen in . . . his own business card . . ., done in a similar block lettering, and with the same kind of mythological reference as his penmanship sample for the Acme Business School. . . . Pegasus is not only a symbol of the arts, but of those who aspire to greater things and Thomson probably did desire to rise above his circumstance. . . ."[7] The existence of the business card (fig. 20) supports the conjecture that Thomson had set himself up as a freelance provider of "commercial designs," but we know of no printed examples of such work.

Thomson's younger brother Ralph is our sole eyewitness of the artist-to-be's Seattle period. Because they roomed together, he had

> a wonderful opportunity to observe his progress as a commercial artist and designer. He very often worked all night long while I watched him try one idea after another. The ones that did not meet with his approval he would either throw in the waste basket, burn up or smear with cigar ashes or the ends of burned matches. Others he would keep for a day or two but they would invariably meet the same fate. At that time he worked in pen and ink, water color and black and white wash. He was continually looking over the various magazines and giving the advertisements a great deal of study, principally from the standpoint of decoration. It was a regular game with him to pick the best of them, change the entire design to suit his own ideas, and then compare their respective merits.[8]

Figure 20 Thomson's business card, line engraving on paper, dimensions and present whereabouts unknown.

Ralph Thomson also was privileged to watch his brother begin to mature as an artist. He recalled that during their frequent fishing trips, "Tom always carried his sketch pad and pencils, whenever an unusual scene showed up."

Among the "sketches" hanging in Ralph's Seattle home, he listed a "water color of a storm on the lake with a sheltered bay in the foreground, [and] a sketch in water color of a water fall with rocky banks and a deep dark pool in the foreground with Bobby Burns poem inserted in old English in a square panel. . . . This is a very unusual decorative idea and we enjoy it very much. These two Tom sent from home at the time of our wedding."[9]

The first of three recorded treatments of this text, *Burns' Blessing* (fig. 21) is the earliest extant example of Thomson's decorative work in both lettering and the devising of decorative borders.

Figure 21 Tom Thomson, *Burns' Blessing*, 1906, watercolour, gouache and ink on paper, 29.3 x 22.0 cm, Tom Thomson Memorial Art Gallery, Owen Sound, Ontario, anonymous gift 1977, donated by the Ontario Heritage Foundation 1988 (988.011.77).

The landscape component already features several elements that became compositional constants, including the framing of a distant prospect or shoreline with stylized, *coulisse*-like trees.

Much as he enjoyed life in Seattle, where he considered moving permanently, Thomson's longing for his native Ontario—and, it seems, a broken heart from a rejected marriage proposal—sent him home in 1904, first to Owen Sound and, shortly thereafter, to Toronto.

Toronto or Bust

Hard facts about Thomson's early Toronto phase are as elusive as details about his Seattle sojourn. We know merely that by 1905 he "was engaged . . . on designing or engraving work."[10] He seems to have been taken on first by the Toronto photo-engraving firm of Legg Brothers in June 1905 as a senior illustrator at a weekly salary of $11, a short engagement disrupted (that devil, "stubbornness," again?) by a disagreement with the owners. It is thought that he might then have worked at Hamilton's prestigious Reid Press, which boasted a state-of-the-art printing service.

Around this time Thomson resumed his outdoor sketching, possibly under the private tutelage of the cantankerous but kindly William Cruikshank (1849–1922), who claimed to have imported the European pen-and-ink technique to North America from his native Scotland. "Old Cruik" (as he was called behind his back by his Central Ontario School of Art and Design students) would have enjoined his pupil to adopt the *Nulla Dies Sine Linea* (No Day without a Line) motto of the Toronto Art Students'

League, of which Cruikshank had been a mainstay. Long after the league's demise, some former members still observed this diktat, among them C.W. Jefferys, J.D. Kelly, F.H. Brigden and J.E.H. MacDonald.

Joan Murray suggests that by 1907 Thomson "was feeling the influence of his work in a photo-engraving house upon his art: he had begun to use the pen rather than the pencil medium for his sketches. With this re-orientation in technique, a certain element of virtuosity comes into his work."[11] The growing amount of "finish" in his pen-and-ink drawings of this period lends credit to the hypothesis that Thomson went to Cruikshank for private lessons. Wielding his nib *en plein air*, Thomson produced a suite of pastoral views of the banks of Toronto's Don River that suggest the influence of contemporary British, European and American illustrators, whose work he could have examined in such sources as *The Studio*, *The Century Magazine* and *Harper's*. In addition, there were the Toronto periodicals and newspapers for which the leading members of the Graphic Arts Club produced illustrations. Much of this line-and-wash work was photo-engraved or lithographed by the venerable firm of Grip, based since 1896 on Adelaide Street West — perhaps a factor in Thomson's decision to risk humiliation by seeking employment with that elite company.

In the Grasp of Grip

Albert H. Robson was no mean cultural/corporate citizen. Himself a landscape painter of some ability, he would also become an art patron, serve as a trustee of the fledgling Art Gallery of Toronto and write several books on Canadian art, including the volume on Thomson in Ryerson Press's *Canadian Art* series. Such activities and benefactions lay some way in the future, after he had achieved financial security and social position. Today he is best remembered as the man who hired Tom Thomson at a crucial stage in his life, setting him on his canoe path to posthumous glory — and inadvertently helping forge the Thomson Myth.

A quarter century after the event, Robson vividly recalled his first meeting with Thomson, which likely took place at Grip in December 1908 or January 1909:

> A tall, lanky young man in a dark blue serge suit and gray flannel shirt applied for a position in the art department of Grip Limited. . . . There was something intriguing about Thomson, a quiet reserve, a reticence almost approaching bashfulness. His samples consisted mostly of lettering and decorative designs applied to booklet covers and some labels. A quick glance at his drawings revealed something more than mechanical and technical proficiency; there was feeling for spacing and arrangement, an over-tone of intellectual as well as æsthetic approach to his work. . . . Shortly after hiring him I received a gratuitous and unsolicited telephone call from his previous employer belittling Thomson as an erratic and difficult man in a department. This was as absurd as it was untrue. Thomson was a most diligent, reliable and capable craftsman.[12]

One of the samples by which Thomson may have won his job is a piece of fancy pen craft inspired by a statement from Belgian poet-playwright Maurice Maeterlinck (fig. 22). This virtuoso exercise demonstrates, if nothing else, the extraordinary degree to

Figure 22 Tom Thomson, quotation from Maeterlinck, pen and ink on paper, 34.3 x 20.6 cm, The McMichael Canadian Art Collection, Kleinburg, Ontario, gift of Margaret Thomson Tweedale, 1978 (1980.3.3).

which Thomson's draughtsmanship had advanced since his arrival in Toronto. (He would, however, never master the human figure.)

Relations between art director and artist were not always cordial; a Lismer cartoon shows a rotund Robson handing Thomson a galley proof to be completed in "a dam hurry," to which the sullen, slouching T.T. replies, "Go to H. — I'm going to the basement to have a smoke" (fig. 23). A less irreverent Lismer drawing depicts a monk-like Thomson hunched diligently over his drawing table, a quill pen in his right hand (see fig. 81, p. 310).

According to Robson, Thomson's specialty at Grip was "lettering and the laying of Ben Day tints on metal plates, surely not an exciting or ambitious start, even in a commercial art room."[13] Writing in October 1955, Thomson's former workmate Stanley Kemp elaborated on the processes the "tint man" had to perfect before moving on to less mechanical tasks: "Then as now, an engraving plant's equipment included an elaborate shading machine known as the Ben Day. By it a considerable variety of shading can be put either on a drawing or a plate for reproduction by the process known as photo-engraving. When more arrogant souls despised the Ben Day (and incidentally were no good at running it), Thomson took it in his stride."[14]

A description of the labour-intensive Ben Day technique is provided in the ninth lesson in *The Art of Drawing for Profit*, a series published by Toronto's Shaw Correspondence School from 1910 to 1919, with texts by J.E.H. MacDonald, deviser of the school's commercial art course. This lesson deals with "Mechanical Aids and Work for Beginners," including the use of the airbrush, tracing-paper "masks," spatter work, negative retouching and

photo-mechanical processes. "Most Ben Day work," MacDonald noted, "is done by a specialist, and the designer has practically nothing to do with it beyond indicating the parts of his design where he would like the shading applied."[15]

Kemp remembered Thomson as being "not only a first-class designer but also a solid and reliable delineator," and Robson related that "recognition of his natural ability as a designer moved him rapidly along to more important work. He developed a fine sense of line and arrangement, and a subtle sense of colour harmony, that soon placed him as one of the important men of the department."[16] But where are examples of such Grip-period work ascribable to Thomson? Was his manner so malleable that he was able to adopt a variety of styles for different tasks? The prohibition against the signing of individual work renders identification the more difficult.

Ironically, in fact, for an authenticated example of his commercial artistry from this period we have to point to a freelance job, from 1910, rather than an assignment from Robson. The commission, a poster (the only example of this popular medium Thomson is known to have designed) advertising the Sydenham Mutual Insurance Company (fig. 24), likely came his way because the vice-president of this Owen Sound firm, T.J. Harkness, was his brother-in-law.

As of 1910, it was MacDonald's superlative hand lettering, border design and layout skills that Thomson was emulating — not always successfully. A comparison of the cluttered, wordy poster with a cover MacDonald devised for the November 1910 issue of *Canadian Magazine* suggests that Thomson had not yet

Figure 23 Arthur Lismer, cartoon depicting Thomson and Robson, brush and ink on paper, dimensions and present whereabouts unknown.

Figure 24 Tom Thomson, poster for the Sydenham Mutual Fire Insurance Company, 1910, watercolour on card, 29.5 x 21.6 cm, Tom Thomson Memorial Art Gallery, Owen Sound, Ontario, gift of the Wawanesa Mutual Insurance Company, 1986 (986.012).

learned the master's lesson of "Harmony, Balance, Rhythm." A better approximation of Thomson's growing mastery of border decoration is a framing device done in ink for a photograph of a Dutch portrait head by Curtis Williamson (pl. 89).[17]

MacDonald's inscriptional style may have inspired a number of quotations from favourite writers that Thomson (like MacDonald a poetry lover of occasionally questionable taste) worked up as family gifts or portfolio samples. Some may have been intended for submission to magazines or for reproduction on calendars, but none seems to have been printed. In 1907, the year of the imperial poet's triumphal trans-Canadian tour, Thomson lettered a quotation from Rudyard Kipling's "Dargai Hill." Another such exercise, from the same literary source, may have been chosen because Thomson applied to himself (in spirit, at least) the hero's exhortation to "sacrifice yourself, and live under orders." More elaborate are his treatments of mystical or hortatory texts by Maeterlinck, Henry Van Dyke, Ella Wheeler Wilcox, Robert Burns and the Canadian writer William Wilfred Campbell. Grouping such exercises under the rubric of "applied art" may be stretching a point, for, while æsthetically pleasing, they are of dubious "utility" except for their social value as gifts for family, friends and lovers, as home decorations or as samples for the artist-designer's portfolio.

Such hothouse flowers as these decorative fancy-pieces seem oddly out of character with the Thomson memorialized by Mac-Donald after his death as the "artist, woodsman and guide" who "lived humbly but passionately with the wild." It seems more likely that Thomson would have been grateful for an opportunity to lend a hand in the campaigns Grip helped to conduct for the

railway companies seeking to lure holiday-makers and sportsmen to the newly accessible Ontario northland. Typical of the genre is a magazine ad for the Canadian Northern Railway's Short Line to Muskoka (fig. 25), dating from 1907, a year before Thomson joined Grip. (This does not rule out his having had a hand in creating this promotion, as he worked as a freelance designer/illustrator after parting ways with Legg Brothers.)

Until he could make his own railway-assisted break for the bush, Thomson found solace in books and magazines, in hikes along the half-wild ravines of Toronto and in honing his painting and drawing skills. Tales of summer sketching and camping trips, illustrated by sketches and snapshots, from fellow Grip artists such as MacDonald, Tom McLean and Ben Jackson, whetted an already keen appetite to experience "canoe country" firsthand. This he was finally able to do in May of 1912, when, with Jackson, he paid his first visit to Algonquin Park. After he'd had this galvanizing experience, the pleasures of life in the Art Room paled, though Thomson continued to enjoy close friendships with the likes of McLean, Jackson, Broadhead, Lismer, Varley, Johnston, Carmichael and, above all, MacDonald.

Fortunately, we have a description of the atelier they shared from another of the identified personages in the 1911 or '12 photo, Leonard Rossell, who, at the behest of the National Gallery of Canada's R.H. Hubbard, wrote a brief memoir recalling what he referred to as "the Grip." It is worth quoting at some length, as it conveys a sense of the shop's atmosphere shortly before the defection of Robson, with some of his best talent, to the recently established Rous and Mann, in October 1912:

Figure 25 Advertisement for the Canadian Northern Railway, designed by Grip, in *Toronto Press Club: Third Annual Theatre Night* program (Toronto, May 1907), 67.

The Grip, about the time of which I write, was the home of a group of artists who were later destined to have a real influence on Canadian art.

Some of the names, obscure then but familiar now, were J.E.H. MacDonald, Frederick H. Varley, Tom Thomson, Arthur Lismer, Frank Carmichael, Frank Johnston, his brother Bob and Smithson Broadhead.

Mr. Robson . . . seemed to have a genius for securing the services of any artist of promise and the Grip became noted for the excellent work turned out. A fine spirit pervaded the Art Room and through all the fun and the pranks we managed to turn out a high standard of work. It would be hard to find a group of artists so different in character and outlook. At one side of the room sat Jimmy MacDonald, as he was then famil-iarly known. His desk was covered with sketches, notebooks, paints and brushes, all in utter confusion. . . . He was probably the oldest there and had brought to himself and the Grip an enviable reputation for fine design. . . .

He used to bring his sketches down to the office and in-spired many of us to make a start at outdoor sketching. It was extremely likely that Tom Thomson caught inspiration from them for I quite well remember the first sketches Tom did. . . .

Tom . . . was also a quiet, retiring fellow. Tall, like Mac-Donald; they had much in common. Indeed, they exercised a steadying influence on some of the too vivacious, lively spirits who worked in the same room.[18]

Rossell credited Robson with possessing "a sixth sense" when it came to attracting to Grip "all the best talent. And, moreover, he kept them as long as he remained Art Director. When he left to join Rous and Mann the artists followed him, and the Grip Limited lost the reputation it had so long kept." (Despite this set-back, Grip survived the defections and went on to thrive under various corporate names, most recently as Batten-Summerville.)

One of the secrets of Robson's success, Rossell believed, "was that the artists felt that he was interested in them person-ally and did all he could to further their progress. Those who worked there were allowed time off to pursue their studies. . . . Tom Thomson, so far as I know, never took definite lessons from anyone, yet he progressed quicker than any of us. But what he did was probably of more advantage to him. He took several months off in the summer and spent them in Algonquin Park."[19] Had Robson not permitted this liberty, the course of Canadian art might not have changed so rapidly or so radically as it soon was to do.

Rous and Mann-ing

Rous and Mann Printing was founded in Toronto by F.J. Mann, H.L. Rous and Carl W. Rous in 1908, with the partners taking command in March 1909. The business was a wholly owned, family-run operation, with no shareholders more interested in short-term profits than high-quality service and artistic integrity. As a stylish promotional drawing (possibly by Varley) boasts, the firm offered a range of services to ensure one-stop shopping for the client: "Writing, Illustrating, Printing."[20] To keep up with the trade, the firm had to specialize in "quality printing" in three or four colours, as well as in excellent design, typography and

presswork. This expensive service was becoming increasingly popular in the booming pre-war economy, as the retail and whole-sale, manufacturing, real estate and transportation sectors were joined by entertainment and cultural industries competing for the patronage of an increasingly affluent populace.[21]

Having followed Robson to Rous and Mann in October 1912, on his return from his Mississagi River canoe trip with Broadhead (who then opted to join Norman Price and Jay Hambidge at the New York branch of Carlton Studios), Thomson remained with the firm for little more than a year.[22] Again, what exactly he did at Rous and Mann is a matter mostly of conjecture. One of the very few pieces of commercial artwork safely attributable to him from this (or any other) period is a decorative lakeside landscape in ink on card, which incorporates a number of elements found in his early Algonquin Park oils.[23]

The drawing's composition is unusual for Thomson, in that it is vertical, which suggests it was made for a calendar or mag-azine advertisement, the letterpress for which would have been inserted in the palette-shaped white space in the foreground (fig. 26). The framing of the distant shoreline by stylized birches, the sinuous roots crawling across the rocks, the tapestry-like foliage and the sense of overall pattern were shortly to become Thomson trademarks: consider, for instance, his *Decorative Land-scape: Birches* (pl. 81), painted in the winter of 1915–16, which employs the motif of the flattened, formalized grove screening the background of broad lake and hilly far shore as if to stress the two-dimensionality of the picture plane. (In fact, as close examination of the two works reveals, the setting is the same.

Figure 26 Tom Thomson, untitled advertising or calendar drawing, c. 1913, ink on card, present dimensions and whereabouts unknown, formerly collection of Leslie J. Trevor, Toronto.

This compositional congruency establishes the draughtsman as Thomson and the drawing as the only known example of a commercial artwork preceding a canvas in the Thomson œuvre).[24] Similarly, the art nouveau S-curves of the trees would find numerous echoes in Thomson's landscapes of this period, most notably in *Northern River* of winter 1914–15 (pl. 40), the gouache study for which (pl. 39) may well have been conceived with colour reproduction as a travel poster or calendar in mind.

The purchase by the Ontario Education Department of *Northern Lake* (pl. 8) from the 1913 OSA exhibition bought Thomson unexpected painting time and emboldened him to hand in his notice to the astute director who had first hired him five years earlier. Thus bankrolled, by May 1913 he was back in the park, where he sketched furiously throughout the summer and fall. Ahead lay the same length of time in which to achieve his painterly vision as he had devoted to the art rooms of Grip and Rous and Mann.

Free(lance) at Last

While after 1913 Thomson could survive, with the help of rare patrons like Dr. James MacCallum, on the occasional sale of a sketch and on seasonal work as a forest ranger or guide, J.E.H. MacDonald, a family man, dared not take such chances with a fickle art market. Besides, the latter's innate love of design — and what he called "the Decorative Idea" — would not permit him to give up illustrating, illuminating and lettering, even when they interfered with his painting and teaching. He continued to maintain genial relations with his former Grip-mates, though

fewer paying jobs were sent his way by Robson than he might have wished.

Meanwhile, in the spring or summer of 1913, MacDonald transferred his family to the village of Thornhill, north of the Toronto city limits. Thus resettled, he accepted a major commission from the board of trustees of the new Toronto General Hospital: designing and illustrating a presentation address to the lieutenant-governor of Ontario, Sir John M. Gibson, to mark the end of his term as honorary governor at the new hospital in January 1914. This rush job required expert assistance from two former Grip-mates in order to meet the deadline. Fortunately, we have an insider's report on the carrying-out of the assignment. "The year Toronto General Hospital was opened in its present location," wrote Stanley Kemp,

J.E.H. MacDonald was doing a sizeable free-lance job for the hospital authorities and he had hired me to work with him all day and through a public holiday. He lived at the time in Thornhill. After all day on the job it was apparent that to finish there was still an all-night job for two men, with the morrow morning fixed for the deadline. I was anxious to get home to my young wife and children and besides I had to go to work at the shop as usual next day. . . . MacDonald was fortunate to get Tommy Thomson on the telephone and greatly happy that the latter would come directly on the radial railway. I can still see MacDonald and me standing as reception committee, watching the last radial car come down the hill and then up the hill, and then, blessed relief, Tommy Thomson getting off as promised. Three pairs of hands, being pumped like pump handles.[25]

MacDonald drew the buildings and did the lettering for the bound presentation album, but either Thomson or Kemp (or both, toiling in tandem) executed the second part of the commission, a pamphlet depicting hospital interiors, including operating rooms and equipment. To expedite the process, photographs may have been traced in ink and then the exposed images bleached out. This would explain the tight literalness of these illustrations, whereas MacDonald in his renderings went for broad, brushlike effects.

Years later, MacDonald's son, Thoreau, recalled that he'd "first heard of Tom about 1910, when I was nine years old. My father . . . talked enthusiastically of him, and I was always anxious to hear of anything connected with the woods. It was in winter, I think, 1912 or '13 [i.e., late 1912?], that he first came to our house to help my father with some work in commercial design that they hoped to finish by working all night. I hung around hoping to hear something about the North, but can only recollect Tom smiling and quietly working. It is his quiet ways I remember best in thinking of him."[26]

Only three other examples of Thomson's applied and decorative art are recorded after this collaboration, one, from 1914, doubtfully attributed.[27] Finally, dated to about 1916 are two autographic text treatments that poignantly frame the painter's entire applied art avocation, if not career. *Decorative Landscape* (pl. 90)— a stylishly lettered treatment of sentimental nature verse by the American poet Ella Wheeler Wilcox—features, above the text, a typical Thomsonian arrangement of curvilinear limbs and boughs both framing and screening a lake or river vista.[28] The use of

Figure 27 Tom Thomson, quotation from *The Light That Failed*, c. 1916, by Rudyard Kipling; gouache, pen and ink on paper, 26.3 x 18.1 cm, present whereabouts unknown, formerly collection of Arthur Birks, Ottawa.

Figure 28 J.E.H. MacDonald, drawing for Thomson memorial plaque, reproduced in *The Rebel* 2, no. 2 (November 1917), as illustration for his article, "A Landmark of Canadian Art."

bold outlines and flat colour patterns instead of shaded tones invokes contemporary poster technique rather than the book illustration style Thomson had previously employed in much of his decorative work.

While this verse setting is of a piece with Algonquin-scapes from the penultimate spring, Thomson harked back to his training in penmanship and lettering at the Acme Business College in a Gothic-scripted rendering of a stirring passage from *The Light That Failed*, Kipling's 1890 novel about a roving "special artist" (i.e., illustrator-reporter) who goes blind (fig. 27). The text clearly expressed his own Emersonian individualist philosophy: "I must do my own work and live my own life in my own way because I'm responsible for both." A year later, Thomson's own life light was quenched in the chill waters of Canoe Lake. This immeasurable loss inspired what is undoubtedly J.E.H. MacDonald's finest achievement in lettering art: the memorial plaque he and J.W. Beatty affixed to a stone plinth of their own construction on the south shore of the lake in the year of their comrade's mysterious drowning (fig. 28).

Conclusion(s)

All art is craft, William Morris contended (although all craft is not necessarily art). His Canadian disciple J.E.H. MacDonald held that painting and architecture are subcategories of design, not the other way around. And Stanley Kemp recorded with pride that at Grip, the designers, illustrators, engravers—even the humble "tint men"—were called "artists" by the management. Despite

his distaste for the advertising racket, Tom Thomson's application of life to art and art to life proves all three right. Like David Milne (who also started out as a commercial artist), he never would have become a "pure" painter had he not first learned a useful craft. His practice of applied art profoundly influenced his landscapes, which in choice of motif, composition, execution and palette are imbued with universal design principles.

Further, his custom of financing his artistic mission through daily toil is yet another instance of a Canadian phenomenon highlighted in 1995 by the design historian Michael Large. What Large wrote of MacDonald could legitimately be said of Thomson, and likewise of most members of the Group of Seven, as well as many of their contemporaries and successors: "The significance of the ease with which MacDonald and many other major Canadian artists moved between the worlds of fine art and commercial art is not generally understood. The bias of traditional art history and the scantiness of the records have not helped. MacDonald was at home in the continuous spectrum of visual production found in industrial societies, a place widely inhabited but still unevenly mapped. Graphic art and fine art must be seen as integral aspects of social, economic and political processes at the heart of culture."[29]

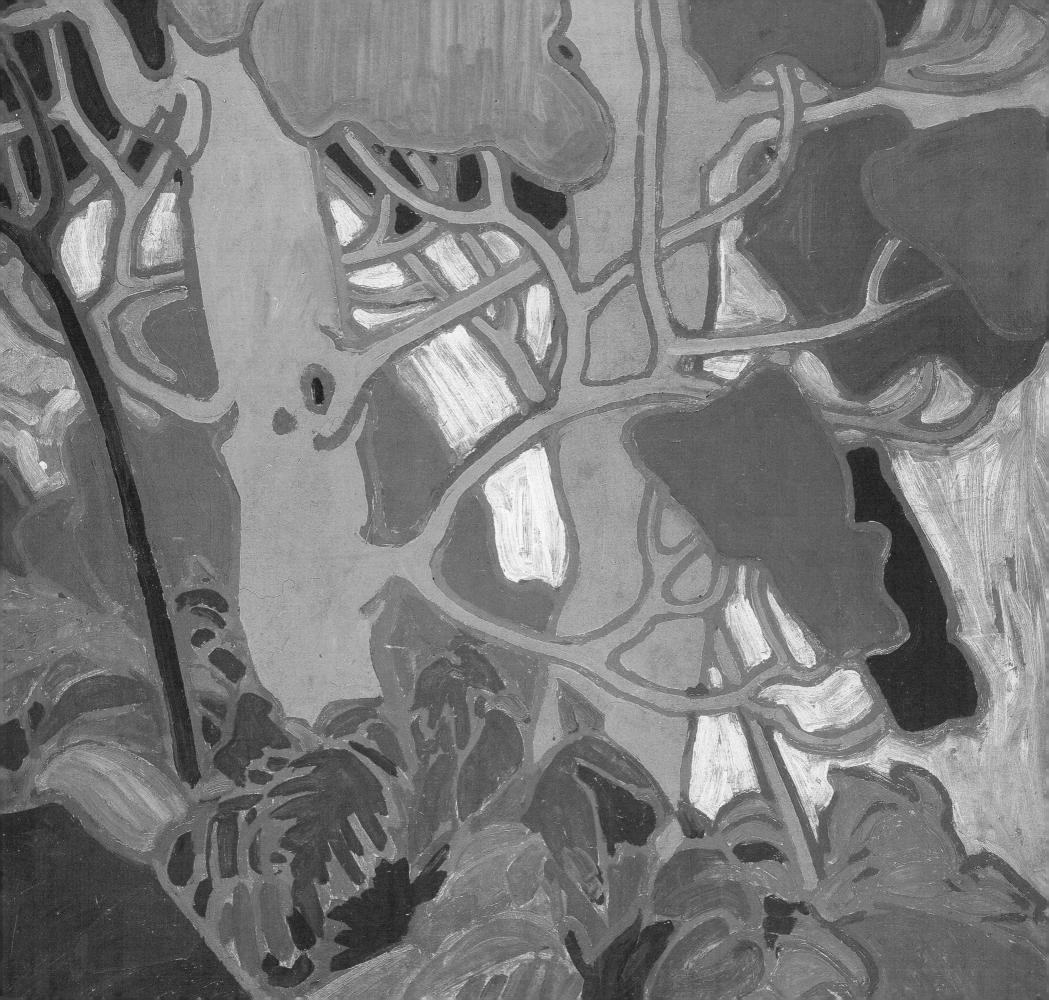

TOM THOMSON
and the Arts and Crafts Movement in Toronto

Dennis Reid

It may be a truism that a person's artistic values are essentially set by the æsthetic prevailing during the period of his or her first significant engagement with art. It is certainly the case with Tom Thomson, who became seriously interested in painting about 1912, some seven years after settling in Toronto to pursue a career in graphic design. During those early years, and after, as his familiarity with the Toronto art world grew, he would have encountered at virtually every turn the values of the Arts and Crafts movement, and those values shaped his emerging personal æsthetic.

The Arts and Crafts movement as it was understood in the early twentieth century was linked inextricably with the life, writings and

Figure 29 Tom Thomson, *Decorative Panel II* winter 1915–16 (detail), oil on Beaverboard, 120.8 x 96.4 cm, National Gallery of Canada, Ottawa, bequest of Dr. J.M. MacCallum, Toronto, 1944 (4718).

artistic production of the Englishman, William Morris (1834–1896).[1] While a student at Oxford in the early 1850s, Morris had become concerned with the dire effects of rapidly increasing industrialization: the despoiling of the landscape but particularly the dehumanizing of the workers, both by the dreadful social conditions they were forced to endure and by the way the division of labour, central to the industrialized system, denied them creative pride. It also guaranteed, he believed, a flood of poorly designed, shoddy wares. The solution to this lay in the affirmation of national artistic values, especially in the pursuit of traditional artistic practices employing the forms of local vegetation. Morris was greatly influenced in this belief by the writings of John Ruskin (1819–1900), particularly his *Stones of Venice* (1851–53), and most specifically a chapter in the second volume, *On the Nature of Gothic*. Here Ruskin persuasively links a humanist æsthetic to the values of a just society, based on an understanding of the "True Functions of the Workman in Art," as the chapter was in part subtitled when published separately as a widely distributed pamphlet in 1854. It was essentially a call for the thoughtful handcrafting of every artifact, from the grandest building to the simplest cup, in celebration of the essential human need to create meaning from all social activity. In a spirit of co-operative production among craftsmen, architects and artists, art and craft would be one.

Following university (where he had first studied for the Church), Morris articled to an architect, then decided to take up painting, but in 1859 he formed a company with a group of friends (later called Morris and Company, always known as the Firm), initially to create commissioned furniture, tapestries, stained-glass windows and murals, then all manner of furnishings, and soon complete interior designs. Throughout his life passionately engaged by writing and its effective dissemination, he established the Kelmscott Press in 1890, which quickly became the standard for fine book design and production.

The Firm was remarkably influential during the later seventies and eighties, and though Morris himself remained committed to the social resolve at the core of Ruskin's teachings (ultimately helping found the Socialist League in 1884), its greatest influence was on those who cared about "taste." Indeed, by the seventies there was a widely recognized Æsthetic Movement, led, according to the popular press, by the painter James McNeill Whistler (1834–1903) and the writer Oscar Wilde (1854–1900), who expressed at every opportunity the view that the reflective, æsthetic consideration of all aspects of life would lead to exquisite personal refinement. Although Æstheticism was distinct from the Arts and Crafts movement (in fact, the former was in part a reaction against the latter), their common commitment to the primacy of æsthetic awareness tended to blur such differences in the popular view, the more so as their influence spread beyond Britain.[2]

Toronto's first direct link with one of these figures was in May 1882, when Wilde included the city in a highly publicized North American lecture tour. He had prepared two lectures for the trip, "The Decorative Arts" and "The House Beautiful," and gave both in Toronto to sold-out audiences who were attracted, it would seem from reports of the time, largely by Wilde's reputation for eccentric dress and exaggerated manner. It is clear from reports of the dress and demeanour of many in the audiences

that Æstheticism had its Toronto acolytes, some of whom must have been motivated by the principles of the movement as much as by its style.[3]

We can imagine that among those who heard Wilde in Toronto was George Agnew Reid (1860–1947), a twenty-one-year-old painter who, with his American wife, Mary Hiester (1854–1921), would in the following decade set the standard for both Æstheticism and Arts and Crafts values in the city. Reid, following training in Toronto, studied under Thomas Eakins at the Pennsylvania Academy of Fine Arts in Philadelphia (1882–85), where he met his wife, and later at the Julian and Colarossi academies in Paris (1888–89), emerging as the major proponent in Toronto of large-scale figure painting, which he exhibited in Paris and Philadelphia as well as widely in Canada.[4]

Reid and his wife always included London in their travels abroad and appear to have contributed to the spread of Morris's ideals in America. That the United States was receptive is clear from the proliferation of Arts and Crafts societies there in the nineties, a movement that flourished particularly in upstate New York after the turn of the century, including a number of establishments in the Buffalo region but most notably in the workshops of Gustav Stickly at Syracuse. Stickly's illustrated monthly magazine, *The Craftsman*, which frequently positioned the æsthetic within a wilderness ethos, became the American bible of the movement during its years of publication between 1901 and 1916.[5]

The Reids were pioneers, then, when in 1891 they became members of the Onteora Club, a community of artists and like-

Figure 30 *Self, Onteora, 1893, in studio before fireplace built by self,* photograph in George A. Reid Scrapbook, p.175, Edward P. Taylor Research Library and Archives, Art Gallery of Ontario, Toronto, gift of Mary Wrinch Reid, 1957.

minded persons in the Catskills of upstate New York. Reid designed and built a cottage and studio there the following year (fig. 30). "I painted part of each day," he remembered years later, "and worked with the carpenters and masons the rest of the day."[6] Onteora stood fully for Arts and Crafts values. (One of the founders, Candace Wheeler, who helped establish the Society of Decorative Arts in New York City in 1877, later was one of the principals, with Louis Tiffany and others, in the important interior decorating firm Associated Artists.) Reid clearly embraced the concept, summering every year at Onteora until 1917, painting

murals, designing numerous buildings and "over a hundred" pieces of furniture for clients there.[7]

Ten years after his first summer at Onteora, Reid opined, "The union of the arts, which I believe ought to exist, can only be brought about, perhaps, when there is greater uniformity of education and general culture."[8] He was clearly expressing, if somewhat circumspectly, one of the underlying precepts of the Arts and Crafts movement: equal access for all to education and culture. Throughout his life in Toronto he worked tirelessly for that cause on many fronts. He had begun teaching at the Central Ontario School of Art and Design in 1890, a calling he pursued for almost forty years.[9] In 1894 he joined with six other artists to form the Society of Mural Decorators to propose a program for the new Toronto City Hall. Initially rebuffed, Reid four years later offered to donate his services to complete a part of the scheme, which was accepted.[10]

The city was encouraged in this decision by a new body, the Toronto Guild of Civic Art, a group of concerned citizens incorporated with the City Planning Ways and Means Committee in 1897 "to increase and to maintain the city's beauty spots."[11] Reid had been elected president of the Ontario Society of Artists (OSA) the previous year, and in that capacity he was asked to join the guild. Also among its members were Byron (later Sir Edmund) Walker (1848–1924) of the Canadian Bank of Commerce, an enthusiastic patron of the arts, and Professor James Mavor (1854–1924) of the University of Toronto. Walker was sympathetic to Arts and Crafts principles (he would commission a mural for the library of his St. George Street home from Reid in 1900).[12] Mavor, however, was the one strong, direct link in Toronto with the roots of the movement.

He arrived from Glasgow in 1892 to take up the chair of political economy and constitutional history at the university, but from the beginning he involved himself in every aspect of the city's cultural and educational life. In Britain he had served with William Morris on the executive of the Socialist League and soon was recognized in Toronto as the authority on all things relating to Morris and the Arts and Crafts movement.[13]

As president of the OSA from 1896 to 1902, Reid also promoted the idea of a public art gallery for Toronto and in 1900 convened an Art Museum Committee (Walker was elected chairman and Mavor was a member), the foundation of the present-day Art Gallery of Ontario. That year the OSA also arranged the first *Applied Art Exhibition* to be held in the city, showcasing the work of a range of architects, designers and craftspeople, as well as contributions from the city's major commercial design studios. In the true Arts and Crafts spirit, all participants received full and equal acknowledgment.[14]

Interest in this event led directly to the formation of the Arts and Crafts Society of Canada in 1903, with Mabel Adamson (1871–1943), then resident in Ottawa, as president, Reid as vice-president, and George A. Howell (1861–c.1924), managing director of Grip Printing and Publishing Company, one of the city's leading design printing firms, as secretary. Among the organizing committee were a number of artists, including E. Wyly Grier (1862–1957), the muralist Gustav Hahn (1866–1962) and the prominent Arts and Crafts architect Eden Smith (1859–1949).[15]

As before, all individuals, as well as firms, are identified in the catalogue, except for the creators of the large collection of traditional crafts from Quebec shown by the Women's Art Association of Montreal, which included some Native material, a carefully described selection of "Tribal Moccasins." After Reid, the largest single exhibitor was Mabel Adamson, another of the driving forces of the movement in Toronto. She was the bohemian youngest daughter of the prominent Cawthra family and had just spent a number of months at C.R. Ashbee's Guild of Handicrafts in England working on her enamelling and metalwork. In 1905 she and her husband, Agar, would establish W. and E. Thornton-Smith and Company in Toronto, an interior design firm inspired by the model of Morris and Company.[16]

Reid and his wife in 1900 had moved into a studio-home on Indian Road near High Park that he had designed (Gustav Hahn and family were neighbours). Then in 1906 they built Uplands Cottage, a quintessential Arts and Crafts studio-home in Wychwood Park, a new co-operative garden suburb on the heights of the escarpment at the northern fringes of the city.[17] Among his neighbours in the venture were Eden Smith, Gustav Hahn, again, and G.A. Howell.

That winter Reid was elected president of the Royal Canadian Academy of Arts (RCA).[18] Over the previous twenty years and more, he had also managed to fulfil numerous mural commissions, both public and private, to exhibit regularly with the OSA, the RCA, in the Paris Salon, as a member in 1893 and 1894 of the Palette Club (the earliest focused expression of Æstheticism in Toronto, described then as "the most advanced art association

we have"),[19] in numerous solo exhibitions, and in many with his wife. When a young commercial artist named Tom Thomson settled in Toronto in 1905 after some three years in Seattle, Washington, the Reids must have represented the pinnacle of artistic sophistication and success, and they manifested the Arts and Crafts movement in every aspect of their lives, of their beings.

We don't actually know what Thomson thought of the Reids in 1905, or of Arts and Crafts values, or even of art. No letters or other records of the early Toronto period are known to have survived, except for a handful of pen-and-ink drawings, a few loose pencil drawings from a sketchbook and two largely intact sketchbooks, one of about 1905, and the other of 1906–11.[20] And there is a watercolour rendering that has been described for years as a *Design for a Stained-Glass Window* (pl. 1), a window for Havergal College, although there is no evidence that such an ambitious decorative program was ever undertaken, or even planned, at that Toronto private girls' school. It does not even necessarily look like a stained-glass design, although the very constraining, containing decorative element suggests an architectural application rather than a commercial illustration. But what this work does tell us is that within a couple of years of his settling in Toronto, Thomson was reflecting Arts and Crafts values: designing for decorative use an image of an idealized female figure holding an open scroll, a symbol of learning; modestly, yet confidently, she displays æsthetic consideration in every aspect of the way she presents herself.

Such values would have permeated the teaching at the Central Ontario School of Art and Design, where George Reid was

chairman of staff as well as a drawing and painting instructor. Thomson is said to have studied in the evening there, soon after his arrival in Toronto, not with Reid, however, but with William Cruikshank (1849–1922), an academically trained painter of Scottish descent who taught drawing from the antique (casts) and from life.[21] The drawings in the sketchbooks—mainly candid, quick "takes," which, while showing much promise, are nonetheless largely tentative and awkward—suggest he did not pursue these classes very seriously, and the figure never did catch his interest. But he did not need to go to school to get the Arts and Crafts message. It would have seemed to be everywhere in Toronto in that first decade of the new century for anyone interested in art and design.

The second exhibition of the Arts and Crafts Society—building on every strength of the first, although renamed the Canadian Society of Applied Art—was held in December 1905, an event that, because it included work from most of the Toronto design studios, Thomson surely must have seen.[22] And anytime he picked up the popular weekly *Toronto Saturday Night*, he would have encountered imaginative advertisements for an organization called the United Arts and Crafts. It initially described itself as a "society of artists and craftsmen," doubtless based on such models as the Associated Artists in New York City or even the Firm, Morris and Company, but by January 1905 was advertising as the United Arts and Crafts. At its peak in 1904 its workshops occupied most, if not all, of the Red Lion Block, 749–65 Yonge Street, with a separate "studio," presumably a showroom, in the Lawlor Building at the corner of King and Yonge. They

were set up to "undertake the complete interior decoration and furnishing of homes" and carried an extensive retail stock, as well as their custom-designed material.[23] That this was an idea whose time had come is underlined by a feature advertisement of May 1906 for the Robert Simpson Company, one of Toronto's largest department stores, "The 'New Art' in Housefurnishing." We read: "One of the most striking results of the New Art Movement relates to housefurnishings, and for want of better name may be called the Arts and Crafts idea."[24]

One might imagine that such broad interest in Arts and Crafts values would have debased them for independent thinkers, but their roots ran very deep, as Thomson would discover when in 1908 he was engaged by Grip Printing and Publishing Company, or Grip Limited, as it was then known. You'll recall the first secretary of the Arts and Crafts Society of Canada was G.A. Howell, at that time managing director of Grip (in 1906 he became a director and secretary-treasurer of the company). Thomson would work there directly with a senior designer who was steeped in the teachings of Morris and the Arts and Crafts movement, J.E.H. MacDonald (1873–1932).

While apprenticing at the Toronto Lithography Company, MacDonald, beginning in 1893, took night classes at the Central Ontario School of Art and Design under Cruikshank and Reid. Two years later he joined the design department of Grip and in 1900 was represented in the OSA *Applied Art Exhibition*. That he already had a certain sense of the Arts and Crafts ethos is suggested by the fact that he designed and helped build the modest cottage he and his new wife moved into on Quebec

Avenue in the High Park area of Toronto the next year.[25] Robert Stacey has suggested elsewhere that about this time MacDonald visited the Roycroft crafts colony run by Elbert Hubbard at East Aurora, New York, near Buffalo, with the hope of getting design work with the Kelmscott-inspired Roycroft Press. He didn't join Hubbard's operation but in 1904 accepted the offer of a position with the Carlton Studios in London. This firm, begun by four Canadians three years earlier, was one of the first in England to combine the services of a design studio and advertising agency.[26] Working in London was an intensely rich experience for MacDonald, and as Stacey has shown, he returned to Toronto in late 1907 to head up the design studio at Grip utterly imbued with the design and life principles of Morris and his associates, values that would shape his design work, his painting and later his teaching until the end of his life.[27]

These guiding principles did not advocate a particular style, it is important to stress, but promoted values meant to establish in each person the potential for creativity, while supporting a non-hierarchical integration of the arts that would bring reflective, æsthetic consideration to all aspects of life, encouraging honest simplicity, dignity and health, in close communion with nature. Such sentiments are embodied in any one of a number of virtuoso penmanship demonstrations Thomson executed during the Toronto years either for his own pleasure or as gifts for family or friends (see pl. 90). They often are remarkably skilful work (he had excelled at penmanship in business school and was valued for his lettering skills in the Grip studio), and we can be sure that at least some of them would have attracted MacDonald's admiration.[28]

A mat Thomson decorated to set off a small photograph of a painting by the Toronto artist Curtis Williamson (1867–1944) is a wonderful example of the sort of design work we might imagine MacDonald encouraged in Thomson (see pl. 89). It is a dense, Morris-like arrangement of botanical forms executed with remarkably assured penwork, then delicately washed with watercolour to create just the right sense of depth for the intertwined forms to achieve their full vigour. The relationship of the confidently elaborate mat to the photograph of a painting (which Williamson signed with pen and ink) affirms the principle of the integration of the arts. And that the whole production seems to have been undertaken for a member of the Arts and Letters Club, which also championed the ideal of the integration of the arts, and is where Thomson likely met Williamson, is fully in the spirit as well.

Although one cannot talk of an Arts and Crafts painting style as such, we can still observe certain shared characteristics in the work of those painters in Toronto who can be identified with the movement in the years just before the war, when Thomson turned seriously to painting. These characteristics have been attributed to the influence of the Continental styles art nouveau, Jugendstil and symbolism, but what the work of these Toronto painters has in common during this period is a strong design element turned to decorative ends, and it invariably reflects Arts and Crafts values both in content and context. The Reids, of course, are among this group of adherents. Mary Hiester Reid was

Figure 32 George A. Reid, *Winter Afternoon*, 1915, oil on canvas, 45.7 x 61.0 cm, The Art Gallery of Peterborough, Peterborough, Ontario, gift of the Peterborough Teachers' College, 1973 (73001015).

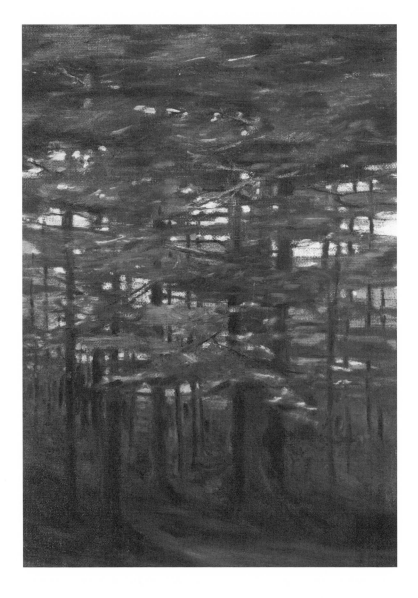

Figure 31 Mary Hiester Reid, *Pines at Sunset*, c.1902, oil on canvas, 72.2 x 49.5 cm, Government of Ontario Art Collection, Toronto, purchase from the artist, 1902 (MGS 622001).

best known for her "Æsthetic" floral still lifes, virtuoso paintings of remarkable sensitivity, redolent of complex moods. But she also painted landscapes throughout her career, and although these are often atmospheric tonal studies, there are a number, such as *Pines at Sunset* (fig. 31), likely painted in 1902, the year it was purchased for the Ontario government collection, that reflect a marked sense of design in the judicious placement of forms in shallow space, a conscious patterning in the repetition of elements, heightened colour, an overall striking decorativeness. George Reid had been turning increasingly to landscape

painting since the beginning of the century, and while there is a heightened decorative quality in his figure paintings of the period, it is particularly marked in the landscapes. *Winter Afternoon* of 1915 is a good example (fig. 32). He has chosen a moody, evocative time of day, and of year, in Wychwood Park, but it is the brilliant, measured bands of high-key colour forming a screen through which we view across the shallow middle ground the stately, tight arrangement of simplified house forms behind that give us pleasure.

A J.E.H. MacDonald canvas of 1912, *Early Evening, Winter*, deploys similar elements and achieves a similarly commanding decorativeness (fig. 33). There's more flair to the MacDonald, however, a greater boldness both in the sharpness of the still-harmonious colour contrasts and in the pattern of brushstrokes denoting the special light of a winter moon in a cold night sky. A large part of the decorative appeal of the piece comes from the way it evokes the hues and textures of a handcrafted environment of wood, copper and burnished leather.

A number of other artists working in Toronto at the time shared this interest in richly decorative painting. One more who was part of the Arts and Letters Club circle was C.W. Jefferys (1869–1951), whose *Dark Woods* of 1913 turns tightly patterned brushstrokes and a broad screen of darkly brooding tree trunks into a compelling haunt for a vaguely predatory female figure (fig. 34).

Although there are aspects of the handling in Thomson's earliest landscapes in oils of 1911–13 that suggest he was, at least in part, responding to this interest in decorative effects, it

Figure 33 J.E.H. MacDonald, *Early Evening, Winter*, 1912, oil on canvas, 83.8 x 71.1 cm, Art Gallery of Ontario, Toronto, gift of the Canadian National Exhibition Association, 1965 (18).

Figure 34 C.W. Jefferys, *Dark Woods*, 1913, oil on canvas, 48.2 x 61.5 cm, Art Gallery of Ontario, Toronto, gift of Mrs. K.W. Helm, daughter of C.W. Jefferys, Kneeland, California, 1980 (80/168).

is only when he is evidently settling into the idea of being a painter, during the winter of 1913–14, that we see him responding fully to that particular reflection of Arts and Crafts values. *Moonlight* (pl. 19) we believe was painted, or finished, in the studio he shared in the new Studio Building the first two months of 1914 with A.Y. Jackson (1882–1974), from Montreal, who by then had spent some three years altogether in France. I once suggested that the unified handling of this painting, so different from his canvas of the previous year, *Northern Lake* (pl. 8), was the result of Jackson's "direct tutelage."[29] It is apparent

now that it is Thomson's response to the work of a range of Toronto painters who shared an interest in the effectiveness of decorative patterning, but particularly to MacDonald's canvases of the previous two years. While the sense of unity, of coherence, that this handling brought to Thomson's painting probably pleased him, he also must have found real pleasure in the rhythmic patterning that so enlivens the sky and water of his landscape and caresses the eye with a constant, though not insistent, reminder of the painter's hand at the surface of the canvas.

The Studio Building also manifests Arts and Crafts values, both in its design and as a concept. The work of Eden Smith, it was commissioned by the painter Lawren Harris (1885–1970) with the help of a patron, the ophthalmologist Dr. James MacCallum (1860–1943). Situated in a natural setting in a corner of the Rosedale Ravine in Toronto, just a couple of blocks from the busy intersection of Yonge and Bloor, it contains six double-height studios, each with a simple, yet comfortable, cottage-like living area and north-facing studio fenestration.[30] Harris had taken this initiative in order to encourage what he, MacCallum, MacDonald and others saw as a new direction in Canadian art, a northern movement dedicated to the pursuit of a distinctive Canadian expression. Although such ideas had been building for years — MacDonald later saw their roots in the work of Cruikshank and Reid, among others, and in the various efforts to focus the ambitions of young graphic designers at the turn of the century[31] — there was the sense by 1913 that momentum was accelerating.

The Studio Building opened in January 1914. Harris and MacDonald each had a studio, as did A.Y. Jackson, who had been lured from Montreal to be part of the new movement. Jackson, as we have noted, shared his space with Thomson, and the other three studios were taken by Curtis Williamson, J.W. Beatty (1869–1941), an academically trained landscape painter who had been sketching in the North for the past few years, and Arthur Heming (1870–1940), an illustrator, writer and painter who pursued northern themes in all his work. According to Jackson, they were all chosen by Harris and MacCallum because of their passion for the North, although the last three, he felt, never really contributed to the co-operative ideal implicit in the concept of the Studio Building.[32]

Dr. MacCallum was the one then most committed to living this northern ideal. He had been attracted to Georgian Bay as the site for a summer home by the establishment of the Madawaska Club at Go-Home Bay by a group of University of Toronto professors in 1898 (Mavor was a charter member). MacCallum, who as a U. of T. professor could have leased club land, chose instead to buy an island just outside the precinct on which to build his cottage, a rustic Arts and Crafts structure beautifully suited to the rocky site that was designed by one of the Madawaska Club members, Professor C.H.C. Wright.[33] The Madawaska Club was part of a widespread cottage movement throughout North America in the decades just before and after the turn of the century, as people tried to deal with the intense urban growth of the period.[34] It was not, like Onteora, predicated on Arts and Crafts principles but nonetheless drew on such ideals in many ways. MacCallum certainly understood that his summers on the island related to his æsthetic principles and was constantly inviting artist friends to join him there.

Even a glance at popular Toronto magazines of the period reveals that the artists hardly needed MacCallum's encouragement to travel north. There was a steady stream of articles on the resorts that seemed to be opening everywhere there was rail access in the North, as well as attractive reports of canoe trips and wilderness camping experiences, particularly in Algonquin Park.[35] So we shouldn't, perhaps, wonder why Thomson followed his very first canoe trip, to Algonquin Park in May 1912, with Ben Jackson (1871–1952), a friend from Grip, almost immediately with a second, into the Mississagi Forest Reserve, with another Grip colleague, William Smithson Broadhead (1889–1960), in August and September, then spent a good part of the open season tripping every year after. We rather should wonder why it took him so long to start. Once he did begin he was an enthusiastic proselytizer, just like MacCallum, always asking artist friends to join him on trips. He talked Jackson into travelling alone to Algonquin in late February 1914 when the snow was still deep on the ground. Thomson went up in late April that year and had Arthur Lismer (1885–1969), whom he had met at Grip in 1911, with him the middle two weeks of May. Jackson returned in mid-September, and he and Thomson were joined by Lismer, who returned in early October with his wife and little girl, accompanied by another colleague from the Toronto design studios, Fred Varley (1881–1969), and his wife, for about a two-week stay.

Figure 35 A.Y. Jackson, *Maple and Birches*, 1915, oil on canvas, 82.6 x 99.7 cm, Art Gallery of Ontario, Toronto, purchase 1942 (2704).

Lismer and Varley were both from Sheffield, England, where they had studied at the Sheffield School of Art (as had Broadhead), a basic technical training, part-time in the case of Lismer, as he concurrently apprenticed in an engraving firm, and likely the same for Varley. They both subsequently studied painting at the Académie Royale des Beaux-Arts in Antwerp (Varley 1900–02, Lismer 1906–08), then worked in commercial design and illustration back in England, and, in Varley's case, at other odd jobs, until immigrating to Canada. Lismer was first, in January 1911, and Varley, following the younger man's success in the New World, set off in July 1912. The British art historian Michael

Tooby has described in wonderful detail the social and intellectual environment in Sheffield that nurtured these two artists. Theirs was a serious craft training, a pragmatic regimen that was leavened, perhaps, by the presence in the city of the Museum of the Guild of St. George, known popularly as the Ruskin Museum. Founded by Ruskin in 1875, it "was a cornucopia of material related to Ruskin's theories," a collection " . . . intended to make accessible to citizens a range of works of art and artefacts that would stimulate, through visual awareness, the desire to explore the revelations of nature."[36] Lismer was also deeply involved with the Heeley Art Club, an organization of serious practising artists that provided twice-yearly exhibitions, lectures, regular field-sketching trips into the spectacular Yorkshire countryside and focused discussion groups. No wonder they slipped so easily into the Toronto ambience of Grip, the Arts and Letters Club and Algonquin Park.

Canoe Lake, the centre for most of this activity in Algonquin that year, must have suggested the beginnings of yet another co-operative artists' community, although the news of war that summer would have curtailed planning. Jackson returned to Montreal shortly before Christmas and enlisted in the army the following May. He managed to paint up two canvases from his October sketches, the famous *Red Maple* (National Gallery of Canada), finished in time for the RCA exhibition that opened in Toronto on November 19, 1914, and *Maple and Birches* (fig. 35), completed in Montreal in January. Both display a highly decorative approach, with an emphasis on flat patterning and dramatically heightened local colour in a simple but graphically dynamic

composition. Varley's *Indian Summer* (fig. 36), likely also completed that winter from sketches done in Algonquin in October, reflects a similar approach, with the figure of his wife firmly grounded in a dynamic confluence of rock and wood against a rhythmic screen of tree trunks, all caught up in a gently whirling pattern of broken sunlight and flashing colour that is a decorative delight. Lismer's *Sumach and Maple, Huntsville* (fig. 37), of 1915, similarly participates in an almost ecstatic frenzy of surging pattern, held in place by both the shallow space — there is just a hint of horizon at the top of the canvas — and the dynamic skein of whiplash lines.

Lawren Harris, who had studied painting in Berlin (1904–07), did not travel to Algonquin that year, but he was deeply involved in the progress of the group, and in a number of works completed before he enlisted in the army in May 1916, he demonstrated his common feeling with the new "school."[37] *Snow II* of 1915 is a good example (fig. 38). It is unabashedly decorative, depicting a foreground row of snow-laden conifers in a shadow of delicate mauve tinged with pearly rose, through which we view a frozen expanse of lake with a sun-bathed far shore of burnt orange hills, topped with a glowing sky of alternating bands of pink and turquoise to azure, washed lightly with lemon. The advancing darkness of the lower portion of the picture plane, and the stratified paint application in the sky, reinforce how much this painting means to be about what is happening at or very near its surface.

There can be no doubt of the clarity with which this group of painters understood their task at this point. They were revelling

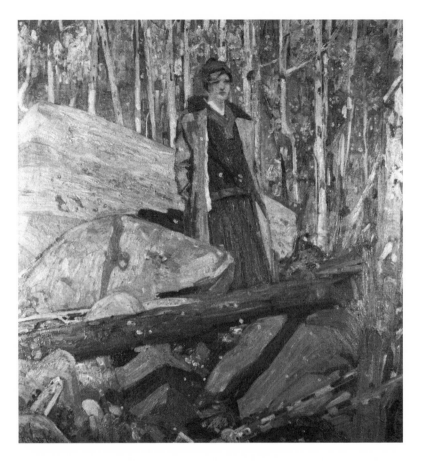

Figure 36 F.H. Varley, *Indian Summer*, 1914–15, oil on canvas, 91.4 x 83.8 cm, private collection.

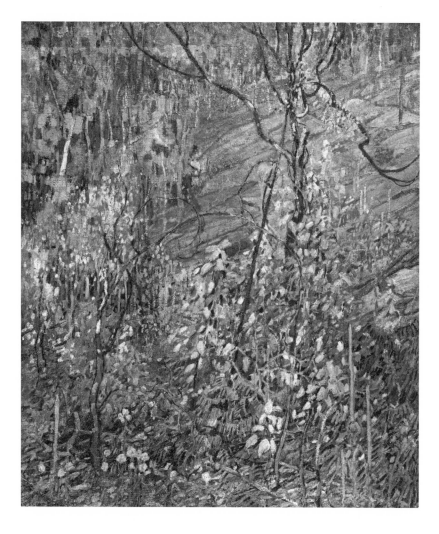

Figure 37 Arthur Lismer, *Sumach and Maple, Huntsville*, 1915,
oil on canvas, 127.0 x 101.6 cm, The Thomson Collection (PC-159).

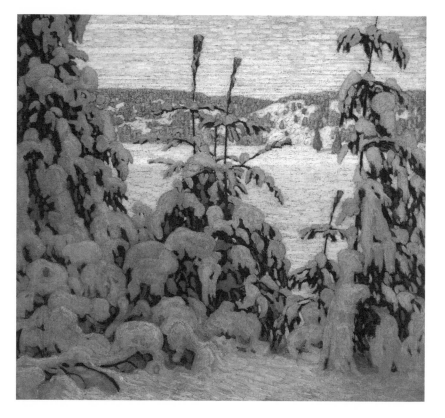

Figure 38 Lawren S. Harris, *Snow II*, 1915, oil on canvas, 120.3 x 127.3 cm,
National Gallery of Canada, Ottawa, purchase 1916 (1193).

in the confidence of shared vision, a vision of a decorative art, meant to constantly enrich the domestic environment with its visual richness, its life-enhancing vibrancy. And they were recognized. They made a strong presentation at the March 1915 exhibition of the OSA. One critic exclaimed that when entering the exhibition, "you are confronted with a glow of color that is startling." It was, he noted, "largely due to a movement among a group of younger painters who have rebelled against the old

convention in favor of cool, dun tones."[38] He didn't mention what they stood *for*: an ideal of co-operative support, the integration of the arts, or at least the visual arts, a celebration of the natural environment, the discovery of a new land, their land, themselves. And Tom Thomson, they soon began to sense, was at the centre of their mission of discovery, especially as the war gradually drew the others away.

That their shared vision of that essentially Arts and Crafts utopia of a non-hierarchical community of artist-craftsmen living in a totally æstheticized environment in healthy accord with nature was based on an acknowledged sense of idealism is reinforced by Thomson's *Study for "Northern River,"* which was painted in gouache, not in the field but in the studio that winter of 1914– 15 (pl. 39). So while it may ultimately rely on the experience of an actual site, it is in its present form an invention, an amalgam of the important issues then swirling about, an ideal. It is, of course, intensely decorative. The canvas closely modelled on it has been variously described as looking like a decorative screen, a stained-glass window, a tapestry (see pl. 40). It seems to be the very embodiment of a concept MacDonald once enunciated of understanding the decorative element as the "universal ether," "the element in which art lives and moves and has its being."[39] An image even more flat and taut than those of his colleagues, it still draws us in, through and beyond.

An early historian of Canadian art, Donald Buchanan, once insightfully observed that Thomson's "originality as a landscape artist and his skill as a woodsman developed hand in hand, one as it were deriving sustenance from the other."[40] And Lismer,

who always valued the time he was able to spend with Thomson, described him as "a thoroughly integrated individual — a craftsman, woodsman, and artist."[41] It is, indeed, this wonderful sense of integration, of focus, of confident purpose, that floods with meaning the work of his last two and a half years. We can single out sketches of 1915 so compellingly decorative that we can immediately imagine them inset as panels in a piece of furniture or otherwise embedded in a domestic interior in the Arts and Crafts manner — for instance, *Marguerites, Wood Lilies and Vetch* (pl. 55), with its intense floral hues picked out of a deep black background, or *Nocturne: Forest Spires* (pl. 76), a radically simplified but still complex landscape that he later worked into a small canvas. Yet neither of these — nor others of their ilk — differ in basic handling, or in conception, from his other sketches of the year. As much as we admire their flat patterns and delicious colour, we still feel close to the experience of a place, of a moment.

The canvases of the period also deliberately seek the "universal ether" as assiduously as the northern experience. *Opulent October* (pl. 82), *After the Sleet Storm* (pl. 83) and *The Birch Grove, Autumn* (pl. 78) are three that appear disparate in style — their handling ranges from loose and gestural through to an almost brutalist construction of blocky forms — yet they all reflect the same desire to create compellingly decorative, flat, but dynamic images of the essential vitality of the northern wilderness. The point to be made is not that Thomson and the others were satisfied to simply achieve a level of decorative appeal but that they understood decorativeness, the manipulation of colour, form,

line and texture to achieve a heightened perception of the material stuff of art, the most effective way of engaging the viewer, particularly of impressing the æstheticized viewer, with the high level of their craft. Oil sketching and easel painting still remained distinct from other forms of decorative art, in their view, but it was a distinction of a relatively small order, mainly having to do with function.

This is clear in the way Thomson, Lismer and MacDonald responded to a classic Arts and Crafts project offered to them by Dr. MacCallum in the fall of 1915. He had decided to commission a mural program for the living room of his Georgian Bay cottage as a birthday surprise the following spring for his wife. MacDonald took the lead, travelling to the island in mid-October to measure the room and lay out the program, apparently with Thomson's, and certainly with MacCallum's, help. The scheme, which was intended to cover the upper half of all the walls, was dominated by two large figural pieces by MacDonald on either side of the great stone fireplace on the west wall (fig. 39), showing classic Go-Home Bay "types" of the past (to the south) and the present (to the north). Another large panel by MacDonald, *The Supply Boat*, dominated the long north wall, facing one by Lismer, *The Picnic*, on the south. Over a door on the east end was another large Lismer, *The "Skinny-Dip."* In between these large panels, over windows and filling other gaps, were a number of smaller panels of decorative motifs based on northern plant forms by Lismer, MacDonald and Thomson. Three Thomsons were installed, and four, which due to some miscalculation, it seems, either were not needed or did not fit, were stored in Toronto and

went to the National Gallery of Canada with the MacCallum bequest in 1944.[42] The three installed Thomsons are a few centimetres smaller than the other four. Perhaps they were cut down to fit. Otherwise, all seven are closely related: stately treatments in rich, full colour of vibrant patterns of tree trunks, tendril-like branches and undergrowth, remarkably vital and satisfyingly resolved works of art. We've reproduced the four panels that were not installed (pl. 85). They differ from his canvases of the period in really only one significant way: the forms are more stylized, each element of the image a discrete shape of unmodulated colour.

The project was noticed in Toronto, reported by the artist Estelle Kerr in December.

Some striking mural decorations have recently been installed in the summer residence of Dr. James MacCallum, Georgian Bay. The word "striking" is used advisedly, for though that adjective is seldom happily applied to mural decorations, the almost barbaric riot of colour is, in this instance, very pleasing in the large and formerly somewhat bare-looking living-room, with its rough raftered ceilings of new pine. The effect is bizarre, suggestive of the Russian, and is essentially harmonious with the wild northland and the gay and cheerful life of the great out-of-doors. . . . On either side of the fire-place and above the windows are low-toned decorations by Tom Thomson [those above the windows are by MacDonald, but the Thomsons left out may have been meant for there], which represent the various kinds of trees found in Georgian Bay, highly conventionalized. . . . Altogether, the room is vastly interesting and the paintings it contains are worthy of the three clever artists. The

only regret is that they are placed so far away that very few will have the opportunity of seeing them.[43]

There is other evidence of Thomson's commitment to the ideal of the æsthetic environment. A number of decorated enamel and stoneware bowls and other objects he appears to have painted for family or friends have usually been dated to the time of the MacCallum murals.[44] The *Decorated Pannikin* (pl. 87) now in the National Gallery of Canada was apparently made for an Algonquin Park friend named McDermott. A *Decorated Demijohn* (pl. 88) was fashioned for Alexander Grant Cumming, the proprietor of the Art Metropole on Yonge Street in Toronto, the leading art supply shop in the city and sometime venue for exhibitions. While the creation of "art" pottery and the painting of commercially produced ceramics with appropriate glazes for secondary firing were both widespread manifestations of the Arts and Crafts ideal, Thomson used common kitchen utensils exclusively, it seems, and painted them with ordinary artists' oils. In all the known examples, broad, lozenge-shaped forms of slightly impastoed oil paint are used to create simple leaf, cone, tendril and, in the case of the demijohn, grape patterns in a rich, dark colour range similar to that seen in the MacCallum murals. Thomson was still painting containers for friends as late as 1917, as reported by Daphne Crombie, who was staying at Mowat Lodge in Algonquin with her husband early that year. He decorated a glass jar for her with a diagonally shaped pussywillow pattern over a solid blue background to be used as a vase for wildflowers.[45]

Another habitué of Mowat Lodge at the time, Dr. R.P. Little, reports that in 1916 Thomson designed the cover for the "booklet

Figure 39 An early view of the fireplace and murals by J.E.H. MacDonald (flanking the chimney) and Thomson (seen partially extreme right and left), MacCallum cottage, Go-Home Bay, private collection.

Figure 40 "Out-Side-In" sign painted by Thomson for the rangers' cabin, Achray, Grand Lake, photograph by Edward Godin, Algonquin Park Museum and Archive (APM #1132).

announcing Mowat Lodge," and when asked by a local guide, George Rowe, "he painted a pennant on the bow of George's canoe to identify it." Little also retells a story that seems to go back to Lismer and the spring of 1914 of Thomson mixing an expensive tube of artist's cobalt blue into a standard grey canoe paint in order to get just precisely the right hue for his new Chestnut canoe.[46] The summer of 1916 he lettered a sign for the rangers' cabin he shared with Ned Godin at Achray, Grand Lake, the "Out-Side-In" (fig. 40).[47] Over the winter of 1915–16 and the next, J.E.H. MacDonald's son, Thoreau, remembers seeing in the "shack" behind the Studio Building where Thomson then lived and worked when in the city, "canoe paddles and axe handles that Tom worked on [carved] in intervals of painting and some homemade trolling spoons and lures hanging on the wall. He made and carved his frames too."[48] And there is at least one other piece, a canvas, that, because of its shape, must have been intended to serve as an over-mantel or in some other architectural application (see pl. 86). The degree of stylization of the trees, undergrowth and group of deer it depicts lies between the MacCallum murals (which were painted on Beaverboard) and other canvases of the period.

The distance between these two "categories" continued to narrow in the oil sketches as well. *Water Flowers* (pl. 56), similar in general approach to the other wildflower studies of the summer of 1915, is broader in handling (in part because of the matter depicted — water lilies, including a pad, cattails, rushes and pickerel weed), the sort of sketch some have argued foretells a move to abstraction. Another sketch that has been cited as evidence of this tendency, *Forest, October* of the fall of 1915 (pl. 67),

is still viscerally rooted in direct experience. In fact, in both of these richly decorative works the connection with the subject, the place in all its particularity, is profound. We are reminded of the Canoe Lake ranger Mark Robinson's tales of Thomson's absolute absorption in the problem of establishing the particular hue and tone of things, his utter fascination with the ranges of grey, for instance, or of brown, found in nature.[49] As exaggerated as his colour might seem, it is grounded in local colour, observed under a special moment of light.

Maple Saplings, October (pl. 125), a canvas of the last winter, the season of *The West Wind* (pl. 131) and *The Jack Pine* (pl. 132), demonstrates how assiduously he maintained his æsthetic course. It represents a remarkably sophisticated manipulation of decorative elements within a shallow field, an electric celebration of the vitality surging through the natural environment as the winter hibernation looms — the long sleep that presages the eternal rebirth of spring.

Many of the sketches of the last year and a half exemplify Thomson's remarkable capacity to fuse design, the act of painting and the lived experience in one breathtaking object. *Snow and Rocks* (pl. 95), with its rich reds, browns, pinks, violets, greys and greens, and its blinding blues and whites, all set within a complex skein that holds them taut within the shallow space but lets them fall into place, into form, when we mentally move back a step to take the whole picture in, is a case in point. Is there any way to adequately describe the pleasure one realizes slipping back and forth between enjoyment of the material object — every single brushstroke a sensuous, satisfying entity, splashed gobs of paint so absolutely right that they seem to have grown in place — and experiencing the immediacy of the rendering of a precise moment of light, temperature and material presence? We can only be grateful that Thomson found the way in Toronto in those years before the war to, as a craftsman, aspire to be an artist, and as an artist to remain true to his craft.

Tom Thomson's PLACES

John Wadland

Tom Thomson lived the essence of his life in what we might call three macro landscapes: the agrarian spaces of his rural home near Owen Sound, where he grew up and spent his childhood and adolescence; the urban spaces of Seattle and Toronto, where he learned and practised his trade as a commercial artist; and the bush spaces of the near northern Canadian Shield, where, in his final six years, he made the art by which he is remembered. In adulthood he travelled often between and within these landscapes, whether on foot, by train, by steamship or by canoe. Indeed, it may be said of Thomson that he liked to be in motion, between spaces. In his art he aspired to capture the spaces that most touched his life in passage.

Figure 41 Driving logs in the spring flood. Archives of Ontario, Toronto (L 276).

In a consideration of any elements of visual culture, the art historian and cultural theorist Irit Rogoff invites us to employ "the notion of 'the curious eye' to counter the 'good eye' of connoisseurship." Curiosity has not already determined what it sees but is conscious of "things outside the realm of the known, of things not yet quite understood or articulated, the pleasures of the forbidden or the hidden or the unthought, the optimism of finding out something one had not known or been able to conceive of before."[1] In this essay I will explore in greatest detail the third Tom Thomson landscape, acknowledging from the outset that he himself did not use the term *wilderness* to describe it, and understanding that he was not overtly a nationalist who unloaded the symbolist baggage that subsequent critical analysts of his work have admonished us to carry through the ages. No attempt will be made to dismiss the importance of Thomson's agrarian and urban landscapes, but I will consider them less as discrete entities, more as they find their way into the environment that inspired his creativity. The agrarian and the urban lived in the "North" every bit as much as they lived in the experience and the mind of Tom Thomson. Paraphrasing the French philosopher and sociologist Henri Lefebvre, Rogoff reminds us of three central principles: (1) "no space . . . is ever devoid of social relations"; (2) "space is constantly in the process of production"; and (3) "spatial analysis . . . [negates] the illusion of transparency." Seeing is not believing. What we see is not the known but an invitation to search for the social relations and the processes of production that animate space. With our "curious eye" we see that "power produces a space which then gets materialized as place" and that "the meaning of a named place is never its designated activity or physical properties but their interaction with far less obvious subjectivities and with the actions and signifying practices that elicit (or mask) these."[2] Tom Thomson's bush spaces were densely populated with people and the memory of people, with their production and their memory of production. These spaces constituted a text, recording a past and entering an emerging future. Prescient of the future, he brought a human (therefore a limited) understanding and an immense creative energy to its expression.

Tom Thomson was not a highly educated man, by no means an intellectual. His experience of space was refracted through the new technologies that characterized the beginning of the past century and that were significantly affecting the lives of Canadians. Owen Sound, with a population approaching 9,000 in 1900, sat at the foot of the Bruce Peninsula on Georgian Bay. The community had been served by the Toronto, Grey, Bruce Railway since 1872. In 1882 this line was leased by the Canadian Pacific Railway, meaning that four years later Thomson could imagine travelling the breadth of Canada, from his back door, in a matter of days. During his childhood he witnessed the birth of the revolutionary capacity to transfer photographic images to the printed page, transforming the daily newspaper from a sea of text into a visual (though still black-and-white) field of mystery. In 1899, having left the family farm and moved to town, Thomson was briefly an apprentice machinist at William Kennedy and Sons, manufacturers of turbine water wheels, among other things. That same year, the Owen Sound inventor Alfred J. Frost built the

fourth automobile in Canada to be powered by an internal com-bustion gasoline engine. By 1900 Owen Sound boasted saw- and flour-milling capacity, a tannery, an iron works, a manufacturer of engines and boilers, a biscuit and confectionary company, furni-ture businesses, excellent schools, a hospital and several banks. From 1855 it was served by a Mechanics Institute[3] (after 1884 the public library), from 1864 by a board of trade and from 1903 by municipally owned utilities. The Bell Telephone Company commenced service in 1884 in tandem with the Owen Sound Telephone Company. The first hydroelectric power was provided in 1887 by the Owen Sound Electrical Illumination and Manu-facturing Company, located at Inglis Falls, immediately south of town. By 1915 Owen Sound was part of the grid controlled by the Ontario Hydro-Electric Power Commission. In other words, this small Southern Ontario town, serving a modest agrarian hinterland, was fully a participant in the information and tech-nological revolution of its time.[4]

Tom Thomson's paintings betray a fascination with water, presumably derived—at least in part—from the physical prox-imity of the family farm at Leith to the actual sound of Owen Sound, on Georgian Bay, and from his fondness for fishing there, and in the creeks feeding it and the neighbouring Sydenham and Pottawatomi Rivers. With a beautiful and well protected harbour situated at the base of the sound (fig. 43), the community centred much of its economic life on the water, often in painful compe-tition with neighbouring ports. Commercial fishing was actively pursued from Mackinaw boats. The local historian James P. Barry estimated that in the 1870s "the total combined [i.e., for all the

Figure 42 Among the 30,000 islands of Georgian Bay, Inside Channel, from Wilfrid Campbell, *The Beauty, History, Romance and Mystery of the Canadian Lake Region* (Toronto: Musson, 1910).

Figure 43 Owen Sound Harbour, Georgian Bay, from Campbell, *The Beauty, History, Romance and Mystery of the Canadian Lake Region*.

bay ports] yearly catch of whitefish, lake trout and yellow pickerel was over two million pounds."[5] The CPR based the terminal for its Upper Lakes steamship fleet at Owen Sound from 1884 to 1912. In 1888 the local shipyard of Polson and Company built the CPR steamer *Manitoba*, the one member of the fleet to continue to call at Owen Sound on the voyage to the head of Lake Superior after 1912. A huge grain elevator complex with a capacity of over a million bushels was constructed by the CPR in the 1890s but tragically burned to the ground in 1911, concluding Owen Sound's role in the grain business until its revival after the war. Schooners had been sailing routinely between Toronto and Georgian Bay ports from the 1850s, transporting cargos of lumber and grain to and from markets in the United States. Collingwood, in Nottawasaga Bay, had been served by the Northern Railway since 1855, and a line had been extended to Meaford by 1872. After 1855 the Northern was also providing sidewheel steamship service from Collingwood to Chicago, Green Bay and eventually the Lakehead. "[T]he new American canal at the Sault allowed steamers to pass easily into Lake Superior, making the trip from Union Station [Toronto] to Fort William [Thunder Bay] a matter of just three or four days. . . ."[6] After Manitoba entered Confederation, and before the building of the transcontinental railway, the steamer trade from the bay to the head of Lake Superior prospered, providing transportation not merely for passengers, but for the mail and freight to various communities as well. Competition for the CPR steamship fleet was provided by large operations with names like the New England Transportation Company, the Great Northern Transit Company, the Meaford Transportation

Company, the Georgian Bay and Muskoka Navigation Company, the White Line and the North Shore Navigation Company. Many of the craft in service on these lines were built in the yards at Owen Sound.[7] After a process of acquisitions and mergers, the Northern Navigation Company emerged as a major player in determining the destiny of local ports. The ownership of this powerful company moved its centre of operations in 1910 from Collingwood to Sarnia, where the Grand Trunk now discharged all its passengers and freight destined for the Lakehead. Indeed, from 1900 to 1912, Owen Sound remained the only bay port providing routine service to Lake Superior. In 1913 the Northern Navigation Company merged with the Richelieu and Ontario Navigation Company to form Canada Steamship Lines. Competition between railroads was never far below the surface of the steamship story.[8]

In 1888 the Northern Railway was taken over by the Grand Trunk, the major competitor of the CPR, merely four years after the latter had made its major investment in Owen Sound. Wiarton, in Colpoy's Bay just to the north of Owen Sound, was connected to another line of the Grand Trunk in 1882. A spur was extended from the Wiarton road to Owen Sound in 1893, thereby adding insult to injury. Logs from the prospering lumber industry entered Wiarton, Owen Sound, Meaford, Collingwood and other nearby ports from a hinterland extending to all the major North Shore rivers and to Parry Sound and Manitoulin Island. In 1897 Parry Sound was reached, at Depot Harbour, by J.R. Booth's Ottawa, Arnprior and Parry Sound Railway, which provided the shortest link between Georgian Bay, Montreal and the New England

coast. But some of the greatest competition for the bay ports came from Midland, nestled in a deep natural harbour in Severn Sound and served by the Midland Railway, which joined Georgian Bay to Lake Ontario at Port Hope. As part of its massive reorganization, the Grand Trunk absorbed the Midland Railway in 1884. And after closing the passenger steamship terminal at Owen Sound in 1912, the Canadian Pacific fleet moved to Port McNicoll, a stone's throw to the east of Midland. By the mid-1870s large sawmills at Spanish River, Waubaushene, Byng Inlet, Sturgeon Bay and Manitoulin Island were busily gutting the pine forest in the annual round that brought loggers to the shanty in the fall, saw them cut through the winter, load their prize in dumps by streams, rivers and lakes till spring breakup, then roll them into the water and facilitate their treacherous traverse to the bay. No one travelling through the bay by steamship could miss the massive booms of logs gathered at or in transit from the mouths of all the major rivers (fig. 41, p. 84). During the late 1880s and 1890s, passing ships might have had to dodge rafts of logs being towed by tugs from the bay across Lake Huron to Michigan, where mill owners had depleted their own supply.

The American Dingley Tariff of 1897—a response to a serious economic depression at mid-decade—sought to protect U.S. producers by placing a heavy duty on Canadian sawn lumber, while freely admitting raw logs. The tariff effectively closed a number of small operations and shrank production, and therefore employment, at all the large ones. The Georgian Bay Lumber Company, perhaps the largest, "reduced the cut in the Waubaushene mill from 30 million board feet to 26 million in 1897 and to 24 million

in 1898."[9] Pressed by the Georgian Bay lumber producers in particular, the Ontario government responded by revising the province's timber regulations, mandating that all logs cut on Crown lands would be subject to a "manufacturing condition" requiring that they be processed at mills in Ontario. Ironically, this legislation had the effect of forcing many Michigan lumbermen to close their mills at home and to relocate them in Ontario.

> Instead of injuring the lumber trade, the Dingley tariff — and the subsequent action of the Ontario government — gave it a period of renewed prosperity. The year after the Ontario law was passed, lumber prices doubled. By the turn of the century, a period of great expansion had begun in Canada and a sizeable home market had developed. Settlers began filling the western plains, and the vast region between the Red River and the Rocky Mountains, which in 1899 was only thinly populated, by 1905 boasted three new provinces. . . . The vigorous economic expansion, as might be expected, benefited the Canadian lumber trade. The years between 1900 and 1914, except for the short depression of 1907–8, were a period of great prosperity for the trade.[10]

The competing Ottawa Valley lumber interests were not as sanguine. Their eastern limits were approaching exhaustion, and their concern had turned to "the failure of pine to regenerate itself. For this sector of the industry with established mills, an efficient transportation system and a secure market, this was the real issue, much more than the debate over the nationality of the processor of the logs."[11] For them, the increasingly pressing issue was not how to *cut*, but how to *grow* more wood. Responsibility for this project lay, in their view, with the province as the

steward of the Crown land on which the trees grew. Through leases and stumpage rates the province was the primary beneficiary of logging activity, turning its huge revenues to the improvement of the South, of its cities and towns, while returning virtually nothing to the source of its wealth on the shield. If there were to be forests in the future to fuel the Ontario economy, something had to be done. To some extent this was the spirit informing the creation of Algonquin Park in 1893, to which we will return later. Certainly it inspired the creation of the Royal Commission on Forestry Protection in Ontario, which reported in 1899, and the Forest Reserve Act of 1898. These symbols of concern suggested that governments were beginning to grasp the notion of conservation emerging simultaneously in the United States.[12] The University of Toronto Forestry School was established in 1907, headed by Bernhard Fernow, a German-educated forester and devotee of scientific sustained yield management, who had come to Canada after serving the United States government for several years as chief of the Division of Forestry. Fernow also became a central player in the federal Commission of Conservation, created by the Laurier government in 1909 to inventory and to recommend measures for the protection of the nation's resources. But, as has frequently been the case in Ontario politics, much depended on the ideological position of the party in power. Where Liberals were beginning to endorse and to foster conservation measures, Conservatives measured success by heavily capitalized development, characterized by rapid growth. The Tories were also committed to promoting and opening up New Ontario[13] as an untapped resource frontier. Unfortunately for conservation, the

Conservatives achieved power in 1905, after a long Liberal hegemony. Simultaneous with their arrival came the ascendancy of the pulp-and-paper sector, driven by an exploding American newspaper and magazine industry, the needs of which could not be met by suppliers in the United States.

Until the turn of the century, pine logs had been the mainstay of Ontario's forest industry. But as pine forests were successively harvested, as the unrelenting northward march of the industry revealed trees of progressively diminishing size unsuited for use in building material and furniture manufacture, and as photogravure was turning the newspaper from a slim text into a bulky tabloid with a voracious appetite for advertising imagery, new markets were eagerly sought and readily found, often with the support of American financing. After 1905,

> [w]ithin the industry the uncontrolled exploitation of forest resources came to be emphasized as the engine for general economic growth regardless of any government or public desire to plan resource utilization on a sustained yield basis. The rise of a new class of entrepreneurs, connected with the pulp and paper industry, appears to have heavily influenced the process. Unlike the Ottawa Valley men . . . their commitment to the forest seems to have been as small as their commitment to the balance sheets of their corporations was large. Because conservation appeared to involve increased costs, it was rejected in spite of the movement's dedication to business-like efficiency. Ontario . . . was unable or unwilling to deal effectively with the fragile, renewable resource of which it boasted so proudly and on which it based so much of its estimate of provincial wealth.[14]

The Georgian Bay lumbermen had been major players in the rapacious consumption of the forest well before 1905. They had also helped to set in motion the logic of the move north. Timber would be cut first where it was most easily accessed and transported—close to rivers, along the shoreline of lakes, near railways. As the southern supply was consumed, new watersheds were let as berths, progressively farther away from towns that had been the traditional sawmilling centres. James Barry describes vividly what kind of landscape this logic was producing:

> The mills at Midland, which quickly used up all of the local forests, could draw for a time almost without competition on much of the Muskoka area and the North Shore up to Parry Sound. . . . [F]rom Midland they could ship by rail to Lake Ontario and thence to the New York market as well as directly by water to the Chicago market. . . . In 1900 the amount of lumber produced at Midland was second only to Ottawa in all of Canada. By 1900 most of the forests that were to be seen fifty years before on the shores of Georgian Bay had disappeared, to be replaced in part by farm land, but in larger part by slashed over terrain where the scars healed only gradually as second growth trees emerged.[15]

We may choose to assume that Tom Thomson lived quietly on the family farm for the first twenty years of his life, but the immediate world around him, recounted in the daily newspapers and in conversation, if not witnessed in daily observation, was hardly a scene of disengaged romantic bliss.

For wealthy and upper-middle-class people from Toronto, or from urban centres in the United States, who made Owen Sound

Figure 44 At Nominigan Camp, Smoke Lake, Algonquin Park, c. 1912. National Archives of Canada, Ottawa, William James Topley Collection (PA 010633).

a stop during their holiday travels, perhaps disembarking on the CPR steamer for an excursion to the Lakehead, the town may have seemed somewhat quaint. Certainly there were young people at the pier observing the tourists as they came and went, hearing their tales of staying at the Seguin House in Parry Sound, or the Georgian Bay House in Penetanguishene, or of swimming at Wasaga Beach. By the late nineteenth century, those who could not afford a visit to a lodge or a cottage might take a canoe trip, and Sault Ste. Marie was a popular tourist destination from the 1850s onward. Ojibway men of the region catered to the trade not merely by guiding and fishing but also by running the St. Mary's rapids in their canoes with paying thrill-seekers aboard.[16] A universally favourite portion of any cruise was the trip through the North Channel between Killarney and Bruce Mines, an area with

economic potential. Many of the tourists to the region were wealthy capitalists with an eye for new development opportunities. Others were looking for a tangible connection with the past.

An extensive network of family cottages was emerging along the North Shore by the turn of the century. These were accessible only by water and therefore primarily by the privileged—in the early years most often Americans. The Ojibway, the famous summer hotel opened in 1906 on an island near Pointe au Baril, catered mainly to American visitors, while the Madawaska Club, established in 1898 at Go-Home Bay, served exclusively faculty members and graduates from the University of Toronto who camped on adjacent islands, eventually leasing them from the club and building cottages. Dr. James MacCallum, who became Tom Thomson's patron, spent much of his own childhood in Collingwood, where his father served as a minister for a period after 1870. "Every summer Mr. MacCallum would take his son James and hire a fisherman to run them up through the islands and back down again as he made his rounds. After the family had moved away from Collingwood, young James would still continue to spend some of his summers in the North."[17] James MacCallum subsequently became one of the earliest members of the Madawaska Club, and on Go-Home Bay as well he built the cottage that Tom Thomson would visit after their first meeting in 1912.

By the turn of the century it was clear that the population of Ontario was becoming increasingly urbanized, that the family farm, while still visibly dominant in the southern landscape, was yielding up many of its sons and daughters to the cities and larger towns where they joined with recently arriving immigrants to oil the machinery of manufacture, commerce and finance. The exciting 1893 Chicago World's Fair—at which many Ontarians exhibited and to which many others travelled simply to witness—offered a graphic illustration of the kind of rapid technological change that was about to overtake the entire continent. Agriculture had not merely explained the production of food, it had been a way of seeing the world—slowly, deliberately, cautiously. New technologies privileged speed and efficiency, with large, often ruthless, financial institutions and corporations as the symbols of the new reality. The population of Toronto doubled from 181,215 in 1891 to 376, 538 in 1911. During the same period the population of the entire province grew from 2,114,321 to 2,527,292. Of this latter figure, in 1911, the combined populations of Toronto, Hamilton, Kingston, Ottawa and London alone accounted for 610,743, or slightly more than 25 per cent. The *Census of Canada* for 1911 indicates that 86.4 per cent of Toronto's population identified itself as ethnically British.[18]

Thomson lived and worked in other towns and cities—Chatham, Seattle, perhaps Hamilton—from 1900 until he moved permanently to Toronto in 1905. He was well travelled, but it is significant that he was drawn so emphatically to urban environments; and when it came time for him to make educational choices, he opted for the Canada Business College in Chatham and the Acme Business College in Seattle, not the Ontario Agricultural College in Guelph. Joan Murray emphasizes the fact that the Thomson family were not successful farmers and that father and son would relish opportunities to abandon their chores

for hiking, hunting and fishing expeditions.[19] Besides, growing up near Owen Sound, Tom Thomson could see which way the wind was blowing. While living in Toronto he could actually have the best of both worlds. He shared his innate love of nature with his aging cousin, the naturalist William Brodie, with whom he spent time tramping through High Park and along the Scarborough Bluffs, collecting specimens to support the relative's research. Brodie was an active member of the Royal Canadian Institute and, from 1903 until his death in 1909, curator of the Ontario Provincial Museum and provincial entomologist.[20] Thomson watched high-profile philanthropists like Sir Edmund Walker, president of the Bank of Commerce, leverage funding to support construction of the new Royal Ontario Museum (successor to the Provincial Museum) in 1913 or the establishment of the Art Museum of Toronto in the Grange in 1911. He witnessed the birth of the true engine of industry, the Ontario Hydro-Electric Power Commission, in 1906, and the delivery of its first power to Toronto in 1911. Massey Hall had been built in 1894 and in the same year A.S. Vogt founded the Mendelssohn Choir. Thomson could have attended the cinema or the Toronto Symphony Orchestra or have taken in professional performances at the Royal Alexandra or Winter Garden Theatres, established in 1907 and 1913 respectively. Perhaps most important, he lived at a centre — in Canada second in power only to Montreal — of speculative activity fuelled in particular by British and American investment in the resource sector. And every day he could ride the streetcar down Yonge Street (fig. 45).[21]

Tom Thomson was fully a participant of the world he had chosen. Working as a commercial artist, first in Seattle, next in

Figure 45 Yonge Street north from King Street, 1911. Toronto Transit Commission Collection, City of Toronto Archives (series 71, item 13234B).

Toronto for Legg Brothers, then Grip, then Rous and Mann, he was able to remain friends with business and creative people alike. In the company of professional photo-engravers he had to understand the complex nature of different papers and their suitability for the absorption of certain inks. Indeed, his daily employment brought him fully into contact with the sophisticated technologies emerging to reproduce improved coloured images on the printed page — and his fascination with three- and four-colour process in the design and printing of advertisements may well have contributed to his highly developed colour sense in the magnificent paintings for which we know him.[22] Nevertheless, the images he made and the processes in which he engaged were part of a relatively new industry, the object of which was

Figure 46 George Bartlett (standing) with his family at the Algonquin Park superintendent's house, Cache Lake, 1913. National Archives of Canada, Ottawa, William James Topley Collection (PA 010701).

Figure 47 Mowat Lodge (first version 1912–29); on the low hill behind and to the left is the old Mowat hospital, also built by Gilmour. Algonquin Park Museum and Archive (APM #186).

to create consumers for urban production, to help fuel the development of the market. Tom Thomson made logos.

The year 1912 was clearly pivotal. Thomson was still working at Grip, where he learned about Algonquin Park from fellow artist Tom McLean. Thomson persuaded his artist friend Ben Jackson, with whom he had also gone on a sketching trip to Lake Scugog, to join him in May for a two-week fishing vacation to the park. Armed with a letter of introduction from McLean to G.W. Bartlett, park superintendent (fig. 46), they took the Grand Trunk from Toronto to Scotia Junction, north of Huntsville, and transferred to the former Ottawa, Arnprior and Parry Sound Railway, finally arriving at Canoe Lake Station. Their fishing licences were verified by the park ranger, Mark Robinson, at whose recommendation they stayed at Camp Mowat, formerly the boarding house of the Gilmour Lumber Company, then about to become a tourist resort, operated by Shannon and Annie Fraser (fig. 47).[23] They stayed at the lodge, then journeyed by canoe to and camped in neighbouring Bonita, Tea, Smoke and Ragged Lakes, at one point venturing outside the park boundary into Crown Lake.[24] By late July Thomson was aboard the CPR with his Toronto housemate William Broadhead, an English artist and another Grip colleague, heading out for a second canoe trip, this time in the Algoma District. They travelled from Biscotasing through the lakes and white water of the Mississagi Forest Reserve, emerging in the North Channel of Georgian Bay not far from Bruce Mines, from where they boarded a steamer, arriving at Owen Sound on September 23. If Thomson was not a strong canoeist before this long and demanding trip, he certainly would have had to become

one during it. On the way the pair dumped, losing most of their sketches and photographic film and nearly drowning. One of Thomson's surviving sketches from this expedition, *Drowned Land* (pl. 5), already recognizes the damage brought to the land by logging operations, the skeletons of trees, flooded years earlier by dams, silhouetted against recovering second growth in the near distance. Quite clearly, reflection on the industrial presence in the land was very much on Thomson's mind from the beginning.[25] Within a month of his return to Toronto he left Grip and joined the printing firm of Rous and Mann. In October he also met Dr. James MacCallum for the first time. Within a year MacCallum had persuaded him to leave Rous and Mann and to make painting a career. All these apparently disparate and unconnected events, tied together only by the year they occurred, constitute the nuanced forms of evidence from which we attempt to reconstruct not only the environment where Tom Thomson chose to paint but the manner in which he understood and received that environment.

To reconstruct what Tom Thomson was looking at, and to attempt to imagine what he saw, it is essential to grasp fully not only the site of Algonquin Park, the place where he most strongly focused his gaze, but the way it was connected to the rest of the world he lived in and from which he brought his baggage. No landscape may be apprehended as a universal truth by those who see it. Every landscape is a social place, with different versions of itself available to different perceptions.

Algonquin Park was marked from its creation in 1893 by boundaries. These boundaries in turn contained within themselves the gridironed boundaries of townships marked out by Ontario Land Surveyors, one of whom, James Dickson, was instrumental, as early as the 1880s, in recommending the creation of the park. Indeed, Dickson joined Alexander Kirkwood,[26] chief clerk in the Land Sales Division, Department of Crown Lands, Robert Phipps, clerk of forestry, Department of Agriculture, Archibald Blue, a mining inspector, and Aubrey White, assistant commissioner of Lands and Forests, to constitute the Royal Commission on Forest Reservation and a National Park, formed in 1892 by the Liberal provincial government of Oliver Mowat to review their respective sense of and purpose for the lands to be protected. The boundaries were fixed in 1893 as an area of eighteen rectangular townships containing the headwaters of seven rivers. Like his fellow commissioners, Dickson was described as a "practical" man who saw no reason to question the advisability of logging in a park dedicated to recreation and wildlife and watershed protection. He opposed wasteful timber practices but not efficient use of the forest.[27] Accordingly, while agriculture,[28] trapping and hunting were among the uses recommended for exclusion, sport fishing and responsible logging were to be encouraged— each activity recognized for its long-term economic potential. Many of the most ardent promoters of the park idea cradled the virtues of watershed protection in the comfortable language of the market. William Houston, librarian of the provincial legislature, opined that "[p]reservation of the forest is not incompatible with the removal of trees that are valuable as the raw material for manufactures, or with the raising and smelting of metallic ores. In view of the possible development in the transmission of

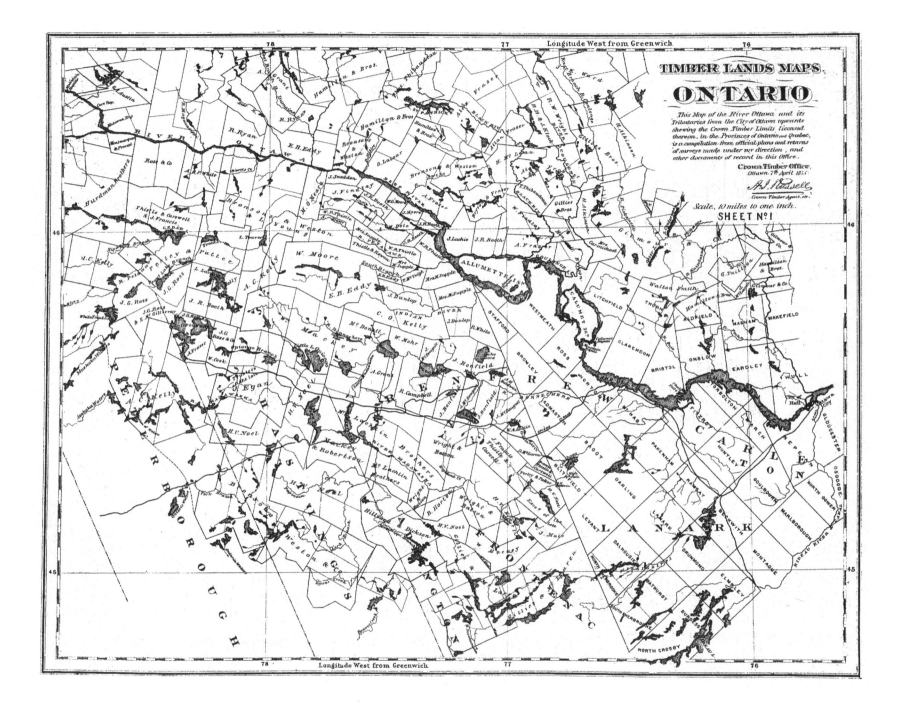

Figure 48 Timber Lands Maps, Ontario, Sheet no. 1, Crown Timber Office, Ottawa, April 7, 1875. Thomas Fisher Rare Book Library, University of Toronto.

electric power, the vast aggregate of water power now useless for any local purpose may yet prove of great economic value, but its continued existence, unimpaired, depends absolutely on the preservation and restoration of the forest."[29] Dickson had surveyed many of the areas that had been opened to the Ottawa Valley lumbermen long before the establishment of the park. A careful look at the accompanying map of timber lands (fig. 48) supervised in 1875 by the Ottawa Agency of the Crown Timber Office reveals another form of rectilinear boundary, the Crown Timber Limit, containing the many licences of those lumbermen named on it.[30] It should be noted on this map, which embraces what was to become most of Algonquin Park, that no limits are shown west of the watershed draining into the Oxtongue River. The map addresses the tributaries of the Ottawa, but in 1892 the southwestern section of the park remained unlicensed and inaccessible to lumbermen. (A mere twenty years passed before Tom Thomson stood for the first time at Tea Lake dam [fig. 49] to witness the changes brought to this particular landscape in the intervening period.) Shortly after it was officially created by an Act of the provincial legislature, Thomas Gibson, the park's first secretary, could write that

> no railways penetrated it, or even approached its borders; no traveled highway passed through it, or even led to it. . . . There was not . . . a cross-roads hamlet within its boundaries; not a post-office, church or schoolhouse; even the ubiquitous squatter . . . has found this district too distant from markets and supplies, and is represented by but one or two of the hardiest of his kind. Here is one of the largest tracts of untouched forest now left

Figure 49 Tea Lake Dam, 1920–22.
Algonquin Park Museum and Archive (APM #85).

within the limits of Ontario untouched, that is, for settlement purposes; for even here the lumberman has been long at work. . . . This vast, solitary aromatic wilderness is as yet almost as little known as if it were in Labrador or on the Hudson Bay slope.[31]

Gibson's disclaimer about the lumberman is vital, for in the reaches northeast, beyond the Oxtongue watershed, the landscape was crisscrossed with tote roads for hauling supplies and dotted with shanties and depot farms to house and feed loggers who worked in the bush all winter.[32] The language of "wilderness" masks the reality of boundaries. And the boundaries of Algonquin Park have proved elusive. After 1893, often through government consolidation and acquisition of spent or abandoned timber limits, the park boundaries grew on several different occasions—in 1894, in 1904, in 1911 and in 1914.[33] The place was shape-shifting even as Tom Thomson guided and painted there.

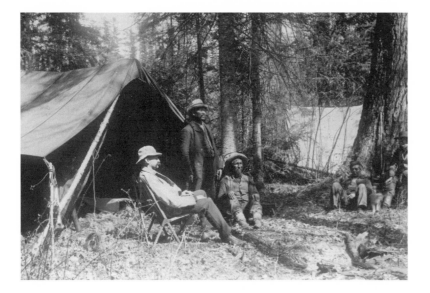

Figure 50 A member of the Hayes fishing party with Native guides in Algonquin Park, 1897. Algonquin Park Museum and Archive, Dr. George Marcy Collection, Hayes Album (APM #587).

Alexander Kirkwood had proudly argued that "[i]n adopting the word [Algonquin], we perpetuate the name of one of the greatest Indian nations that has inhabited the North American continent."[34] It was sadly ironic that a park that bore their name and a society that acknowledged the power of their culture should privilege the lumberman over them. Among other factors, it was the process of assigning timber limits that drove before it the Aboriginal populations of the entire region, from the Ottawa River west to Georgian Bay. The prohibition against hunting and trapping in the park guaranteed that it would be avoided except by those seeking work as guides (fig. 50)[35] and loggers. There is abundant archæological evidence of generations of Aboriginal life in Algonquin Park, demonstrating that lands adjacent to many of its lakes and rivers were important wintering and spiritual sites.[36] The portages that Tom Thomson walked over, indeed the very canoe he carried, were reminders that these were ancient highways. The names of lakes held the stories of families, like the Joes from Rama, "who were members of a band trapping as far north as Burnt Lake. The Joes were known to some of the early Park guides. . . ."[37] On Manitou Lake, at the mouth of the Amable du Fond River coming down from Kioshkokwi Lake, lived the Algonquins Ignace and Francis Dufond, farmers: "The first lumber companies in this section of the Park were glad to buy whatever the Dufonds could produce on their farm. William Mackey, who cut square timber on limits in this area, and J.R. Booth, who afterwards took out saw logs, were both on friendly terms with the Dufond brothers. In this way the Dufonds grew so prosperous that they came to be regarded by Indians and white settlers alike throughout the Mattawa district as persons of consequence. At one time, Peter Ranger says, they had a cash reserve of six hundred dollars in the bank. . . ."[38] Tom Thomson would certainly have known the Dufonds from his extensive travels through the northwestern section of the park where he loved to sketch and fish.[39]

Irrespective of his contacts with people like the Dufonds, Thomson had grown up in Owen Sound, very close to Midland and the location of the seventeenth-century mission, Sainte-Marie Among the Hurons. The contemporary level of understanding of this important site is probably mirrored in these comments by the poet Wilfred Campbell: "On the Georgian Bay side was the famous Huron Mission of the Jesuit fathers, where lived and died

the great French Count and priest Bœuf [*sic*] and his devoted followers. In the beautiful mountain country of Collingwood these missionaries wandered, ministering to the simple folk of the region, who dwelt in the peace of their cornfields until the fierce storm of Iroquois hate burst upon and overwhelmed them. I have often wandered, as a boy, through forests sacred to the Peton or Tobacco Indians. . . . Here are still found remains of old burial grounds of these and more ancient peoples."[40] In his childhood and on his canoe trips down rivers like the Mississagi and the Magnetawan and along the shore of Georgian Bay, Thomson would routinely have encountered Native reserves at places like Cape Croker, Spanish River, Garden River, Shawanaga and Parry Island. He would likely have been familiar with the story of the Dokis family, who for years fought, ultimately in vain, and with no support from the Department of Indian Affairs, to protect their reserve on the French River from the saws of the Georgian Bay and Michigan lumber interests.[41] Among the few local Native communities Thomson probably did not encounter were those that were home to the people whose ancestors had once occupied Algonquin Park. They had moved to reserves at Desert Lake, established north of the Ottawa River in 1854, and to Golden Lake on the Bonnechere River in 1864. Both of these reserves lie outside the park.[42]

Thus, there were Aboriginal traces on the land. In some sense these find their way into virtually every Tom Thomson painting because the canoe that carried him, and the portages that delivered him from one lake to the next, constituted the *sine qua non* of his art. Thomson's sensitivity to issues of race and race-in-landscape may not have found any overt expression in his work,

but his life was cut short while he was yet a young man whose apprehension of such things was delayed by a limited education and by a social environment that privileged a British imperialist vision. As I have tried to suggest, after 1912 Tom Thomson was learning mightily. Certainly we cannot, as some have, fault him for a failure to people his landscapes and infer from that an erasure of the Aboriginal presence. As the Toronto painter Harold Town remarked, Thomson and David Milne "shared in common a similar inability to draw the human figure,"[43] a qualification embarrassingly evident in paintings like *In the Sugar Bush* (pl. 45), *Larry Dickson Splitting Wood*, and *Figure of a Lady*, where the attempt is made. Wilfred Campbell, who had also grown up in Wiarton and Owen Sound, and was well educated, probably reflected many of Thomson's emerging feelings when, in 1910, he wrote,

> The world gradually changes, though perchance not for the better. We have seen a century of Huron, passing slowly from the dominion of the savage to what we call the civilization of the white man. We have seen the great forests destroyed, the pure waters polluted, the kindly climate changed, the great aspect of nature's beauty marred and obliterated. We have brought about all of this in the name of civilization, and we call it progress. . . . It is true that there are hundreds of lovely towns and villages and hamlets on the Canadian shores of Huron, which are the homes of our people. But are we as a people as true to the Spartan virtues as they were, in their way, the Indians whom we have displaced . . . ? If we are not, it is not the fault of our environment.[44]

This lament, which regrettably places Aboriginals in the past tense, nevertheless reveals an awareness that they and their legacy

are being betrayed by modern industrial society, by the "cruel din and whirr of the child-enslaving factory, the hideous squeezing of our peoples into the rotten purlieus of teeming, unhealthy cities."[45]

What Thomson's images do reflect of the human presence in the landscape is a keen awareness of the impact of logging within the boundaries of the boundaries of the shifting boundary, of Algonquin Park. Logging in Algonquin Park probably began about1831, the date assigned by William Hawkins to a timber operation he mapped on Lake Traverse during his survey of the Magnetawan-Petawawa region in 1837.[46] From then on timber limits "were laid out like a patchwork quilt over the Algonquin landscape" until "[b]y 1853, timber-making had reached Radiant and Cedar Lakes, and beyond."[47] Access to the forest was achieved westward from the Ottawa River, and ever northward as limits in the south and east were exhausted.

Throughout the [Ottawa] valley firms such as J.R. Booth, McLach-lin Brothers, Gillies Brothers, Perley and Pattee, E.B. Eddy, Alex Barnet and others built mills to convert sawlogs to lumber for local use and export. . . . Square-timber and sawlog operators moved farther afield, reaching the headwaters of the Madawaska and Petawawa rivers in the early 1880s. . . . The log drive was not a haphazard event; it had to be carefully engineered and its success depended on logistics, technology and luck. . . . There are few rivers or streams in Algonquin Park that don't show evidence of course modification. Riverbank vegetation was cut back and companies and the government spent thousands of dollars on river improvements. . . . River courses had to be widened and debris removed to ensure unobstructed passage. Crews of men

removed rocks from the stream by hand, or channels were blasted with dynamite. Wooden timber or log chutes were built—often hundreds of metres long—to bypass rapids and falls or to cut off troublesome bends in the river. . . . Dams were built on many lakes along a waterway so the logs could be moved down-stream in stages.[48]

As mentioned earlier, the devastation being visited on the forests in the northern and eastern portions of the present park had not reached the lakes of the Oxtongue watershed to the south-west before 1893. But in 1892 the government sold at public auction in Toronto rights to cut timber in virtually all the lands remaining in the area designated for the new park. The largest bidder was David Gilmour, owner of the legendary Gilmour and Company of Trenton, who purchased limits surrounding most of present-day Burnt Island, Tom Thomson, Potter, Joe, Tepee, Canoe, Bonita and Tea Lakes (fig. 51). Having exhausted most of the huge Quinte hinterland in the South, including the head-waters of the Salmon, Moira and Trent Rivers, David Gilmour set his sights on running pine logs down the Oxtongue River through the Gull and Trent River watersheds—a distance of 445 kilo-metres—to his voracious mill at Trenton, on Lake Ontario. To accomplish this extraordinary feat he contrived to build what he called a "tramway" (fig. 52) to lift the logs from the Muskoka River watershed at Dorset on Lake of Bays, into Raven Lake, the Black River and thence to the Gull River watershed at St. Nora's Lake. From here they would travel the route south through lakes and rivers that had been used for generations by the Mossom Boyd Company[49] and by Gilmour himself. This project required a

massive infrastructure, including an extension of the Bobcaygeon colonization road from Dorset to the bottom of Tea Lake. His dam at Tea Lake "was a 60-metre-long timber structure that raised the water level behind it some 2.5 metres. Gilmour built it for two purposes: to store water to help flush logs down the Oxtongue . . . and to facilitate navigation on a chain of lakes upstream by flooding out the shallow connecting streams. The dam created in effect a single water sheet out of four lakes — Tea, Bonita, and Canoe on the main line of drainage, and Smoke on a southern tributary. Gilmour also constructed a dam just above Canoe Lake at the outlet of Joe Lake. This one created another extensive chain of navigation encompassing Joe, Little Joe, Tepee, Littledoe, and Bear (now Tom Thomson) lakes."[50]

To protect the precious cargo from smashing to bits at Ragged Falls and High Falls on the Oxtongue, he built two huge log slides. The tramway at Dorset moved the logs over the height of land and required construction of nine jackladders powered by a steam engine and water turbine, centrifugal water pumps, an elevated reservoir receiving ninety thousand litres of water a minute from the lake and depositing this into a massive log slide. "In all, the tramway consisted of 822 metres of jackladder and 969 metres of slide . . . a total length of 1.8 kilometres."[51] A series of slides and dams, including a diversion canal on the Black River, completed the route into St. Nora's Lake. Nearly five hundred men worked on the project, completing it late in 1893. The success of the entire scheme was dependent on two unique watercraft. One was the "pointer," which could be used to direct logs and to carry the provisions and camping equipment of the logging

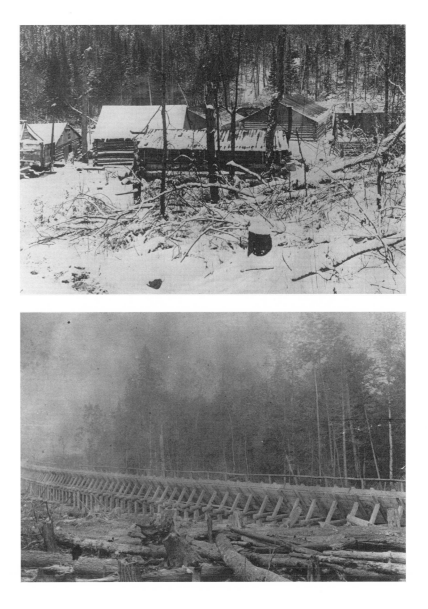

Figure 51 Gilmour Lumber Company Depot at Tea Lake, 1893. Algonquin Park Museum and Archive (APM #1093).

Figure 52 Gilmour tramway log slide, 1894. Algonquin Park Museum and Archive (APM #3005).

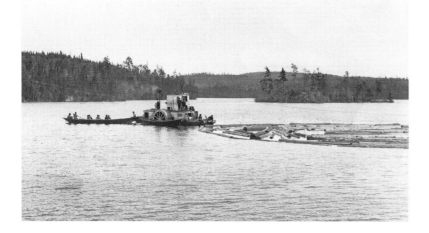

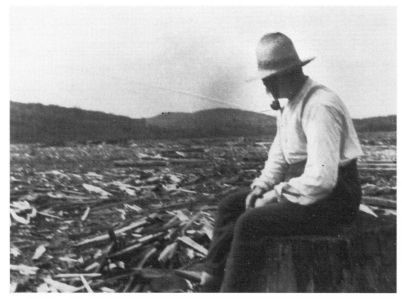

Figure 53 Alligators and pointers on Burntroot Lake, 1908. Algonquin Park Museum and Archive (APM #3005).

Figure 54 A photograph by Tom Thomson of the chipyard at Mowat. National Archives of Canada, Ottawa (PA 193569).

crew. Pointers could also navigate rapids and be easily portaged. The other was a small side-wheeled steam tug, or "alligator," so named for its ability to move on land and water (fig. 53). The alligator could tow a boom of logs across a large lake, where they would be run through a stream to the next lake. The alligator would portage on hardwood rollers, using a winch and cable to pull itself from one lake to the next, where it would again receive its cargo and continue south. David Gilmour's alligator ended its journey at the Trenton mill and was then shipped back toward his limits by train in preparation for the next season.[52]

Unhappily for Gilmour, his tramway scheme proved unable to deliver logs to the Trenton mill expeditiously, and by 1896 he had abandoned it altogether, commencing construction of a mammoth subsidiary milling operation at the north end of Canoe Lake, right in the park, and establishing the village of Mowat (after the Ontario premier) to house his workers (figs. 47 and 54).[53] This move was strategically timed to anticipate Booth's new Ottawa, Arnprior and Parry Sound Railway, which passed within two kilometres of Mowat on its route across the southern portion of the park from Ottawa to Depot Harbour on Georgian Bay. The most compelling language to hint at the human and environmental costs of this achievement comes from the writer Roy MacGregor:

> Booth was ruthless in completing his line. He hired children as labourers and ignored the laws that forbade this. He found an anchorage at Depot Harbour, near Parry Sound, and ignored the protestations of the Natives who claimed the property belonged to them. He shoved the Natives out of the way and built a logging community large enough to support three churches and

several businesses. . . . It was an astonishing engineering feat, and involved filling in the swamps and dynamiting through the granite and passing over rivers on the largest trestles ever built entirely out of timber.[54]

Booth diversified his operation, making Depot Harbour a transshipment point for logs from his own and others' limits in the interior of the park and for eastbound grain from the Prairies. The O.A. and P.S. was quickly absorbed by the Canada Atlantic Railway, also owned by Booth, and running into New England, thus serving interests with a variety of international markets. David Gilmour's company was merely one of a number springing up along the line. Perhaps the other most significant beneficiary was the St. Anthony Lumber Company of Minneapolis, Minnesota, which purchased huge limits around Opeongo and built a mill on Galeairy Lake that became the site of Whitney.[55] Gilmour's new mill, the first of many to be built by other companies within the park boundary, went into operation in 1897, a spur line, with extensive sidings, connecting his yard to Booth's railway at Canoe Lake Station. Despite heavy production—sixty million feet, or 18.3 million metres, in 1899—Gilmour was unable to recover the massive capital investment in his limits and infrastructure. His bankers foreclosed in 1901 and shut down the Algonquin operation for good.

Tom Thomson arrived in Algonquin Park in 1912 on rails laid by J.R. Booth; he stayed at the loggers' boarding house built by David Gilmour; and he visited Tea Lake dam, a site elected for later paintings, which made navigable many of the places to which he paddled his canoe. This was an industrial landscape, complete

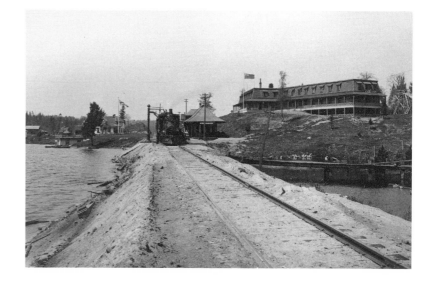

Figure 55 Highland Inn, 1913. National Archives of Canada, Ottawa, Fred Cook Collection (C 056135).

with alligators and pointers, cadge cribs, steam engines, stations, sawmills, shanties, log chutes, wagon tote roads and depot farms.[56] The land was visibly scarred, not only from logging activity but from fires started in slash along the line of the railway by sparks flying off the locomotives. Booth's railways having been folded into the Grand Trunk system, by 1910 "there were 120 [car]loads of grain a day passing through" the park from Depot Harbour.[57] The involvement of the Grand Trunk also spelled the real beginning of the tourist industry. To encourage passenger traffic on its newly acquired line, it built the Highland Inn (fig. 55) at the Algonquin Park Station on Cache Lake in 1908, immediately adjacent to the new park headquarters (fig. 56). In the same year, L.E. Merrill opened the Hotel Algonquin at Joe Lake Station. By 1913 the Highland Inn contained seventy-five guest rooms and the

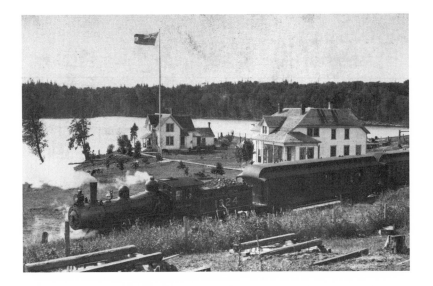

Figure 56 View of Headquarters Buildings, Cache Lake, Algonquin Park, 1913. National Archives of Canada, Ottawa, Department of Mines and Resources Collection (PA 020593).

Hotel Algonquin thirty-five. In 1913 the Grand Trunk built two outpost hotels, Minnesing on Burnt Island Lake and Nominigan on Smoke Lake, both reached by stagecoach from the Highland Inn.[58] Mowat Lodge, formerly Camp Mowat, was not considered a functioning resort until 1914. Gasoline engines of Ontario manufacture were powering boats in Algonquin as early as 1902, making it feasible to take guests from the lodges on "outings." Clearly, as with tourist activity in Georgian Bay, these services were available only to the elite, particularly to wealthy Americans, lured in droves after the turn of the century.[59] Americans were the first, and before 1917 the only, operators of youth camps in the park, beginning with Northway Lodge, a camp for girls on Cache Lake, opened by Fanny Case of Rochester, New York, in

1908.[60] In his report of November 1915, Park Superintendent Bartlett applauds the completion of the new Canadian Northern Railway through the top of the park.[61]

By 1916 a daily mixed freight and passenger train was running over the Canadian Northern, with nine stations in the park. "At Grand lake we have built a good frame shelter . . . at a station called Achray."[62] This was merely one of many such shelters that dotted the landscape of the park, all constructed by the staff of full-time rangers (thirty-two in number in 1916) to provide stopping-off places, especially on winter rounds in the war against poachers.[63] Private family cottages were popping up on more of the lakes, "the parties paying a $10.00 survey fee and $7.50 per year rent on each acre, the maximum being two acres."[64] In his report of 1916, Superintendent Bartlett reveals to his minister the opinion that "it would be a great boon to our towns and cities if we had a road into the park so that motor parties could run their cars right to this point; they now run as far as Kearney, within thirty miles of the road to Smoke lake and thirty-five miles west of [park] headquarters."[65] The first telephone lines in the park appeared as early as 1911, linking some of the nearest shelter huts to headquarters. By 1917, thanks to the railroads, Bell Telephone connections were in place to Orillia and North Bay. Camps, lodges, shelter huts, railway stations, logging camps— all were within easy reach of rapid communication to the outside world. Distance had ceased to be a factor. As one patronizing British tourist to the park noted in 1910, "You will find it hard to realize when you are paddling your birch-bark canoe with a solid, silent Indian, that you are only a week from the roar and

rush of the Strand; that London is but six days' travelling from where you are; that in so short a time you can be back there looking at your friends bending over their office desks, or tearing frantically down Fleet Street after an omnibus."[66]

The Grand Trunk Railway from Toronto to North Bay passed through South River just outside the northwest boundary of the park (fig. 57). South River, which rises at Winifred Lake in the park, drains into Lake Nipissing and provided Tom Thomson easy access to the French River and Georgian Bay by canoe. Thomson sometimes stayed at the hamlet of South River, where he is said to have obtained his favoured birch panels, and mentions in one letter to James MacCallum that "there are stretches of country here that is [sic] a good deal like that near Sudbury mostly burnt over like some of my sketches up the Magnettewan River [sic], of running the logs."[67] Access to the Magnetawan River was equally easy by train. The river actually rises in the park, passing through both Kearney, on Booth's line of the Grand Trunk, from Ottawa to Parry Sound, and Burk's Falls on the north-south line. A Grand Trunk promotional pamphlet from 1909 boasted that the upper Magnetawan was "situated in the center of a magnificent fishing district, as it is within an hour's drive of any one of *over thirty lakes*, many of which can be reached by canoe right from the village. These lakes are being yearly stocked with trout fry by the Government."[68] From Burk's Falls, one could take a steamer twenty-five kilometres downstream, through Cecebe and Ahmic Lakes, about eighteen and twenty kilometres long respectively, passing through locks at the town of Magnetawan. From the end of Ahmic, the pamphlet tells us, "the more adventurous may continue

[by canoe] . . . to Lake Wa-Wa-Kesh [sic], and thence to Byng Inlet . . . on the Georgian Bay. In this distance there are twenty portages of varying length."[69] Much is made of Tom Thomson's return trip to visit James MacCallum by canoe in the summer of 1914. Yet no author has yet satisfactorily explained how he got to the sites where he painted images at French River, Byng Inlet, Parry Sound and Go-Home Bay in such a short time — i.e., between May 24 and August 10.[70] It is quite likely that he loaded his canoe on trains at intervals, moving quickly and easily to dropoff points en route. Similarly, having grown up in Owen Sound, he was thoroughly familiar with steamship travel in Georgian Bay. He could, for example, take a train from Algonquin Park Station directly to Parry Sound. From there he could board any one of a number of steamships voyaging north or south, with his canoe as baggage. But this explanation rather undermines the romance and turns our Tom into just another tourist.

The point is that Tom Thomson's Algonquin, like the rest of the spaces around him, was already caught up in a world of systems, control, timetables and efficiency. As Wayland Drew, a writer whose themes were often the Canadian wilderness, said, the park was just another "managerial unit definable in quantitative and pragmatic terms."[71] It was "an adjunct to the metropolis, a thing most fully understood by those who spent the bulk of their time somewhere else."[72] George Bartlett had left his job as a foreman on J.R. Booth's limits in the Upper Ottawa valley to assume the position of park superintendent in 1898. He remained in this position, and lived in the park, during the six-year period when Thomson came for visits (fig. 58). But he, too, was caught in the

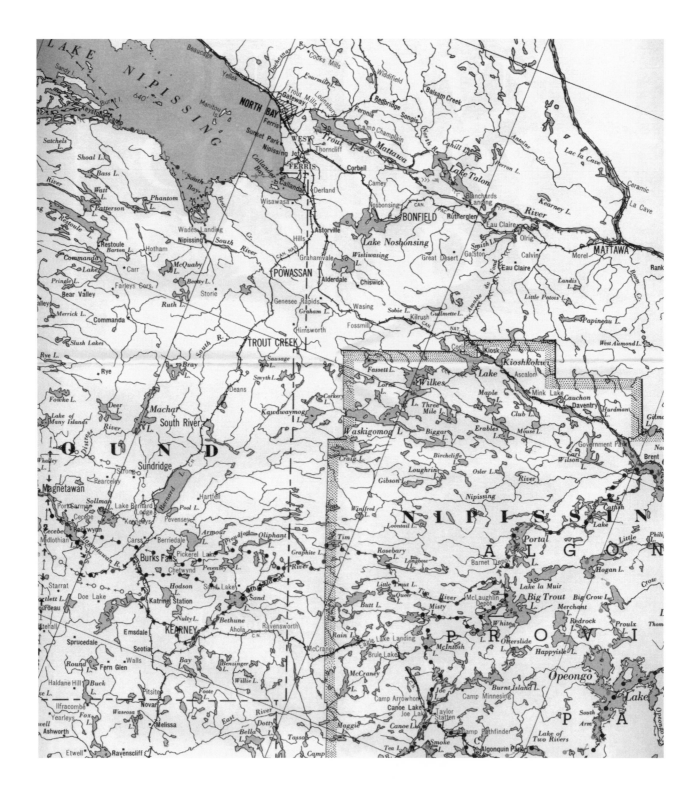

Figure 57 Detail of "Map Showing the Exploration Routes through the Huron & Ottawa Territory Between the Years 1615–1854 in the Province of Ontario." Compiled and drawn in the Chief Geographer's Office, Surveys and Engineering Division, 1946 (revised 1963).

same web as his visitor. His annual reports constitute goldmines of evidence for an agenda that merely duplicated the logic of the metropolis. He did not understand that the prohibition against trapping and hunting would harm the local Aboriginal population, routinely thanking lumbermen in the bush for their assistance in addressing "the problem" of poaching. For him, a poacher was a poacher. In 1899, to enhance the attractiveness of the park to anglers, he introduced small mouth bass, a species unknown to Algonquin waters, into the lakes along the route of the Booth railway. He routinely recommends "stocking Cache, Cranberry and White Lakes, as these being within easy reach of the hotel provide sport for those who cannot reach more distant waters."[73] Bartlett also introduced nonindigenous species, such as capercailzie from Norway. "Wild celery has been planted and sown in several of our lakes and streams with a view to encourage wild ducks to remain with us."[74] Isaac Gardner, one of the park rangers, wrote the report for 1904, revealing a taste for a better groomed and more manicured park to suit the urban æsthetic: "I hope the Government may see their way clear to taking out the large, crooked and unsightly trees that mar the general appearance of the forest here. It would give the smaller trees a chance to grow up straight and better proportioned. The undergrowth in some places is so dense that it is becoming very difficult to get through it. A proper thinning out of the old trees would be a benefit to the bush and the proceeds from the sale of same could be used to beautify the picnic grounds and give the park a much better appearance."[75]

Bartlett guarantees that the park boundary is well tended. "I had the south boundary cut out last summer, and hope this year

Figure 58 Superintendent George W. Bartlett's office at Cache Lake, c. 1910. From *A Pictorial History of Algonquin Park* (Toronto: Ontario Ministry of Natural Resources, 1977).

to continue the work till it is so well defined that there can be no mistaking it."[76] He repeatedly mentions his conviction that the protection of wildlife within the park would enhance the supply of game for legal hunting beyond it. But the reduction of trapping and hunting, thoroughly policed by the rangers, meant that wildlife populations, particularly deer and beaver, grew exponentially. This naturally attracted wolves as a check against those species outstripping their food supply. But in each of his reports, Bartlett rails against these "brutes": "Wolves, notwithstanding the fact that we kill a great number each year, continue to destroy the deer. Last season our men brought in thirty-five, a large percentage

of which were females. No doubt many were also killed that were not found. Owing to the ease with which they can procure deer, we find it difficult to get them to take poison."[77]

By 1910 the beaver were beginning to overrun the park, necessitating a systematic trapping program directed by the rangers. Live trapping of beaver and other species also became a lucrative project, meeting demand from all over North America for zoo animals. Obviously abreast of the work of the Commission of Conservation, Bartlett the entrepreneur sees promise in the fur-farming industry.

> It is now recognized that owing to the increased demand and the steady encroachments which civilization is making on the waste places of the world inhabited by fur-bearing animals, a large part of the fur supply of the future must necessarily be got from animals bred in captivity or under control. Fur-farming is rapidly coming into favour. . . . The Department has thought proper to give Ontario fur-farmers an opportunity of obtaining such fur-bearing animals as are found in Algonquin Park in order to stock their ranches. . . . The live animals sell for considerably higher prices than do the furs.[78]

The value of the forest industry in the park is a topic of routine concern for Bartlett. After 1914, the worst season for fires on record in the park,[79] he becomes particularly diligent in seeing to the construction of lookout towers. He applauds the Grand Trunk Railway for following directives of the Railway Commission, constructing and outfitting a water-tank car to anticipate fires along the line. Rangers and extra helpers are deployed to "clean and stump the right-of-way, and draw the debris out of the woods for some distance back from it."[80] This work also "adds a great deal to the appearance of the Park when travelling through by train."[81] He laments the decline in lumbering during the war, "owing to the difficulty of getting men, and the depression in the market."[82] Each year Bartlett sums up his analysis by noting how well the revenues derived from fishing licences, fur trapping, live animal sales, cottage rentals, leases, camp fees and fines from poaching — even use of the telephone — help to pay the costs of operating the park.

By 1900 the agrarian landscape of Ontario had all but reached the edge of its own boundary, the Precambrian Shield. Colonization roads attempted to carry it onto marginal lands, and the Great Clay Belt still beckoned in New Ontario. But those serious about farming were more likely looking west than north and were more likely immigrants than Anglos from Toronto. With increased technology, the farm itself began to assume more of an entrepreneurial air, especially as Toronto and other rapidly expanding cities became more visibly "markets" and less obviously mere dens of iniquity. The decline of the *culture* of agriculture left in its wake a vacuum of nostalgia for the land, particularly among those in cities who had always equated agriculture with a pastoral peacefulness, a simplicity that their own increasingly hectic environment had severed off from them. It was becoming clear that the real experience of the land could never be theirs if to be on the land meant farming the land. The suburb was one response, the "North" another. Perhaps the least value-laden definition of this place called the North is that offered us by the historian W.L. Morton in his famous essay, "The 'North' in

Canadian Historiography," read in 1970 to the Fellows of the Royal Society of Canada. The North, he said, is "all that territory beyond the line of minimal growth of the known cereal grains."[83] Not a hint of wilderness. But this North understands agriculture, and just as the conservation movement was emerging, astride concepts like "sustained yield" and "multiple use," there was a keen awareness that the economic future, and possibly the new seat of virtue, was to be found on the land in the bush, on the other side of the shield. Agriculture itself might be impossible there, but the renewable "harvest" could be applied to trees and fish and water. Because it belonged to the Crown, it could also be visited and returned from, without the awkward requirement of personal ownership and maintenance. It could simply be viewed. There was a choice. As the bush housed so much of the wealth on which the province depended for its preeminence,[84] it could also be regarded as an extension of the metropolitan system itself, fully integrated into the manufacturing, banking, transportation and communications sectors of the economy where its uses were defined. It was the members of the urban elite who invented this system, and it was they who, in taking their vacations to rest up for their more relaxed direction of it, decided what to call the bush that made it —

and them — possible. They elected the abstraction "wilderness," leaving to artists and intellectuals the project of assigning it meaning for them. For the urban poor who could not leave the city, they made urban parks. For themselves, they set aside Muskoka and Georgian Bay and Algonquin, displacing those for whom these places were home, or assigning to them uses to which they could be put in furtherance of the metropolitan system. As part of this system, writes the historian Allan Smith, Thomson was among a group of painters "who themselves had little sustained contact with the land" and whose paintings were "produced for those who, having even less, were the more dependent for their sense of that land on what their minds and intellects could do with the artificial objects they found themselves confronting." As time passed, there emerged "a belief that contemplation of the image rather than contact with the reality could do what was required."[85]

For Aboriginal people and bush workers, this North was home, where people lived year-round. They did not require Toronto to assign them, or their home, definition. We cannot fault Tom Thomson for his complicity in the metropolitan system. As his paintings — seen through Rogoff's "curious eye" — reveal, he was only beginning to understand it himself — and then he died.

Tom Thomson, PAINTER

Charles C. Hill

Tom Thomson emerged on the Canadian scene in the second decade of the twentieth century and left us a heritage that has become key to our understanding of the evolution of Canadian art. His career is all the more remarkable for its brief span, a career as a painter of merely six years. Yet Thomson remains an almost invisible figure. There is little contemporary documentation concerning his life. He was an infrequent correspondent and he always remained out of the public eye. He is known to us mostly through anecdotal and posthumous accounts, including information collected in the early 1930s by Blodwen Davies, author of the first monographs on Thomson, from friends and members of the family, crucial to any study of the artist. His death has

Figure 59 Tom Thomson, *Byng Inlet, Georgian Bay* 1914–15, oil on canvas, 71.5 x 76.3 cm, The McMichael Canadian Art Collection, Kleinburg, Ontario, purchased 1977 with assistance from donors and Wintario (1977.31).

been the subject of more public interest than his life, even though it is his life that provides the reason for any curiosity about the manner of his death and it is his paintings that justify a study of his life.

Thomson had no formal training as a painter. He learned from his fellow artists. Like other landscape painters of his generation in Canada, he made studies around the city[1] and on trips outside Toronto, painting oil sketches. He did not make preparatory drawings on paper or on panel (though a few sketches do have graphite drawings by Thomson on the back unrelated to the composition on the front). These oil sketches were painted, for the most part, in front of the subject during the late winter, spring, summer or fall. Occasionally Thomson would paint on the front and back of the same panel during different times of the year. In his sketches one is able to follow the seasons' passing, from the late winter snow to the budding of spring, the skies of summer and changing of fall leaves from red to yellow to the first snows of winter. These were his prime subjects, a limited number of motifs endlessly repeated in constantly evolving perceptions. It is his intense observation and sensitivity to the seasons' colours and lights that are the source of his contributions to Canadian art. He saw and was able to express what had not been caught with such accuracy and expression before.

Many oil sketches have inscriptions on the verso written by Thomson's patron, Dr. James MacCallum, who, according to those who knew him well, had a prodigious memory.[2] It was MacCallum who dated and titled most sketches. He certainly knew Thomson as an artist better than any other person and had the largest col-

lection of his paintings, most acquired directly from Thomson himself, which he bequeathed to the National Gallery of Canada at his death in December 1943.[3] The information MacCallum supplied through these inscriptions, as well as in his correspondence, is key to our understanding of Thomson's art. Yet even MacCallum was fallible and had his own preferences among Thomson's paintings, eschewing the high keyed and overtly decorative for those that were "true to nature."[4] While in this study I rely extensively on the doctor's information, I do not always agree with his dating of works. Through the comparison of the Thomson paintings that I have been able to examine, I shall propose some guidelines for his development as a painter.

The canvases, of which there are approximately forty-five, were painted in the studio during the winter. Thomson sketched extensively, and many subjects were painted in a variety of compositions. The process of painting up a selected sketch into a larger canvas posed its own demands, and the results don't show the diversity or experimentation evident in the sketches. In most instances, the canvases were painted from the previous season's studies, though "[n]ever was he satisfied with his own performance. Pictures were put away again and again in the spring, to be dragged forth on his return in the fall, some change made in the design or the colour, as suggested by the added observation of the year."[5]

The Early Years

Thomson's life revolved around four different, though overlapping, communities: his family, the world of commercial design,

life in Algonquin Park and adjacent areas, and the art world of Toronto in the years preceding and during the First World War. His first associations were with his family around Owen Sound, Ontario. It was family connections that led him to work in graphic design, first in Seattle and later in Toronto. This was his means of earning a living, his first æsthetic definition and the context in which he developed friendships with professional painters and was introduced to Northern Ontario.

Thomson was born in August 1877 on a farm near Claremont in Pickering Township, northeast of Toronto. When he was two months old, his parents, both of Scottish ancestry, moved to a farm near Leith, a settlement close to Owen Sound on the south shore of Georgian Bay. He was raised on the farm, receiving his education locally, though ill health kept him from school for a year.[6] The family was musical (Tom later played the mandolin[7]) and his mother keenly interested in literature. As a youth he was an excellent swimmer and fisherman, the latter a passion he inherited from his grandfather and father.[8]

Tom was the sixth of ten children, each of whom, on reaching maturity, received an inheritance from their paternal grandfather.[9] With apparently no thought of farming, Tom apprenticed for eight months as a machinist with William Kennedy and Sons in Owen Sound, leaving that firm in August 1899.[10] Following the example of his older brothers George and Henry, for about a year he attended the Canada Business College in Chatham.[11] The school offered instruction in shorthand, stenography, bookkeeping, business correspondence and "plain and ornamental penmanship."[12] In 1901 Thomson joined his brothers in Seattle,[13] where for six

months he attended the Acme Business College, established by George Thomson and his cousin F.R. McLaren. He then found employment as an artist with Maring and Ladd (later Maring and Blake) photo engravers, Maring also being a Chatham graduate.[14] In 1903 he moved to the Seattle Engraving Company[15] and returned to Owen Sound in 1904 or 1905. By 1905 he was working with Legg Brothers, Photo Engravers, in Toronto, and around 1909 Thomson moved to the firm of Grip Limited.[16] He may have spent at least one session at the local art school, the Central Ontario School of Art and Industrial Design, and, if so, he most likely took evening classes, as he was working during the day. Evening classes consisted of primary and advanced drawing and industrial art and mechanical drawing courses.[17] In 1907 he completed his first surviving oil, which was favourably received by his teacher William Cruikshank.[18]

Thomson's surviving artwork prior to 1911 consists of drawings in ink, watercolour and coloured chalk, of women's heads very much in the vein of the American illustrator Charles Dana Gibson, who had established the "Gibson girl" look (fig. 60), landscapes in ink and watercolour done around Leith and Owen Sound and on the Humber River in Toronto and illuminated texts presented as gifts to members of his family or friends (see fig. 21, p. 52).[19] They show a certain mastery of technique and competent draughtsmanship and evidence of his training in penmanship. The arrangement of some texts and designs (fig. 21 and pl. 1) has a similarity to the patterning of stained glass and are most likely characteristic of the Arts and Crafts–influenced commercial work he might have done.

Figure 60 Tom Thomson, *Study of a Woman's Head*, c.1903,
ink and coloured pencil on card, 10.9 x 8.1 cm,
Tom Thomson Memorial Art Gallery, Owen Sound, Ontario,
gift of Fraser Thomson, 1967 (967.015).

Grip

Thomson's supervisor, Albert Robson (1882–1939), art director at Grip, wrote that Thomson made friends slowly and that it was some time before he found common interests with other members of the art staff.[20] The senior designer at Grip was J.E.H. MacDonald (1873–1932). One of Canada's leading designers, he had started painting in 1907 and by 1910 had already achieved some recognition in that field. In November 1911 he left Grip to freelance and devote more time to painting,[21] his departure possibly stimulated by the Ontario Government's purchase that spring of his canvas of loggers, *By the River (Early Spring)*.[22] As a freelancer MacDonald retained his old friendships at Grip.

In December 1910 a young artist from Sheffield, England, William Smithson Broadhead (1889–1960) was hired at Grip, and he was joined by Arthur Lismer (1885–1969), also from Sheffield, the following February.[23] Lismer described the environment at Grip at this time.

> Tom Thomson when I first met him in February 1911 was one of a large staff of young commercial artists at the Grip Ltd., a prosperous and up-to-date engraving house in Toronto. Previous to joining this firm he had worked for one or two other similar concerns. Commercial artists at that time were fairly well paid, making designs and illustrations for catalogues, railway folders, real estate publicity and many other kinds of pictorial publicity. Thomson had a fine and well proportioned sense of design, and he could letter in good style. Usually he prepared working drawings from sketches for engravers. . . . On the

same staff were other artists — Jim MacDonald, Frank Johnston, Tom McLean, Fred Varley, Frank Carmichael and myself. . . . MacDonald was the most important influence on Tom Thomson at this stage. These young artists worked hard all week and sketched on Saturdays and Sundays. On Monday it was MacDonald in his corner seat who gave his opinion on the sketches and offered philosophical encouragement. He was already recognized as a Canadian artist. Thomson in 1911 had not tried his hand at sketching out of doors. Perhaps it was that hitherto he did not feel he could do anything with the medium of oil painting, or . . . he was not ready to emerge. It was in the summer and fall 1911 that Thomson first emerged as a sketcher. His first efforts were primitive. They had a child[-like] quality, but like a child's work, with good quality and character. It was in the country around Toronto, on the Humber River, in the bush near York Mills and on excursions into the country around Lindsay and L[ake] Scugog where he and others went fishing that Thomson first painted.[24]

Being a designer himself, MacDonald stressed the importance of Thomson's commercial work in the awakening of the latter's early development. "Gradually [Thomson] got into a steady connection with a living art by working at designing for the modern business of Photo Engraving. He made fine Catalogue covers and pages, or quaint advertisements, and learned that good art may be developed outside of schools and academies by the full expression of an idea in easy conformity to business needs and technical processes."[25] It was only at MacDonald's instigation that A.Y. Jackson, who met Thomson in December

1913, gave somewhat grudging credit to Thomson's work in the graphic arts.[26]

Thomson was what is generally known as a commercial artist. He had a refined taste, a fertile imagination, and in the more or less limited opportunities of designing title pages, catalogue covers, presentation addresses, etc., he acquired a knowledge and practice which were of great service in his later work. . . . This engraving house where he worked possessed an art atmosphere; originality was not discouraged; colour, line, proportion, pattern were problems which bear a close relation to his later work, wherein he was able to apply them with absolute freedom.[27]

Grip's employees included a number of artists who had been associated with the old Toronto Art Students' League (1886–1904), an informal organization of newspaper artists, illustrators and commercial artists who sketched together in various regions of eastern Canada. From 1893 to 1904 they published an annual calendar illustrating themes from Canadian history or rural life, and in 1903 a group of league members made a trip to Algonquin Park, sketching flowers, beaver dams and logging operations.[28] The romance of the North was very present, though its direction was not Algonquin Park as much as Temagami, Mattagami and the Magnetawan River, as seen in MacDonald's 1910 canvas *Clearing after Rain, Magnetawan River* (fig. 61). Tom McLean had worked in Northern Ontario as a prospector, fire ranger and surveyor,[29] and in 1903 he and fellow designer Neil McKechnie canoed in the Abitibi region. The following year the two artists applied for jobs as fire rangers in the Mississagi Forest Reserve. Before receiving confirmation of their appointment they set off on

Figure 61 J.E.H. MacDonald, *Clearing after Rain, Magnetawan River*, 1910, oil on canvas, 71.1 x 30.6 cm, Beaverbrook Art Gallery, Fredericton, New Brunswick, purchased with funds donated in memory of Phyllis Osler Aitken by her children and with the assistance of a grant from the Government of Canada under the terms of the Cultural Property Export and Import Act, 1984 (1984.04).

a canoe trip near Fort Metagami, where McKechnie was drowned when his canoe overturned while shooting rapids. McLean wrote a friend in Toronto, "This thing has overwhelmed me. I feel lost; the country overpowers me; it is so big, so untamed, so strong, and withal, so magnificent."[30]

In the absence of any viable art dealers, Toronto artists promoted the visual arts and their own careers through professional art societies, the Ontario Society of Artists (OSA) being the most prominent, though it had suffered reverses when a number of members seceded to form the Canadian Art Club in 1907. A.Y. Jackson later wrote that unlike in Montreal, there was little distinction between commercial artists and painters in Toronto. Commercial artists painted and painters worked in the commercial arts to make a living.[31] The OSA and the Graphic Arts Club, successor to the Toronto Art Students' League, included commercial artists, illustrators and printmakers as well as painters. The national artists' body was the Royal Canadian Academy of Arts, which held its annual exhibitions sequentially in Montreal, Ottawa and Toronto. The annual juried exhibitions organized by the various societies were the occasions for artists to present their most recent work and to hope for possible sales. The Arts and Letters Club (founded in 1908) brought together professional writers, dramatists, artists and architects with a minority of lay people interested in the arts.

These were exciting times in the Toronto art world, as a number of painters returned to Canada, having spent years of study or work abroad, and saw their native land with new eyes. MacDonald had come back to Toronto from England in 1907,

Lawren Harris from four years in Germany in 1908 and J.W. Beatty from Holland in 1909. Soon after his return, Beatty set off for Temagami and the following year painted *The Evening Cloud of the Northland* (fig. 62), a panoramic view of a forest fire raging over the northern hills, executed largely in browns and maroons with touches of reds. MacDonald and Harris worked to stimulate new energy and direction within the OSA, acting on selection committees for the annual exhibitions and encouraging new aggressiveness in sales and publicity. In 1913 and 1914 they organized exhibitions of *Little Pictures* (oil sketches) at the Toronto Public Library, the principal exhibiting space in Toronto at that time. It was at the Arts and Letters Club that the various protagonists met and discussions took place.

Yet Tom Thomson was never a member of the Arts and Letters Club, nor did he participate in any of the activities of the OSA, of which he was elected a member in 1914, apart from submitting paintings to their annual exhibitions.[32] Thomson was older than all his associates, save for MacDonald, and would continue to be somewhat an outsider in the burgeoning Toronto art scene, never attracted to the social imperatives of urban life. It was his friends and supporters who promoted his work, and MacDonald was the key person in initially pulling Thomson out of the commercial field into painting, not only by encouraging his weekend and holiday sketching trips but also introducing him to his fellow painters.

Painting was not something Thomson learned easily, and the process was accompanied by much self-doubt. Jackson recounted that in the fall of 1914 in Algonquin Park Thomson threw his

Figure 62 J.W. Beatty, *The Evening Cloud of the Northland*, 1910, oil on canvas, 99.4 x 142.4 cm, National Gallery of Canada, Ottawa, purchase 1911 (41).

sketch box into the woods in frustration,[33] and said he was "so shy he could hardly be induced to show his sketches."[34] He remained diffident about his paintings throughout his career, not even signing canvases he submitted to exhibitions.[35] "Tom had no opinion of his own work," Lawren Harris later wrote. "He might sit in front of a canvas that was set with thick paint and flick burnt matches at it in a kind of whimsical scorn. . . . If admirers got into Tom's shack and praised a particular sketch or sketches, Tom would immediately give them the sketch or sketches. This came to such a pass that we foresaw that Tom would have no sketches left, so by various devices we managed to keep the majority of admirers away from the shack."[36]

The Beginnings 1911–12

After Thomson's death there was some debate among his associates about when and in what environment he did begin to emerge as a painter. His colleagues in the graphic art world had experienced his initial efforts while working with him at Grip. MacDonald wrote to Arthur Lismer, "My memories in connection with Tom seem to begin with B[roadhead]."[37] Lismer, however, took exception to the assertion by the Montreal critic Harold Mortimer-Lamb that Broadhead deserved credit for starting Thomson's career,[38] and Jackson repeatedly protested that the graphic sources of Thomson's growth were overemphasized and that his real development as a painter began only in 1914 when he and other artists painted with Thomson in Algonquin Park.[39]

Thomson's first working associations were, however, in the graphic arts, and it was with fellow Grip employees that he made his first trips north. In 1911 he painted on trips home to Owen Sound and at Lake Scugog, where he went to fish with a Grip employee, Ben Jackson (1871–1952), a specialist in tourism publicity. *Near Owen Sound* (pl. 2), dated November 1911 in Thomson's hand, is a subtle tonal study in brown, painted with a relatively small brush, the drawing of the trees and fence tight and precise. Other sketches from 1911 are on canvasboards or wood panels of irregular dimensions.

Tom McLean (1881–1951) told Ben Jackson and Thomson about Algonquin Park, and in May 1912 the two artists went north with an introduction from McLean to the park superintend-ent, G.W. Bartlett.[40] According to Jackson, it was at this time that Thomson acquired his first sketching equipment,[41] though the pair mostly fished and Thomson did little serious sketching except for "a few notes, skylines and colour effects"[42] (see fig. 4, p. 26). The two artists took the train to Canoe Lake station and camped on nearby Smoke Lake, where Thomson met the ranger Harry (Bud) Callighen.[43] On their return to Toronto, Jackson published an article on the park in the *Toronto Sunday World*, illustrated with a portrait of Thomson (see fig. 83, p. 311).[44]

Over the next few years Algonquin Park became an alternative community to that of the Toronto art world. Thomson's future base would be the small settlement of Mowat on Canoe Lake, formerly a thriving lumber centre. By 1912 the permanent residents consisted of the postmaster, Shannon Fraser, and his family, proprietors of a boarding house that became Mowat Lodge in September 1914;[45] and two guides, George Rowe and Larry Dickson. Mark Robinson was the park ranger at Joe Lake, Bud Callighen at Smoke Lake and Tom Wattie at North Tea Lake. Others came to Mowat in the winter for health reasons, the cold, dry winter air being considered beneficial for lung ailments like tuberculosis. Summer residents included the Blechers from Buffalo and the Trainors from Huntsville.[46] In future years Thomson would arrive in late winter, stay at Mowat Lodge or in the Trainors' cabin for a few weeks until the lakes and rivers opened up, then camp for the summer, returning to Mowat for the first winter snows before leaving for Toronto.

In 1912 Thomson made his first major canoe trip in Northern Ontario with William Broadhead, in the region where McLean

and McKechnie had travelled in 1904.[47] In the last week of July they took the train from Toronto to Biscotasing, northwest of Sudbury and canoed and portaged through Biscotasing and Ramsey Lakes, up the Spanish River through Spanish Lake to Canoe (now Bardney), Osagama, Green and Clear Lakes, through the Mississagi Forest Reserve to the Aubinadong River. From Aubrey Falls they continued along the Mississagi River, ending up at Squaw Chute, from where they were driven to Bruce Mines to get a boat to Owen Sound, arriving there the last week of September.[48] It was a long and gruelling trip, especially as it rained almost the entire two months. They sketched and photographed along the way, most likely with another magazine article in mind. But they capsized twice, first on Green Lake in a rain squall and a second time "in the forty mile rapids near the end of the trip," this time losing most of their photographs and sketches.[49] Thomson returned to Toronto and in October followed Albert Robson to another commercial art firm, Rous and Mann,[50] where they were joined by Fred Varley (1881–1969), Franklin Carmichael (1890–1945) and Arthur Lismer (1885–1969). That same month Thomson met Dr. James MacCallum in J.E.H. MacDonald's studio.[51]

James Metcalfe MacCallum (1860–1943) was born in Richmond Hill, Ontario, the son of a Methodist minister. Around 1870 the family moved to Collingwood on Georgian Bay, not far from Owen Sound, where the young James learned to canoe. He studied ophthalmology in Toronto and London, England, taught at the University of Toronto until 1907 and then spent a further two years in London, returning to Toronto in 1909. A member since 1898 of the Madawaska Club, a U. of T.–related cottage settle-

ment at the north end of Georgian Bay, he built his own cottage in 1911 on an adjacent island at Go-Home Bay. He became a member of the Arts and Letters Club in January 1912, and there he met the artists J.W. Beatty (1869–1941), Arthur Heming (1870–1940), J.E.H. MacDonald and Lawren Harris (1885–1970). In 1912 MacCallum invited MacDonald and his family to his cottage, and in 1913 Lismer and his family.[52] MacCallum had a just appreciation of artists and a genuine sensitivity to the æsthetic qualities of paintings and he could wax lyrical in his comparisons of the ærial perspective in Thomson's *Woodland Hill in Autumn* to the work of Velasquez, and the jewel-like quality of *The Brook* (pl. 31) to a Monticelli in the Metropolitan Museum in New York.[53] Yet his initial attraction to the work of these younger artists was instigated by his love of the Northern Ontario landscape.

MacCallum had heard of Thomson's trip to the Mississagi Forest Reserve from a friend[54] and on seeing the sketches was struck by "their truthfulness, their feeling and their sympathy with the grim, fascinating northland. . . . They made me feel the North had gripped Thomson as it had gripped me since I was eleven when I first sailed and paddled through its silent places." He described them as "dark, muddy in colour, tight and not wanting in technical defects," but nonetheless he bought "some of the sketches fished up from the foot of the rapids."[55]

It is difficult to identify the sketches Thomson painted in 1912. We know that soon after they met, he gave Bud Callighen the sketch titled *Smoke Lake, Algonquin Park* (pl. 4), showing Nominigan Point, recently cleared of trees for the construction of a new hotel.[56] Freely brushed with rich blue water and modulated pink

sky, the foreground trees frame the panoramic view of the logged-over point on the far shore. While differing considerably from that sketch, the small oil *Old Lumber Dam, Algonquin Park* (pl. 3), titled by the artist on the back, must also date from this May trip. Somewhat awkward in drawing, it nonetheless shows a sensitivity to colour and a delight in the linear arabesques of the dead trees and roots that was characteristic of Thomson's early works. *Drowned Land* (pl. 5),which Albert Robson identified as having been painted on the canoe trip to the Mississagi Forest Reserve,[57] is similar to *Near Owen Sound* (pl. 2) in colour, drawing and texture. One is struck by the simplicity of the motif as well as Thomson's attraction to the desolate, though common, subject, unprecedented in Canadian painting since the early-nineteenth-century topographers. Two other sketches painted that year, *The Canoe* (pl. 6), formerly belonging to Shannon Fraser of Mowat, and *A Northern Lake* (pl. 7), are on canvas glued to secondary supports. One is a study of Thomson's canoe beached on the rocks between two dead cedars, the other of whitecaps on a lake and a far shore. In both paintings he focuses on the foreground, carefully drawing the branches of the bare trees that frame the distant view. They show an immediate sensitivity to the rawness of the northern landscape effectively expressed by the crude, textured brushwork and grey skies.

A Canvas of Winter 1913

Back in Toronto Thomson was encouraged by his friends to paint up one of his sketches. The resultant canvas, *Northern Lake* (pl. 8),

was shown in the OSA annual exhibition in March 1913. It was effectively described by Dr. MacCallum as a "picture [of] one of the small northern lakes swept by a north west wind; a squall just passing from the far shore, the water crisp, sparklingly blue & broken into short, white-caps—a picture full of light, life and vigour."[58]

To the best of our knowledge, this was the first time Thomson had ever publicly exhibited his paintings, yet by association he was already being identified with a new direction in Ontario art.

Reviewing the [OSA] exhibition as a whole, the first and last impressions are that it is dominated almost entirely by the younger men, who, casting aside formulas, start out to record only what are their own individual impressions. The result is virile work, fearless brushing, strange, crude color— all a reflection or echo of the spirit of the times. Sometimes, seen at the right distance, the painting is astonishingly truthful, as in Mr. Lismer's "Sunny Afternoon" or Mr. Tom Thomson's "Northern Lake" or Mr. Jackson's "Yellow Tree": sometimes it is chaotic as in Mr. Varley F. Horsman's [sic] "The Hillside"; sometimes it is crudely repellant, as in Mr. Hans Johnston's "Silver Beech [sic]." It is well that the younger men should find a place and a large place at our exhibitions, but not to the almost entire exclusion of the older element, in whose work are to be found dignity, serenity, sound draughtsmanship and all the solid qualities of good design and color which are to be found in the great art of all ages.[59]

Northern Lake was purchased by the Government of Ontario for $250, as was Arthur Lismer's painting *The Clearing*. The purchase of a painting done by a neophyte in the Toronto art world must

have been rather surprising, though possibly the presence on the government selection committee of his old teacher, William Cruikshank, might have helped.[60] Harsh and aggressive in treatment, full of a raw energy, the painting shows more promise than accomplishment.

The year 1912 marks the beginning of Thomson's career as a painter. At the age of thirty-five he had made his first major canoe trip, discovered the subject of his art in the Northern Ontario landscape, produced his first cohesive body of sketches and exhibited his first canvas. There was no precedent in his life to predict the passion with which he would now pursue his art.

The Sketches of 1913

Thomson worked at Rous and Mann during the winter of 1912–13. His friendships with his guides of 1912 were severed when Broadhead left Toronto for the United States in late 1912 and Ben Jackson soon after.[61] There is no documentation of Thomson's travels or activities in 1913, though he probably set out for Algonquin Park in May.[62] One account says he guided fishing parties, but that seems unlikely as he had only been in the park for a few weeks the previous year.[63] In August he is said to have paddled to Manitou and North Tea Lakes in the northwestern part of the park, where he met the ranger Tom Wattie, and by September 19 was back at Canoe Lake, returning to Toronto via Huntsville in November.[64]

Dr. MacCallum visited Thomson's boarding house on Isabella Street after the artist's return from the park and remembered the walls being covered with sketches of "lightning flashes, moving thunder storms, trees with branches lashing in the wind."[65] Yet most of the sketches identified as having been painted in 1913 are distant views of far shores in horizontal and occasionally vertical compositions, painted on canvas boards. A.Y. Jackson later described his impressions of Thomson's sketches from 1913:

He had a few dozen sketches that were not remarkable except that they showed a great knowledge of the country and were very faithful and painstaking. One felt he would not move a branch or change the contour of a hill, however much the composition demanded it. His sketches were also surprisingly sombre and dead in colour, and were peculiar in composition in that many of them were of an upright panel shape, showing a low shore line and a big sky. The country in them seemed always to be viewed extensively. There were no gay little rapids or wood interiors or patterned rocks, but only the opposite shores of lakes, far hills or wide stretches of country.[66]

In their simplicity of composition, the sketches of 1913 recall Beatty's *Evening Cloud of the Northland* (fig. 62) and some of MacDonald's 1912 sketches of Georgian Bay or the Magnetawan River (fig. 63), but without the latter's bright palette. Sunsets, storms and dramatic clouds are his subjects as much as the narrow silhouettes of the far shores. *Northland Sunset* (pl. 13) and *Canoe Lake* (pl. 14), which he gave to Arthur Lismer, are painted with a more fluid brush and somewhat subtler colour, while the clouds in *Lake, Shore and Sky* (pl. 11), which Thomson gave A.Y. Jackson that winter, and *Sketch for "Morning Cloud"* (pl. 12) are arranged in sweeping diagonals. *Thunderhead* (pl. 10) with its

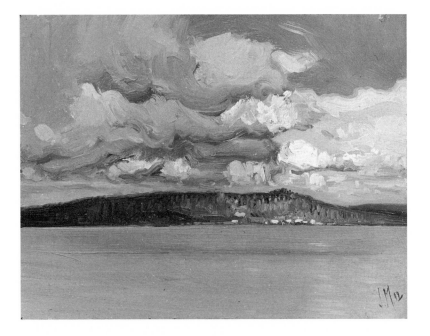

Figure 63 J.E.H. MacDonald, *Sawmill, Lake Cecebe, Magnetawan River*, 1912, oil on paperboard, 20.1 x 25.3 cm, National Gallery of Canada, Ottawa, bequest of Dr. J.M. MacCallum, Toronto, 1944 (4741).

The Winter of 1913–14

In 1913 MacCallum and Lawren Harris began construction of the first edifice intended specifically for artists' studios in Canada. The Studio Building was to be on Severn Street, near Bloor and Yonge Streets, where Harris had his studio over the Bank of Commerce. The Montreal painter A.Y. Jackson, with whom J.E.H. MacDonald had been in correspondence since 1911, passed through Toronto in the summer of 1913 and met Lismer, Varley and MacDonald, and soon afterwards Harris. He spent the rest of the summer and autumn at Georgian Bay, where MacCallum sought him out and urged him to move to Toronto. Jackson was on the verge of leaving for the United States, but MacCallum offered him a guaranteed income for one year through purchases of his paintings. Jackson accepted and in late October came down from the bay to share Harris's studio until the new building was completed. There, while painting the large canvas *Terre sauvage* (National Gallery of Canada) he met Tom Thomson and saw his 1913 sketches. Jackson and MacCallum encouraged Thomson to "take up painting seriously, [but] he showed no enthusiasm. The chances of earning a livelihood by it did not appear to him promising. He was sensitive and independent, and feared he might become an object of patronage." Thomson finally agreed to leave commercial art for one year and devote himself fully to painting on the same terms as Jackson.[68] Thomson did not entirely abandon design work, and it is possible he did freelance in later years, but a commitment to painting had been made. In January Thomson and Jackson moved into the Studio

swirling cloud rising above the driftwood littered shore, and *View Over a Lake: Shore with Houses* (pl. 9), the houses mere dots of white and red, may have been among the sketches MacCallum purchased in October 1912,[67] though their greater technical sophistication suggests they were painted in 1913. Hesitant in his use of colour, Thomson is still attracted to dark, grey days, as seen in *Red Forest* (pl. 15); however, the occasional sketch is startling in its subtlety or boldness of colour, as in the glowing light of *Evening* (pl. 16) or the sophisticated overlaying of oranges, reds, browns and greens of *Autumn, Algonquin Park* (pl. 17).

Building, sharing studio number one. Other tenants included J.E.H. MacDonald, Arthur Lismer, Lawren Harris, J.W. Beatty, Curtis Williamson and Arthur Heming.

In December 1913 an exhibition of Jackson's sketches at the Arts and Letters Club instigated a satirical article titled "The Hot Mush School" from a fellow club member, H.F. Gadsby, to which MacDonald replied.[69] The fulmination and the publicity were undoubtedly gratifying to the artists. It affirmed their common goals, united them in purpose and gave them the opportunity to articulate their ideals for Canadian art. Yet, as in future journalistic confrontations, Thomson took no public role in these debates.

Encouraged by Jackson and MacCallum, Thomson began working up his 1913 sketches. One canvas he painted that winter, possibly as an overmantel decoration, and which he gave to his father,[70] shows a lone canoeist on a northern lake (see pl. 18). It is an evocative self-portrait of the artist in his new identity as canoeist and outdoorsman in the landscape of Algonquin Park. In composition and tonality it is similar to his 1913 sketches, painted in greys with a touch of green in the dunnage, but with more sophistication in the handling of colour and form than the previous year's *Northern Lake*. Two other canvases, *Morning Cloud* (pl. 20) and *Moonlight* (pl. 19) were painted with a broken brushwork. This technique Thomson had undoubtedly learned from MacDonald and Jackson, the latter who had painted in France in an impressionist-derived manner for several years. They show a greater technical sophistication but are tight in design, largely uniform in texture and somewhat forced in their application of the directional stroke, as if he was not yet at ease with the process.

The more successful is *Morning Cloud*, in which he enhanced the colour from the blue and cream yellow of the sketch to more intense yellows and pinks that frame the brown, red and purple hills. These two canvases of dawn and night were exhibited with the OSA in March 1914, and the smaller *Moonlight* was purchased for the National Gallery of Canada.

The Sketches of 1914

Following the example of Beatty and Jackson, Thomson that winter made himself a sketch box to hold panels of a standard size, $8\frac{1}{2}$ x $10\frac{1}{2}$ inches (21.6 x 26.7 cm), enabling them to order their panels in larger quantities and at less cost. The lower part of the box served as a palette, and the upper part became a painting support (see fig. 71, p. 144). Slots in the upper part permitted him to carry three panels at a time, separating them so they didn't stick together and flatten the paint when wet. Thomson used this box for the first time in 1914,[71] though that spring he still painted on canvas glued to boards, not, like Jackson, directly on wood panels.

If Jackson could teach Thomson about composition, colour and technique, Thomson in turn stimulated Jackson's curiosity about Algonquin Park. In mid-February Jackson arrived at Mowat on Canoe Lake. "The woods look very wonderful and full of 'decoratif motifs,' " Jackson wrote. "It appears that Tom Thomson is some fisherman, quite noted around here."[72] He found Mowat unpretentious. "The population is eight, including me. . . . Our only means of locomotion are snowshoes. There is only one

road, to the station a mile away, and it stops there. However, the snowshoeing is good—there are lots of lakes and all frozen, so you can walk for miles on the level. As soon as you get off the lakes you are in the bush, which is very rough, a very tangle of birch and spruce."[73] In March Jackson was joined by Beatty and MacDonald,[74] and he was back in Toronto by mid-April,[75] in time to see Thomson before the latter left for Algonquin Park with Arthur Lismer.[76]

When Thomson arrived in the park late April,[77] there was still wet snow in the woods, as seen in his sketch *Larry Dickson's Shack* (pl. 21).[78] Lismer arrived on May 9, and they camped on Molly's Island in Smoke Lake, where they were photographed in a canoe by Bud Callighen (see fig. 85, p. 313).[79] They travelled and sketched in Canoe, Smoke, Ragged, Crown and Wolf Lakes, and Lismer was entranced by the experience:

> We were there just after the ice had gone out of the lakes and before it had completely gone from the southern slopes of the shores of the lakes. We were there before the maple and birch burst into leaf, and we stayed to see the wonderful miracle of a northern spring come again. . . . I reached Canoe Lake where I met my friend Thomson (who had been staying at a boarding-house on the lake for two weeks) about ten o'clock in the evening, after a stuffy nine hours in the train. I was met by Thomson who had brought down the wagon and we drove through the bush to where he was staying. Imagine a glorious full moon coming over the tops of the spruce, big and yellow, shedding a mysterious light on everything. . . . We stayed overnight at Fraser's, Canoe Lake, and pulled out the next forenoon. Our canoe was a sixteen-

footer Chestnut, canvas covered, roomy, and capable of carrying the weight we had to put in it, stores for two weeks, tent, blankets, a cooking oven and utensils, plates and pannikins of aluminum, fishing tackle, axe, and sketching impedimenta, this last consisting (for me) of two dozen $12\frac{1}{2}$ x $9\frac{1}{2}$ three-ply veneer boards. . . . These fit into a holder designed to carry six or more in a flat sketch box, also about twelve to fifteen pounds of paint, oil and brushes per man. When our canoe was fully laden, we had about $2\frac{1}{2}$ inches of free board above the water line and with our two selves about 560 lbs in all. . . . Thomson is one of finest canoe men I know. . . . [H]e knows the country, the winds and currents, portages and camping grounds, withal he is a splendid companion and a sincere and able artist with fine knowledge of this country. . . . [W]e made camp on a little island on Smoke Lake . . . [and] made excursions in all directions into corners and little lakes. . . . [W]e made long excursions into the bush, which, in early spring, is penetrable in places for the undergrowth is not so dense and tangled. . . . Down at the water's edge grow the spruce, cedar, pine, with a few birch, then behind come the hardwoods, maple mostly. From the lake the picture of the sombre pinnacled spruce silhouetted against the grey, purple and browns of the top branches of the maple and birch is very beautiful. . . . [G]reen came and it all seemed to happen in a night. . . . [T]here were miles of birch lands, a glorious display of spring greens and silvery trunks reflecting perfectly in the lake.[80]

For all Lismer's delight in the rich colouring of the northern spring, Thomson's sketches are muted in colour, painted on roughly textured canvas in browns, purples, dirty whites and dense blues and greens. Yet in both *Larry Dickson's Shack* and *Hoar Frost* (pl. 22),

Thomson breaks out of the tight draughtsmanship of the previous year and experiments with non-naturalistic colour. In October Thomson wrote MacCallum, asking him not to sell a sketch of rocks and water "I would like to paint up," (see fig. 74, p. 299),[81] most probably the sketch of ice breaking up on a river (pl. 23) from which he painted a canvas originally titled *Early Spring* (pl. 36). The sketch is painted with a heavily brushed, rough texture. The subject was later identified by Dr. MacCallum as being painted on the Petawawa River: "The ice is seen emerging from the Gorges in the back and upper part of the canvas — at this point another tributary comes into the lake-like expansion of the Petawawa — the two waters meeting cause a swirling current which will drift the ice further along the river."[82] We have no reference, however, to Thomson's being at the north end of the park that spring. The foreground rock introducing the viewer into the space finds its echo in *Canoe Lake, Mowat Lodge* (pl. 30) painted later that summer. *Spring* (pl. 24) is the first appearance of a composition that he would revert to frequently over the following years. The foreground rises to one side, cutting the panel in half on the diagonal, and the far horizon is raised and viewed through a screen of trees. Jackson had painted a similar sketch in the park earlier that year (fig. 64). Lismer and Thomson sketched in an area where there were brush fires,[83] as evidenced by the smoky sky in *Burnt Country, Evening* (pl. 25). Here Thomson painted the vertical trees first. He then painted the sky and hills but less densely, allowing the thin plywood panel, a support Thomson used that summer and that often shows vertical cracking, to show between the brushstrokes. The palette is similar to the other

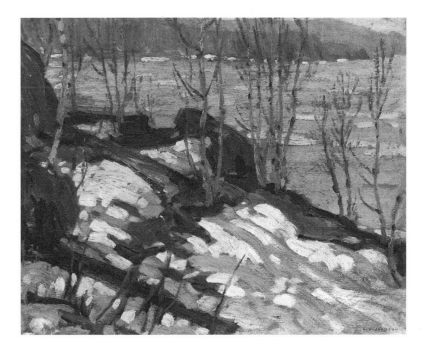

Figure 64 A.Y. Jackson, *Lake Shore, Canoe Lake*, 1914, oil on wood, 22.1 x 27.1 cm, National Gallery of Canada, Ottawa, purchase 1939 (4546).

sketches from this spring, and Thomson has added a curving sapling before the hill at the right.

Dr. MacCallum was keen to introduce the artists to the landscape around his cottage on Georgian Bay. MacDonald had painted at Go-Home Bay in 1912 and Lismer and Jackson in 1913. This was Thomson's year. He and Lismer left the park on May 24,[84] and the following week he arrived at Parry Sound by train. He and the doctor camped at French River.[85] *Parry Sound Harbour* (pl. 26) has been dated by MacCallum to May 30, 1914, and *Spring, French River* (pl. 27) to June 1, 1914. Both are painted

with more controlled brushstrokes in the browns, greens and purples of his spring sketches, with touches of broken colour in the water. *Cottage on a Rocky Shore* (pl. 28) is a sketch of MacCallum's cottage, but the primary subject is the vast expanse of sky and clouds over the water, while in *Spring, French River* and *Evening, Pine Island* (pl. 29) the rocks and windblown trees are the dominant motifs. *Evening, Pine Island* was painted the last afternoon Thomson was at MacCallum's island. "I had planned to take him up to the North West Wooded Pine where there is a tree that always has inspired me," MacCallum wrote. "[W]e were late in getting started, so that instead I had to take him to the South West Wooded Pine — an island of granite about a quarter of a mile in length by 100 yards wide and say 50 feet high."[86] The paint is applied more thinly, the space is less dense and the bare wood shows through, allowing the trees to breathe. The linear tracery of the windblown trees, framed in a vertical composition, is not an applied design but rather a felt experience of a particular site and of the luminous evening light.

Thomson sketched a fair bit around the islands but had lost interest by mid-June. The reason for his departure appears to have been the rather active social life at the cottage, "too much like north Rosedale," and his desire to get back to camping in the park.[87] He left Go-Home Bay early August, canoeing and portaging north along the French River to Lake Nipissing and then south to Canoe Lake,[88] a demanding trip for a canoeist travelling alone. Jackson, who had been painting in the Rockies with J.W. Beatty during the summer, joined Thomson at Canoe Lake around mid-September,[89] and they travelled and painted on Canoe, Smoke and Ragged Lakes. In early October they were joined by Fred Varley and his wife, Maud, and Arthur Lismer and his wife and daughter, Esther and Marjorie Lismer. The Algonquin artists reported back to Toronto the excitement of this joint enterprise. "Tom is doing some exciting stuff," wrote Jackson to MacDonald. "He keeps one up to time. Very often I have to figure out if I am leading or following. He plasters on the paint and gets fine quality but there is a danger of wandering too far down that road."[90] Thomson also was pleased.

> [J]ust now the maples are about all stripped of leaves . . . but the birches are very rich in colour. . . . [W]e are all working away but the best I can do does not do the place much justice in the way of beauty. Jackson and myself are having a fine time and seem to have about the same habits about camping and can always find sketching near the same place. . . . I thought of putting in my application for a park ranger's job and went down to headquarters with that idea, but there is so much red tape about it that I might not get on for months, so I will try to get work in some engraving shop for a few months this winter.[91]

And to the doctor, Jackson wrote in a jocular manner, "Varley, Lismer and company . . . have had as much good weather in the last twelve days as Tom and I have had in a month. . . . Tom is doing some good work. Very different from last year's stuff. He shows decided cubistical tendencies and I may have to use a restraining influence on him. . . . It is just as well the studio is sub-letted [*sic*]. Neither Thomson nor I are likely to turn over much money during the next few months."[92] Jackson left for Toronto October 23[93] and Thomson around mid-November.[94]

The mutual enthusiasm is evident in the variety of approaches in each artist's work. Jackson painted a young red maple over a sketch of a rushing stream, the basis for his canvas *The Red Maple*.[95] Lismer painted the muted, roughly textured *Hillside*, later worked up for the canvas *Sunlight and Shade—October in Algonquin Park*,[96] as well as the higher-keyed sketch of Larry Dickson's cabin, *Sketch for "The Guide's Home, Algonquin"* (fig. 65).[97] Thomson also painted Dickson's shack, though with a heavier hand and more angular brushwork (pl. 34). *The Brook* (pl. 31) is painted on a coarse canvas, the dense brown foliage flattened and dotted with touches of red, yellow, green and orange. *Soft Maple in Autumn* (pl. 32) is similar to Jackson's *Maples in Autumn, Algonquin Park*.[98] Both artists blocked in the red leaves first, but Thomson's colour is more brilliant, the red leaves set against the background of green, orange, tangerine and blue. He added thin touches of additional colours over the ground colour and over that drew in branches to animate the design, procedures he repeated in future years. There is still a certain awkwardness in the structure of buildings and hills in Thomson's sketches of 1914; however, as seen in the touches of red and yellow that illuminate *The Hill in Autumn* (pl. 33), he quickly surpassed both Jackson and Lismer in brilliancy of colour. "No longer handicapped by literal representation, he was transposing, eliminating, designing, experimenting, finding happy colour motives amid tangle and confusion and revelling in paint," Jackson later wrote. "The amount of work he did was incredible."[99]

Jackson and Lismer were correct in recognizing that Thomson's painting moved in a radically different direction in 1914.

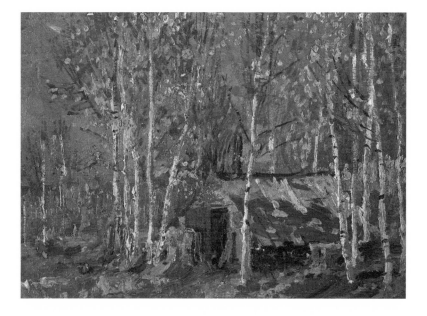

Figure 65 Arthur Lismer, *Sketch for "The Guide's Home, Algonquin,"* 1914, oil on wood, 23.5 x 31.5 cm, National Gallery of Canada, Ottawa, bequest of Dr. J.M. MacCallum, Toronto, 1944 (6520).

Thomson had started to paint in 1911, but it was only in 1914 that he gave any evidence of his future talents. Having the time to devote to painting and stimulated by his contacts with his fellow artists, he abandoned the linear precision and subdued colouring of his earlier work as he experimented with texture, colour and a variety of compositions.

Thomson's most remarkable sketch of the season is *Winter* (pl. 35), painted after the others had left Algonquin Park. The clouds are broadly brushed, the trees freely delineated. There is a lightness of touch and a naturalness and spontaneity about the sketch that show how rapidly he had advanced within a very short period.

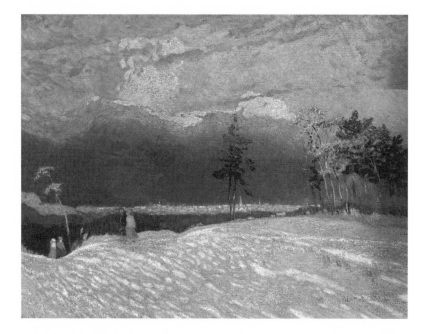

Figure 66 J.E.H. MacDonald, *The Edge of the Town, Winter Sunset*, 1914, oil on canvas, 81.8 x 102.7 cm, National Gallery of Canada, Ottawa, purchase 1960 (7795).

The Winter of 1914–15

Thomson was back in Toronto in November,[100] but the future was clouded with uncertainty. Jackson's letters from the park are filled with concern about the war that had been declared that summer and, their year of support from Dr. MacCallum coming to an end, about Thomson's financial situation.[101] Jackson was thinking of enlisting, but if he left Toronto Thomson would have to assume the full rent of the studio, which he could ill afford. As William Colgate writes, "With the outbreak of war in the summer of 1914 all artistic effort ceased. The public, numbed

by the suddenness of the cosmic tragedy, no longer wanted the work of the painter. Almost overnight, dealers' galleries were denuded of patrons; and, because the facilities of railway and steamship companies were diverted to move troops and munitions, orders for tourist publicity, folders and advertisements, hitherto the mainstay of Thomson and his colleagues, were cancelled. The art departments of engraving houses cut staffs wholesale, so that the artists, forced to the street, enlisted or vainly sought jobs that no longer existed."[102] After Jackson left for Montreal in December, Thomson shared a studio with the former Grip employee Franklin Carmichael, who had cut short his studies in Antwerp and returned to Canada in September.

Notwithstanding the troubled times, in the last months of 1914 Thomson and his friends worked with a passion, still animated by their shared experiences in Algonquin Park. Lismer painted *The Guide's Home, Algonquin* and Jackson *The Red Maple*, and in mid-November Thomson exhibited two paintings with the Royal Canadian Academy in Toronto: *A Lake, Early Spring* and *Frost after Rain*. Neither has been securely identified, though the former might be the canvas now called *Petawawa Gorges* (pl. 36).[103] And within weeks of his return, Thomson submitted *In Algonquin Park* (pl. 37) to the exhibition organized by the academy to raise money for the Patriotic Fund war effort. Paintings donated by the artists were sold to the highest bidders at the end of the exhibition's tour, and for a bid of $50 Marion Long, a more recent artist-tenant of the Studio Building, acquired Thomson's painting. *In Algonquin Park* was clearly a homage to J.E.H. MacDonald, who was working on *The Edge of the Town, Winter Sunset* (fig. 66), a reworking

of his 1912 composition *Morning Shadows*, when Thomson returned to Toronto.[104] Painting from the sketch *Winter*, Thomson raised the horizon line, extended the foreground to accentuate the trees and blue shadows, as in MacDonald's painting, and completely reworked the sky. Both *Petawawa Gorges* and *In Algonquin Park* differ considerably from the previous winter's paintings. The surfaces are taut and roughly textured and the compositions more painterly. They are conceived as integrated, textured wholes, not as flat designs.

During the winter of 1914–15, Thomson realized his first major body of work. He painted three canvases from his Georgian Bay sketches, and each differs markedly from the others: *Split Rock, Georgian Bay* (National Gallery of Canada, 4575), *Byng Inlet, Georgian Bay* (originally titled *Georgian Bay Pines*; fig. 59, p. 110) and *Pine Island, Georgian Bay* (pl. 38). The first two were exhibited with the OSA the following spring. MacCallum said that Thomson worked on the latter canvas over an extended period,[105] and it was never exhibited during the artist's lifetime. All the artists were experimenting with broken, high-keyed colour, as can be seen in Lismer's *Sunglow* (fig. 67) and Thomson's *Byng Inlet, Georgian Bay*. Lismer employs the technique in the water only, while Thomson applies it over all the composition and in *Pine Island, Georgian Bay* less obviously and with subtler colour. From the sketch for the latter (pl. 29) he reworked the sky from a pink glow to more low-toned greens, opened the space at the right and created a linear arabesque of the trunks and branches painted in blue, red and green with a textured surface. For MacCallum, this painting had "more emotion and feeling than any other of his canvases."[106]

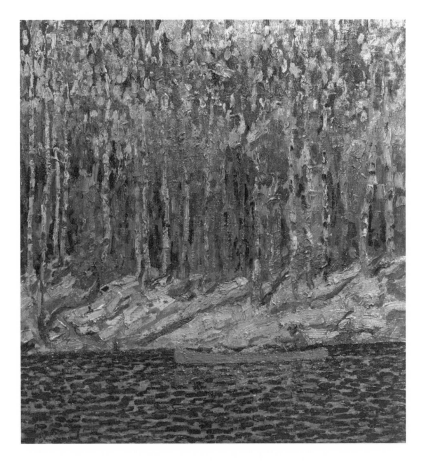

Figure 67 Arthur Lismer, *Sunglow*, 1914–15, oil on canvas, 50.3 x 46.5 cm, Art Gallery of Nova Scotia, Halifax, acquired 1919 (1919.1).

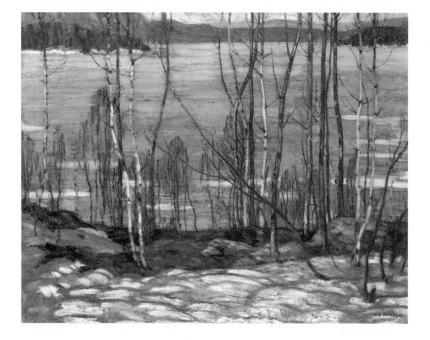

Figure 68 A.Y. Jackson, *A Frozen Lake*, 1914, oil on canvas, 81.4 x 99.4 cm, National Gallery of Canada, Ottawa, bequest of Dr. J.M. MacCallum, Toronto, 1944 (4732).

Each sketch selected for reworking posed different problems, and each of the canvases painted that winter stands on its own. *Burnt Land* (pl. 41) has some of the simplicity of composition of *Petawawa Gorges*, but Thomson's concern was not with texture but with the silhouette of the far hill and flattened sky, which contrast with the jumble of logs, rampikes and foliage in the foreground. He has simplified the arrangement of trees, creating a tighter and remarkably forceful depiction of a subject that he would return to over the next few years. The small canvas was acquired by Lawren Harris from Thomson.

The sketch for the seventh canvas Thomson painted that winter is in gouache (see pl. 39), a medium used by commercial artists for window boards and advertisements. Probably painted in his Toronto studio, it is most likely a memory—an amalgam of experiences rather than a specific site. Like *Pine Island, Georgian Bay*, it is a vertical composition and uses the motif of the linear arrangement of branches and trunks; but the canvas *Northern River* (pl. 40) is more obviously decorative and designed. In contrast to *Northern Lake* of 1913 (pl. 8), in which the trees framed the empty open space, here the view is screened, filled with a delicate tracery of thin branches and crossed by a sinuous, curving branch, a device borrowed from Jackson's 1914 canvas *A Frozen Lake* (fig. 68).[107] The major change from the gouache study is the orange-pink ground under the sky and water, over which he painted pale blues and greys. Exceptionally for Thomson, black is the dominant colour. He painted the trunks and branches of the larger trees first, then added the water, sky and background between the principal forms, drawing in the thinner branches in liquid black paint over the previously applied colours. While the composition as a whole follows that of the gouache, he made numerous alterations in the tracery of branches and added small saplings in the foreground. The working process he had adopted in such sketches as *Soft Maple in Autumn* he now applied to the canvas, though the scale inhibited a similar freedom of design. His "swamp picture," as he nicknamed it, was bought by the National Gallery of Canada.[108]

Thomson's interest in the decorative arrangement of *Northern River* was a response to the concerns of his colleagues. Both Harris

and MacDonald had been to Buffalo in January 1913 and been inspired by the paintings and tapestries of Gustav Fjæstad and others in an exhibition of Scandinavian art, their interest enhanced by articles in *Studio* magazine on Swedish decorative arts. For MacDonald it was a confirmation of a direction he had already embarked in, but for Harris it was a complete redirection. The paintings of both artists became increasingly decorative, space compressed, screens of foreground elements arranged across the canvas and colour harmonized to create a unified effect. Aspects of this are seen in *Northern River* but with a moody austerity of colour and linear two-dimensionality that betray its source in the gouache study. Only in the foreground does Thomson indulge in rich, dark colour, while the background trees are arranged in a diluted graphic silhouette.

The Sketches of 1915

Thomson was back in Algonquin Park earlier than ever in the spring of 1915.[109] He had already been to Owen Sound and Huntsville and painted twenty-eight sketches by April 22. "The snow in the woods here was about two or three feet deep when I got here and disappeared gradually until now it is gone excepting spots in the thick swamps," he wrote from Mowat. "The ice is still on the lakes but is getting pretty rotton [*sic*] and will break up the first good wind so I will soon be camping again."[110] He took out a fishing licence on April 27 and left with a fishing party from Pittsburgh the following day, returning May 19.[111] He assisted various groups through Bear, Smoke and Swan Lakes[112]

and was back at Mowat by July 22. Tourists were few, and there were more guides than jobs; as a result he had only two or three weeks' work. He had already made "quite a few" sketches, but he was restless. He thought of returning to the French River and canoeing along the shore of Georgian Bay to Bruce Mines and going west to work on the wheat harvests,[113] but instead he canoed to the Magnetawan River in August. There he painted the running of the logs and ended up at South River, from where he wrote, "Have travelled over a great deal of country this summer, and have done very few sketches — it will be about a hundred so far."[114] From there he went back up the South River to North Tea Lake and Lake Cauchon and possibly all the way to Mattawa. "[I]t's fine country up this river about 10 miles, so there is lots to do without travelling very far. There are stretches of the country around here . . . a good deal like that near Sudbury, mostly burnt over like some of my sketches up the Magnetawan River. . . . We have had an awful lot of rain this summer and it has been to some extent disagreeable in the tent."[115] On the back of the sketch *Sand Hill* (pl. 69), Dr. MacCallum wrote, "Sand Hill on road to South River — fall 1915 — on this day Thomson tramped 14 miles carrying a sketch box and gun — a fox and seven partridge which he shot that day and did this and another sketch." He was at Mowat again from the end of September to mid-October[116] and then took a fishing party to Crown Lake, where he was photographed fly-casting from a rock.[117] In November he was at Round Lake (now Lake Kawawaymog) with Tom Wattie and Dr. Robert McComb, a physician from South River.[118]

When Thomson returned to Toronto in late November, he moved into a shack behind the Studio Building, formerly used as a woodworking shop,[119] that had been fitted up for him by Harris and MacCallum. This would be his Toronto home and studio for the next two winters. An exhibition of his sketches was held at the Arts and Letters Club in December.[120]

Having done practically no guiding, Thomson found 1915 a productive year, as he sketched in the various regions of the park and along the Magnetawan. According to his own account, he had painted 128 sketches by September. While he sometimes had used hard wood-pulp board (learned from MacDonald) in 1914,[121] he more consistently used it for his sketches in 1915, exploiting the tones of applied grounds, ochre, coral and grey-green as an element of the design. However, he was not consistent in his use of supports, painting on different kinds in the same season. *Fraser's Lodge* (pl. 42) was painted on wood, and *The Opening of the Rivers: Sketch for "Spring Ice"* (pl. 43) on a wood-pulp board. The latter was probably painted just north of Hayhurst's Point on Canoe Lake[122] and was clearly conceived with Jackson's 1914 canvas *A Frozen Lake* (fig. 68) in mind. Thomson defined the foreground with a rise to the left, and on the right he sketchily painted a young tree with a few brushstrokes on the medium brown ground. The relationship of foreground, middle and distance is more fluid than in *Northern River* (pl. 40), opening the view of the water and far shore. While he is consciously arranging nature for pictorial effect, the clear spring light and patterned shadows in *Northern Spring* (pl. 44) have the immediacy of a lived experience. That spring he painted a portrait of Shannon Fraser of Mowat

Lodge (pl. 45) in the sugar bush with the pails and taps on the maple trees, which cast their shadows across the bare ground. Pipe in mouth, Fraser sports a maroon jacket, a deep blue shirt and pink tie, echoing the touches of blue sky visible through the trees at the crest of the hill.

Sky effects would be one of Thomson's principal interests this year, painted with increasingly generalized form and heightened colour. The sky in *Wild Cherries, Spring* (pl. 46) is painted with short brushstrokes on an ochre ground, the intense reds and yellows in *Sunset* (pl. 50) with dramatic sweeps and the greens, purples, yellows and blues in *Hot Summer Moonlight* (pl. 51) with a more staccato brushwork. The taupe ground of *Summer Day* (pl. 48) enhances the luminosity in the middle distance between the green of the hills and brilliant blue sky, and a coral paint has been applied as the ground for *Burnt Land at Sunset* (pl. 52). *Evening* (pl. 49) and *Sunset* are painted on a grey-green ground, contributing to the rich depth of the evening light in the sky and in the reflections on the still water. Light is the central subject of all these sketches.

Possibly stimulated by J.E.H. MacDonald's sketches of logging on the Gatineau River from the previous year, Thomson also painted a number of lumbering subjects this year. Dr. MacCallum has dated *Timber Chute* (pl. 61) to the fall of 1915, though the pink blossoms suggest spring, and has inscribed on the back of *Crib and Rapids* (pl. 62), "Entrance to Aura Lee Lake from Little Cauchon Lake." Both *Timber Chute* and *Crib and Rapids* are densely painted in rich, dark colours, while others are painted in astonishingly high-keyed palettes, as he experimented with colour and brushwork. Pinks and oranges contrast with the dark greens and browns

of *Abandoned Logs* (pl. 63) and the dominant browns and olive greens of *Backwater* (pl. 64) are modulated with touches of red, orange and blue. The foreground rock in *Lumber Dam* (pl. 53) is painted in strokes of salmon, yellow, greys, blues and greens on an ochre ground, while *Fire-Swept Hills* (pl. 59) is a lava flow of purples, blues, greens, pinks and browns painted over a coral ground.

In July Thomson received an invitation to send some paintings to the Nova Scotia Provincial Exhibition in September.[123] Among those selected by his friends, as he was in the park, were two unidentified works titled *Autumn Colours* (thus dating from fall 1914) and a sketch titled *Canadian Wildflowers*,[124] painted earlier that summer.[125] In two closely related works, *Wildflowers* (pl. 54) (oxeye daisies, yellow wild snapdragon, blue vipers bygloss and Indian paintbrush) and *Marguerites, Wood Lilies and Vetch* (pl. 55), Thomson painted the flowers in a loose arrangement against dark, freely brushed backgrounds. *Water Flowers* (pl. 56) (pickerel weed and white and yellow water lilies) is more broadly treated in flat colour areas and in *Pink Birches* (pl. 57), the trees are painted in pink with a viscous texture and are crowned by flattened areas of blue and green foliage, the linear tracery of black branches and saplings uniting the flattened elements. Always sensitive to the colours and lights of nature, Thomson is no longer tied to the particularities of the motif but arranges colour and form on the panel. In *Moonlight, Algonquin Park* (pl. 58) the white birches define the foreground, rising from the bottom to the top of the panel and are set against the flattened moonlit hill encircled by the trees and shadows. The sky is painted in bands of mauve and turquoise, harmonizing with the purple trees below.

Thomson worked in two different directions in his sketches this autumn, one more naturalistic, the other more abstract, though both were concerned with decorative design. In *Blue Lake* (pl. 65) and *Maple Woods, Bare Trunks* (pl. 66), as well as in *Algonquin Park* (pl. 68), he arranged the foreground screen of trees and painted them with a textured brushstroke. In *Blue Lake* he accentuated the foreground, in *Maple Woods, Bare Trunks* the space between the trees and clouds behind, in *Forest, October* (pl. 67) the purple shadows and geometry of the trees. He painted the screen of trees in the foreground of *Algonquin Park* with the now-familiar curving sapling, and a deep, rich blue over the orange paint, isolating the "island" of orange upper right. Although these sketches grow out of his spring studies, *Sand Hill* (pl. 69) and *Tamarack* (pl. 70) are painted with a few tones, daringly selected, and the elements are flattened. The dappled water of *Round Lake, Mud Bay* (pl. 71) recalls the sky studies of the summer though the intense yellow of the sky, silhouette of the hills and geometric arrangement of the geese create a more two-dimensional effect. Yet in *The Tent* (pl. 72), also done at Round Lake, the tent is painted in strokes of white and blue and bare wood, a virtuoso treatment with a minimum of elements. The sketches of 1915 show a constant experimentation with an increasing sensitivity to the expressive qualities of colour.

The Winter of 1915–16

From the anecdotes later recounted by Mark Robinson, it would appear that Thomson often had a particular idea of a subject or

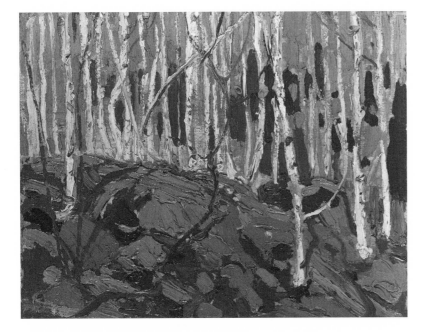

Figure 69 Tom Thomson, *Birches*, fall 1915, oil on wood, 21.5 x 26.9 cm, National Gallery of Canada, Ottawa, bequest of Vincent Massey, 1968 (15554).

impression of nature he wanted to depict and for which he sought verification or comparison in nature, asking Robinson where he could find such and such a plant, tree or colour.[126] By the end of 1915, however, he was experimenting in a new way, and the contact with the source motif was not always a prerequisite. A number of sketches dating from this time may have been painted from memory in his Toronto studio rather than in the region of the park. In *Sketch for "Autumn's Garland"* (pl. 73), *Autumn Foliage* (pl. 74), *Autumn Colour* (pl. 75) and *Nocturne: Forest Spires* (pl. 76),[127] Thomson arranged the elements in increasingly flat areas of intense colour generously painted with a wide brush. Space is shallow, and the

sketches become almost two-dimensional designs, the decorative concerns seen in a number of preceding works pushed further than in any other paintings. It is possible these are the sketches that Jackson referred to as "experimental" or the ones "which Tom kept more for reference in carrying out larger things."[128]

The canvases Thomson painted that winter are as diverse as those from the previous winter, though certain directions became more evident as he continued his explorations in the decorative arrangement of the composition. MacCallum wrote that it was he who suggested to Thomson that he paint up the sketch *Blue Lake* (pl. 65) and Varley selected another sketch for a canvas the same size, but added that "it did not click for Tom."[129] This other canvas is most likely *The Birch Grove, Autumn* (pl. 78), which was exhibited in 1920 as "unfinished." *In the Northland* (pl. 77) (or *Blue Lake*, MacCallum's preferred title)[130] must have been completed in December, as it is dated 1915, one of the very few dated Thomson canvases. The two works are similar in composition and had evolved out of the previous winter's *Northern River* (pl. 40). Each closely follows the arrangement of its initial sketch, but they differ considerably in colour. Shadows are treated like patterned bands on the birches and foreground of *In the Northland*. The rich colouring of this work contrasts with the more limited palette of oranges and browns of *The Birch Grove, Autumn*. The tracery of the trunks, shadows and branches is the dominant subject of the sketch for the latter (fig. 69), whereas the rocky foreground, painted in parallel or intersecting bands, occupies a greater part of the canvas. The linear pattern is more stylized, and the foliage at the crest of the hill denser and more schematic (as

in the "experimental" sketches). There is a tension between the two-dimensionality of the design and the construction of a natural perspective. In *The Birch Grove, Autumn* the flattened background limits the spatial recession, whereas in *In the Northland* the addition of the tree at the left and the diagonal thrust of the dead tree behind the birches in the centre, rather than in front as in the sketch, counteracts the two-dimensionality of the image.

Spring Ice (pl. 80), a third canvas from this winter, is similar in composition to *In the Northland*, but the format is more horizontal (reinforced by the addition of trees left and right) and the space more open. Thomson once again altered the muddy, warm tones of the sketch, painting in a higher key of greens, pinks, yellows, blues and white, often brushed over with pale blue to diminish the contrast. He arranged the foreground into colour areas, painted the far shore in vertical, textured strokes of blue over terra cotta patterned with flat blue shadows and stylized the sky and clouds as in his *Tea Lake Dam* sketch (pl. 60).

The decorative approach to painting evident in these three canvases preoccupied not only Thomson but also Harris, Lismer and MacDonald that winter. In Thomson's paintings colour was heightened, space flattened, forms arranged in flat vertical bands and linear tracery of branches and trunks more stylized. In *Opulent October* (pl. 82) a variety of jewel-like colours shimmer across the canvas (as in *In the Northland*), while in *After the Sleet Storm* (pl. 83) the palette is limited to pinks, whites, purples, blues and browns, brushed vertically and arranged in a horizontal pattern. No preliminary sketch for either work has been identified. In both paintings texture and colour are the unified expressive elements, whereas in *Silver Birches* (pl. 84), painted from the sketch *Moonlight, Algonquin Park* (pl. 58), texture is less evident and the space more two-dimensional. Thomson altered the colours of the sketch, creating a harmonious nocturne in blues, greens and whites in generalized forms.

He probably began painting *Autumn's Garland* (pl. 79) in the winter of 1915–16, but as it was never exhibited during his lifetime, he may have worked on it over an extended period. Harris recounted how Thomson mended the rip in the "canvas by cross stitching it and painted a wood interior on it, using the stitches as part of a tree trunk,"[131] as seen at the left. The animated foreground of *In the Northland* is set against the schematicized background of *Birch Grove*, but unlike those works, colour is toned down from that in the sketch (see pl. 73). He failed to carry through in the larger scale the energetic brushwork and colour of the study and was unable to pursue the two-dimensionality of the picture plane that he explored in the "experimental" sketches. The linear complexity of the vines and foliage in the foreground effectively carries the picture, but he has sacrificed expressive colour for a decorative effect. A softer, more harmonious colour arrangement is also evident in *Decorative Landscape: Birches* (pl. 81), where again he toned down rather than heightened the intense colour seen in the sketch *Pink Birches* (pl. 57). All elements were flattened, the green grass replaced by rocks painted in a manner similar to the foreground of *Spring Ice*, colour made autumnal, a dark tree added in the foreground, the centre space opened, the horizon lowered and the upper part of the composition closed by a canopy of foliage.

Decorative Landscape: Birches relates closely to a project initiated earlier that year. MacDonald, Lismer and Thomson were commissioned to paint decorative panels for Dr. MacCallum's cottage at Go-Home Bay. The intent was in part to assist them financially, as they were all in straitened circumstances. It is not certain when Thomson learned of the project, though we know that MacDonald went up to Georgian Bay to measure the spaces in October 1915.[132] The three artists worked on the decorations during the winter of 1915–16, painting them in oil on Beaverboard. MacDonald's figurative panels, which were to frame the chimney, are said to include a portrait of Thomson as a lumberjack, though the resemblance seems distant (see fig. 39, p. 81).[133] Thomson's four panels (pl. 85) were probably intended to go over the windows,[134] but when Lismer and MacDonald went to install them in April 1916, they found that MacDonald had erred in his measurements and the panels didn't fit.[135] MacDonald painted new decorations for these spaces, and Thomson painted three additional panels on the same themes. Thomson's panels are similar to those by MacDonald, taking as their motifs the local foliage, jack pine, maple and birches. The forms are outlined in dark colour and painted with little modulation. The flattened decorative arrangements, animated by a linear energy, were appropriate to the somewhat restricted space of the room. The patterned trunks and foliage of panel III are similar to *Decorative Landscape: Birches*.

Thomson exhibited four canvases with the OSA in March 1916: *The Birches* (now titled *In the Northland*), *Spring Ice, Moonlight* (a nocturne, similar in composition to *Pine Island*),[136] and *The Hard-*woods (now titled *October*[137] and painted from the sketch *Maple Woods, Bare Trunks* [pl. 66]). The National Gallery's chairman and director, Sir Edmund Walker and Eric Brown, wanted to purchase *The Birches* but acquiesced to the wishes of the Montreal trustee Dr. Francis Shepherd and purchased *Spring Ice*.[138]

At that same exhibition MacDonald showed three paintings that created a furor in the Toronto press and that were caricatured by Hector Charlesworth in *Saturday Night*, as "A Drunkard's Stomach," "Hungarian Goulash," and "A Huge Tomato Salad." Charlesworth reproduced *Moonlight*, the most conservative of Thomson's submissions, in this article, but he made no reference to Thomson's paintings in his text.[139] Thomson's paintings were associated with the offending group, though the opinions expressed were not as vitriolic as those thrown at MacDonald. "Mr. Tom Thomson's 'The Birches' and 'The Hard Woods' show a fondness for intense yellows and orange and strong blue, altogether a fearless use of violent colour which can scarcely be called pleasing, and yet which seems an exaggeration of a truthful feeling that time will temper," wrote Margaret Fairbairn in the *Toronto Daily Star*.[140] For the *Christian Science Monitor*, the artist Wyly Grier wrote more favourably: "Tom Thomson again reveals his capacity to be modern and remain individual. His early pictures — in which the quality of naivete had all the genuineness of the effort of the tyro and was not the counterfeit of it which is so much in evidence in the intensely rejuvenated works of the highly sophisticated — showed the faculty for affectionate and truthful record by a receptive eye and faithful hand; but his work today has reached higher levels of technical accomplishment.

His *Moonlight*, *Spring Ice* and *Birches* are among his best."[141] Similar praise came from Estelle Kerr in *The Courier*. In a brief review of Thomson's solo exhibition at Toronto's Heliconian Club in late March, she described him as "one of the most promising of Canadian painters who follows the impressionist movement and his work reveals himself to be a fine colourist, a clever technician, and a truthful interpreter of the north land in its various aspects."[142]

The Sketches of 1916

Thomson may have already left for Algonquin Park by the time of his exhibition at the Heliconian Club, given the number of snow studies he painted that spring. He painted with no formula. Each sketch stands on its own, indicative of the demands he put on himself and of a rapidly developing and constantly renewed vision. *Spring Woods* (pl. 91) and *Winter Hillside, Algonquin Park* (pl. 92) are painted with fluid strokes, using a thin brush in the wet paint, adding details and picking up traces of the preceding colour to edge his strokes. The tips and branches of fir trees occupy the foreground of *Snow Bank* (pl. 93), framing the view of the snow-covered hillside behind, an unusual composition in Thomson's œuvre. He painted the sky in *March* (pl. 94) with broken brushwork, but not the lower part of the panel, though in other sketches from this spring the technique was applied overall.[143] He is especially adept at depicting the clarity of spring light, as evidenced in *Snow and Rocks* (pl. 95), another vertical sketch, with its curving rhythms of branches and light-filled blue shadows.[144] Characteristic of this spring's work, in *Snow and Rocks* he laid out the general arrangement, drawing with his brush in crimson paint before filling in the forms.

In April or early May Dr. MacCallum, Lawren Harris and his cousin Chester Harris joined Thomson at Cauchon Lake. After MacCallum and Chester Harris left, Lawren Harris and Thomson paddled down to Aura Lee Lake.[145] Traces of snow are still evident in the woods in the superb sketch of a man fishing by a waterfall in *Little Cauchon Lake* (pl. 96), painted with the same crimson underdrawing and curving rhythms as *Snow and Rocks*. The thin, nervous lines of saplings and branches whip across the panel like the cast line of the fisherman. Traces of snow can be seen on the far purple hills in *Sketch for "The Jack Pine"* (pl. 97), in which Thomson drew the branches in crimson, leaving the surrounding wood visible, and painted the sky and foreground with pale greens. While there is no crimson drawing in *Sketch for "The West Wind"* (pl. 98), Thomson uses the bare wood in a similar way. The sky is painted with self-contained strokes, in contrast to the curving, blending rhythms of *Sketch for "The Jack Pine."* The wind blows through the painting, clearing the clouds and choppy water. MacCallum was present when Thomson painted this sketch that spring. "It may interest you to know that the decorative pine in the foreground was blown down on Thomson just before he had finished the original sketch," he wrote to the director of the Albright Gallery in Buffalo in 1921,[146] later adding that Harris thought Thomson had been killed, "but he sprang up and continued painting."[147]

In late May Thomson took a job as a fire ranger, following the Booth Lumber Company's drives down the Petawawa River

at the north end of the park. He was stationed at Achray on Grand Lake, east of Cauchon Lake, with Ed Godin.[148] Thomson painted a sign for Godin's cabin, "Out-Side-In" (see fig. 40, p. 82).[149] In August they took a canoe trip down the south branch of the Petawawa (now the Barron) River and up the north branch of Lake Traverse. "Tom sketched the Capes on the South Branch but we also did a lot of fishing," recalled Godin.[150] From Achray Thomson wrote, "We have had no fires so far. This is a great place for sketching, one branch of the river runs between walls of rock about 300 feet straight up."[151] By October he was at Basin Depot, where the fall colour had just commenced. "Have done very little sketching this summer as the two jobs don't fit in . . .," he wrote. "When we are travelling two go together, one for canoe and the other the pack. And there's no place for a sketch outfit when your [sic] fire ranging. We are not fired yet but I am hoping to get put off right away."[152] He probably returned to Toronto late October or early November.

The sketches of 1916 are characterized by directness of construction and sophisticated colour. Green foliage frames the top of *Spring Foliage on the Muskoka River* (pl. 100) and *The Waterfall* (pl. 99), painted broadly in wide strokes of saturated colour. On the left of *The Waterfall* Thomson included a tree running the full height of the panel. Touches of snow are visible in *Cranberry Marsh and Hill* (pl. 101)[153] with its foreground shadows feeding into the composition. There is a great elegance in *Nocturne: The Birches* (pl. 102), *Tamarack Swamp* (pl. 107) and *The Sumacs* (pl. 115), and delightful contrasts of colour in *Spring, Canoe Lake* (pl. 103). Most of this season's sketches were painted on wood panels, and

Thomson effectively used visible patches of the wood to open the space. The sky studies this year are more fluid; air breathes through the sketches, making the previous year's studies appear dense in comparison, as seen in *Sunset* of 1915 (pl. 50) when contrasted with *Yellow Sunset* of 1916 (pl. 104).[154] The bare wood, edged with crimson, asserts the shoreline in *Rocky Shore* (pl. 105), which is painted with an austerity of drawing and form.

While a few sketches of the lumber industry can be dated from this summer, including *Bateaux* (pl. 106), *The Alligator, Algonquin Park* (pl. 110) and the sketch for *The Drive* (pl. 114), the latter most probably painted at Grand Lake,[155] there were far fewer than the previous year, even though he was working around logging sites all summer. As he said, fire ranging and painting didn't go well together. *Sandbank with Logs* (pl. 108), painted on a wood-pulp board, is unique, characterized by a fluidity of paint, low contrast of tones and an elegance of drawing, especially in the roots on the sandbank and the ends of the logs at its base.

In September Thomson painted a number of sketches of the Petawawa Gorges, each differing in approach (pls. 111–113), and the same variety is seen in the sketches painted later that autumn. *Autumn Foliage* (pl. 117) is painted with a brilliance of colour and fluidity of movement, the sky in dappled strokes. *Near Grand Lake, Algonquin Park* (pl. 118) is more angular, with a cold light, befitting the late autumn snow. *The Sumacs* has a delicate transparency, while *Red Sumac* (pl. 116) reverts to the decorative concerns of the previous autumn but with the lighter touch and more energetic drawing of *Snow in the Woods* (pl. 119) and *Snow-Covered Trees* (pl. 120). MacCallum identified a third sketch of snowbound spruce, *First*

Snow in Autumn (pl. 121), as being used by Thomson for the canvas *Snow in October* (pl. 123) painted the following winter.[156] Thomson painted *First Snow in Autumn* on a small panel of thicker, less dense wood than his normal panels, possibly cut off a crate. In theme and design this sketch does relate to the two previous studies and is the first use of such a panel, a support Thomson used on several occasions the following spring.[157] On the back of the sketch *Moose at Night* (pl. 122) MacCallum wrote, "Winter 1916—at studio," clearly a painting done from memory.

The Winter of 1916–17

This would be Thomson's last winter in his studio, and as he wrote to his brother-in-law Tom Harkness, he "got quite a lot done,"[158] though for unknown reasons he submitted no works to the OSA exhibition in the spring of 1917. It is possible that he was not totally satisfied with the stage they had arrived at. Dr. Mac-Callum identified several as being unfinished, including *Woodland Waterfall* (pl. 126), *The Pointers* (pl. 127) and *The Drive* (pl. 130).[159] Shortly after Thomson's death, Barker Fairley described *The West Wind* (pl. 131) as unfinished.[160] All the canvases were titled after Thomson's death.

Thomson had not abandoned his interest in the decorative arrangement of the canvas. The organization of the snowbound branches in *Snow in October* was derived from the two sketches *Snow-Covered Trees* and *First Snow in Autumn*. Thomson set the trees farther back to open the foreground, moved the young sapling to left of centre and painted the background in flat, vertical areas

of orange, green and white, recalling *Autumn's Garland* (pl. 79). *Snow in October* appealed to MacCallum for its shadows. "I have nowhere else seen shadows so full of air,"[161] he wrote. Certain aspects of this winter's production recall the canvases of the previous year, yet the decorative canvases painted this winter are lighter and the space more open. The background of *Maple Saplings, October* (pl. 125) is broadly painted and flattened, and the linear tracery of the saplings gives the work an exciting nervous energy. Thomson uses the same curving tree in both *Snow in October* and in the foreground of *Early Snow* (pl. 124), but the space is not flattened in the latter. The birch tree is set against a hillside, possibly the same as in *Snow Bank* (pl. 93), and the whiplash branches and vines are richly painted.

Although MacCallum reproduced *Woodland Waterfall* in his tribute to Tom Thomson published in *The Canadian Magazine* in March 1918, he later claimed that it was unfinished and "didn't come off at the top."[162] Looking at this fully realized, richly coloured painting today, we have no reason to believe that it is unfinished. As in *Autumn's Garland*, vertical trees and red leaves frame the foreground, but the contrast of lighter-coloured vertical patterning in the foliage and darker horizontal bands of colour in the background of *Woodland Waterfall* creates a richer and more complex image. The water, simplified from the sketch (pl. 99) to one stream, is painted in parallel strokes of blue and white. Thomson has effectively co-ordinated the movement of the water and the flatter patterning of its frame.

During the winter of 1916–17 he reverted to earlier compositions but offered completely new interpretations. The open

foreground of water before a hill in *The Pointers* and *Chill November* (pl. 128) recalls his 1914 canvas *Morning Cloud* (pl. 20), and *The West Wind* and *The Jack Pine* (pl. 132), both of trees against a body of water and hills, grow out of *Pine Island, Georgian Bay* (pl. 38). Of *The Pointers* Dr. MacCallum wrote, "You no doubt realize it is an unfinished picture. Tom painted it with those huge brushstrokes just to show the critics (newspapers) that *any* technique could be used—but he never regarded it as a finished picture. He put it away intending to do more at it later—but the time never came."[163] It is uncertain what criticism Thomson might have been reacting to, save possibly that directed at MacDonald, and the bold impressionist-derived broken colour is even more sophisticated in handling than in the 1914 canvas *Byng Inlet, Georgian Bay* (fig. 59, p. 110). It is a fully integrated painting vibrating with colour. One of two logging subjects painted by Thomson that winter, both of which include figures, it is a remarkable panorama of the northern landscape or as MacCallum also called it, *The Pageant of the North*.[164] *Chill November*, or *First Snow Ducks*,[165] is also painted with broken brushwork, but in restrained cold, late autumn greys over a grey-pink ground in the sky and a purple ground in the water. The flight of the geese is not the geometric arrangement of the Round Lake sketch but a natural, flowing, constantly changing arrangement. In scale and in their feeling for the vastness of the Northern Ontario landscape, these canvases are the forerunners of the major Algoma canvases painted by Thomson's associates after the war.

The inclusion of figures in *The Pointers* is unprecedented in Thomson's canvases, and it may also have been in the same winter of 1916–17 that he painted *The Fisherman* (pl. 129), with its flat blue sky and rocks of parallel strokes of pinks, yellows and blues. Figures are also included in the sketch and the canvas of *The Drive* (pls. 114 and 130). While the sketch is thinly painted, with much bare wood showing through, the canvas is dense. The logs in the foreground are broadly painted and the water treated as wide parallel bands, and there is a certain unresolved tension between the handling of these elements and the trees to the right and left of the dam. MacCallum wrote that *The Drive* was an unfinished picture—"Tom had just laid it in and not really started to paint it when he went north in the spring."[166] There is no reason, however, to believe that it was modified subsequent to Thomson's death, as has been stated.[167]

A similar irresolution is seen in *The West Wind*, which J.E.H. MacDonald described as "faulty and inconsistent."[168] The trunk of the tree is unmodulated and outlined in a darker colour, and the foreground rocks are blocked in a schematic way, while the sky and water are treated with a feathery touch. The disparity in treatment creates a disturbing tension, but in its directness and boldness of conception it surges with energy. From the sketch (pl. 98), Thomson moved the tree to the right, extended the far hills to the left and strengthened the colouring. MacCallum explained that "inartistic reality makes me tell you that on that occasion the wind was north."[169]

More resolved, and very different in mood, is *The Jack Pine*. From the sketch (pl. 97), Thomson enhanced the drawing of the tree, lowered the far hills so that the tree appears more massive, stylized the foliage and completely altered the light and colouring.

The decorative character is emphasized by its almost square format. Land, water and sky are painted in parallel bands, similar to his treatment of the rocks in his spring sketch *Spring Foliage on the Muskoka River* (pl. 100). This more formal construction Thomson derived from Lawren Harris's recent paintings ("Harris's patent sky," said MacCallum)[170] (see fig. 38, p. 78). In contrast to the breezy energy of *The West Wind*, it is a contemplative picture enriched by the delicate crimson tracery of the drooping branches and foliage and the glowing evening light.

The 1917 Sketching Season

Thomson was back at Canoe Lake at the beginning of April to paint the late snow in the bush and the breaking-up of the ice on the lakes. Financially things were straitened, but he wrote home that he could still manage for a year. His plans were unsettled, though he had decided against fire ranging, as it interfered with sketching, and he again thought of going out West.[171] By April 21, rain had cleared off most of the snow save in the bush on the north sides of the hills and in the swamps, and the ice had not yet broken. On the 28th he took out a guide's licence.[172] He helped Larry Dickson and the Frasers put in their gardens[173] and did some guiding for fishing parties, but unlike in previous years, Thomson stayed at Mowat.[174]

There are five sketches of the northern lights by Thomson painted in differing winter landscapes (pl. 133).[175] The ranger Mark Robinson, who had been on active military service since October 1915, returned to the park in April 1917[176] and later

recounted how Thomson stood contemplating the aurora borealis for a considerable time before painting a sketch in a cabin by lamplight.[177] Thomson had painted numerous moonlit landscapes and nocturnes since 1913, and given the difficulty of painting by moonlight, it is most likely that they also were painted away from the motif or from memory. As the season unfolded, Thomson painted the snow in the woods (pl. 134), the swollen rapids (pl. 136) and spring floods (pl. 138). Among the people at Mowat Lodge that spring were Lieutenant Crombie, who was recuperating from an illness, and his wife, Daphne, and Thomson painted a sketch of Mrs. Crombie and Annie Fraser in front of Larry Dickson's cabin (pl. 137). When Thomson displayed his spring sketches in Mowat Lodge, he told Mrs. Crombie to select one as a gift,[178] and she chose *Path Behind Mowat Lodge* (pl. 135). Dr. MacCallum and his son Arthur visited Thomson at Mowat in May,[179] and MacCallum later wrote on the back of *Tea Lake Dam* (pl. 139), "Thundercloud in spring at chute where Muskoka River flows out of Lake looked at from the left side the rush of water and the feeling of daylight is very marked as well as the feeling of spring — in trees or bushes in the foreground on the right side of creek I found a poacher's bag with beaver skins &c — sketched just before his drowning."

There is a crispness and freshness in the sketches of 1917, and the light is clear and sharp. This year Thomson painted a number of small sketches (pl. 134),[180] several of which are curiously tight in handling and painted on boards cut from crates, though why he chose to paint on these panels is not clear. It certainly was not for lack of wood panels, as his brother George

Figure 70 Photograph taken by J.E.H. MacDonald, September 1917, of the cairn constructed to the memory of Tom Thomson at Canoe Lake, Algonquin Park, Arthur Lismer Papers, Edward P. Taylor Research Library and Archives, Art Gallery of Ontario, Toronto (file 19).

sent a crate of unused "sketching boards" from Mowat to Toronto after Thomson's death.[181] In contrast to the precision of the smaller works he painted in early spring, the late spring and early summer skies (pls. 138–140) were painted with increasing energy, boldly generalizing the forms of the landscape, the tips of the spring trees with just a few strokes of the brush.

On Sunday July 8, 1917, Thomson left Mowat. His body was found floating in Canoe Lake eight days later.[182] His watch had stopped at 12:14.[183] Thomson would have celebrated his fortieth birthday on August 5. His body was first buried at Mowat,[184] then removed and reburied at Leith on July 21.[185] In September MacCallum financed the construction of a cairn on Canoe Lake decorated with a bronze plaque designed and inscribed by J.E.H. MacDonald (fig. 70).[186] MacDonald wrote to Thomson's father, "I have just returned from Canoe Lake where I spent the weekend helping Mr. [J.W.] Beatty to put on the plate and give the cairn a few finishing touches. The cairn is a fine piece of work, and with the brass plate in position it looks quite imposing. It stands on a prominent point in Canoe Lake right at the head of the lake facing north and can be seen from all directions. It is situated near an old favorite camping spot of Tom's. . . . The result goes a long way to beautifying the tragedy of Tom's death."[187]

As a painter, Thomson learned much from his close associates, and they in turn learned much from him. Lismer had moved to Halifax to teach in the fall of 1916, and on learning of Thomson's death he wrote,

We've lost a big man—both as an artist and a fine character. . . . When one recalls the few years that he had been painting, it is

remarkable what he achieved. He has put a new note into all his associates, just as he made his art sing with a lively Canadian note. He was the simplest soul and most direct worker I ever knew. Whilst we others speculated as to how it should be done, Tom did it with that amazing freshness that was always an inspiration to look at. He had no preconceived notions like the rest of us. He never tackled a canvas like anybody else. Everything he produced grew out of his experience, and he painted himself into it all.[188]

And from England where he was with the Canadian army, Jackson wrote, "without Tom the north country seems a desolation of bush and rock. He was the guide, the interpreter and we the guests partaking of his hospitality so generously given. . . . [M]y debt to him is almost that of a new world, the north country and a truer artist's vision."[189]

The last word must go to his friend and patron Dr. MacCallum. "Thomson painted not merely to paint, but because his nature compelled him to paint — because he had a message. The north country gradually enthralled him, body and soul. He began to paint that he might express the emotions the country inspired in him; all the moods and passions, all the sombreness and all the glory of colour, were so felt that they demanded from him pictorial expression. . . . Words were not his instruments of expression — colour was the only medium open to him. Of all Canadian artists he was, I believe, the greatest colourist."[190]

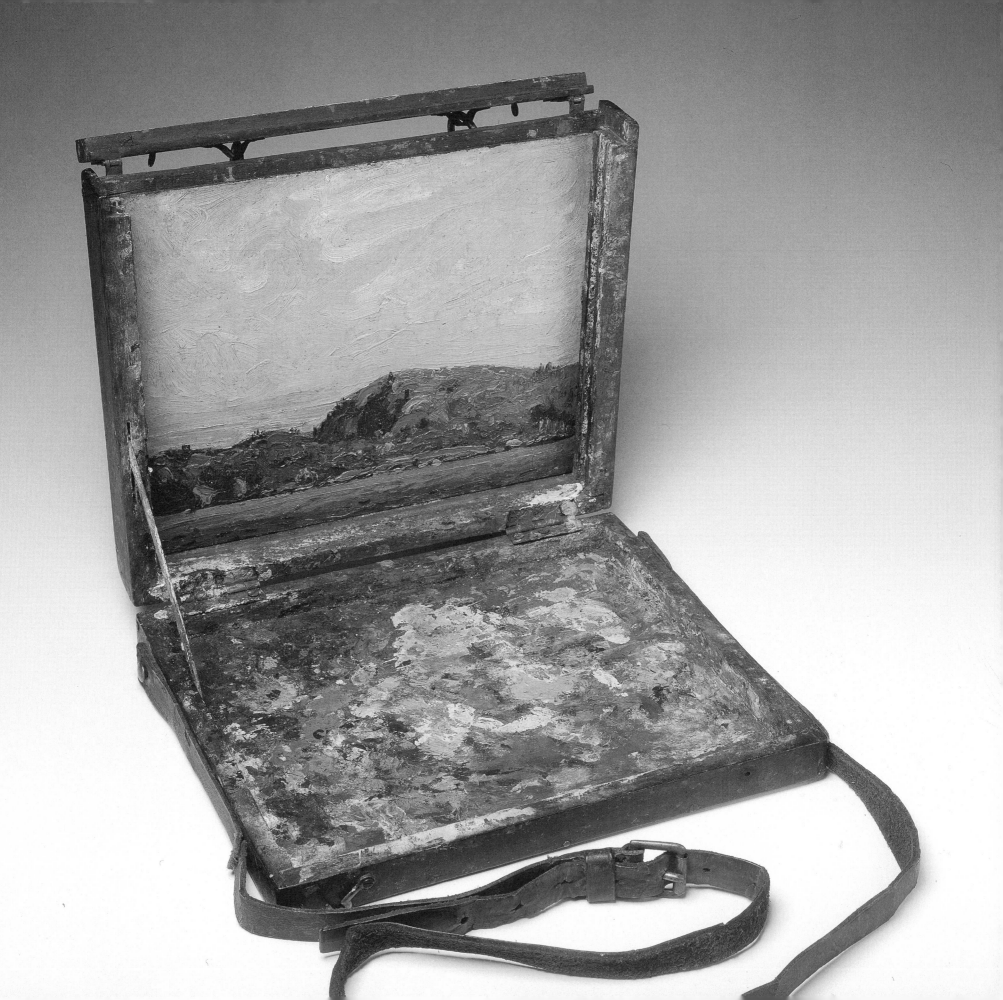

TECHNICAL STUDIES
on Thomson's Materials and Working Method

Sandra Webster-Cook and Anne Ruggles

The Supports and Preparation Layers

In the course of the organization of the Tom Thomson exhibition, more than 150 of his works were examined in the conservation studios of the Art Gallery of Ontario and the National Gallery of Canada. This process led to a deeper understanding of his materials and working method, building on an analytical study, "The Materials and Techniques of Tom Thomson," by the Canadian Conservation Institute in Ottawa.[1] The information thus accumulated helps to position paintings in the chronology of the artist's working life. In the examination of his supports,

Figure 71 Thomson's sketch box, Study Collection, National Gallery of Canada, Ottawa, purchase 1947 (ST 34).

145

it was especially interesting to observe the development of his use of a foundation colour, which contributes in varying degrees to the design surface.

The Sketches

When Thomson and fellow artists who would later form the Group of Seven travelled into the Canadian wilderness to paint, they required convenient lightweight materials for on-site sketching. Many such supports had been developed by colourmen's firms (suppliers of artists' materials) in the nineteenth century, when sketching *en plein air* became so popular. Thomson used some of these commercial supports as well as a variety of inexpensive alternative materials, as will be noted below, which were probably more readily available to him. Although many sketches are appreciated and respected as finished in themselves, they were originally intended as preliminary to final work: captured moments from nature to be developed into finished paintings in the artist's studio. Some of Thomson's sketches made this transition to a larger canvas format during the confinement of the winter months.

Thomson's small supports were quite varied, especially in his early years of painting (1909–13). *Near Owen Sound*, from 1911 (pl. 2), is painted with oil on a wafer thin (1 mm) light-coloured wood panel, thought to be pine[2] and sealed with shellac. *Drowned Land*, 1912 (pl. 5) is oil on paper with an embossed canvas texture, mounted on plywood. This support is very similar to the one for *View Over a Lake: Shore with Houses* (pl. 9), from 1912 or 1913. *Old Lumber Dam, Algonquin Park* (pl. 3), spring 1912, is oil on paperboard

(a Winsor & Newton watercolour sketching board). Other supports he used in 1912 include Birchmore board, canvas laid down on paperboard, canvas laid down on wood and commercial canvasboard. Thomson may have constructed some of his own supports during 1912 and 1913. Many of the sketches he painted in those years conform to the small size of his first sketch box, acquired in 1912.[3] It held sketches approximately 7 x 10 in. (17.8 x 25.4 cm).

In January 1914 Thomson and A.Y. Jackson began to work together at the Studio Building in Toronto. Thomson found the larger wood panel favoured by Jackson (the French size of $8\frac{1}{2}$ x $10\frac{1}{2}$ in. [21.6 x 26.7 cm]) very attractive and that winter duplicated his friend's sketch box.[4] "A supply of birch panels were ordered from the Kitchener woodworking plant"[5] for both artists, in preparation for their spring trips to Algonquin Park. That year, Thomson continued to employ canvas mounted on paperboard and on wood, but also in the larger size. Some sketches were executed on poor-quality plywood panels that developed disfiguring crack lines. Thomson also used a very thin veneer wood panel (1 mm thick), similar to ones from the early years. A number of the surviving panels were mounted on a thick five-ply plywood by George Harbour during restoration treatment at the National Gallery of Canada in 1940–41,[6] for example, *Cottage on a Rocky Shore* (pl. 28).

In the fall of 1914, Thomson began to use a grey composite wood-pulp board[7] cut with a board cutter to the French dimensions. This is an unusual support for oil painting and may have been manufactured as a bookbinder's board.[8] It was attractive to Thomson and his fellow artists for outdoor sketching possibly

because of its non-reflective dark colour, easily modified to suit their purposes.

Thomson used some wood panels in 1915, but his sketches were predominantly on the grey composite wood-pulp boards. (According to one account,[9] he turned to these supports when he ran out of wood panels.) His use of plywood and paperboard supports this year was minimal. Decorative panels (pl. 85) created for the cottage of Dr. James MacCallum in 1915–16 were on a manufactured wooden board called Beaverboard.

In 1916, Thomson painted primarily on wood panels, at least some of which were probably ordered from the veneer mill in South River at the entrance to Algonquin Park,[10] but he continued to use the composite wood-pulp boards and occasionally the commercially prepared Birchmore board. *First Snow in Autumn* (pl. 121) is painted on a small board cut from a crate, a support that appeared more frequently in his work the following year. These small softwood panels, possibly cedar, have a very open grain and measure about 5 x 7 in. (12.7 x 17.7 cm), approximately 0.5 cm thick. Fragments of brand names (Gold Medal Purity Flour and possibly California oranges)[11] are stamped on the back of some.

In the last year, 1917, Thomson painted on the small crate boards in the early spring but later primarily on wood panels, occasionally on plywood, as in *Northern Lights* (pl. 133).

Works on Canvas

Thomson's larger paintings, inspired by selected sketches from his trips to the North, are painted on a variety of canvases: linen seems to have been in use over the span of his career (*Moonlight*, pl. 19, for instance); cotton canvas has been identified from 1915–16 (*Autumn's Garland*, pl. 79); and jute (*The West Wind*, pl. 131) and a mixed fibre canvas thought to be linen and jute (*Early Snow*, pl. 124) date from the later years, 1916–17. The open-textured jute canvas is undoubtedly from a roll purchased by Lawren Harris in New Jersey[12] and shared by several artists, including Thomson, who painted in the Studio Building in Toronto during these years.

Preparation of the Supports for Painting

When an artist begins to paint in oils, the canvas or solid support is traditionally sized and prepared with a ground layer usually composed of pigments of neutral colour and animal glue (traditional gesso) or pigments and a drying oil. The ground may be used to reduce or enhance canvas texture and prevents components of the overlying paint layers from being absorbed into the support, ensuring a good bond between the canvas and paint. Some artists add an additional toning layer or "priming" to modify overlying colour, often creating a sense of depth in the tone, a practice introduced in the sixteenth-century.[13] Thomson used this technique to a limited extent in 1911 in the application of a dilute red-brown undercolour in the foreground of *Near Owen Sound*. In the oil on canvas *Sketch for "Morning Cloud"* (pl. 12), painted in 1913, he was experimenting with a coloured priming over a commercially applied light ground. The thinly applied red-brown imparts depth

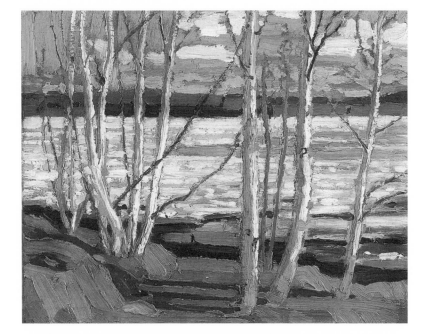

Figure 72 Tom Thomson, *Early Spring*, 1917, oil on wood, 21.6 x 26.9 cm, The Thomson Collection (PC-598).

and luminosity to the limited range of surface colour in the sky and low-lying clouds on the horizon. He similarly modified the off-white commercial ground of the canvas-on-paperboard support of *Canoe Lake* (pl. 14), from the summer of the same year, with a dilute brown priming.

In the fall of 1913, Thomson painted *Evening* (pl. 16), an oil on canvas mounted on paperboard, and began to move away from the more traditional use of undercolour. He applied a light grey priming over a commercial light ground and exposed some of this colour in the sky between thin strokes of violet-blue.

The following year, he explored this idea further. His solid supports (wood panels, paperboards and composite wood-pulp

boards) were generally not prepared with a traditional ground layer, but his coloured priming or toning layer is of particular interest. In some sketches, he exposed some of the natural or stained wood surface, or a coloured priming layer on the paperboard supports, as an independent element, a component of the image. In the sketch *Shack in the North Country* (pl. 34), Thomson has applied a dilute redwood stain to a selected foreground area of the wood panel. On the composite wood-pulp boards can be found opaque oil primings in grey,[14] warm grey-brown[15] and a stronger earth colour, a yellow ochre.[16]

In 1915 Thomson enjoyed greater freedom with foundation colour. He explored a broader range of hue, including stronger colour values and heightened contrast in his choice of priming colour. The oil-on-linen canvas *Burnt Land* (pl. 41), painted in the spring of 1915, has a coral pink priming colour over a white ground. Thomson played with dramatic contrast in the coloured priming of *After the Sleet Storm* (pl. 83), an oil on canvas of mixed fibre content. Its greyed orange priming is in marked contrast to the pastel colours of the ice-covered forms. Pale pink and soft orange undercolour have also been observed on wood panels from this year. The sketch on wood panel *Moonlight, Algonquin Park* (pl. 58) is prepared with a deep orange-sienna oil. Sketches on composite wood-pulp board dated 1915 have warm earth undercolours, like the soft yellow ochre of *Timber Chute* (pl. 61), and more vibrant tones, like the deep coral of *Burnt Land at Sunset* (pl. 52). Thomson sometimes primed the support with an overall tone and applied a second colour over a defined area. *Lakeside, Spring, Algonquin Park* (pl. 47) has been painted on a composite wood-pulp

board with an overall greyed pink (flesh tone) priming, and a deep red toning layer under the area of the water, which further contributes to the surface colour. *In the Sugar Bush* (pl. 45) is anomalous, in that Thomson used the unmodified dark grey support.

Thomson in 1916 continued to use a range of hues as priming colour, but with more muted tones. A selective streaked application of a redwood stain is found on the wood support of *Bateaux* (pl. 106). A soft orange earth stain has been applied to the support of *Autumn, Petawawa* (pl. 112). Composite wood-pulp boards from that year were prepared with oil colours that include a medium grey in *Autumn, Three Trout* (pl. 109), a deep red-brown in *First Snow in Autumn* (pl. 121) and a greyed ochre in *Sandbank with Logs* (pl. 108).

In his last spring, 1917, Thomson largely abandoned priming colour in his small sketches. One notable exception, *Early Spring* (fig. 72), is closely related to the earlier *After the Sleet Storm* (pl. 83) in the bold use of a deep orange-red dilute priming on the wood panel. Many sketches from 1917 are on bare wood panel, the surface continuing to function as a design element, as in *Path Behind Mowat Lodge* (pl. 135) and *The Rapids* (pl. 136). Thomson was not known to varnish his sketches, so the later overall application of varnish to many works has altered somewhat the original colour of both paint and visible support, owing to the effect of saturation. A dark brown priming layer was identified over a white ground in the painting on jute canvas *The West Wind* (pl. 131) and in one on linen, *The Jack Pine* (pl. 132).[17] This colour is visible but does not contribute significantly to the design surface.

The foundation colour of Thomson's paintings often recalls the transient and variable seasonal hue of light on the landscape.

It may also, for him, have served to establish a mood, from which the painting emerged. This was his unique way of translating his vision into two-dimensional space.

S.W.-C.

The Sketches: The Paint and Its Application

Trained as a graphic artist, Tom Thomson bought his first oil sketch box in 1912, as he continued to explore the medium of oil painting in the open air. Even as early as November 1911 he had sketched outdoors, catching, according to traditional nineteenth-century technique, the fleeting effects of colour and light in his small work *Near Owen Sound* (pl. 2). Using broad strokes of dilute red-brown paint, he blocked out the foreground and further described the area with strokes of a more opaque earth colour. The sky was painted wet-in-wet with a 10 mm wide brush, and its subtle colours most likely include vermilion and viridian-pigmented white paint. Thin 1 mm wide brushstrokes charged with brown or opaque white paint created fence and trees. Touches of white highlights appear in the mid-ground. In general, the paint is applied with fluid brushstrokes, little impasto is developed, the colour harmonies are subtle, the colour range is limited, the contribution from the warm tone of the support is significant but the brushwork is not imposing.

In succeeding years, Thomson made a number of trips to the North to paint outdoors with other artists like A.Y. Jackson. By

1915 his mature painting technique had evolved, as illustrated in his sketch *Northern Spring* (pl. 44). The opaque paint is so stiff that traces of individual brush hairs remain visible, and each brushstroke maintains its integrity. The texture of the paint stands up on the wood support. Green, purple, ochre, yellow, orange, ultramarine blue, pink, white and grey, as well as the golden-wood-coloured support and the red-brown of the underpainting are present in the image. No specific analysis of pigments from this sketch has been undertaken, but the appearance of the paint is consistent with the presence of alizarin lake, vermilion, cadmium yellows, cobalt yellow, viridian and ultramarine blue that have been reported most frequently in Thomson oil sketches.[18] The paint is principally applied with fairly short, energetic, abrupt strokes, except for gentle arcs of fluid purple and grey, added as final touches. Other than in the purple and grey passages, the paint appears to contain a substantial amount of opaque white pigmentation. This is consistent with reports of substantial amounts of a specific mixture of lead sulfate and zinc white (possibly Freeman's White, ground under great pressure) in a number of other sketches by 1915.[19] The direction of the paint strokes is expressive, with a vertical predominance in the sky and a diagonal in the foreground. The paint is applied wet-in-wet and the sketch appears to have been painted in a single session with mostly 4 mm wide brushstrokes.

In 1914 Thomson made a lightweight sketch box similar to that used by A.Y. Jackson. The lid could accommodate three panels, and the lower part was the palette.[20] A sketch box that Thomson used is in the study collection of the National Gallery of Canada (fig. 71). The box was given by Dr. J.M. MacCallum to the artist Curtis Williamson after Thomson's death, and Williamson gave it in turn to his nephew, the painter John Beynon. Beynon wrote, "It has not been cleaned or touched in any way. It is exactly the same as at the time of his passing."[21] Interestingly, the wood support for *Northern Spring* has bevelled edges on the verso, and it will slide into the box's lid. Thomson's sketches of this size often have fingermarks at the top centre, where the small freshly painted panels would have been grasped to slot them into the sketch box — see, for example, *Blue Lake: Sketch for "In the Northland"* (pl. 65). Also, the paint along the front vertical sides is frequently rubbed from being moved in and out of the sketch box slots while the paint was still fresh.

A peculiarity of a number of Thomson's sketches is a flattening of the tops of paint impasto, visible in numerous areas of *Northern Spring*. The flattened patches of the most raised portions of the paint are often soiled and occasionally include debris such as wood. Thomson seems to have been aware of the dangers of stacking his sketches, as he wrote in a letter of 1915, "Will send some sketches down in a day or so, and would ask if you would unpack them and spread them in the shack, as I am afraid they will stick together a great deal."[22] Although his cleverly designed and competently fabricated 1914 sketch box seems to have separated the pictures, it was not entirely protective. Flattened paint and the commonly found accumulation of sooty particulate matter over the surface are physical reminders of the problems of working in the wilderness and the difficulties encountered in transporting groups of sketches to the studio.

Little is known about the paints Thomson used, but we do know that Jackson employed both Winsor & Newton (Cambridge) and Lefranc paints in 1915 for *Maple and Birches* (see fig. 35, p. 76).[23] It seems likely that Thomson, who learned from the technique of the other Studio Building residents and A.Y. Jackson in particular, would have used the same prepared tube paints. The quality of Thomson's oils, viewed from both an æsthetic and scientific[24] perspective, also suggests that the paints were not artist prepared.

The pigments analyzed from Thomson's paintings[25] include alizarin lake, vermilion, cadmium yellow, cobalt yellow, viridian and ultramarine blue. Although I have not located Lefranc paint catalogues, Winsor & Newton's from 1914 offered artists a full range of tube paints described as cadmium yellows and oranges and cobalt yellow, as well as the more traditional vermilion-, alizarin- and ultramarine-containing paints. In Toronto in 1914, Winsor & Newton paints and supplies were both available.[26] Notably absent from the 1914 Winsor & Newton catalogue, though, are references to a mixture of lead sulfate and zinc white (possibly Freeman's White) that has been characteristically identified in Thomson's paint. Further, Winsor & Newton is now unable to substantiate any suggestion that a lead sulfate and zinc white combination was added to their 1914 paints.[27] Clearly, Thomson acquired this component of his palette elsewhere.

The crisp texture of Thomson's brushwork distinguishes itself from Jackson's and indeed from the work of the other residents of the Studio Building. Exactly how Thomson was able to achieve the dramatic texture of *Northern Spring*, typical of the majority of his painted sketches after 1914, remains a mystery. It does seem likely that he began with commercially prepared paints. Winsor & Newton in 1914 offered a "stiff" form of their paint at a 50 per cent price increase.[28] Probably the firm manufactured this stiff paint by adding less oil.[29] Another way to achieve crisp paint texture would have been to drain oil from the prepared tube paint by spreading it out on an absorbent material. By setting out his paints on his sketch box lid prior to painting sessions, Thomson may in fact have unknowingly been doing this. Or he could have quite consciously increased the stiffness of his paint by adding something like egg to the tube paint on his palette[30] or have avoided the use of such paint thinners as turpentine and applied the paint straight from the tube with vigorous strokes of a stiff brush. Yet another suggestion[31] is that the artist himself added the white commercially prepared mixture of lead sulfate[32] and zinc white to achieve the desired "feel" on the brush to enhance the paint's stiffness.

Further research into Thomson's paint may one day reveal what he did to create its special texture. It, along with his celebrated use of colour, is left to us as a distinctive feature of his artistic expression.

A.R.

Glossary of Terms

Beaverboard A type of wood fibre board, a solid support of wood chips held rigid with adhesive. It was manufactured as a wallboard.

Birchmore board A paperboard with facing paper prepared with a thin ground layer and canvas texture embossed on the surface, manufactured by George Rowney and Company Ltd., London.

Canvasboard A paperboard support with a prepared canvas adhered to one side, introduced between 1875 and 1880. The canvas is wrapped over the edge and adhered to the verso.

Composite wood-pulp board A board manufactured primarily from mechanical wood-pulp fibres but with unidentifed other fibres, adhesive(s) and black pigmentation. It is thought to be milled or rolled under pressure by iron or steel rolls to smooth the surface. This board may have been manufactured for the bookbinding industry.

Illustration board A pulpboard with a facing paper; not prepared for oil painting.

Paperboard A flat sheet of stiff and thick paper, varying in thickness and in composition from pure rag (cotton, flax, hemp fibres) to wood, straw and other substances. It may be made from one thickness, the pulp forming a single thick layer. Sheets may be adhered together (laminated), or combined while wet on the Foudrinier or cylinder mould machine, to form layers of the same pulp throughout the thickness of the sheet, producing a stratified structure. The term *pasteboard* is sometimes used and refers to a specific type of paperboard commercially manufactured in Europe since 1580. Two or more individual sheets of paper are glued together with an adhesive. Early pasteboards would have been pasted together by hand, later with a gumming roll and, later still, combined while wet without an adhesive.

Plywood A wooden board laminated in plies or veneers, glued together under pressure with the grain of each layer running perpendicular to that of adjacent layers to minimize warpage. It has been available since the eighteenth century. Standard plywood has three plies (layers). Double plywood is a five-ply board. In the eighteenth century, decorative woods were applied over cheaper wood; later several veneers were glued together, primarily for the building industry.

Pulpboard A type of paperboard with a single mass of cellulosic fibres in random orientation, sometimes held rigid with adhesive. This term is sometimes reserved for thicker paperboards.

Winsor & Newton watercolour sketching board A paperboard with a Whatman facing paper applied to the recto and verso surfaces. Available in smooth or rough textured surfaces. Manufactured by Winsor & Newton, London.

Wood panel Hardwood and softwood species are used as wood supports for paintings.

Wood-pulp board A board made from mechanical wood pulp, formed in one layer on the paper-making mould.

Wove paper Handmade or machine-made paper formed from a felted or web-like mass of interlaced plant fibres in sheet form, cast on a finely woven wire screen, and thus without the coarser wire marks characteristic of laid paper.

Bibliographic Note The glossary of terms was developed by Sandra Webster-Cook from the following references, in consultation with some of the authors and AGO paper conservators, Margaret Haupt and John O'Neill.

Carlyle, Leslie. *The Artist's Assistant, Oil Painting Instruction Manuals and Handbooks in Britain 1800–1900 With References to Selected Eighteenth-century Sources.* London: Archetype Publications Ltd., 2001.

Jaques, Shulla. "A Brief Survey of Paperboard and Some of the Literature Describing It with Some Definitions of Marketing Terms for Mount Boards Used in Conservation." *The Paper Conservator* 23 (1999).

Katlan, Alexander. *American Artists' Materials Vol. II: A Guide to Stretchers, Panels, Millboards, and Stencil Marks.* Connecticut: Sound View Press, 1992.

——. "The American Artist's Tools and Materials for On-Site Oil Sketching." *JAIC* 38 (1999): 21–32.

Krill, John. *English Artists Paper.* London: Trefoil Publications Ltd., 1987.

1 **Design for a Stained-Glass Window** c. 1905–07
graphite, pen and ink and watercolour on wove paper, 34.2 x 17.1 cm
Art Gallery of Ontario, Toronto, gift of Mr. and Mrs. Allan Manford, Toronto, 1981 (81/132)

2 **Near Owen Sound** November 1911
oil on wood, 14.9 x 21.4 cm
National Gallery of Canada, Ottawa, bequest of Dr. J.M. MacCallum, Toronto, 1944 (4702)

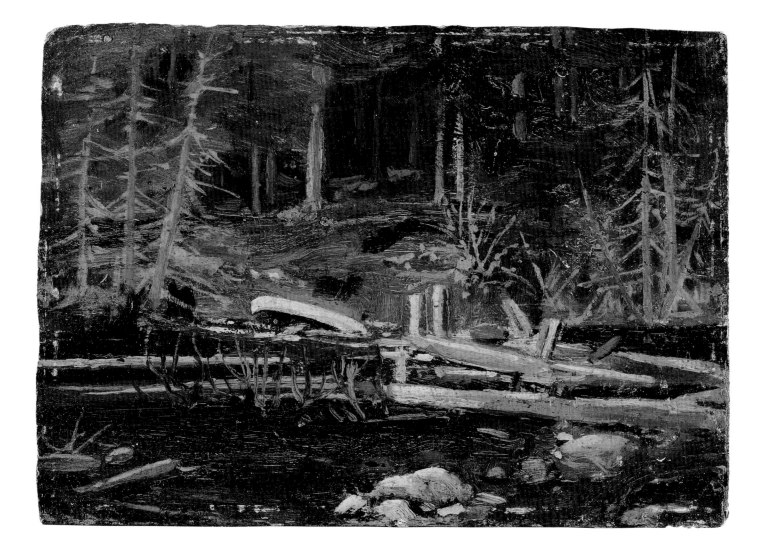

3 **Old Lumber Dam, Algonquin Park** spring 1912
oil on paperboard (Winsor & Newton watercolour sketching board), 15.5 x 21.3 cm
National Gallery of Canada, Ottawa, bequest of Dr. J.M. MacCallum, Toronto, 1944 (4671)

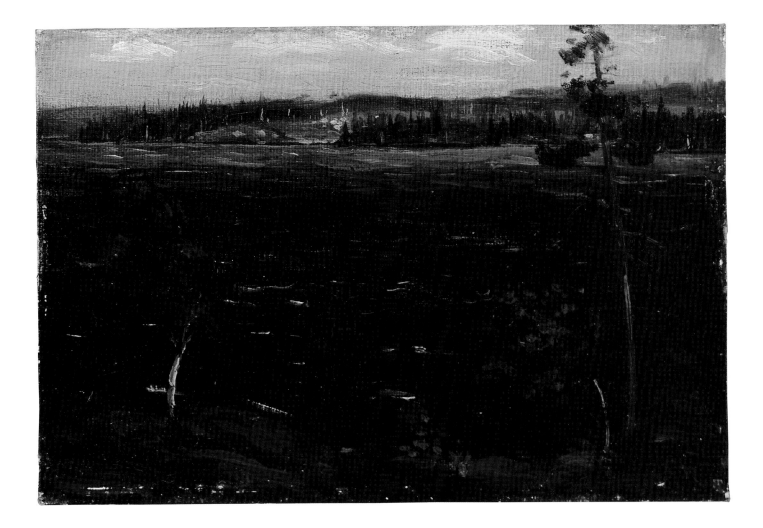

4 **Smoke Lake, Algonquin Park** spring 1912
oil on paperboard (Birchmore board), 16.8 x 24.7 cm
Tom Thomson Memorial Art Gallery, Owen Sound, Ontario, gift of John M. Hodgson
and Joan W. Hodgson, Toronto, in memory of Mary L. Northway, 1987 (987.024)

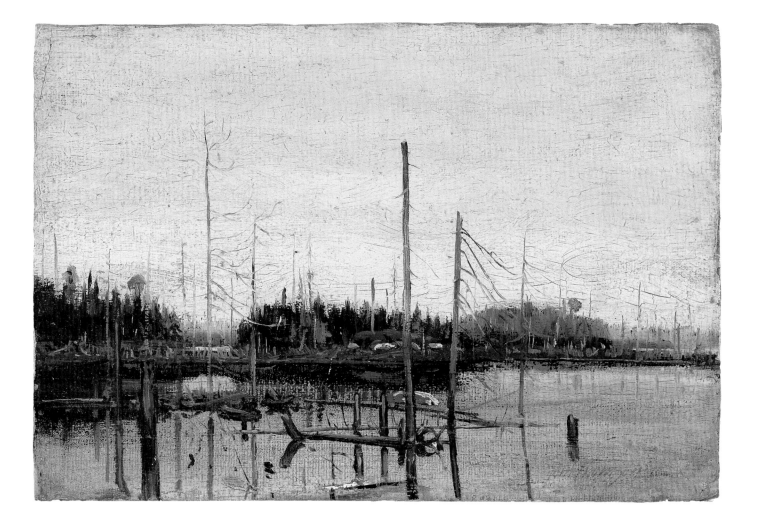

5 **Drowned Land** fall 1912
oil on paper (with embossed canvas texture) on plywood, 17.5 x 25.1 cm
Art Gallery of Ontario, Toronto, purchase 1937 (2449)

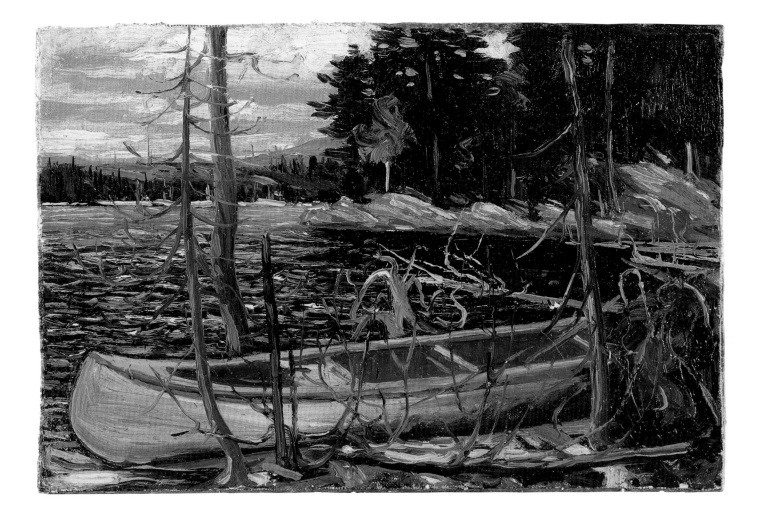

6 **The Canoe** spring or fall 1912
oil on canvas, 17.3 x 25.3 cm
Art Gallery of Ontario, Toronto, gift from the J.S. McLean Collection, Toronto, 1969,
donated by the Ontario Heritage Foundation, 1988 (L69.48)

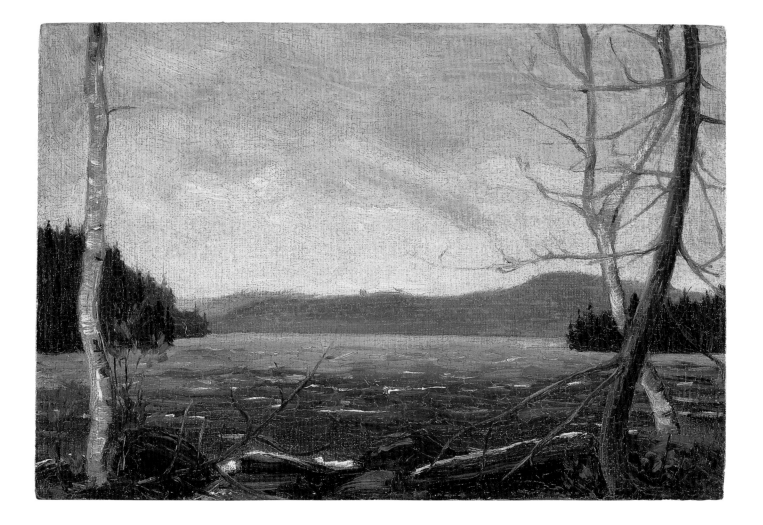

7 **A Northern Lake** spring or fall 1912
oil on paperboard (Birchmore board), 17.8 x 25.4 cm
Camp Tanamakoon, Algonquin Park, Ontario

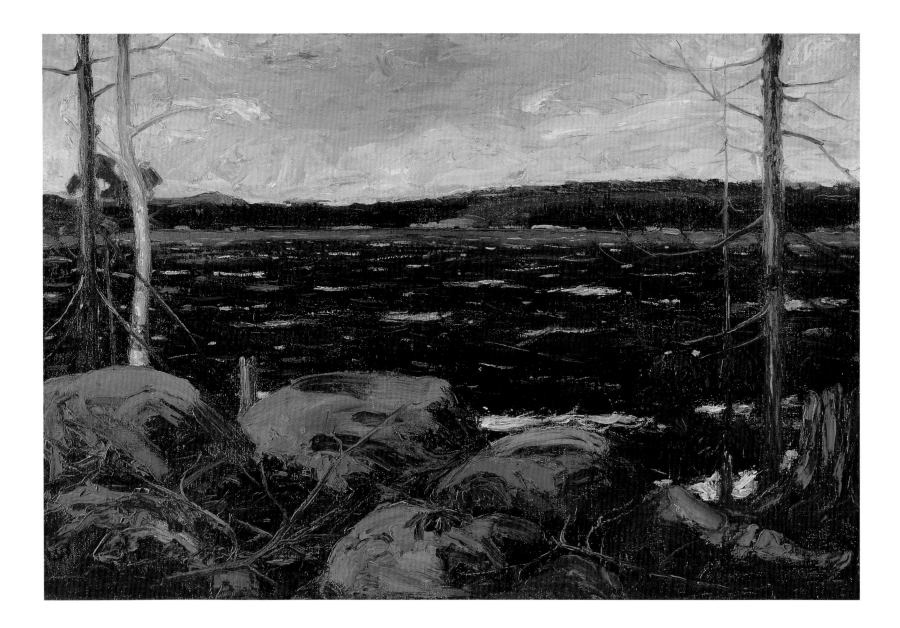

8 **Northern Lake** winter 1912–13

oil on canvas, 71.7 x 102.4 cm

Art Gallery of Ontario, Toronto, gift of the Government of the Province of Ontario, 1972 (72/25)

160

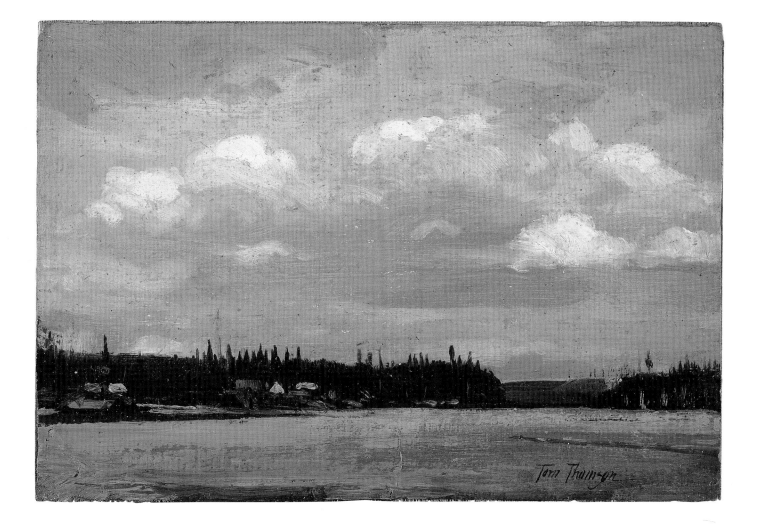

9 **View Over a Lake: Shore with Houses** summer 1912 or 1913
oil on paper (with embossed canvas texture) on plywood, 17.9 x 25.8 cm
National Gallery of Canada, Ottawa, purchase 1946 (4632)

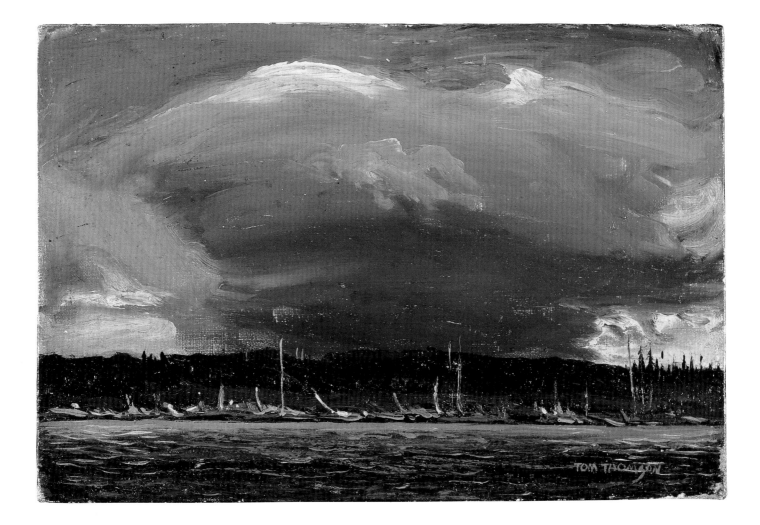

10 **Thunderhead** summer 1912 or 1913
oil on canvasboard, 17.5 x 25.2 cm
National Gallery of Canada, Ottawa, purchase 1946 (4631)

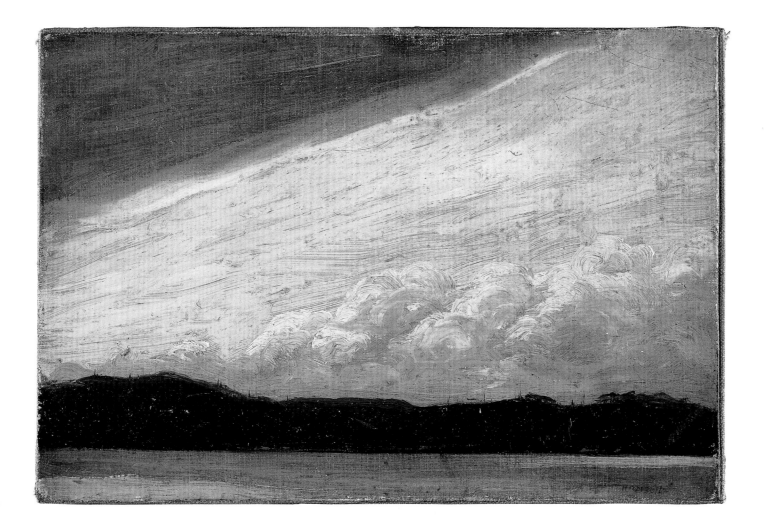

11 **Lake, Shore, and Sky** summer 1913
oil on canvas, 17.8 x 25.4 cm
National Gallery of Canada, Ottawa, gift of A.Y. Jackson, Toronto, 1933 (4565)

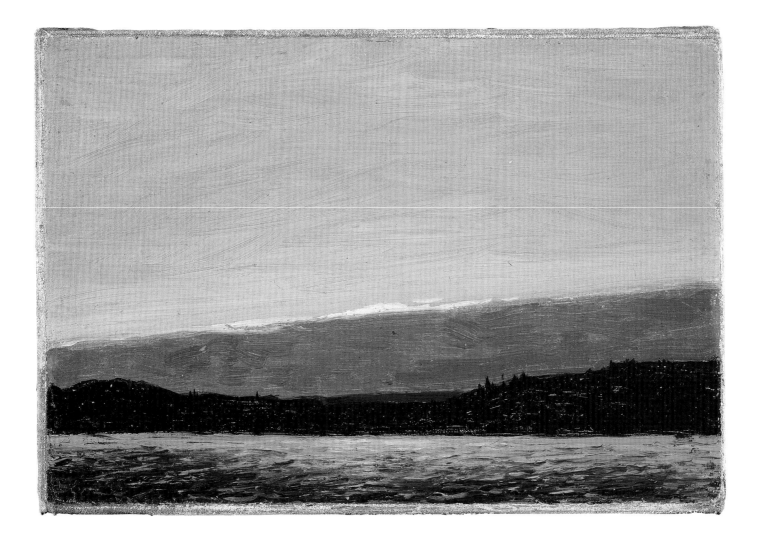

12 **Sketch for "Morning Cloud"** summer 1913
oil on canvas, 17.8 x 25.3 cm
Art Gallery of Ontario, Toronto, gift of Mrs. Doris Huestis Mills Speirs, Pickering, Ontario, 1971 (70/368)

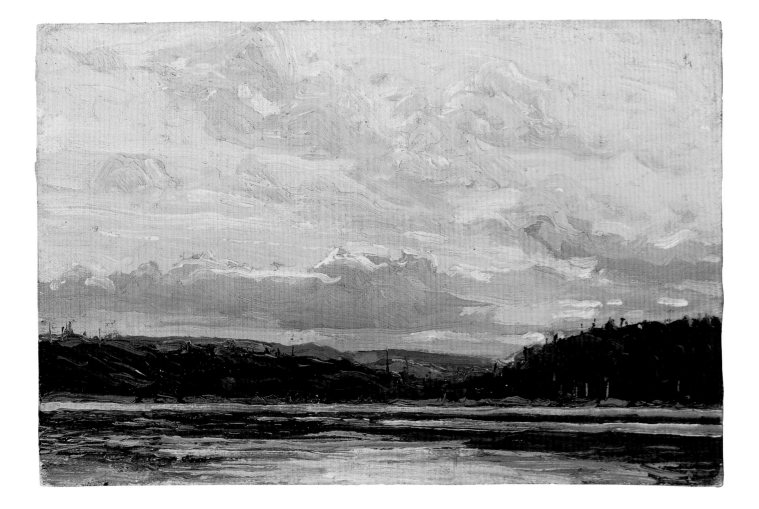

13 **Northland Sunset** summer or fall 1913
oil on canvas on paperboard, 14.6 x 21.6 cm
Tom Thomson Memorial Art Gallery, Owen Sound, Ontario,
gift of Mrs. J.G. Henry, Saskatoon, 1967 (967.055)

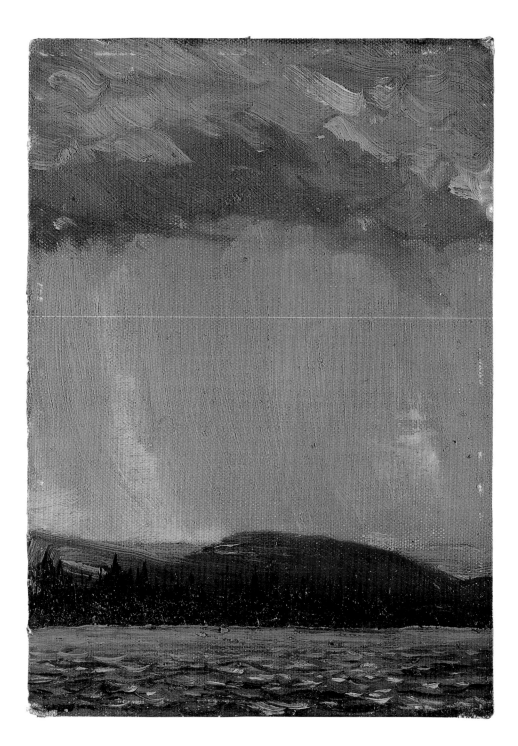

14 **Canoe Lake** summer or fall 1913
oil on canvas on paperboard, 25.2 x 17.2 cm
National Gallery of Canada, Ottawa, gift of Arthur Lismer, Montreal, 1951 (6118)

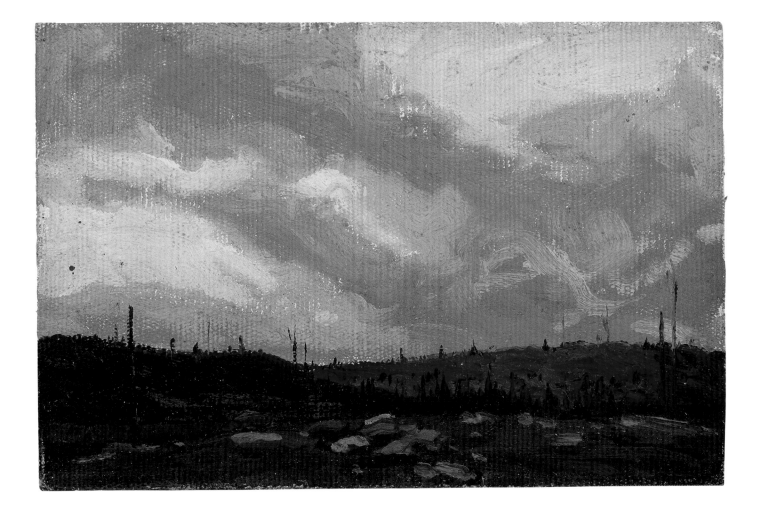

15 **Red Forest** fall 1913
oil on canvas on paperboard, 17.3 x 25.2 cm
The McMichael Canadian Art Collection, Kleinburg, Ontario,
gift of the Founders, Robert and Signe McMichael, 1966 (1966.16.65)

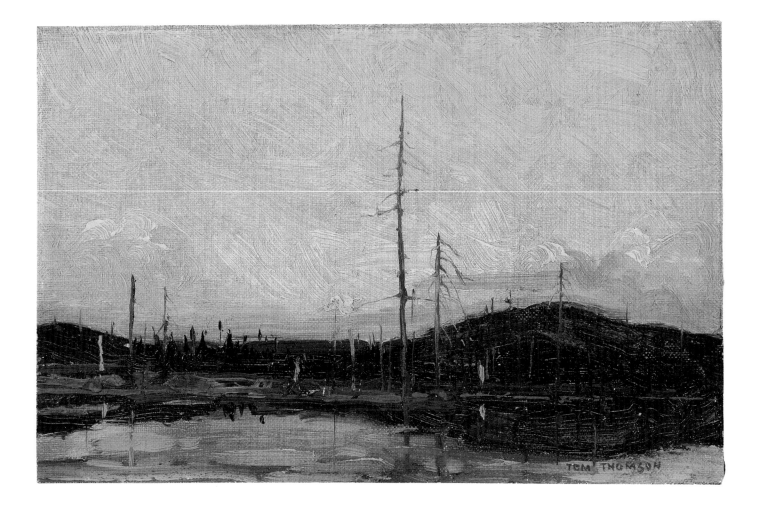

16 **Evening** fall 1913
oil on canvas on paperboard, 16.6 x 24.7 cm
The Thomson Collection (PC-668)

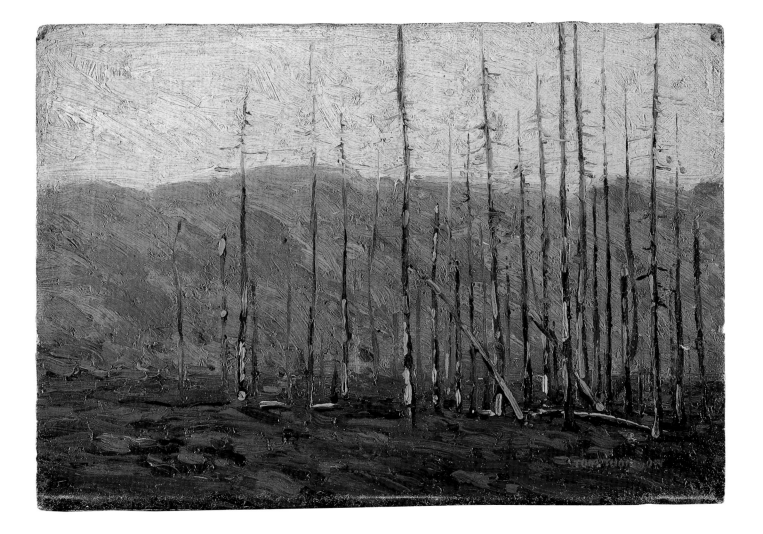

17 **Autumn, Algonquin Park** fall 1912 or 1913
oil on canvas on paperboard, 17.8 x 25.2 cm
Alan O. Gibbons

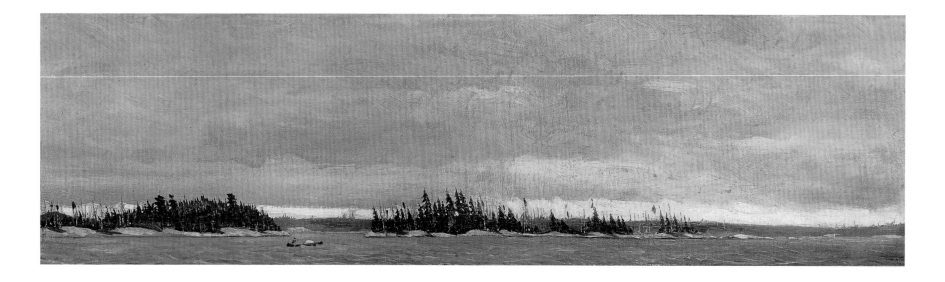

18 **Grey Day in the North** winter 1913

oil on canvas, 22.0 x 71.3 cm

Private collection

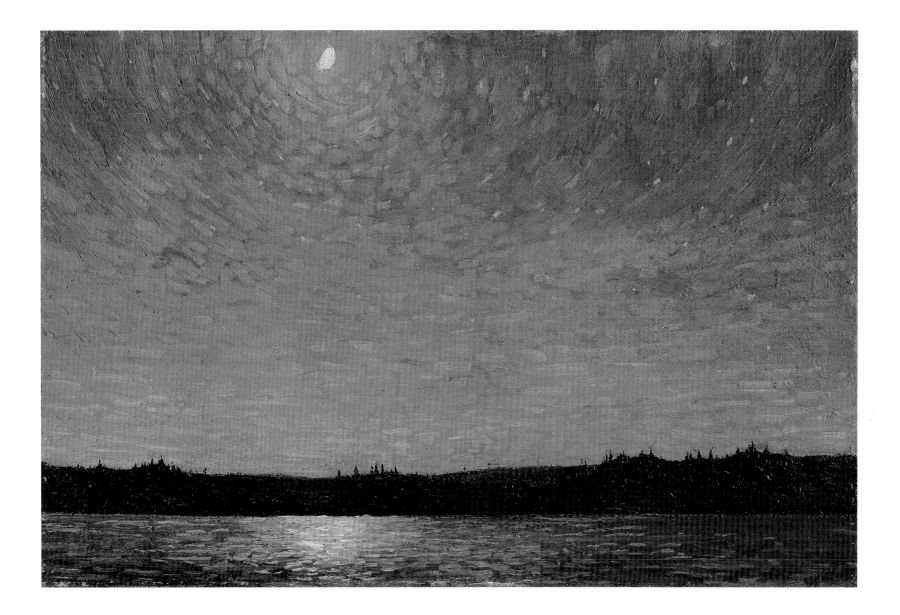

19 **Moonlight** winter 1913–14
oil on canvas, 52.9 x 77.1 cm
National Gallery of Canada, Ottawa, purchase 1914 (943)

20 **Morning Cloud** winter 1913–14
oil on canvas, 72.0 x 101.8 cm
The Thomson Collection (PC-1051)

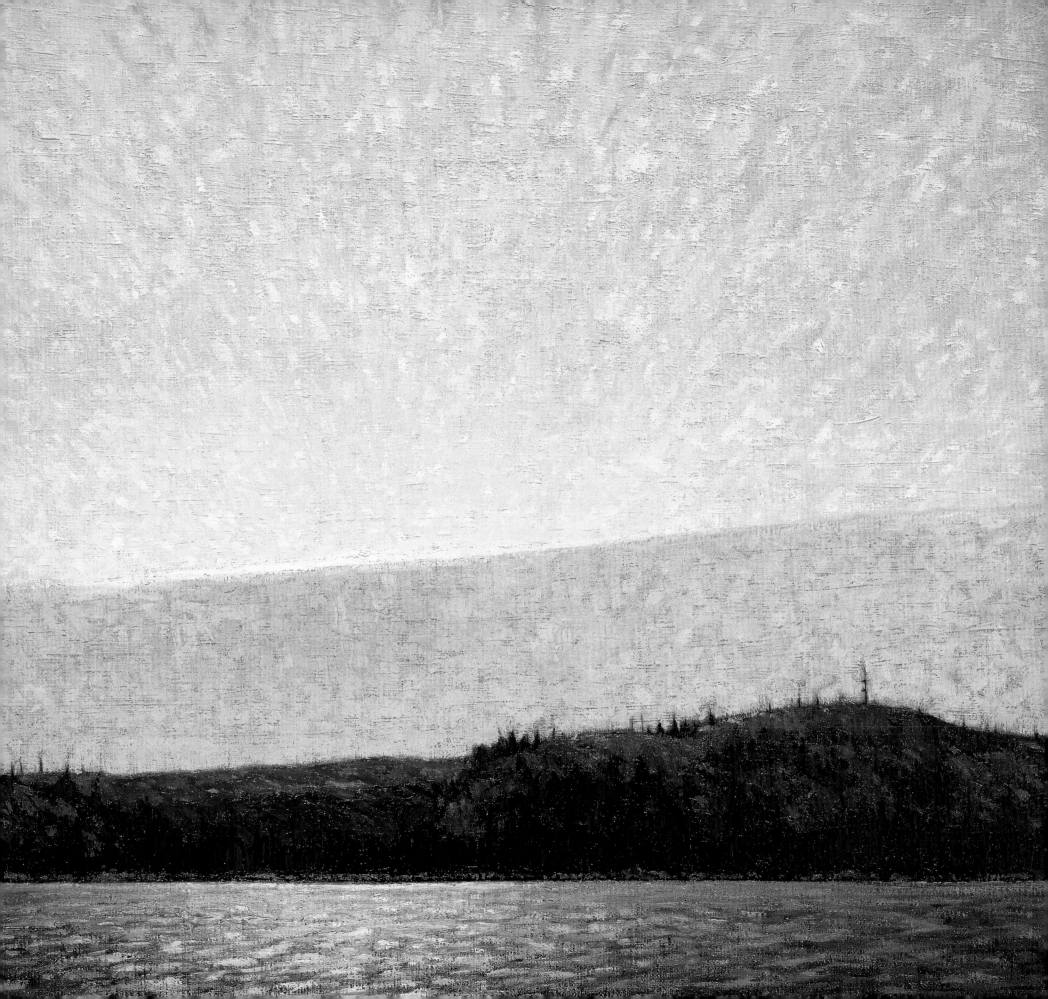

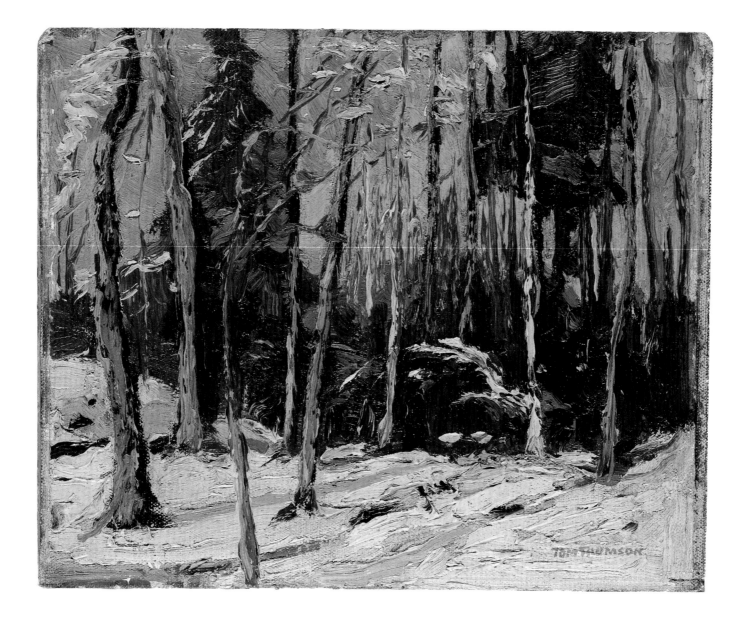

21 **Larry Dickson's Shack** spring 1914
oil on canvas on paperboard, 22.4 x 25.8 cm
National Gallery of Canada, Ottawa, bequest of Dr. J.M. MacCallum, Toronto, 1944 (4656)

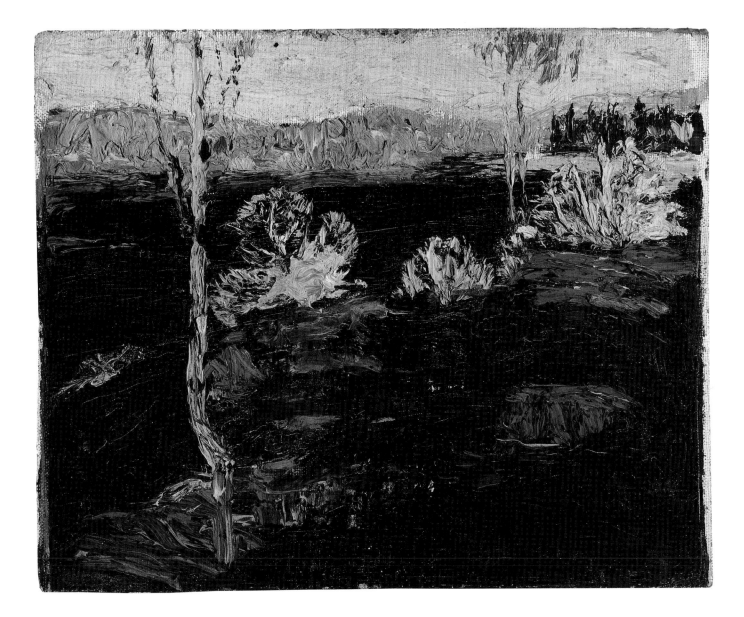

22 **Hoar Frost** spring 1914
oil on canvas on paperboard, 22.4 x 26.8 cm
The McMichael Canadian Art Collection, Kleinburg, Ontario,
gift of C.A.G. Matthews, Toronto, 1968 (1968.25.21)

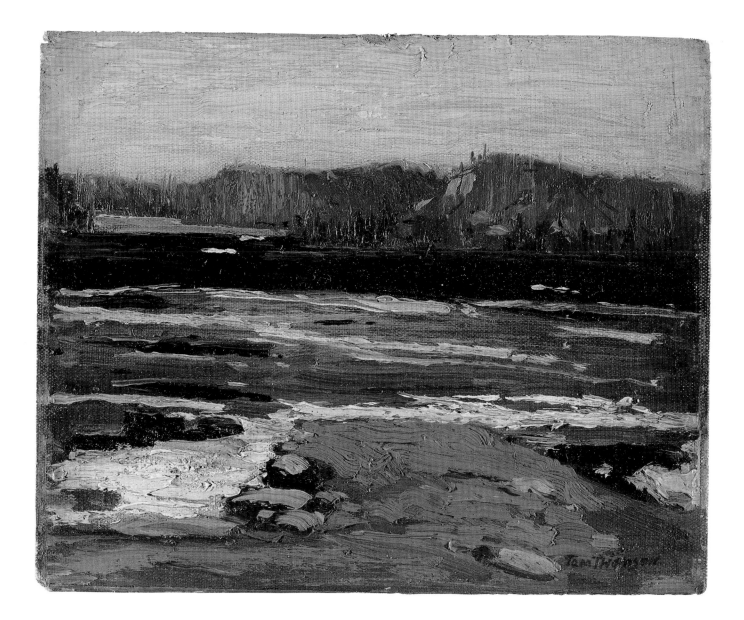

23 **Petawawa Gorges** spring 1914
oil on canvas on paperboard, 22.2 x 26.9 cm
National Gallery of Canada, Ottawa, bequest of Dr. J.M. MacCallum, Toronto, 1944 (4683)

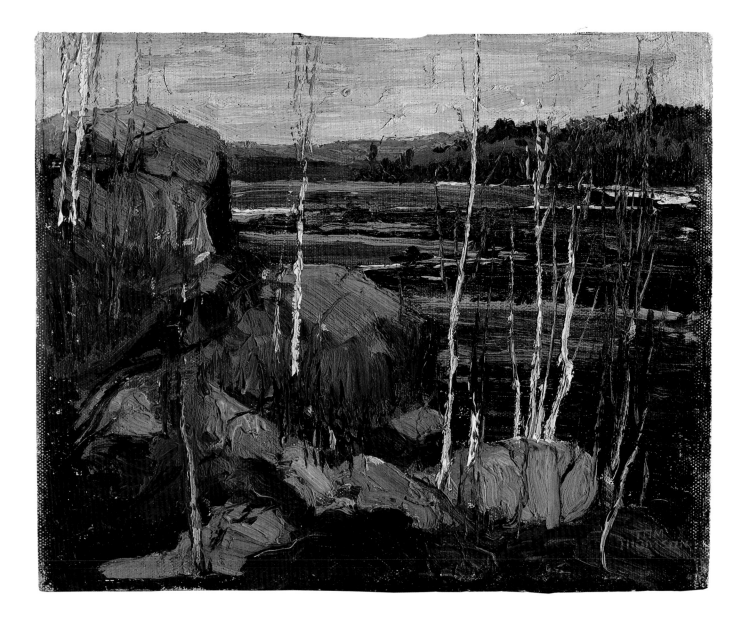

24 **Spring** spring 1914
oil on canvas on wood, 22.2 x 26.7 cm
The McMichael Canadian Art Collection, Kleinburg, Ontario, purchase 1972 (1972.5.4)

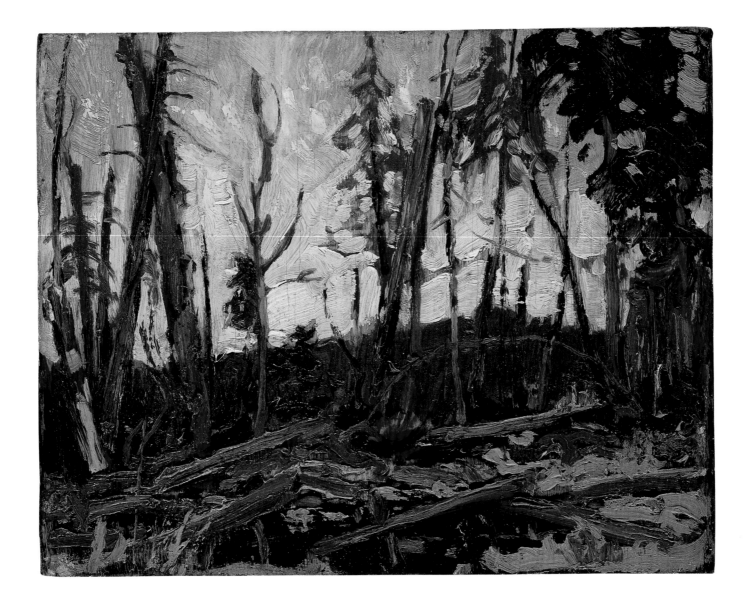

25 **Burnt Country, Evening** spring 1914
oil on plywood, 21.5 x 26.6 cm
National Gallery of Canada, Ottawa, bequest of Dr. J.M. MacCallum, Toronto, 1944 (4661)

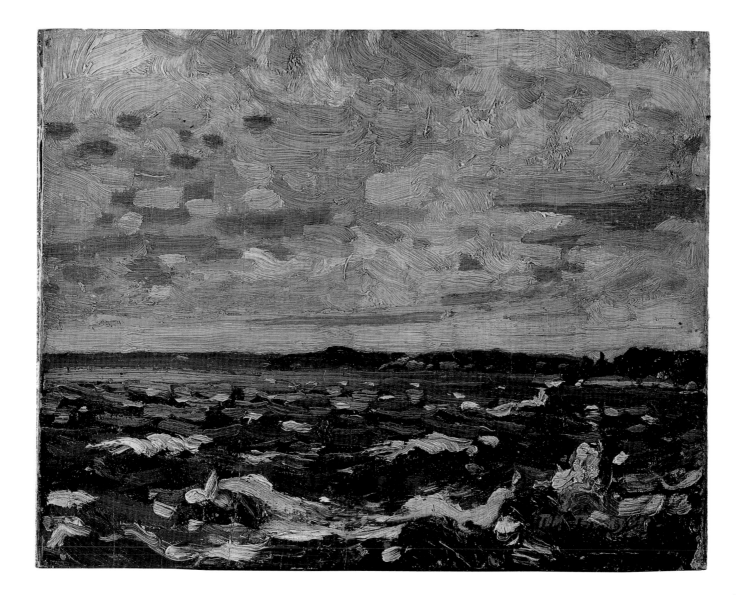

26 **Parry Sound Harbour** 30 May 1914
oil on wood, 21.7 x 26.7 cm
National Gallery of Canada, Ottawa, bequest of Dr. J.M. MacCallum, Toronto, 1944 (4664)

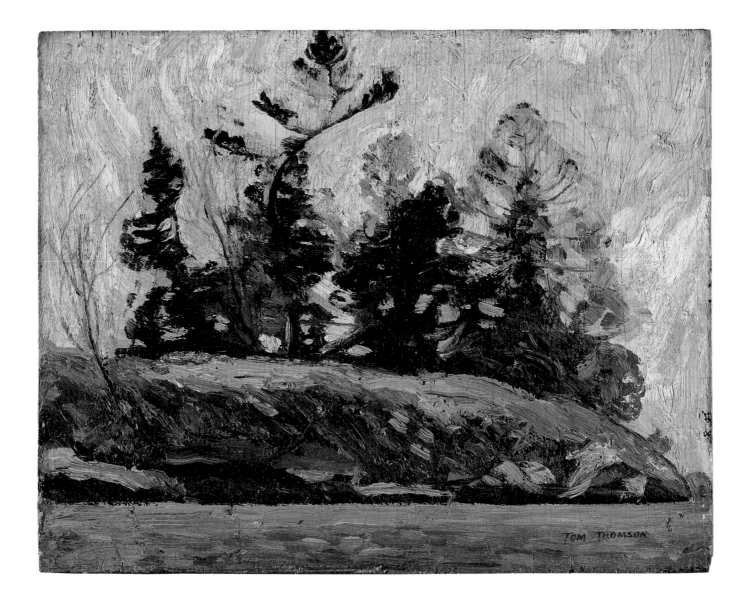

27 **Spring, French River** 1 June 1914
oil on plywood, 21.6 x 26.9 cm
National Gallery of Canada, Ottawa, bequest of Dr. J.M. MacCallum, Toronto, 1944 (4657)

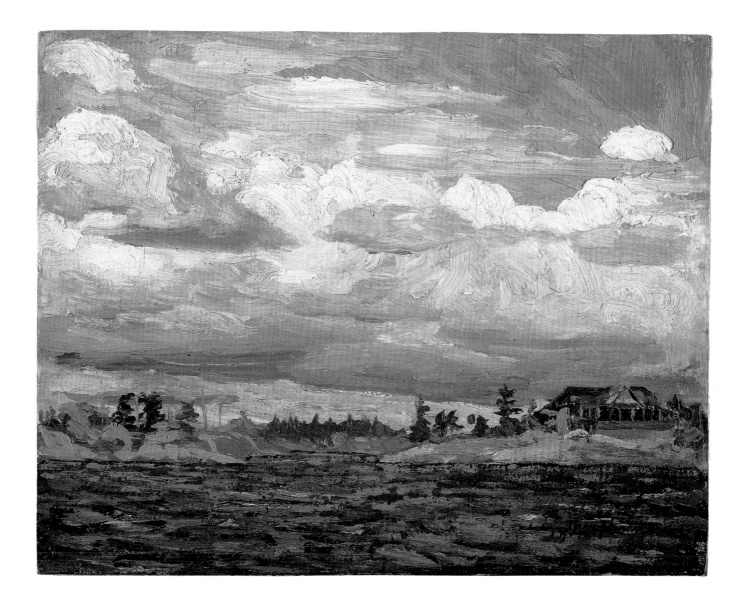

28 **Cottage on a Rocky Shore** summer 1914
oil on wood, 21.6 x 26.7 cm
National Gallery of Canada, Ottawa, bequest of Dr. J.M. MacCallum, Toronto, 1944 (4665)

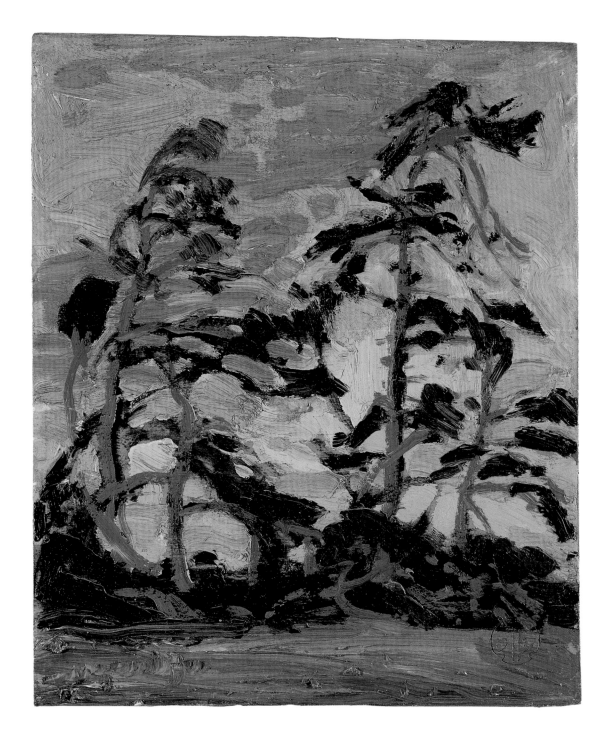

29 **Evening, Pine Island** summer 1914
oil on plywood, 26.4 x 21.6 cm
Private collection

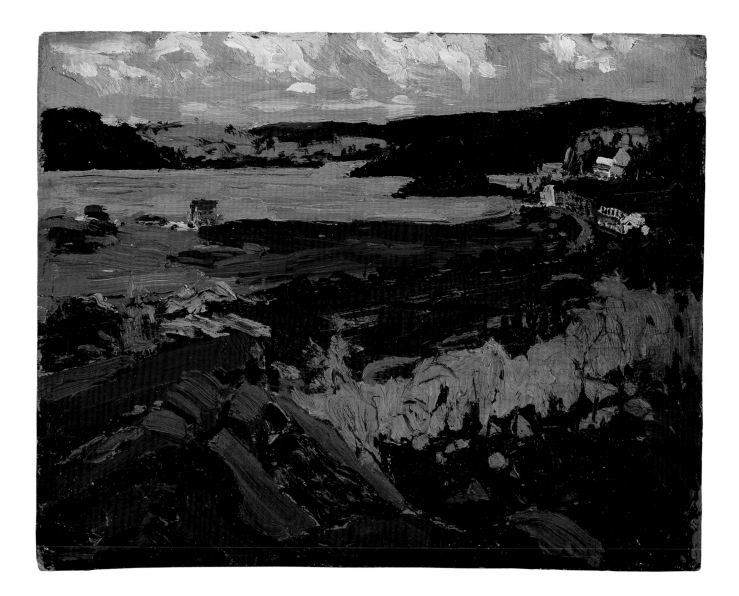

30 **Canoe Lake, Mowat Lodge** summer 1914
oil on plywood, 21.4 x 26.7 cm
Tom Thomson Memorial Art Gallery, Owen Sound, Ontario, bequest of Stewart and Letty Bennett,
Georgetown, Ontario, 1982, donated by the Ontario Heritage Foundation, 1988 (988.011.078)

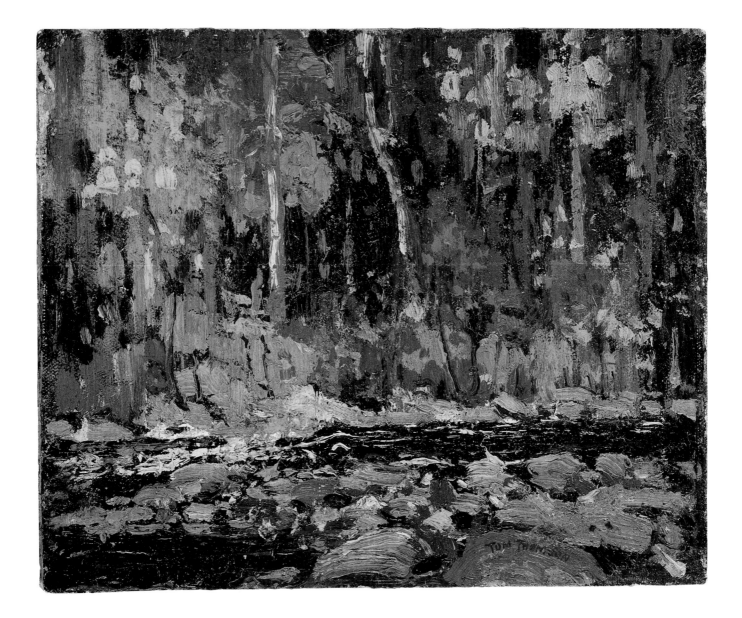

31 **The Brook** fall 1914

oil on canvas on paperboard, 22.4 x 27.0 cm

National Gallery of Canada, Ottawa, bequest of Dr. J.M. MacCallum, Toronto, 1944 (4710)

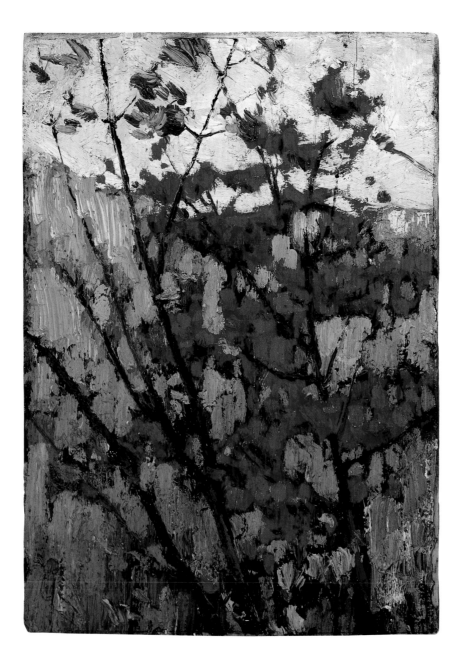

32 **Soft Maple in Autumn** fall 1914
oil on plywood, 22.0 x 15.1 cm
Tom Thomson Memorial Art Gallery, Owen Sound, Ontario,
gift of Mrs. J.G. Henry, Saskatoon, 1967 (967.061)

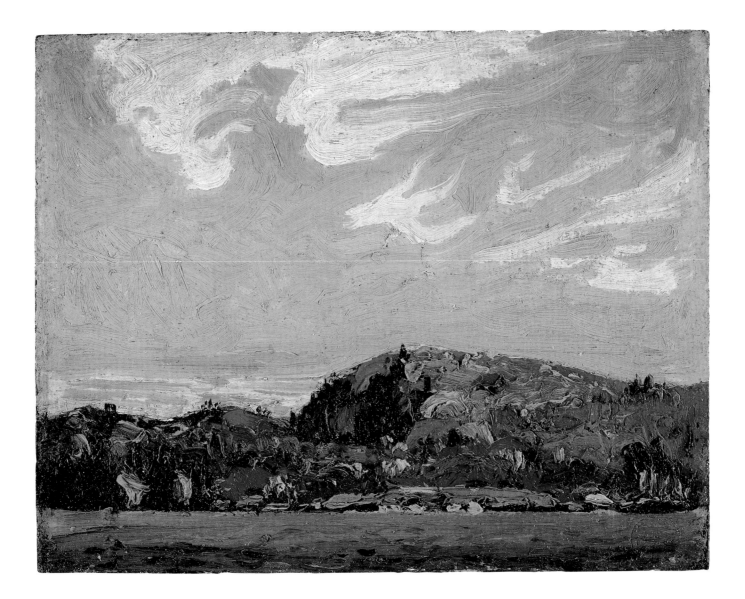

33 **The Hill in Autumn** fall 1914

oil on composite wood-pulp board, 21.5 x 26.7 cm

National Gallery of Canada, Ottawa, bequest of Dr. J.M. MacCallum, Toronto, 1944 (4713)

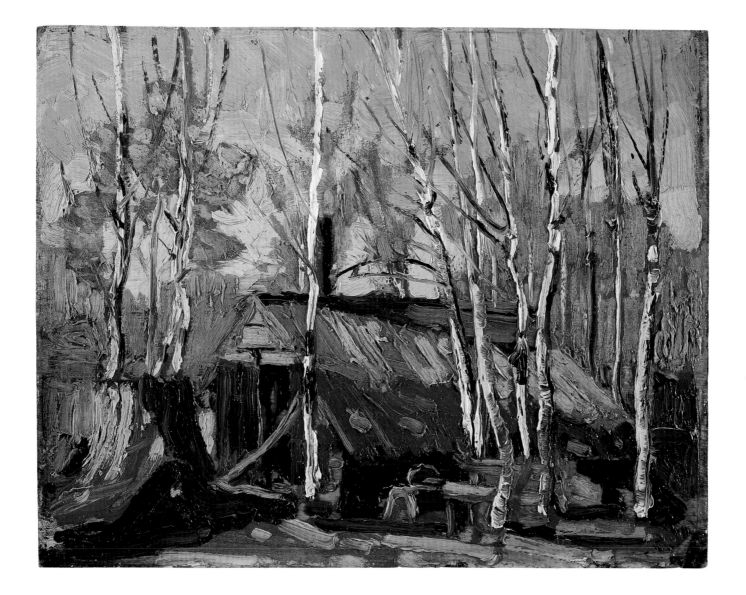

34 **Shack in the North Country** fall 1914
oil on wood, 22.0 x 27.2 cm
Art Gallery of Ontario, Toronto, gift from the Fund of the T. Eaton Co. Ltd.
for Canadian Works of Art, 1953 (53/13)

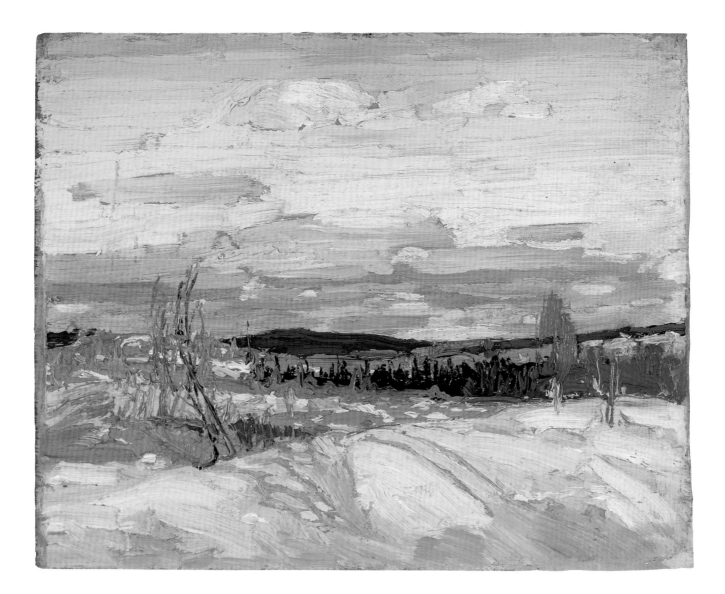

35 **Winter: Sketch for "In Algonquin Park"** fall 1914
oil on wood, 21.7 x 26.7 cm
The McMichael Canadian Art Collection, Kleinburg, Ontario,
gift of Mr. and Mrs. R.G. Mastin, Toronto, 1980 (1980.19.1)

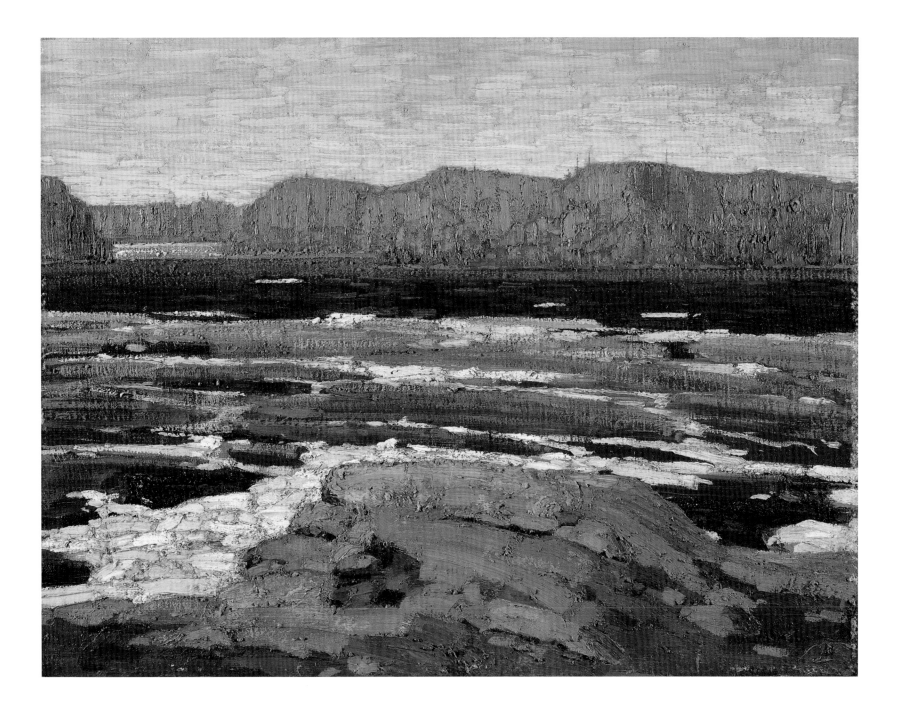

36 **Petawawa Gorges (Early Spring)** fall 1914
oil on canvas, 63.9 x 81.5 cm
National Gallery of Canada, Ottawa, bequest of Dr. J.M. MacCallum, Toronto, 1944 (4723)

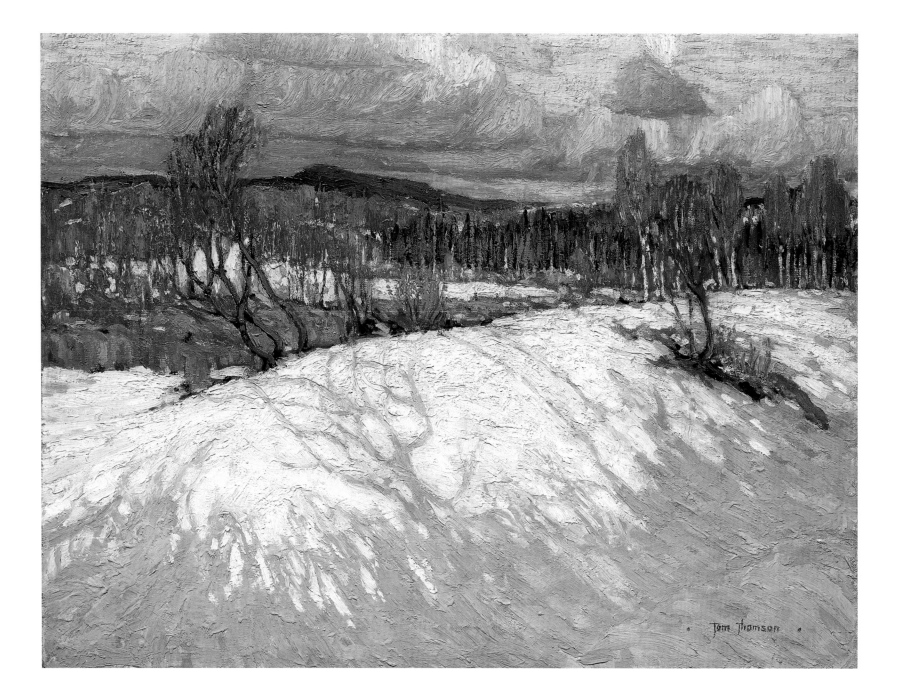

37 **In Algonquin Park** fall 1914
oil on canvas, 63.2 x 81.1 cm
The McMichael Canadian Art Collection, Kleinburg, Ontario, gift of the Founders, Robert and
Signe McMichael, in memory of Norman and Evelyn McMichael, 1966 (1966.16.76)

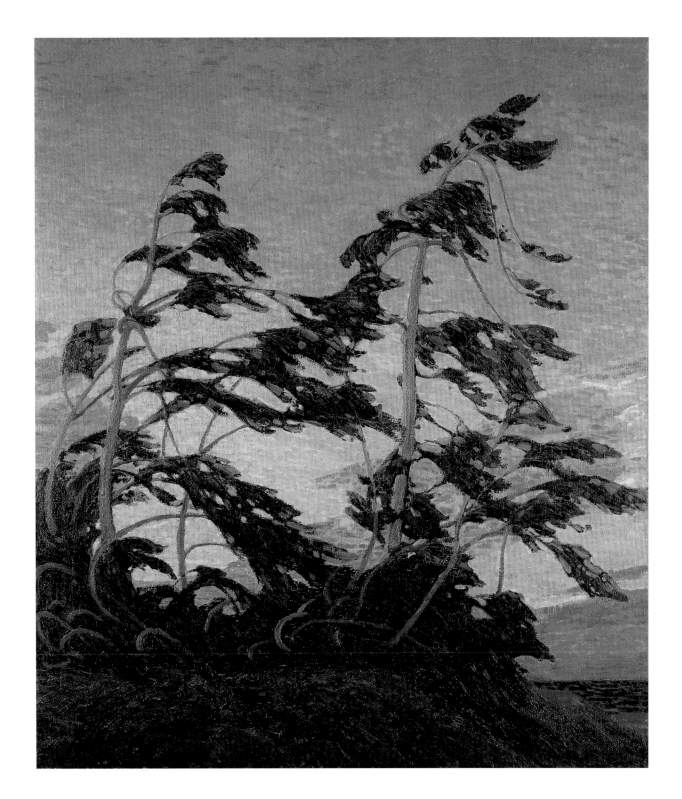

38 **Pine Island, Georgian Bay** 1914–16
oil on canvas, 153.2 x 127.7 cm
National Gallery of Canada, Ottawa, bequest of Dr. J.M. MacCallum, Toronto, 1944 (4726)

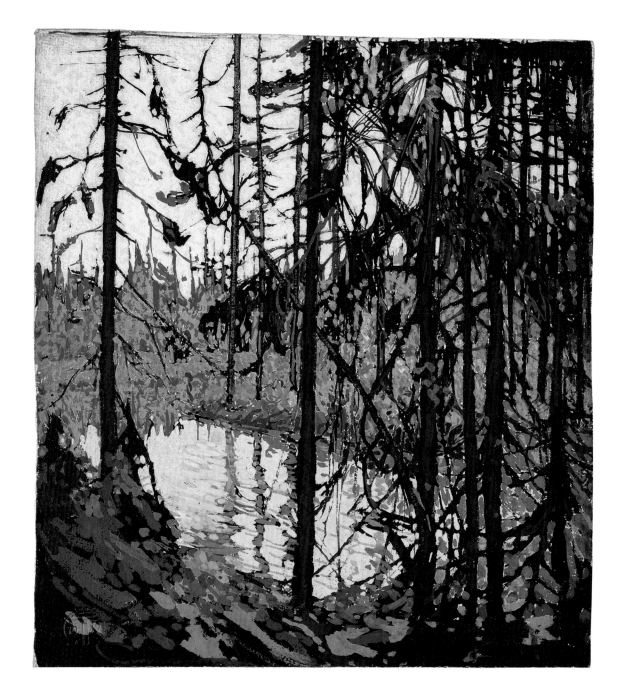

39 **Study for "Northern River"** winter 1914–15
graphite, brush and ink and gouache on illustration board, 30.0 x 26.7 cm
Art Gallery of Ontario, Toronto, purchase 1982 (82/176)

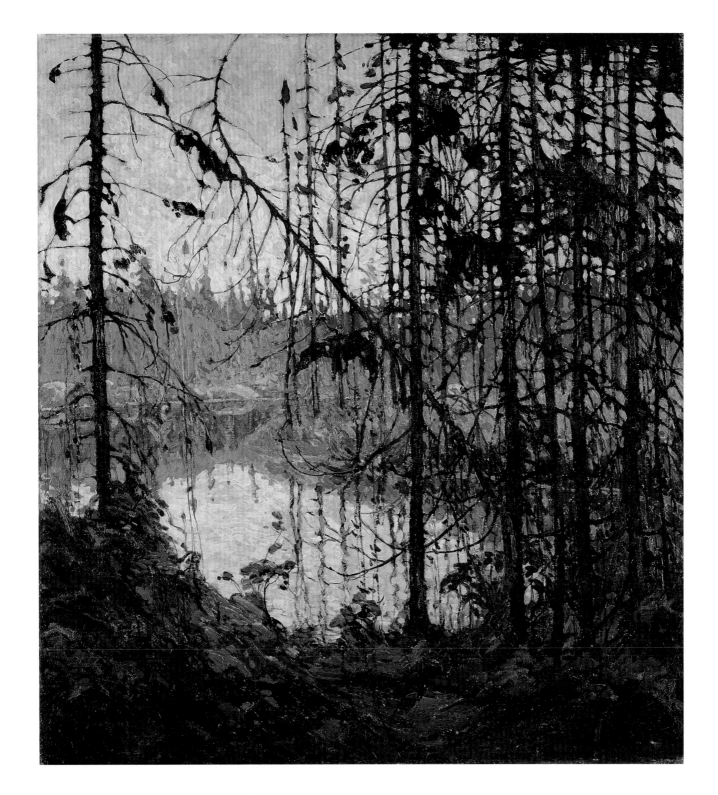

40 **Northern River** winter 1914–15
oil on canvas, 115.1 x 102.0 cm
National Gallery of Canada, Ottawa, purchase 1915 (1055)

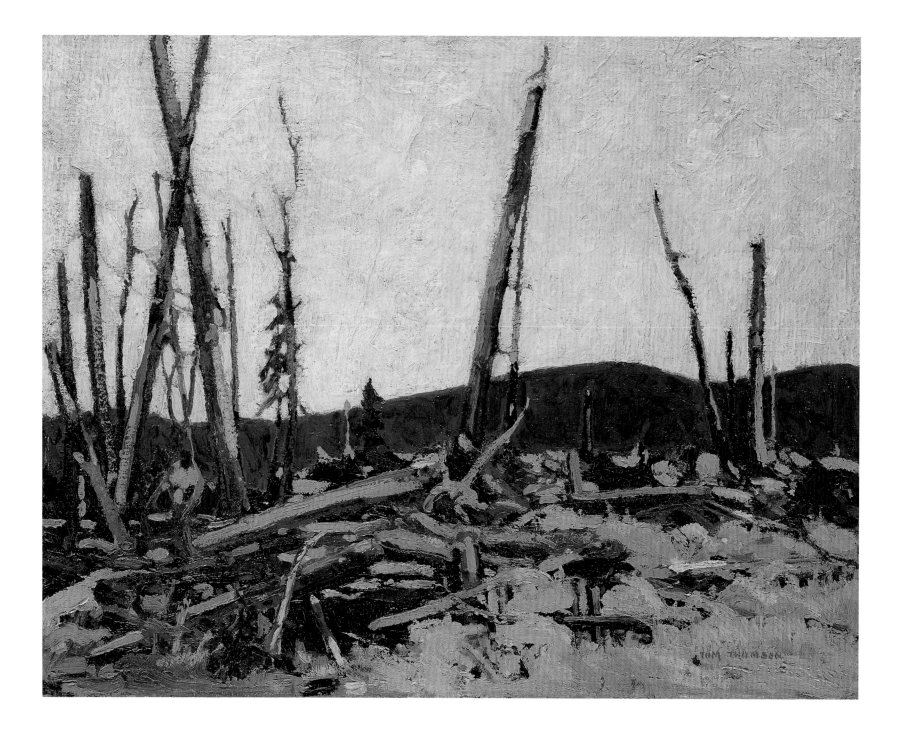

41 **Burnt Land** spring 1915
oil on canvas, 54.6 x 66.7 cm
National Gallery of Canada, Ottawa, purchase 1937 (4299)

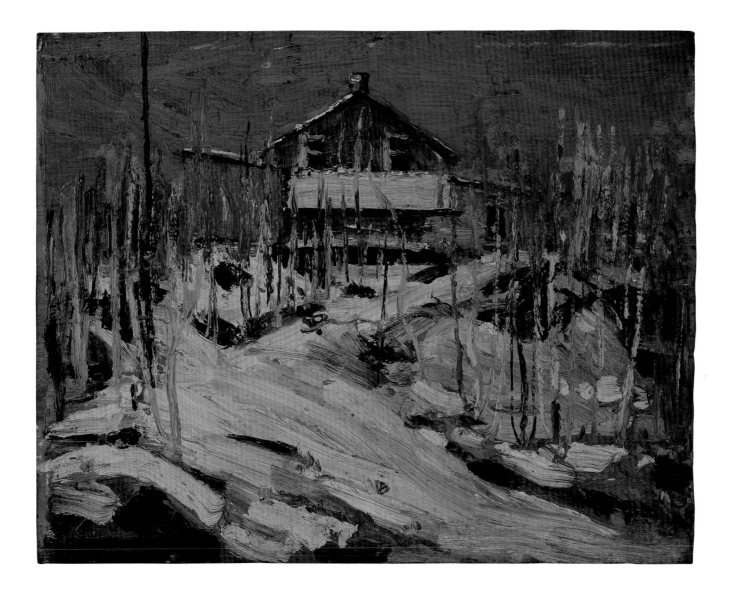

42 **Fraser's Lodge** spring 1915
oil on wood, 21.9 x 27.0 cm
Edmonton Art Gallery, gift of Mrs. Gertrude Poole, Edmonton, 1977 (77.30)

43 **The Opening of the Rivers: Sketch for "Spring Ice"** spring 1915
oil on composite wood-pulp board, 21.6 x 26.7 cm
National Gallery of Canada, Ottawa, bequest of Dr. J.M. MacCallum, Toronto, 1944 (4662)

44 **Northern Spring** spring 1915
oil on wood, 21.6 x 26.8 cm
National Gallery of Canada, Ottawa, bequest of Vincent Massey, 1968 (15555)

45 **In the Sugar Bush (Shannon Fraser)** spring 1915
oil on composite wood-pulp board, 26.8 x 21.8 cm
Art Gallery of Ontario, Toronto, gift from the Fund of the T. Eaton Co. Ltd.
for Canadian Works of Art, 1954 (53/17)

46 **Wild Cherries, Spring** spring 1915
oil on composite wood-pulp board, 21.6 x 26.7 cm
The McMichael Canadian Art Collection, Kleinburg, Ontario,
gift of the Founders, Robert and Signe McMichael, 1966 (1966.16.72)

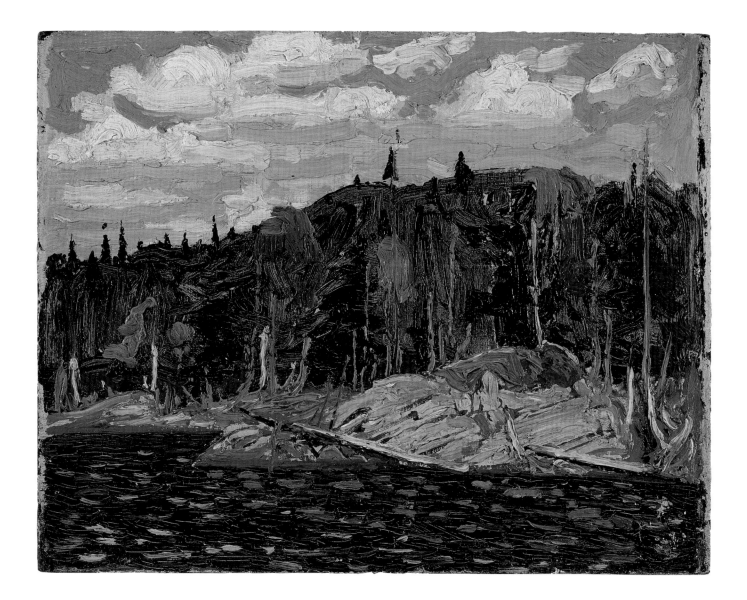

47 **Lakeside, Spring, Algonquin Park** spring 1915
oil on composite wood-pulp board, 21.7 x 26.9 cm
The Thomson Collection (PC-127)

48 **Summer Day** summer 1915
oil on composite wood-pulp board, 21.6 x 26.8 cm
The McMichael Canadian Art Collection, Kleinburg, Ontario,
gift of R.A. Laidlaw, Toronto, 1965 (1966.15.18)

49 **Evening** summer 1915
oil on composite wood-pulp board, 21.6 x 26.7 cm
The McMichael Canadian Art Collection, Kleinburg, Ontario,
gift of R.A. Laidlaw, Toronto, 1965 (1966.15.20)

50 **Sunset** summer 1915
oil on composite wood-pulp board, 21.6 x 26.7 cm
National Gallery of Canada, Ottawa, bequest of Dr. J.M. MacCallum, Toronto, 1944 (4701)

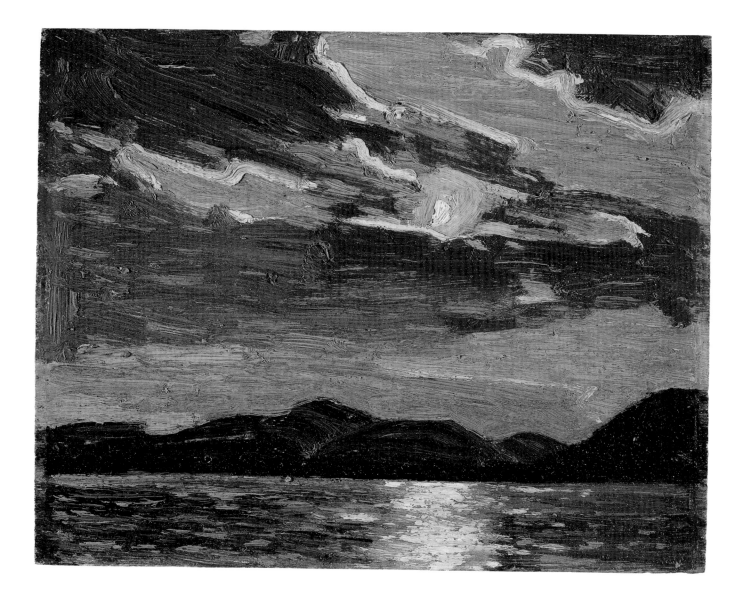

51 **Hot Summer Moonlight** summer 1915
oil on wood, 21.4 x 26.7 cm
National Gallery of Canada, Ottawa, bequest of Dr. J.M. MacCallum, Toronto, 1944 (4648)

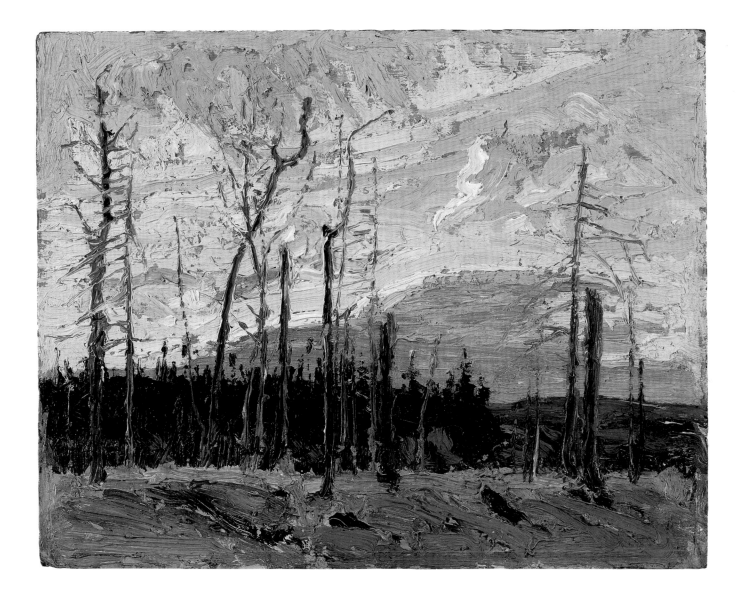

52 **Burnt Land at Sunset** summer 1915
oil on composite wood-pulp board, 21.7 x 26.9 cm
The Thomson Collection (PC-989)

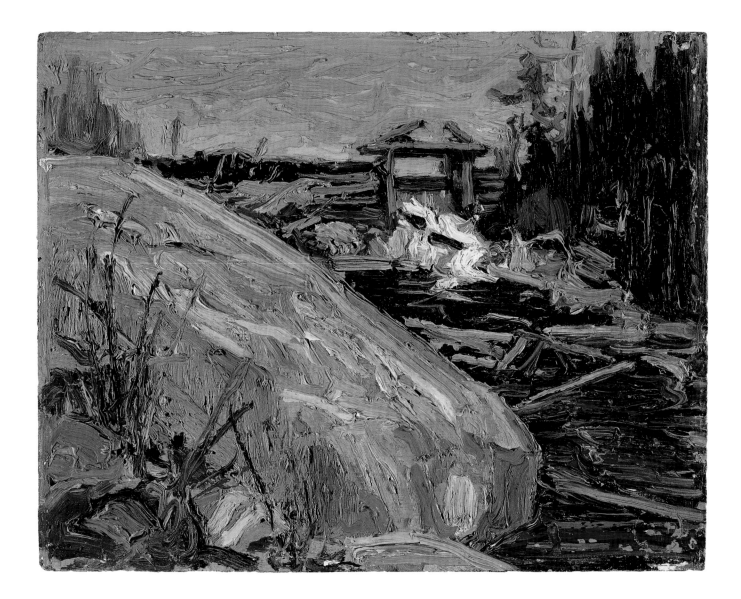

53 **Lumber Dam** summer 1915
oil on composite wood-pulp board, 21.6 x 26.7 cm
National Gallery of Canada, Ottawa, purchase 1958 (6946)

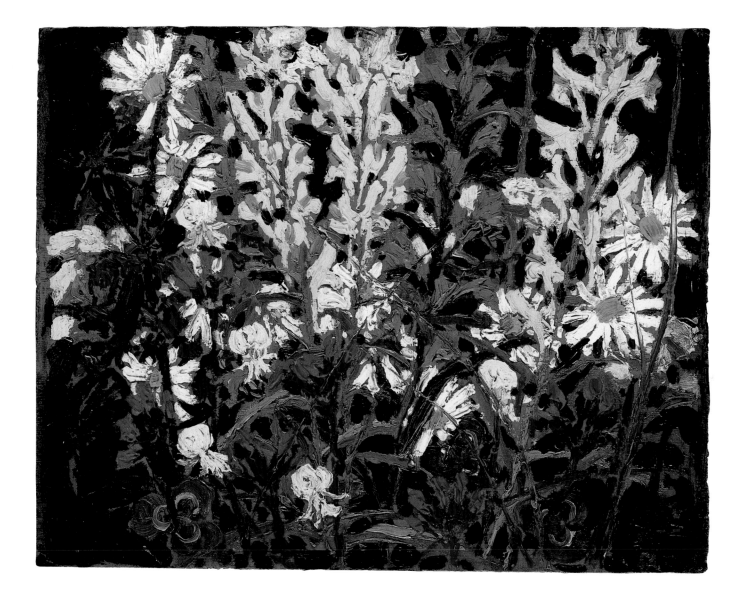

54 **Wildflowers** summer 1915
oil on composite wood-pulp board, 21.6 x 26.8 cm
The McMichael Canadian Art Collection, Kleinburg, Ontario,
gift of R.A. Laidlaw, Toronto, 1970 (1970.12.2)

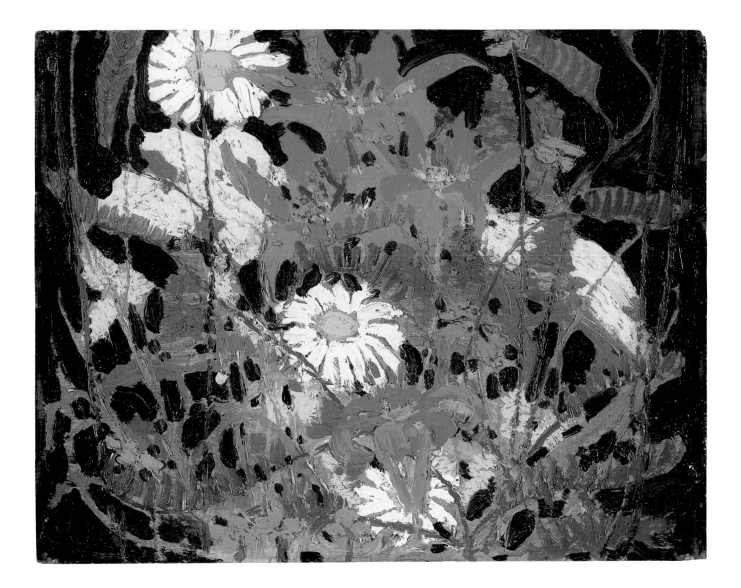

55 **Marguerites, Wood Lilies and Vetch** summer 1915
oil on wood, 21.4 x 26.8 cm
Art Gallery of Ontario, Toronto, gift from the Albert H. Robson Memorial Subscription Fund, 1941 (2563)

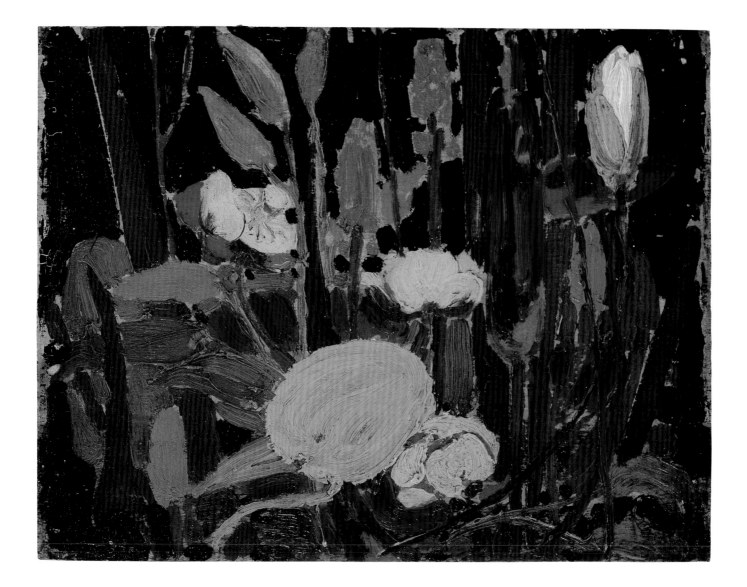

56 **Water Flowers** summer 1915
oil on wood, 21.0 x 26.7 cm
The McMichael Canadian Art Collection, Kleinburg, Ontario, purchase 1976 (1976.20)

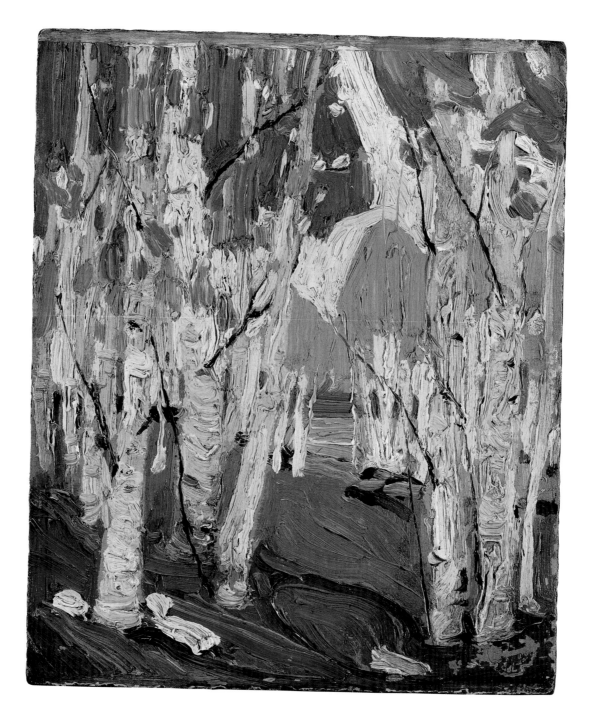

57 **Pink Birches** summer 1915
oil on composite wood-pulp board, 26.9 x 21.7 cm
The Thomson Collection (PC-261)

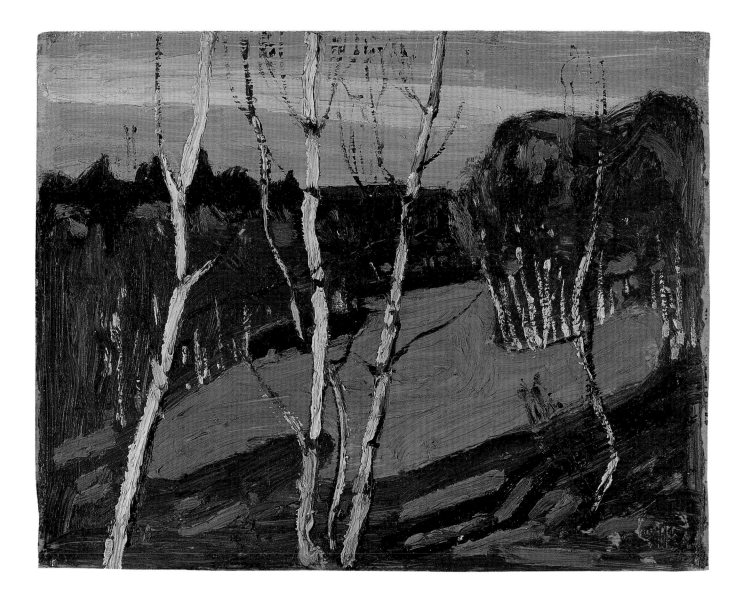

58 **Moonlight, Algonquin Park** summer 1915
oil on wood, 21.6 x 26.7 cm
The Thomson Collection (PC-468)

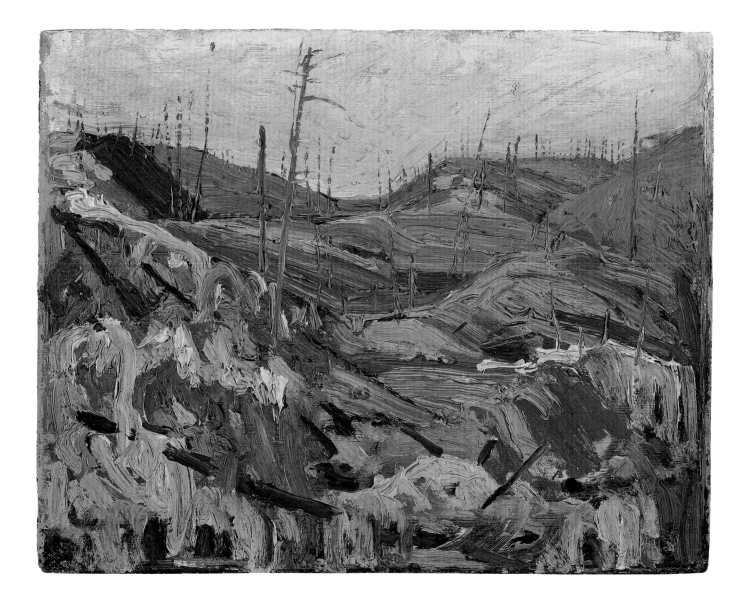

59 **Fire-Swept Hills** summer or fall 1915
oil on composite wood-pulp board, 23.2 x 26.7 cm
The Thomson Collection (PC-799)

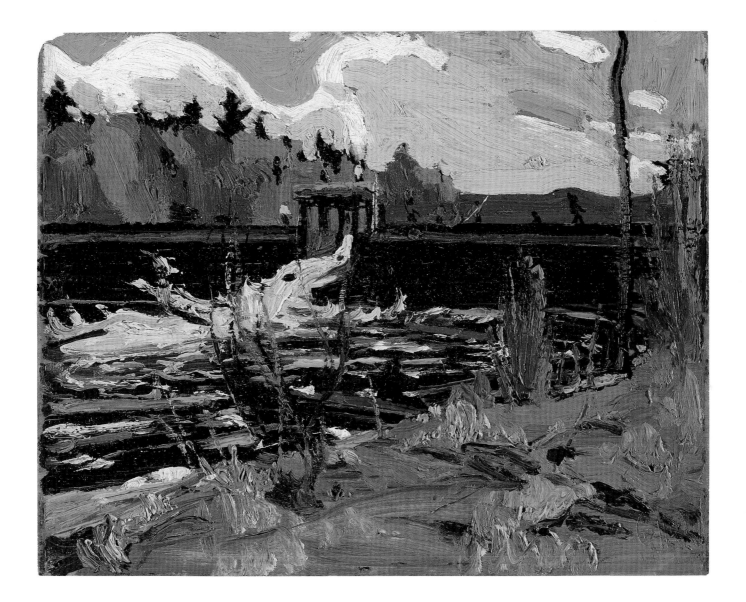

60 **Tea Lake Dam** fall 1915
oil on wood, 21.3 x 26.2 cm
National Gallery of Canada, Ottawa, purchase 1918 (1523)

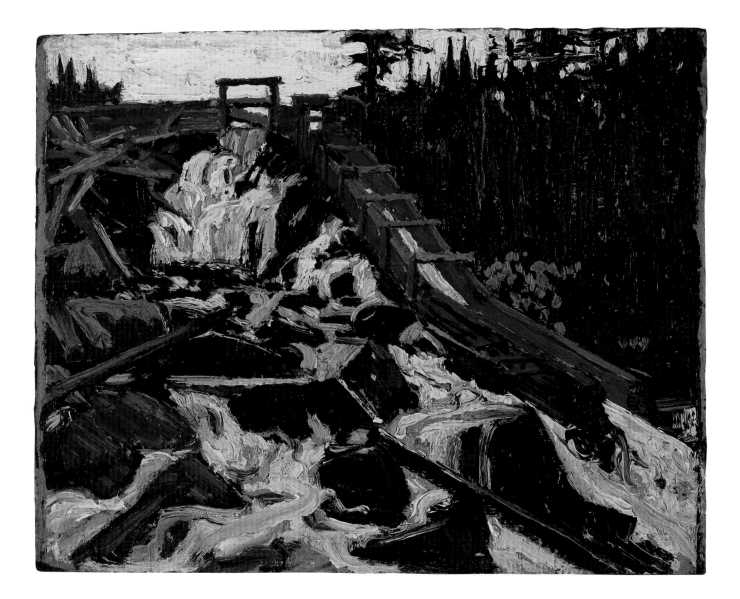

61 **Timber Chute** fall 1915
oil on composite wood-pulp board, 21.6 x 26.7 cm
Art Gallery of Ontario, Toronto, gift from the Reuben and Kate Leonard Canadian Fund, 1927 (854)

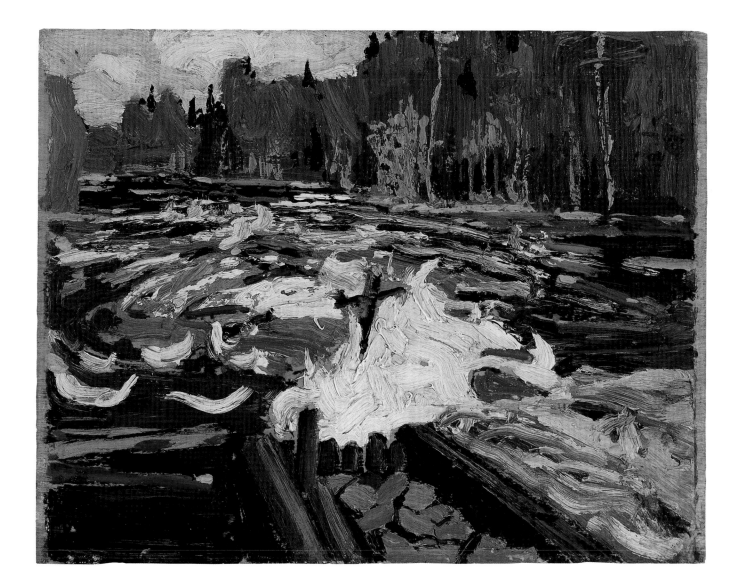

62 **Crib and Rapids** fall 1915
oil on wood, 21.6 x 26.7 cm
Private collection

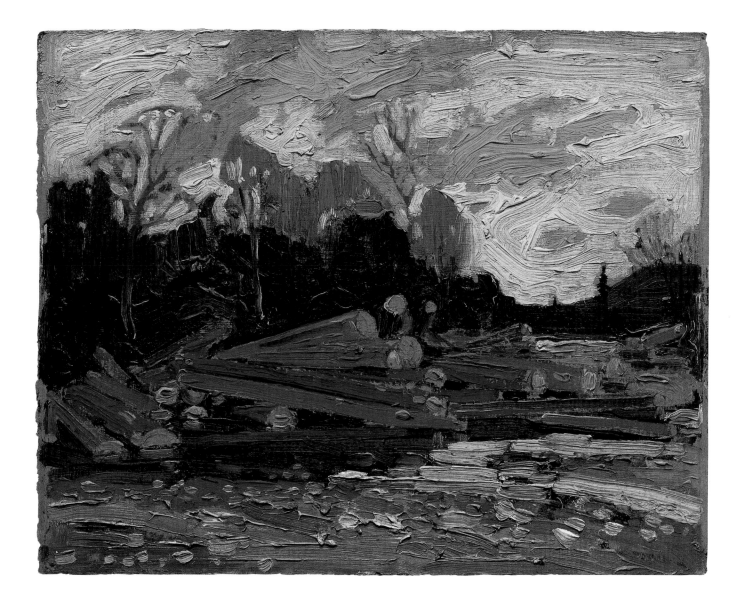

63 **Abandoned Logs** fall 1915
oil on composite wood-pulp board, 21.6 x 26.6 cm
The McMichael Canadian Art Collection, Kleinburg, Ontario, purchase 1974 (1974.3)

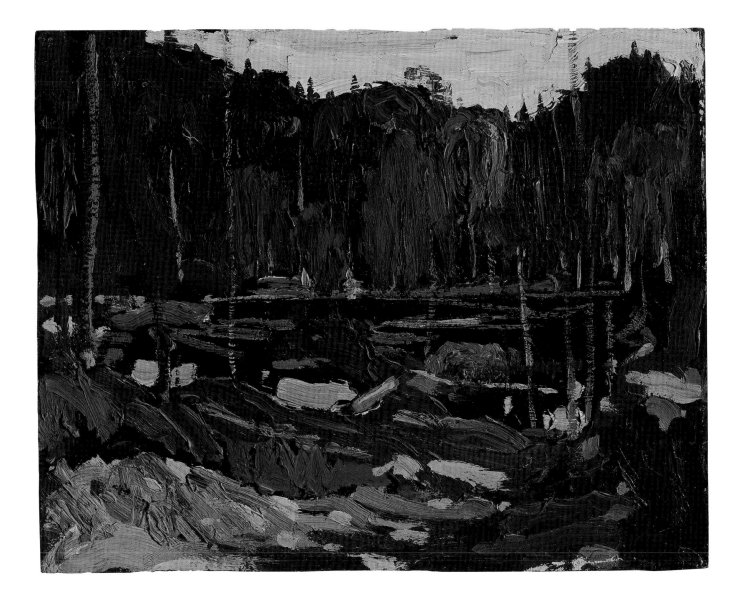

64 **Backwater** fall 1915
oil on composite wood-pulp board, 21.8 x 26.8 cm
The McMichael Canadian Art Collection, Kleinburg, Ontario,
purchased with funds donated by R.A. Laidlaw, Toronto, 1970 (1981.39)

217

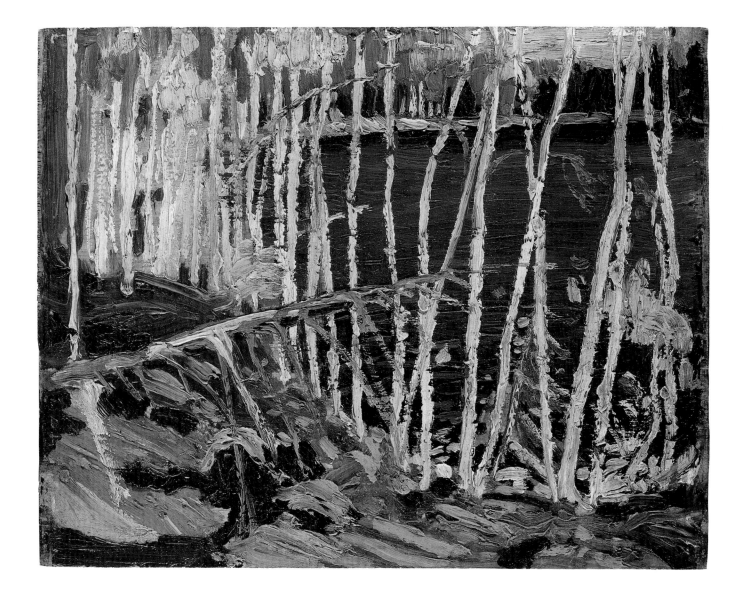

65 **Blue Lake: Sketch for "In the Northland"** fall 1915
oil on wood, 21.7 x 26.9 cm
National Gallery of Canada, Ottawa, bequest of Dr. J.M. MacCallum, Toronto, 1944 (4716)

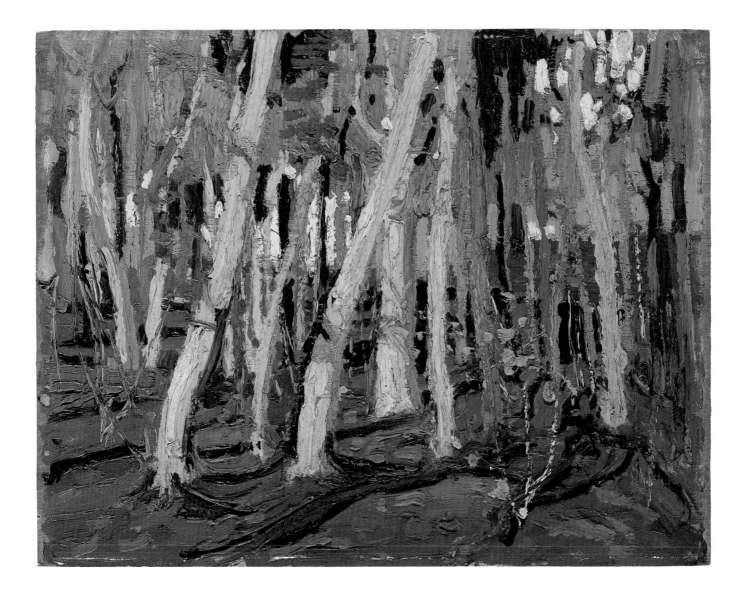

66 **Maple Woods, Bare Trunks** fall 1915
oil on wood, 21.3 x 26.6 cm
National Gallery of Canada, Ottawa, bequest of Dr. J.M. MacCallum, Toronto, 1944 (4682)

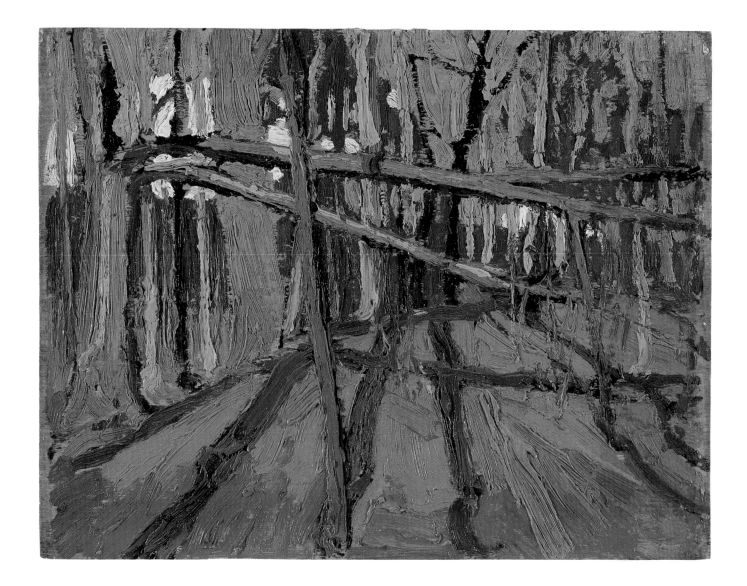

67 **Forest, October** fall 1915
oil on wood, 21.3 x 26.9 cm
Art Gallery of Ontario, Toronto, gift from the J.S. McLean Collection, Toronto, 1969,
donated by the Ontario Heritage Foundation, 1988 (L69.50)

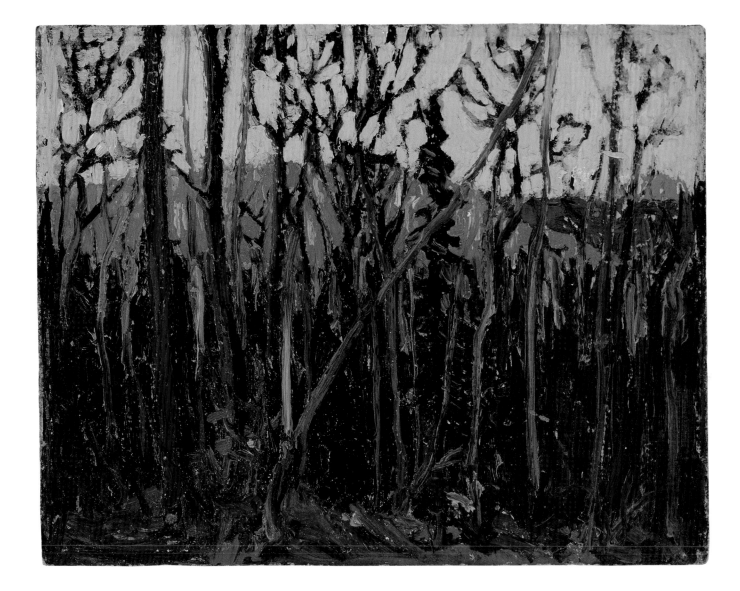

68 **Algonquin Park** fall 1915
oil on composite wood-pulp board, 21.6 x 26.5 cm
Tom Thomson Memorial Art Gallery, Owen Sound, Ontario,
gift of Mrs. J.G. Henry, Saskatoon, 1967 (967.062)

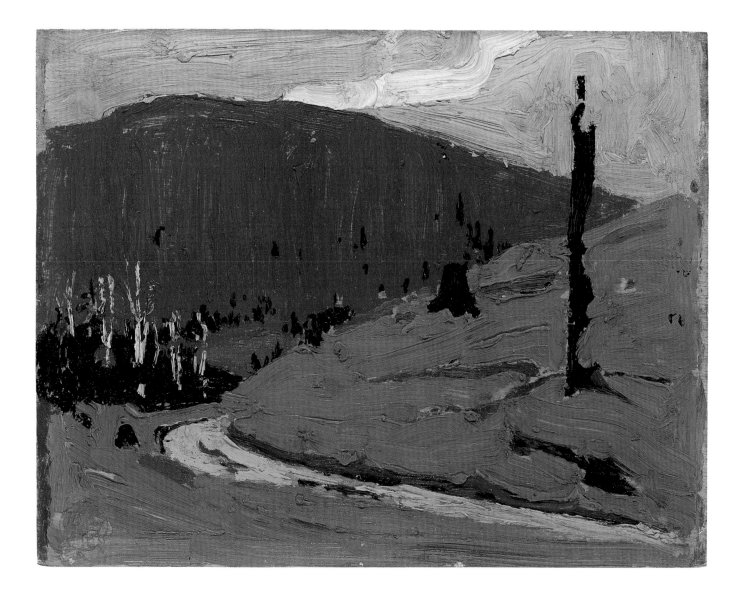

69 **Sand Hill** fall 1915
oil on wood, 21.4 x 26.8 cm
The Thomson Collection (PC-971)

222

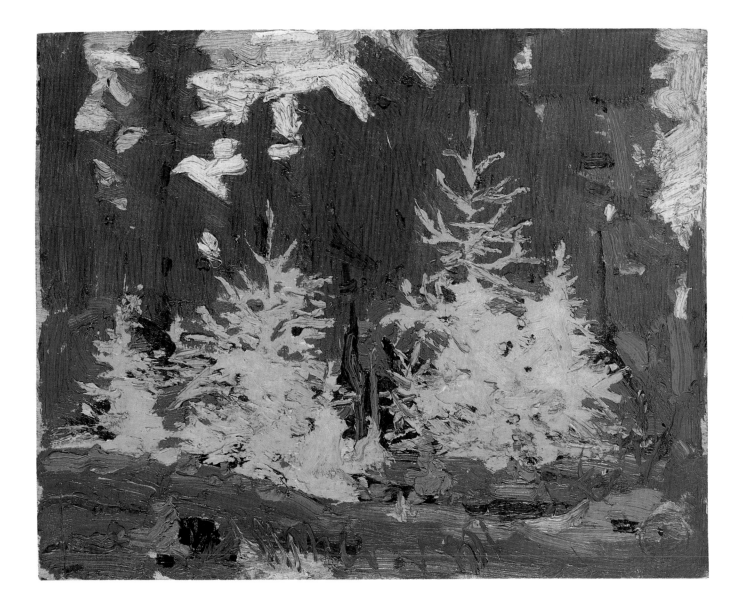

70 **Tamarack** fall 1915
oil on wood, 21.5 x 26.2 cm
National Gallery of Canada, Ottawa, purchase 1918 (1522)

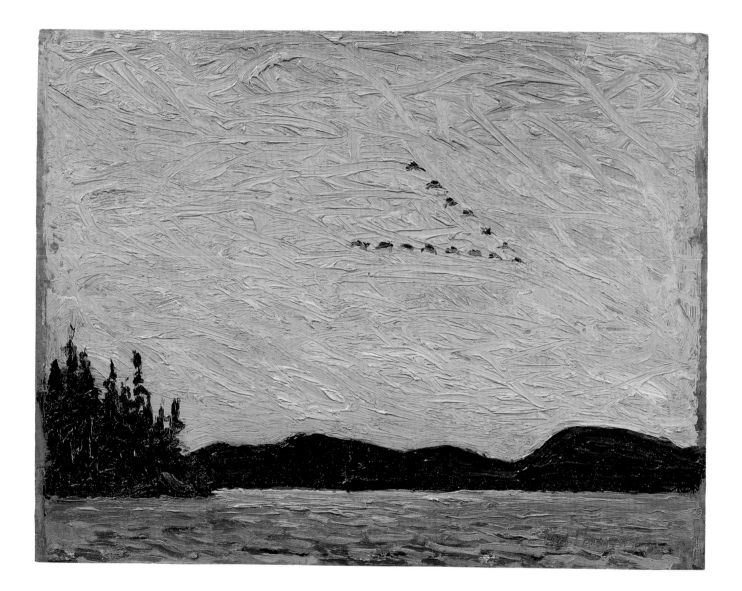

71 **Round Lake, Mud Bay** fall 1915
oil on wood, 21.5 x 26.8 cm
Art Gallery of Ontario, Toronto, gift from the J.S. McLean Collection, Toronto, 1969,
donated by the Ontario Heritage Foundation, 1988 (L69.51)

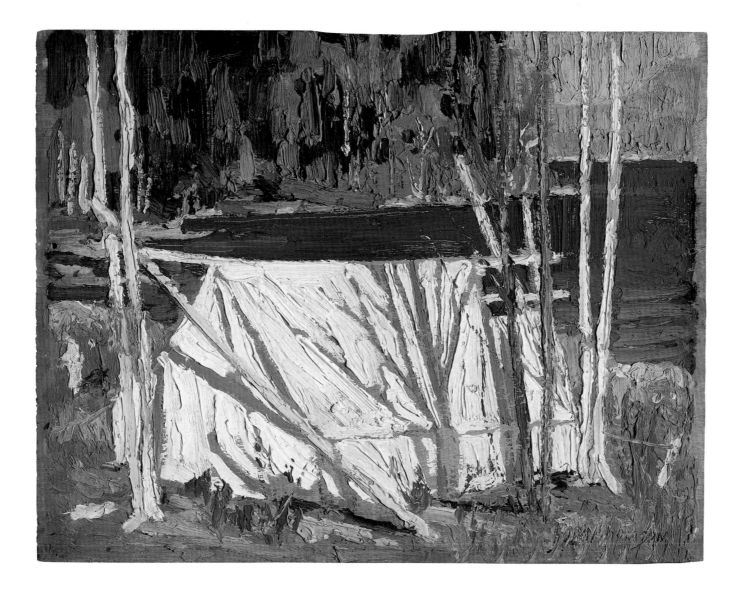

72 **The Tent** fall 1915
oil on wood, 21.6 x 26.7 cm
The McMichael Canadian Art Collection, Kleinburg, Ontario, purchase 1979 (1979.18)

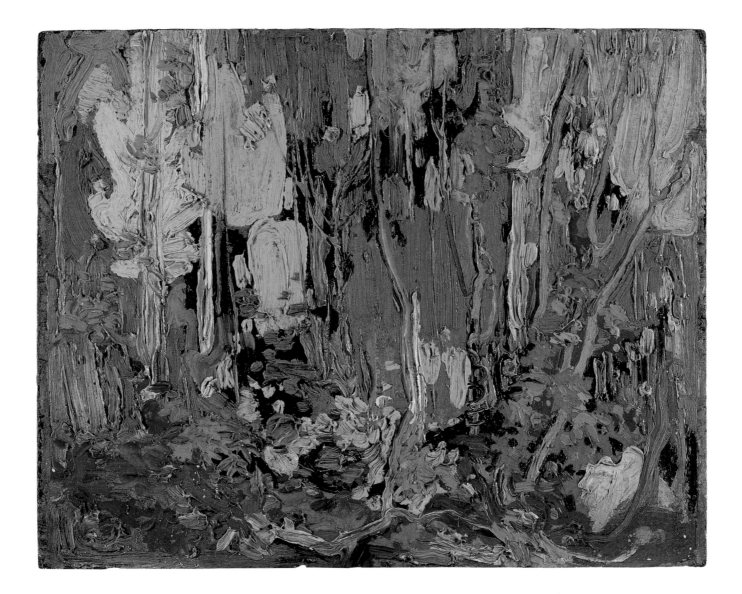

73 **Sketch for "Autumn's Garland"** fall or winter 1915
oil on composite wood-pulp board, 21.5 x 27.0 cm
The Thomson Collection (PC-163)

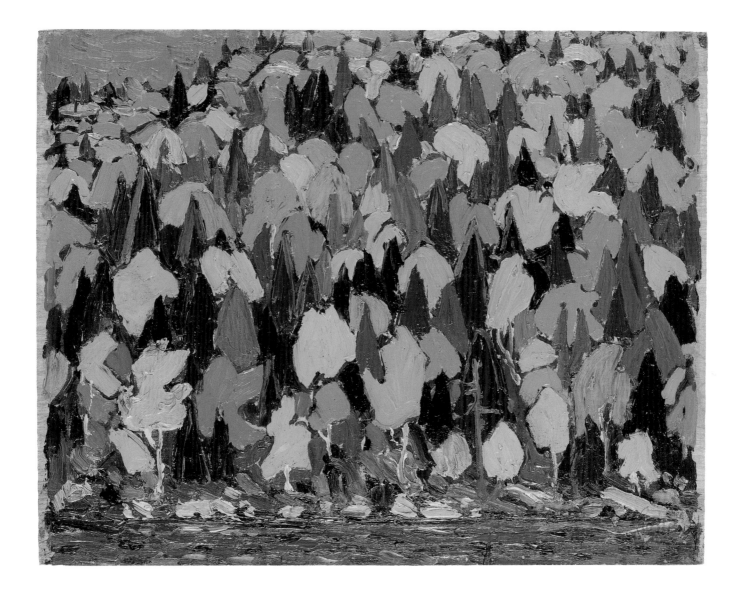

74 **Autumn Foliage** fall or winter 1915

oil on wood, 21.6 x 26.8 cm

Art Gallery of Ontario, Toronto, gift from the Reuben and Kate Leonard Canadian Fund, 1927 (852)

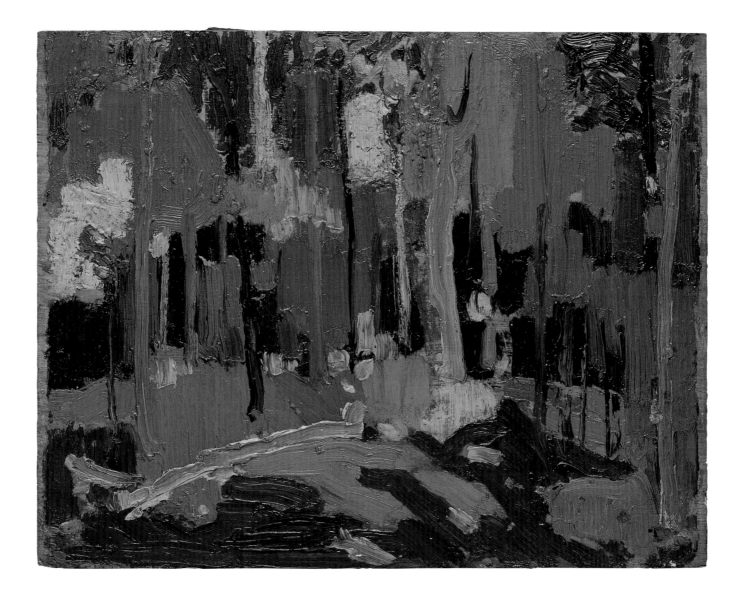

75 **Autumn Colour** fall or winter 1915
oil on wood, 21.4 x 26.7 cm
The McMichael Canadian Art Collection, Kleinburg, Ontario,
purchased with funds donated by R.A. Laidlaw, Toronto, 1970 (1970.6)

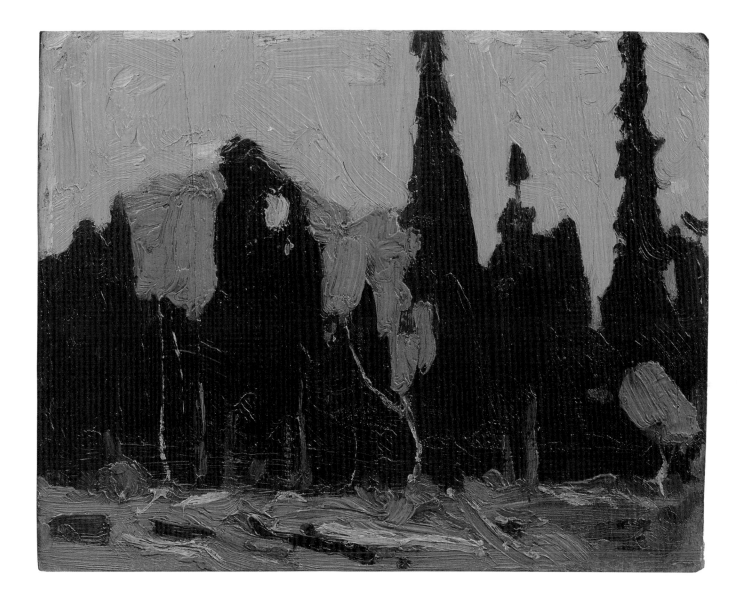

76 **Nocturne: Forest Spires** winter 1915
oil on plywood, 21.6 x 26.6 cm
Vancouver Art Gallery, presented in memory of Robert A. de Lotbinière-Harwood by his friends, 1952 (52.8)

77 **In the Northland** winter 1915
oil on canvas, 101.7 x 114.5 cm
The Montreal Museum of Fine Arts, gift of Friends of the Museum, 1922 (1922.179)

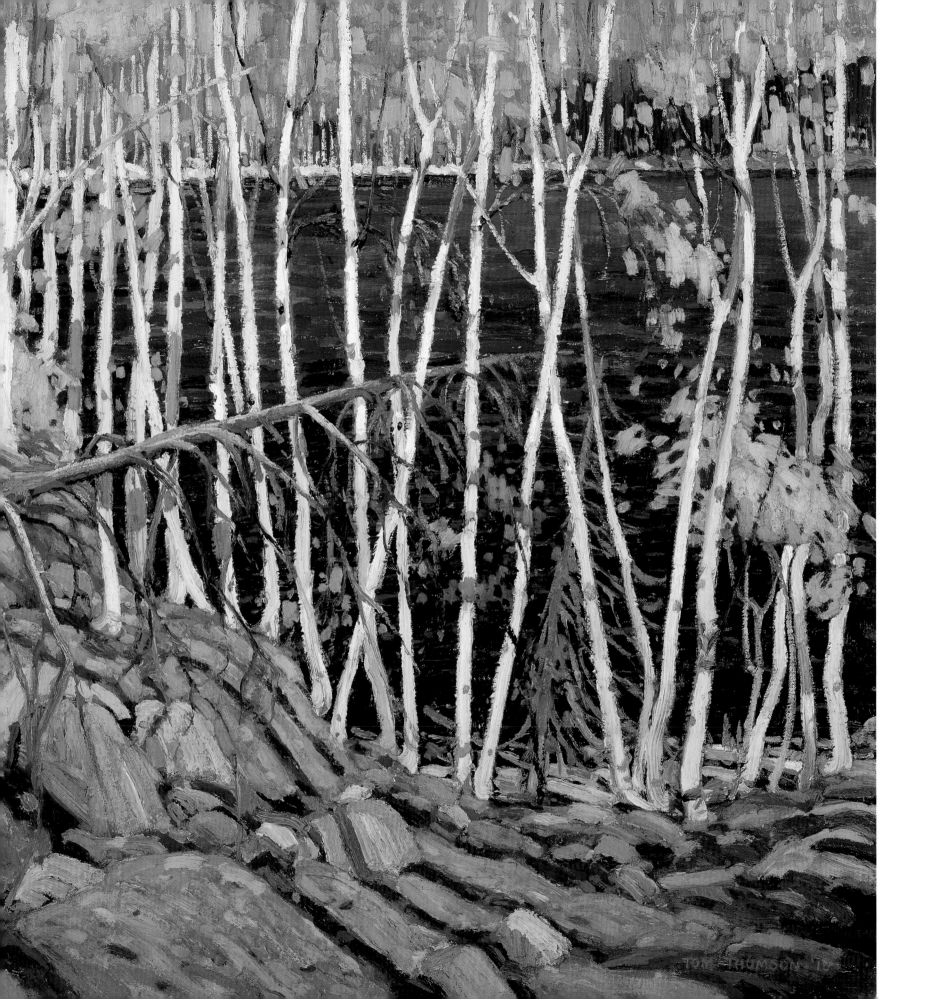

78 **The Birch Grove, Autumn** winter 1915–16
oil on canvas, 101.6 x 116.8 cm
Art Gallery of Hamilton, gift of Roy G. Cole, Hamilton, in memory of his parents,
Matthew and Annie Bell Gilmore Cole, 1967 (1967.112.2)

79 **Autumn's Garland** winter 1915–16
oil on canvas, 122.5 x 132.2 cm
National Gallery of Canada, Ottawa, purchase 1918 (1520)

80 **Spring Ice** winter 1915–16
oil on canvas, 72.0 x 102.3 cm
National Gallery of Canada, Ottawa, purchase 1916 (1195)

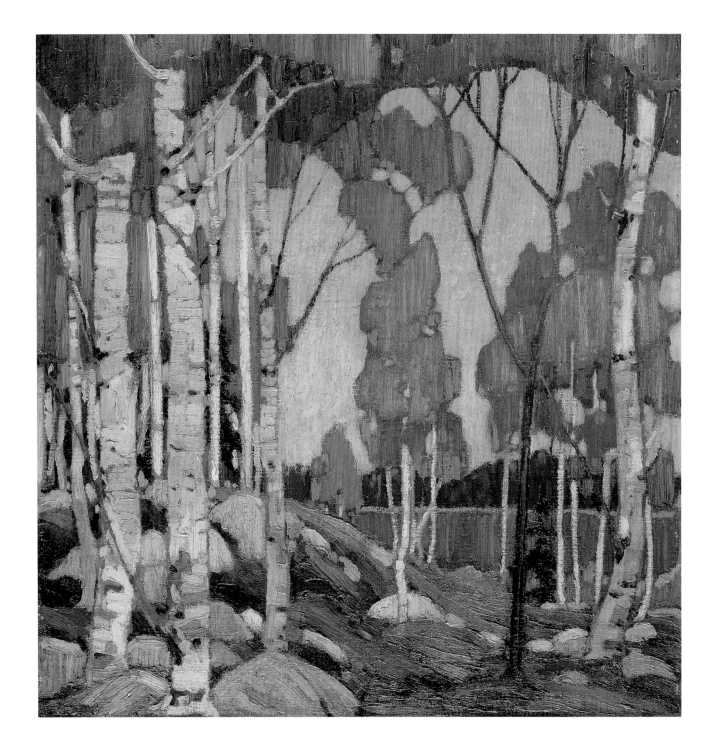

81 **Decorative Landscape: Birches** winter 1915–16

oil on canvas, 77.1 x 72.1 cm

National Gallery of Canada, Ottawa, bequest of Dr. J.M. MacCallum, Toronto, 1944 (4724)

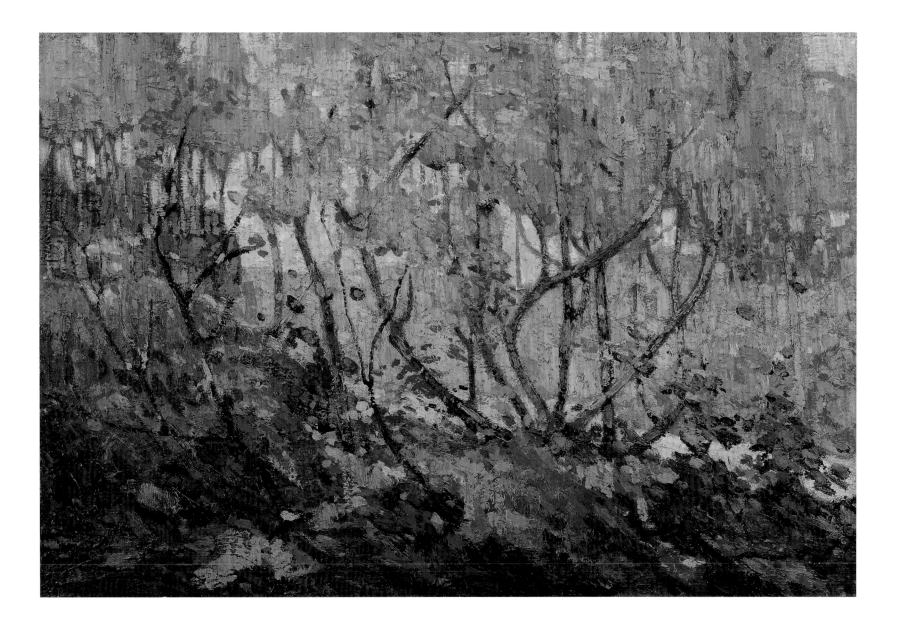

82 **Opulent October** winter 1915–16
oil on canvas, 54.0 x 77.3 cm
Private collection

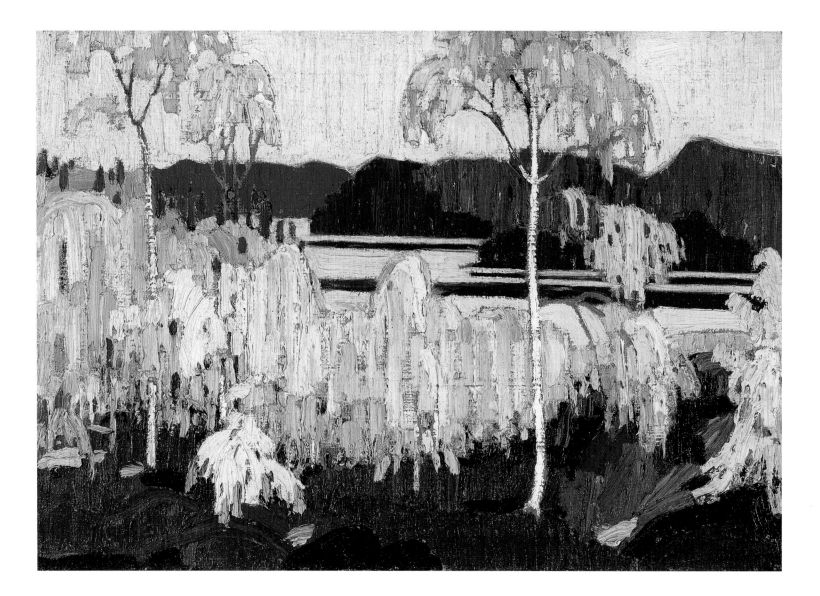

83 **After the Sleet Storm** winter 1915–16
oil on canvas, 40.9 x 56.2 cm
The Thomson Collection (PC-733)

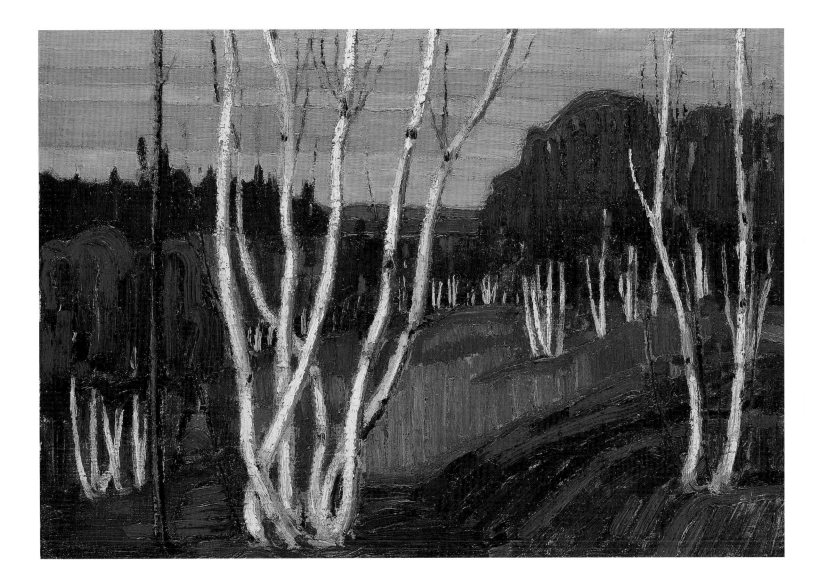

84 **Silver Birches** winter 1915–16
oil on canvas, 40.9 x 56.0 cm
The McMichael Canadian Art Collection, Kleinburg, Ontario,
gift of Colonel R.S. McLaughlin, Oshawa, 1968 (1968.7.12)

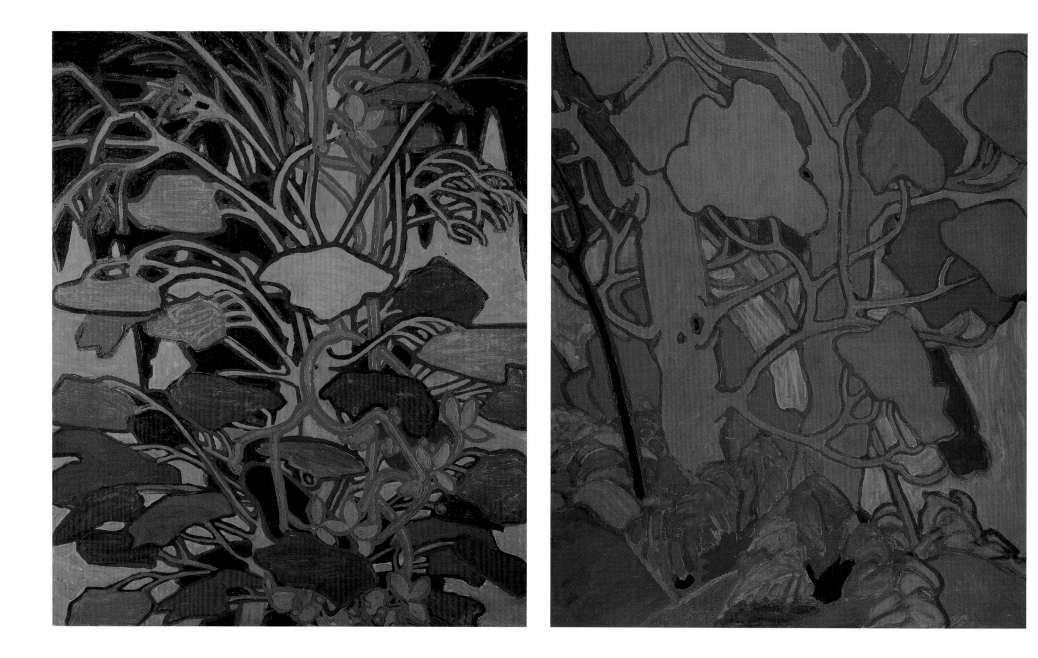

85 **Decorative Panels (I–IV)** winter 1915–16
oil on Beaverboard, 120.8 x 96.4 cm each
National Gallery of Canada, Ottawa, bequest of Dr. J.M. MacCallum, Toronto, 1944 (4717–20)

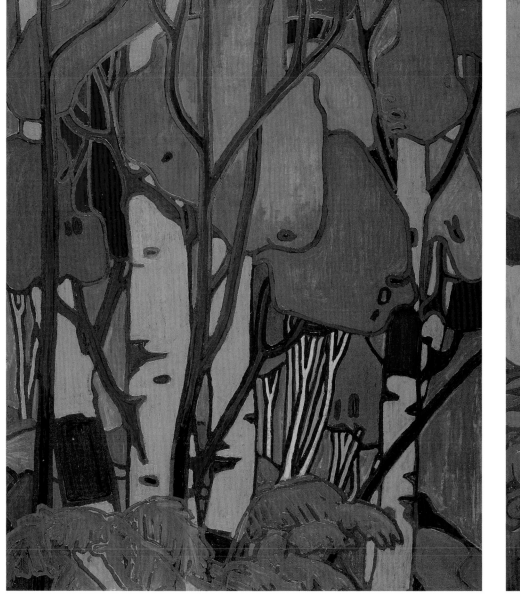

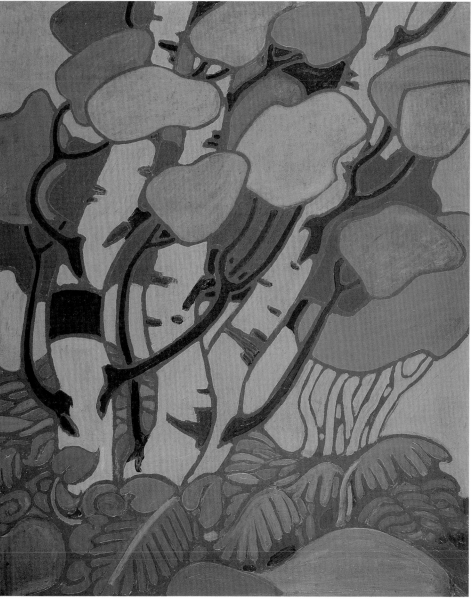

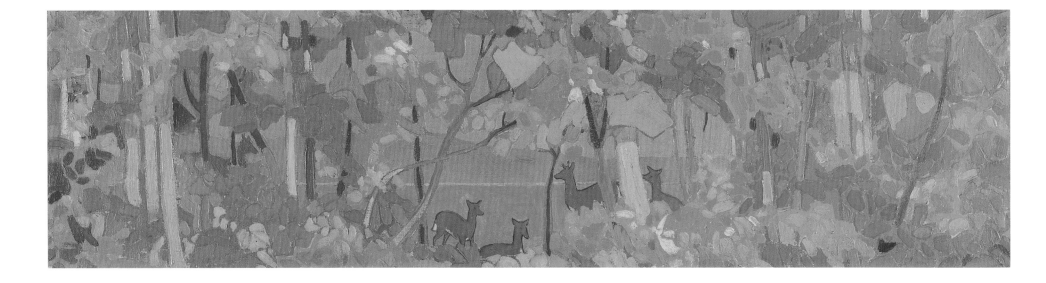

86 **Decoration: Autumn Landscape** winter 1915–16

oil on canvas, 31.1 x 113.0 cm

Private collection

87 **Decorated Pannikin** c. 1915
oil on enamelled metal pannikin, 7.9 x 23.8 cm diameter
National Gallery of Canada, Ottawa, purchase 1936 (7924)

88 **Decorated Demijohn** c. 1915
oil on stoneware, 55.0 x 30.5 x 28.0 cm diameter
Art Gallery of Ontario, Toronto, purchase 2001 (2001/92)

89 Decorative Mat for a Photograph of a Painting by Curtis Williamson c. 1915
pen and ink, watercolour, oil and gouache on wove paper, 24.3 x 21.2 cm
Art Gallery of Ontario, Toronto, purchase 2001 (2001/90)

90 **Decorative Landscape: Quotation from Ella Wheeler Wilcox** c. 1916
pen and ink, graphite, watercolour and gouache on illustration board, 36.7 x 27.0 cm
Private collection

245

91 **Spring Woods** spring 1916
oil on composite wood-pulp board, 21.7 x 26.9 cm
Alan O. Gibbons

92 **Winter Hillside, Algonquin Park** spring 1916
oil on wood, 21.2 x 27.0 cm
The Thomson Collection (PC-469)

93 **Snow Bank** spring 1916
oil on composite wood-pulp board, 21.7 x 26.7 cm
University College Art Collection, University of Toronto Art Centre,
gift of Elizabeth Jaques Winegard and the Honourable Dr. William C. Winegard, Guelph, Ontario, 1997 (UC 531)

94 **March** spring 1916
oil on wood, 26.9 x 21.4 cm
National Gallery of Canada, Ottawa, bequest of Dr. J.M. MacCallum, Toronto, 1944 (4699)

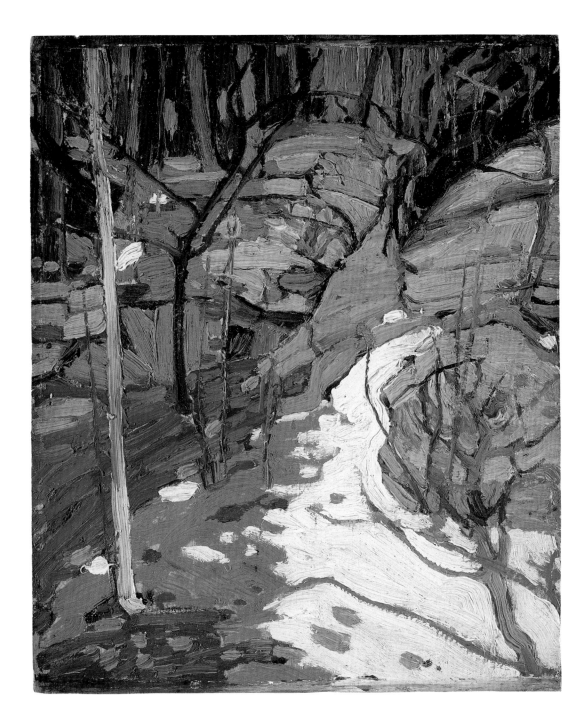

95 **Snow and Rocks** spring 1916
oil on wood, 26.8 x 21.5 cm
National Gallery of Canada, Ottawa, bequest of Dr. J.M. MacCallum, Toronto, 1944 (4695)

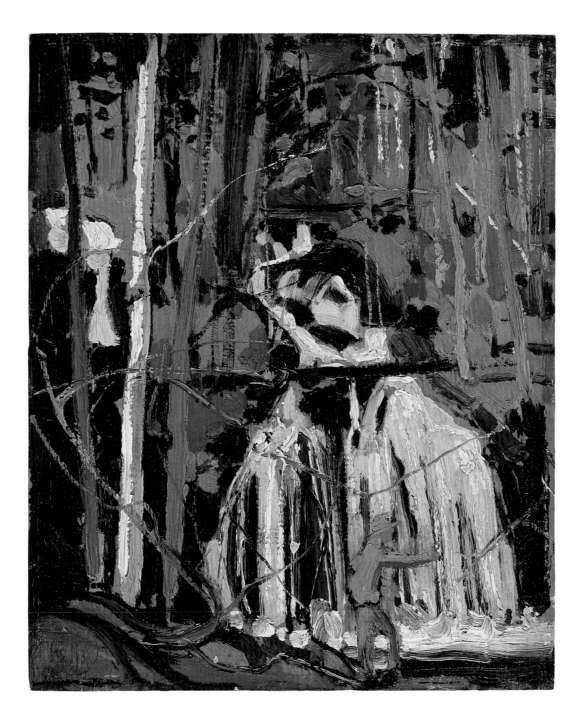

96 **Little Cauchon Lake** spring 1916
oil on wood, 26.6 x 21.4 cm
National Gallery of Canada, Ottawa, bequest of Dr. J.M. MacCallum, Toronto, 1944 (4681)

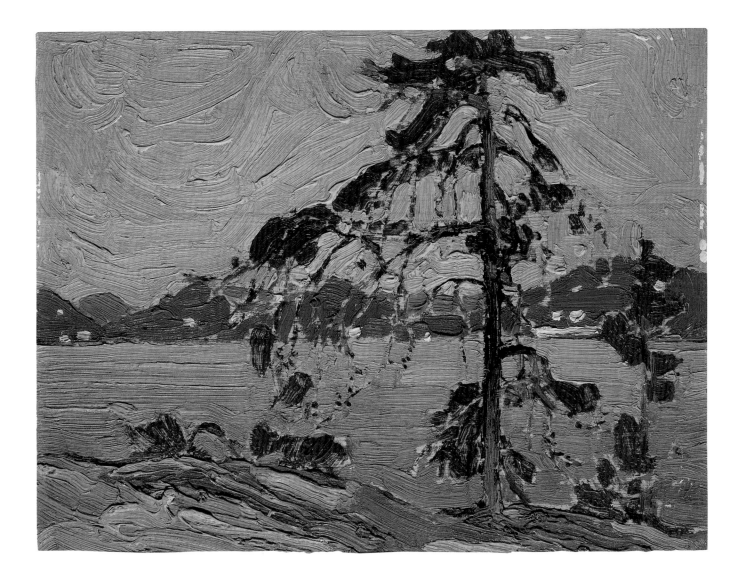

97 **Sketch for "The Jack Pine"** spring 1916
oil on wood, 21.0 x 26.7 cm
The Weir Foundation, RiverBrink, Queenston, Ontario, purchase 1947 (982.65)

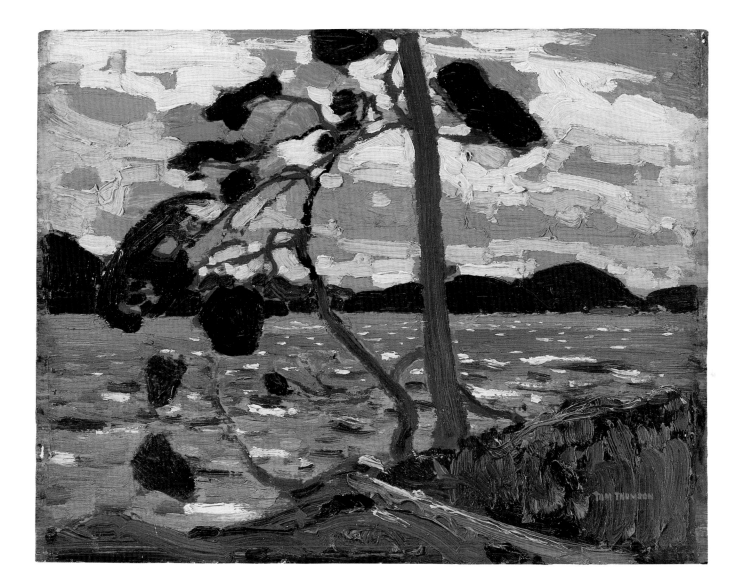

98 **Sketch for "The West Wind"** spring 1916
oil on wood, 21.4 x 26.8 cm
Art Gallery of Ontario, Toronto, gift from the J.S. McLean Collection, Toronto, 1969,
donated by the Ontario Heritage Foundation, 1988 (L69.49)

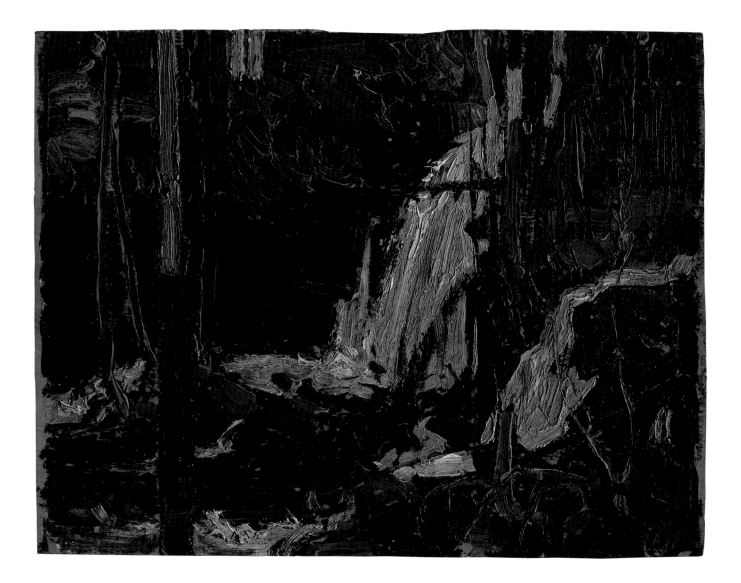

99 **The Waterfall** spring 1916
oil on wood, 21.1 x 26.7 cm
Vancouver Art Gallery, presented in memory of
Robert A. de Lotbinière-Harwood by his friends, 1952 (52.9)

254

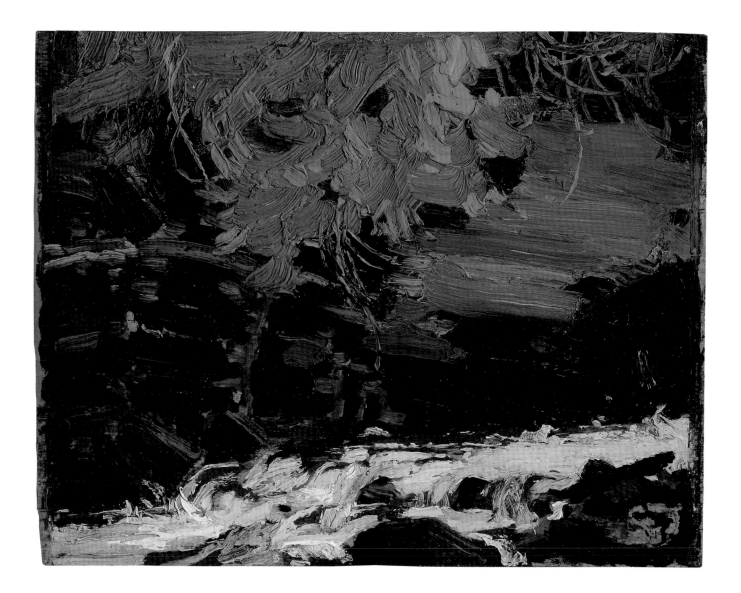

100 **Spring Foliage on the Muskoka River** spring 1916
oil on wood, 21.5 x 26.7 cm
The McMichael Canadian Art Collection, Kleinburg, Ontario,
purchased with funds donated by R.A. Laidlaw, Toronto, 1969 (1970.1.3)

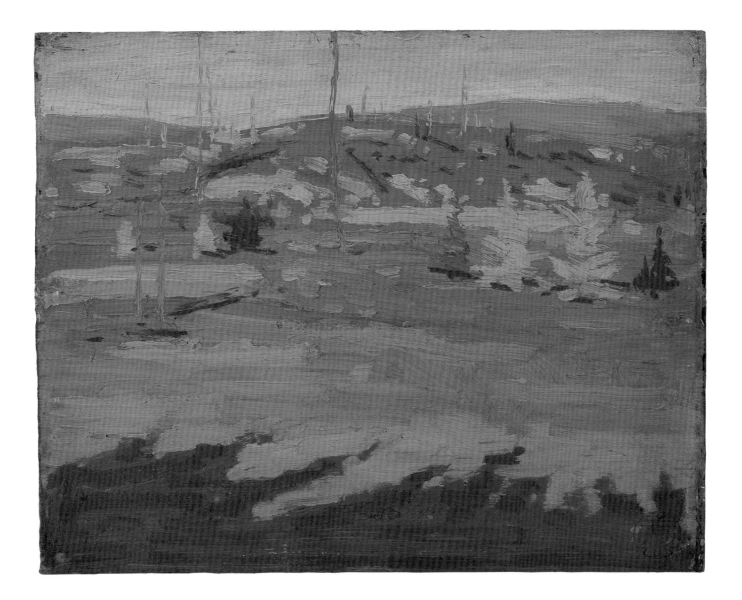

101 **Cranberry Marsh and Hill** spring 1916
oil on wood, 21.9 x 26.7 cm
Art Gallery of Hamilton, purchase 1953 (1953.112.E)

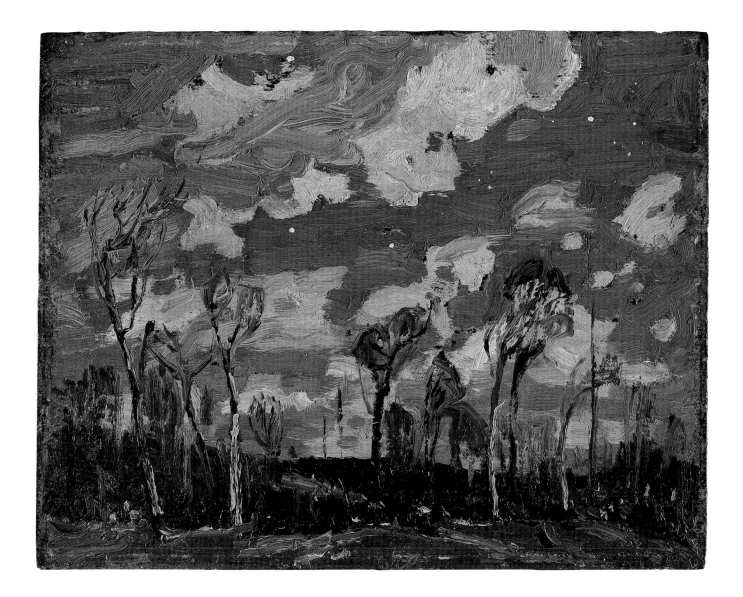

102 **Nocturne: The Birches** spring 1916
oil on composite wood-pulp board, 21.6 x 26.8 cm
National Gallery of Canada, Ottawa, bequest of Dr. J.M. MacCallum, Toronto, 1944 (4711)

103 **Spring, Canoe Lake** spring 1916
oil on wood, 21.6 x 26.8 cm
The Thomson Collection (PC-636)

104 **Yellow Sunset** spring or summer 1916
oil on wood, 21.3 x 26.7 cm
National Gallery of Canada, Ottawa, bequest of Dr. J.M. MacCallum, Toronto, 1944 (4684)

105 **Rocky Shore** summer or fall 1916
oil on wood, 21.4 x 26.5 cm
National Gallery of Canada, Ottawa, purchase 1918 (1535)

106 **Bateaux** summer 1916
oil on wood, 21.5 x 26.8 cm
Art Gallery of Ontario, Toronto, gift from the Reuben and Kate Leonard Canadian Fund, 1927 (853)

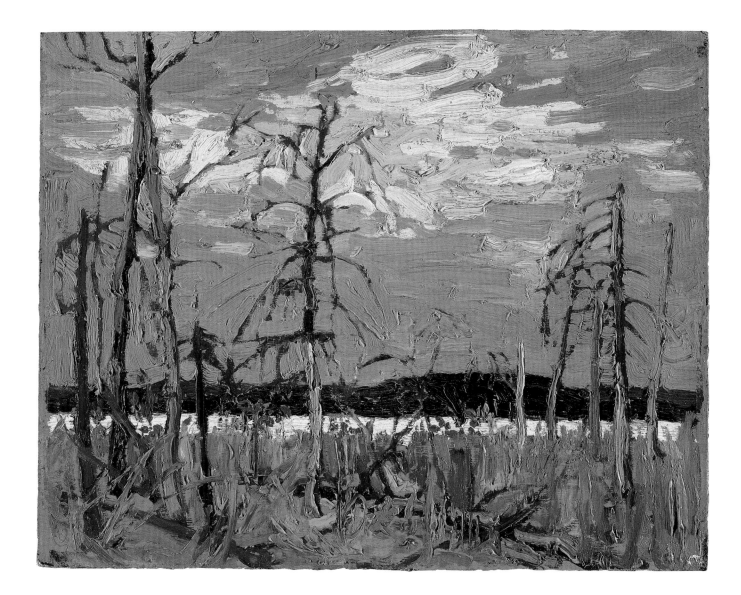

107 **Tamarack Swamp** fall 1916
oil on composite wood-pulp board, 21.4 x 26.7 cm
National Gallery of Canada, Ottawa, purchase 1918 (1534)

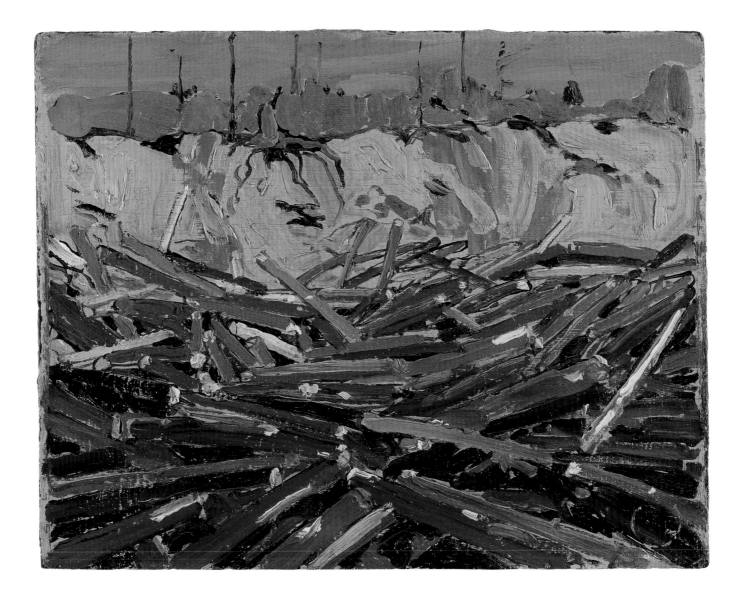

108 **Sandbank with Logs** summer or fall 1916
oil on composite wood-pulp board, 21.3 x 26.3 cm
The Thomson Collection (PC-840)

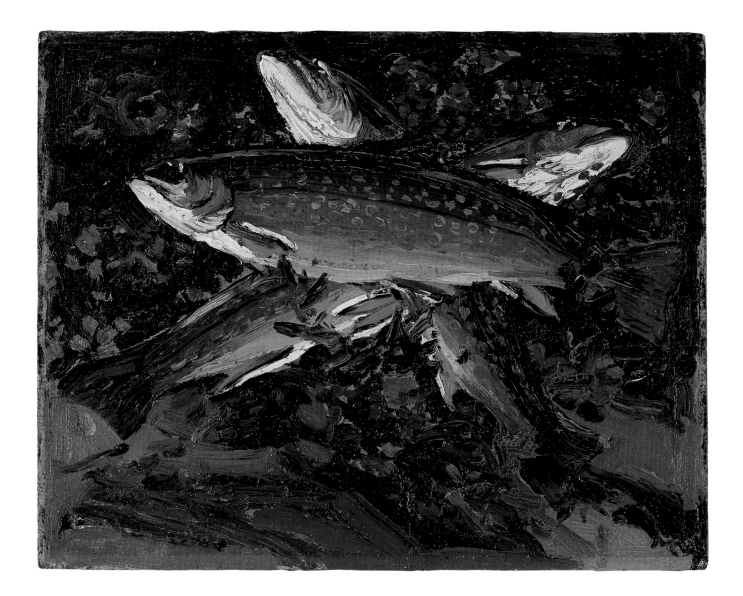

109 **Autumn, Three Trout** fall 1916
oil on composite wood-pulp board, 21.6 x 26.7 cm
The Thomson Collection (PC-966)

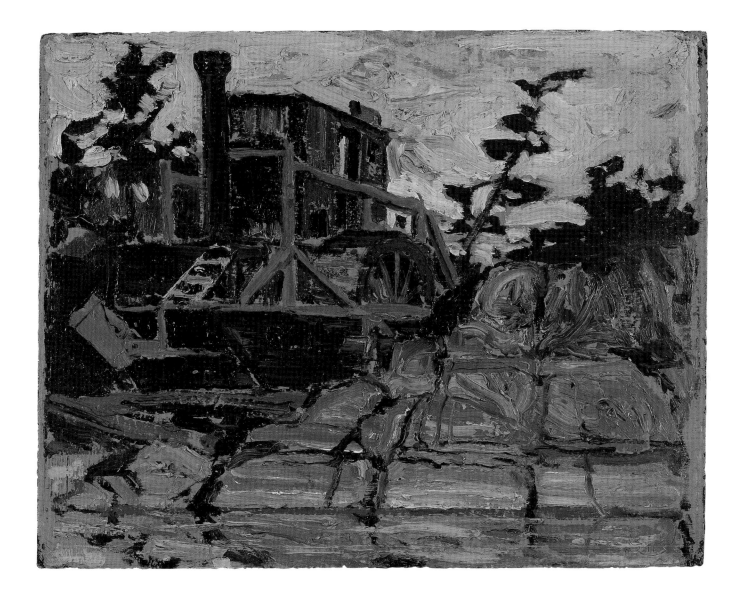

110 **The Alligator, Algonquin Park** summer or fall 1916
oil on composite wood-pulp board, 21.5 x 26.8 cm
University of Guelph Collection, Macdonald Stewart Art Centre, Guelph, Ontario, bequest of Stewart and Letty Bennett,
Georgetown, Ontario, 1982, donated by the Ontario Heritage Foundation, 1988 (UG989.096)

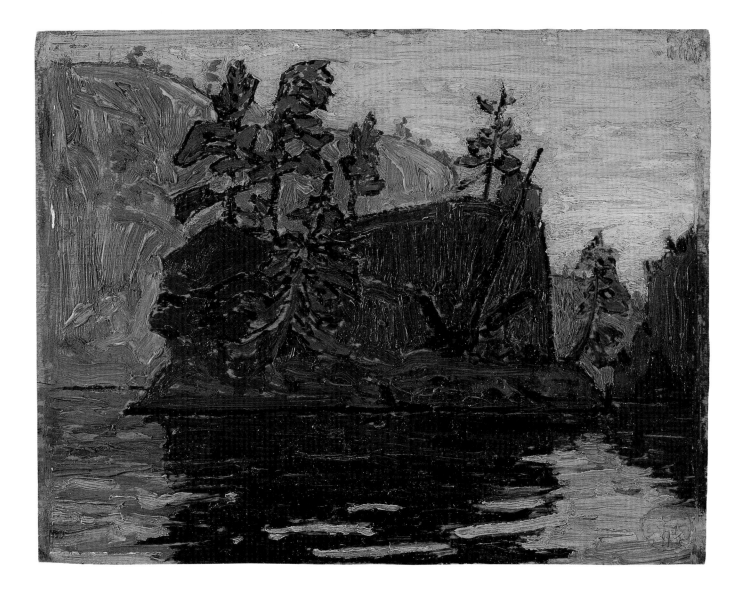

111 **Petawawa Gorges** fall 1916
oil on wood, 21.5 x 26.8 cm
Art Gallery of Ontario, Toronto, gift of Miss Hilda Harkness, Ottawa, 1983 (84/40)

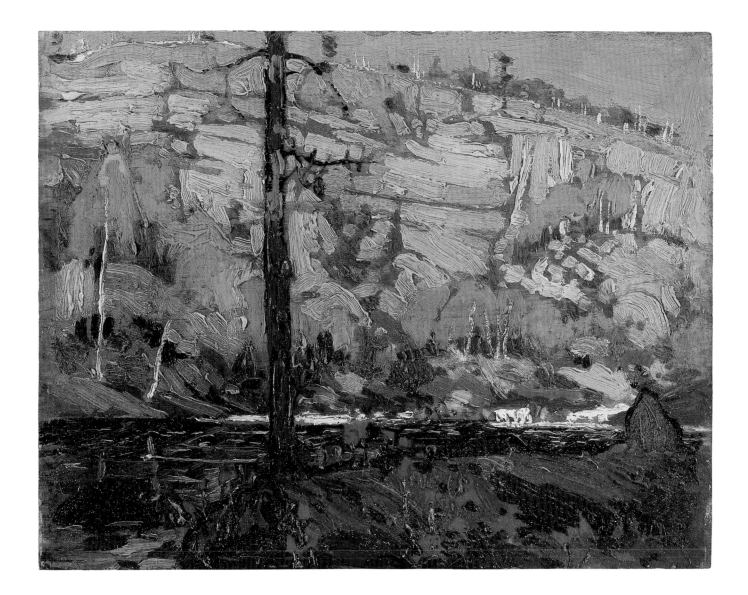

112 **Autumn, Petawawa** fall 1916
oil on wood, 21.5 x 26.8 cm
The Thomson Collection (PC-814)

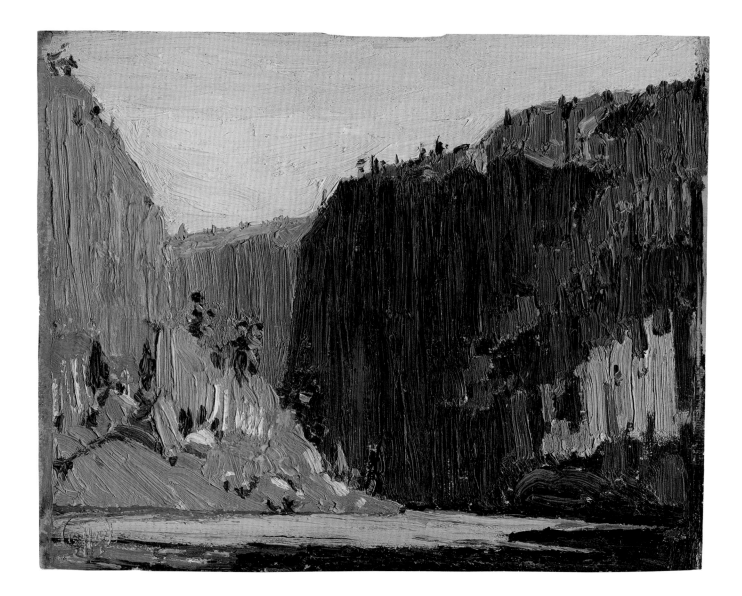

113 **Petawawa Gorges** fall 1916
oil on wood, 21.5 x 26.6 cm
The McMichael Canadian Art Collection, Kleinburg, Ontario,
purchased with funds donated by Major F.A. Tilston, V.C., Toronto, 1981 (1981.9.2)

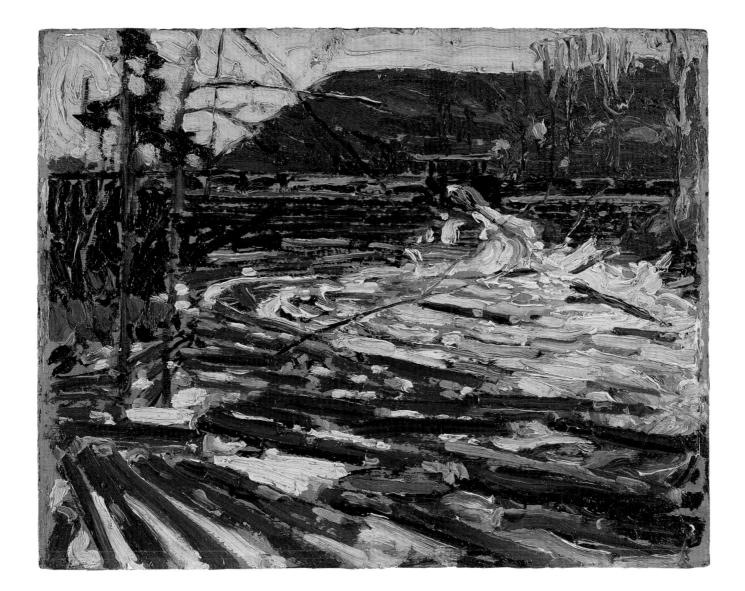

114 **Log Jam: Sketch for "The Drive"** fall 1916
oil on composite wood-pulp board, 21.8 x 26.8 cm
The Thomson Collection (PC-162)

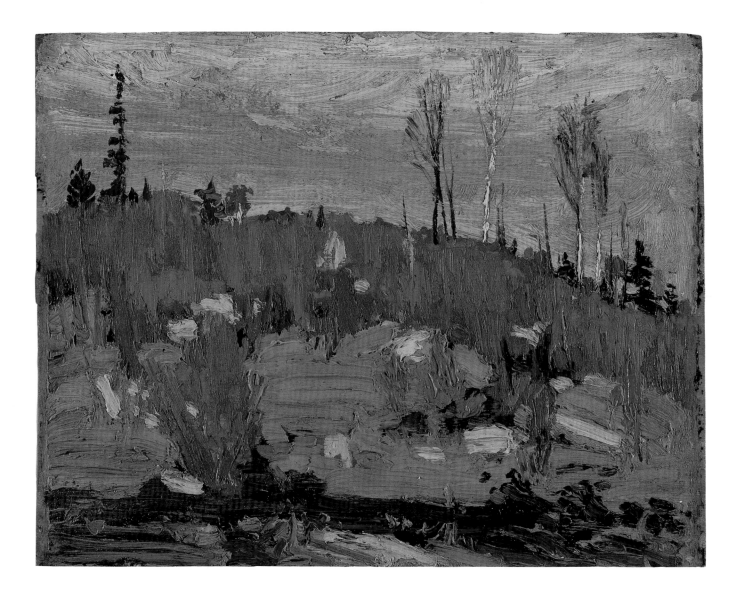

115 **The Sumacs** fall 1916
oil on wood, 21.3 x 26.6 cm
The McMichael Canadian Art Collection, Kleinburg, Ontario, purchase 1980 (1981.19)

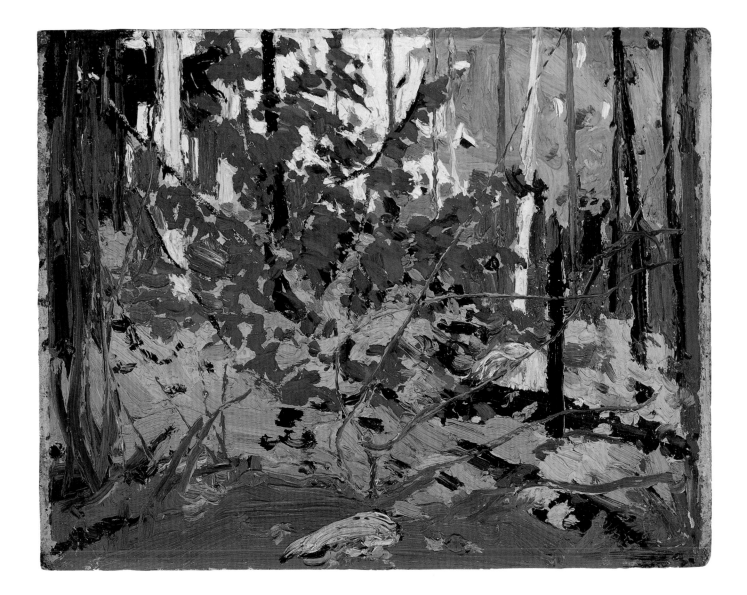

116 **Red Sumac** fall 1916
oil on composite wood-pulp board, 21.6 x 26.7 cm
Tom Thomson Memorial Art Gallery, Owen Sound, Ontario,
gift of Mr. and Mrs. J.G. Henry, Toronto, in memory of Mrs. William Henry, 1968 (968.001)

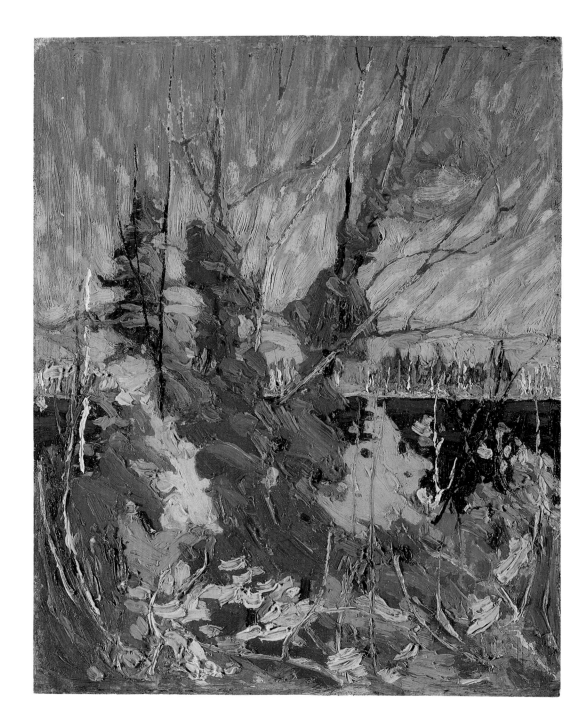

117 **Autumn Foliage** fall 1916
oil on wood, 26.7 x 21.5 cm
National Gallery of Canada, Ottawa, purchase 1918 (1544)

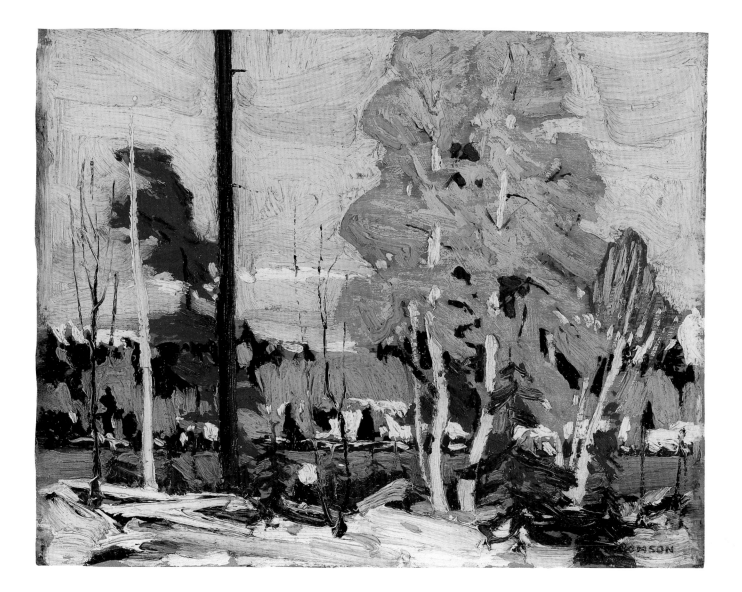

118 **Near Grand Lake, Algonquin Park** fall 1916
oil on wood, 21.6 x 26.7 cm
The Thomson Collection (PC-569)

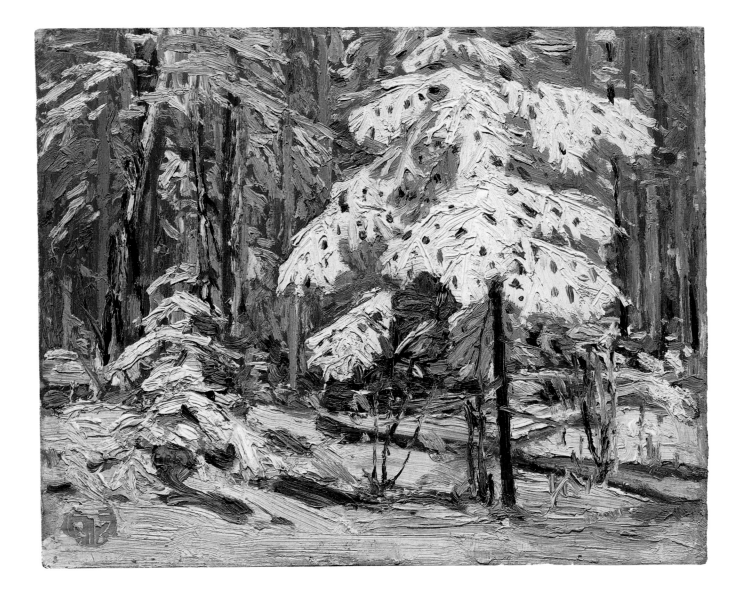

119 **Snow in the Woods** fall 1916

oil on wood, 21.9 x 27.0 cm

The McMichael Canadian Art Collection, Kleinburg, Ontario,

purchased with Funds donated by R.A. Laidlaw, Toronto, 1971 (1981.78.1)

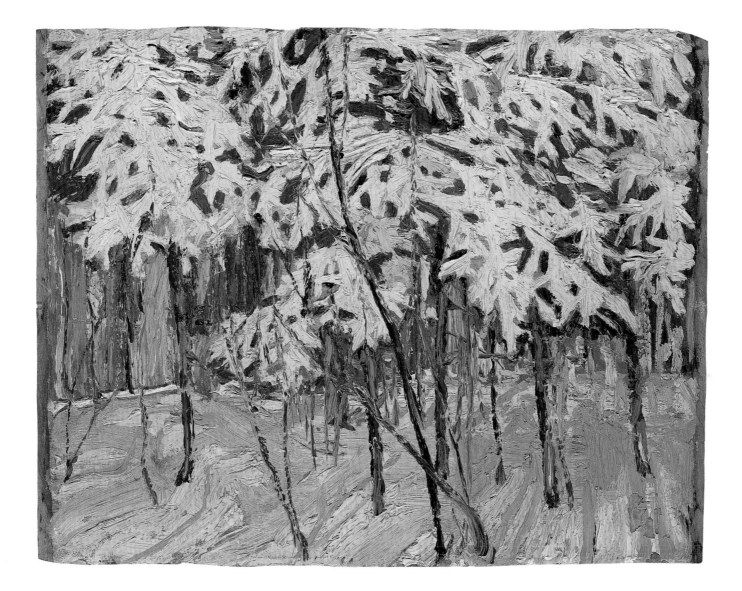

120 **Snow-Covered Trees** fall 1916
oil on wood, 20.6 x 26.0 cm
National Gallery of Canada, Ottawa, bequest of Vincent Massey, 1968 (15547r)

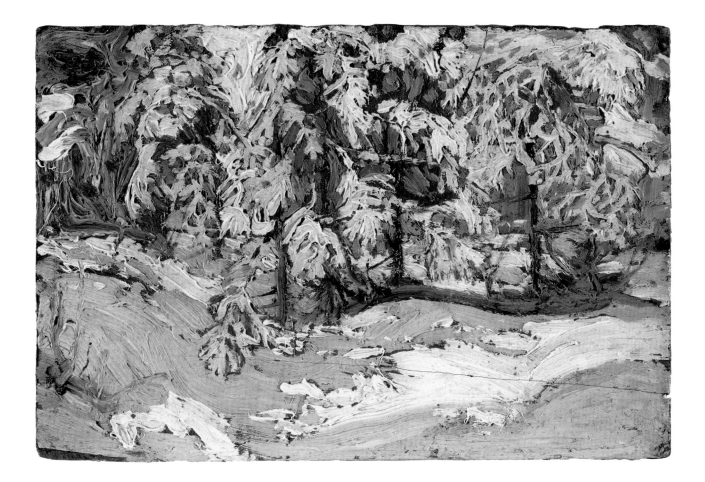

121 **First Snow in Autumn** fall 1916
oil on wood, 12.8 x 18.2 cm
National Gallery of Canada, Ottawa, bequest of Dr. J.M. MacCallum, Toronto, 1944 (4670)

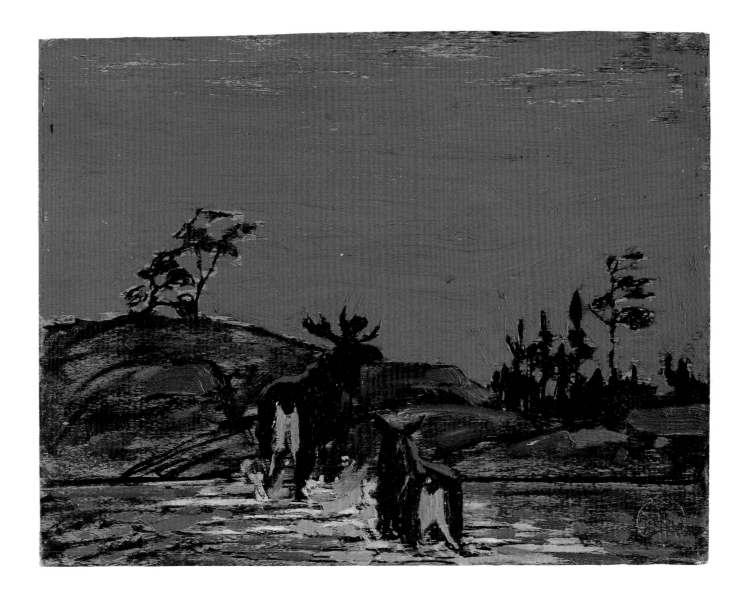

122 **Moose at Night** winter 1916
oil on wood, 20.9 x 26.9 cm
National Gallery of Canada, Ottawa, purchase 1918 (1545)

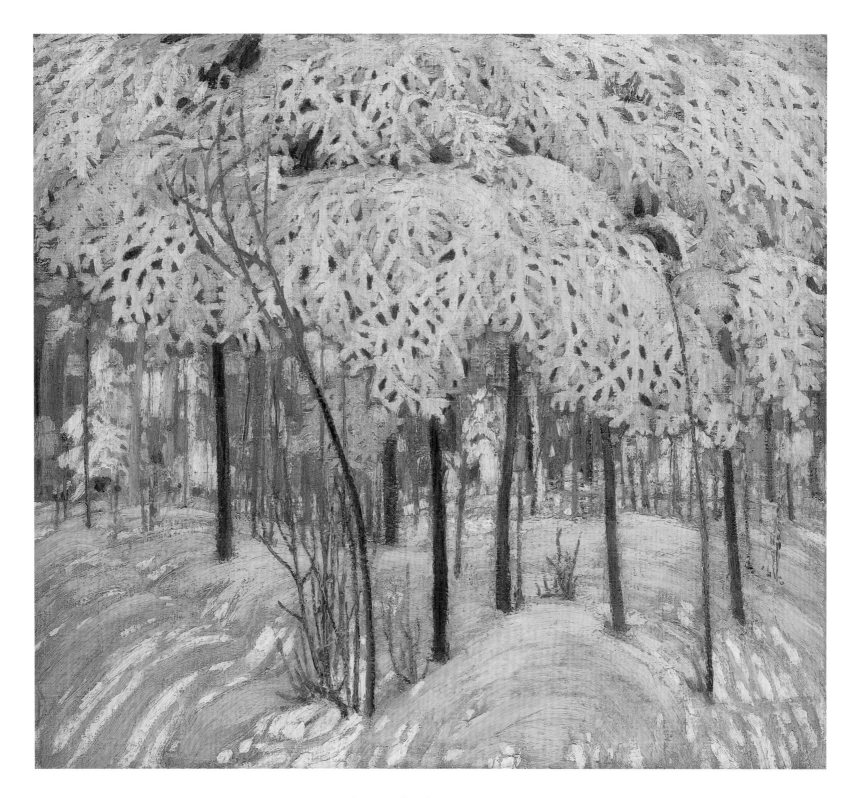

123 **Snow in October** winter 1916–17
oil on canvas, 81.2 x 87.8 cm
National Gallery of Canada, Ottawa, bequest of Dr. J.M. MacCallum, Toronto, 1944 (4722)

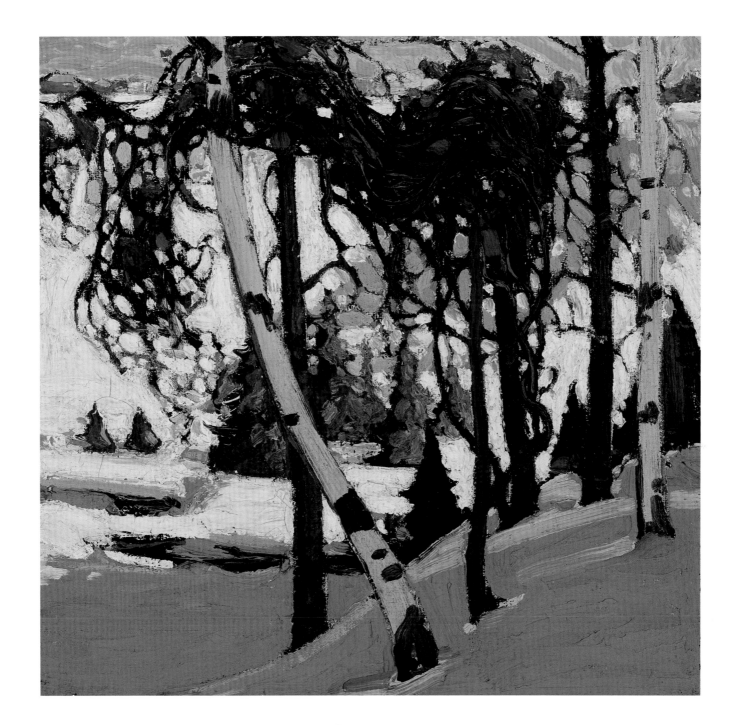

124 **Early Snow** winter 1916–17

oil on canvas, 45.5 x 45.5 cm

Winnipeg Art Gallery, acquired with the assistance of a grant from the Government of Canada, through the Canadian Cultural Property Import and Export Act, and with contributions by The Winnipeg Foundation, The Thomas Sill Foundation Inc., The Winnipeg Art Gallery Foundation Inc., Mr. and Mrs. G.B. Wiswell Fund, DeFehr Foundation Inc., Loch and Mayberry Fine Art Inc., and several anonymous donors, 2000 (2000-1)

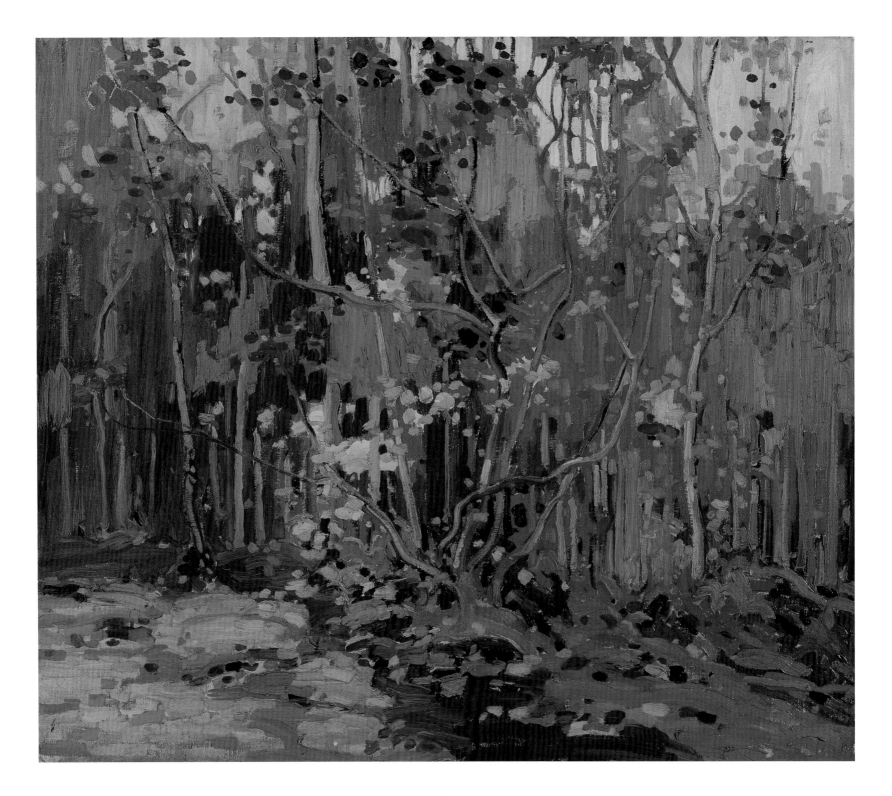

125 **Maple Saplings, October** winter 1916–17
oil on canvas, 91.5 x 102.3 cm
The Thomson Collection (PC-735)

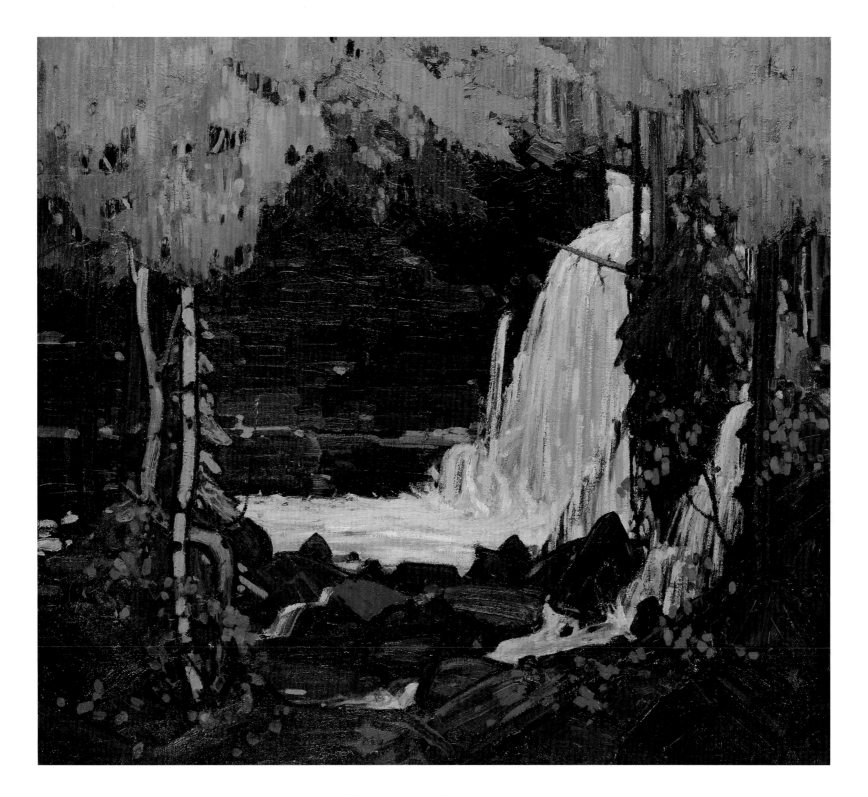

126 **Woodland Waterfall** winter 1916–17
oil on canvas, 121.9 x 132.5 cm
The McMichael Canadian Art Collection, Kleinburg, Ontario,
purchased with funds donated by the W. Garfield Weston Foundation, 1977 (1977.48)

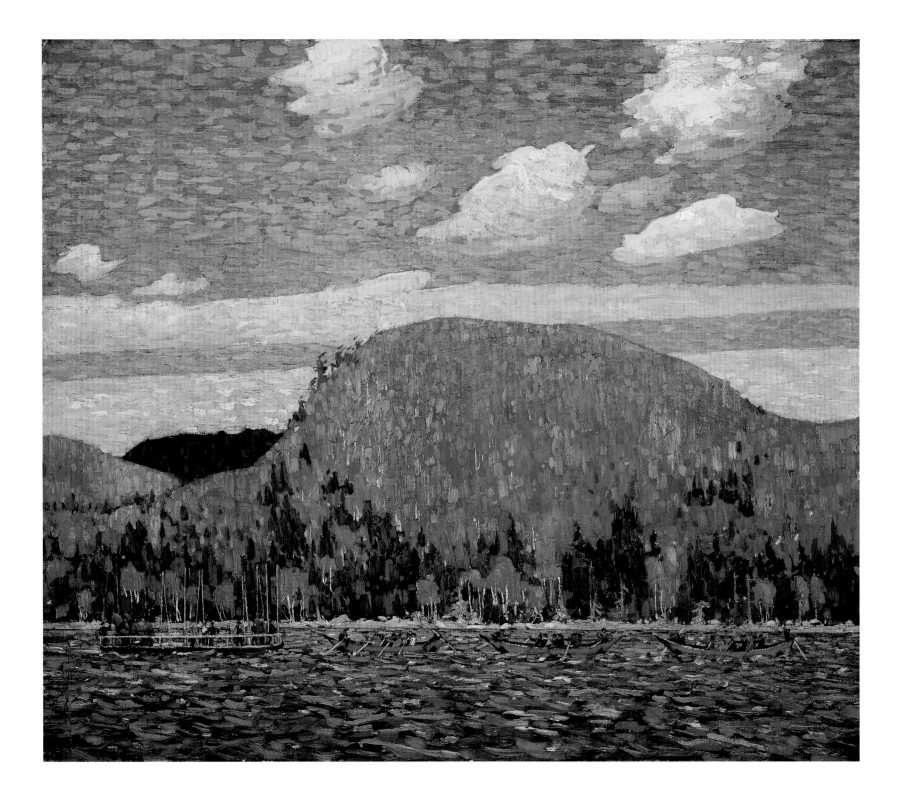

127 **The Pointers** winter 1916–17
oil on canvas, 101.0 x 114.6 cm
Hart House Permanent Collection, University of Toronto, purchase 1928–29

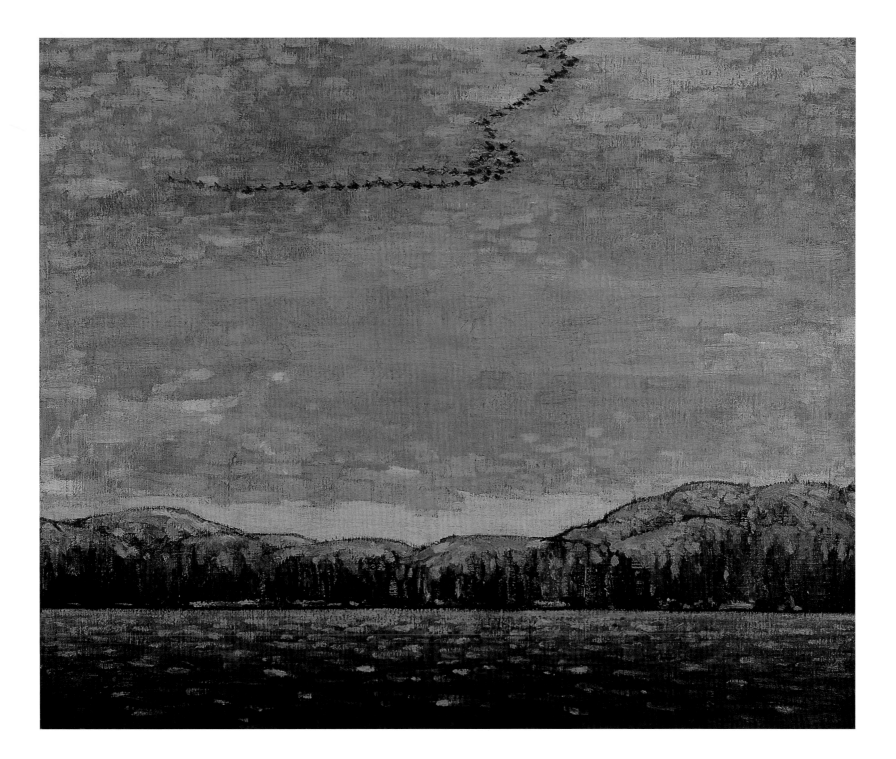

128 **Chill November** winter 1916–17
oil on canvas, 87.5 x 102.4 cm
Gallery Lambton, Sarnia, Ontario, gift of the Sarnia Women's Conservation Art Association, 1956 (56.26)

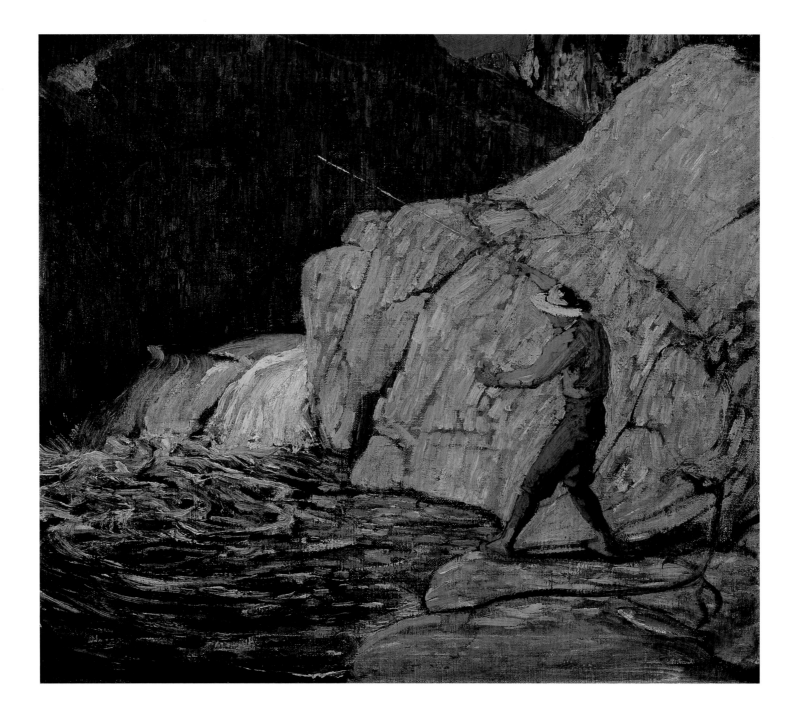

129 **The Fisherman** winter 1916–17
oil on canvas, 51.3 x 56.5 cm
Edmonton Art Gallery, gift of the Ernest E. Poole Foundation, 1975 (68.6.84)

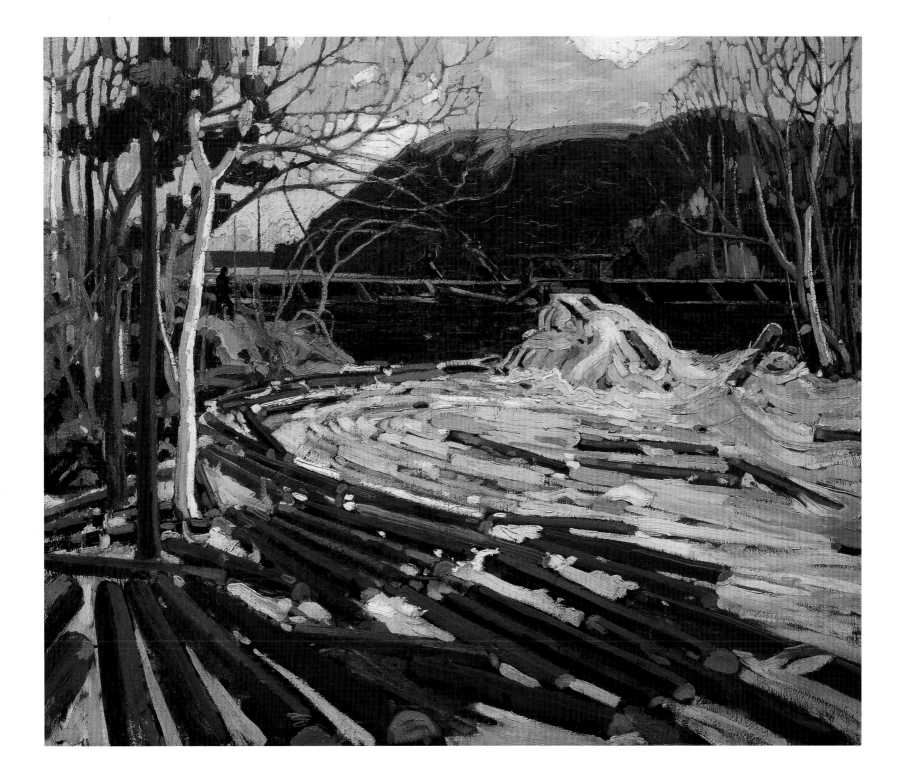

130 **The Drive** winter 1916–17
oil on canvas, 120.0 x 137.5 cm
University of Guelph Collection, Macdonald Stewart Art Centre, Guelph, Ontario,
Ontario Agricultural College purchase with funds raised by students, faculty and staff, 1926 (0.134)

131 **The West Wind** winter 1916–17
oil on canvas, 120.7 x 137.9 cm
Art Gallery of Ontario, Toronto, gift of the Canadian Club of Toronto, 1926 (784)

132 **The Jack Pine** winter 1916–17
oil on canvas, 127.9 x 139.8 cm
National Gallery of Canada, Ottawa, purchase 1918 (1519)

133 **Northern Lights** spring 1917
oil on plywood, 21.5 x 26.5 cm
Alan O. Gibbons

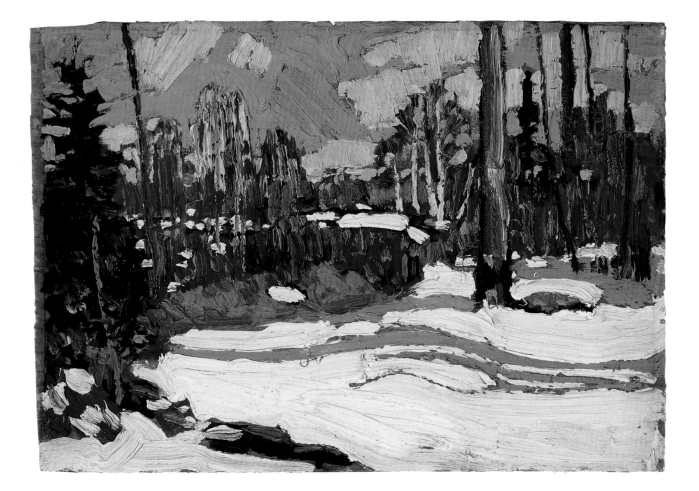

134 **Woods in Winter** spring 1917
oil on wood, 14.6 x 20.0 cm
Tom Thomson Memorial Art Gallery, Owen Sound, Ontario,
gift of Mrs. J.G. Henry, Saskatoon, 1967 (967.056)

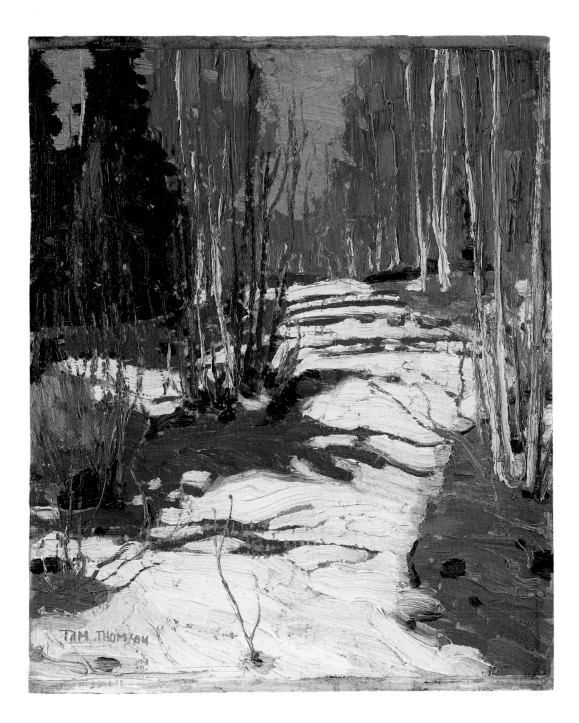

135 **Path Behind Mowat Lodge** spring 1917
oil on wood, 26.3 x 21.3 cm
The Thomson Collection (PC-774)

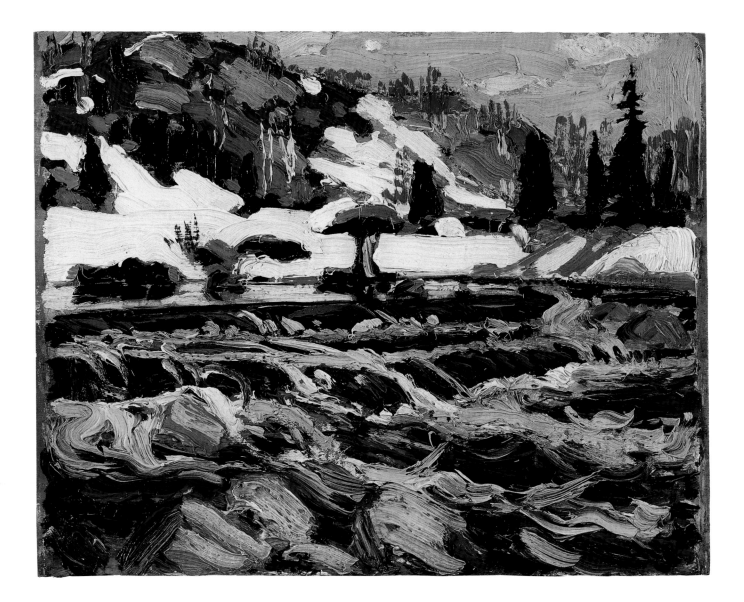

136 **The Rapids** spring 1917
oil on wood, 21.6 x 26.8 cm
The Thomson Collection (PC-809)

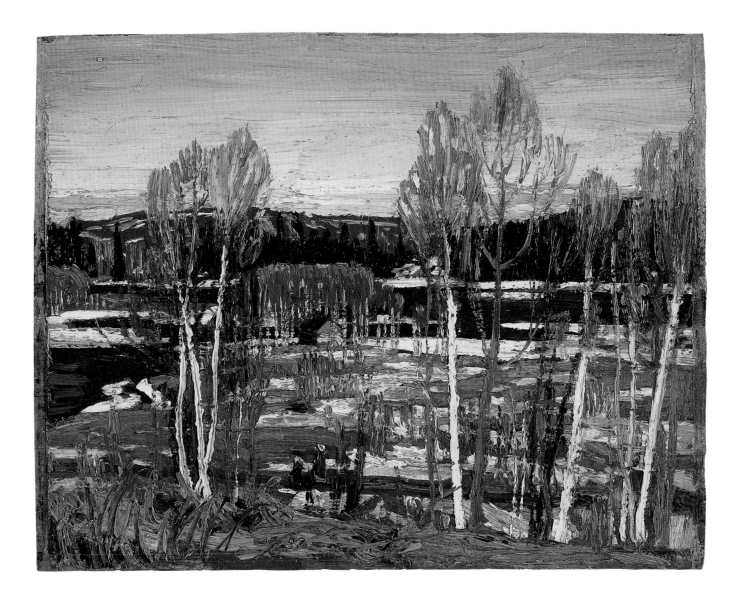

137 **Larry Dickson's Cabin** spring 1917
oil on wood, 21.3 x 26.6 cm
National Gallery of Canada, Ottawa, purchase 1918 (1528)

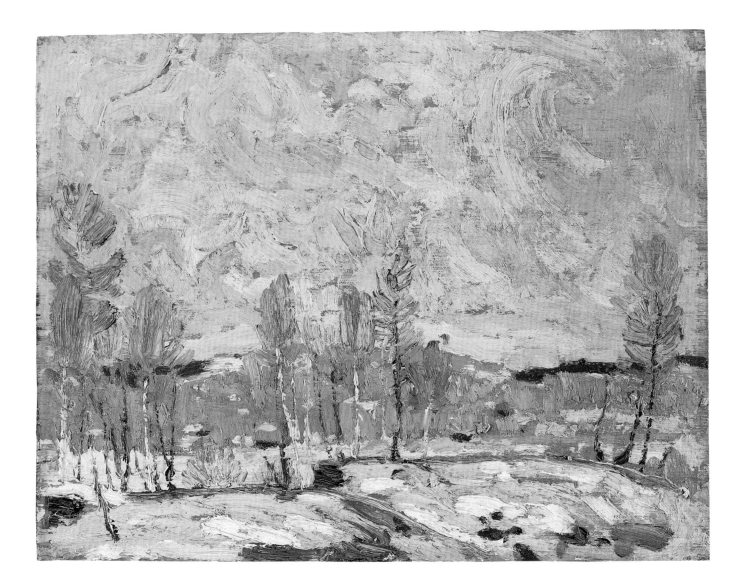

138 **Spring Flood** spring 1917
oil on wood, 21.6 x 26.8 cm
The McMichael Canadian Art Collection, Kleinburg, Ontario,
gift of R.A. Laidlaw, Toronto, 1965 (1966.15.23)

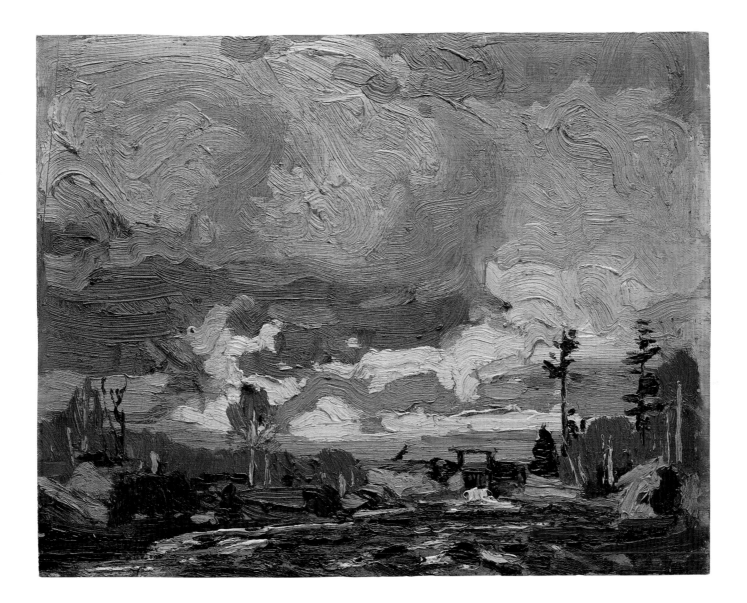

139 **Tea Lake Dam** summer 1917
oil on wood, 21.3 x 26.2 cm
The McMichael Canadian Art Collection, Kleinburg, Ontario,
purchased with funds donated by R.A. Laidlaw, Toronto, 1969 (1970.1.4)

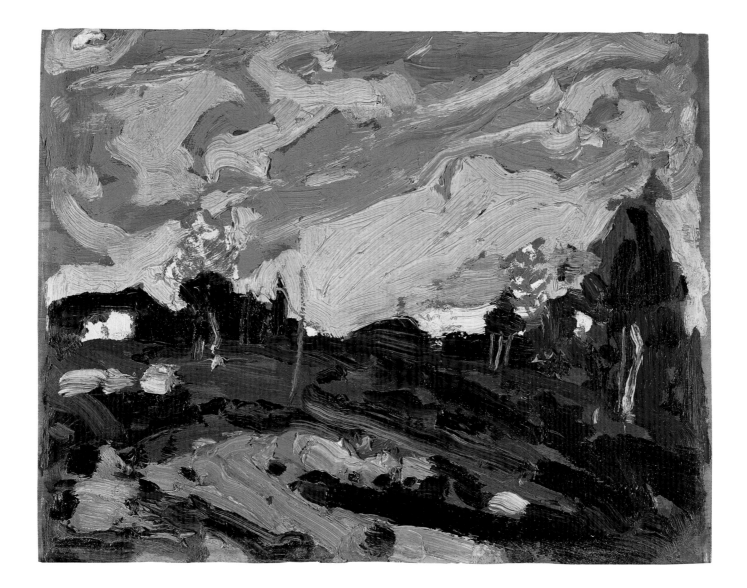

140 **After the Storm** summer 1917
oil on wood, 21.5 x 26.0 cm
Private collection

Tom Thomson's Letters

compiled by Joan Murray

Tom Thomson's spelling and punctuation have been retained.

—

[Fragment of a letter to the Harkness family in Annan, Ontario, c.1904 (Thomson's older sister Elizabeth married T.J. Harkness in 1892)]

when you write put in some news of how the bairns are and some of the happenings around Annan as I have not been supplied well of late with news from home.

With love to the household at Aldersyde, I remain / TT

Private collection, Toronto

—

[Postmarked October 17, 1912]
c/o W.S. Broadhead / 119 Summerhill Avenue, / Toronto

Dr. M.J. McRuer, / Huntsville, Ont

Hello Doc:

I have at last got back to civilization and came down by way of the Soo to Owen Sound so did not make a call at Huntsville as I said I might do.

We started in at Bisco and took a long trip on the lakes around there going up the Spanish River and over into the Mississauga [Mississagi] water we got a great many good snapshots of game

Figure 73 Fragment of a letter from Thomson, Seattle, to the Harkness family, Annan, Ontario, c.1904, with self-portrait smoking a pipe. Private collection, Toronto.

—mostly moose and some sketches, <u>but</u> we had a dump in the forty-mile rapids which is near the end of our trip and lost most of our stuff—we only saved 2 rolls of films out of about 14 dozen. Outside of that we had a peach of a time as the Mississauga is considered the finest canoe trip in the world.

Dr Hicks told me of a man who was through the trip last year and who had a fine lot of photos—will you ask him where to find that man and let me know.

The weather has been very rotten all through our trip never dry for more than 24 hours at a time and sometimes raining for a week steady.

How are you feeling? Did you have good fishing out at Jackson's this summer? I have to thank you people for the good time I had

297

while in Huntsville and hope that sometime we may have a fishing trip where the fish bite.

All the fishing there is up in the north country is pike and they are so thick there is no fun in it.

Hoping yourself, Mrs Mc. & Dr Hicks are well and everything lovely. I remain

Yours truly, / Tom Thomson

P.S. If Dr Hicks can remember that man with the photos he may save a life.

The McMichael Canadian Art Collection Archives, Kleinburg, Ontario

⤙

[Postmarked July 8, 1914] Tuesday night / Go Home P.O. / Georgian Bay, Ont. / c/o Dr. McCallum

Dear Fred:

This is only to be a short note. I am leaving here about the end of the week and back to the woods for summer. Am sorry I did not take your advice and stick to camping.

This place is getting too much like north Rosedale to suit me — all birthday cakes and water ice etc.

Will be over in Algonquin Park from about a week from today. Couldn't you and Mrs Varley come up and camp for a month or two. If you could get hold of a small tent about 4' x 7' or anything that I could sleep in, you people could use mine, which is about 7 x 10 and you would have lots of room. The one cooking outfit and canoe would be OK to get along with. Have not

made any sketches for a few weeks but feel like starting in again.

How is the weather down your way? Suppose it is some warm. It will be alright up in this country as you should smoke up and come. If you write me this week send here later to Mowat, Algonq. Park.

Say hello to Mrs Varley, Mrs Pinder Dorothy John and the fellows at the shop. Say, Fred, it will be fine to be camping again.

Tom Thomson

The Thomson Collection (PC-936)

⤙

Camp Mowat / J.S. Fraser / Mowat P.O., Canoe Lake Station, / Algonquin Park, Ontario / Mowat P.O., Ontario. Oct 6, 1914

Dr Jas MacCallum

Dear Dr —

I received your letter this morning and also your messages from Lismer. About the sketch if I could get 10 or $15 for it I should be greatly pleased but if they don't care to put in so much let it go for what they will give. The same applys to all the others except one with the rocks and water which would like to paint up.

Jackson & myself have been making quite a few sketches lately and I will send a bunch down with Lismer when he goes back. He & Varley are greatly taken with the look of things here, just now the maples are about all stripped of leaves now but the birches are very rich in color. We are all working away but the best I can do does not do the place much justice in the way of beauty.

Camp Mowat

J. S. FRASER

MOWAT P.O., CANOE LAKE STATION,
ALGONQUIN PARK, ONTARIO.

Telegraphic Address : Canoe Lake, Algonquin Park, Ont.

MOWAT P.O., Oct 6 1914
ONTARIO.

Dr Jas MacCallum,

Dear Dr, I received your letter this morning and also your messages from Lismer, About the sketch if I could get 10 or 15 for it I should be greatly pleased but if they dont care to put in so much let it go for what they will give the same applys to all the others except one with the rocks & water ⬚ which would like to print up.

Jackson & myself have been making quite a few sketches lately and I will send a bunch down with Lismer when he goes back, He & Varley are greatly taken with the look of things here just now the maples are about all stripped of leaves now but the birches are very rich in color we are all working away but the best I can do does not do the place much justice in the way of beauty

Jackson & myself are having a fine time and seem to have about the same habits – about camping and can always find sketching near the same place so everything is O.K. Alex has made some fine sketches here

I thought of putting in my application for a park Rangers job and went down to Headquarters with that idea but there is so much red tape about it that – I might not get on for months so I will try and get work in some engraving shop for a few months this winter. Jackson has written Harris (who has my Bank Book) to find out my Bank balance I have probably used most of it up by this time and it is just to find out if I should ride or walk back to Toronto, Could you phone the Bank and find out?

Remember me to Mrs MacCallum, the children and all the kind people that I met at Go Home – Thanking you for many favors

I am yours truly

Tom Thomson

4.7.95

Figure 74 Tom Thomson, Camp Mowat, Algonquin Park, to Dr. James MacCallum, Toronto, October 6, 1914, in National Gallery of Canada Archives, Ottawa.

Jackson & myself are having a fine time and seem to have about the same habits — about camping and can always find sketching near the same place so everything is OK. Alex has made some fine sketches here.

I thought of putting in my application for a park Rangers job and went down to Headquarters with that idea but there is so much red tape about it that I might not get on for months so I will try and get work in some Engraving shop for a few months this winter. Jackson has written Harris (who has my Bank Book) to find out my Bank balance — I have probably used most of it up by this time and it is just to find out if I should ride or walk back to Toronto. Could you phone the Bank and find out?

Remember me to Mrs MacCallum, the children and all the kind people that I met at Go Home — thanking you for many favors.

I am yours truly / Tom Thomson

47.90 (pencil notation)

MacCallum Papers, National Gallery of Canada Archives, Ottawa

❧

MOWAT LODGE / J.S. Fraser / Mowat P.O., Canoe Lake Station, / Algonquin Park, Ontario / Mowat P.O., Ontario. Apr. 22, 1915

Dr Jas McCallum

Dear Sir —

I stayed at Owen Sound for a week and made a few sketches and had to go back to Toronto to make connections for the park. Stayed in Huntsville for two days and have been here since then.

The snow in the woods here was about two or three feet deep when I got here and disappeared gradually until now it is gone excepting spots in the thick swamps.

The ice is still on the lakes but it is getting pretty rotton [sic] and will break up the first good wind, so I will soon be camping again.

Have made quite a lot of sketches (about 28). Some of them might do for canvases but will not pick out any until something better turns up.

Received your card and have made use of your deposit to the extent of about $13.00.

I hear that my swamp picture is down at Ottawa on appro. Hope they keep it.

Yours truly / Tom Thomson

MacCallum Papers, National Gallery of Canada Archives, Ottawa

❧

MOWAT LODGE / J.S. Fraser / Mowat P.O., Canoe Lake Station, / Algonquin Park, Ontario. July 22, 1915

Dear Mr MacDonald

Thanks for sending on my mail and for your letter.

Things are very quiet around the park this summer, have so far had only 2 or 3 weeks work and prospects are not very bright as the people are not coming in as they were expected. Of course there are a few jobs but there are more guides than jobs.

I have made quite a few sketches this summer but lately have not been doing much and have a notion of starting out on a long

hike and will likely wind up somewhere around the French River and go up the shore to Bruce Mines and later on may take in the Harvest Excursion and work at the wheat for a month or two.

As with yourself I can't get used to the idea of Jackson being in the machine and it is rotton that in this so-called civilized age that such things can exist but since this war has started it will have to go on until one side wins out, and of course there is no doubt which side it will be, and we will see Jackson back on the job once more.

Am sending along a letter from Halifax recd. some time ago. Don't know if I have anything that I could send or not but if there are any of the fellows around the Bldg sending and you see any of mine that would do tell Boughton to send it along.

Will send some sketches down in a day or so and would ask if you would unpack them and spread them around in the shack as I'm afraid they will stick together a good deal.

Remember me to Lismer and tell him that I will expect him to be up here in the fall for a month or so. If I go out west will be back about the end of Sept. and will camp from then until about November.

Regard to Mrs MacDonald & Thoreau also to Lawren, Heming and Williamson.

Yours truly / Tom Thomson

Tom Thomson Memorial Art Gallery Archives, Owen Sound, Ontario

❧

THE NEW QUEEN'S HOTEL / South River, Ont., Sept. 8, 1915
Dr MacCallum
Dear Sir.

I sent a check down to the Bank at Bloor & Yonge which would arrive there Sat. morning and so far have not heard from it so conclude that my account has gone broke there. It was for $25.00 for stocking up again, could you see Harris and get the amt. from him and have it sent to me here as I am stranded.

Sent down my sketches (up to a month or so ago) in a in a [*sic*] suit case to Macdonald and have not heard if it landed.

Have travelled over a great deal of country this summer, and have done very few sketches, it will be about a hundred so far.

I may possibly hear from the Bank today but have almost given up hope but another week in here & I will be sent to Orillia.

Yours truly / Tom Thomson

MacCallum Papers, National Gallery of Canada Archives, Ottawa

❧

THE NEW QUEEN'S HOTEL / South River, Ont., Sept. 9, 1915
Dr MacCallum
Dear Sir.

I am always getting excited when there is no cause for it, my letter from the Bank came last night after I had posted yours so I will get on the trail again this morning. Will go back up South River and cross into Tea Lake and down as far as Cauchon and may make it out to Mattawa but it's fine country up this river

about 10 miles, so there is lots to do without travelling very far.

There are stretches of the country around here that is a good deal like that near Sudbury mostly Burnt over like some of my sketches up the Magnettewan River, of running the logs — but have not heard if they ever got to Toronto.

We have have [sic] had an awful lot of rain this summer and it has been to some extent disagreeable in the tent, even with a new one, the very best, you get your blankets wet and if you spread them out to dry it is sure to rain again. But if Lismer or any of the boys can come up get them to write me at South River. I should like awfully well to have some company.

Yours truly / Tom Thomson

One of the Park Rangers comes out here quite often & will take my mail in to me so I could come out here & meet anyone at anytime.

MacCallum Papers, National Gallery of Canada Archives, Ottawa

[Tom Thomson note on the bottom of an Eric Brown letter to J.E.H. MacDonald of June 28, 1916]

Mr MacDonald

Dear Sir,

Am sending you this in case Lawren is away as I think he will be. It may be too late to do anything about now but we only get our mail every 2 or 3 weeks.

If I were sending any sketches my choice would be one I gave Dr McCallum last Xmas or one that Lawren has of some rapids,

however suit yourselves and if its not, too late send something down with yours. We have had no fires so far. This is a great place for sketching, one part of the river (South Branch Pettawawa) runs between Walls of Rock about 300 feet straight up. Will camp there when this fire job is finished.

Yours truly / Tom Thomson

P.S. / Got a letter from Halifax. Would you give Boughton a few sketches to send down with the others.

The McMichael Canadian Art Collection Archives, Kleinburg, Ontario

Basin Depot / Oct. 4. 19 [1916?]

Dr MacCallum / 26 Warren Rd.

Dear Sir —

I received both your letters at the same time and was glad to hear about things in Toronto. The Country up here is just taking the fall colour and by the end of the week will be at its best.

Could you arrange to come up this week. You could get a train to Achray at Pembroke Sat. night at 7.30 or more likely 10 o'clock and be here somewhere around 12. That train leaves from Brent Sunday morning then the next one down is Wednesday morning but I could paddle you down to Pettawa from here any day you should want to go out.

Have done very little sketching this summer as I find that the two jobs don't fit in. It would be great for two artists or whatever you call us but the natives can't see what we paint for. A photo would

be great but the painted things are awuful. When we are travelling, two go together one for the canoe and the other the pack and there's no place for a sketch outfit when your fireranging.

We are not fired yet but I am hoping to get put off right away.

I will expect you Sat. night or any time you can get away.

Thanking you for your letters I am
Yours truly / Tom Thomson

MacCallum Papers, National Gallery of Canada Archives, Ottawa

[Postmarked January 23, 1917]
Monday / Studio Bldg / Severn St. / Toronto

Dear Father:

I got both your letters Saturday night. The first one had got down behind the directory in the hall and was out of sight until I looked for it where I got two other letters for people in the bldg.

The cranberries were shipped from Achray between North Bay and Pembroke on the C.N.R. I think they are charging too much as I was only charged 55¢ for two boxes the same size and weight and a packsack weighing more than both together that included delivering from the shed to my place which is three miles so you can see that compared with my stuff they are charging much more.

I will pay the freight myself later on as I could not do so at the place they were shipped from, there is no agent at Achray and the conductor could not attend to it on the train.

I was very sorry to hear that you have all been ill and hope that you get over it quickly. I hope that Peggie didn't start away too soon after her sickness and that she will be all right at North Bay.

For myself I have been first rate and am getting considerable work done.

It is too bad about your first letter but I have fixed the board so it cannot happen again. / Hoping you folks are all well soon, I am

Your affectionate son / Tom

Location unknown

[Envelope, now lost, was postmarked April 16, 1917]
Mowat P.O. / Algonquin Park

Dear Father:

I have been up here for two weeks making sketches. Had intended going up home for a day or two before coming here but wanted to be here before the snow was gone so could not spare the time. The lakes are still frozen over and will be for two or three weeks yet and there is still about two to three feet of snow in the bush so I expect to get a lot more winter sketches before the snow and ice are all gone.

Tom Harkness & Walter Davidson were in to see me the day before I came here also Miss Andrews and Low Julian (I don't know if the last name is spelled properly or not) but I don't think they enjoyed the show a great deal as they are taking lessons from Manley the worst painter in Canada.

Am stopping at the Post Office here until the ice goes out when I will start to camp again. Have tried fishing thro the ice two or three times but have had no success yet have caught some 'ling' which is a cross between an eel and a fish but they don't use them up here.

I did not send any paintings to the O.S.A. Exhibition this year and have not sold very many sketches but think I can manage to get along for another year at least I will stick to painting as long as I can.

I got quite a lot done last winter and so far have got some pretty good stuff, (since I came here and expect to do a great deal between now and June.

Have not decided if I will stay here the whole summer or not.

Hoping you are all well. I remain your loving son. / Tom Thomson

Tom Thomson Papers, National Archives of Canada, Ottawa (MG30 D284)

◆

Mowat P.O. / Apr. 21 [1917?]

Dr James McCallum

Dear Dr:

I have been here for over three weeks and they have gone very quickly. For the last two or three days the weather has been fairly warm and last night we had quite a heavy thunder storm and the snow is pretty well cleared off, just patches in the bush on the north side of the hills and in the swamps so now I will

have to hunt for places to sketch when I want snow. However the ice is still on the lakes but it is very thin this year on account of deep snow over it through the winter so it will not last very long.

If you can come up here this spring — I think we could have some good fishing and the animals are more plentiful on this side of the park than where we were last spring. I would suggest that you come some time around the tenth 10th [*sic*] of May as the flies are not going properly until about the 24th.

It is likely that the ice will be out sometime this month.

Have made quite a few sketches this spring. Have scraped quite a few and think that some that I have kept should go the same way, however I keep on making them.

Yours truly / Tom Thomson

MacCallum Papers, National Gallery of Canada Archives, Ottawa

◆

[Postmarked April 23, 1917] Mowat P.O. / Algonquin Park

Dear Tom [Harkness],

I have been here over three weeks and have done considerable work for that length of time.

I got a copy of the O.S. Sun and it seemed to be well filled with bunk, however the foolishness of newspaper matter is well known and I knew nothing about it in time to have it stopped.

I have been talking to the people here at the Post Office about pigs. Have been advising them to get about 6 or 8 small ones and

keep them till fall which they could do without much expense and hang them up for the winter.

Supposing they decide to try it out what would they have to pay for the pigs and where would be the place to send for them — and could they be shipped by express or freight any distance.

Am staying at the P.O. until the ice goes out of the lakes, which I expect it to do sometime this week then I will be camping again for the rest of the summer. I have not applied for the firerangers job this year as it interferes with sketching to the point of stopping it altogether so in my case it does not pay. In other words I can have a much better time sketching and fishing and be farther ahead in the end.

I may possibly go out on the Canadian Northern this summer to paint the Rockys but have not made all the arrangements yet. If I go it will be in July & August. We still have a foot or two of snow on the north side of the hills yet but another week will see the end of it and we have nearly another month before my friends the black flies are here. The leaves do not come here before May 24th and often not until on in June.

Well, I will get this started towards Annan hoping you are all well there. I remain

Your aff. Brother / Tom Thomson

Tom Thomson Papers, National Archives of Canada, Ottawa (MG 30 D284)

MOWAT LODGE / J.S. Fraser / Mowat P.O., Canoe Lake Station / Algonquin Park, Ontario. / Mowat P.O., Ontario May 8, 1917

Dr MacCallum

Dear Sir:

Could you not stop off at Canoe Lake on your way up. It is eight miles this side of the Highland Inn and is the best starting point going either north or south. If you wanted to see the outfit at Cache Lake would you come back to Canoe Lake on the afternoon train which leaves there at about 2.30 PM. and you would be back here in about 20 minutes otherwise I would have to pack the outfit over about 2 or 3 miles portage and we would have it back again where we could see the same places from Smoke Lake going light.

You can get any extra blankets or stuff from Fraser, and I have all the supplies including 1 gallon maple syrup, pail of jam plenty bacon, potatoes, Bread, tea, sugar, all kinds canned stuff, tents canoes cooking outfit plates etc. I tried to get some chocolate and failed have no "Klim" & no coffee. That I think is everything we need for two or three weeks including Williamson. The weather for the last two days has been fine and warm.

Will expect you either Friday or Saturday and will not go over to Highland Inn unless you want specially to start out from there.

If the weather is bad we may arrange to get in one of the Rangers shelter Huts.

Yours truly, / Tom Thomson

MacCallum Papers, National Gallery of Canada Archives, Ottawa

MOWAT LODGE / J.S. Fraser / Mowat P.O., Canoe Lake Station / Algonquin Park, Ontario. / Mowat P.O., Ontario, July 7, 1917

Dr MacCallum

Dear Sir:

I am still around Frasers and have not done any sketching since the flies started. The weather has been wet and cold all spring and the flies and mosquitos much worse than I have seen them any year and fly dope doesn't have any effect on them. This however is the second warm day we have had this year and another day or so like this will finish them. Will send my winter sketches down in a day or two and have every intention of making some more but it has been almost impossible lately. Have done a great deal of paddling this spring and the fishing has been fine. Have done some guiding for fishing parties and will have some other trips this month and next with probably sketching in between. Received this slip of paper a day or so ago and don't know anything about it. Would you give it to Jim McDonald or someone around the bldg. with permission to do anything about it they see fit. If they will I will be greatly obliged.

Hoping you are well, I am

Yours truly / Tom Thomson

Location unknown, facsimile copy in MacCallum Papers, National Gallery of Canada Archives, Ottawa

Figure 75 Tom Thomson, Mowat Lodge, Algonquin Park, to Dr. James MacCallum, Toronto, July 7, 1917, location unknown, facsimile copy in National Gallery of Canada Archives, Ottawa.

Chronology

Joan Murray

1877

August 5: Thomas John Thomson is born in Claremont, Ontario, in a home on R.R. #5, the sixth of ten children of John Thomson (1840–1930) and Margaret J. Matheson (sometimes spelled Mathison or Mathewson) (1842–1925). The eldest child of the family, George, was born in 1868; then came Elizabeth in 1869, Henry in 1871, Louise in 1873, Minnie in 1875, Ralph in 1880, James Brodie in 1882, Margaret in 1884 and Fraser in 1886.

October 23: John Thomson pays $6,600.00 for one hundred acres with a house and barn, lot number thirty-six, concession A, at Leith in the Township of Sydenham, Ontario, eleven kilometres from Owen Sound. The family moves in.

1898

Receives an inheritance of about $2,000 from his grandfather, Thomas ("Tam") Thomson (1806–1875).

1899

Works at William Kennedy & Sons Ltd., a foundry, machine shop and pattern shop in Owen Sound, as a machinist apprentice, but quits after eight months, in August.

1900

September: Moves to Chatham, Ontario, to attend the Canada Business College. He boards with a family named Baxter, likely

Figure 76 The Thomson children, c. 1887. From left: Henry, Tom, Elizabeth, Minnie, Fraser, George, Margaret, Ralph, Louise. Private collection.

that of William Baxter, a printer with a "Book and Job" shop on King Street, whose residence is on Delaware Avenue (*Vernon's City of Chatham Directory*, 1900–1902). He stays eight months.

1901

Spring: Returns to Owen Sound.

Late summer: Stops in Winnipeg en route to Seattle, Washington, where his brother George and cousin F.R. McLaren, both graduates

of Canada Business College in Chatham (McLaren was also an instructor), started the Consolidated College Company in 1894–95, a school they had formed by consolidating their own school, the Acme Business College, with the Seattle & Puget Sound Business College (advertisement in *Seattle City Directory*). By 1903, the main operation of the Consolidated College Company is the Acme Business College (*Seattle City Directory*).

Works at the Diller Hotel, Seattle, as a lift boy, rooming with Mabel and P. Pitt Shaw, 703 Twenty-First Street.

1901–02

Brother Ralph arrives in Seattle.

1902

In January, brother Henry arrives in Seattle.

Attends the Acme Business College, S.E. Corner Second Avenue and Pike for six months.

Late autumn: Joins Maring and Ladd as a pen artist and engraver. C.C. Maring, the head of the firm, had also been an instructor at the Canada Business College in Chatham.

John and Margaret Thomson sell the farm at Leith. They live for a short time with their daughter Elizabeth and son-in-law Thomas J. Harkness on a farm below Annan, then they buy a property near Sydenham school on Eighth Street in Owen Sound (exact date of purchase unknown).

1903

Thomson, still with Maring and Blake (the firm's name changes

Figure 77 (top left) Tom Thomson, c.1893, private collection.

Figure 78 (top right) Tom Thomson, c.1905, National Gallery of Canada Archives, Ottawa, gift of Dr. C.S. Sanborn, Windsor, Ontario.

Figure 79 (bottom) The Thomson brothers. From left: Tom, Ralph, George, Henry, Tom Harkness (brother-in-law), c.1905, private collection.

this year), continues to room with the Shaws, who move this year to 2014 East Cherry, around the corner from their old house.

First published work appears in an advertisement for the Acme Business College, which appears on Christmas Day 1903 in the *Seattle Republican*. Although inspired by an advertisement for the Canada Business College in a pamphlet from Chatham, "Canada's Greatest School of Business" (1903), Thomson simplifies the design, giving it more impact. He signs it "Thomson."

Thomson moves to the Seattle Engraving Company, 115 Third Avenue South. He is still boarding at 2014 East Cherry.

1904—05

Thomson returns to Owen Sound.

1905

March: George Thomson and Frank McLaren sell the Acme Business College.

June: Thomson joins the art department of Legg Brothers, a photo-engraving firm in Toronto, Ontario, as senior artist.

1906

Resident at 34 Elm Street (*Toronto City Directory*).

Is said to have enrolled in night classes at the Central Ontario School of Art and Design, 165 King Street West, Toronto, probably studying drawing from the antique (plaster casts) and from life; is said to have continued his studies with William Cruikshank.

Visits Owen Sound on weekends.

Figure 80 Tom Thomson, *Self-Portrait*, c.1905, 17.8 x 14.4 cm, ink on card, from a sketchbook, Art Gallery of Peel, Brampton, Ontario, gift of Robert and Betty Bull, 1993 (AGP1993.130.3).

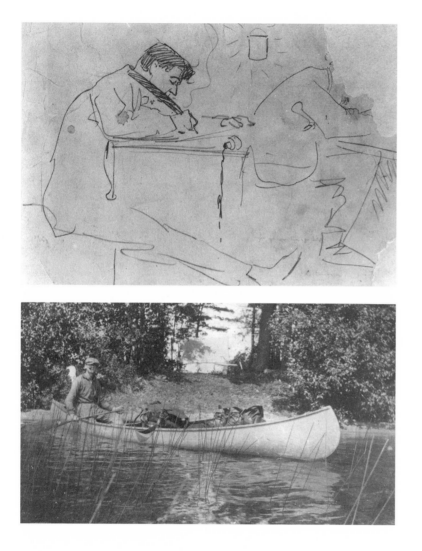

Figure 81 Arthur Lismer, *Tom Thomson at Grip Limited*, 1912, graphite on paper, 20.3 x 30.0 cm, The McMichael Canadian Art Collection, Kleinburg, Ontario, gift of the Founders, Robert and Signe McMichael, 1966 (1966.16.115).

Figure 82 Tom Thomson in a canoe, 1912, Arthur Lismer Papers, Edward P. Taylor Research Library and Archives, Art Gallery of Ontario, Toronto, gift of Marjorie Lismer Bridges (file 19).

1907

Resident at 54 Elm Street, home of Joseph R. Walton, Harness Maker (*Toronto City Directory*).

1908

Resident at 54 Elm Street (*Toronto City Directory*).

August 18: John and Margaret Thomson pay $525 for the land for a house they build at 528 Fourth Avenue East, Owen Sound.

1909

Resident at 99 Gerrard Street East, home of Mrs. Esther Plewes (Plewis) (*Toronto City Directory*).

January (or December 1908): Hired at Grip Limited, Engravers, 48 Temperance Street, Toronto, where he works for J.E.H. MacDonald, senior artist with the firm, and Albert H. Robson, art director.

1910

Resident at 99 Gerrard Street East (*Toronto City Directory*).

1911

Resident at 99 Gerrard Street East (*Toronto City Directory*).

February: Arthur Lismer joins the Grip firm, followed by Franklin Carmichael in April.

Thomson paints at Lake Scugog with H.B. (Ben) Jackson, a Grip employee.

November: Meets Lawren Harris at an exhibition of J.E.H. MacDonald's sketches at the Arts and Letters Club, Toronto.

1912

Resident at 54 Alexander Street, home of Noah Luke (*Toronto City Directory*); later boards with William S. Broadhead, another Grip employee, at 119 Summerhill Avenue, and writes Dr. M.J. McRuer from that address; also boards with Benjamin Catchpole at the home of Mrs. McKenzie, Breadalbane Street (deposition on the painting *On the Sydenham River*, November 19, 1973).

May: Travels to Canoe Lake Station, Algonquin Park, with Ben Jackson; camps at Tea Lake Dam and Canoe Lake; meets the ranger Harry (Bud) Callighen.

Late July–23 September: Travels in the area of the Mississagi Forest Reserve, west of Sudbury, with William Broadhead. There they meet Archie Belaney, later known as Grey Owl, who is working as a ranger. Starting at Biscotasing, they paddle in a Peterborough canoe down Bisco Lake to Ramsey Lake, up the Spanish River, through Spanish Lake and portage into Canoe Lake, portage to Osagama Lake, then to Green Lake, then to the Mississagi Forest Reserve and reach the Aubinadong River, a branch of the Mississagi. They spend some time at Aubrey Falls, then make their way along the Mississagi River through the forty-mile (64 km) rapids to Squaw Chute.

August: F.H. Varley joins the Grip firm.

October: With other Grip artists, Thomson follows their art director, Albert Robson, to Rous and Mann Press Limited, 72 York Street

Meets Dr. J.M. MacCallum, an ophthalmologist, at J.E.H. MacDonald's studio.

Figure 83 Article written and illustrated by H.B. Jackson following his visit with Tom Thomson to Algonquin Park, *The Toronto Sunday World* (11 August 1912).

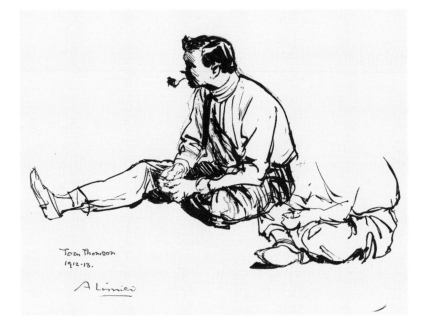

Figure 84 Arthur Lismer, *Tom Thomson 1912–13*, ink over graphite on paper, 25.7 x 30.8 cm, The McMichael Canadian Art Collection, Kleinburg, Ontario, gift of the Founders, Robert and Signe McMichael, 1966 (1966.16.116).

1913

Resident on Isabella Street; later moves to 66 Wellesley Street East.

April 5–26: Ontario Society of Artists Forty-first Annual Exhibition, Toronto. Thomson exhibits *Northern Lake*. It is purchased by the Ontario Government for $250. In the catalogue, his address is given as 66 Wellesley Street.

Decides to paint full-time; gets a two-month leave of absence from Rous and Mann for a sketching trip north.

Spring and summer: May work as a fire ranger on the Metagami

Reserve, just south of Timmins, Ontario (the name Thomas Thomson appears in the 1913 pay list).

August (?): Goes to Algonquin Park, where he canoes from Canoe Lake to Manitou and North Tea Lakes in the northern part of the park and meets Tom Wattie, a ranger stationed on North Tea Lake, before returning to Canoe Lake.

November: Returns to Toronto via Huntsville. Dr. MacCallum introduces him to A.Y. Jackson, who is sharing Lawren Harris's studio.

1914

January: Shares studio number one with Jackson in the new Studio Building on Severn Street.

February 7–28: Second Annual Exhibition of *Little Pictures by Canadian Artists*, Art Galleries of the Public Reference Library, Toronto. Thomson exhibits five sketches ranging in price from $20 to $25: *Cumulus Clouds*, *Evening*, *Grey Day*, *Northern Lake*, *Winter*.

March 14–April 11: Ontario Society of Artists Forty-second Annual Exhibition, Toronto. Thomson exhibits *Morning Cloud* and *Moonlight*. *Moonlight* is bought by the National Gallery of Canada for $150. Thomson's address is given in the catalogue as Studio Building, Severn Street.

March: Elected a member of the Ontario Society of Artists.

Late April: Returns to Algonquin Park, staying at Camp Mowat on Canoe Lake.

May 9–24: Camps in Algonquin Park with Arthur Lismer on Molly's Island, Smoke Lake; they travel to Canoe, Ragged, Crown and Wolf Lakes.

May 30: Is at Parry Sound and two days later camps with Dr. Mac-Callum at French River; passes the next two months at MacCallum's cottage, Go-Home Bay, Georgian Bay, sketching in the region.

Early August: Paddles and portages to Algonquin Park, travelling north along the French River to Lake Nipissing, then via South River to the park.

Mid-September: Is joined by A.Y. Jackson and they travel to and paint at Canoe, Smoke and Ragged Lakes.

Early October: They are joined by Arthur Lismer, his wife, Esther, and their daughter, Marjorie, F.H. Varley and his wife, Maud.

Mid-October: Lismers and Varleys return to Toronto.

October 23: Jackson leaves for Toronto.

November 18: Thomson leaves for Toronto.

November: Royal Canadian Academy of Arts Thirty-seventh Annual Exhibition, Toronto. Thomson exhibits *A Lake, Early Spring* (possibly the canvas called *Petawawa Gorges*) and *Frost After Rain*. His address is given as Studio Building, Severn Street.

December 13: Royal Canadian Academy of Arts Patriotic Fund Sale. Thomson exhibits *In Algonquin Park*, which is purchased by the artist Marion Long for $50.

December: Shares a studio in the Studio Building with Franklin Carmichael.

1915

March 13–April 10: Ontario Society of Artists Forty-third Annual Exhibition, Toronto. Thomson exhibits *Northern River, Split Rock*

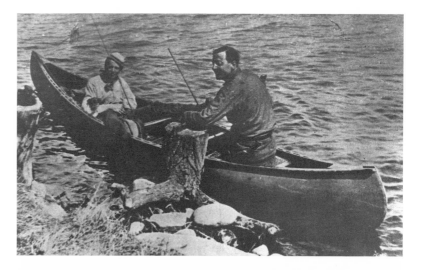

Figure 85 Arthur Lismer and Tom Thomson, Smoke Lake, Algonquin Park, photographed by H.A. Callighen, May 1914, The McMichael Canadian Art Collection Archives, Kleinburg, Ontario.

Figure 86 Tom Thomson, F.H. Varley, A.Y. Jackson, Arthur, Marjorie and Esther Lismer in Algonquin Park, likely photographed by Maud Varley, October 1914, National Gallery of Canada Archives, Ottawa.

Figure 87 Tom Thomson bending over at campsite, probably October 1914, from A.Y. Jackson scrapbook, National Gallery of Canada Archives, Ottawa, bequest of Dr. Naomi Jackson Groves, Ottawa, 2001.

Figure 88 Thomson at Go-Home Bay. From left: Dr. MacCallum, Thomson and J.E.H. MacDonald, possibly October 1915, National Gallery of Canada Archives, Ottawa, gift of Thoreau MacDonald, Thornhill, Ontario.

and *Georgian Bay Pines*. *Northern River* is bought by the National Gallery of Canada for $500. His address is given as Studio Building, Severn Street.

Mid-March: Arrives in Algonquin Park, via Huntsville, where he stays at the home of Winifred Trainor for two days; he travels to Tea Lake and Big Cauchon Lake; in the Kearney area, he stays at McCann's Half-way House.

April 28–May 19: Thomson and George Rowe guide the Johnston Brothers of Pittsburgh, Pennsylvania, to Pine River; they travel to Tea Lake. On their return, Thomson and Rowe travel to Big Bear Lake.

July 17: Assists H.A. Callighen in bringing tourists from Joe Lake Station to Smoke Lake by canoe.

July 21: Returns from Swan (Rain) Lake.

Late July or early August: Buys a new Chestnut canoe, silk tent and other camping supplies and starts out from Canoe Lake on a long trip, likely to the Magnetawan River, coming out at South River around Labour Day.

August 28–September 13: Canadian National Exhibition, Toronto. Thomson exhibits *In Georgian Bay* and *Pines, Georgian Bay*. His address is given as Studio Building, Severn Street.

September 8–16: Provincial Exhibition, Halifax. Thomson exhibits a canvas, *A Northern Lake*, *Early Spring*, and six sketches, *Canadian Wildflowers*, *Winter Morning*, *Sun in the Bush*, *Birches*, and two of *Autumn Colours*. The canvas is priced at $350, the sketches $25 each.

September: Paddles back up South River, crosses into North Tea Lake and Cauchon Lake, travelling perhaps as far as Mattawa.

Figure 89 (top left) Arthur Lismer; *Lawren Visits the Studio*, from Lismer sketchbook, c.1915, graphite on paper,
25.3 x 20.0 cm, McMichael Canadian Art Collection, Kleinburg, Ontario, gift of Marjorie Lismer Bridges (1981.217.5).
Figures 90–92 Arthur Lismer, (top right) *Shack at No.25 Severn Street, Toronto*, (bottom left) *T.T. Priming a Canvas*,
(bottom right) *Too Much Mulligan*, 1915, graphite on wove paper, 25.3 x 19.5 cm, 25.5 x 19.5 cm, 19.7 x 25.5 cm,
National Gallery of Canada, Ottawa, gift of Arthur Lismer, Montreal, 1951 (16783, 16773, 16778).

Figure 93 Thomson shaving in camp, 1916, National Archives of Canada, Ottawa (C 7900).

Figure 94 Thomson's Shack behind 25 Severn Street, from *The Canadian Magazine* 50, no. 5 (March 1918).

End September to mid-October: At Mowat.

Mid-October: Visits the MacCallum cottage on Georgian Bay with J.E.H. MacDonald to measure for a series of decorative panels commissioned by Dr. MacCallum as murals for his cottage.

November: Camps at Round (now Kawawaymog) Lake with Tom Wattie and Dr. Robert McComb; paints at Mud Bay.

Late November: At first snow, travels to Huntsville for a brief stay at the home of Winifred Trainor before returning to Toronto. Moves into the shack, formerly used by a cabinet maker, behind the Studio Building on Severn Street, which he shares with Arthur Lismer.

December–January: Exhibits a group of sketches at the Arts and Letters Club, Toronto.

Winter: Paints seven decorative panels for the MacCallum cottage. When they are installed in April 1916, only three of Thomson's fit.

1916

Mid-March: Stops in Huntsville at the home of Winifred Trainor on his way to Algonquin Park.

March 11–April 15: Ontario Society of Artists Forty-fourth Annual Exhibition, Toronto. Thomson exhibits *The Birches*, *Spring Ice*, *Moonlight* and *The Hardwoods*. *Moonlight* is illustrated in the catalogue. *Spring Ice* is bought by the National Gallery of Canada for $300. His address is given as the Studio Building, Severn Street.

March: Exhibits landscapes of Northern Ontario at the Toronto Heliconian Club.

April or early May: Is visited by Lawren Harris, his cousin Chester

Harris and Dr. MacCallum; they travel to Lake Cauchon; Harris and Thomson then proceed on to Aura Lee Lake.

Late May: Takes a job as a fire ranger and reports to Achray, a park station at Grand Lake on the south branch of the Petawawa (now Barron) River, where he works with Edward Godin.

August: Thomson and Edward Godin canoe down the south branch of the Petawawa River to the Barron Canyon, then canoe up the north branch of the river to Lake Traverse.

August 26–September 11: Canadian National Exhibition, Toronto. Thomson exhibits *Moonlight*. It is reproduced in the catalogue. His address is given as Studio Building, Severn Street.

September 13–21: Nova Scotia Provincial Exhibition, Halifax. Thomson exhibits *The Hardwoods* priced at $300.

October 4: Is at Basin Depot.

Late October or early November: Returns to Toronto.

November 16–December 16: Thirty-eighth Annual Exhibition of the Royal Canadian Academy of Arts, Montreal. Thomson exhibits *The Hardwoods*. His address is given as 25 Severn Street.

1917

Early April: Arrives at Mowat Lodge.

April 28: Buys a guide's licence.

May 24: Dr. MacCallum and his son Arthur arrive for a fishing trip.

July 8: Park Ranger Mark Robinson, Mrs. Thomas (the wife of the local railway section head) and Mrs. Colson (the wife of the owner of the Hotel Algonquin on Joe Lake) see Thomson and

Figure 95 At Mowat Lodge, Algonquin Park, May 1917, photographed by Emily C. Robinson. From left: J. Shannon Fraser, Tom Thomson, Charles Robert Edward Robinson. The McMichael Canadian Art Collection Archives, Kleinburg, Ontario, gift of the family of Charles R. and Emily C. Robinson.

Shannon Fraser walking down to Joe Lake Dam in the morning. Robinson notes in his diary that Thomson "left Fraser's Dock after 12:30 pm to go to tea lake Dam or west lake."

July 16: Thomson's body is recovered from Canoe Lake and buried at once, overlooking the lake.

July 21: An undertaker from Huntsville arrives to collect the body and ship it to Owen Sound on the instructions of George Thomson. It is buried in the family plot at Leith.

September 27: A memorial cairn with a bronze tablet designed by J.E.H. MacDonald is erected at Canoe Lake by MacDonald, J.W. Beatty, Shannon Fraser and George Rowe.

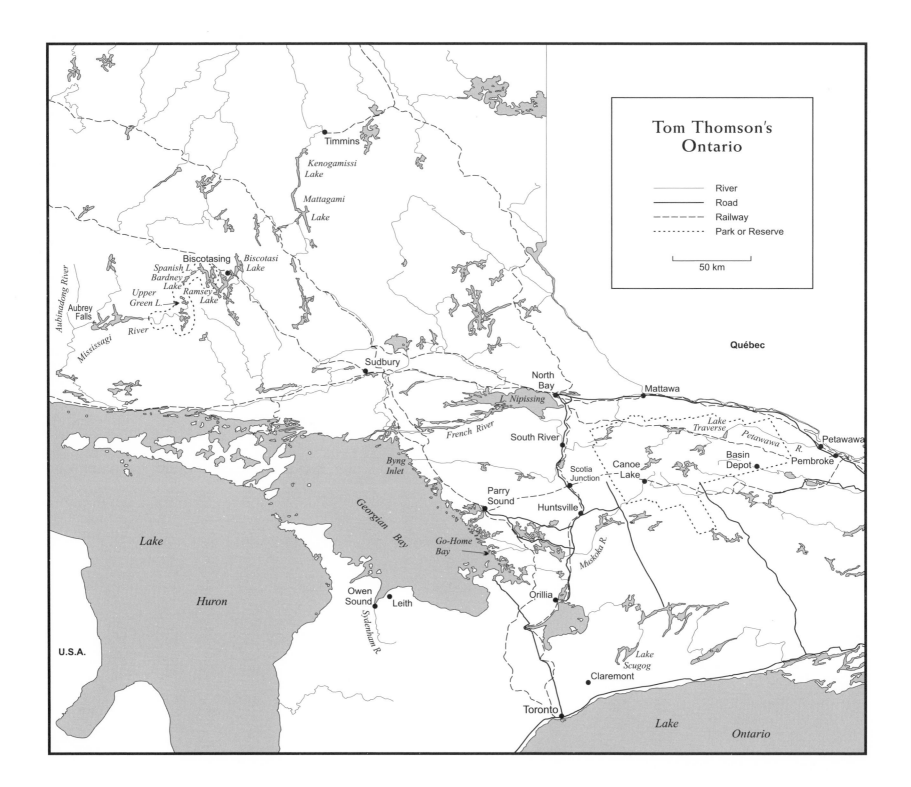

Tom Thomson's Ontario

River
Road
Railway
Park or Reserve

50 km

Timmins

Kenogamissi Lake

Mattagami Lake

Aubinadong River

Biscotasing

Spanish L.
Bardney Lake
Upper Green L.
Ramsey Lake

Biscotasi Lake

Aubrey Falls

Mississagi
River

Sudbury

North Bay

Mattawa

Québec

L. Nipissing

French River

South River

Lake Traverse

Petawawa
R.

Petawawa

Byng Inlet

Scotia Junction

Canoe Lake

Basin Depot

Pembroke

Parry Sound

Huntsville

Go-Home Bay

Georgian Bay

Muskoka R.

Lake Huron

Owen Sound

Leith

Sydenham R.

Orillia

Lake Scugog

U.S.A.

Claremont

Toronto

Lake Ontario

Tom Thomson's Algonquin Park

Current Park Boundary
Former Park Boundary

(1893)
Year Park Section
Established

Dam
River
Railway
Road

20 km

Mattawa

Ottawa River

Trout Creek

South River

Manitou Lake

Kawawaymog Lake

Cauchon L.

1894

Aura Lee L.

Little Cauchon L.

N. Tea Lake

Cedar Lake

Brent

Radiant Lake

Magnetawan R.

1894

Blue L.

Big Trout L.

Lake Traverse

Petawawa River

1904

1914

Bear L.

Lake Lavieille

Grand Lake

Achray

Mowat

Opeongo Lake

Barron River

Canoe Lake

Joe L.

Canoe L.

Cache Lake

Tea L.

Smoke L.

Cache L.

Basin Depot

Swan L.

Ragged L.

Island Lake

Petawawa

Crown L.

1951

1911

1951

Round Lake

Kawagama Lake

1960-61

Hay Lake

Lake of Bays

Kennisis Lake

Notes

"Mapping Tom"
by Andrew Hunter

1. Grand Trunk Railway System brochure, Algonquin Provincial Park, "The Highway to Health and Happiness," 1917. Algonquin Park Museum and Archive.
2. Advertisement for Lawrence Park development, *Toronto Saturday Night* 23, no. 36 (18 June 1910): 7.
3. Advertisement for Alexandra Gardens development, *Toronto Saturday Night* 23, no. 35 (11 June 1910): 23.
4. Tom Thomson was J.E.H. MacDonald's colleague at both firms.
5. Advertisement for Kempenfelt development on Lake Simcoe, *Toronto Saturday Night* 26, no. 30 (3 May 1913): 11.
6. Advertisement for Brantwood development, *Toronto Saturday Night* 26, no. 36 (14 June 1913): 29.
7. Ibid.
8. *Toronto Saturday Night* 22, no. 44 (14 August 1909): 8. The Grand Trunk Railway used the same language in its brochures emphasizing "rejuvenation."
9. See Patricia Jasen, *Wild Things: Nature, Culture, and Tourism in Ontario 1790–1914* (Toronto: University of Toronto Press, 1995), 114–15.
10. *Toronto Saturday Night* 26, no.44 (9 August 1913): 30.
11. *Toronto Saturday Night* 27, no. 32 (23 May 1914): 35.
12. *Toronto Saturday Night* 27, no. 34 (6 June 1914): 36.
13. *Toronto Saturday Night* 27, no. 40 (18 July 1914): 33.
14. *Toronto Saturday Night* 30, no. 37 (30 June 1917): 9.
15. *Toronto Saturday Night* 23, no. 35 (11 June 1910): 7.
16. *Toronto Saturday Night* 25, no. 40 (13 July 1912): 14.
17. W.H. Withrow, *Our Own Country Canada, Scenic and Descriptive: Being an account of the extent, resources, physical aspect, industries, cities and chief towns of the provinces of Nova Scotia, Prince Edward Island, Newfoundland, New Brunswick, Quebec, Ontario, Manitoba, The North-West Territory, and British Columbia, with sketches of travel and adventure* (Toronto: William Briggs, 1889).
18. George Munro Grant, ed. *Picturesque Spots of the North: Historical and descriptive sketches of the scenery and life in the vicinity of Georgian Bay, The Muskoka Lakes, The Upper Lakes, in Central and Eastern Ontario, and in the Niagara District*, illustrated with wood engravings from original drawings by F. Hopkinson Smith, F.B. Schell, L.R. O'Brien, W.C. Fitler and others (Chicago: Alexander Belford & Co., 1899).
19. *Seattle Mail & Herald* 7, no. 38 (30 July 1904), cover.
20. *Seattle Mail & Herald* 8, no. 3 (26 November 1904), cover.
21. *Toronto Saturday Night*, cover of Women's Section 25, no. 28 (20 April 1912): 29.
22. *Toronto Saturday Night* 30, no. 34 (9 June 1917): 4–5.
23. *Toronto Saturday Night* 30, no. 43 (11 August 1917): 5.
24. *Toronto Saturday Night* 21, no. 33 (30 May 1908): 11.
25. "Naturalist to the Government of Manitoba," according to the title page of many of his books.
26. The Boy Scouts were defined by "the work and attributes of backwoodsmen, explorers, and frontiersmen." *Canadian Boy Scout Manual*, 1911, ix. Founded by Lieut.-Gen. Sir Robert S. Baden-Powell, the Scouts were a much more military organization than Seton's Woodcraft League.
27. J. Harry Smith, "September in Algonquin Park," *Canadian Magazine* 37 (May 1911): 27.
28. *Toronto Saturday Night* 21, no. 46 (29 August 1908): 10.
29. Aubrey Fullerton, "Men Who Run Risks," *Toronto Saturday Night* 20, no. 15 (16 February 1907): 5.
30. *Toronto Saturday Night* 19, no. 38 (28 July 1906): cover.
31. Grand Trunk Railway System brochure, "Algonquin National Park," 1909, Algonquin Park Museum and Archive.
32. *1900: A Canadian Calendar for the Year with Notes and pictured things suggesting the impress of the Century on the land and its peoples*, designed by the Toronto Art League (Toronto: George N. Morang, 1899).
33. Robert Service's poem "The Call of the Wild" was published in 1907.
34. Letter from H.B. Jackson to Blodwen Davies, 25 May 1930, Blodwen Davies fonds, National Archives of Canada, MG30 D38, vol. 11.
35. Izaak Walton biographical note, *The Compleat Angler*, Modern Library paperback ed. (New York: Random House, 1998), vi.
36. Letter from Minnie Henry to Blodwen Davies, 2 February 1931, Blodwen Davies fonds, NAC, MG30 D38, vol. 11. Thomson produced a pen-and-ink illustration of this Henry Van Dyke text apparently as a gift. It is now in the McMichael Canadian Art Collection, Kleinburg, Ontario (1980.3.1).
37. Letter from H.B. Jackson to Blodwen Davies, 25 May 1930.
38. Letter from Tom Thomson to Fred Varley, sent from Go-Home Post Office, Georgian Bay, 8 July 1914. The Thomson Collection (PC-936).
39. A popular story, often repeated, is that Thomson was heading off to try to catch a particularly large bass at Joe Lake on the day he disappeared. Considering the number of strange tales that have been put forward to explain his death (suicide, murder, and so on), it is surprising that no one has ever implicated that "monster" bass in the artist's demise.
40. Letter from A.Y. Jackson to J.E.H. MacDonald, postmarked 14 February 1914, MacDonald fonds, NAC, MG30 D111, vol. 1.
41. Interview with Jack Wilkinson and Rose Thomas by Rory MacKay, Kish-Kaduk Lodge, Algonquin Park,

11 February 1976. Algonquin Park Museum and Archive.

42. This photo has been credited to Lawren Harris, but the following description from a letter to Thomson suggests another source: "I was under the impression that we took a photo of you fly casting from a rock in Canoe Lake but perhaps we used your camera." Leonard E. Mack, letter to Tom Thomson, 16 March 1913 or 13 March 1916, Thomson fonds, NAC, MG30 D284. Thoreau MacDonald produced a drawing and edition of prints based on this picture, which he believed had been taken by Harris.

43. The photograph is NAC (PA-67311), the postcard Algonquin Park Museum and Archive. Mr. and Mrs. Edwin (Ted) Thomas ran the Canoe Lake Station where they lived with their daughter Rose during Thomson's time in Algonquin Park. The text on the back of the post-card reads, "Hello Mr. & Mrs. Thomas: This picture was taken at Canoe Lake, in 1916 do you remember these people. We sure had some good times, when Rose caught the Bass with a bent pin. — Love & Best Wishes, Jean K."

44. I am not trying to suggest that Thomson was engaged in a project of documenting fishing sites. It is my opinion that the documentary "card" has been overplayed in interpreting Thomson, to the detriment of the work.

45. "The Highway to Health and Happiness," Grand Trunk Railway System brochure, Algonquin Provincial Park, 1917. Algonquin Park Museum and Archive.

46. James Dickson, A Nineteenth-Century Algonquin Adventure (first published in 1886 as Camping in the Muskoka Region), edited and with an introduction and notes by Gary Long (Huntsville, Ont.: Fox Meadow Creations, 1997), 154.

47. Ibid., 118.

48. See Gary Long and Randy Whiteman, When Giants Fall: The Gilmour Quest for Algonquin Pines (Hunstville, Ont.: Fox Meadow Creations, 1998).

49. Wilkinson and Thomas interview, 11 February 1976.

50. A "pointer" boat was specifically designed for log drives by John Cockburn of Pembroke, Ontario, for the J.R. Booth lumber company in the 1850s. These elegant boats ranged from twenty to fifty feet in length and were built of heavy pine. The "alligator" was a combination steam-powered tug and winch used to move log booms. Invented in 1889 by John Ceburn West, the craft was capable of "crawling" over land. Dan Strickland, Algonquin Logging Museum handbook.

51. Dan Strickland, Trees of Algonquin Provincial Park ([Toronto]: Ontario Ministry of Natural Resources, 1996), 19.

52. Ibid.

53. Probably the sketch for The Drive (pl. 114).

54. Peter Sauvé interviewed by Taylor Statten, Algonquin Park, c.1970. Algonquin Park Museum and Archive oral histories. Sauvé worked as a cook at Statten's Camp Ahmek on Canoe Lake.

55. Edith Fowke, Lumbering Songs from the Northern Woods (Toronto: NC Press Ltd., 1985).

56. James Whelan died in 1878 on Ontario's Mississippi River, a tributary of the Ottawa River.

57. Fowke, Lumbering Songs, 113.

58. Edward E. Baptist, in his essay "My Mind Is to Drown You and Leave You Behind," in Over the Threshold: Intimate Violence in Early America, Christine Daniels and Michael V. Kennedy, ed., credits A.P. Hudson with coining this term (New York: Routledge, 1999), 98.

59. This sketch has been previously exhibited and published as Log Run and Edge of the Log Run.

60. Letter from Edward Godin to Blodwen Davies, 15 June 1931, Blodwen Davies fonds, NAC, MG30 D38, vol.11.

61. A.Y. Jackson, A Painter's Country: The Autobiography of A.Y. Jackson (Toronto: Clark, Irwin, 1958), 26.

62. Albert H. Robson, Tom Thomson: Painter of the North Country, 1877–1917, (Toronto: The Ryerson Press, 1937), 3.

63. Barker Fairley, "Tom Thomson and Others," The Rebel 3, no. 6 (March 1920): 246.

64. Harold Mortimer-Lamb, "Studio Talk: Montreal," Studio 77, no. 316 (July 1919): 124.

65. F.B. Housser, A Canadian Art Movement: The Story of the Group of Seven (Toronto: Macmillan, 1926), 120.

66. J.M. MacCallum, "Tom Thomson: Painter of the North," The Canadian Magazine 50, no. 5 (March 1918): 375.

67. J.E.H. MacDonald, poem from Tom Thomson Cairn, Canoe Lake, Algonquin Park, 1917.

68. Robson, Tom Thomson, 4.

69. MacCallum, "Tom Thomson": 378.

70. Mortimer-Lamb, "Studio Talk": 124.

71. O.J. Stevenson, "Out of the North Country," in A People's Best (Toronto: Musson, 1927), 72.

72. Blodwen Davies, Paddle and Palette: The Story of Tom Thomson (Toronto: The Ryerson Press, 1930), 7.

73. Housser, A Canadian Art Movement, 116.

74. Stevenson, "Out of the North Country," 72.

75. Davies, Paddle and Palette, 22.

76. "Book of Pictures," The Canadian Forum 6, no. 70 (July 1926): 313.

77. From the film West Wind, produced and directed by Graham McInnes, National Film Board of Canada, 1944.

78. Fairley, "Tom Thomson and Others": 246.

79. Blodwen Davies, "Art and Esotericism in Canada," The Canadian Theosophist 18, no. 2 (April 1937): 57.

80. Robson, Tom Thomson, 6–7.

81. See Donald B. Smith, From the Land of Shadows: The Making of Grey Owl (Vancouver: Greystone Books [Douglas & McIntyre] and University of Washington Press, 1990).

82. Audrey Saunders, Algonquin Story ([Toronto]: Department of Lands and Forests, Ontario), 1946.

83. Ottelyn Addison, Early Days in Algonquin Park, (Toronto: McGraw-Hill Ryerson, 1974).

84. Ottelyn Addison in collaboration with Elizabeth Harwood, Tom Thomson: The Algonquin Years (Toronto: The Ryerson Press, 1969).

85. Interview with Audrey (Saunders) Miller at her home in Meaford, Ontario, 28 November 1979, by Ron Pittaway. Algonquin Park Museum and Archive.

86. Mark Robinson's diaries are in the collection of Trent University Archives, Peterborough, Ontario.

87. H.A. Callighen's diaries are in the collection of the Archives of Ontario, Toronto (F1059).

88. Arthur Lismer was based in Halifax for much of the war, but this was not for military reasons; he had become principal of the Victoria School of Art and Design.

89. Davies, Paddle and Palette, 29–31.

90. "Margaret Thomson Reminiscences of Tom Thomson," New Frontiers 5, no. 1 (spring 1956): 21–24.

91. William Colgate, Two Letters of Tom Thomson 1915 and 1916 (Weston, Ont.: The Old Rectory Press, 1946), 15.

92. Ibid., 10.

93. Letter from Edward Godin to Blodwen Davies, 15 June 1931, Blodwen Davies fonds, NAC, MG30 D38, vol.11.

94. Letter from Tom Thomson to J.E.H. MacDonald, 22 July 1915. Tom Thomson Memorial Art Gallery Archives, Owen Sound. It is interesting that Thomson used the term machine to describe the war. It is clearly invoked as a derogatory term and was used in a similar way to describe civilization by those who wished to define Thomson as a man of the wilderness.

95. Robert Service, from "The Call of the Wild," 1907.

96. See Jonathan F. Vance, *Death So Noble: Memory, Meaning, and the First World War* (Vancouver: University of British Columbia Press, 1997) and Desmond Morton, *When Your Number's Up: The Canadian Soldier in the First World War* (Toronto: Random House of Canada, 1993).

97. John McCrae's poem was first published in the English magazine *Punch* in 1915. It is inscribed into the stone walls of the University of Toronto's war memorial at Hart House. As has been noted by numerous writers, the first line was supposed to be "In Flanders fields the poppies *grow*," but *blow* is the final word usually printed. The U. of T. war memorial repeats this error.

98. J.E.H. MacDonald fonds, NAC, MG30 D111, vol. 2, file 6.

99. This poem was published in *The Rebel* 4, no. 2 (November 1919): 66, as J.M. "Below the Rapid," with no reference to Neil McKechnie. The words *for Neil McKechnie* appear on several typed and handwritten draft versions of the poem. J.E.H. MacDonald fonds, NAC, MG30 D111, vol. 2, file 6.

100. "Neil McKechnie, Toronto, Drowned," *Toronto Daily Star*, 28 June 1904, 1.

101. "Drowned in New Ontario," *Globe* (Toronto), 29 June 1904, 12.

102. Tom McLean, "The Drowning of Neil McKechnie," *Toronto Daily Star*, 30 June 1904, 4.

103. J.E.H. MacDonald, "A Landmark of Canadian Art," *The Rebel* 2, no. 2 (November 1917): 41–50.

104. Ibid., 46–47.

105. Sid Howard, "The Red Gods Called," *Toronto Saturday Night* 17, no. 35 (9 July 1904): 10.

106. Ironically, McKechnie no longer lies where he perished. The area was flooded owing to hydro development between the wars. His remains were rescued and reburied by members of the Mattagami Indian Band in the 1920s. I am grateful to Gerald Luke and members of the Mattagami First Nation at Gogama for showing me McKechnie's grave, which is now located in the band's cemetery. While McKechnie may have been largely forgotten in Toronto, he has been well looked after by the Mattagami First Nation. In 1995, as part of a cemetery restoration project, a hand-hewn wooden cross was added to his grave.

107. Howard, "The Red Gods Called": 10.

"Tom Thomson as Applied Artist" by Robert Stacey

1. That alumnus is Leonard Rossell (1880–1953), who, after studying at the Leicester School of Art, emigrated to Canada in 1899. In Toronto he studied under F.M. Knowles and C.W. Jefferys. After working at Grip, he taught night classes at the Ottawa Technical School and held several exhibitions of his Ottawa-area landscapes.

2. There are some difficulties with Rossell's annotations, which were supplied at the request of the National Gallery's R.H. Hubbard. Broadhead is not identified on the verso of the photograph, but his name is scribbled, along with those of other Grip personnel, on an invitation to an exhibition of *Original Small Paintings* by Rossell, held at the Ottawa branch of the Young Men's Christian Association in December 1947 (National Gallery of Canada Archives). The man standing to Lismer's right may in fact be Stanley Kemp, and it's uncertain that the man on Lismer's left is Varley, who arrived in Toronto around 1 August 1912. In his first extant letter to his wife, Maud, dated 9 August, National Archives of Canada, Varley fonds, MG30 D401, Varley wrote that he had been hired for a fortnight's try-out at Grip. If Varley is indeed in the photograph, it would have had to have been taken shortly after 23 September of that year, as Thomson and Broadhead were away on a northern Ontario canoe trip until that date. By October 1912 the "Grip Gang," minus J.E.H. MacDonald and Broadhead, had decamped with Robson to Rous and Mann, as related later in this essay.

3. Six degrees of separation: Frederick Bridgen Sr., the founder of the Toronto Engraving Company, apprenticed alongside Crane as a wood engraver in England and took drawing lessons from Ruskin; his son, Fred Jr., head of the firm's Toronto branch, had been a member of the TASL and contributed to its annual souvenir calendar (1891–1904), Canada's most significant instance of Æsthetic Movement graphics; it was the younger Brigden who initiated the search for young design talent in the industrial Midlands that produced Broadhead, Lismer and Varley; Crane occasionally freelanced for Carlton Studios in the 1910s. See Robert Stacey, "Harmonizing Means and Purpose," in David Latham, ed., *Scarlet Hunters: Pre-Raphaelitism in Canada* (Toronto: Archives of Canadian Art and Design, 1998), 92–98.

4. *Applied Art Exhibition* (Toronto: Ontario Society of Artists, 1900).

5. See Joan Murray, *The Art of Tom Thomson* (Toronto: Art Gallery of Ontario, 1971), 9.

6. Fraser Thomson to Blodwen Davies, 19 May 1930. Blodwen Davies fonds, NAC, MG30 D38, vol. 11.

7. Murray, *The Art of Tom Thomson*, 11.

8. Henry Thomson to H.O. McCurry, 19 October 1946, with typed copy of draft letter from Ralph Thomson to Blodwen Davies. National Gallery of Canada Archives, 7.1–Thomson.

9. Ibid.

10. Ivan R. Mackintosh to Stewart Dick, 31 August 1938. Blodwen Davies fonds, NAC.

11. Murray, *The Art of Tom Thomson*, 14.

12. A.H. Robson, *Canadian Landscape Painters* (Toronto: Ryerson Press, 1932), 138.

13. A.H. Robson, *Tom Thomson* (Toronto: Ryerson Press, 1937), 5.

14. S.H.F. Kemp, "A Recollection of Tom Thomson," unpublished typescript (Toronto, 1955); Archives, The McMichael Canadian Art Collection. Excerpts of this memoir appear in W.T. Little, *The Tom Thomson Mystery* (Toronto: McGraw-Hill, Ryerson, 1970), 173–78.

15. [J.E.H. MacDonald,] *Commercial Design: Lesson IX* (Toronto: Shaw Correspondence School, 1919), 8–10.

16. Robson, *Canadian Landscape Painters*, 139–40.

17. The border device employs the complex vegetal interweave we associate with William Morris and his disciples, but the swastikas on the frame may have been suggested by Rudyard Kipling's adopting as his personal emblem this ancient Jain symbol for Siddha, a perfect being free from reincarnation.

18. Leonard Rossell, "Reminiscences of Grip, Members of the Group of Seven and Tom Thomson," c.1951 (typescript), 1, National Gallery of Canada Archives.

19. Ibid., 3.

20. This ink-on-card drawing was found pasted into a company sample book rescued from the trash by the late Les Trevor, former Rous and Mann art director, when the firm was disposing of its archives on merging with Brigden's in the 1970s. Unfortunately, the scrapbook was lost following Trevor's death in the 1980s. See also note 23.

21. See the forthcoming Joyce Sowby, "Quality Printing: A History of Rous & Mann Limited, 1909–54" Randall Speller, ed. *DA* 51 (fall 2002).

22. Thomson's Rous and Mann rate card states that he was engaged on 16 October 1912 as "Artist," at the wage of seventy-five cents per hour over a week of forty-six and one-half hours. Carmichael's card states that he started on 21 October 1912, at a rate of thirty-three cents per hour. Varley's card merely notes that he was taken on in 1912. Michael Large photocopied these cards (on loan from Brigden's—Rous and Mann); they have since been lost and are presumed destroyed.

23. This now-unlocated drawing was identified for me as Thomson by Les Trevor, who allowed me to have it photographed in connection with my *Canadian Poster Book* in 1979. See also note 20.

24. That the drawing dates from Thomson's brief employment at Rous and Mann is suggested by the fact that it was bound in the Rous and Mann sample book cited in note 20. This would indicate a date of c.1913, during which year Thomson summered in the park.

25. S.H.F. Kemp, "A Recollection of Tom Thomson," quoted in Little, *The Tom Thomson Mystery*, 178.

26. Thoreau MacDonald, "Some Memories of Tom Thomson," typescript, 1958; William Colgate Papers, Archives of Ontario, Toronto, F1066.

27. A set of souvenir stamps ordered in 1914 from Legg Brothers to promote Owen Sound were ascribed to Thomson by J. Stuart Fleming, an officer of the Owen Sound branch of the Children's Aid Society, who owned the plates. The stamps were reissued in 1977 by the Tom Thomson Memorial Art Gallery to mark the centenary of the artist's death and reproduced as the final plate in *The Silence and the Storm*, but hard evidence is lacking for Thomson's involvement in their design or production, especially as the "modernesque," poster-like style is completely out of keeping with what we know of his commercial art from this period.

28. This work bears the following inscription on a label on the backing: "Design by Tom Thomson/about 1916/from Dr. J.M. McCallum [sic] Collection/Thoreau MacDonald, Thornhill." The text is an excerpt from Wilcox's poem "Not Quite the Same," which originally appeared in the author's *Poems of Passion* (1883), later reprinted in *Poetical Works by Ella Wheeler Wilcox*.

29. Michael Large, foreword, *J.E.H. MacDonald: Designer*, by Robert Stacey and Hunter Bishop (Ottawa: Carlton University Press, 1995), x.

"Tom Thomson and the Arts and Crafts Movement in Toronto" by Dennis Reid

1. There is extensive literature on Morris and the Arts and Crafts movement. See David and Sheila Latham, *An Annotated Critical Bibliography of William Morris* (London/New York: Harvest Wheatsheaf/St. Martin's Press, 1991). For a good general survey of the movement, see Gillian Naylor, *The Arts and Crafts Movement* (London: Trefoil Publications, 1971).

2. See Lionel Lambourne, *The Æsthetic Movement* (London: Phaidon Press, 1996), and for the distinction between the Æsthetic and Arts and Crafts movements, see Paul Greenhalgh, "*Le Style Anglais*: English Roots of the New Art," in Paul Greenhalgh, ed., *Art Nouveau: 1890–1914* (New York: Harry N. Abrams, 2000), 137–39.

3. See Kevin O'Brien, *Oscar Wilde in Canada, An Apostle for the Arts* (Toronto: Personal Library, 1982), 97–112.

4. See Christine Boyanoski, *Sympathetic Realism: George A. Reid and the Academic Tradition* (Toronto: Art Gallery of Ontario, 1986); Brian Foss and Janice Anderson, *Quiet Harmony: The Art of Mary Hiester Reid* (Toronto: Art Gallery of Ontario, 2000).

5. Robert Judson Clark, ed., *The Arts and Crafts Movement in America 1876–1916* (Princeton, N.J.: Princeton University Press, 1972), 9, 13.

6. Address by George Reid on his retirement from the Ontario College of Art, 13 May 1929. Reid Papers, Edward P. Taylor Research Library and Archives, Art Gallery of Ontario. Cited in Chris Dickman, *G.A. Reid: Toward a Union of the Arts* ([Whitby, Ont.]: Durham Art Gallery, 1985), 13.

7. Dickman, *G.A. Reid*, 13–17, 21–25.

8. "The Summer Cottage and Its Furnishings," *Canadian Architect and Builder* 14 (March 1901): 57.

9. He became chairman of staff in 1901, and when the school was incorporated as the Ontario College of Art in 1912, Reid became principal, a position he held until 1929. He also designed the first purpose-built building for the college, which opened next to the Art Gallery of Toronto in Grange Park in September 1921.

10. Muriel Miller Miner, *G.A. Reid, Canadian Artist* (Toronto: Ryerson Press, 1946), 92–93; in the revised edition, Muriel Miller, *George Reid, a Biography* (Toronto: Summerhill Press, 1987), 82–83.

11. Miner, *G.A. Reid*,78; rev. ed., 71.

12. Ibid., 95–96; 84.

13. E. Lisa Panayotidis, "James Mavor: Cultural Ambassador and Æsthetic Educator to Toronto's Elite," in David Latham, ed., *Scarlet Hunters: Pre-Raphaelitism in Canada* (Toronto: Archives of Canadian Art and Design, 1998), 161–63, 165.

14. See *Ontario Society of Artists. Applied Art Exhibition. Catalogue 1900*. The exhibition extended from 17 April to probably 26 May. See Jean Grant, "Studio and Gallery," *Toronto Saturday Night* 13, no. 20 (31 March 1900): 9; Jean Grant, "Studio and Gallery," *Toronto Saturday Night* 13, no. 27 (19 May 1900): 9.

15. See *The Arts and Crafts Society of Canada, Catalogue of the First Exhibition Held at the Galleries of the Ontario Society of Artists, 165 King St. West, April 7th to April 23rd, 1904*.

16. Rosalind Pepall, "Under the Spell of Morris: A Canadian Perspective," in Katharine Lochnan *et al.*, *The Earthly Paradise: Arts and Crafts by William Morris and His Circle from Canadian Collections* (Toronto: Art Gallery of Ontario/Key Porter Books Limited, 1993), 28; Sandra Gwyn, *The Private Capital: Ambition and Love in the Age of Macdonald and Laurier* (Toronto: McClelland and Stewart Limited, 1984), 347–48, 369.

17. Miner, *G.A. Reid*, 109–10; rev. ed., 93–95.

18. He served until 1909 and was largely responsible for the establishment of an Advisory Arts Council for the National Gallery of Canada in 1907. Byron Walker served on the council and became chairman in 1910, hiring Eric Brown as the first full-time curator (later director) and setting the stage for the National Gallery of Canada Act of 1913, which finally, after thirty-three years, put the institution on a firm footing. See Jean Sutherland Boggs, *The National Gallery of Canada* (Toronto: Oxford University Press, 1971), 6–11.

19. "The Palette Club Exhibition," *Toronto Saturday Night*, 8 (1 December 1894): 7. For the Palette Club, see Dennis Reid, *Lucius R. O'Brien: Visions of Victorian Canada* (Toronto: Art Gallery of Ontario, 1990), 103–106.

20. The former, now in the National Gallery of Canada (35621.1-20), is partially published in Harold Town and David P. Silcox, *Tom Thomson: The Silence and the Storm* (Toronto: McClelland and Stewart, 1977), 210–15, although they include some drawings they have incorrectly assumed once were in the sketchbook. For the other

sketchbook, now in the Art Gallery of Peel, see Joan Murray, *A Tom Thomson Sketchbook* ([Brampton: Ont.]: Art Gallery of Peel, 1996).

21. Joan Murray, *The Best of Tom Thomson* (Edmonton: Hurtig Publishers, 1986), 6. The only document supporting a connection between Thomson and Cruikshank is a note from the latter to James Mavor arranging to bring someone he calls "Tomson" to meet him. Letter from Wm. Cruikshank, 14 February, no year, to Prof. Mavor. Thomas Fisher Rare Book Library, University of Toronto, James Mavor Papers, box 4a. The school's class lists do not survive.

22. See *The Canadian Society of Applied Art, Catalogue of the Second Exhibition Held at the Galleries of the Ontario Society of Artists, 165 King St. West, Dec. 9th to Dec. 23rd, 1905*.

23. See, for instance, *Toronto Saturday Night* 17 (12 March 1904): 11; 17 (9 April 1904): 13; 18 (21 January 1905): 15. The advertisement at the time of the first exhibition of the Arts and Crafts Society of Canada in April 1904 is worded in a way that might suggest some affiliation. That interpretation is no longer possible once the firm is clearly designated a limited company, and the society changes its name. The United Arts & Crafts, Limited, was bought by John Kay Company, Limited, in June 1907 and its entire stock liquidated. See *Toronto Saturday Night* 20 (15 June 1907): 19.

24. *Toronto Saturday Night* 19 (12 May 1906): 10.

25. Robert Stacey, "Harmonizing 'Means and Purpose': The Influence of Ruskin, Morris, and Crane on J.E.H. MacDonald," in Latham, ed., *Scarlet Hunters*, 102–103.

26. Ibid., 104.

27. MacDonald joined the staff of the Ontario College of Art in 1921 and succeeded George Reid as principal

in 1929, a position he held until his death late in 1932.

28. For his own graphic design work, see Robert Stacey and Hunter Bishop, *J.E.H. MacDonald, Designer: An Anthology of Graphic Design, Illustration and Lettering* ([Ottawa:] Carleton University Press/Archives of Canadian Art, 1996).

29. Dennis Reid, *The Group of Seven* (Ottawa: The National Gallery of Canada, 1970), 55.

30. See W. Douglas Brown, "The Arts and Crafts Architecture of Eden Smith," in Latham, ed., *Scarlet Hunters*, 151, 158.

31. See letter from J.E.H. MacDonald, 20 December 1926, to Fred Housser [never mailed]. The present whereabouts of this widely cited letter is unknown, although a number of photocopies are available, for instance Thoreau MacDonald Collection/The Papers of L. Bruce Pierce, McMichael Canadian Art Collection Archives, gift of Mr. L. Bruce Pierce.

32. A.Y. Jackson, *A Painter's Country: The Autobiography of A.Y. Jackson* (Toronto: Clarke, Irwin & Company Limited, 1958), 32–33. In the Centennial Edition (1967), 27–28.

33. See Pierre B. Landry, *The MacCallum-Jackman Cottage Mural Paintings* (Ottawa: National Gallery of Canada, 1990), 12.

34. See Douglas Cole, "Artists, Patrons and Public: An Enquiry into the Success of the Group of Seven," *Journal of Canadian Studies* 13 (summer 1978): 70. For the broader social context of the phenomenon in Ontario, see Patricia Jasen, *Wild Things: Nature, Culture, and Tourism in Ontario* (Toronto: University of Toronto Press, 1995), especially chapter 5, "A Rest Cure in a Canoe." For the Madawaska Club, see *The Madawaska Club, Go-Home Bay, 1898–1948* (n.p., [1948]).

35. See, for instance, J. Harry Smith, "September in Algonquin Park," *Canadian Magazine* 35 (May 1911): 27–32; "A Holiday in Algonquin Park," *Toronto*

Saturday Night 25 (25 May 1912): 4,5,7; Mark Robinson, "Through Algonquin with a Dog-Team," *Toronto Saturday Night* 26 (1 March 1913): 4–5.

36. Michael Tooby, *Our Home and Native Land: Sheffield's Canadian Artists* (Sheffield: Mappin Art Gallery, 1991), n.p.

37. Harris later described the years preceding the future Group of Seven's first exhibition in 1920 as the "decorative phase," cited in Bess Harris and R.G.P. Colgrove, eds., *Lawren Harris* (Toronto: Macmillan, 1969), 45, 51.

38. Hector Charlesworth, "O.S.A.'s Exhibition 1915," *Toronto Saturday Night* 28 (20 March 1915): 4.

39. "The Decorative Element in Art," unpublished manuscript, MacDonald fonds, National Archives of Canada; cited in Stacey, "Harmonizing 'Means and Purpose,'" 119.

40. Donald Buchanan, *The Growth of Canadian Painting* (London and Toronto: Collins, 1950), 30.

41. Arthur Lismer, "Tom Thomson (1877–1917) Canadian Painter," *The Educational Record of the Province of Quebec* 80 (July–September 1954): 170.

42. Landry, *The MacCallum-Jackman Cottage Mural Paintings*, 28–29, 44. See also Dennis Reid, *The MacCallum Bequest of Paintings by Tom Thomson and Other Canadian Painters & the Mr and Mrs H.R. Jackman Gift of the Murals from the Late Dr MacCallum's Cottage Painted by Some of the Members of the Group of Seven* (Ottawa: National Gallery of Canada, 1969), 69–71.

43. Estelle M. Kerr, "Murals in Georgian Bay," *The Canadian Courier* 21 (16 December 1916): 15.

44. First in Joan Murray, *The Art of Tom Thomson* (Toronto: Art Gallery of Ontario, 1971), 42.

45. Ottelyn Addison in collaboration with Elizabeth Harwood, *Tom Thomson: The Algonquin Years* (Toronto: The Ryerson Press, 1969), 64. Addison and Harwood report that the vase was

broken later that year, but in a subsequent interview (1977) Mrs. Crombie speaks of the jar Thomson painted as a replacement for one that was broken; transcription quoted in Joan Murray, *Tom Thomson: The Last Spring* (Toronto, Oxford: Dundurn Press, 1994), 95.

46. Dr. R.P. Little, "Some Recollections of Tom Thomson and Canoe Lake," *Culture* 16 (1955): 204. For the report of Lismer's account of painting the canoe see Audrey Saunders, *Algonquin Story* ([Toronto]: Department of Lands and Forests, [1947]), 167.

47. Ottelyn Addison, *Early Days in Algonquin Park* (Toronto: McGraw-Hill Ryerson Limited, 1974), 126.

48. Addison and Harwood, *Tom Thomson*, 85.

49. See "Mark Robinson Talks about Tom Thomson," transcribed in William T. Little, *The Tom Thomson Mystery* (Toronto: McGraw-Hill, 1970), 187–88.

"Tom Thomson's Places" by John Wadland

I wish to thank Dennis Reid for his faith in inviting me to participate in this project, Andrew Hunter for so generously sharing his many insights, Laura Brown for so skilfully guiding me through the process, Alison Reid for her love of language and its shapes and especially Julia Harrison for her love and constant encouragement.

1. Irit Rogoff, *Terra Infirma: Geography's Visual Culture* (London: Routledge, 2000), 33.

2. Ibid., 22–24. Rogoff is referring to Henri Lefebvre, *The Production of Space* (Oxford: Blackwell, 1991).

3. Mechanics Institutes were found across Canada after 1827, modelled on their British antecedents. They were supported initially by modest government subventions and membership fees and were designed as voluntary local educational associations for the edification of workers. As school facilities

were developed by church and state, the institutes gradually dropped their pedagogical role to become libraries serving the emerging middle class. There were many Mechanics Institutes in rural Ontario communities at the end of the nineteenth century, and in 1895 provincial legislation effectively converted them into public libraries.

4. Arthur T. Davidson, *A New History of the County of Grey* (Owen Sound: Grey County Historical Society, 1972), 318–25.

5. James P. Barry, *Georgian Bay: the Sixth Great Lake*, rev. ed. (Toronto: Clarke, Irwin, 1978), 110.

6. Patricia Jasen, *Wild Things: Nature, Culture and Tourism in Ontario, 1790–1914* (Toronto: University of Toronto Press, 1995), 92.

7. Barry, *Georgian Bay*, 128–34.

8. Ibid., 136–38.

9. James T. Angus, *A Deo Victoria: The Story of the Georgian Bay Lumber Company, 1871–1942* (Thunder Bay: Severn Publications, 1990), 232–33.

10. Ibid., 233–34.

11. R. Peter Gillis and Thomas R. Roach, *Lost Initiatives: Canada's Forest Industries, Forest Policy and Forest Conservation* (Westport, Conn.: Greenwood Press, 1986), 87.

12. Samuel P. Hays, *Conservation and the Gospel of Efficiency: The Progressive Conservation Movement, 1890 to 1920* (Cambridge: Harvard University Press, 1959).

13. New Ontario was the designation assigned to what is now called Northern Ontario. It was a term in common use after the turn of the twentieth century, especially following the construction of the Canadian Northern and the Temiskaming and Northern Ontario Railways. New Ontario was distinctively an "industrial, wage-earning, and urban" frontier with a rich Aboriginal and multicultural society. See Morris Zaslow, *The Opening of the Canadian North, 1870–1914* (Toronto: McClelland and Stewart, 1971), 192–93.

14. Gillis and Roach, *Lost Initiatives*, 105.

15. Barry, *Georgian Bay*, 78–79.

16. Ibid.

17. Dennis Reid, *The MacCallum Bequest of Paintings by Tom Thomson and Other Canadian Painters* (Ottawa: National Gallery of Canada, 1969), 9–10.

18. This census data is taken from tables prepared by J.M.S. Careless, *Toronto to 1918: An Illustrated History* (Toronto: James Lorimer, 1984), 200–201.

19. Joan Murray, *Tom Thomson: Design for a Canadian Hero* (Toronto: Dundurn Press, 1998), 14–15, 22–25.

20. Ibid., 15–17, 43, 45, 49, 56, 87. Dr. William Brodie (1831–1909) was a dentist who practised in Toronto and Markham for more than forty years. His real love was natural history, and he became recognized as an international authority in the fields of botany and entomology. "By 1900 Brodie's biological collections ranked among the finest on the continent, and contained 100,000 specimens of Ontario flora and fauna," a large number of which he eventually sold to the Smithsonian Institution in Washington. "He rejected the traditional emphasis on morphology in favour of a greater focus on ecology, the relation of living things to their environment." Suzanne Zeller, "William Brodie," *Dictionary of Canadian Biography*, vol. 13, 1901–1910 (Toronto: University of Toronto Press, 1994), 112–14. Brodie was also a thoughtful mentor to other young naturalists, including Ernest Thompson Seton. See John Henry Wadland, *Ernest Thompson Seton: Man in Nature and the Progressive Era, 1880–1915* (New York: Arno, 1978). Having an innate love of nature and learning actually to *see* nature with Rogoff's "curious eye" were two quite different sensibilities.

21. Careless, *Toronto*, 149–93. For the best analysis of early Toronto architecture, see Eric Arthur, *Toronto, No Mean City* (Toronto: University of Toronto Press, 1964; the third edition revised by Stephen A. Otto, 1986). For the general look and feel of Canadian economic and political culture in this period, see Ramsay Cook, *Canada 1896–1921: A Nation Transformed* (Toronto: McClelland and Stewart, 1974).

22. In the course of this research I have learned how important it is to examine the history and development of the processes of photo-engraving at the turn of the twentieth century. Clearly, as a "new technology," it was a major contributor to the "information revolution" of the time. I found trade publications not only helpful but fascinating to read and to look at, as works of art in their own right. See, for example, Louis Flader, ed., *Achievement in Photo-Engraving and Letter Press Printing* (Chicago: American Photo-Engraving Association, 1927). Louis Flader was also editor of *The Photo-Engravers Bulletin*, a periodical serving the trade from 1911. The work of several Canadian printing and photo-engraving houses is featured in the pages of these publications.

23. Dr. R.P. Little writes of meeting Tom Thomson for the first time in 1914: "About September 7 Mark Robinson told me that Shannon Fraser of Canoe Lake was starting a tourist lodge. I therefore paddled down there in a canoe to see about getting accommodations. . . . Tom was camped in a grove of birch trees on the north shore of Canoe Lake immediately opposite the old [Gilmour] mill.[This was Hayhurst Point, his favourite campsite, immediately below the hill where the Tom Thomson memorial cairn was placed by J.E.H. MacDonald and J.W. Beatty.] This site had been selected for Park headquarters but later abandoned [for the site on Cache Lake]. . . . He suggested that I see the Frasers. I therefore went to Mowat Lodge and had dinner, being their first guest." Thomson and Jackson likely stayed in the same place, but before it had actually been dignified by the name 'lodge'. R.P. Little, "Some Recollections of Tom Thomson and Canoe Lake," *Culture* 16 (1955): 202. "Tom usually camped out when the weather permitted, from April till the first snowfall in October or November, and he was perfectly at home in his gypsy tent. . . . In early spring and late fall Tom lived with the Frasers as one of the family." Ibid., 204.

24. Ottelyn Addison and Elizabeth Harwood, *Tom Thomson: The Algonquin Years* (Toronto:Ryerson, 1969), 6–8; 88 n4, n6. S. Bernard Shaw, *Canoe Lake, Algonquin Park: Tom Thomson and Other Mysteries* (Burnstown, Ont.: General Store Publishing, 1996), 40. It is worth noting here that as early as 1902, Park Superintendent G.W. Bartlett reported that "a great many of the portages throughout the park have been measured and notices have been put up at each end . . . stating name of lake, route, length. . . . These notices are fastened to trees at the water's edge, and are in zinc frames with glass fronts." G.W. Bartlett, Appendix 37, *Report of the Commissioner of Crown Lands, Province of Ontario, 1902* (Toronto: L.K Cameron, 1903), 71.

25. Dennis Reid, "Photographs by Tom Thomson," National Gallery of Canada *Bulletin* 16, 1970 (Ottawa: National Gallery of Canada, 1971): 2–10.

26. See Alexander Kirkwood and J.J. Murphy, *The Undeveloped Lands in Northern and Western Ontario: Information Regarding Resources, Products and Suitability for Settlement—Collected and Compiled from Reports of Surveyors, Crown Land Agents and Others, with the Sanction of the Honourable Commissioner of Crown Lands* (Toronto:

Hunter, Rose, 1878); Alexander Kirkwood, *Algonkin, Forest and Park, Ontario. Letter to the Honourable T.B. Pardee, M.P.P., Commissioner of Crown Lands for Ontario.* (Toronto: Warwick, 1886).

27. Gary Long, "James Dickson and Algonquin," in James Dickson, *A Nineteenth-Century Algonquin Adventure,* edited and with an introduction and notes by Gary Long. (Huntsville, Ont.: Fox Meadow Creations, 1997), 28–29. This book, originally published in 1886 under the title *Camping in the Muskoka Region,* provides an excellent description of the portion of the park bounded by Tea, Canoe, Misty, Big Trout, Opeongo, Two Rivers, Cache, Ragged and Smoke Lakes. Long's detailed notations of the text are particularly helpful in explaining the changes about to befall this immediate region following the establishment of the park and the commencement of logging in 1893. Dickson takes the reader on a canoe trip through territory that he himself had surveyed, explaining in intimate detail the landmarks along the way. There is extensive discussion of fish and wildlife encountered and reflections on logging and trapping practice.

28. See especially Florence B. Murray, "Agricultural Settlement on the Canadian Shield: Ottawa River to Georgian Bay," in *Profiles of a Province: Studies in the History of Ontario,* Edith G. Firth, ed. (Toronto: Ontario Historical Society, 1967), 178–86.

29. William Houston, quoted in James Cleland Hamilton, *The Georgian Bay: An Account of Its Position, Inhabitants, Mineral Interests, Fish, Timber and Other Resources* (Toronto: Carswell, 1893), 152. Hamilton was a colleague of William Brodie in the Royal Canadian Institute, which actively promoted the idea of a park. Hamilton was himself a bit more romantic than Houston, linking the proposed park "with the most

romantic period of our provincial history, the time of Champlain, the Hurons and the hardy voyageurs." Ibid., 150. For a short biography of Hamilton, see W. Stewart Wallace, ed. *The Royal Canadian Institute: Centennial Volume 1849–1949* (Toronto: Royal Canadian Institute, 1949), 194.

30. *Timber Lands Maps, Ontario. Sheet no. 1.,* Crown Timber Office, Ottawa 7 April 1875 (sgd in print) A.J. Russell Crown Timber Agent, etc., in *The New Standard Atlas of the Dominion of Canada* (Montreal and Toronto: Walker and Miles, 1875), 175. Reprinted in R. Louis Gentilcore and C. Grant Head, with Joan Winearls, *Ontario's History in Maps* (Toronto: University of Toronto Press, 1984), 138. An individual licence was restricted to 25 acres on surveyed land and 50 acres on unsurveyed land. A timber limit contained several licences. A careful look at the map indicates that several lumbermen held many limits, widely distributed throughout the region.

31. W. Gibson, "The Algonquin National Park of Ontario," Clerk of Forestry, *Report,* 1896, 122. Quoted in Richard Lambert and Paul Pross, *Renewing Nature's Wealth: a Centennial History of the Public Management of Lands, Forests and Wildlife in Ontario, 1763–1967* (Toronto: Ontario Department of Lands and Forests, 1967), 280.

32. See James Dickson's account, for example, of his party's discovery of a caboose near Otterslide Lake in McLaughlin Township in 1886: "The building is at least thirty by forty feet, and seven or eight in height. . . . [A]s the interior of the shanty is now filled with provisions for both man and beast, it is evidently the intention of the owners to reoccupy next winter. The construction of roads is so expensive in this unbroken wilderness that the owner of timber limits finds it cheaper and more convenient, before

the ice in the lakes and streams breaks up in the spring and the smooth winter roads have become impassable, to lay in a sufficient supply of provisions to last his gang of men — usually sent into the woods about the end of autumn — till the ice has again taken and the snows of early winter render the roads passable. A few men are generally left in charge during the summer to raise vegetables at some central point known as the farm or depot." Dickson, *A Nineteenth-Century Algonquin Adventure,* 148. Another important depot existed on the site of the Dennison farm, built in the 1870s by Capt. John Dennison and his sons at the narrows on Lake Opeongo, the site of a former Native encampment. The Dennisons had reached this site from the southeast. "From Bark Lake the travelers went up the Madawaska River, across to Victoria Lake, and then through a chain of lakes to the Opeongo River." In 1882 the Dennisons moved away, and the site was taken over in 1885 by the Fraser Lumber Company to be operated as a depot farm. Audrey Saunders, *The Algonquin Story,* rev. ed. (Toronto: Department of Lands and Forests, 1963), 58–59.

33. See Lambert and Pross, *Renewing Nature's Wealth,* 165–73. Further additions in the 1950s and 1960s have brought the park to its present definition. For a map showing the original park and the additions, see Lambert and Pross, 278–79.

34. Kirkwood, *Algonkin, Forest and Park,* 8. Alexander Kirkwood was an Irish immigrant who began work in the Crown Lands office in 1854, eventually becoming chief clerk in the Land Sales office. He was among the most articulate campaigners for the creation of Algonquin Park and was appointed chairman of the Royal Commission on Forest Reservation and a National Park in 1893.

35. Ralph Bice, who began guiding in the park in 1917, speaks of Indian guides from Golden Lake: "Paul Tenniscoe and his three sons, Bill, Joe and Seymour, two men, brothers named Benoit, two named Joe Lavellee (one was named Hay Lake Joe) and John Parks." Ralph Bice, *Along the Trail in Algonquin Park* (Toronto: Natural Heritage/Natural History, 1980), 58–59.

36. See, for example, K.E. Kidd, "A Prehistoric Camp Site at Rock Lake, Algonquin Park, Ontario," *Southwestern Journal of Anthropology* 4, no. 1 (1948): 98–106; B.M. Mitchell, "Archaeology of the Petawawa River. The Second Site at Montgomery Lake, *Michigan Archæologist* 15, no. 1 and 2 (1969): 1–53; B.M. Mitchell, D.A. Croft, P.J. Butler and R.J. Cawthorn, "The Petawawa Small Sites Report," *Ontario Archaeology* 15 (1970): 1–53; W.C. Noble, "Vision Pits, Cairns and Petroglyphs at Rock Lake, Algonquin Provincial Park, Ontario," *Ontario Archaeology* 11 (1968): 47–64. There are numerous other sources listed in Ron Tozer and Nancy Checko, *Algonquin Provincial Park Bibliography.* Algonquin Park Technical Bulletin no. 12 (Whitney, Ont.: Friends of Algonquin Park, 1996): 6–7.

37. H. Eleanor (Mooney) Wright, *Joe Lake: Reminiscences of an Algonquin Park Ranger's Daughter* (Eganville, Ont.: HEW Enterprises, 2000), vii.

38. Saunders, *Algonquin Story,* 54.

39. The park superintendent remarked in his annual report that Francis Dufond died in 1918: "The old Indian, Francis Dufond, at Manitou lake died this fall, and I believe his old wife intends to move out to Mattawa as soon as the ice takes. This will leave the farm vacant, and as it is a rendezvous for the Indian trappers from Mattawa, I thought of stationing a ranger there. There are . . . a large clearing and several buildings on the farm, which belongs to the Government." *Report of*

the Minister of Lands, Forests and Mines of the Province of Ontario, 1918 (Toronto: Legislative Assembly of Ontario, 1919), 95.

40. Wilfred Campbell, The Beauty, History, Romance and Mystery of the Canadian Lake Region (Toronto: Musson, 1910), 111. William Wilfred Campbell (1860–1918) had grown up in Meaford and Wiarton, completing high school in Owen Sound in 1879. He attended the University of Toronto and in 1886 was ordained an Anglican priest. By 1891, when he moved to Ottawa, he had become a well-established poet. He joined the civil service in Ottawa, where, with colleagues Duncan Campbell Scott and Archibald Lampman, he wrote the column "At the Mermaid Inn" for the Globe, 1892–93. He was a prolific author, publishing several works of poetry and fiction. He was elected to the Royal Society of Canada in 1894. In many ways his thought was a holdover from the Imperialist tradition of the nineteenth century, favouring a strong Canadian nationalism grounded in unflagging loyalty to the British Empire. Laurel Boone, "William Wilfred Campbell," Dictionary of Canadian Biography, vol. 14, 1911–1920 (Toronto: University of Toronto Press, 1998), 180–83. To place Wilfred Campbell in the context of his time, see Susan Glickman, The Picturesque and the Sublime: A Poetics of the Canadian Landscape (Montreal: McGill-Queen's University Press, 1998).

41 After the death of Alex Dokis, the pine timber on his reserve was sold in 1908 at public auction, in Ottawa, for $871,500. The one virtue of the sale was that the proceeds from it were returned to the band. "The bonus money, subsequent timber dues, and ground rent netted the band the amazing sum of $1.1 million. . . . Thus, the Dokis Indians, then numbering eighty-one souls, became per capita

the richest Indians in Canada." The story is told in full, and extremely well, in Angus, A Deo Victoria, 247–66.

42. Roderick MacKay and William Reynolds, Algonquin (Erin, Ont.: Boston Mills, 1993), 21.

43. Harold Town and David P. Silcox, Tom Thomson: The Silence and the Storm (Toronto: McClelland and Stewart, 1977), 26.

44. Campbell, Canadian Lake Region, 112–13.

45. Ibid., 113. Jonathan Bordo, "The Jack-Pine—Wilderness Sublime or the Erasure of the Aboriginal Presence from the Landscape," Journal of Canadian Studies 27, no. 4 (winter 1992): 98–128, opened a conversation in which this section aspires to be a respectful participant. His thoughtful and absorbing paper has been followed by others, equally stimulating and challenging, which engage the issue of race and landscape. I would single out for special mention Scott Watson, "Race, Wilderness, Territory and the Origins of Modern Canadian Landscape Painting," Semiotext(e) 6, no. 2 (1994): 93–104; Peter C. van Wyck, Primitives in the Wilderness: Deep Ecology and the Missing Human Subject (Albany: State University of New York Press, 1997); Ian Angus, A Border Within: National Identity, Cultural Plurality and Wilderness (Montreal: McGill-Queen's University Press, 1997). What has emerged for me in the research for this paper is the distinction to be made between those who make art and those who make "use" of art (acknowledging, of course, that these may sometimes be the same people). James MacCallum and Lawren Harris, among others, were wealthy and powerful figures who combined to become the voice of Tom Thomson after his death. In their hands he himself became a logo, a representation of the place in which he chose to make his art and of racial-

ized notions of the "North" that their families had carried out of the nineteenth century. See, for example, J.M. MacCallum, "Tom Thomson: Painter of the North," Canadian Magazine 50, no. 5 (March 1918): 375–85. For some interesting variations on the point, see Carolyn Machardy, "An Inquiry into the Success of Tom Thomson's 'The West Wind,'" University of Toronto Quarterly 68, no. 3 (summer 1999): 768–89. On this issue it is essential to revisit Carl Berger, The Sense of Power: Studies in the Ideas of Canadian Imperialism (Toronto: University of Toronto Press, 1970). As Tom Thomson's voice is all but silent in the record, except through his art, we really have no way of knowing his thoughts on matters of race.

46. Ottelyn Addison, Early Days in Algonquin Park (Toronto: McGraw-Hill Ryerson, 1974), 11.

47. MacKay and Reynolds, Algonquin, 31.

48. Ibid., 35–39.

49. See Grace Barker, Timber Empire: The Exploits of the Entrepreneurial Boyds (Fenelon Falls, Ont.: Dawn Publishing, 1997); H.R. Cummings, Early Days in Haliburton (Toronto: Ontario Department of Lands and Forests, 1962); C.D. Howe and J.H. White, Trent Watershed Survey: A Reconnaissance. (Commission of Conservation: Ottawa, 1913).

50. Gary Long and Randy Whiteman, When Giants Fall: The Gilmour Quest for Algonquin Pine (Huntsville, Ont.: Fox Meadow Creations, 1998), 106.

51. Ibid., 117–21.

52. Ibid., 127–43; MacKay and Reynolds, Algonquin, 39.

53. "Mowat was a stark place with its rough wooden buildings, railway tracks, the huge mill belching smoke and steam, and a barren 9-hectare expanse known as the 'chip-yard' where slabs were dumped and lumber stacked. A sawdust burner 10.7 metres in diameter and rearing 24.4 metres into the

Algonquin sky generated a constant plume of smoke that drifted across the hills. . . . Partly as a consequence of the despoliation of the scenery by the Gilmour operation, Park headquarters was moved in the summer of 1897 from Canoe Lake to a new site 10 kilometres to the east on Cache Lake." Long and Whiteman, When Giants Fall, 153.

54. Roy MacGregor, A Life in the Bush: Lessons from My Father (Toronto: Viking, 1999), 88–89.

55. Ibid., 90–91. The general manager of the St. Anthony Lumber Company was Edwin C. Whitney, whose brother, James, became premier of Ontario in 1905.

56. To obtain a thorough sense of the intensity of industrialization in the park, see Ed McKenna, A Systematic Approach to the History of the Forest Industry in Algonquin Park, 1835–1913, with an Evaluation of Algonquin Park's Historical Resources and an Assessment of Algonquin Park's Historical Zone System (Algonquin Region: Ministry of Natural Resources, 1976); Ron Edwards, Petawawa River Survey Sites: A History (Algonquin Region: Ministry of Natural Resources, 1976); Donald L. Lloyd, Canoeing Algonquin Park (Toronto: By the author, 2000).

57. MacGregor, Life in the Bush, 89.

58. Niall MacKay, Over the Hills to Georgian Bay: A Pictorial History of the Ottawa, Arnprior and Parry Sound Railway (Erin, Ont.: Boston Mills, 1981), 64. Ottelyn Addison identifies the proprietor of the Algonquin as Tom Merrill of Rochester, New York, and its opening date as 1905. Addison, Early Days, 74. G.W. Bartlett does not mention either of the hotels until his report for 1910–11. Then he mentions L.E. Merrell (sic) as owner. G.W. Bartlett, Appendix 44, Report of the Minister of Lands, Forests and Mines, Province of Ontario, 1911 (Toronto: L.K. Cameron, 1912), 98. Ralph Bice says the hotel was opened

by L.E. Merrill "in 1907 or 1908." Bice, *Along the Trail*, 56. These are apparently minor details, but they illustrate how careful one must be in attempting to reconstruct the place in its time.

59. Roy I. Wolfe, "The Summer Resorts of Ontario in the Nineteenth Century," *Ontario History* 54, no. 3 (1962): 159–60.

60. The other camps, all for boys, included Camp Waubuno on Cache Lake (operated by George Brower, a mathematics teacher at the State Model School, Trenton, New Jersey); Camp Minne-Wawa on Lake of Two Rivers (operated by W.L. Wise, head of the English Department at the Military Institute, Bordentown, New Jersey); and Camp Pathfinder on Source Lake (operated by teachers at West High School in Rochester, New York). G.W. Bartlett also mentions the Long Trail Camp for boys on Joe Lake. "The Y.M.C.A. also of Buffalo send in a camp of young men each year." G.W. Bartlett, Appendix 30, *Report of the Minister of Lands, Forests and Mines, Province of Ontario, 1912* (Toronto: L.K. Cameron, 1913), 72. Grand Trunk Railway System, General Passenger Department, *The Playgrounds of Canada: A Short Treatise on Tourist, Fishing and Hunting Resorts Reached by the Grand Trunk System* (1915), 40–56.

61. G.W. Bartlett, Appendix 24, *Report of the Minister of Lands, Forests and Mines, Province of Ontario, 1915* (Toronto: A.T. Wilgress, 1916), 65–66.

62. G.W. Bartlett, Appendix 33, *Report of the Minister of Lands, Forests and Mines, Province of Ontario, 1916* (Toronto: A.T. Wilgress, 1917), 96. This was the location of the cabin where Tom Thomson lived while working as a fire ranger with Ned Godin in the summer of 1916. Caracajou Bay, directly across from the beach at Achray, is said to be the source for *The Jack Pine*. Lloyd, *Canoeing Algonquin Park*, 225, 237. Joan Murray, *Tom Thomson Trees*

(Toronto: McArthur and Company, 1999), 112. Winifred Trainor believed the sketch for *The West Wind* was painted that spring on Cedar Lake, but James MacCallum maintained that it was accomplished in his and Lawren Harris's company on one of the Cauchon Lakes. Addison and Harwood, *Tom Thomson*, 93. What I find interesting, in the context of this research, is that the proximity of the new Canadian Northern Railroad is never mentioned. In fact, it was mere metres away from the edge of the water along the full length of the Petawawa River and its headwater lakes, seldom out of range of sight or hearing, yet it appears in none of the paintings made in this area. Today the tracks are gone and the land has recovered. It is easy to forget.

63. In each of his annual reports to the minister, Superintendent Bartlett begins by identifying the number of rangers on staff and by locating the shelter huts they have built in that particular year. In the early days he tells us that they also built their own snowshoes and bark canoes to carry them on their rounds.

64. G.W. Bartlett, Appendix 33, *Report of the Minister of Lands, Forests and Mines, Province of Ontario, 1916* (Toronto: A.T. Wilgress, 1917), 97.

65. Ibid., 99.

66. E. Way Elkington, *Canada: The Land of Hope* (London: Adam and Charles Black, 1910), 48.

67. Tom Thomson to James MacCallum, 9 September 1915. National Gallery of Canada Archives. To return from South River to the park, Thomson probably paddled up the South to Nahma Lake, thence to Craig, Pishnecka, Charr, Jeepi Cayuga and North Tea.

68. Grand Trunk Railway System, Passenger Department, *Haunts of Fish and Game*. rev. ed. (1909), 30.

69. Ibid., 15–16. See also Astrid Taim, *Almaguin: a Highland History* (Toronto: Natural Heritage/Natural History, 1998).

70. Charles C. Hill, in his essay later in this volume (pp. 125–26) cites the diary of H.A. Callighen, a park ranger stationed at Smoke Lake, where he notes seeing Thomson and Lismer "on their way out" on 24 May 1914. On 30 May he is at Parry Sound and on 1 June at French River with Dr. Mac-Callum. According to Joan Murray's Chronology (p. 313), for "the next two months" he is at Go-Home Bay, and on 10 August ranger Callighen sees him back in the park. It is not impossible to do this, but one would have to be an extraordinary canoeist to manage it—especially on the open water of Georgian Bay, from the mouth of the French to Go-Home Bay (and back again). The difficulty is augmented by the fact of stopping to sketch at intervals along the way. Addison and Harwood simply say, "In the summer of 1914 Thomson paid a visit to Georgian Bay where Dr. Mac-Callum had a summer home. He travelled to Lake Nipissing via South River by lake, stream and portage, crossed the lake and paddled down the French River. Although he did a number of sketches at this time, he found much of the country inland monotonously flat and the rapids ordinary. In August he returned to Algonquin Park." *Tom Thomson*, 32. This really tells us very little—and anyone who has paddled down the French River will know that the rapids are hardly "ordinary."

71. Wayland Drew, "Killing Wilderness," *Ontario Naturalist* 12, no. 3 (September 1972): 23.

72. Allan Smith, "Farms, Forests and Cities: The Image of the Land and the Rise of the Metropolis in Ontario, 1860–1914," in *Old Ontario: Essays in*

Honour of J.M.S. Careless, David Keane and Colin Read, ed. (Toronto: Dundurn Press, 1990), 83.

73. G.W. Bartlett, Appendix 44, *Report of the Minister of Lands, Forests and Mines, Province of Ontario, 1911* (Toronto: L.K. Cameron, 1912), 99.

74. G.W. Bartlett, Appendix 26, *Report of the Minister of Lands, Forests and Mines, Province of Ontario, 1909* (Toronto: L.K. Cameron, 1910), 83.

75. Isaac Gardner, Appendix 65, *Report of the Commissioner of Crown Lands, Province of Ontario, 1904* (Toronto: L.K. Cameron, 1905), 123.

76. G.W. Bartlett, Appendix 52, *Report of the Minister of Lands and Mines, Province of Ontario, 1905* (Toronto: L.K. Cameron, 1906), 125.

77. Ibid., 84.

78. G.W. Bartlett, Appendix 36, *Report of the Minister of Lands, Forests and Mines, 1914* (Toronto: L.K. Cameron, 1915), 86. See also J. Walter Jones, *Fur-Farming in Canada*, 2d ed. (Ottawa: Commission of Conservation, 1914).

79. Ibid., 88.

80. G.W. Bartlett, Appendix 24, *Report of the Minister of Lands, Forests and Mines, Province of Ontario, 1915* (Toronto: A.T. Wilgress, 1916), 62.

81. G.W. Bartlett, Appendix 29, *Report of the Minister of Lands, Forests and Mines, Province of Ontario, 1917* (Toronto: A.T. Wilgress, 1918), 93.

82. G.W. Bartlett, Appendix 33, *Report of the Minister of Lands, Forests and Mines, Province of Ontario, 1916* (Toronto: A.T. Wilgress, 1917), 98.

83. W.L. Morton, "The 'North' in Canadian Historiography," *Transactions of the Royal Society of Canada* Series 4, 8 (1970): 32.

84. H.V. Nelles, *The Politics of Development: Forests, Mines and Hydro-Electric Power in Ontario, 1849–1941* (Toronto: Macmillan, 1974).

85. Smith, "Farms, Forests and Cities," 90–91. I am deeply indebted to this

wonderful article by Allan Smith for my entire concluding analysis.

"Tom Thomson, Painter" by Charles C. Hill

1. J.M. MacCallum to Edmund Walker, 16 December 1913: Thomson "has done some sketches here around the city that are quite interesting." Thomas Fisher Rare Book Library, University of Toronto, Sir Edmund Walker Papers, ms. coll. 1, box 11, file 32. I have been able to identify only two sketches by Thomson painted in Toronto, *Rosedale Ravine Near Studio Building* (sold Toronto, Sotheby's, 11–12 November 1980, lot 94 reproduced) and *Twilight* (Weir Foundation, Queenston, 982.66).

2. A.Y. Jackson, "Dr. MacCallum, Loyal Friend of Art," *Saturday Night* 59, no. 14 (11 December 1943): 19; *Evening Telegram* (Toronto), 11 December 1943.

3. See Dennis Reid, *The MacCallum Bequest . . .* (Ottawa: National Gallery of Canada, 1969).

4. J.M. MacCallum, "Tom Thomson: Painter of the North," *The Canadian Magazine* 50, no. 5 (March 1918): 378.

5. Ibid., 382.

6. Louise Henry to Blodwen Davies, 11 March 1931, in Blodwen Davies fonds, National Archives of Canada MG30 D38, vol. 11; J.E.H. MacDonald, "Landmark of Canadian Art," *The Rebel* 2, no. 2 (November 1917): 47.

7. Fraser Thomson to Davies, 19 May 1930, in NAC, MG30 D38, vol. 11. A drawing of Thomson playing the mandolin is on the verso of Thomson's oil sketch *Hillside, Smoke Lake* (NGC 4714), repr. in Joan Murray, *The Art of Tom Thomson* (Toronto: Art Gallery of Ontario, 1971), 33.

8. On Thomson's youth, see letters from Alan H. Ross to Davies, 1 June 1930 and 11 June 1930, Minnie (Thomson) Henry to Davies, 2 February 1931, and Louise (Thomson) Henry to Davies,

11 March 1931, in NAC, MG30 D38, vol. 11. Thomson remained close to his family and kept in touch as much as the dispersed family would permit. His parents moved into Owen Sound in 1902, his sister Elizabeth Harkness lived in nearby Annan, Henry and Ralph were in Seattle, his sisters Louise Henry and Minnie Henry lived in Guernsey (later Aberdeen), Saskatchewan, his youngest brother Fraser in Prince Albert, Margaret Thomson taught in Timmins, Ontario, and George Thomson moved from Seattle to New York in 1906 and later to New Haven, Connecticut.

9. Minnie Henry to Davies, 2 February 1931, and Ross to Davies, 11 June 1930.

10. Ross to Davies, 11 June 1930.

11. Ross to Davies, 1 June 1930 and 11 June 1930.

12. Canada Business College, *Canada's Greatest School of Business* (1903), formerly in the Chatham Public Library, copy courtesy of Joan Murray. Former students listed in this promotional booklet include C.C. Maring, "Pen artist of Maring & Ladd, Engravers, Seattle," F.R. McLaren, "Teacher of Shorthand, Associate Principal and Proprietor Acme Business College, Seattle," George Thomson, "Penman and Associate Principal and Proprietor Acme Business College, Seattle," (p.16) and Henry Thomson, "late Penman, International Business College, Bay City, Mich., now of Seattle," Thomas Thomson, artist and engraver with Maring & Ladd, Seattle" (p.20).

13. He might have worked on harvest teams in Manitoba on the way to Seattle. See Ross to Davies, 11 June 1930.

14. Fraser Thomson to Davies, 19 May 1930.

15. Thomson is listed in the 1903 Seattle city directory as working with Maring & Blake and in the 1904 directory as being with the Seattle Engraving Com-

pany. As the information was collected before the first of the year, I surmise Thomson was with the Seattle Engraving Company by December 1903. See Joan Murray, *Tom Thomson: The Last Spring* (Toronto: Dundurn Press, 1994), 18.

16. In the *Toronto City Directory* for 1906, (p. 975), 1907 (p. 1031), 1908 (p. 1093) and 1909 (p. 1087) Thomson is listed as artist with Legg Bros. Photo Engravers. In the directory for 1910 (p. 1173) he is merely listed as artist living at 99 Gerrard E. with no place of employment given. It is possible he moved to Grip late 1909, after the information for the 1910 directory was collected. He is listed as being at Grip in the 1911 directory (p. 1178). Albert H. Robson, *Canadian Landscape Painters* (Toronto: The Ryerson Press, 1932), 138, says Thomson came to Grip around 1907 and Robson, *Tom Thomson* (Toronto: The Ryerson Press, 1937), 5, says around 1908.

17. *Central Ontario School of Art and Industrial Design Annual Prospectus 1903–1904*, 8–9.

18. The painting, *Untitled (Farmer Leading Two Horses)*, is in the Tom Thomson Memorial Art Gallery, Owen Sound (H-994.1.02). Minnie Henry to Davies, 2 February 1931, states Tom gave her the oil for Christmas 1907, two days before her wedding. See also H.B. Jackson to Davies, 29 April 1931, NAC, MG30 D38, vol. 11: "Tom studied from life & the antique in art school. If I remember right Cruikshank was the instructor." Cruikshank taught drawing at the Central Ontario School of Art and Design, so it is possible Thomson took private lessons from him.

19. *Burns' Blessing* (fig.21) was given to Ralph Thomson, Seattle, on the occasion of his marriage to Ruth Shaw, 25 December 1906. Henry Thomson to H.O. McCurry, 19 October 1946, with typed copy of draft letter from Ralph Thomson to Blodwen Davies,

National Gallery of Canada Archives, 7.1–Thomson. Wedding certificate in private collection.

20. Robson, *Tom Thomson*, 6.

21. Robert Stacey and Hunter Bishop, *J.E.H. MacDonald, Designer: An Anthology of Graphic Design, Illustration and Lettering* (Ottawa: Archives of Canadian Art, Carleton University Press, 1996), 118.

22. Fern Bayer, "The 'Ontario Collection' and the Ontario Society of Artists Policy and Purchases, 1873–1914," *RACAR* 8, no. 1 (1981): 52.

23. Michael Tooby, *Our Home and Native Land: Sheffield's Canadian Artists* (Sheffield: Mappin Art Gallery, 1991), n.p.

24. A. Lismer, "Tom Thomson," c.1942, NAC, Arthur Lismer fonds, MG 30 D184, vol. 2 "Tom Thomson."

25. J.E.H. MacDonald, "Landmark of Canadian Art": 47.

26. A.Y. Jackson to J.E.H. MacDonald, 13 January 1919, in NAC, J.E.H. MacDonald fonds, MG 30 D111, vol. 1 (1-2a); A.Y. Jackson to H.O. McCurry, 14 July 1944, in NGC Arch., 1.71–MacCallum.

27. A.Y. Jackson, "Foreword," in *Catalogue of an Exhibition of Paintings by the Late Tom Thomson* (Montreal: The Arts Club, 1919), n.p.

28. Robert Stacey, "Making Us See the Light: Franklin Brownell's 'Middle Passage,' " in *North by South: The Art of Peleg Franklin Brownell (1857–1946)* (Ottawa: Ottawa Art Gallery, 1998), 96 n9.

29. John K. Grande, "Tom McLean: A Canadian Art Enigma," *Antiques and Art* 7, no. 6 (June 1981): 30.

30. *Toronto Daily Star*, 28 June 1904; *Toronto Daily Star*, 29 June 1904; *Toronto Daily Star*, 30 June 1904; *Globe* (Toronto) 29 June 1904.

31. A.Y. Jackson, *A Painter's Country: The Autobiography of A.Y. Jackson* (Toronto: Clarke, Irwin & Co., 1958), 21.

32. Thomson was nominated a member

of the OSA by Lismer and T.G. Greene, 3 March 1914, and elected 17 March 1914. Archives of Ontario, Ontario Society of Artists Papers, F1140, Minute Books, Minutes of the meetings of 3 March and 17 March 1914.

33. Blodwen Davies, *A Study of Tom Thomson* (Toronto: The Discus Press, 1935), 74–75; Jackson, *A Painter's Country*, 31. This story is confirmed by the Algonquin Park ranger H.A. Callighen in his journal entry for 22 September 1914. Arch. of Ont., H.A. Callighen papers, F1039, Journal 1914. My thanks to Andrew Hunter for sharing this source.

34. A.Y. Jackson to Mrs. Henry Jackson, 4 August 1917, private collection.

35. *Northern Lake* (Art Gallery of Ontario), *Morning Cloud* (The Thomson Collection), *Moonlight* (National Gallery of Canada), *Split Rock, Georgian Bay* (National Gallery of Canada), *Canadian Wildflowers* (National Gallery of Canada), *Moonlight* (private collection) and *The Hardwoods* (private collection) were all exhibited during Thomson's lifetime and are unsigned.

36. Notes prepared by Lawren Harris, with Graham McInnes to H.O. McCurry, 19 June 1941, in NGC Arch., 7.4 Film–Thomson.

37. J.E.H. MacDonald to A. Lismer, 16 March 1919, The McMichael Canadian Art Collection Archives, Arthur Lismer Papers.

38. A. Lismer to J.E.H. MacDonald, 21 March 1919, NAC, MG30 D111, vol. 1. The reference in Mortimer-Lamb's draft essay was not published in H. Mortimer-Lamb, "Studio Talk: Montreal," *The Studio* 77, no. 316 (July 1919): 119–26. See H. Mortimer-Lamb to the Editor, *Studio Magazine*, 29 March 1919, with attached draft article. British Columbia Archives, Harold Mortimer-Lamb Papers, MS 2834, Box 2, File 13.

39. A.Y. Jackson to Norah Thomson,

21 May 1924, NAC, Norah De Pencier fonds, MG30 D322, vol. 1. A.Y. Jackson to Marius Barbeau, 31 March 1933, Canadian Museum of Civilization, Marius Barbeau Collection, A.Y. Jackson, box 19. A.Y. Jackson to Eric Brown, 6 November 1933, in NGC curatorial file for *Lake, Shore and Sky* (NGC 4565).

40. Entry for 17 and 18 May 1912, in Mark Robinson's Daily Journal, Trent University Archives. My thanks to Andrew Hunter for the information on the references to Thomson in Robinson's journal. H.B. Jackson to Davies, 5 May 1931, NAC, MG30 D38, vol. 11; Ottelyn Addison and Elizabeth Harwood, *Tom Thomson, The Algonquin Years* (Vancouver, Winnipeg, Toronto: The Ryerson Press, 1969), 88 n4.

41. H.B. Jackson to Davies, 29 April 1931, NAC, MG 30 D38, vol. 11.

42. H.B. Jackson to Davies, 5 May 1931.

43. Mary L. Northway, *Nominigan: The Early Years* (Toronto: University of Toronto Press, 1970), 6; Addison, *Tom Thomson*, 75; Davies, *A Study of Tom Thomson*, 35–36. Ottelyn Addison to Dennis Reid, 11 May 1971, in NGC Arch. D. Reid (scholar).

44. H.B. Jackson to Eric Brown, 9 February 1929, in NGC curatorial file for H.B. Jackson: *Tom Thomson* (NGC 3690); H.B. Jackson, "A Camping Trip in Algonquin National Park," *Toronto Sunday World*, 11 April 1912.

45. R.P. Little, "Some Recollections of Tom Thomson and Canoe Lake," *Culture* 16, no. 2 (June 1955): 202.

46. Ibid., 205; Addison, *Tom Thomson*, 24, 91 n25.

47. H.B. Jackson to Davies, 29 April 1931.

48. *Owen Sound Sun*, 27 September 1912. Shannon Fraser later questioned Thomson's canoeing abilities when he first met Thomson in 1912 (Gertrude Pringle, "Tom Thomson the Man: Painter of the Wilds, Was a Very Unique Individuality," *Saturday Night*

41, no. 21 (10 April 1926): 5; however, no novice could have embarked on such a trip.

49. Tom Thomson to Dr. M.J. McRuer, McMichael Coll. Arch., Thomson Papers.

50. Fred Varley, Toronto, to Maud Varley, 9 August 1912. NAC, Varley fonds, MG 30 D401, vol. 1.

51. MacCallum, "Tom Thomson": 375.

52. See Dennis Reid, *The MacCallum Bequest*; R.M. Matthews, "James Metcalfe MacCallum, BA, MD, CM (1860–1943)," *CMA Journal* 114, no. 3 (April 1976): 621–24; Pierre Landry, *The MacCallum-Jackman Cottage Mural Paintings* (Ottawa: National Gallery of Canada, 1990).

53. J.M. MacCallum to Norman Gurd, postmarked 23 April 1923. Wyoming, Ontario, Lambton County Library Headquarters, Lambton Room, Box 24 JA-DA, Gurd correspondence. My thanks to David Taylor, Curator, Gallery Lambton, for sending me copies of this corrrspondence. I have not been able to identify *Woodland Hill in Autumn*.

54. Davies, *A Study of Tom Thomson*, 42.

55. MacCallum, "Tom Thomson": 376. In the typescript for the article (in Arch. of Ont., William Colgate Papers, F1066), he notes the purchase of the sketches, deleted from the published article.

56. Northway, *Nominigan*, 6; Addison, *Tom Thomson*, 75; Davies, *A Study of Tom Thomson*, 35–36. Addison to Dennis Reid, 11 May 1971. H.A. Callighen noted in his Journal that the building site was selected by W.H. Bartlett and officials from the Grand Trunk Railway, 21 May 1912, and that cutting and burning of brush on the site began 18 July 1912. It is possible that the point had been partially cleared before.

57. Robson, *Tom Thomson*, 6.

58. MacCallum, "Tom Thomson": 376.

59. Margaret L. Fairbairn, "Younger Painters Dominate This Time at

O.S.A. Exhibition," *Toronto Daily Star*, 12 April 1913.

60. The Hanging Committee for the 1913 Ontario Society of Artists exhibition consisted of Lawren Harris, Herbert Palmer and J.E.H. MacDonald. The Committee for the government purchases was composed of William Cruikshank, Dr. James Loudon and Dr. John Seath. Arch. of Ont., F1140, Minutes of meetings of 5 November 1912 and 6 May 1913. See also *Globe* (Toronto) 23 April 1913 and *Ontario Society of Artists Annual Report for 1914*, 5–6.

61. Tooby, *Our Home and Native Land*, n.p.; H.B. Jackson to Davies, 29 April 1931.

62. Fred Varley to Maud Varley, n.d. [c.26 February 1913], NAC, Varley fonds, MG 30 D 401, vol. 1. Joan Murray notes that a Thomas Thomson appears on the pay list as a fire ranger on the Metagami Forest Reserve (see Chronology).

63. Addison, *Tom Thomson*, 18; William Little, *The Tom Thomson Mystery*, 13.

64. Addison, *Tom Thomson*, 24–25.

65. MacCallum, "Tom Thomson": 376. The typescript gives his address on Isabella Street. In February 1914 Thomson exhibited five sketches in the Little Picture Exhibition at the Toronto Public Library: *Cumulus Clouds, Evening* (pl. 16 here), *Grey Day, Northern Lake* and *Winter*.

66. A.Y. Jackson, "Foreword."

67. In 1941 MacCallum wrote that a group of eight early sketches he had given to his son James "practically all of them had been done in the water of the Mississauga [sic] Reserve." Eight early sketches were considered for purchase from James MacCallum in 1944, four of which were acquired, including *Thunderhead* (pl. 10) and *View Over a Lake: Shore with Houses* (pl. 9). J.M. MacCallum to H.O. McCurry, 30 October 1941; Jones Jones & Gibbons to McCurry, 20 November

1944. NGC Archives, file 1.71 MacCallum. James MacCallum to McCurry, 15 December 1944. McCurry to James MacCallum, 19 March 1945, in NGC curatorial file for Thomson: *Sky: "The Light That Never Was"* (4629).

68. A.Y. Jackson, Foreword; A.Y. Jackson to Marius Barbeau, 31 March 1933.

69. H.F. Gadsby, "The Hot Mush School," *Toronto Daily Star*, 12 December 1913; J.E.H. MacDonald, "The Hot Mush School in Rebuttal of H.F.G.," *Toronto Daily Star*, 20 December 1913.

70. *Toronto Daily Star*, 4 February 1926.

71. Davies, "Tom Thomson's Sketchbox," n.d. (c.1930) in NAC, MG 30 D38, vol. 11. A.Y. Jackson to Eric Brown, 6 November 1933.

72. A.Y. Jackson, to J.E.H. MacDonald, postmarked 14 February 1914, NAC, MG30 D111, vol.1, Correspondence 1914–1924.

73. A.Y. Jackson to Jackson family, n.d. [late February 1914], private collection.

74. A.Y. Jackson to J.M. MacCallum, 25 March 1914, NGC Arch., MacCallum Papers. A.Y. Jackson, "J.E.H. MacDonald," *The Canadian Forum* 13, no. 148 (January 1933): 138.

75. Irene B. Wrenshall, "The Field of Art," *Toronto Sunday World*, 26 April 1914.

76. A.Y. Jackson, "Tom Thomson," April 1947, in Queen's University Archives, Kingston, Ont., Lorne Pierce Papers (coll. 2001a), Box 38-002.

77. Entry for 1 May 1914, H.A. Callighen Journal.

78. Harry Callighen noted in his Journal that it snowed all day April 20 and 25, 1914. When catalogued by the National Gallery in 1946, the sketch bore the title *March, Larry Dixon's Shack*, most likely on a label that has since disappeared, but Thomson was not in the park in March 1914. Dr. Robert Little identified the shack as George Rowe's and claims to have seen Thomson painting this sketch; however, Little did not arrive in the

park until the summer of 1914. Though the shack is hardly decipherable in the painting, it does not appear to accord with the drawing in Little's letter of 1 April 1949. It is also not certain from the correspondence that Little ever saw this sketch. Letters from Dr. Robert Little to H.O. McCurry, 26 March 1949, and 1 April 1949, in NGC curatorial file for Thomson: *Larry Dickson's Shack* (NGC 4656), and R.P. Little, "Some Recollections . . . ": 202–203.

79. R.P. Little, "Some Recollections": 203.

80. A. Lismer, "Algonquin Park First Impressions," c.1914. Private collection. My thanks to Joan Murray for providing a copy of this document.

81. Tom Thomson to J.M. MacCallum, 6 October 1914. NGC Arch., MacCallum Papers. In this letter Thomson includes a rough drawing of a sketch that accords with the general composition of *Petawawa Gorges*.

82. J.M. MacCallum to H.O. McCurry, 8 July 1938, NGC Arch., 5.4-Century of Canadian Art, 1938, file 2.

83. Wrenshall, "The Field of Art," *Toronto Sunday World*, 26 July 1914.

84. Entry for 24 May 1914, H.A. Callighen Journal.

85. J.M. MacCallum "Notes on Tom Thomson," c.2 May 1941, NGC Arch. 7.4-Film–Thomson.

86. J.M. MacCallum to H.O. McCurry, 16 June 1939, and H.O. McCurry to J.M. MacCallum, 7 November 1939, annotated with a response from Dr. MacCallum, in NGC curatorial file for Thomson: *Pine Island, Georgian Bay* (NGC 4726).

87. Tom Thomson to Fred Varley, postmarked 8 July 1914. The Thomson Collection (PC-936).

88. MacCallum, "Tom Thomson": 376.

89. Entry for 21 September 1914, H.A. Callighen Journal.

90. A.Y. Jackson to J.E.H. MacDonald, 5 October 1914. NAC, MG 30 D111, vol. 1, correspondence 1914–24.

91. Tom Thomson to J.M. MacCallum, 6 October 1914. NGC Arch., MacCallum Papers.

92. A.Y. Jackson to J.M. MacCallum, 13 October 1914. NGC Arch., MacCallum Papers. Jackson's use of *cubistical* is mere hyperbole.

93. Entry for 23 October 1914, H.A. Callighen Journal.

94. *Globe* (Toronto), 21 November 1914.

95. The sketch *The Red Maple* (McMichael Canadian Art Collection, 1968.8.18), the canvas (NGC 1038).

96. *Hillside* (NGC, 6522). *Sunlight and Shade—October in Algonquin Park*, current location unknown, reproduced in catalogue of 1915 OSA exhibition.

97. R.P. Little, "Some Recollections . . . ": 201, 203. Lismer also did a drawing of the cabin on a wood panel (McMichael Canadian Art Collection 1981.190.23).

98. Reproduced in *Canadian Art* (Toronto: Joyner, 22 May 1998), lot 116.

99. A.Y. Jackson, Foreword.

100. *Globe* (Toronto), 21 November 1914.

101. "Tom is getting to the end of his tether and I guess there is not much commercial work to do in Toronto." A.Y. Jackson to J.E.H. MacDonald, 5 October 1914, NAC, MG30 D111, vol. 1, correspondence 1914–1924.

102. William Colgate, *Two Letters of Tom Thomson 1915 & 1916* (Weston, Ont.: The Old Rectory Press, 1946), 10.

103. The painting was titled *Early Spring* in the first Group of Seven exhibition to tour in the United States. See Charles C. Hill, *The Group of Seven: Art for a Nation* (Ottawa: National Gallery of Canada/Toronto: McClelland and Stewart, 1995), 117, fig. 69.

104. *The Edge of the Town, Winter Sunset* was exhibited at the RCA exhibition in Toronto, 19 November 1914. While the sketch *Winter* was painted before his return to Toronto, Thomson may have seen the 1914 canvas at an earlier stage in the spring or the 1912 paint-

ing *Morning Shadows* (Art Gallery of Ontario, 72/17), which was purchased by the Government of Ontario in 1912.

105. Art Gallery of Ontario, Edward P. Taylor Research Library and Archives, Tom Thomson Collection, Lists of Thomson canvases dated 29 June 1936 and 13 May 1937, prepared by Martin Baldwin with information from Dr. MacCallum.

106. J.M. MacCallum to H.O. McCurry, 18 July 1938, NGC Arch., 1.71–MacCallum. MacDonald found it "rather commonplace in color & composition & not representative of Thomson at his best." J.E.H. MacDonald to Eric Brown, 14 October 1921, NGC Arch. MacCallum Collector's file.

107. Jackson may have begun the painting in Algonquin Park but certainly had completed it before he left for the Rockies with Beatty summer 1914, as it was first exhibited at the Canadian National Exhibition in Toronto 29 August 1914 as *A Frozen Lake* (together with another picture titled *Early Spring, Algonquin Park*, the usual and incorrect title, *A Frozen Lake, Early Spring, Algonquin Park* being a combination of the two titles). Thomson probably saw the canvas when he returned from the park in November 1914 and before Jackson took it to Montreal with him in December to exhibit at the Spring Exhibition at the Art Association of Montreal, 26 March 1915. MacCallum purchased the painting in the summer of 1915. See A.Y. Jackson to J.M. MacCallum, postmarked 6 July 1915 in NGC Arch., MacCallum Papers.

108. Tom Thomson to J.M. MacCallum, 22 April 1915, NGC Arch., MacCallum Papers.

109. Entry for 16 March 1915, H.A. Callighen Journal.

110. Tom Thomson to J.M. MacCallum, 22 April 1915. NGC Arch., MacCallum Papers.

111. Entries for 28 April, 10 May, 11 May 1915, Mark Robinson Journal; entry for 19 May 1915, H.A. Callighen Journal.

112. Entries for 7 June, 17 July and 21 July 1915, H.A. Callighen Journal; entry for 28 June 1915, Mark Robinson Journal.

113. Tom Thomson to J.E.H. MacDonald, 22 July 1915, Tom Thomson Memorial Art Gallery Archives, Owen Sound.

114. Tom Thomson to J.M. MacCallum, 8 September 1915. NGC Arch., MacCallum Papers.

115. Tom Thomson to J.M. MacCallum, 9 September 1915, NGC Arch., MacCallum Papers.

116. R.P. Little, "Some Recollections . . .": 205.

117. L. Mack to Tom Thomson, dated 16-3-13, NAC, Tom Thomson fonds, MG30 D284, vol. 1, correspondence 1912–1917. This letter has been dated to 16 March 1913 by Addison, *Tom Thomson*, 88–89 n6; however, Leonard Mack thanks Thomson for guiding him and Harry Bracken six months earlier, and Thomson was not in the park guiding in October 1912, so the letter must date from 13 March 1916 and refer to a trip in October 1915, though Leonard Mack is only listed in the Toronto city directories 1910–14 inclusive, at 15 Clarence Square, the address on the letter.

118. Percy Ghent, "Tom Thomson at Island Camp, Round Lake, November 1915," *Telegram* (Toronto), 8 November 1949; Addison, *Tom Thomson*, 46.

119. Thoreau MacDonald, "My Memories of Tom Thomson," 1959, in Addison, *Tom Thomson*, 84, and W.T. Little, *The Tom Thomson Mystery*, 179.

120. Arts and Letters Club Archives, Minutes of 1 December 1915. A.S. Wrenshall, "Toronto," *American Art News* 16 (22 July 1916): 9.

121. *Grey Day, Giant's Tomb* (NGC 4653) and *The Hill in Autumn* (pl. 33) are both painted on composite wood-pulp board.

122. Audrey Saunders, *Algonquin Story* (Toronto: Department of Lands and Forests, 1947), 170; W.T. Little, *The Tom Thomson Mystery*, 34.

123. Tom Thomson to J.E.H. MacDonald, 22 July 1915, Tom Thomson Memorial Art Gallery Archives, Owen Sound.

124. *Canadian Wildflowers*, (NGC 1532) repr. in Harold Town and David P. Silcox, *Tom Thomson: The Silence and the Storm* (Toronto: McClelland and Stewart, 1977), 112. On the back of this sketch the title *Canadian Wildflowers* has been written in graphite with a price of $25, the price in the Halifax catalogue.

125. Tom Thomson to J.M. MacCallum, 8 September 1915, NGC Arch., MacCallum Papers.

126. The anecdotes concern Thomson's asking Robinson where he can find a particular brown, black spruce trees "against a cold green grey northern sky," an old rampike, etc. See Robinson to Davies, 23 March 1930, NAC, MG30 D38, vol. 11; Davies, *A Study of Tom Thomson*, 108–109; W.T. Little, *The Tom Thomson Mystery*, 187–89.

127. *Nocturne: Forest Spires* (pl.76) is painted on the thin plywood Thomson used in 1914 and has been dated on the back *1915*, with *4* written over the *5*. A related work, *Nocturne*, in the Art Gallery of Windsor (repr. Murray, *The Art of Tom Thomson*, 70, no. 30) is also on plywood and is dated 1914 on the back. Stylistically they relate to no other works from 1914, so I would argue that they date from 1915. We know that Thomson did sketch in Toronto, and *Moose at Night* (pl. 122) is inscribed on the back by Dr. MacCallum, "Winter 1916—at studio," which I understand to mean that it was painted from memory in Toronto.

128. A.Y. Jackson to T.J. Harkness, 10 January 1922, in NAC, MG 30 D284, vol. 1, Estate Corrrespondence 1922.

129. J.M. MacCallum to M. Baldwin, 20 Feb. 1937, AGO Arch., Tom Thomson Collection.

130. J.M. MacCallum to T.J. Harkness, 19 June 1922, in NAC, MG 30 D284, vol. 1, Estate Correspondence 1922. J.M. MacCallum to H.O. McCurry, 25 August 1938, NGC Arch., 5.4–Century of Canadian Art, 1938, file 4.

131. Lawren Harris, notes with letter from Graham McInnes to H.O. McCurry, 19 June 1941.

132. Landry, *The MacCallum-Jackman Cottage Mural Paintings*, 26.

133. A.Y. Jackson to Charles Comfort, 28 July 1949, NAC, Charles Comfort Papers, MG30 D81, vol. 58.

134. MacDonald's measurements for the spaces over the windows were 44 $\frac{1}{2}$ x 37", while the panels MacDonald later installed there are 27 x 37". Thomson's rejected panels are 47 $\frac{1}{2}$ x 38". See Reid, *The MacCallum Bequest*, 49, 69. MacDonald's measured drawing is reproduced in Hunter Bishop, *J.E.H. MacDonald: Sketchbook, 1915–1922* (Moonbeam, Ont.: Penumbra Press, 1979), pl. x.

135. Dennis Reid, *The Group of Seven* (Ottawa: National Gallery of Canada, 1970), 93; Stacey, *J.E.H. MacDonald, Designer*, 119.

136. Reproduced in Murray, *The Art of Tom Thomson*, 80. no. 79. The sketch is in the Thomson Collection (PC-660).

137. Reproduced ibid., 81, no. 80.

138. E. Walker to Eric Brown, 1 April 1916, in NGC curatorial file for Thomson: *Spring Ice* (NGC 1195).

139. Hector Charlesworth, "Pictures That Can Be Heard: A Survey of the Ontario Society of Artists' Exhibition," *Saturday Night* 29, no. 23 (18 March 1916): 5, 11.

140. Margaret Fairbairn, "Some Pictures at the Art Gallery," *Toronto Daily Star*, 11 March 1916. See also *Mail and Empire* (Toronto), 11 March 1916.

141. Wyly Grier, "Pictures at the Ontario Society of Artists, Toronto, Canada," typescript in Arch. of Ont., Wyly Grier Papers, F1108, file 2.

142. Estelle M. Kerr, "At the Sign of the Maple," *Canadian Courier* 19, no. 17 (25 March 1916): 13.

143. See *Islands, Canoe Lake* (McMichael Canadian Art Collection 1966.16.73), *Ice Reflections, Spring* (NGC 4709) and *Petawawa Gorges, Night* (NGC 15548), the latter painted in the fall of 1916.

144. On the back of this sketch is a horizontal graphite drawing of trunks of trees and curving branches.

145. L.S. Harris notes, 1941, with Graham McInnes to H.O. McCurry, 19 June 1941. Harris enlisted in the army on his return to Toronto, received his COTC certificate on 5 May 1916 and was appointed to the 10th Royal Grenadiers as a lieutenant on 12 June. Reid, *The Group of Seven*, 126.

146. J.M. MacCallum to Mrs. Quinton, 21 September 1921, in Albright-Knox Art Gallery Archives, Buffalo, Exhibition Records R.G. 3:1, box 28, folder 3: "Canadian Group of Seven," September 1921; J.M. MacCallum to Eric Brown, 21 September 1921, in NGC Arch., MacCallum Collector's file. T.W. Dwight to Davies, 2 February 1932, stated that both *The West Wind* and *The Jack Pine* were painted on the eastern end of Grand Lake. NAC, MG30 D38, vol. 11.

147. J.M. MacCallum to A.L. Beatty, 14 May 1937, in AGO Arch., Thomson Papers.

148. Letters from Ed. Godin to Davies, 16 June 1930, 17 November 1930 and 15 June 1931, in NAC, MG 30 D38, vol. 11.

149. Ottelyn Addison, *Early Days in Algonquin Park* (Toronto: McGraw-Hill Ryerson, 1974), 126.

150. Ed Godin to Davies, 17 Nov. 1930.

151. Tom Thomson to J.E.H. MacDonald, n.d., on letter from Eric Brown to Tom Thomson, 28 June 1916, in McMichael Canadian Art Collection, Thomson Papers.

152. Tom Thomson to J.M. MacCallum, 4 October [1916], in NGC Arch., MacCallum Papers.

153. *Cranberry Marsh* (NGC 4698), a sketch of the same site and certainly painted the same season is inscribed on the back, "1916 Cranberry Marsh & Hillside on Ragged Lake going over into Crown Lake Callighen says Island Lake." Pl. 101 has been dated 1915 on the back.

154. On the verso of *Yellow Sunset* is a sketch very close in composition and colour to *Aura Lee Lake* (McMichael Canadian Art Collection 1970.2) painted on Thomson's trip with Harris in the spring of 1916.

155. Davies, *A Study of Tom Thomson*, 102–103; Saunders, *Algonquin Story*, 173; letter of 25 August 1953, from T.W. Dwight, professor of Forestry, University of Toronto to NGC, in NGC Arch., T.W. Dwight, scholar. The canvas was reproduced as *The Drive, South River* in Mortimer-Lamb, "Studio Talk: Montreal": 120.

156. The inscription on the back reads, "used in First Snow in Autumn," a variant title for *Snow in October*.

157. See Joan Murray, *Tom Thomson: The Last Spring*, 32–34, 39, 51, 56.

158. Tom Thomson to T.J. Harkness, 16 April 1917. NAC, Tom Thomson fonds, MG30 D284, vol. 1, Tom Thomson correspondence 1912–1917.

159. *The Waterfall* and *The Drive* were nonetheless reproduced in MacCallum, "Tom Thomson": 375–85.

160. Barker Fairley, "Tom Thomson and Others," *The Rebel* 4, no. 6 (March 1920): 246.

161. J.M. MacCallum to H.O. McCurry, 15 August 1938, in NGC Arch., 5.4–Century of Canadian Art, 1938, file 4.

162. List of Tom Thomson canvases prepared by Martin Baldwin, dated 7 May 1937, in AGO Arch., Tom Thomson Collection.

163. J.M. MacCallum to H.O. McCurry, 8 July 1938. NGC Arch., 5.4–Century of Canadian Art, 1938, file 2. See also copy of letter from J.M. MacCallum to J.C. McLennan, 31 October 1924 in Nutana Collegiate Institute Archives, Saskatoon, Memorial Art Gallery correspondence, and J.M. MacCallum to Bobby [R.A. Laidlaw?], 24 January 1930, in Arch. of Ont., F1066, in which he recounts the same story.

164. J.M. MacCallum to Eric Brown, 23 December 1921, in NGC Arch., file 1.12 Thomson.

165. N. Gurd to F.B. Housser, 7 January 1927, copy in Lambton Arch., Box 24 JA-DA, Gurd correspondence.

166. J.M. MacCallum to Elizabeth Harkness, 12 January 1926. NAC, MG30 D284, vol. 1, Estate correspondence 1926.

167. William C. Forsey, *The Ontario Community Collects: A Survey of Canadian Painting from 1766 to the Present* (Toronto: Art Gallery of Ontario, 1975), 188, says the painting was altered after Thomson's death; however, there appear to be no differences from the work as reproduced in MacCallum, "Tom Thomson": 380.

168. J.E.H. MacDonald to Eric Brown, 14 October 1921, in NGC Arch., MacCallum Collector's file.

169. J.M. MacCallum to Eric Brown, 21 September 1921, in NGC Arch., MacCallum Collector's file.

170. J.M. MacCallum to Bobby [R.A. Laidlaw?], 24 January 1930.

171. Tom Thomson to John Thomson, (postmarked 16 April 1917), and Thomson to T.J. Harkness, postmarked 23 April 1917, both in NAC, MG30 D284, vol. 1 Tom Thomson correspondence 1912–1917.

172. In NAC, MG 30 D284, vol. 1, reproduced in Murray, *The Last Spring*, 91.

173. W. Trainor to George Thomson, 17 Sept. 1917, in NAC, MG30 D284, vol. 1 Estate correspondence 1917.

174. Tom Thomson to J.M. MacCallum, 7 July 1917, NGC Arch., MacCallum Papers.

175. Also National Gallery of Canada (4677) on the back of which is a sketch of a rushing stream in winter; Montreal Museum of Fine Arts (1947.984); Tom Thomson Memorial Art Gallery, Owen Sound (971.004) and one with Yaneff Gallery, Toronto, 24 September 1981, half of a split panel, the other half being *Smoke Lake* of 1916 in the McMichael Canadian Art Collection (1968.21).

176. Entries for 15 October 1915 and 11 April 1917 in Mark Robinson diary.

177. In a 1953 interview published in W.T. Little, *The Tom Thomson Mystery*, 198.

178. R.P. Little, "Some Recollections . . .": 205–206.

179. Letters from Tom Thomson to J.M. MacCallum, 21 April and 8 May [1917], NGC Arch., MacCallum Papers; J.M. MacCallum to Tom Thomson, 28 May 1917, in NAC, MG30 D284, vol. 1 Tom Thomson correspondence 1912–1917.

180. J.M. MacCallum to George Thomson, 1 September 1917, NAC, MG30 D284, vol. 1, Estate correspondence 1917. "I want to buy some of those last sketches of Tom's especially the little ones."

181. George Thomson to J.M. MacCallum, 19 July 1917, NGC Arch., MacCallum Papers.

182. Telegram from Shannon Fraser to J.M. MacCallum, 10 July 1917, in NGC Arch., MacCallum Papers. Entry for 16 July 1917 in Mark Robinson diary.

183. George Thomson to Davies, 23 April 1934, in NAC, MG30 D38, vol. 11.

184. Shannon Fraser to John Thomson, 18 July 1917, NAC, MG30 D284, vol. 1, Estate correspondence 1917.

185. George Thomson to J.M. MacCallum, 21 July 1917, NGC Arch., MacCallum Papers.

186. Shannon Fraser to J.M. MacCallum, 3 September 1917, and J.E.H. MacDonald to John Thomson, 3 October 1917, NAC, MG30 D284, vol. 1, Estate correspondence 1917. J.E.H. MacDonald to J.M. MacCallum, 15 November 1917, NGC Arch., MacCallum Papers. The cairn was erected by J.W. Beatty, Shannon Fraser and George Rowe. Copy of letter from Mark Robinson to Bud [Callighen], 6 April 1937 with H.A. Callighen to C. Comfort, 23 September 1960 in NGC Arch., 7.1–Thomson.

187. J.E.H. MacDonald to John Thomson, 3 October 1917.

188. A. Lismer to J.M. MacCallum, 21 July 1917, private collection.

189. A.Y. Jackson to J.E.H. MacDonald, 4 August 1917, copy in McMichael Canadian Art Collection Archives, J.E.H. MacDonald Papers.

190. MacCallum, "Tom Thomson": 378.

"Technical Studies on Thomson's Materials and Working Method" by Sandra Webster-Cook and Anne Ruggles

1. Marie-Claude Corbeil, Elizabeth A. Moffatt, P. Jane Sirois and Kris M. Legate, "The Materials and Techniques of Tom Thomson," *Journal of the Canadian Association for Conservation* 25 (2000): 3–10.

2. Description of Thomson supports in the MacCallum bequest as catalogued by the National Gallery of Canada, June 1946. NGC Archives, 1.7–MacCallum.

3. "Tom did get his painting outfit in spring 1912.". H.B. Jackson to Blodwen Davies, 5 May 1931, National Archives of Canada, MG30 D38, vol. 11.

4. B. Davies, "Tom Thomson's Sketch Box" (typescript), 4, NAC, MG30 D38, vol. 11.

5. Ibid.

6. See correspondence between Dr. J.M. MacCallum and H.O. McCurry, from 17 December 1940 to 8 November 1941. National Gallery of Canada Archives, Dr. J.M. MacCallum collector's file.

7. Davies, "Tom Thomson's Sketch Box," 5.

8. According to Robert McMichael, Thomson, MacDonald, Jackson and others used a grey bookbinder's board obtained from the firm of Warrick Brothers and Rutter Limited. Robert McMichael, *One Man's Obsession* (Scarborough, Ont.: Prentice-Hall Canada, Inc., 1986), 190.

9. Davies, "Tom Thomson's Sketch Box," 5.

10. Ottelyn Addison and Elizabeth Harwood, *Tom Thomson, The Algonquin Years* (Vancouver, Winnipeg, Toronto: The Ryerson Press, 1969), 43.

11. Joan Murray, *Tom Thomson: The Last Spring* (Toronto, Oxford: Dundurn Press, 1994), 7.

12. Bess Harris to Russell Harper, 14 July 1962. NGC Arch., file 12-4-196, vol. 1, p. 5.

13. J. Dunkerton and M. Spring, "The Development of Painting on Coloured Surfaces in Sixteenth-Century Italy," *Painting Techniques: History, Materials and Studio Practice*, Ashok Roy and Perry Smith, eds. (London: The International Institute for Conservation of Historic and Artistic Works, c. 1998), 120–30.

14. *Georgian Bay, near Dr. MacCallum's Island*, The Thomson Collection (PC-287).

15. *Giants' Tomb, Georgian Bay*, The Thomson Collection (PC-875).

16. *Sunset, Algonquin Park*, The Thomson Collection (PC-541).

17. Corbeil *et al.*, "The Materials and Techniques . . . ," 7.

18. Ibid., 3.

19. Dr. Leslie Carlyle, "Getting to the Source: 19th Century Artists' Oil Painting Materials and Techniques," *CCI Newsletter* 10 (September 1992), and Corbeil et. al., 6.

20. Davies, "Tom Thomson's Sketch Box," 5.

21. Letters from J.H. Beynon to H.O. McCurry, 11 November 1946 and 18 November 1946. NGC Arch., 1.12–Thomson.

22. Tom Thomson to J.E.H. MacDonald, 22 July 1915, Tom Thomson Memorial Art Gallery Archives, Owen Sound.

23. Art Gallery of Toronto artist information sheet, brought to the author's attention by Sandra Webster-Cook.

24. Corbeil *et al.*, 7.

25. Ibid., 8.

26. The back page of the *Prospectus Ontario College of Art, Toronto for Session 1913–1914* includes an advertisement for Winsor & Newton, and *Old Lumber Dam, Algonquin Park* (pl. 3) was painted on a Winsor & Newton sketching board.

27. Author conversation with Alan Foster, chief chemist, Winsor & Newton, August 2001.

28. *Winsor & Newton Limited Catalogue 1914*, London, 38.

29. Alan Foster conversation.

30. Dr. Leslie Carlyle suggested this possibility to the author in 2001.

31. Author correspondence with George Stegmier, retired, Grumbacher Company, August 2001.

32. Lead sulfate paint: "If made into a paste with oil it hardens, so it is used dry; some of the largest paint manufacturers refuse to use it because it is dusty and the dust is poisonous; white lead, being supplied in paste form, is sanitary in this respect. This quality also prevents its use, as a paint by itself, because the painter requires his pigments to be supplied in paste form. It is used as only as a substitute for white-lead in mixed paints; it costs less, but it chalks worse, appears to be less durable, and is not as white. It is finer than white-lead, is nearly as opaque, and in not too great a proportion its oil-hardening property does not appear to interfere with its use in mixed paints." A.H. Sabin, *White-Lead, Its Use in Paint* (New.York: John Wiley & Sons, Inc./London: Chapman & Hall, Limited, 1920), 59–60. My thanks to Dr. Leslie Carlyle for bringing this to my attention.

Catalogue

compiled by Joan Murray and Charles C. Hill

1

Design for a Stained-Glass Window
c. 1905–07
graphite, pen and ink and watercolour
on wove paper
34. 2 x 17. 1 cm

Collection: Art Gallery of Ontario,
Toronto (81/132)

Provenance: Edgar Burke, Toronto, before
1910; Mrs. Edgar Burke, Swift Current,
Sask, 1962; R. McMichael, Kleinburg,
1963; Allan Manford, Toronto, by
1971; gift of Mr. and Mrs. Allan Manford,
Toronto, 1981

Literature: Dulmage 1963 (repr.);
Murray 1971, 18 (repr.); Town & Silcox
1977, 101 (repr.); Murray 1994, 60

2

Near Owen Sound November 1911
oil on wood
14. 9 x 21. 4 cm

Inscription recto: l.r., *Tom Thomson*

Inscription verso: c.l., in graphite, by
artist, *Near Owen Sound / November 1911/15.00*;
u.r. in graphite, *8*

Collection: National Gallery of Canada,
Ottawa (4702)

Provenance: Dr. J.M. MacCallum,
Toronto; bequest of Dr. J.M. MacCallum,
Toronto, 1944

Exhibitions: MacCallum 1969, no. 46;
Thomson 1969, no. 16; NGC 1970, no. 16
(repr.); Thomson 1971, no. 2 (repr.);
Thomson 1977, no. 4

Literature: Hubbard 1960b, 307; Reid
1970, 49–50 (repr.); Murray 1971, 21, 65,
91 (repr.); Town & Silcox 1977, 24, 41,
53 (repr. col.); Town 1977a, 174; Davis
1998, 996

3

Old Lumber Dam, Algonquin Park
spring 1912
oil on paperboard (Winsor & Newton
watercolour sketching board)
15. 5 x 21. 3 cm

Inscription recto: l.r., *TOM THOMSON*

Inscription verso: c.l., in graphite, by
artist, *12.00 / Old Lumber Dam / Algonquin
Park*; l.r., in graphite, *7*

Collection: National Gallery of Canada,
Ottawa (4671)

Provenance: Dr. J.M. MacCallum,
Toronto, c. 1912; Bequest of Dr. J.M.
MacCallum, Toronto, 1944

Exhibitions: NGC 1966, no. 17; MacCallum
1969, no. 55, as c. 1913; Mirvish 1977

Literature: Hubbard 1960b, 303; Town
and Silcox 1977, 140 (repr. col.)

4

Smoke Lake, Algonquin Park spring
1912
oil on paperboard (Birchmore board)
16. 8 x 24. 7 cm

Inscription verso: u.l., in graphite, *Smoke
Lake / Algonquin Park / 1912*; c.r., in ink,
C.A. Callighan; l.l., in graphite, *TT12*;
l.l., in graphite, *TOM THOMSON*; l.l., in
graphite, *1845G*; b.c., in graphite, *14/L*

Collection: Tom Thomson Memorial Art
Gallery, Owen Sound (987. 024)

Provenance: H.A. Callighen, Algonquin
Park, 1912; by descent to his son; Mary
L. Northway, Toronto, 1973; J. Hodgson,
Toronto; gift of John M. Hodgson and
Joan W. Hodgson, Toronto, in memory
of Mary L. Northway, 1987

Literature: R.P. Little 1955, 202;
Northway 1970a, 17; Northway 1970b,
6; W.T. Little 1970, 64, 122–23, 214;
Addison 1974, 75

5

Drowned Land fall 1912
oil on paper (with embossed canvas
texture) on plywood
17. 5 x 25. 1 cm

Inscription recto: l.r., *Tom Thomson*

Inscription verso: c., in red pencil, *54*

Collection: Art Gallery of Ontario,
Toronto (2449)

Provenance: Purchased from Mellors Fine
Arts, Toronto, 1937

Exhibitions: Thomson 1937, no. 90;
London 1942, no. 44; Vancouver 1954,
no. 68; Thomson London 1957, no. 38;
Thomson Windsor 1957, no. 13; Stratford 1967, no. 16; Thomson 1971, no. 4
(repr.); Sault Ste. Marie 1982

Literature: Robson 1937, 6; Hubbard 1962,
fig. 4 (repr.); Addison 1969, 8 (repr.);
Bradfield 1970, 444; Murray 1971, 65,
91 (repr.); Reid 1971, 5–6 (repr.); Lord
1974, 126 (repr.); Town & Silcox 1977,
39 (repr. col.); Murray 1994, 71; Davis
1998, 996

6

The Canoe spring or fall 1912
oil on canvas
17. 3 x 25. 3 cm

Inscription verso: in graphite, *Tom Thompson
1914* [*b* crossed out]

Collection: Art Gallery of Ontario,
Toronto (L69. 48)

Provenance: J.S. Fraser, Mowat and
Kearney, Ontario; J.S. McLean, Toronto,
1936; gift from the J.S. McLean Collection, Toronto, 1969; Donated by the
Ontario Heritage Foundation, 1988

Exhibitions: McLean 1952, no. 85 as 1914;
McLean 1968, no. 78; Thomson 1971,
no. 12 (repr.); McMichael 1998 (repr. col.)

Literature: R.P. Little 1955, 204; W.T.
Little 1970, 35, 217; Murray 1971, 67, 91
(repr.); Addison 1974, 123

7

A Northern Lake spring or fall 1912
oil on paperboard (Birchmore board)
17. 8 x 25. 4 cm

Inscription verso: u.c., in ink,
authenticated by / J.W. Beatty / Jany / 27; on
old backing: u.r., in ink, *Authenticated by
J.W. Beatty / Jany / 27*; c.r., in graphite,
*In my opinion a typical / early Tom Thomson /
Thoreau MacDonald / Oct./67*

Collection: Camp Tanamakoon,
Algonquin Park, Ontario

Provenance: Mrs. Chalmers (relative of

Dr. J.M. McRuer of Huntsville, Ontario); Irving Chalmers, Toronto; Beth Tzedec Auction, Toronto; Dr. and Mrs. H.H. Rosenberg, Toronto, 1971; Kyle's Gallery, Victoria; private collection, Victoria; Sotheby's, Toronto, 3 Dec. 1997, lot 141 (repr. col.)

Exhibitions: Thomson 1971, no. 7 (repr.)

Literature: Murray 1971, 66, 91 (repr.)

8

Northern Lake winter 1912–13
oil on canvas
71.7 x 102.4 cm

Collection: Art Gallery of Ontario, Toronto (72/25)

Provenance: Purchased from the artist through the Ontario Society of Artists by the Government of Ontario, 1913; gift of the Government of the Province of Ontario, 1972

Exhibitions: OSA 1913, no. 88; Thomson 1932, no. 18 as lent by the Normal School, Ottawa; AGT Margaret Eaton 1935, no. 153; Thomson 1941 as *Northern Lake* or *Stormy Bay*; Thomson 1967, no. 1; NGC 1970 no. 18 (repr.); Thomson 1971 no. 1 (repr. col.); Sault Ste. Marie 1982; AGO 1984, no. 116 (repr.)

Literature: Fairbairn 1913; *Globe* (Toronto) 23 April 1913; Kyle 1913, 186–87; OSA 1914, 6; MacCallum 1918, 376; F.B. Housser 1926, 62–63; Robson 1937, 7; Hubbard 1962, 7, 15, fig. 5 (repr.); Harper 1966, 278 as *Northern River*; Davies 1967, 34, 41–42; Groves 1968, 110; Addison 1969, 9 (repr.); Mellen 1970, 30–31, 61 (repr. col.); Reid 1970, 52–53, 55 (repr.); Murray 1971, 25, 56–57 (repr. col.); Arbec 1972; Lord 1974, 126 (repr.); Reid 1975, 5–6 (repr.); Varley 1978 (repr.); Town & Silcox 1977, 55; Nasgaard 1984, 179 (repr.); Town 1985, 1817; Robert McMichael 1986, 327; Davies 1998, 996, 998; Murray 1998, 53

9

View Over a Lake: Shore with Houses
summer 1912 or 1913

oil on paper (with embossed canvas texture) on plywood
17.9 x 25.8 cm

Inscription recto: l.r., *Tom Thomson*

Inscription verso: u.l., graphite, *Jackson film / strip*; u.l., graphite, *6*; c., graphite, *ante 1914*

Collection: National Gallery of Canada, Ottawa (4632)

Provenance: Dr. J.M. MacCallum, Toronto, c. 1913; James MacCallum, Toronto, before 1940; purchased from James MacCallum, Toronto, 1946

Exhibitions: Thomson 1966, no. 9; Berlin 1982, no. 49 (repr.); Thomson 1990

Literature: Hubbard 1960b, 299; Town & Silcox 1977, 61 (repr. col.); Farr 1981, 25 (repr.)

10

Thunderhead summer 1912 or 1913
oil on canvasboard
17.5 x 25.2 cm

Inscription recto: l.r., *TOM THOMSON*

Inscription verso: u.r., in ink, *Dr. James MacCallum*

Collection: National Gallery of Canada, Ottawa (4631)

Provenance: Dr. J.M. MacCallum, Toronto, c. 1913; James MacCallum, Toronto, before 1940; purchased from James MacCallum, Toronto, 1946

Exhibitions: Thomson 1966, no. 8; Thomson 1990; Mexico City 1999, no. 58 (repr. col.); Beijing 2001, no. 58 (repr. col.)

Literature: Hubbard 1960b, 299; Town & Silcox 1977, 62 (repr. col.); Murray 1986a, 27 (repr. col.)

11

Lake, Shore, and Sky summer 1913
oil on canvas
17.8 x 25.4 cm

Inscription verso: on lining canvas in ink, *FROM TOM THOMSON / TO A.Y. JACKSON / PAINTED 1913*

Collection: National Gallery of Canada, Ottawa (4565)

Provenance: A.Y. Jackson, Toronto, 1913; gift of A.Y. Jackson, Toronto, 1933

Exhibitions: NGC 1970, no. 20 (repr.); Thomson 1976, no. 2

Literature: Hubbard 1960b, 298 (repr.); Hubbard 1962, fig. 6 (repr.); Mellen 1970, 30 (repr.); Reid 1970, 54–55 (repr.); Davis 1998, 997

12

Sketch for "Morning Cloud" summer 1913
oil on canvas
17.8 x 25.3 cm

Collection: Art Gallery of Ontario, Toronto (70/368)

Provenance: Gordon and Doris Huestis Mills, Toronto, prior to 1941; gift of Mrs. Doris Huestis Mills Speirs, Pickering, Ontario, 1971

Exhibitions: Thomson 1941, lent by W. Gordon Mills

Literature: Reid 1975, 7–9 (repr.)

13

Northland Sunset summer or fall 1913
oil on canvas on paperboard
14.6 x 21.6 cm

Inscription verso: c.l., in ink, *Northland Sunset*; c.r., in graphite, *J. Henry*; c., inscription covered by label

Collection: Tom Thomson Memorial Art Gallery, Owen Sound (967.055)

Provenance: Mrs. J.G. (Louise Thomson) Henry, Guernsey, Saskatchewan, prior to 1917; gift of Mrs. J.G. Henry, Saskatoon, 1967

Exhibitions: Saskatoon 1927; Owen Sound 1968, no. 8; Thomson 1969, no. 25; Thomson, 1977, no. 38

Literature: Town & Silcox 1977, 61 (repr. col.)

14

Canoe Lake summer or fall 1913
oil on canvas on paperboard
25.2 x 17.2 cm

Inscription verso: u.l., in ink, by Lismer *Tom Thomson / painted 1913 – Canoe Lake / property of A. Lismer*

Collection: National Gallery of Canada, Ottawa (6118)

Provenance: Arthur Lismer, Toronto, c. 1913; gift of Arthur Lismer, Montreal, 1951

Exhibitions: Thomson 1976, no. 1

Literature: Hubbard 1960b, 312

15

Red Forest fall 1913
oil on canvas on paperboard
17.3 x 25.2 cm

Inscription verso: u.l., *Thoreau MacDonald / T.T. gave me this / 15 / T.M.*; c., artist, *TOM THOMSON / 1913*; c.l., in ballpoint, *R. McMichael*; l.l., in ink, *Thoreau / MacDonald*; u.r., in ink, *TT*; in graphite, on Art Gallery of Toronto label, *Dec. 30 / 40 / from Dr. Mason*

Collection: The McMichael Canadian Art Collection, Kleinburg (1966.16.65)

Provenance: Thoreau MacDonald, Toronto, 1915; Dr. A. Mason, Toronto, by 1940; R. McMichael, Kleinburg, 1960; gift of the Founders, Robert and Signe McMichael, 1966

Exhibitions: Thomson 1941, as one of three sketches lent by Dr. A.D.A. Mason; McMichael 1988

Literature: Duval 1967 (repr.); Duval 1970 (repr.); Duval 1973, 169 (repr.); McMichael 1976, 183 (repr.); McMichael 1979, 196 (repr.); Robert McMichael 1986, 119–20

16

Evening fall 1913
oil on canvas on paperboard
16.6 x 24.7 cm

Inscription recto: l.r., in brown, *TOM THOMSON*

Inscription verso: u.l., in graphite, *Evening*; u.l., in graphite, *17781*; u.l., in graphite, *276*; u.r., brushed ink, *178*; c.l., in ink, *To Jo / With all my love, / Ian / 15/8/42*; typed on printed label, Laing Fine Art Galleries Limited, 60 Bloor St. East, *"EVENING" / by / TOM THOMSON 1877–1917 / FROM THE ESTATE OF J.W. BEATTY, R.C.A.*

Collection: The Thomson Collection (PC-668)

Provenance: J.W. Beatty, Toronto, prior to 1917; Laing Fine Art Galleries, Toronto, 1942. Joyner Fine Art, Toronto, 25–26 Nov. 1986, lot 110 (repr.); purchased December 1986

Exhibitions: Little Pictures 1914, no. 276; Algonquin 1998, no. 26

17

Autumn, Algonquin Park fall 1912 or 1913
oil on canvas on paperboard
17.8 x 25.2 cm

Inscription recto: l.r., in red, *TOM THOMSON*

Inscription verso: c., in ink, *James M. MacCallum*

Collection: Alan O. Gibbons

Provenance: Dr. J.M. MacCallum, Toronto, prior to 1917; James MacCallum, Toronto, prior to 1940; Laing Fine Art Galleries, Toronto, 1945; purchased 1945

18

Grey Day in the North winter 1913
oil on canvas
22.0 x 71.3 cm

Collection: Private

Provenance: Gift from the artist to his parents, Owen Sound; Henrietta Thomson, Owen Sound, by descent; Mrs. F.E. Fisk, Toronto, by descent

Exhibitions: Thomson 1977, no. 16; Algonquin 1998, no. 28

Literature: *Toronto Daily Star* 4 February 1926; Waddington's, Toronto, 12 June 2001 (auction catalogue), 26 (repr.)

19

Moonlight winter 1913–14
oil on canvas
52.9 x 77.1 cm

Collection: National Gallery of Canada, Ottawa (943)

Provenance: Purchased from the artist through the Ontario Society of Artists, 1914

Exhibitions: OSA 1914, no. 138; Thomson 1932, no. 5 as *Moonlight, Early Evening*; NGC 1970, no. 21 (repr.); Thomson 1971, no. 13 (repr.); AGO 1974, no. 114 (repr.)

Literature: J.E.S. 1914, 147; MacCallum 1918, 376; Davies 1935, 69; Hubbard 1960b, 293; Hubbard 1962, 8; Davies 1967, 59; Addison 1969, 27; Mellen 1970, 208 (repr.); Reid 1970, 54–55 (repr.); Murray 1971, 26–27, 67, 91 (repr.); Murray 1973, 137 (repr.); Town & Silcox 1977, 57; Varley 1978 (repr.); Walton 1990, 173, 204 (repr.); Murray 2001, 133

20

Morning Cloud winter 1913–14
oil on canvas
72.0 x 101.8 cm

Collection: The Thomson Collection (PC-1051)

Provenance: Estate of the artist; Sen. F.F. Pardee, Sarnia, 1925; Mrs. John Cowan, Sarnia, 1927, by descent; private collection, by descent; Sotheby's, Toronto, 7 Nov. 1989, lot 88, not sold; Kaspar Gallery, Toronto; private collection, Vancouver; purchased 2001

Exhibitions: OSA 1914, no. 137; Thomson Owen Sound 1922, no. 32; Sarnia 1925 (1); Thomson 1932, no. 16; Thomson 1937, no. 23; Toronto 1941; Thomson 1956, no. 6 lent by the Sarnia Library; Thomson Windsor 1957, no. 3; Thomson 1971, no. II (repr. col.); Thomson 1990

Literature: J.E.S. 1914, 147; Davies 1935, 69; Hubbard 1962, 8; Davies 1967, 59; Addison 1969, 27; Murray 1971, 26, 56, 57 (repr. col.); G.L. Smith 1974, 25, 30, 31, 41–42 as *Dawn, Smoke Lake* and *Morning Cloud*; Reid 1975, 7–9 (repr.); Murray 2001, 133

21

Larry Dickson's Shack spring 1914
oil on canvas on paperboard
22.4 x 25.8 cm

Inscription recto: l.r., *TOM THOMSON*

Inscription verso: u.l., in graphite, *321 . . . / 5*

Collection: National Gallery of Canada, Ottawa (4656)

Provenance: Dr. J.M. MacCallum, Toronto, c. 1914; Bequest of Dr. J.M. MacCallum, Toronto, 1944

Exhibitions: MacCallum 1969, no. 79, as *March, Larry Dickson's Shack 1915*

Literature: Hubbard 1960b, 301 as *March, Larry Dickson's Shack*

22

Hoar Frost spring 1914
oil on canvas on paperboard
22.4 x 26.8 cm

Inscription verso: u.l., graphite, *Hoar-Frost*; u.c., in graphite, *1913*; u.r., on label [in red], *T.49*, and [in graphite], *Carmichael*; c., in ballpoint, *This is one of the finest Tom Thomsons / I have ever seen. A.Y. Jackson*; l.l., in ballpoint, *With love to Dorothy – / – as a wedding gift – / March 2nd 1963 / Charles*; l.r., in ballpoint, *Tom Thomson gave this sketch to Frank Carmichael / as a wedding gift in 1915 / After Frank's death it was / purchased by / C.A.G. Matthews and has / never been shown / It is a fine example of Thomson's / mastery of subtle painting / A.J. Casson / I purchased this for C.A.G.M.*

Collection: The McMichael Canadian Art Collection, Kleinburg (1968.25.21)

Provenance: Wedding gift from the artist to Franklin Carmichael, 1915; estate of

Franklin Carmichael, Toronto; C.A.G. Matthews, per A.J. Casson after 1945; gift of C.A.G. Matthews, Toronto, 1968

Exhibitions: Thomson 1937, no. 60

Literature: Duval 1970, as 1915 (repr.); Duval 1973, 28 (repr.); McMichael 1979, 197 (repr.)

23

Petawawa Gorges spring 1914
oil on canvas on paperboard
22.2 x 26.9 cm

Inscription recto: l.r., *TOM THOMSON*

Inscription verso: u.l., in graphite, *Spring Ice* (crossed out) / *Petawawa / Gorges / 1914 ?*; c., in graphite, *37*

Collection: National Gallery of Canada, Ottawa (4683)

Provenance: Dr. J.M. MacCallum, Toronto, c. 1914; Bequest of Dr. J.M. MacCallum, Toronto, 1944

Exhibitions: Thomson, 1941 as *Sketch for Spring Ice, Petawawa Gorges*; AGT 1945, no. 131; Albany 1946, no. 49; CNE 1949, no. 142; Thomson 1955; Thomson 1956, no. 11; Thomson, London 1957, no. 24; Thomson Windsor, 1957, no. 21; Los Angeles 1958; Thomson 1966, no. 21; MacCallum 1969, no. 80 as 1915; Thomson 1969, no 14; NGC 1970, no. 64 as 1916 (repr.); Thomson 1971, no. 15 (repr.); Tokyo 1981, no. 24 as 1915 (repr.); Algonquin 1998, no. 13

Literature: Hubbard 1960b, 304–305; Hubbard 1962, 10–11 as 1916; Reid 1970, 100–101 (repr.); Murray 1971, 31, 68 (repr.); Town & Silcox 1977, 72 (repr. col.); Davis 1998, 998 as 1916

24

Spring spring 1914
oil on canvas on wood
22.2 x 26.7 cm

Inscription recto: l.r., in red, *TOM / THOMSON*

Inscription verso: c.l., in graphite, *024876*; l.l., in ballpoint, *819*; u.r., in graphite,

$8\frac{3}{4} \times 10\frac{1}{2}$; c.r., 85277; l.r., in graphite, *mel [. . .] / $\frac{3}{8}$ gold*

Collection: The McMichael Canadian Art Collection, Kleinburg (1972. 5. 4)

Provenance: S. Casey Wood, Oakville; purchased 1972

Literature: McMichael 1976, 184 as 1914 (repr.); McMichael 1979, 196 (repr.)

25

Burnt Country, Evening spring 1914
oil on plywood
21.5 x 26.6 cm

Inscription verso: u.l., in black pencil, *5.*; c., in graphite, *39*; l.r., label, in ink, *Burnt Country – Evening / 40. James MacCallum*

Collection: National Gallery of Canada, Ottawa (4661)

Provenance: Dr. J.M. MacCallum, Toronto, c.1914; Bequest of Dr. J.M. MacCallum, Toronto, 1944

Exhibitions: Thomson 1919, no. 40 lent by MacCallum; MacCallum 1969, no. 75; Thomson 1976, no. 6 as 1915; Thomson 1990, as c.1915

Literature: *Gazette* (Montreal) 28 March 1919; Burgoyne 1937a; Hubbard 1960b, 301

26

Parry Sound Harbour 30 May 1914
oil on wood
21.7 x 26.7 cm

Inscription recto: l.r., in red , TOM THOMSON

Inscription verso: u.c., in ink, *Parry Sound Harbour – May 30th, 1914*

Collection: National Gallery of Canada, Ottawa (4664)

Provenance: Dr. J.M. MacCallum, Toronto, 1914; Bequest of Dr. J.M. MacCallum, Toronto, 1944

Exhibitions: Thomson 1919, no. 28 lent by MacCallum; AGT Canadian 1926, no. 53; MacCallum 1969, no. 60, as 1914; NGC 1970, no. 45 (repr.); Saint John 1976, no. 12; Barbican 1991, no. 105

Literature: *Gazette* (Montreal) 28 March 1919; Hubbard 1960b, 302; Reid 1970, 75 (repr.); Murray 1971, 31; Reid 1971, 3; Reid 1973, 142

27

Spring, French River 1 June 1914
oil on plywood
21.6 x 26.9 cm

Inscription recto: l.r., TOM THOMSON

Inscription verso: l.l., estate stamp; u.l. in graphite, *70*; u.l., in black crayon, *16*; u.l., in graphite, *Shaddow* [sic] *Box / [illegible]*; u.r., label in red pencil, *T 9-*; t., in ink, *Spring – French River – Tom Thomson / June.1/1914*

Collection: National Gallery of Canada, Ottawa (4657)

Provenance: Estate of the artist; Dr. J.M. MacCallum, Toronto; Bequest of Dr. J.M. MacCallum, Toronto, 1944

Exhibitions: Los Angeles 1958; MacCallum 1969, no. 66; Thomson 1971, no. 19 (repr.); Thomson 1976, no. 3; Tokyo 1981, no. 20 (repr.)

Literature: Hubbard 1960b, 301; Murray 1971, 32, 68, 91 (repr.); Reid 1975, 9–10 (repr.)

28

Cottage on a Rocky Shore summer 1914
oil on wood
21.6 x 26.7 cm

Inscription recto: l.r., *Tom Thomson*

Inscription verso: u.c., in black pencil, *14*

Collection: National Gallery of Canada, Ottawa (4665)

Provenance: Dr. J.M. MacCallum, Toronto, 1914; Bequest of Dr. J.M. MacCallum, Toronto, 1944.

Exhibitions: MacCallum 1969, no. 61; Thomson 1971, no. 16 (repr.); Thomson 1990

Literature: Hubbard 1960b, 302; Murray 1971, 31, 68 (repr.); Long 1999, 44–45 (repr. col.)

29

Evening, Pine Island summer 1914
oil on plywood
26. 4 x 21.6 cm

Inscription recto: l.r., estate stamp

Inscription verso: c., estate stamp; t., in graphite, *Evening – Pine Island / 1914*; c.r., in graphite, *OK / GT*

Collection: Private

Provenance: Estate of the artist. Mrs. Ethel Dunbar, Toronto; loan from estate of Ethel Dunbar to the McMichael Canadian Art Collection, 1972; M.I. Humphries, Toronto; Roberts Gallery, Toronto; purchased 1984

Exhibitions: Thomson 1971, no. 21 (repr.); AGO 1988, no. 53 (repr.)

Literature: Murray 1971, 69, 91 (repr.); Murray 1986a, 28 (repr. col.); Murray 1998, 32 (repr. col.)

30

Canoe Lake, Mowat Lodge summer 1914
oil on plywood
21.4 x 26.7 cm

Inscription recto: l.l., estate stamp

Inscription verso: c., estate stamp; t. in graphite, *Canoe Lake – Mowat Lodge 1914*; u.c, in ink, *TT 75*; l.r., in graphite, *20*

Collection: Tom Thomson Memorial Art Gallery, Owen Sound (988.011.078)

Provenance: Estate of the artist; Mellors Fine Arts, Toronto, 1938; Stewart and Letty Bennett, Toronto, 1948; bequest of Stewart and Letty Bennett, Georgetown, Ontario, 1982, donated by the Ontario Heritage Foundation, 1988

Exhibitions: Bennett 1984, no. 54 (repr. col.); Hunter 1997; Algonquin 1998, no. 1

31

The Brook fall 1914
oil on canvas on paperboard
22.4 x 27.0 cm

Inscriptions recto: l.r., TOM THOMSON

Inscriptions verso: u.c., in ink on Art Gallery of Toronto label, *Dec. 31/40 / Dr. MacCallum*; u.r., in graphite on label, *J.M. MacCallum / T61*; u.r., in ink, *Miss Hobson Glen Hobson* (?) (illegible); c., in graphite, *T. Thomson*; c., in graphite, *56*; c.r., in graphite, *30* (in circle); l.c., in black crayon, *6* (in circle); l.c., in graphite, *probably 1914 A.Y.J.*; l.l., in ink on label, *The Brook / 51. / James MacCallum*

Collection: National Gallery of Canada, Ottawa (4710)

Provenance: Dr. J.M. MacCallum, Toronto, c.1914; Bequest of Dr. J.M. MacCallum, Toronto, 1944

Exhibitions: Thomson 1919, no. 51 as *The Brook — Fall*; Sarnia 1923; Thomson 1937, no. 77; Thomson 1941; Thomson 1955; Thomson 1956, no. 22; Thomson London 1957, no. 21; Thomson Windsor 1957, no. 25; Los Angeles 1958; MacCallum 1969, no. 67; NGC 1970, no. 47 (repr.); Saint John 1976, no. 13; Thomson 1977, no. 8

Literature: *Gazette* (Montreal) 28 March 1919; *Sarnia Observer* 22 March 1923; Burgoyne 1937a; Hubbard 1960b, 308; Reid 1970, 78 (repr.); Smith 1974, 17; Murray 1998, 60 (repr.)

32

Soft Maple in Autumn fall 1914
oil on plywood
22.0 x 15.1 cm

Inscription recto: l.r, estate stamp

Inscription verso: c., estate stamp; l.r., estate stamp; u.l., in graphite, *4 in circle*; t., in graphite, *8209/5/513 1/2*; u.c., in ink, *Soft Maple in Autumn*; c.l., in graphite, *7 full* (?) + *104*; c.r., partially covered by label, in graphite, *. . . [164] M. Thomson*

Collection: Tom Thomson Memorial Art Gallery, Owen Sound (967.061)

Provenance: Estate of the artist; Mrs. J.G. (Louise Thomson) Henry, Guernsey, Sask., c.1918; gift of Mrs. J.G. Henry, Saskatoon, 1967

Exhibitions: Saskatoon 1927; Owen Sound 1968, no. 8; Thomson 1969, no. 31; Thomson 1971, no. VI; AGO 1975, no. 92 (repr.); Thomson 1977, no. 44

Literature: *Sun Times* (Owen Sound) 23 October 1967; Murray 1971, 35, 56, 59 (repr. col.); Murray 1986a, 30 (repr. col.); Murray 1998, 32 (repr. col.); Murray 1999b, 34–35 (repr. col.)

33

The Hill in Autumn fall 1914
oil on composite wood-pulp board
21.5 x 26.7 cm

Inscription recto: l.r., estate stamp

Inscription verso: c., estate stamp; u.l., in graphite, *AM*; u.l., in graphite, *8.*; c., in graphite, *6A*; below stamp, in graphite on label, *The Hill in Autumn / 1914-J* and in ink, *Dr. James MacCallum*

Collection: National Gallery of Canada, Ottawa (4713)

Provenance: Estate of the artist; Dr. J.M. MacCallum, Toronto, by 1937; Bequest of Dr. J.M. MacCallum, Toronto, 1944

Exhibitions: Thomson 1937, no. 84, lent by MacCallum; Los Angeles 1958; MacCallum 1969, no. 68; NGC 1970, no. 46 (repr.); Mirvish 1977

Literature: Hubbard 1960b, 309; Reid 1970, 78 (repr.); Town & Silcox 1977, 161 (repr. col.); Murray 1986a, 31 as 1914 or 1915 (repr. col.)

34

Shack in the North Country fall 1914
oil on wood
22.0 x 27.2 cm

Inscription verso: u.l., in graphite, *39*; u.c., in graphite, *Tom Thomson Shack in the / North Country / By Tom Tomson* (sic); u.r., in ink, *–11*; c.r., by artist in ink, on paper (cut out from invoice ?), *tom thomson*; in ink, *The property of A.J. Boughton*

Collection: Art Gallery of Ontario, Toronto (53/13)

Provenance: A.J. Boughton, Toronto; Mrs. A.J. Boughton, Toronto; gift from the Fund of the T. Eaton Co. Ltd. for Canadian Works of Art, 1953

Exhibitions: Thomson 1941, lent by A. Boughton; Thomson 1971, no. 31 (repr.)

Literature: Bradfield 1970, 443–44 as *The Shack*; Little 1970, 34, 212, 216; Murray 1971, 70, 92 (repr.)

35

Winter: Sketch for "In Algonquin Park" fall 1914
oil on wood
21.7 x 26.7 cm

Inscription verso: c., estate stamp; u.l., in graphite, *Winter*; u.c., in graphite, *1914*; l.l., artist, *Tom Thomson / Studio Bldg / Severn St. Toronto*; label, *T.50 / Carmichael*

Collection: The McMichael Canadian Art Collection, Kleinburg (1980.19.1)

Provenance: Estate of the artist; Franklin Carmichael, Toronto; Ada Carmichael, Toronto, 1945; Mary Mastin, Toronto, by descent; gift of Mr. and Mrs. R.G. Mastin, Toronto, 1980

Exhibitions: Thomson 1937, no. 61 as *Winter*; Thomson 1971, no. 35 as *Sketch for Afternoon, Algonquin Park* (repr.); Barbican 1991, no. 108 (repr.)

Literature: Murray 1971, 35, 71, 92 (repr.); Town & Silcox 1977, 190 (repr. col.); Robert McMichael 1986, 141; Murray 1986a, 34 (repr. col.)

36

Petawawa Gorges (Early Spring) fall 1914
oil on canvas
63.9 x 81.5 cm

Inscription recto: l.r., *TOM THOMSON*

Collection: National Gallery of Canada, Ottawa (4723)

Provenance: Dr. J.M. MacCallum, Toronto, between 1922 and February 1925; Bequest of Dr. J.M. MacCallum, Toronto, 1944

Exhibitions: RCA 1914, no. 190 as *A Lake, Early Spring* (?); Halifax 1915, no. 181 as *A Northern Lake, Early Spring* (?); Thomson

1920, no. 30 as *A Lake, Early Spring* (?); Sarnia 1920 (1); Worcester 1920, no. 27 as *Early Spring*; Thomson Owen Sound 1922, no. 35 as *Early Spring*; Thomson 1925; Thomson 1941, as *Spring Ice, Petawawa Gorges*; DPC 1945, no. 131 (repr.) as *Petawawa Gorges* c. 1915; Albany 1946, no. 49; CNE 1949, no. 142; Thomson 1955; Thomson 1956, no. 2; Thomson London 1957, no. 24; Thomson Windsor 1957, no. 4; Los Angeles 1958; Mexico 1961, no. 116; Bordeaux 1962, no. 61; NGC (1) 1967, no. 30; MacCallum 1969, no. 86 as 1915; NGC 1970, no. 67 as 1916 (repr.); Thomson 1971, no. 45 (repr.); Thomson 1977, no. 5; Tokyo 1981, no. 25 as 1916 (repr.); Algonquin 1998, no. 14 (repr. col.); Sarnia 2000, no. 1

Literature: Hubbard 1960b, 311 (repr.) as 1915; Hubbard 1962, 10, fig. 17 (repr.) as *Petawawa Gorges, Ice Going Out*; Hubbard 1963 (repr. back cover); Reid 1970, 100–101, 103 as 1916 (repr.); Murray 1971, 36, 73, 93 (repr.); Reid 1971, 4; Reid 1973, 145 (repr.) as 1916; G.L. Smith 1974, 5; Reid 1975, 23 as 1916–17; Town & Silcox 1977, 28–29, 73 (repr. col.); Town 1977a, 178; Boulet 1982, 200–201 (repr. col.)

37

In Algonquin Park fall 1914
oil on canvas
63.2 x 81.1 cm

Inscription recto: l.r., *Tom Thomson*

Inscription verso: label of the Canadian Artists Patriotic Fund Exhibition 1914; label, *Studio, Severn St.*; on Art Gallery of Toronto label, *Dec. 30/40 / Miss Marion Long*

Collection: The McMichael Canadian Art Collection, Kleinburg (1966.16.76)

Provenance: Marion Long, Toronto, 1915; Robert McMichael , Kleinburg, 1958; gift of the Founders, Robert and Signe McMichael, in memory of Norman and Evelyn McMichael, 1966

Exhibitions: Patriotic Fund 1914, no. 21; AGT 1920, no. 43 as *Winter, Canoe Lake*;

Thomson 1941, hors cat.; CNE 1959, as *Snow Shadows, Algonquin Park*, lent by Mr. and Mrs. R. McMichael; NGC 1970, no. 54 (repr.); Thomson 1971, no. 41 (repr.); McMichael 1976, no. 1; McMichael 1978, no. 1; Barbican 1991, no. 106

Literature: Mortimer-Lamb 1915, 260 (repr.); Hubbard 1962, 9, fig. 8 (repr.); Joy Brown 1962; Duval 1967 as *Afternoon, Algonquin Park* 1914–15 (repr.); Duval 1970 (repr. col.); Reid 1970, 82 (repr.); Murray 1971, 36, 72, 92 (repr.); McMichael 1976, 25 (repr. col.); Town & Silcox 1977, 190 (repr. col.); McMichael 1979, 21 as 1915 (repr. col.); Boulet 1982, 202–203 (repr. col.); Robert McMichael 1986, 101–105, 325; Murray 1986a, 34, 35 (repr. col.); McMichael 1989, 19 (repr. col.); Murray 1994b, 62–63 (repr. col.)

38

Pine Island, Georgian Bay 1914–16
oil on canvas
153.2 x 127.7 cm

Collection: National Gallery of Canada, Ottawa (4726)

Provenance: Dr. J.M. MacCallum, Toronto, between 1922 and 1926; Bequest of Dr. J.M. MacCallum, Toronto, 1944

Exhibitions: Thomson 1919, no. 54 as *Pine Islands*; Thomson 1920, no. 29; OSA Retrospective 1922, no. 169 lent by estate of artist; Thomson Owen Sound 1922, no. 33 as *Pines, Georgian Bay*; AGT Inaugural 1926, hors cat., lent by MacCallum (repr.); Tate 1938, no. 208; Thomson 1941; Thomson 1955; Thomson 1956, no. 4; Thomson London 1957, no. 26; Thomson Windsor 1957, no. 5; Los Angeles 1958; NGC (1) 1967, no. 29; MacCallum 1969, no. 88; Thomson 1971, no. 40 (repr.); Mexico City 1999, no. 62 (repr. col.)

Literature: MacCallum 1918, 377 (repr.); *Gazette* (Montreal) 28 March 1919; Mortimer-Lamb 1919, 123 (repr.); *Toronto Daily Star* 18 February 1920; *Mail and Empire* (Toronto), 14 February 1920; *Toronto Daily Star*, 18 February 1920;

Globe (Toronto), 13 February 1922; F.M. Harris 1926; Canadian Homes and Gardens, March 1926, 25 (repr.); Lismer 1926b, 70 (repr.); McInnes 1938, 8 (repr.); Cummings 1938; *Canadian Review of Music and Art*, May 1942, 11 (repr.); Colgate 1943, 91 (repr.); *Canadian Art* October 1944, 2 (repr.); Buchanan 1945, fig. 40 (repr.); Hedley 1955; Swinton 1956; Simmins 1956 (repr.); Hubbard 1960b, 311 (repr.) as 1914–16; Hubbard 1962, 11, fig. 11 (repr.); Murray 1971, 23, 31, 37 n23, 72, 92 (repr.); Boulet 1982, 207 (repr.); Murray 1999b, 44–45 (repr. col.)

39

Study for "Northern River" winter 1914–15
graphite, brush and ink and gouache on illustration board
30. 0 x 26. 7 cm

Inscription recto: l.l., estate stamp

Inscription verso: estate stamp; hand-written note with directions for framing; on Art Gallery of Toronto label, *Dec.30/40 . . . from Carl Hunter.*

Collection: Art Gallery of Ontario, Toronto (82/176)

Provenance: Estate of the artist; Sir Edmund Walker, Toronto, 1918; E.M. Walker, Toronto; Carl Hunter, Toronto; Dr. Harry Hunter, Toronto; purchased 1982

Exhibitions: Thomson 1925, lent by E.M. Walker; Thomson 1941 lent by Mrs. Carl Hunter, Toronto; Thomson 1971, no. 36 (repr.)

Literature: Murray 1971, 71, 92 (repr.); Reid 1975, 11; Town & Silcox 1977, 94 (repr. col.); Gamester 1983; Murray 1986a, 33 (repr. col.); Stacey 1991, 51; Murray 1994b, 54 (repr. col.); Murray 1999a, 46 (repr. col.)

40

Northern River winter 1914–15
oil on canvas
115. 1 x 102. 0 cm

Inscription recto: l.r., *TOM THOMSON*

Collection: National Gallery of Canada, Ottawa (1055)

Provenance: Purchased from the artist through the Ontario Society of Artists, 1915

Exhibitions: OSA 1915, no. 125 (repr.); St. Louis 1918, no. 31; Thomson 1920, no. 1; Thomson NGC 1922; Thomson Owen Sound 1922, no. 2; Wembley 1924, no. 241 (repr.); Ghent 1925, no. 730; AGT Inaugural 1926, no. 261; Paris 1927, no. 237; Thomson 1932, no. 3; Thomson 1941; London 1942, no. 40; AGT 1944, no. 73; New Haven 1944; DPC 1945, no. 132; Richmond 1949, no. 71; Boston 1949, no. 90; Thomson Windsor 1957, no. 9; Los Angeles 1958; Mexico City 1960, no. 114; Vancouver 1966, no. 71; NGC (2)1967, no. 188; NGC 1970, no. 55 (repr.); Thomson 1971, no. 37 (repr.); Spokane 1974, no. 113; Thomson 1977, no. 2; AGO 1984 (repr. col.)

Literature: Charlesworth 1915 (repr.); Brown 1917, 7, 32 (repr.); MacCallum 1918, 379; *Shawville Equity*, 29 May 1919; Fairley 1920, 246; Charlesworth 1922; Hind 1924, 250; *Canadian Magazine* July 1924, 132 (repr.); NGC 1924 (repr.); F.B. Housser 1926, 99–100; Paillard 1927 (repr.); Dick 1928; Davies 1930, 9 (repr.); McLennan 1931, 1–2 (repr. frontispiece); *Canadian Bookman* January 1932; Lismer 1932b; Robson 1932, 143 (repr. col.); Davies 1935, 78, 91 (repr. col.); Robson 1937, 14–15 (repr. col.); *United Empire* September 1938, 401 (repr.); Shoolman & Slatkin 1942, 693, pl. 712 (repr.); Buchanan 1945, fig. 41 (repr.) as 1913; *Canadian Geographical Journal* October 1946 (repr. col.); Saunders 1947, 170, 174 (repr. col.); Buchanan 1950, 31, fig. 17 (repr.); Lismer 1954, 173 (repr.); Jackson 1958, 106; Hubbard 1960b, 293 (repr.); Hubbard 1962, 9, fig. 10 (repr.); Hubbard 1963, 88–89, pl. 153 (repr.); Maud Brown 1964 (repr. col.); Harper 1966, 282 (repr.); Davies 1967,

64, 74 (repr. col.); Addison 1969, 36, 40, 44, 81 (repr. col.); Mellen 1970, 49, 50–51 (repr. col.); Reid 1970, 82–83 (repr.); Murray 1971, 19, 36, 37 n47, 71, 76, 92 (repr.); Reid 1971, 5; Reid 1973, 142–43; Lord 1974, 128; Reid 1975, 11–12, 15, 17 (repr.); Brink 1977, 32 (repr.); Town & Silcox 1977, 28, 58, 95 (repr. col.); Town 1977a, 178; Zemans 1977, 11; Varley 1978 (repr.); Martinsen 1984, 11–12 (repr.); Nasgaard 1984, 177, 179, 184 (repr. col.); Town 1985, 1817; Murray 1991, 28 (repr.); Murray 1994b, 55–56 (repr. col.); Booth 1995, 6–7 (repr. col.); Murray 1998, 32; Murray, 1999b, 46–47 (repr. col.); Davis 1998, 998

41

Burnt Land spring 1915
oil on canvas
54. 6 x 66. 7 cm

Inscription recto: l.r., *TOM THOMSON*

Collection: National Gallery of Canada, Ottawa (4299)

Provenance: Lawren S. Harris, Toronto, c. 1915; purchased 1937

Exhibitions: Thomson 1925; Thomson Windsor 1957, no. 10; Los Angeles 1958; Thomson 1969, no. 4; Thomson 1971, no. 45 (repr.); Peking 1975, no. 34; Mexico City 1999, no. 59 (repr. col.); Beijing 2001, no. 59 (repr. col.)

Literature: McInnes 1943, 400 (repr.); Hubbard 1960b, 298 (repr.); Addison 1969, 17 (repr.); Murray 1971, 35–36, 73, 93, (repr.)

42

Fraser's Lodge spring 1915
oil on wood
21. 9 x 27. 0 cm

Inscription recto: l.r., estate stamp

Inscription verso: c., estate stamp; l.l., graphite, *Fraser Lodge / 1915 – J.M.*; l.r., in graphite, *FRASER'S LODGE*; b.r., stamp, *E.E. POOLE / No.*; b., in graphite, *sketch #16 104 M. Thomson*; l.r., *T-T-22*; b.r., label stamped in red, *231*

Collection: Edmonton Art Gallery (77. 30)

Provenance: Estate of the artist; Mellors Fine Arts, Toronto; Ernest E. Poole, Edmonton; gift of Mrs. Gertrude Poole, Edmonton, 1977

Exhibitions: Poole 1959, no. 24 (repr.); Poole 1965, no. 60; Edmonton 1973; Edmonton 1978 (repr. col.); Barbican 1991, no. 110 (repr.); Hunter 2001

Literature: Harper 1966, 283–84 (repr.); Town & Silcox 1977, 179 (repr. col.); Fenton 1978, 22, pl. 1 (repr. col.)

43

The Opening of the Rivers: Sketch for "Spring Ice" spring 1915
oil on composite wood-pulp board
21. 6 x 26. 7 cm

Inscription recto: l.l., *TOM THOMSON*; l.r., estate stamp

Inscription verso: c., estate stamp; l.l., on label, (in graphite) *Canoe Lake –* / and in ink *The opening of the Rivers*; in graphite *breaking up of the ice* (ink) *47 James MacCallum*; r., in ink, *Dr. W* [. . .]; u.l., in graphite, *19*

Collection: National Gallery of Canada, Ottawa (4662)

Provenance: Estate of the artist; Dr. J.M. MacCallum, Toronto, by 1919; Bequest of Dr. J.M. MacCallum, Toronto, 1944

Exhibitions: Thomson 1919, no. 47 as *The Opening of the Rivers*, lent by MacCallum; AGT Canadian 1926, no. 50 as *Ice Breaking Up*; Thomson 1941; Thomson 1955; Thomson 1956, no. 30; Thomson London 1957, no. 14; Thomson Windsor 1957, no. 20; Los Angeles 1958; London 1961; Thomson 1966, no. 16; MacCallum 1969, no. 104 as 1916; NGC 1970, no. 58 (repr.); Thomson 1971, no. 51 (repr.); Saint John 1976, no. 18; Mirvish 1977

Literature: *Gazette* (Montreal) 28 March 1919; McInnes 1937a; Saunders 1947, 170; Swinton 1956; Hubbard 1960b, 301 (repr.); Hubbard 1962, fig. 18 (repr.); Addison 1969, 40, 42 (repr.); Little 1970:

34; Reid 1970, 95 (repr.); Murray 1971, 38, 75, 93, (repr.); Town & Silcox 1977, 70 (repr.); Murray, 1994b, 58 (repr. col.); Newlands 1995, 26 (repr. col.); Davis 1998, 997

44

Northern Spring spring 1915
oil on wood
21.6 x 26.8 cm

Inscription recto: l.r., estate stamp

Inscription verso: c., estate stamp; in ink on printed label, Block for Weekly Edition / *THE TIMES* (stamped) / *Page V no.1* / Subject *NORTHERN SPRING* / SIZE 9 ¼" wide x 7 ¼" deep / Special instructions / *11;* c.r., in graphite, *No.9;* c., in graphite, *B;* u.r., in graphite, *17;* printed label, ROWLEY / 140-2 CHURCH ST. / KENSINGTON W. 8

Collection: National Gallery of Canada, Ottawa (15555)

Provenance: Estate of the artist; Alice and Vincent Massey, Toronto, 1918; Vincent Massey Bequest, 1968

Exhibitions: AGT Canadian 1926, no.78 as *Early Spring* (?); Massey 1934, no.195 as *Birches in Spring*, or no.199 as *Birches and Rocks;* Massey 1968, no.14; Thomson 1990

45

In the Sugar Bush (Shannon Fraser)
spring 1915
oil on composite wood-pulp board
26.8 x 21.8 cm

Inscription recto: l.l., estate stamp

Inscription verso: c., estate stamp; in graphite on printed label, ART GALLERY OF TORONTO / GRANGE PARK / 7/12/53 / PROPERTY A.G.T. / *Canoe Lake / Where TT boarded / Shannon Fraser;* c., in graphite, *#322 / Sugar Bush / TOM THOMSON*

Collection: Art Gallery of Ontario, Toronto (53/17)

Provenance: Estate of the artist. Stewart Bennett, Toronto; Laing Galleries, Toronto,

1952; gift from the Fund of T. Eaton Co. Ltd. for Canadian Works of Art, 1954

Exhibitions: Thomson 1971, no.91 (repr.)

Literature: Hubbard 1962, 8; Murray 1971, 84, 95 (repr.); Dumas 1972; Town & Silcox 1977, 137 (repr. col.); Murray 1986a, 15 as 1916 (repr.)

46

Wild Cherries, Spring spring 1915
oil on composite wood-pulp board
21.6 x 26.7 cm

Inscription recto: l.r., estate stamp

Inscription verso: c., estate stamp; t. in, graphite, *Wild Cherries J.M. 1915;* on backing, on red bordered label, in graphite, *Wild Cherries / Spring / 2;* u.c., in graphite, *1st class*

Collection: The McMichael Canadian Art Collection, Kleinburg (1966.16.72)

Provenance: Estate of the artist. Prof. Sam Hook, Toronto and London, England; Robert McMichael, Kleinburg by 1961; gift of the Founders, Robert and Signe McMichael, 1966

Exhibitions: Charleston 1981, no.5 as *Sunrise*

Literature: Berton 1961; Carmichael 1966, 8; Duval 1967 as *Sunrise* 1917 (repr.); Duval 1970 as 1916–17 (repr. col.); Duval 1973, 25 (repr. col.); McMichael 1976, 25 (repr. col.); McMichael 1979, 21 (repr. col.); Robert McMichael 1986, 139; McMichael 1989, 21 as c.1915 (repr. col.); Murray 1994a, 64 (repr.)

47

Lakeside, Spring, Algonquin Park
spring 1915
oil on composite wood-pulp board
21.7 x 26.9 cm

Inscriptions recto: l.r., estate stamp

Inscriptions verso: c., estate stamp; u.c., in graphite, *TT 68*

Collection: The Thomson Collection (PC-127)

Provenance: Estate of the artist; George Thomson, Owen Sound; Mellors Fine Arts, Toronto, 1935. G. Blair Laing Ltd., Toronto; purchased September 1970

48

Summer Day summer 1915
oil on composite wood-pulp board
21.6 x 26.8 cm

Inscription recto: l.r., estate stamp

Inscription verso: c., estate stamp; u.l., in red pencil, *18;* t., in ink, *Blue Sky – White Clouds – Green Trees;* u.r., in red pencil, *2;* u.r., on label in red pencil, *T 4 / W.C.L.;* above stamp in red pencil, *Laidlaw;* l.r., in graphite, *139 M. Thomson;* l.r., in red pencil, *Gift to McMichael / R.A. Laidlaw;* b.c., on label, in ink, *258 Gift of / 1966.15.18 / R.A. Laidlaw;* l.l., in black, *7;* l.l., on label, in red pencil *Gift to McMichael / R.A. Laidlaw*

Collection: The McMichael Canadian Art Collection, Kleinburg (1966.15.18)

Provenance: Estate of the artist; Margaret Thomson Tweedale, Toronto; R.A. Laidlaw, Toronto; gift of R.A. Laidlaw, Toronto, 1965

Exhibitions: Laidlaw 1949 as *No Title (Summer clouds and sky);* McMichael 1977, no.4 as 1915–16 (repr. col.); McMichael 1988 (repr.);

Literature: Duval 1967 as *Blue Sky, White Clouds, Green Trees* 1917 (repr.); Duval 1970, as *Summer Day* 1915–16 (repr. col.); Duval 1973, 33 (repr. col.); McMichael 1976, 33 (repr. col.); McMichael 1979, 33 (repr. col.); McMichael 1989, 28 as 1916 (repr. col.); Peck 1989, 44–45 (repr.); Booth 1995, 16–17 (repr. col.); Newlands 1995, cover (repr. col.); *Canadian Geographic*, March–April 2000, 50

49

Evening summer 1915
oil on composite wood-pulp board
21.6 x 26.7 cm

Inscription recto: l.r., estate stamp

Inscription verso: c., estate stamp; l.r., in graphite, *no.61 Mrs. Harkness;* u.r., in red pencil, *31;* u.r., in graphite, *#7;* u.r., graphite, *1915;* u.l., in graphite, *R.A. Laidlaw;* u.l., in graphite, *"Evening" / T. Thomson;* u.l. quadrant, in red pencil, *R.A. Laidlaw;* u.c., in red, *Gift to McMichael / R.A. Laidlaw*

Collection: The McMichael Canadian Art Collection, Kleinburg (1966.15.20)

Provenance: Estate of the artist; Elizabeth Thomson Harkness, Annan and Owen Sound; W.C. Laidlaw and R.A. Laidlaw, Toronto, 1922; gift of R.A. Laidlaw, Toronto, 1965

Exhibitions: Sarnia 1920(2), no.35 as *Evening* (?); AGT Canadian 1926, no.81 as *Evening*, lent by R.A. and W.C. Laidlaw; Laidlaw 1949 as *Evening (Sunset sky);* McMichael 1982; McMichael 1988; McMichael 1998

Literature: Duval 1967 as *Evening Clouds 1915* (repr.); Duval 1970 (repr.); Duval 1973, 30 (repr.); McMichael 1976, 30 (repr.); McMichael 1979, 197 (repr.); Robert McMichael 1986, 143

50

Sunset summer 1915
oil on composite wood-pulp board
21.6 x 26.7 cm

Inscription recto: l.r., estate stamp

Inscription verso: c., estate stamp; u.l. of stamp, in graphite, *33;* u.l., in black crayon, *18;* l.l., on label, [in ink] *Sunset* [in graphite] *T 62* / [in ink] *34* [crossed out] [in graphite] *33* / [in ink] *James MacCallum*

Collection: National Gallery of Canada, Ottawa (4701)

Provenance: Estate of the artist; Dr. J.M. MacCallum, Toronto, by 1919; Bequest of Dr. J.M. MacCallum, Toronto, 1944

Exhibitions: Thomson 1919, no.34, lent by MacCallum; AGT Canadian 1926, no.62; Thomson 1937, no.78; Thomson 1955; Thomson 1956, no.19; Thomson

London, 1957, hors cat.(?); Thomson Windsor 1957, no. 31; Los Angeles 1958; MacCallum 1969, no. 91; Thomson 1971, no. 65 (repr.); Madison 1973, no. 47 (repr.); Thomson 1976, no. 8; Atlanta, 1986 (repr.); Thomson 1990

Literature: Hubbard 1960b, 307; Hubbard 1962, pl. 30 (repr. col.); Hubbard 1963, 88; Mellen 1970, 53, 55 (repr. col.); Murray 1971, 38, 78, 94 (repr.); Town & Silcox 1977, 6 (repr. col.); Brink 1977, 33 (repr.); Boulet 1982, 198–99 (repr. col.); Davis 1998, 998

51

Hot Summer Moonlight summer 1915
oil on wood
21.4 x 26.7 cm

Inscription verso: u.c., estate stamp; u.c., on label [in ink], *James MacCallum* / [in graphite] *Moonlight – Hot Summer Night*; u.r., in graphite, on label , *T.89*; c.r., in graphite, *Hot Summer / Moonlight*; l.r., in black, upside down, *23*; b.c., in graphite, *H. Mortimer Lamb / 503 Drummond Bldg. / Montreal*

Collection: National Gallery of Canada, Ottawa (4648)

Provenance: Estate of the artist; Dr. J.M. MacCallum, Toronto; Bequest of Dr. J.M. MacCallum, Toronto, 1944

Exhibitions: MacCallum 1969, no. 92; Thomson 1971, no. 66 (repr.); Thomson 1990

Literature: Saunders 1947, 112; Hubbard 1960b, 300; Murray 1971, 38, 78, 94 (repr.)

52

Burnt Land at Sunset summer 1915
oil on composite wood-pulp board
21.7 x 26.9 cm

Inscription verso: u.l., in graphite, *reserved / III bob Laidlaw / per / Lawren Harris / IV McLennan / II Robson / I [Gordon?] Davis*; stamped u.r. quadrant, *17½ X*; u.r., in white, *SA630 / TOP*

Collection: The Thomson Collection (PC-989)

Provenance: Estate of the artist. Frank P. Wood, Toronto; by descent; London, Christie's, 17 Sept. 1998, lot 70 (repr. col.); purchased September 1998

53

Lumber Dam summer 1915
oil on composite wood-pulp board
21.6 x 26.7 cm

Inscription recto: l.r., estate stamp

Inscription verso: c., estate stamp; right of stamp,in ink, *T.-T-38*; below stamp in black crayon, *Sketch #14*; l.c., in graphite, *OK/GT*; l.r., in red pencil, *2*; l.l., in graphite, *11*; u.l., in graphite, *AYJ (?)*; u.l., in graphite, *1913?*

Collection: National Gallery of Canada, Ottawa (6946)

Provenance: Estate of the artist; W. Gordon Mills, Toronto and Ottawa; purchased 1958

Literature: Hubbard 1960b, 312 as *Timber Chute*; Addison 1969 (repr. col.); Town & Silcox 1977, 82 (repr. col.)

54

Wildflowers summer 1915
oil on composite wood-pulp board
21.6 x 26.8 cm

Inscription recto: l.l., estate stamp

Inscription verso: c., estate stamp; above stamp in graphite, *1st class*; u.l., in ink, *H*; u.c., in graphite, *J.M.*; u.r., in ink, *AM*; u.r., in ink, *PROPERTY OF / HARKNESS*; l.r., in graphite, *89 M. Thomson*; on label (removed), [in orange pencil] *T-27* / [in ink] *M. Tweedale / Toronto*

Collection: The McMichael Canadian Art Collection, Kleinburg (1970.12.2)

Provenance: Estate of the artist; Elizabeth Harkness, Annan and Owen Sound; Margaret Thomson Twaddle (later Tweedale), Toronto, by 1937; R.A. Laidlaw, Toronto, 1970; gift of R.A. Laidlaw, Toronto, 1970

Exhibitions: Thomson 1937, no. 45 as *Wild Flowers*, lent by Mrs. W.M. Twaddle (later Tweedale), Toronto; Thomson 1939, no. 48 (?); West Palm Beach 1984; Atlanta 1986, 168 (repr. col.)

Literature: Weiers 1964; Duval 1973, 18 as 1917 (repr. col.); McMichael 1976, 18 (repr. col.); Town & Silcox 1977, 5 (repr. col.); Town 1977a, 45 as 1917 (repr.); McMichael 1979, 18 (repr. col.); Robert McMichael 1986, 268–70; McMichael 1989, 33 (repr. col.); Booth 1995, 10 (repr. col.)

55

Marguerites, Wood Lilies and Vetch
summer 1915
oil on wood
21.4 x 26.8 cm

Inscription verso: u.l., in graphite, *20*; u.l., in graphite, by artist, *Study of Wild Flowers Tom Thomson*; u.r., on label in graphite, *J Lawson – T.6*; u.l., in brushed ink, *NOT FOR SALE / J.E.H.MACDONALD*; c.l., in ink, *Property of J.S. Lawson / Emmanuel College*; in graphite on torn blue-bordered label, *Marguerite-Wood / Lily and Vetch Not for Sale / 20*; l.r., in red pencil, *12*; on label, *J. Lawson-T.6.*

Collection: Art Gallery of Ontario, Toronto (2563)

Provenance: J.E.H. MacDonald, Toronto, by 1917; J.S. Lawson, Toronto, by 1937; gift from the Albert H. Robson Memorial Subscription Fund, 1941

Exhibitions: Thomson 1919, no. 20 *Wood Lilies and Vetch* lent by J.E.H. MacDonald; Thomson 1937, no. 53 as *Cow Lily, Wild Flowers*, lent by J.S. Lawson; Thomson 1941; London 1942, no. 43; AGT 1947 as *Flowers*, c. 1916; Vancouver 1954, no. 69; Thomson Windsor 1957, no. 14; London, Eng. 1965, no. 334; Thomson 1971, no. 59 (repr.)

Literature: Robson 1937, 12–13 (repr. col.) as *Wildflowers*, collection J.S. Lawson; McInnes 1940 (repr.); Addison 1969, (repr.

col.) as *Flowers*; Bradfield 1970, 445; Murray 1971, 77, 93 (repr.); Town & Silcox 1977, 110 (repr. col.); Murray 1986a, 41 (repr. col.)

56

Water Flowers summer 1915
oil on wood
21.0 x 26.7 cm

Inscription recto: l.r., estate stamp

Inscription verso: c., estate stamp; l. of stamp [in brushed ink], *SB* / in graphite, *NOT FOR SALE*; u.l., in graphite, *Spring* [crossed out] *1916*; b.c., in graphite, *Pickerel Weed / White Waterlilies / Yellow Lilies*; c.r., in graphite, *17 M Thomson*; on label of Mellors Fine Arts, 759 Yonge St., "*Water Flowers*" by Tom Thomson

Collection: The McMichael Canadian Art Collection, Kleinburg (1976.20)

Provenance: Estate of the artist; Margaret Thomson Twaddle (later Tweedale), Toronto; Mellors Fine Arts, Toronto, before 1941. Pearl Sutton, Oshawa, Ontario; purchased 1976

Exhibitions: Thomson 1919, no. 21 as *Water Plants (lilies, cats' tail and water hyacinth)* or no. 65 *Water Lilies*, lent by H. Mortimer-Lamb; Atlanta 1986 (repr. col.)

Literature: Town & Silcox 1977, 113 (repr. col.); McMichael 1979, 198 as 1916 (repr.); Murray 1986a, 58 (repr. col.)

57

Pink Birches summer 1915
oil on composite wood-pulp board
26.9 x 21.7 cm

Inscription recto: l.r., estate stamp

Inscription verso: c., estate stamp; u.l., in ink, *J.S. Lawson*; u.l., in graphite, *NG / 1915* [5 over 6]; c., in graphite, *7*

Collection: The Thomson Collection (PC-261)

Provenance: Estate of the artist; Mellors Fine Arts, Toronto; J.S. Lawson, Toronto, by 1937; Mellors-Laing Galleries,

Toronto; D.R. Doig, Brandon, Manitoba, c. 1940; Christie's, Montreal, 2 May 1973, lot 109 (repr.) as *Pink Birches and a Lake*; G. Blair Laing Ltd., Toronto; purchased August 1973

Exhibitions: Thomson 1937, no. 54 lent by J.S. Lawson; Brandon 1954, no. 59; Brandon 1968, no. 31 as 1917 (repr.)

58

Moonlight, Algonquin Park
summer 1915
oil on wood
21.6 x 26.7 cm

Inscription recto: l.r., estate stamp

Inscription verso: c., estate stamp; above stamp in black crayon, *Sketch #18*; below stamp, in ink, *T-T-19*; l.r., in graphite, *82 M Thomson*; b.c., typed on label of Laing Fine Art Galleries Ltd., 60 Bloor St. E., *"MOONLIGHT, ALGONQUIN PARK"* / *by* / *TOM THOMSON, 1877–1917*

Collection: The Thomson Collection (PC-468)

Provenance: Estate of the artist; Margaret Thomson Tweedale, Toronto; Laing Fine Art Galleries, Toronto, before 1950; Dr. G.H. Henderson, Halifax; private collection, Calgary, by descent; G. Blair Laing Ltd., Toronto, 1978; purchased September 1978

Exhibitions: Halifax 1951, no. 38 as *Algonquin Park*, lent by Mrs. George H. Henderson

59

Fire-Swept Hills summer or fall 1915
oil on composite wood-pulp board
23.2 x 26.7 cm

Inscription verso: u.l., in ink, *Very few of Tom Thomsons / sketches were signed. but / here is no question about this / being genuine. A.Y. Jackson*; l.r., in graphite on torn label, MELLORS FINE ARTS / LIMITED / RA . . . / Marc . . . / 19 . . .

Collection: The Thomson Collection (PC-799)

Provenance: Dr. J.M. MacCallum, Toronto; Mellors Fine Arts, Toronto; R.A. Mac-kenzie, Toronto; R.A. Mackenzie, Toronto (?); R.A. Laidlaw, Toronto; private collection, Toronto; Sotheby's, Toronto, 6 May 1991, lot 110 (repr. col.); purchased May 1991

Literature: Town & Silcox 1977, 89 (repr. col.)

60

Tea Lake Dam fall 1915
oil on wood
21.3 x 26.2 cm

Inscription recto: l.r., estate stamp

Inscription verso: c., estate stamp; u.l., in graphite, *NG*; u.l., in graphite, by MacCallum, *Tea Lake Dam 1915*

Collection: National Gallery of Canada, Ottawa (1523)

Provenance: Estate of the artist; purchased 1918

Exhibitions: Thomson NGC 1922; Thomson Owen Sound 1922; Saskatoon 1927; Canoe Lake 1930; Thomson 1932, no. 6; Thomson 1941; Windsor 1948, no. 31 as *Tea Lake (Dawn)*; Thomson 1955; Thomson 1956, no. 24; Thomson London 1957, no. 29; Thomson Windsor 1957, no. 33; Los Angeles 1958; Thomson 1969, no. 8; NGC 1970, no. 59 (repr.); Thomson 1971, no. 69 (repr.); Madison 1973, no. 46 (repr.); Tokyo 1981, no. 23 (repr.); West Palm Beach 1984; Thomson 1990; Algonquin 1998, no. 2 (repr. col.); Mexico City 1999, no. 60 (repr. col.); Beijing 2001, no. 60 (repr. col.).

Literature: Saunders 1947, 172; Buchanan 1950, 32, pl. IV (repr. col.); Canadian Pulp and Paper Association 1954 (repr. col.); Swinton 1956; Hubbard 1960b, 295 (repr.); Hubbard 1962, fig. 26 (repr.); Harper 1962, 430 (repr. col.); Addison 1969 (repr. col.); Mellen 1970, 57 (repr. col.); Reid 1970, 95 (repr.); Murray 1971, 38, 78, 94 (repr.); Hubbard 1973, 128; Town & Silcox 1977, 81 (repr. col.); Murray 1986a, 37 (repr. col.); Walton 1990, 178 n17; Davis 1998, 997–98

61

Timber Chute fall 1915
oil on composite wood-pulp board
21.6 x 26.7 cm

Inscriptions recto: l.l., estate stamp

Inscriptions verso: c., estate stamp; r. of stamp, in graphite, *RAL*; below stamp, in graphite, *6*; u.l., in graphite, *1915 – Fall – Timber Chute – JM*

Collection: Art Gallery of Ontario, Toronto (854)

Provenance: Estate of the artist; gift from the Reuben and Kate Leonard Canadian Fund, 1927

Exhibitions: Thomson 1937, no. 37; AGT 1947 as c. 1916; Windsor 1948, no. 42; Thomson 1971, no. 68 (repr.)

Literature: *Canadian Review of Music and Art*, May 1942: 10 (repr.); Addison 1969, 11 (repr.); Bradfield 1970, 445; Murray 1971, 78, 94 (repr.); Town & Silcox, 1977, 78 (repr. col.)

62

Crib and Rapids fall 1915
oil on wood
21.6 x 26.7 cm

Inscription recto: l.r., estate stamp

Inscription verso: c., estate stamp; u.c., in graphite, *1915 Crib – River with rapids and logs spill [?] each side Entrance to Aura Lee Lake from Little Cauchon Lake*; u.r., on blue-bordered label, *Crib and Rapids AYJ 3 Montreal Art Assn*; u.l., in graphite, *reserved Studio Bldg.*; c., in black, *S.B.*; c., in black crayon, *Sketch #28*; u.l., in graphite, *no.5 Mrs Harkness*; u.l., in graphite, *8*. Frame: u.l., in graphite, *11*; u.l., label in ink, *Property of Mrs. H.A. Dyde / 9910–115 Street / Edmonton*; in ink on backing below label, *440 Roxborough Road / Rockcliffe, Ottawa*

Collection: Private

Provenance: Estate of the artist; Elizabeth Thomson Harkness, Annan and Owen Sound; Mellors Fine Arts, Toronto; Alan

Plaunt, Ottawa, 1939; Mrs. H.A. Dyde, Ottawa and Edmonton

Exhibitions: Thomson 1919, no. 3; Thomson 1941 as sketch lent by Alan Plaunt, Ottawa; Victoria 1955, no. 3 as *The Dam* 1917

Literature: Lismer 1947, 60 (repr.) as *Edge of the Log Run*; Buchanan 1950, fig. 19 (repr.); Hubbard 1962, pl. 23 (repr.); Town & Silcox 1977, 82 as *Log Run* (repr. col.)

63

Abandoned Logs fall 1915
oil on composite wood-pulp board
21.6 x 26.6 cm

Inscription recto: l.r., estate stamp

Inscription verso: u.r., in graphite, *Mr. W.P. McKenzie*; u.l., in graphite, *1915*; on Art Gallery of Toronto label, *Nov 8–63, Mrs. Douglas Simpson Algonquin Restoration*

Collection: The McMichael Canadian Art Collection, Kleinburg (1974.3)

Provenance: Estate of the artist; W.P. McKenzie; G. Stuart McKenzie, Concord, Massachusetts, by 1945. Douglas Simpson, Montreal; purchased 1974

Literature: McMichael 1976, 183 as 1914 (repr.); McMichael 1979, 196 (repr.)

64

Backwater fall 1915
oil on composite wood-pulp board
21.8 x 26.8 cm

Inscription verso: t., in graphite, *By Tom Thompson [sic] 1915*; c., in graphite, *5198*; c., in graphite, *37020 1/2 texture as Cassons / Campbell 6th (or 600 ?)*

Collection: The McMichael Canadian Art Collection, Kleinburg (1981.39)

Provenance: Mrs. Irving H. Campbell, Toronto; purchased with funds donated by R.A. Laidlaw, Toronto, 1970

Literature: Duval 1970 (repr. col.); Duval 1973, 33 (repr. col.); McMichael 1976, 33 (repr. col.); McMichael 1979, 33 (repr. col.)

65

Blue Lake: Sketch for "In the Northland" fall 1915
oil on wood
21.7 x 26.9 cm

Inscription verso: u.l., in graphite, *38*; u.l., in black crayon, *20*; l.l., in ink, *Blue Lake / 38 / James MacCallum*; l.c., in graphite, *57*; u.r., on Art Gallery of Toronto label in ink, *Dec.31/40 / Dr. MacCallum*; u.l., in graphite, *1915*; u.r., in graphite, *HML*; c.r. in graphite, *29*

Collection: National Gallery of Canada, Ottawa (4716)

Provenance: Dr. J.M. MacCallum, Toronto, c. 1915; Bequest of Dr. J.M. MacCallum, Toronto, 1944

Exhibitions: Thomson 1919, no. 38 lent by MacCallum; Sarnia, 1923; Thomson 1941 as *Sketch for In the Northland*; Hamilton 1953, no. 54 as *Study for In the Northland*; Thomson 1955 as *In the Northland*; Thomson 1956, no. 13; Thomson Windsor 1957, no 23; Los Angeles 1958; Thomson 1966, no. 28 as *Blue Lake*; MacCallum 1969, no. 94; Thomson 1971, no. 84 (repr.); Thomson 1976, no. 5; Thomson 1990

Literature: *Sarnia Observer* 22 March 1923; Atherton 1947, 57 (repr.); Hubbard 1960b, 309 (repr.); Hubbard 1962, fig. 15 (repr.); Murray 1971, 82, 95 (repr.); Smith 1974, 17; Reid 1975, 15 (repr.); Brink 1977, 33; Davis 1998, 998

66

Maple Woods, Bare Trunks fall 1915
oil on wood
21.3 x 26.6 cm

Inscription verso: u.l., estate stamp; u.l., in graphite, *68*; u.l., in black, *22*; u.l., in graphite, *3271*; u.r., on torn label in graphite, *T69*; c., on label in ink, *Dr. James M. MacCallum*; c., in graphite, *25*

Collection: National Gallery of Canada, Ottawa (4682)

Provenance: Estate of the artist; Dr. J.M. MacCallum, Toronto; bequest of Dr. J.M. MacCallum, Toronto, 1944

Exhibitions: Thomson 1941 as *Sketch for 'October'*; Los Angeles 1958; Stratford 1967, no. 25; MacCallum 1969, no. 114, as c. 1916; Thomson 1971, no. 81 (repr.)

Literature: Hubbard 1960b, 304; Murray 1971, 81, 94 (repr.); Town & Silcox 1977, 160 (repr. col.)

67

Forest, October fall 1915
oil on wood
21.3 x 26.9 cm

Inscription recto: l.r., estate stamp

Inscription verso: c., estate stamp; r., in graphite, *To Mrs. Newton / 32 Lincoln Ave., Montreal*; in black marker, *Box / 8*

Collection: Art Gallery of Ontario, Toronto (L69.50)

Provenance: Estate of the artist. Lilias Torrance Newton, Montreal; J.S. McLean, Toronto, 1946; gift from the J.S. McLean Collection, Toronto, 1969, donated by the Ontario Heritage Foundation, 1988

Exhibitions: McLean 1952, no. 91; McLean 1968, no. 77; Thomson 1971, no cat. no.(repr. col. cover); AGO 1982, no. 59; Berlin 1982, no. 57

Literature: Murray 1971, 56 (repr. col. cover); Town & Silcox 1977, 164 (repr. col.); Murray 1986a, 68 as 1916 (repr. col.); Murray 1994a, 75 (repr.); Murray 1994b, 66–67 (repr. col.); Murray 1999b, 92–93 (repr. col.)

68

Algonquin Park fall 1915
oil on composite wood-pulp board
21.6 x 26.5 cm

Inscription recto: l.r., estate stamp

Inscription verso: c., estate stamp; u.r., in graphite, *Algonquin Park / 1915*; l.r., in black crayon, *20*; l.l., in graphite, *Algonquin Park*; u.l., in graphite, *9 or 8*

Collection: Tom Thomson Memorial Art Gallery, Owen Sound (967.062)

Provenance: Estate of the artist; Mrs. J.G. (Louise Thomson) Henry, Guernsey,

Saskatchewan; gift of Mrs. J.G. Henry, Saskatoon, 1967

Exhibitions: Saskatoon 1927; Owen Sound 1968, no. 8; Thomson 1969, no. 32; Thomson 1971, no. 55 (repr.); Thomson 1977, no. 45

Literature: *Sun Times* (Owen Sound), 23 October 1967; Murray 1971, 38, 76, 93 (repr.); Murray 1986a, 36 (repr. col.); Murray 1998, 32 (repr. col.)

69

Sand Hill fall 1915
oil on wood
21.4 x 26.8 cm

Inscription recto: l.l., estate stamp

Inscription verso: c., estate stamp; t., in graphite, *Sand Hill on road to South River fall 1915 – on this day Thomson / tramped 14 miles carrying a sketch box and gun – a fox and / seven partridge which he shot that day and did this and / another sketch / James MacCallum*; c.l., in brown ink, *H*; c.l., in brown ink, *AM / PROPERTY OF / HARKNESS*; l.l., in graphite by Lawren Harris, *1st class*; l.l., in ballpoint, *Owner – Mrs. F.E. Fisk*; l.l., in ink on red-bordered label, *SAND HILL / FISK*; c.r., in red pencil, *10 ½" x 8 ½"*; l.r., in graphite, *85 M. Thomson*; l.r., typed on label of Tom Thomson Memorial Art Gallery, *no.17 / Sand Hill oil on board / Collection of Mrs. F.E. Fisk / niece of the artist*

Collection: The Thomson Collection (PC-971)

Provenance: Estate of the artist; Elizabeth Thomson Harkness, Annan and Owen Sound; Mrs. F.E. Fisk, Owen Sound, by descent; private collection, by descent; purchased June 1997

Exhibitions: Owen Sound 1922, no. 41 as *Sand Hill, South River*; Thomson London 1957, no. 5 lent by Mrs. Fred Fiske [sic]; Thomson 1967, no. 7; Thomson 1977, no. 17

Literature: Stevenson 1927, 76; Addison 1969, 46; Town & Silcox 1977, 90 (repr. col.)

70

Tamarack fall 1915
oil on wood
21.5 x 26.2 cm

Inscription recto: l.r., estate stamp

Inscription verso: c., estate stamp; l.r., in graphite, *NG*; c.r., in graphite, *1915*

Collection: National Gallery of Canada, Ottawa (1522)

Provenance: Estate of the artist; purchased 1918

Exhibitions: NGC 1922; Owen Sound 1922; Wembley 1924, no. 242; Saskatoon 1927; Canoe Lake 1930; Thomson 1932, no. 6; Thomson 1941; Thomson 1977, no. 3 as *Dead Spruce*; Thomson 1990; Mexico City 1999, no. 63 (repr. col.); Beijing 2001, no. 65 (repr. col.).

Literature: Hubbard 1960b, 295 as *Dead Spruce*; Town & Silcox 1977, 166 (repr. col.); Murray 1999b, 64–65 (repr. col.)

71

Round Lake, Mud Bay fall 1915
oil on wood
21.5 x 26.8 cm

Inscription recto: l.r., *Tom Thomson / 15*

Inscription verso: u.l., in ink, by Mrs. Frank Cooper, *Round Lake, Mud Bay / Painted as the First Flock of of* [sic] */ Geese flew back from the South* [crossed out] *North / Painting By The World's Best Artist / Tom Thomson "1915" He was Drowned at / Algonquin park July 8th 1916* [sic]

Collection: Art Gallery of Ontario, Toronto (L69.51)

Provenance: Thomas Wattie, South River, Ontario; Mrs. Frank Cooper, South River, by descent; J.S. McLean, Toronto, 1936; gift from the J.S. McLean Collection, Toronto, 1969, donated by the Ontario Heritage Foundation, 1988

Exhibitions: McLean, 1952, no. 86 as *Geese, Round Lake, Mud Bay*; McLean 1968, no. 79; Thomson 1971, no. 70 (repr.)

72

The Tent fall 1915
oil on wood
21.6 x 26.7 cm

Inscription recto: l.r., incised, *TOM THOMSON*

Inscription verso: t., in ink, by Mrs. Frank Cooper, *The tent where Dr. R.M. McComb, T. Wattie, / and Tom Thomson Camped. Round / Lake – 1915 / painted by Tom Thomson / The World's greatest artist;* on frame, *Property of Margaret Ghent bequeathed to Jennifer Ghent / 2/7/60*

Collection: The McMichael Canadian Art Collection, Kleinburg (1979.18)

Provenance: Tom Wattie, South River, Ontario, 1915; Mrs. Frank Cooper, South River, by descent; Mrs. Newton Pincock, North Tea Lake, prior to 1936; Margaret A. Ghent, Foxboro, Ontario, by 1960; loan to the McMichael Canadian Art Collection from 1967; purchased 1979

Exhibitions: Algonquin 1998, no.16

Literature: Ghent 1940; Ghent 1942; Ghent 1949; Addison 1969, 46–47; Town & Silcox 1977, 144 (repr. col.)

73

Sketch for "Autumn's Garland" fall or winter 1915
oil on composite wood-pulp board
21.5 x 27.0 cm

Inscription recto: l.r., estate stamp

Inscription verso: c., estate stamp; u.c.in black crayon, *Sketch #31;* below stamp in ink, *T-T-7*

Collection: The Thomson Collection (PC-163)

Provenance: Estate of the artist; George Thomson, Owen Sound; Mellors Fine Arts, Toronto, 1937; M.A.Cowper-Smith, Byron, Ontario, by 1957; Blair Laing, Toronto, by 1970; purchased December 1970

Exhibitions: Thomson Windsor, 1957,

no. 48 as *Autumn's Garland,* lent by Mr. and Mrs. M.A. Cowper-Smith, Byron

Literature: Hubbard 1960b, 293

74

Autumn Foliage fall or winter 1915
oil on wood
21.6 x 26.8 cm

Inscription recto: l.r., estate stamp

Inscription verso: c., estate stamp; right of stamp, in red crayon, *14;* right of stamp, in graphite, *G;* l.r., in graphite, *No.4 – Mrs. Harkness;* u.r., in graphite, *reserved / Studio Bldg.* l.l., in graphite, *J&H;* c.l., in graphite, *1915;* u.l., in black ink, *SB*

Collection: Art Gallery of Ontario, Toronto (852)

Provenance: Estate of the artist; Elizabeth Thomson Harkness, Annan and Owen Sound; gift from the Reuben and Kate Leonard Canadian Fund, 1927

Exhibitions: Thomson, 1937, no. 35; AGT 1947 as c.1916; Thomson London 1957, no. 43; Expo 1967, no. 4 (repr.); Thomson 1971, no. 73 (repr.); Atlanta 1986 (repr. col.); Barbican 1991, no. 114 (repr. col. cover)

Literature: Hubbard 1962, pl. 27 (repr.); Harper 1966, 278; Ballantyne 1967, 18; Bradfield 1970, 442; Mellen 1970, 53 (repr. col.); Murray 1971, 79, 94 (repr.); Town & Silcox 1977, 11 (repr. col.); Wistow 1982 (repr.col.); Murray 1984, 42 (repr. col.); Town 1985, 1817 (repr. col.); Murray 1999b, 54–55 (repr. col.)

75

Autumn Colour fall or winter 1915
oil on wood
21.4 x 26.7 cm

Inscription recto: l.r., estate stamp

Inscription verso: c., estate stamp; l. of stamp, in ink, *T-T-20;* u.l., in graphite, *1915;* u.l., in ink, *#276-A;* t., *JM for [?] painted a large [decoration?] [illegible] / JM;* b.c., in graphite, *sketch #17*

Collection: The McMichael Canadian Art Collection, Kleinburg (1970.6)

Provenance: Estate of the artist; Mellors-Laing Galleries, Toronto; Charles E. Hendry, Toronto, 1941; Sotheby's, Toronto, 25–27 May 1970, lot 34, not sold; purchased from Hendry through Roberts Gallery, Toronto, with funds donated by R.A. Laidlaw, 1970

Exhibitions: Thomson 1971, no. 77 (repr.); Algonquin 1998, no. 5 (repr. col.)

Literature: Duval 1970, as 1916 (repr.); Murray 1971, 40, 46 n16, 80, 84, 94 (repr.); McMichael 1976, 185 (repr.); McMichael 1979, 199 (repr.); Robert McMichael 1986, 267–68; Murray 1986a, 45 (repr. col.)

76

Nocturne: Forest Spires winter 1915
oil on plywood
21.6 x 26.6 cm

Inscription recto: l.r., estate stamp

Inscription verso: c., estate stamp; r. of stamp, in red, *TT #49;* below stamp, in black crayon, *Sketch #21;* u.l., in graphite, *Nocturne – 1915* [4 written over 5]; u.l., in graphite on label, *Nocturne, 7,* in softer graphite, *Forest Spires;* u.r., in graphite, *#373;* c.r., in graphite, *From collection of / Dr. J.M. MacCallum / Toronto;* b.c., in graphite, *No.33 Mrs. Harkness*

Collection: Vancouver Art Gallery (52.8)

Provenance: Estate of the artist; Elizabeth Thomson Harkness, Annan and Owen Sound; Dr. J.M. MacCallum, Toronto; D.M. Dunlap, Toronto; Laing Galleries, Toronto, 1949; presented in memory of Robert A. de Lotbinière-Harwood, by his friends, 1952

Exhibitions: Victoria 1979, no. 23; Thomson 1990

Literature: Murray 1971, 37 n37 as 1914; Town & Silcox 1977, 85 (repr. col.)

77

In the Northland winter 1915
oil on canvas
101.7 x 114.5 cm

Inscription recto: l.r., *TOM THOMSON '15*

Collection: The Montreal Museum of Fine Arts (1922.179)

Provenance: Estate of the artist; purchased by subscriptions from Dr. F.J. Shepherd, Sir Vincent Meredith, Dr. Lauterman, Dr. W. Gardner and Mrs. Herbert Molson, 1922; gift of Friends of the Museum, 1922

Exhibitions: OSA 1916, no. 123 as *Birches;* Ottawa 1917, no. 147 as *October, Algonquin Park;* Thomson 1917; Thomson 1920, no. 18 as *October, Algonquin Park;* Winnipeg 1921, no. 80 as *October-Algoma* (sic); NGC 1922 as *Autumn in Algonquin Park;* AAM 1922, no. 294A as *Landscape;* Wembley 1925, as *In the North Land* and no. E.E. 22 as *October, Algonquin Park;* Paris 1927, no. 229; Thomson 1932, no. 7; Tate 1938, no. 210; Thomson 1941; New York 1942, no. 279; Hamilton 1953, no. 53; Victoria 1955, no. 1; Thomson 1956, no. 35; Stratford 1963; NGC 1970, no. 62 (repr.); Thomson 1971, no. 83 (repr.)

Literature: *Mail and Empire* (Toronto) 11 March 1916, as *The Birches;* Fairbairn 1916; *Herald* (Montreal) 25 March 1922; *Chatelaine* February 1936 (repr.); Robson 1937, 9; *Standard* (Montreal) 10 September 1938; de Tonnancour 1940; Ayre 1941 (repr.); *Canadian Geographical Journal* October 1945 (repr. col.); Atherton 1947, 56 (repr. col.); Stegman 1960, 41; Hubbard 1962, 16 (repr.); Addison 1969, 83; Mellen 1970, 210 (repr.); Reid 1970, 98 (repr.); Ostiguy 1971, 31, fig. 55 (repr.); Murray 1971, 42, 82, 94 (repr.); Ayre 1972; Reid 1975, 14–17 (repr.); Murray 1984, 40; Murray 1994b, 62, 63 (repr. col. dust jacket); Newlands 1995, 32–33 (repr. col.); Davis 1998, 998

78

The Birch Grove, Autumn winter 1915–16
oil on canvas
101.6 x 116.8 cm

Inscription verso: l.r., on canvas, *24;* stretcher: horizontal cross bar, in graphite, *FRANK WORRALL / LINER / 28-2-61;* on

c. bar, *BIRCH GROVE AUTUMN / BY TOM THOMSON / 1877–1917*

Collection: Art Gallery of Hamilton (1967.112.2)

Provenance: Estate of the artist; George Thomson, Owen Sound; Mellors-Laing Galleries, Toronto, 1941; Hamilton Club, 1943; Roy Cole, Hamilton, 12 October 1967; gift of Roy G. Cole, in memory of his parents, Matthew and Annie Bell Gilmore Cole, 1967

Exhibitions: Thomson 1920, no. 22 as *Birch and Rocks, Autumn* (unfinished); Hamilton 1953, no. 30 (repr.); Thomson 1956, no. 7; Thomson 1967, no. 4 lent by the Hamilton Club; Thomson 1971, no. 111 (repr.); Guelph 1974, no. 33; Hunter 2001

Literature: *Maclean's* 1 October 1946 (repr. col.); Murray 1971, 45, 88, 96 (repr.); Hamilton Club 1973; Reid 1975, 23 as 1916–17; Town & Silcox 1977, 168 (repr. col.); Laing 1979, 78; Robert McMichael 1986, 200–205; Murray 1986a, 74–75 (repr. col.); Art Gallery of Hamilton 1989, 25, pl. 66 (repr. col.); Walton 1990, 173, 205 (repr.); Murray 1999b, 110–11 as c. 1916–17 (repr. col.); Hunter 2001, 18 (repr.)

79

Autumn's Garland winter 1915–16
oil on canvas
122.5 x 132.2 cm

Collection: National Gallery of Canada, Ottawa (1520)

Provenance: Estate of the artist; purchased 1918

Exhibitions: St. Louis, 1918, no. 33; Thomson 1920, no. 3; Thomson NGC 1922; Thomson Owen Sound 1922, no. 29; Wembley, 1924; Paris 1927, no. 238; Thomson 1932, no. 4; Thomson 1941, hors. cat.; Thomson 1967, no. 2; Thomson 1971, no. 107 (repr.); Madison 1973, no. 49 (repr.); Berlin 1982, no. 55 (repr.); Mexico City 1999, no. 65 (repr. col.)

Literature: Brown 1922a (repr.); Dick 1928

as *Nature's Garland*; Saunders 1947, 172; Jackson 1958, 42; Hubbard 1960b, 293 (repr.); Hubbard 1962, 11; Hubbard 1963, 89; Murray 1971, 19, 44, 86, 96 (repr.); Reid 1975, 37 as 1916–17; Boulet 1982, 215 (repr.); Davis 1998, 999; Murray 1998, 80 (repr.)

80

Spring Ice winter 1915–16
oil on canvas
72.0 x 102.3 cm

Inscription recto: l.r., *TOM THOMSON*

Collection: National Gallery of Canada, Ottawa (1195)

Provenance: Purchased from the artist through the Ontario Society of Artists, 1916

Exhibitions: OSA 1916, no. 124; Halifax 1918, no. 26; Thomson 1920, no. 4; Thomson NGC 1922; Thomson Owen Sound 1922, no. 26; Wembley 1925, no. E.E. 26; Paris 1927, no. 235; Thomson 1932, no. 1; Tate 1938, no. 212; Richmond 1949, no. 72; Boston 1949, no. 92; Washington 1950, no. 80; NGC 1953, no. 66; Vancouver 1954, no. 67; Thomson Windsor 1957, no. 11 (repr.); Los Angeles 1958; NGC (2) 1967, no. 194; NGC 1968, no. 15; NGC 1970, no. 63 (repr.); Thomson 1971, no. 78 (repr.)

Literature: *Mail and Empire* (Toronto) 11 March 1916; Ball 1916; Brown 1917, 33 (repr.); *Toronto Daily Star* 18 February 1920; Fairley 1920, 246; NGC 1926, 64, 70; Lismer 1932c; Brown 1932, 319 (repr. col.); Robson 1932, 149 (repr. col.); Davies 1935, 37 (repr. col.); Robson 1937, 20–21 (repr. col.); McInnes 1937b, 67 (repr. col.); Buckman 1937, 570 (repr.); Buchanan 1938, 289 (repr.); McInnes 1939b (repr. col.); Buchanan 1945, fig. 45 (repr.); Buchanan 1946, 99 (repr. col.); Saunders 1947, 170; Buchanan 1950, 31; McInnes 1950, 55 (repr. col.); Hubbard 1960b, 294 (repr.); Hubbard 1962, 10, pl. 2 (repr. col.); Hubbard 1963, 91 (repr. col.); Davies 1967, repr. col.; Addison 1969,

40, 43, 50, 79 (repr.); W.T. Little, 1970, 34; Reid 1970, 99 (repr.); Murray 1971, 41, 80, 94 (repr.); Ostiguy 1971, 31, fig. 56 (repr.); Town & Silcox 1977, 28–29, 70, 71 (repr. col.); Town 1977a, 178; Boulet 1982, 204–205 (repr. col.); Burnett 1990, 84–85 (repr.); Murray 1994b, 59 (repr. col.); Newlands 1995, 26–27 (repr. col.); Davis 1998, 998

81

Decorative Landscape: Birches
winter 1915–16
oil on canvas
77.1 x 72.1 cm

Collection: National Gallery of Canada, Ottawa (4724)

Provenance: Estate of the artist (?); Dr. J.M. MacCallum, Toronto; Bequest of Dr. James MacCallum, Toronto, 1944

Exhibitions: Thomson 1920, no. 36 as *Birches, Springtime* (?); Thomson 1937, no. 71 as *Birches, Twilight*, lent by MacCallum; Thomson 1941 as *Birch Trees*; MacCallum 1969, no. 78; Thomson 1971, no. 85 (repr.); NGC 1972, no. 17; Mirvish 1977; Algonquin Park 1998, no. 23

Literature: Hubbard 1960b, 310; Murray 1971, 42, 82, 95 (repr.); Town & Silcox 1977, 47 (repr. col.)

82

Opulent October winter 1915–16
oil on canvas
54.0 x 77.3 cm

Collection: Private

Provenance: Estate of the artist; Malloney Galleries, Toronto; Dr. J.S. Lawson, Toronto, 1932; Roy G. Cole, Hamilton; Paul Duval, Toronto; purchased 1967

Exhibitions: Thomson, 1937, no. 57 lent by J.S. Lawson; Thomson 1941; Thomson 1971, no. VIII (repr. col.); Thomson 1977, no. 31; AGO 1988, no. 55 (repr. col.); Montreal, Galerie Walter Klinkhoff, September 1998, Hommage à Walter Klinkhoff

Literature: Murray 1971, 41, 56, 60 (repr. col.); Kritzwiser 1977; Murray 1986a, 48–49 (repr. col.)

83

After the Sleet Storm winter 1915–16
oil on canvas
40.9 x 56.2 cm

Inscription verso: in black paint, *After the Sleet Storm / – by – / Tom Thomson / authenticated by / his brother Geo. Thomson*; on stretcher, u.r., in ink, *J. MacD*; in ballpoint on label, *78–25 / T. THOMSON / AFTER THE / SLEETSTORM*

Collection: The Thomson Collection (PC-733)

Provenance: Estate of the artist; George Thomson, Owen Sound; Mellors-Laing Galleries, Toronto, 1941; Dr. George Henderson, Halifax; private collection, Calgary, by descent; G. Blair Laing Ltd., Toronto, 1978; purchased August 1989

Exhibitions: Thomson 1920, no. 23; Halifax 1951, no. 35 coll. Mrs. George H. Henderson (repr.)

Literature: Laing 1979, 68, 78, as *Sleet Storm in the Cedar Bush* (repr. col.)

84

Silver Birches winter 1915–16
oil on canvas
40.9 x 56.0 cm

Inscription verso: label of Mellors Fine Arts

Collection: The McMichael Canadian Art Collection, Kleinburg (1968.7.12)

Provenance: Estate of the artist; Mellors Fine Arts, Toronto; Col. R.S. McLaughlin, Oshawa, 1941; gift of Col. R.S. McLaughlin, Oshawa, 1968

Exhibitions: McLaughlin 1947 as, *in R.S. McL[aughlin] cat.* as *Birch Glade, Evening*, on back *Sketch #18–1915, from Mellors Fine Art Gallery 1941, #82 Mrs. Thomson*; CNE 1959, as *Silver Birches*; Thomson 1971, no. 82 (repr.); McMichael 1982; Barbican 1991, no. 107

Literature: Duval 1970, as 1914 (repr.); Murray 1971, 41–42, 81, 94 (repr.); Duval 1973, 170 (repr.); McMichael 1976, 184 (repr.); McMichael 1979, 196 (repr.); Boulet 1982, 194–95 (repr. col.); Robert McMichael 1986, 325

85

Decorative Panels (I–IV) winter
1915–16
oil on Beaverboard
120.8 x 96.4 cm each

Collection: National Gallery of Canada, Ottawa (4717-4720)

Provenance: Dr. J.M. MacCallum, Toronto, 1916; bequest of Dr. J.M. MacCallum, Toronto, 1944

Exhibitions: Thomson 1920, nos. 44–47; Thomson 1941; MacCallum 1969, nos. 95–98; Thomson 1969, nos. 5–6 (panels III and IV); Mirvish 1977 (panel I)

Literature: Kerr 1916b; Comfort 1951a; Comfort 1951b; Hubbard 1960b, 309–10; Addison 1969, 49–50; Hale 1969; Reid 1969 (repr.); Mellen 1970, 47 (repr. col. panel III); Murray 1971, 41, 55 (repr. panel I); Godsell 1976, 126–27 (repr. panel III); Town & Silcox 1977, 48 (repr. panel I col.); Landry 1990, 28–29, 44-45 (repr.); Davis 1998, 998; Long 1999

86

Decoration: Autumn Landscape
winter 1915–16
oil on canvas
31.1 x 113.0 cm

Collection: Private

Provenance: Estate of the artist; S.J. Williams, Kitchener, Ontario, 1926; Mrs. S.J. Williams, Preston, Ontario, by 1937; Esther Williams, Preston and Toronto, by 1941; Laing Galleries, Toronto, 1960

Exhibitions: Thomson 1920, no. 20 as *Decoration, Autumn*; Thomson 1932, no. 15, lent by S.J. Williams, Kitchener; Thomson 1937, no. 29 as *Mantle* [sic] *Decoration*, lent

by Mrs. S.J. Williams, Preston; Thomson 1941 lent by Miss Esther Williams, Preston; Thomson 1956, lent by Miss D. Esther Williams, Toronto; Thomson 1971, no. XII (repr. col.); McMichael 1987

Literature: Hubbard 1962, fig. 29 (repr.); Murray 1971, 44, 56, 62 (repr. col.); Murray 1998 (repr.)

87

Decorated Pannikin c. 1915
oil on enamelled metal pannikin
7.9 x 23.8 cm diameter

Collection: National Gallery of Canada, Ottawa (7924)

Provenance: McDermott, Algonquin Park; J. Lorne McDougall, Ottawa; purchased 1936

Literature: Murray 1971, 42, 55 (repr.)

88

Decorated Demijohn c. 1915
oil on stoneware
55.0 x 30.5 x 28.0 cm diameter

Collection: Art Gallery of Ontario, Toronto (2001/92)

Provenance: Alexander Grant Cumming, Toronto; Mrs. Kate Waumsley Moore, Toronto; Colleen Gill, Toronto, by descent; purchased 2001

89

Decorative Mat for a Photograph of a Painting by Curtis Williamson
c. 1915
pen and ink, watercolour, oil and gouache on wove paper
24.3 x 21.2 cm

Inscription recto: on photograph, l.r., *Curtis Williamson*

Inscription verso: in ink, *Design by Tom Thomson*; on label, *A.B. Fisher / 96 Glen St. / Toronto / TIA TIA*

Collection: Art Gallery of Ontario, Toronto (2001/90)

Provenance: A member of the Arts and

Letters Club, Toronto; A.B. Fisher, Toronto; Mrs. Thompson, Toronto, by descent; J. Worthington Jull, Toronto; John Jull, Toronto; Roberts Gallery, Toronto; purchased 2001

Literature: Town & Silcox 1977, 150 (repr.) as *Decorative border for portrait by Curtis Williamson*; Murray 1998, 66 as 1914 (repr.)

90

Decorative Landscape, Quotation from Ella Wheeler Wilcox c. 1916
pen and ink, graphite, watercolour and gouache on illustration board
36.7 x 27.0 cm

Inscription recto: l.r., in image, in ink, *TOM THOMSON*; below image, *NOT QUITE THE SAME THE SPRINGTIME SEEMS TO ME / SINCE THAT SAD SEASON WHEN IN SEPARATE WAYS / OUR PATHS DIVERGED. THERE ARE NO MORE SUCH DAYS / AS DAWNED FOR US IN THAT LAST TIME WHEN WE / DWELT IN THE REALM OF DREAMS, ILLUSIVE DREAMS. / SPRING MAY BE JUST AS FAIR NOW, BUT IT SEEMS / NOT QUITE THE SAME. ELLA WHEELER WILCOX*

Inscription verso: frame, u.c., on label, in ink, *Design by Tom Thomson / about 1916 / from Dr. J.M. MacCallum Collection / Thoreau MacDonald, Thornhill*

Collection: Private

Provenance: Dr. J.M. MacCallum, Toronto; Thoreau MacDonald, Thornhill; Mr. and Mrs. Max Merkur, Toronto, by 1970; Joyner Fine Art, Toronto, 20 November 1998, lot 79

Exhibitions: Thomson 1971, no. 43 (repr.)

Literature: Mellen 1970, 47 (repr. col.); Murray 1971, 17–19, 20 n46, 36, 73, 92–93 (repr.)

91

Spring Woods spring 1916
oil on composite wood-pulp board
21.7 x 26.9 cm

Inscription recto: l.r., estate stamp

Inscription verso: c., estate stamp; u.c., in graphite, *1916*; u.r., in graphite, *5*; t., in graphite, *light of late afternoon, sun going [down?] and giving / light to east – aerial perspective is good* [illegible]

Collection: Alan O. Gibbons

Provenance: Estate of the artist; Mellors Fine Arts, Toronto, 1939; Mrs. Mary Boyd, Toronto; by descent

Literature: Murray 1971, 47, n32

92

Winter Hillside, Algonquin Park
spring 1916
oil on wood
21.2 x 27.0 cm

Inscription recto: l.r., scratched in paint, *T.T.*

Inscription verso: u.l., in graphite, *51*; u.c., in faded ink, *N [. . .] / 2*

Collection: The Thomson Collection (PC-469)

Provenance: Family of the artist; Laing Fine Art Galleries, Toronto; Dr. G.H. Henderson, Halifax, 1947; private collection, Calgary, by descent; G. Blair Laing Ltd., Toronto, 1978; acquired September 1978

93

Snow Bank spring 1916
oil on composite wood-pulp board
21.7 x 26.7 cm

Inscription verso: c., estate stamp; *Snow Bank, #320*; u.c., in graphite (upside down), *84–198 M. Thomson*

Collection: University College Art Collection, University of Toronto Art Centre (UC 531)

Provenance: Estate of the artist; Laing Fine Art Galleries, Toronto; Stewart and Letty Bennett, Toronto, 1948; Dr. W.C. Winegard, Guelph, Ontario, 1971; gift of Elizabeth Jaques Winegard and the Honourable Dr. William C. Winegard, Guelph, Ontario, 1997

94

March spring 1916
oil on wood
26.9 x 21.4 cm

Inscription verso: l.l., estate stamp; l.r., graphite, *53* (in circle); l.l., in ink on blue-bordered label, *March / 45. / James MacCallum*; c., on torn printed label BOMAC-FED . . . L . . . ; u.l., in graphite, *12*

Collection: National Gallery of Canada, Ottawa (4699)

Provenance: Estate of the artist; Dr. J.M. MacCallum, Toronto by 1919; Bequest of Dr. J.M. MacCallum, Toronto, 1944

Exhibitions: Thomson 1919, no. 45 lent by MacCallum; Los Angeles 1958; MacCallum 1969, no. 103; Thomson 1971, no. 89 (repr.)

Literature: Mortimer-Lamb 1919, 121 (repr. col.); Robertson 1949 (repr. col. cover); *Canadian Art*, Christmas 1949 (repr. col. cover); Hubbard 1960b, 307 (repr.); Hubbard 1962, fig. 22 (repr.); Hubbard 1963, 89 (repr. col.); Murray 1971, 43, 47 n32, 83, 95 (repr.); Murray 1986a, 55 (repr. col.); Murray 1991, 30 (repr.); Murray 1994a, 11 (repr.)

95

Snow and Rocks spring 1916
oil on wood
26.8 x 21.5 cm

Inscription verso: graphite sketch of trees; l.r., estate stamp; c.r., in ink, *90/10*; u.r., in ink, *James MacCallum*; u.r., in ink, *10*

Collection: National Gallery of Canada, Ottawa (4695)

Provenance: Estate of the artist; Dr. J.M. MacCallum, Toronto; bequest of Dr. J.M. MacCallum, Toronto, 1944

Exhibitions: MacCallum 1969, no. 124, as c. 1917; Thomson 1971, no. 118 (repr.); Thomson 1976, no. 12 as 1917; Mexico City 1999, no. 69 (repr. col.)

Literature: Hubbard 1960b, 306; Murray 1971, 48, 90, 96 as 1917 (repr.); Town

& Silcox 1977, 176 (repr. col.); Murray 1986a, 54 (repr. col.)

96

Little Cauchon Lake spring 1916
oil on wood
26.6 x 21.4 cm

Inscription recto: l.l., estate stamp

Inscription verso: c., estate stamp; above stamp in black pencil, *12*; below stamp in graphite, *29*; t., in graphite, *Little Cauchon Lake 1916*; u.l., in graphite, *6*; u.r., on label, in graphite, *1916* [crossed out] / in ink, *James M. MacCallum*

Collection: National Gallery of Canada, Ottawa (4681)

Provenance: Estate of the artist; Dr. J.M. MacCallum, Toronto; Bequest of Dr. J.M. MacCallum, Toronto, 1944

Exhibitions: MacCallum 1969, no. 109; Thomson 1971, no. 97 (repr.); Thomson 1976, no. 9; Mirvish 1977; Thomson 1990

Literature: Hubbard 1960b, 304; Murray 1971, 44, 85, 95 (repr.); Reid 1975, 19–21 (repr.); Town & Silcox 1977, 143 (repr. col.); Walton 1990, 178 n17; Murray 1994a, 74 (repr.)

97

Sketch for "The Jack Pine" spring 1916
oil on wood
21.0 x 26.7 cm

Inscription verso: u.l., in graphite, *13 / Top left*; c.l., in ink, *C&V / 19-3-47 / F.W.*; u.c., in ink, [illegible]

Collection: The Weir Foundation, River-Brink, Queenston, Ontario (982.65)

Provenance: Mrs. B.P. Watson, Toronto and New York, 1917; T. Eaton Co., Toronto, 1947; Samuel E. Weir, London, Ontario, 6 May 1947

Exhibitions: London 1950; Thomson London 1957, no. 1; Thomson Windsor 1957, no. 40

Literature: Forester Subscriber 1948; *London Evening Free Press*, 13 July 1957;

Hubbard 1960, 294; Hubbard 1962, fig. 19 (repr.); Reid 1975, 20–22 (repr.); David Taylor 1984 (repr.); Murray 1986a, 56 (repr. col.); Murray 1994b, 74 (repr. col.); Davis 1998, 998

98

Sketch for "The West Wind" spring 1916
oil on wood
21.4 x 26.8 cm

Inscription recto: l.r., in red, *TOM THOMSON*

Inscription verso: l.l., estate stamp; u.l., in graphite, *28 / (black) 2*; c., in ink on blue-bordered label, *Dr. James MacCallum*; c., in ink on red-bordered label, *Original sketch of / West Wind*

Collection: Art Gallery of Ontario, Toronto (L69.49)

Provenance: Estate of the artist; Dr. J.M. MacCallum, Toronto, by 1921; James MacCallum, Toronto, 1943; the Quarter Century Club of Canada Packers, 1946; presented to J.S. McLean, Toronto, May 1946; gift from the J.S. McLean Collection, Toronto, 1969, donated by the Ontario Heritage Foundation, 1988

Exhibitions: AGT Canadian 1926, hors. cat.; Thomson 1937, no. 81; Thomson 1941; McLean 1952, no. 88; Hamilton 1953, no. 52; AGT 1957, no. 77; Vancouver 1966, no. 69 (repr. col.); McLean 1968, no. 80 (repr.); NGC 1970, no. 66 (repr.); Thomson 1971, no. 99 (repr.); Edmonton 1978 (repr. col. pl. 1)

Literature: Davies 1935, 104; Bridle 1937b; McInnes 1937a; Saunders 1947, 173–74; McLean 1952, 7 (repr.); AGT 1959 (repr. col frontispiece); Hubbard 1962, fig. 20 (repr.); Davies 1967, 82–83; Addison 1969, 51, 54–56 (repr.); Mellen 1970, 212 (repr.); Reid 1970, 102 (repr.); Murray 1971, 85, 95 (repr.); Lord 1974, 128 (repr.); Addison 1974, 124; Reid 1975, 18–20 (repr.); Town & Silcox 1977, 174 (repr. col.); Fenton 1978, 23, pl. 2

(repr. col.); Murray 1994b, 76 (repr. col.); Murray 1995 (repr.); Murray 1999b, 78–79 (repr. col.); Davis 1998, 998

99

The Waterfall spring 1916
oil on wood
21.1 x 26.7 cm

Inscription verso: u.r., in graphite, *Tom Thomson / The Waterfall / From the collection of / Fred S. Haines, R.C.A.*; label l.r. removed

Collection: Vancouver Art Gallery (52.9)

Provenance: Fred S. Haines, Toronto; Laing Galleries, Toronto; presented in memory of Robert A. de Lotbinière-Harwood by his friends, 1952

Exhibitions: Thomson 1971, no. 76 (repr.); Edmonton 1978; Thomson 1990 as c. 1915

Literature: Mellen 1970, 58 (repr. col.); Murray 1971, 40, 80, 94 as fall 1915 (repr.); Town & Silcox 1977, 132 (repr. col.); Murray 1994b, 72 (repr. col.)

100

Spring Foliage on the Muskoka River spring 1916
oil on wood
21.5 x 26.7 cm

Inscription recto: l.r., estate stamp

Inscription verso: c., estate stamp; u.l., in ink, *AM*; c.r., in graphite, *1915*; l.r., label, in ink, *James MacCallum*; under label in graphite, *No.69 Mrs. Harkness*; u.c., in graphite, *Needs frame of shape to bring up* [further] *back / something with a deep roll-spring foliage on Muskoka River / a very good example of success* [sureness?] *of brush stroke*

Collection: The McMichael Canadian Art Collection, Kleinburg (1970.1.3)

Provenance: Estate of the artist; Elizabeth Thomson Harkness, Annan and Owen Sound; Mrs. W.T. Goodison, Sarnia 1925; private collection, by descent; Roberts Art Gallery, Toronto; purchased with funds donated by R.A. Laidlaw, Toronto, 1969

Exhibitions: Sarnia 1925 (2); McMichael

1976, no. 2 as 1915; McMichael 1976, no. 2 as *Rushing Stream 1915*; Algonquin 1998, no. 4

Literature: Duval 1970 as *Rushing Stream 1915* (repr.); Duval 1973, 20 (repr.); G.L. Smith 1974, 33–34; McMichael 1976, 20 (repr.); McMichael 1979, 197 (repr.); Robert McMichael 1986, 266–67

101

Cranberry Marsh and Hill spring 1916
oil on wood
21.9 x 26.7 cm

Inscription recto: l.r., estate stamp

Inscription verso: c., estate stamp; u.l., by MacCallum, in graphite, *Cranberry Marsh & Hill*; u.r., in blue pencil, *From Collection / Mrs. Harkness / Sister of Artist*; u.c., *1915* [4 over 5 which has been crossed out]; u.c., in graphite, *#335*; l.r., *84 M. Thomson*; b., in black crayon, *Sketch #6*; l.r., in graphite, *1*

Collection: Art Gallery of Hamilton (1953.112.E)

Provenance: Estate of the artist; Elizabeth Thomson Harkness, Annan and Owen Sound; Laing Galleries, Toronto; purchased 1953 (by exchange)

Exhibitions: Thomson 1937, no. 8 as *Cranberry Marsh*, lent by artist's family; Hamilton 1953, no. 57; Chautauqua 1963; Hunter 1997

Literature: Town & Silcox 1977, 132 (repr. col.)

102

Nocturne: The Birches spring 1916
oil on composite wood-pulp board
21.6 x 26.8 cm

Inscription verso: u.l., in black crayon, *7*; u.c., in graphite, *1916*; c., in graphite, *2* [. . .]

Collection: National Gallery of Canada, Ottawa (4711)

Provenance: Dr. J.M. MacCallum, Toronto; Bequest of Dr. J.M. MacCallum, Toronto, 1944

Exhibitions: Stratford 1967, no. 24; MacCallum 1969, no. 111; Thomson 1990

Literature: Hubbard 1960b, 308; Town & Silcox 1977, 117 (repr. col.); Murray 1986a, 47 as 1915 (repr. col.)

103

Spring, Canoe Lake spring 1916
oil on wood
21.6 x 26.8 cm

Inscriptions recto: l.r., estate stamp

Inscriptions verso: c., estate stamp; below stamp, in graphite, *160 M Thomson*; u.l., in graphite, *RAL*; u.c., in red pencil, *21*; u.c., in red pencil, *R.A. Laidlaw*; u.r., in graphite, *#5*; u.r., in graphite, *copper*; c.l., in graphite, *6*; l.c., in red pencil, *Gift to RWR Laidlaw / R.A. Laidlaw*

Collection: The Thomson Collection (PC-636)

Provenance: Estate of the artist; Margaret Thomson Tweedale, Toronto. R.A. Laidlaw, Toronto; private collection; purchased November 1984

104

Yellow Sunset spring or summer 1916
oil on wood
21.3 x 26.7 cm

Inscription recto: l.r., *TOM THOMSON*

Inscription verso: an oil sketch, possibly of Aura Lee Lake in spring; u.l., in black crayon, *74*

Collection: National Gallery of Canada, Ottawa (4684)

Provenance: Dr. J.M. MacCallum, Toronto; bequest of Dr. J.M. MacCallum, Toronto, 1944

Exhibitions: Thomson 1955 as *Yellow Sky*; Thomson 1956, no. 21; Thomson London 1957, no. 22; Thomson Windsor 1957, no. 36; Los Angeles 1958; MacCallum 1969, no. 101 as 1915–16; Thomson 1990; Mexico City 1999, no. 67 (repr. col.); Beijing 2001, no. 67 (repr. col.)

Literature: Hubbard 1960b, 305 as *Yellow Sunset*; Town & Silcox 1977, 115 (repr. col.); Murray 1986a, 61 (repr. col.)

105

Rocky Shore summer or fall 1916
oil on wood
21.4 x 26.5 cm

Inscription recto: l.r., estate stamp

Inscription verso: c., estate stamp; c. in graphite, *1916*; l.r., in graphite, *NG*

Collection: National Gallery of Canada, Ottawa (1535)

Provenance: Estate of the artist; purchased 1918

Exhibitions: NGC 1922; Owen Sound, 1922; Wembley 1924, no. 242; Saskatoon 1927; Canoe Lake 1930; Thomson 1932, no. 6; Thomson 1941; Los Angeles, 1958; Mirvish 1977

Literature: Hubbard 1960b, 297; Town & Silcox 1977, 129 (repr. col.)

106

Bateaux summer 1916
oil on wood
21.5 x 26.8 cm

Inscription recto: l.l., estate stamp

Inscription verso: c., estate stamp; l.l., in graphite, *no.48 Mrs. Harkness*; c., in red pencil, *46*; u.r., in graphite, *W.C.L.*; below stamp in graphite, *G*

Collection: Art Gallery of Ontario, Toronto (853)

Provenance: Estate of the artist; Elizabeth Thomson Harkness, Annan and Owen Sound; gift from the Reuben and Kate Leonard Canadian Fund, 1927

Exhibitions: Thomson 1937, no. 36; AGT 1947 as c. 1916; AGT 1957, no. 81; Thomson 1969, no. 7; Thomson 1971, no. 94 (repr.)

Literature: Robson 1937, 22–23 (repr. col.); Buchanan 1938, 288 (repr. col.); McInnes 1940 (repr.); *Canadian Review of Music and Art*, October 1942: 9

(repr. col.); Canadian Pulp and Paper Association 1954 (repr. col.); AGT 1959, 41 (repr. col.); Bradfield 1970, 442 (repr.); Murray 1971, 84, 95 (repr.); Town & Silcox 1977, 79 (repr. col.); Murray 1984, 45 (repr. col.); Booth 1995, 26–27 (repr. col.) Murray 1994b, 61 (repr. col.)

107

Tamarack Swamp fall 1916
oil on composite wood-pulp board
21.4 x 26.7 cm

Inscription recto: l.l., estate stamp

Inscription verso: c., estate stamp; u.l., graphite, *NG*

Collection: National Gallery of Canada, Ottawa (1534)

Provenance: Estate of the artist; purchased 1918

Exhibitions: NGC 1922; Owen Sound 1922; Saskatoon 1927; Canoe Lake 1930; Thomson 1932, no. 6; Thomson 1941; Thomson 1966, no. 3; Mirvish 1977; West Palm Beach 1984; Thomson 1990

Literature: Hubbard 1960b, 297; Town & Silcox 1977, 127 (repr. col.)

108

Sandbank with Logs summer or fall 1916
oil on composite wood-pulp board
21.3 x 26.3 cm

Inscription recto: l.r., estate stamp

Inscription verso: c., estate stamp; above stamp in black crayon, *Sketch #10*; below stamp in ink, *T.T-35*; l.r., on label in ball-point, *D.T. / Levis [Lavis ?]*

Collection: The Thomson Collection (PC-840)

Provenance: Estate of the artist; Mellors-Laing Galleries, Toronto, c. 1940; E.E. Poole, Edmonton. Sotheby's, Toronto, 27–28 May 1985, lot 755 as *Log Jam* (repr.); purchased May 1985

Exhibitions: Poole 1959, no. 23 as *The Ledge* (?)

109

Autumn, Three Trout fall 1916
oil on composite wood-pulp board
21.6 x 26.7 cm

Inscription recto: l.l., estate stamp

Inscription verso: c., estate stamp; u.l. of stamp, in graphite, *1916*; u.r., in graphite, *OK/GT*; l.l., in graphite, *230*; u.l., in graphite, *AO* [?]; b. in black marker, *ORIGINAL TOM THOMSON*

Collection: The Thomson Collection (PC-966)

Provenance: Estate of the artist; Fraser Thomson, Seattle; private collections, Seattle; Toronto Empire Auction, 19 January 1997, lot 48; purchased January 1997

Exhibitions: Owen Sound 1922, no. 43 as *Speckled Trout* (?)

110

The Alligator, Algonquin Park
summer or fall 1916
oil on composite wood-pulp board
21.5 x 26.8 cm

Inscription recto: l.r., estate stamp

Inscription verso: c., estate stamp; t., in graphite, *The Alligator 1916 Algonquin Park / JM*; c.r., in graphite, *#315*; l.r., in graphite, *101 M. Thomson*; l.r., in graphite, *#89 / MS*

Collection: University of Guelph Collection, Macdonald Stewart Art Centre, Guelph, Ontario (UG989.096)

Provenance: Estate of the artist; Margaret Thomson Twaddle (later Tweedale), Toronto; Mellors Fine Arts, Toronto, 1938; Stewart and Letty Bennett, Toronto, 1948; bequest of Stewart and Letty Bennett, Georgetown, Ontario, 1982, donated by the Ontario Heritage Foundation, 1988

Exhibitions: Bennett 1984, no. 58 (repr. col.)

Literature: Town & Silcox 1977, 82 as *Alligator*

111

Petawawa Gorges fall 1916
oil on wood
21.5 x 26.8 cm

Inscription recto: l.r., estate stamp

Inscription verso: c., estate stamp; u.l., in graphite, hidden by AGO label, *1st . . .*; u.l., in graphite, *Tom considered this sketch / his best & intended / it a large picture / J. MacD*; l.l. of stamp, in ink, *PROPERTY OF / HARK-NESS*; l.r., in graphite, *No. 97 M. Harkness*; u.r., in graphite, *1916*

Collection: Art Gallery of Ontario, Toronto (84/40)

Provenance: Estate of the artist; Elizabeth Thomson Harkness, Annan and Owen Sound; Hilda Harkness, Ottawa; gift of Miss Hilda Harkness, Ottawa, 1983

Exhibitions: Thomson 1971, no. 95 (repr.)

Literature: Murray 1971, 43–44, 84, 95 (repr.)

112

Autumn, Petawawa fall 1916
oil on wood
21.5 x 26.8 cm

Inscription verso: u.r., in graphite, *From Estate of / Fred S. Haines RCA*; b.c., in ink on printed label of G. Blair Laing Ltd., *"Autumn Petawawa" / by Circa 1916 / Tom Thomson / G. Blair Laing*

Collection: The Thomson Collection (PC-814)

Provenance: Fred S. Haines, Toronto; Dorothy Hoover, Toronto, 1960, by bequest; G. Blair Laing Ltd., Toronto, c. 1960; W. Allen Manford, Toronto; purchased November 1991

113

Petawawa Gorges fall 1916
oil on wood
21.5 x 26.6 cm

Inscription recto: l.l., estate stamp

Inscription verso: t., in graphite, *Petawawa – Oct. 1916 J. MacCallum*; u.l., in ink, *AM*; u.c., in graphite, *J. Henry*; c., in graphite, *Not for Sale*; l.r., in graphite, *No. 93 Mrs. Harkness*

Collection: The McMichael Canadian Art Collection, Kleinburg (1981.9.2)

Provenance: Estate of the artist; Elizabeth Thomson Harkness, Annan and Owen Sound (?); Mrs. J.G. (Louise Thomson) Henry, Aberdeen, Saskatchewan; Nutana Collegiate Institute, Saskatoon, by 1930; W.A. Cameron, Saskatoon; Alan M. Cameron, Copper Cliff and Sudbury; purchased with funds donated by Maj. F.A. Tilston, V.C., Toronto, 1981

Exhibitions: Saskatoon 1927; Barbican 1991, no. 116 (repr.); Algonguin 1998, no. 15

Literature: Davies 1930d, 826; Town & Silcox 1977, 130 (repr. col.); Robert McMichael 1986, 399; Murray 1991, 36, 38 (repr.) as Private Collection, Copper Cliff, Ontario; Murray 1994a, 76 (repr.)

114

Log Jam: Sketch for "The Drive"
fall 1916
oil on composite wood-pulp board
21.8 x 26.8 cm

Inscriptions verso: c., estate stamp; l.r., estate stamp; u.c., in graphite, *TT 58*; u.l., in ink, *AM*; l.c., in graphite, *No. 59 Mrs Harkness*

Collection: The Thomson Collection (PC-162)

Provenance: Estate of the artist; Elizabeth Thomson Harkness, Annan and Owen Sound; George Thomson, Owen Sound; Mellors Fine Arts, Toronto, 1937. G. Blair Laing Ltd., Toronto, 1970; purchased December 1970

Exhibitions: Thomson 1937, no. 12 as *The Jam*, lent by the artist's family (?); CNE 1956, no. 58 as *The Log Drive* (?)

Literature: Davies 1935, 102–104; Saunders 1947, 173; Davies 1967, 81–82; W.T. Little 1970, 111

115

The Sumacs fall 1916
oil on wood
21.3 x 26.6 cm

Inscription recto: l.r., estate stamp

Inscription verso: c., estate stamp; r. of stamp, *A557*; c.r., in graphite, *1916*; l.r., in graphite, *6–4*; on old paper backing u.l., *1919 – Sent to me by my / Grandfather – one of the / two sketches allotted to / me from Tom's work. / Geo Thomson*; l.l., *29/4/29 / The Sumacs / by Tom Thomson / Sketched at an early / period in his career as an artist / Property of Mr. & Mrs. / Geo. M. Thomson / March '32 – Arthur Lismer says / Tom painted this in the fall of 1916 / and that he and Tom were together at the time. In any event / he recollects clearly that this sketch / was made in the fall of 1916 / GMT / March 1947. Sketch has / 1916 in pencil on back / also has Tom's seal.*

Collection: The McMichael Canadian Art Collection, Kleinburg (1981.19)

Provenance: Estate of the artist; George Thomson, New Haven, Ct., and Owen Sound; George M. Thomson, Brantford, Ontario; Norman R.H. Thomson, Brantford, Ontario; purchased 1980

Exhibitions: Thunder Bay 1981, no. 26

Literature: Murray 1971, 46 n11 as *Northern Sunset*; Murray 1986a, 66 (repr. col.); McMichael 1989, 24 (repr. col.)

116

Red Sumac fall 1916
oil on composite wood-pulp board
21.6 x 26.7 cm

Inscription recto: l.r., estate stamp

Inscription verso: c., estate stamp; c. in black crayon, *1*; l.r., in ink, *Sumac in Autumn*

Collection: Tom Thomson Memorial Art Gallery, Owen Sound (968.001)

Provenance: Estate of the artist; Mrs. J.G. (Louise Thomson) Henry, Saskatoon; J.G. Henry, Toronto; gift of Mr. and Mrs. J.G. Henry, Toronto, in memory of Mrs. William (Minnie Thomson) Henry, 1968

Exhibitions: Saskatoon 1927; Thomson 1969, no. 33; Thomson 1971, no. 103; Thomson 1977, no. 56

Literature: Murray 1971, 86, 96 (repr.); Kritzwiser 1977 (repr.); Murray 1999b, 98–99 (repr. col.)

117

Autumn Foliage fall 1916
oil on wood
26.7 x 21.5 cm

Inscription recto: l.r., estate stamp

Inscription verso: c., estate stamp; u.l., in graphite, *NG*; u.c., in graphite, *1916*

Collection: National Gallery of Canada, Ottawa (1544)

Provenance: Estate of the artist; purchased 1918

Exhibitions: Thomson NGC 1922; Thomson Owen Sound 1922; Wembley 1924, no. 242; Saskatoon 1927; Canoe Lake 1930; Thomson 1932, no. 6; Thomson 1941; NGC 1970, no. 65 (repr.); Thomson 1976, no. 10; Thomson 1990; Mexico City 1999, no. 67 (repr. col.)

Literature: Hubbard 1960b, 298; Reid 1970, 102 (repr.); Reid 1973, 144, pl. XXI (repr.); Town & Silcox 1977, 27; Town 1977a, 178; Burnett 1990, 82–83 (repr.); Murray 1999b, 106–107 (repr. col.)

118

Near Grand Lake, Algonquin Park
fall 1916
oil on wood
21.6 x 26.7 cm

Inscription recto: l.r., *TOM THOMSON*

Inscription verso: former inscription, now faded, in graphite, *Near Grand Lake / Algonquin Park / Sept. 1917* [sic] / *W. Davidson / M.184 / 188 Luke Street*; l.r., in graphite, *D.L. Davidson*; b.c., in graphite, *2015*

Collection: The Thomson Collection (PC-569)

Provenance: W. Davidson, Toronto, 1917; Dorothy Davidson, Toronto, by descent; Waddington's, Toronto, 7–8 May 1981, lot 839A; G. Blair Laing Ltd. and McCready Galleries Inc., Toronto; purchased July 1981

Exhibitions: Thomson 1969, no. 18, lent by Dorothy Davidson

119

Snow in the Woods fall 1916
oil on wood
21.9 x 27.0 cm

Inscription recto: l.l., estate stamp

Inscription verso: u.r., in ink, *M. Tweedale*; c.r., in graphite, *OK/GT*; on backing, in graphite on torn label removed from verso, *02M* [?]; on label removed from verso, *T.28 / M. Tweedale*

Collection: The McMichael Canadian Art Collection, Kleinburg (1981.78.1)

Provenance: Estate of the artist; Margaret Thomson Tweedale, Toronto; purchased with funds donated by R.A. Laidlaw, Toronto, 1971

Exhibitions: Barbican 1991, no. 112

Literature: Duval 1973, 21 (repr. col.); McMichael 1979, 23 (repr. col.); Robert McMichael 1986, 268–70; Murray 1986a, 70 (repr. col.); McMichael 1989, 31 (repr. col.); Murray 1998, 80 (repr.)

120

Snow-Covered Trees fall 1916
oil on wood
20.6 x 26.0 cm

Inscription recto: l.r., estate stamp

Inscription verso: a sketch of a rainbow over hills in summer or early autumn; l.r., estate stamp; u.l., in graphite, *1916*

Collection: National Gallery of Canada, Ottawa (15547r)

Provenance: Estate of the artist; Alice and Vincent Massey, Toronto, 1918; Vincent Massey Bequest, 1968

Exhibitions: AGT Canadian 1926, no. 72 as *Snow on the Pines*; Massey 1934, no. 201 as *Woods in Winter*; Massey 1968, no. 80 (repr.); Thomson 1971, no. 105 (repr.)

Literature: Murray 1971, 44, 86, 96 (repr.); Town & Silcox 1977, 180 (repr. col.)

121

First Snow in Autumn fall 1916
oil on wood
12.8 x 18.2 cm

Inscription verso: on cardboard backing: u.l., in green pencil, *J. MacCallum / used in / First Snow in Autumn*; b.c., in graphite, *86*; l.r., in graphite, *7*; u.c., in graphite, *4*

Collection: National Gallery of Canada, Ottawa (4670)

Provenance: Dr. J.M. MacCallum, Toronto; bequest of Dr. J.M. MacCallum, Toronto, 1944

Exhibitions: MacCallum 1969, no. 53 as 1912–13; Mirvish 1977

Literature: Jacob 1927 (repr.); Hubbard 1960b, 303; Town & Silcox 1977, 184 (repr. col.); Booth 1995, 25 (repr.col.)

122

Moose at Night winter 1916
oil on wood
20.9 x 26.9 cm

Inscription recto: l.r., estate stamp

Inscription verso: c., estate stamp; u.l., graphite, *NG*; t., in graphite, *Winter 1916 – at studio J.M.*; u.r., in graphite, *Tom Thomson*; l.l., in graphite, *Moose at night / Moonlight*

Collection: National Gallery of Canada, Ottawa (1545)

Provenance: Estate of the artist; purchased 1918

Exhibitions: Thomson 1920, one of nos. 5 to 17; Thomson NGC, 1922; Thomson Owen Sound 1922; Wembley 1924, no. 242; Saskatoon 1927; Canoe Lake 1930; Thomson 1932, no 6; Thomson 1941; Thomson 1955; Thomson 1956, no. 27; Thomson Windsor 1957, no. 24; Los Angeles 1958; Thomson 1966, no. 6; NGC (2) 1967, no. 197; Thomson 1971, no. 96 (repr.); Madison 1973, no. 48 (repr.); Calgary 1976, no. 51 (repr.); Beijing 2001, no. 66 (repr. col.)

Literature: *Toronto Daily Star* 18 February 1920; Lismer 1947, 61 (repr.); Saunders 1947, 112; Totzke 1956; Hubbard 1960a, 92 (repr.); Hubbard 1960b, 298 (repr.); Hubbard 1962, pl. I (repr. col.); Hubbard 1963, 88; Kilbourn 1966, title page, 40

(repr. col.); Addison 1969, 28; Mellen 1970, 53–54 (repr. col.); Murray 1971, 44, 84, 95, as possibly at Petawawa Gorges August 1916 (repr.); Dumas 1972; Hubbard 1973, 132; Lord 1974, 127–28, pl. VII (repr. col.); Town & Silcox 1977, 171 (repr. col.); Davis 1998, 998

123

Snow in October winter 1916–17
oil on canvas
81.2 x 87.8 cm

Collection: National Gallery of Canada, Ottawa (4722)

Provenance: Estate of the artist; Dr. J.M. MacCallum, Toronto, by 1926; Bequest of Dr. J.M. MacCallum, Toronto, 1944

Exhibitions: Thomson 1919, no. 55 as *First Fall of Snow*; Thomson 1920, no. 31 as *Snow Pattern*; Thomson 1921; AGT Inaugural 1926, no. 257 as *Snow in Autumn*, lent by MacCallum; Paris 1927, no. 232; AFA 1930, no. 56 as *First Snow*; Thomson 1932, no. 11 as *Snow in October*; Thomson 1941 as *First Snow*; Vancouver 1954, no. 66 (repr.); Thomson 1955; Thomson 1956, no. 1; Thomson Windsor 1957, no. 7; Los Angeles 1958; NGC (1) 1967, no. 31; MacCallum 1969, no. 77 as 1914–16; Thomson 1971, no. 106 (repr.); Spokane 1974, no. 112; Thomson 1977, no. 6; Dallas 1993; Beijing 2001, no. 63 (repr. col.)

Literature: Fairbairn 1920 as *Snow Pattern*; Fairbairn 1921; A.M.D. 1927; Swinton 1956; Simmins 1956; Hubbard 1960b, 310 (repr.); Mellen 1970, 46 (repr.); Murray 1971, 44, 86, 96 (repr.); Boggs 1971, pl. 126 (repr.); Town & Silcox 1977, 181 (repr. col.); Boulet 1982, 212–13 (repr. col.); Martinsen 1984, 5 (repr.); Murray 1984, 44 as c. 1915

124

Early Snow winter 1916–17
oil on canvas
45.5 x 45.5 cm

Inscription verso: u.r., *163 M. Thomson*

Collection: The Winnipeg Art Gallery (2000-1)

Provenance: Estate of the artist; Margaret Thomson Twaddle (later Tweedale), Toronto; George Thomson, Owen Sound; Mellors Fine Arts, Toronto, 1941; John A. MacAulay, Winnipeg, 1951; J. Blair MacAulay, Oakville, Ontario; acquired with the assistance of a grant from the Government of Canada, through the Canadian Cultural Property Import and Export Act, and with contributions by The Winnipeg Foundation, The Thomas Sill Foundation Inc., The Winnipeg Art Gallery Foundation Inc., Mr. and Mrs. G.B. Wiswell Fund, DeFehr Foundation Inc., Loch and Mayberry Fine Art Inc., and several anonymous donors, 2000

Exhibitions: MacAulay 1954, no. 50; Thomson 1971, no. XI (repr. col.); Winnipeg 2000, no. 117 (repr. col.)

Literature: Murray 1971, 56, 61 (repr. col.); Town & Silcox 1977, 46 (repr. col.); Laing 1979, 78; St. Germain 2000; Oswald 2000

125

Maple Saplings, October winter 1916–17
oil on canvas
91.5 x 102.3 cm

Inscription verso: stretcher: c.r., in graphite, 38; u.l., in black crayon, 28

Collection: The Thomson Collection (PC-735)

Provenance: Estate of the artist; George Thomson, Owen Sound; A.R. Laing, Toronto, by 1941; Mr. Cresswell, Montreal, after 1947; L.T. Porter, St. Andrew's East, Quebec, through Watson Art Galleries, Montreal, 1948; Mrs. L.T. Porter, St. Andrew's East; by descent; G. Blair Laing Ltd., Toronto, 1973; purchased January 1990

Exhibitions: Thomson 1941, lent by A.R. Laing; Laing 1959, no. 20 (repr.); CNE

1959 (repr.); Thomson 1971, no. 108 (repr.)

Literature: Murray 1971, 87, 96 (repr.); Town & Silcox 1977, 160 (repr. col.); Laing 1979, 71, 78 (repr. col.); Robert McMichael 1986, 199–204; Murray 1986a, 72–73 (repr. col.); Murray 1998, 80 (repr. col.)

126

Woodland Waterfall winter 1916–17
oil on canvas
121.9 x 132.5 cm

Collection: The McMichael Canadian Art Collection, Kleinburg (1977. 48)

Provenance: Estate of the artist; Mellors Fine Arts, Toronto, by 1939; Roy Cole, Hamilton; W. Allan Manford, Toronto, 1967; purchased with funds donated by the W. Garfield Weston Foundation, 1977

Exhibitions: Thomson, 1920, no. 27 as *The Waterfall*; Thomson 1937, no. 1, lent by the artist's family; Thomson 1939, no. 38; CNE 1939, no. 219, *The Waterfall*, lent by Mellors Fine Art Galleries; Thomson, 1971, no. X (repr. col.); Thomson 1990

Literature: MacCallum 1918, 379 (repr.); Mortimer-Lamb 1919, 124 (repr.) as *The Waterfall*; Bridle 1937b; *Saturday Night* 10 June 1937 (repr.); *Toronto Telegram* 8 February 1939; Mellen 1970, 58–59 (repr. col.); Murray 1971, 42, 56, 61 (repr. col.); Edinborough 1976a; *Toronto Star*, 17 June 1976; Purdie 1976; Edinborough 1976a; Edinborough 1976b; McMichael 1976, 17 (repr. col.); McMichael 1979, 17 (repr. col.); Robert McMichael 1986, 199, 205, 327–38, 340–43; Murray 1986a, 74, 76–77 (repr. col.); McMichael 1989, 27–28 (repr. col.); Murray 1994b, 72–73 (repr. col.); Davis 1998, 998

127

The Pointers winter 1916–17
oil on canvas
101.0 x 114.6 cm

Collection: Hart House Permanent Collection, University of Toronto

Provenance: Estate of the artist; Elizabeth Thomson Harkness, Annan and Owen Sound; purchased by the House Committee of Hart House and with the Print Fund, 1928–29

Exhibitions: Thomson 1919, no. 57; Thomson 1920, no. 25; Thomson NGC 1922, as *The Pointers* or *The Pageant of the North*; Thomson Owen Sound 1922, no. 30; Wembley 1925, no. EE47; Paris 1927, no. 227; Thomson 1932, no. 8; Tate 1938, no. 207 as *Pageant of the North*; Thomson 1941; Boston 1949, no. 91; CNE 1950, no. 22; Washington 1950, no. 79 as c. 1915; NGC 1953, no. 65; Vancouver 1954, no. 64; Thomson London 1957, no. 35; Thomson Windsor 1957, no. 12; Mexico 1960, no. 115; London 1965, no. 36; Vancouver 1966, no. 70; NGC (2) 1967, no. 195; Thomson 1969, no. 1; Thomson 1971, no. XIII (repr. col.); Madison 1973, no. 50 (repr.); Thomson 1977, no. 9 as 1915–16; AGO 1977, no. 27; Owen Sound 1980, no. 9; Sault Ste. Marie 1980 (repr.); Kitchener 1981, no. 1 (repr.col.); Berlin 1982, no. 53; West Palm Beach 1984 as 1915; Hart House 1987, no. 20; Washington 1991, no. 12; New York 1995, no. 50

Literature: *Mail and Empire* (Toronto), 14 February 1920; Fairley 1920, 245; Kahn 1927a; Kahn 1927b; A.M.D. 1927; *Mail and Empire* (Toronto) 18 April 1929; Lismer 1929, 62 as *Pageant of the North*; Barbeau 1932a; Davies 1935, 112; Robson 1937, 9; Buchanan 1945, fig. 38 (repr.); Buchanan 1947, 63, 66 (repr. col.); Saunders 1947, 172–73; McInnes 1950, 55; Harper 1955, 21 (repr. col.); Hubbard 1960a, 93 (repr. col.); Hubbard 1962, 12 as 1915 (repr. col.); Hubbard 1963, 89, 91; Montagnes 1963, 218 (repr.); Harper 1966, 281–82 (repr. col.); Davies 1967, 88; Adamson 1969, 21, 108, (repr. col.); Addison 1969, 81, 83; Murray 1971, 44–45, 47 n43, 56, 62 (repr. col.);

Art Magazine, winter 1972 (repr. col. cover); Lord 1974, 129; Reid 1975, 23, 37; Town & Silcox 1977, 26–27, 86, 87 (repr. col.); Brink 1977, 34; Town 1977a, 177; Siddall 1987, 42, 53, 102 (repr.); Duval 1990, 126–27 (repr. col.); Murray 1991, 31; Murray 1994b, 60 as 1915–16 (repr. col.); Murray 1998, 80 as c. 1916–17 (repr. col.)

128

Chill November winter 1916–17
oil on canvas
87.5 x 102.4 cm

Inscription recto: l.r., *TOM THOMSON*

Collection: Gallery Lambton, Sarnia (56.26)

Provenance: Estate of the artist; Women's Conservation Association, Sarnia, November 1920; gift of the Women's Conservation Art Association, 1956

Exhibitions: Thomson 1919, no. 56; Thomson 1920, no. 19; Sarnia 1920(2), no. 41; Wembley 1925, no. E.E.21; Paris 1927, no. 228; AFA 1930, no. 55 as *Wild Geese*; Thomson 1932, no. 14; AGT Margaret Eaton 1935, no. 155; Thomson 1937, no. 58; Tate 1938, no. 211; Thomson 1941; Thomson 1956, no. 3; Thomson London 1957, no. 30; Thomson Windsor 1957, no. 6; Vancouver 1966, no. 68; NGC (1) 1967, no. 32; Thomson 1969, no. 2; Thomson 1971, no. 110 (repr.); Sarnia 1975, no 43; AGO 1975, no. 90 (repr.)

Literature: *Gazette* (Montreal) 28 March 1919; Fairley 1920, 246; *Sarnia Observer* 20 November 1920; *Sarnia Observer* 31 January 1926; F.B. Housser 1926, 117, 121–22 as *First Snow Ducks*; Barbeau 1932a; Davies 1935, 110; *Canadian Homes and Gardens* December 1935 (repr.); Burgoyne 1937a; *Sarnia Observer* 25 August 1938; Buchanan 1945, fig. 39 (repr.); Jackson 1958, 42; Davies 1967, 87; Addison 1969, 46; Murray 1971, 44, 88, 96 (repr.); G.L. Smith 1974, 12–14, 20, 38, 41; Forsey 1975, 186–87, 233–34 (repr.); Town & Silcox 1977, 139 (repr. col.)

129

The Fisherman winter 1916–17
oil on canvas
51.3 x 56.5 cm

Inscription verso: by George Thomson,
The Fisherman / by / Tom Thomson; stamp,
E.E. Poole Collection *no.101*; on frame,
T.T.36

Collection: Edmonton Art Gallery
(68.6.84)

Provenance: Estate of the artist; George
Thomson, Owen Sound; Mellors Fine
Arts, Toronto; Ernest E. Poole, Edmonton;
gift of Ernest E. Poole Foundation, 1975

Exhibitions: Thomson 1920, no. 39; Owen
Sound 1922, no. 37 as *Fishing*; Thomson
1937, no. 4; Thomson 1939, no. 40; Poole
1959, no. 20; Poole 1965, no. 59; Poole
(1) 1966, no. 57; Poole (2) 1966, no. 18;
Thomson 1971, no. 49 (repr.); Edmonton
1978; Lethbridge 1978, no. 19 (repr.);
Thomson 1990, as c. 1914; Hunter 2001

Literature: Harper 1966, 279, 282; Murray
1971, 75, 93 (repr.); Dumas 1972; Town
& Silcox 1977, 142 (repr. col.); Hunter
2001, 16 (repr.)

130

The Drive winter 1916–17
oil on canvas
120.0 x 137.5 cm

Collection: University of Guelph,
Macdonald Stewart Art Centre, Guelph
(0.134)

Provenance: Estate of the artist; Ontario
Agricultural College purchase with funds
raised by students, faculty and staff, 1926

Exhibitions: Thomson 1920, no. 28 as *The
Log Chute*; Thomson 1941; CNE 1952,
no. 140; Stratford, 1963; Thomson 1967,
no. 3 (repr.); Thomson 1971, no. XV
(repr. col.); AGO 1975, no. 91 (repr.);
Algonquin Park 1998, no. 3 (repr. col.)

Literature: MacCallum 1918, 380 (repr.);
Mortimer-Lamb 1919, 120 as *The Drive,
South River* (repr.); Ontario Agricultural

College 1926; *Quality Street* January 1926;
Guelph Mercury 9 January 1926; Bess
Housser 1926, 33; F.B. Housser 1926, 218;
Davies 1935, 102–103; Buckman 1937,
571 (repr.); McInnes 1950, 55; Hubbard
1962, 12, fig. 24 (repr.); Davies 1967, 81;
University of Guelph News Bulletin February
1969, 1 (repr.); Addison 1969, 58, 83;
Murray 1971, 45, 47 n47–48, 56, 63
(repr. col.); Lord 1974, 129–30 (repr.);
Forsey 1975, 188–89, 234 (repr.); Reid
1975, 23; Town & Silcox 1977, 83 (repr.
col.); Nasby 1980, 352–53 (repr. col.);
Murray 1994b, 44; Davis 1998, 998

131

The West Wind winter 1916–17
oil on canvas
120.7 x 137.9 cm

Collection: Art Gallery of Ontario,
Toronto (784)

Provenance: Estate of the artist; gift of
the Canadian Club of Toronto, 1926

Exhibitions: CNE 1917, no. 214, (repr.)
as *West Wind, Algonquin Park*; Thomson
1920, no. 41; Worcester 1920, no. 30; OSA
Retrospective 1922, no. 170; Thomson
Owen Sound 1922, no. 31; Wembley
1924, no. 239; Ottawa 1926, no. 62; AGT
Inaugural 1926, no. 259; Philadelphia
1926, no. 1550; Paris 1927, no. 230;
Saskatoon 1927; Thomson 1932, no. 2;
AGT 1935, no. 69; AGT 1935 Margaret
Eaton, no. 154; San Francisco 1939, no. 24;
Thomson 1941; London 1942, no. 42;
New Haven 1944; AGT 1944, no. 74;
Chicago 1944 (repr.); DPC 1945, no. 133;
CNE 1948, no. 20; Hamilton 1953, no. 51
(repr.); Vancouver 1954, no. 63 (repr.);
AGT 1957, no. 78; Vancouver 1966,
no. 70; NGC (2) 1967, no. 200 (repr.);
Owen Sound 1968, no. 7; NGC 1970,
no. 68 (repr.); Thomson 1971, no. XVI
(repr. col.); Thomson 1977, no. 1; Tokyo
1981, no. 26 (repr. col.); Berlin 1982,
no. 59; West Palm Beach 1984; Barbican
1991, no. 113 (repr. col.)

Literature: *Globe* (Toronto), 27 August
1917; MacCallum 1918, 383 (repr.);

Fairley 1920, 244, 246; *Mail and Empire*
(Toronto), 11 February 1922; *Globe*
(Toronto), 13 February 1922; Jacob 1922
(repr.); Hind 1924, 250; NGC 1924b,15,
20–21; *Toronto Daily Star*, 21 January
1926; R.B.M. 1926; L.S. Harris 1926, 46;
Evening Telegram (Toronto) 4 February 1926;
Toronto Daily Star 4 February 1926; Locke
1926; *Canadian Bookman* March 1926;
Jackson 1926, 180, 182; *Christian Science
Monitor* 8 March 1926; Lismer 1926b,
71; Pringle 1926; Brown 1926 (repr. col.);
NGC 1926, 13, 17, 34; F.B. Housser
1926, 117, 120, 211, 218 (repr.); *Chatelaine*
October 1928 (repr.); Perry 1928; Dick
1929; Davies 1930 (rep. col.) Lismer
1930a, 16–17 (repr.); Salinger 1930b
(repr.); Davies 1930d, 826; McLennan
1931, 1–3 (repr.); Grayson 1932, 120–
23 (repr.); Robson 1932, 147 (repr. col.);
H.R. MacCallum 1933, 248; Lismer
1934, 163–64 (repr. col.); Davies 1935,
73, 96, 104 (repr. col.); Mulligan 1937
(repr.); Robson 1937, 10–11 (repr. col.);
Buckman 1937, 569 (repr.); Storm 1938
(repr.); Lismer 1940, 19–20 (repr. col.);
New World Illustrated December 1941
(repr.); Shoolman and Slatkin 1942, 693,
pl. 710; McRae 1944, 49 (repr.); Colgate
1945; Macfarlane 1945; Buchanan 1945,
12; Saunders 1947, 4, 173 (repr. col.);
Mayfair May 1947 (repr.); Buchanan 1950,
fig. 18 (repr.); AGT 1950, 28 (repr.);
Harold Walker 1950, 22 (repr.); Lismer
1954, 171; R.P. Little 1955, 203; Jackson
1958, 44; AGT 1959 (repr. col.); Hub-
bard 1962, 11, pl. 12; Hubbard 1963, 91;
Brieger, Vickers and Winter 1964, 182
(repr.); Harper 1966, 282; Davies 1967,
41, 76, 82–83 (repr. col.); Addison
1969, 54–56, 59, 78, 93 (repr.); Mellen
1970, 49, 60–61, 208 (repr. col.); Reid
1970, 104–105 (repr.); Bradfield 1970,
447–48, 537 (repr. col.); W.T. Little 1970,
33–34, 195, 215; Murray 1971, 45, 56,
64 (repr. col.); Reid 1971, 9; Winnipeg
Tribune 13 March 1972; Arbec 1972;
Reid 1973, 145; Lord 1974, 128–29
(repr.); Reid 1975, 18–23; Town & Silcox

1977, 175, 193 (repr. col.); Mellen 1978,
172–73 (repr. col.); Wistow 1982, 8–9
(repr. col.); Nasgaard 1984, 184; Murray
1984, 50 (repr. col.); Murray 1986a, 62,
80–81 (repr. col.); MacGregor 1987, 58
(repr.); Murray 1989; Murray 1991,
32–33, 44–45; Teitelbaum 1991, 72, 74
n14 (repr.); Murray 1994b, 76–77 (repr.
col.); Murray 1995 (repr.); Murray 1996,
115–24; Davis 1998, 998–99; Murray
1999a, 26 (repr. col.); Murray 1999b, 114–
15 (repr. col.)

132

The Jack Pine winter 1916–17
oil on canvas
127.9 x 139.8 cm

Collection: National Gallery of Canada,
Ottawa (1519)

Provenance: Estate of the artist; purchased
1918

Exhibitions: St. Louis 1918, no. 32;
Thomson 1920, no. 2; Thomson NGC
1922; Thomson Owen Sound 1922,
no. 28; Wembley 1924, no. 240 (repr.);
Ghent 1925, no. 729; AGT Inaugural
1926, no. 260; Paris 1927, no. 236 (repr.);
Thomson 1932, no. 2; Tate 1938, no. 213;
Thomson 1941; London 1942, no. 41;
Boston 1949, no. 89 (repr.); Toronto
1949, no. 29 (repr.); Washington 1950,
no. 78 (repr.); Vancouver 1954, no. 65
(repr.); Los Angeles 1958; NGC (2) 1967,
no. 196 (repr.); Owen Sound 1968, no. 6
(repr. col.); NGC 1970, no. 69 (repr.);
Thomson 1971, no. XV (repr. col.); Madi-
son 1973, no. 51 (repr. col.); Thomson
1976, no. 11; AGO 1984, no. 117 (repr.);
Montreal 1999 (repr.col.)

Literature: MacCallum 1918, 381 (repr.);
Mortimer-Lamb 1919, 125 (repr.) as
The Jack Pine, Lake Cauchon; *Mail and Empire*
(Toronto) 14 February 1920; *Toronto
Daily Star* 18 February 1920; Fairley 1920,
244–47; *Ottawa Journal* 18 February 1922;
Ottawa Citizen 22 February 1922; Brown
1922a, 28 (repr.); Hind 1924, 250; NGC
1924a (repr.); *Canadian Magazine* July 1924,

136 (repr.); Lee 1924, 338–39; NGC 1924b, 7, 15, 20; *Canadian Annual Review of Public Affairs* 1925, 486; Richmond 1925, 21, no. 182 (repr. col.); MacTavish 1925, 150 (repr.); L.S. Harris 1926, 46; *Christian Science Monitor* 8 March 1926; Lismer 1926b, 71; F.B. Housser 1926, 117, 120–21; NGC 1926, 5, 13, 17, 34, 38, 41; Chassé 1926 (repr.); Brown 1927a, 192 (repr.); Dick 1928; Grayson 1929, 196–98, 275–76 (repr. col. frontispiece); Salinger 1930c, 7–8 (repr.); Davies 1930, 23 (repr.); *Onward* 5 September 1931 (repr.); Lismer 1932a; Barbeau 1932a; Barbeau 1932b (repr.); Robson 1932, 145 (repr. col.); Davies 1935, 96,107, 110–11 (repr. col.); Robson 1937, 20–21 (repr. col.); Burgoyne 1937a (repr.); McInnes 1940, 27 (repr. col.); Buchanan 1945, fig. 43 (repr.); Buchanan 1946, 99 (repr. col.); Saunders 1947, 173; *Forester Subscriber* 1948; Department of Citizenship and Immigration 1957, 75 (repr. col.); Atherton 1958, 20 (repr. col.); Hubbard 1960b, 294 (repr.); Hubbard 1962, 7, 11, pl. 3 (repr. col.); Hubbard 1963, 89–91 (repr. col.); Maud Brown 1964, 72; Harper 1966, 279, 282 (repr.); Davies 1967, 24, 76, 87–88 (repr. col.); Boggs 1969, 4 (repr.); Addison 1969, 54, 59, 76, 81 (repr.); Mellen 1970, 49, 60–63, 198, 208 (repr. col.); Reid 1970, 106–107 (repr. col.); Boggs 1971, pl. XXVIII (repr. col.); Murray 1971, 45, 59, 63 (repr. col.); Dumas 1972; Hubbard 1973, 138–39 (repr. col.); Reid 1973, 145; Lord 1974, 128–29; Reid 1975, 17–33 (repr. col.); Town & Silcox 1977, 124, 125, 193 (repr. col.); Mellen 1978, 9, 172 (repr. col.); Boulet 1982, 210–11 (repr. col.); Nasgaard 1984, 180, 184 (repr. col.); Murray 1986a, 78–79 (repr. col.); Burnett 1990, 86–87 (repr.); Walton 1990, 173,175, 206 (repr.); Murray 1991, 32–33; Bordo 1992, 108–25 (repr. col.); Murray 1994b, 74–75 (repr. col.); Booth 1995, 19 (repr. col.); Newlands 1995, 36–37 (repr. col.); Davis 1998, 998–99; Murray 1999a, 25 (repr. col.); Murray

1999b, 112–13 (repr. col.); MacHardy 1999 (repr.); Murray 2001, 134

133

Northern Lights spring 1917
oil on plywood
21.5 x 26.5 cm

Inscription verso: l.c., in graphite, *No.63 Mrs. Harkness*; u.l., in ink, *A.M.*; c., in black crayon, *Sketch #4*; u.l, in graphite, *#1665 Northern Lights / Tom Thomson*; l.l., in graphite, *43*; u.c., in graphite, *2*

Collection: Alan O. Gibbons

Provenance: Estate of the artist; George Thomson, Owen Sound; Mellors Fine Arts, Toronto, 1939; purchased 1939

Exhibitions: Thomson 1937, no. 6 (?); Thomson 1939, no. 43; NGC 1959; NGC (2) 1967, no. 199 (repr.); Thomson 1971, no. 123 (repr.); Thomson 1995, no. 38

Literature: Robson 1937, 24–25 (repr. col.) as collection George Thomson; McInnes 1940 (repr.); Hubbard 1962, fig. 28 (repr.); Saunders 1947; Petrie 1963 (repr. cover); Addison 1969, 61–62, 67 (repr.); Little 1970, 27, 198; Mellen 1970, 53–54 (repr. col.); Murray 1971, 90, 96 (repr.); Town & Silcox 1977, 173 (repr. col.); Murray 1994a, 50 (repr.)

134

Woods in Winter spring 1917
oil on wood
14.6 x 20.0 cm

Inscription verso: in graphite, $\frac{1}{2}$ *BLUE – BACKED BY* $\frac{3}{8}$ *ANTIQUE*; in ink, *J. HENRY*; in graphite, *Woods in Winter*

Collection: Tom Thomson Memorial Art Gallery, Owen Sound (967. 056)

Provenance: Estate of the artist; Mrs. J.G. (Louise Thomson) Henry, Guernsey, Sask.; gift of Mrs. J.G. Henry, Saskatoon, 1967

Exhibitions: Saskatoon 1927; Owen Sound 1968, no. 8; Thomson, 1969, no. 26; Thomson, 1977, no. 39; Thomson 1995, no. 9

Literature: *SunTimes* (Owen Sound) 23 October 1967; Town & Silcox 1977, 191 (repr. col.); Murray 1994a, 32 (repr. col.)

135

Path Behind Mowat Lodge spring 1917
oil on wood
26.3 x 21.3 cm

Inscription recto: l.l., *TOM THOMSON*

Inscription verso: b.c., in graphite, *2951*

Collection: The Thomson Collection (PC-774)

Provenance: Mrs. Daphne Crombie, Toronto, spring 1917; Brissenden Collection, Vancouver per P. McCready, Toronto, 1969; Joyner Fine Art, Toronto, 20–21 November 1990, lot 58; purchased December 1990

Exhibitions: Thomson 1941 as sketch lent by Mrs. R.L. Crombie, Toronto

Literature: R.P. Little 1955, 205–206; Addison 1969, 65; W.T. Little 1970, 218–19; Town & Silcox 1977, 176

136

The Rapids spring 1917
oil on wood
21.6 x 26.8 cm

Inscription verso: u.l., in graphite, *42* / u.l. in ink, *OWNED BY / A.Y. JACKSON*; u.c., in graphite, *reserved / Studio Bldg / L.S. Harris*; u.r., on label, *T.12*; in red pencil, in graphite, *A.Y. Jackson / Toronto*; c.l., in ink, *S.B.*; l.l., in ink on Art Gallery of Toronto label, *Dec 31/40 / A.Y. Jackson / in graphite, photo Y01.2*; l.r., in ink, *"THE RAPIDS / PAINTED BY / TOM THOMSON / PROBABLY IN THE SPRING OF 1917*

Collection: The Thomson Collection (PC-809)

Provenance: Estate of the artist; A.Y. Jackson, Toronto; Dr. Naomi Jackson Groves, Ottawa; purchased July 1991

Exhibitions: Thomson 1937, no. 15; Thomson, 1941; Thomson 1995, no. 26

Literature: Murray 1994a, 43 (repr. col.)

137

Larry Dickson's Cabin spring 1917
oil on wood
21.3 x 26.6 cm

Inscriptions verso: u.l., in graphite, *11A*; u.l., in graphite, *NG*; u.l., in graphite, *THE ARTIST HUT*; u.r., in graphite, *Rom Gold*

Collection: National Gallery of Canada. Ottawa (1528)

Provenance: Estate of the artist; purchased 1918

Exhibitions: Thomson NGC 1922; Thomson Owen Sound 1922; Wembley 1924, no. 242; Saskatoon 1927; Canoe Lake 1930; Thomson 1932, no. 6; Thomson 1941; Thomson 1955, as *The Artist's Hut*; Thomson 1956, no. 29; Thomson London 1957, no. 29; Thomson Windsor 1957, no. 27; Los Angeles 1958; Thomson 1969, no. 9; Thomson 1995, no. 25

Literature: Buchanan 1945, pl. III as *The Artist's Hut*; Colgate 1946b (repr. col.); *Canadian Geographical Journal* October 1946 (repr. col.); *Canadian Art*, Christmas 1947 (1947–48) (repr. col. cover); Saunders 1947, 112; R.P. Little 1955, 204; Hubbard 1960b, 296 (repr.); Addison 1969, 65; W.T. Little 1970, 35, 216, 218; Murray 1986a, 82 (repr. col.); Murray 1994a, 42 (repr. col.)

138

Spring Flood spring 1917
oil on wood
21.6 x 26.8 cm

Inscription verso: u.l., in graphite, *R.A.L. / reserved / Lawren Harris / for B.L.*; u.r., in graphite, *RAL*; u.r., in red pencil, *Laidlaw*; u.r., in red pencil, *40*; l.r., in graphite, *No.40 Mrs. Harkness*

Collection: The McMichael Canadian Art Collection, Kleinburg (1966.15.23)

Provenance: Estate of the artist; W.C. and R.A. Laidlaw, Toronto, 1922; gift of R.A. Laidlaw, Toronto, 1965

Exhibitions: AGT Canadian 1926, no. 89 as *Spring* lent by R.A. and W.C. Laidlaw, Toronto; CNE, 1959 as *Spring Flood* lent by Mr. and Mrs. R.A. Laidlaw; Thomson 1995, no. 18

Literature: Duval 1967 as 1915 (repr.); Duval 1970 (repr. col.); Duval 1973, 23 (repr. col.); McMichael 1976, 23 (repr. col.); McMichael 1979, 26 (repr. col.); McMichael 1989, 32 (repr. col. as 1917); Murray 1994a, 37 (repr. col.)

139

Tea Lake Dam summer 1917
oil on wood
21.3 x 26.2 cm

Inscription verso: three graphite sketches of birds; t., in graphite, *Thundercloud in spring at chute where Muskoka River flows out of Lake / looked at from the left side the rush of water and the feeling of daylight is / very marked as well as the feeling of spring — In the trees or bushes in the foreground on right / side of creek I found a poacher's bag with beaver-skins &c — sketched just before his drowning / JMM.* Backing: on label, *Dr. James MacCallum*

Collection: The McMichael Canadian Art Collection, Kleinburg (1970.1.4)

Provenance: Dr. J.M. MacCallum, Toronto; Mrs. W.T. Goodison, Sarnia, 1925; private collection, by descent; Roberts Art Gallery, Toronto; purchased with funds donated by R.A. Laidlaw, 1969

Exhibitions: Sarnia 1925(2); McMichael 1977, no. 5 (repr. col.); West Palm Beach, 1984; Atlanta, 1986 (repr.); McMichael 1988 (repr. col.); Thomson 1995, no. 28

Literature: Duval 1970, as 1916 (repr. col.); Duval 1973, 17 (repr. col.); G.L. Smith 1974, 33–34; Town & Silcox 1977, 80, 229; McMichael 1979, 32 (repr. col.); Robert McMichael 1986, 266–67; McMichael 1989, 32 as 1917 (repr. col.); Murray 1991, 36–37; Murray 1994a, 45 (repr. col.)

140

After the Storm summer 1917
oil on wood
21.5 x 26.0 cm

Inscription verso: l.r., estate stamp; t., in ink, *This sketch was done by Tom Thomson in the late spring of the year in which / he was drowned. It is one of the few done in green. When the foliage had / come on [southly?] he usually gave up sketching and took to fishing / and canoeing until the fall color appeared. / J.M.;* c.r., in graphite, *Dr. James MacCallum;* c.l., in graphite, *1917;* c.l., on label in ink, *Dr. Tovell;* c., in blue ink on printed label, *Art Gallery of Toronto / Loaned by / Mrs. R.M. Tovell;* l.c., *Tovell;* l.r., in graphite, *No. 45 Mrs. Harkness;* l.l., fragment of printed label, *[. . .] A OTTAWA*

Collection: Private

Provenance: Estate of the artist; Elizabeth Thomson Harkness, Annan and Owen Sound; Dr. H. Tovell, Toronto, by 1937; Mrs. R.M. Tovell, Toronto

Exhibitions: Thomson 1937, no. 65 lent by Harold Tovell, M.D.; NGC 1959

Bibliography

compiled by Beth Greenhorn

Books and Articles, by Author

Adamson, Jeremy.
1969. *The Hart House Collection of Canadian Painting*. Toronto: University of Toronto Press, 1969.

Addison, Ottelyn.
1974. *Early Days in Algonquin Park*. Toronto: McGraw-Hill Ryerson, 1975.

Addison, Ottelyn, and Elizabeth Harwood.
1969. *Tom Thomson, The Algonquin Years*. Vancouver, Winnipeg, Toronto: Ryerson Press, 1969. Toronto: McGraw-Hill Ryerson, 1975. Anniversary ed., Toronto: McGraw-Hill Ryerson, 1995.

A.E.F.
1927. "Canadian Comes to Defense of Canada's Artists." *Sunday Province* (Vancouver), 11 September 1927.

AGO (Art Gallery of Ontario).
1974. *Handbook/Catalogue illustré*. Introduction by Richard J. Wattenmaker. Toronto: Art Gallery of Ontario, 1974.
1987. *Masterpieces from the Art Gallery of Ontario*. Toronto: Art Gallery of Ontario, Key Porter Books, 1987.

AGT (Art Gallery of Toronto).
1936 *Canadian Picture Study*. Toronto: Art Gallery of Toronto, 1936.
1950. *Fifty Years and the Future*. Toronto: Art Gallery of Toronto, 1950.
1959. *Painting and Sculpture: Illustrations of Selected Paintings and Sculpture from the Collection*. Toronto: Art Gallery of Toronto, 1959.

Alexandre, Arsène.
1927a. "La vie artistique." *Le Figaro* (Paris), 10 April 1927.
1927b. "Les Canadiens et le 'Primitivisme.'" *Le Renaissance* (Paris), 15 April 1927.

Algie, Jim.
1987. "Thomson Still Inspiration for Others." *SunTimes* (Owen Sound), 4 May 1987.
1992. "Tom Thomson Legacy Lives On." *SunTimes* (Owen Sound), 2 May 1992.
1996. "Artist's Death Still Haunting." *SunTimes* (Owen Sound), 15 July 1996.

Altmeyer, George
1976. "Three Ideas of Nature in Canada, 1893–1914." *Journal of Canadian Studies* 11, no. 3 (August 1976): 21–36.

A.L.W.
1928. "Art, Music and Drama." *The Varsity* (University of Toronto), 24 October 1928.

Amaya, Mario
1970. "Canada's Group of Seven." *Art in America* 58, no. 3 (May – June 1970): 122–25.

A.M.D.
1927. "Canadian Art Exhibit, Place de la Concorde." *Montreal Daily Star*, 7 May 1927.

A.M.S.
1924. "Canadian Art." *Canadian Theosophist*, 5, no. 3 (15 May 1924): 46.

Andrews, Bernadette
1971. "AGO Opens Retrospective on Tom Thomson." *Toronto Telegram*, 30 October 1971.
1975. "One Family's Tale of Two Houses." *Toronto Star*, 1 July 1975.

Another Thomson
1938. "A Tom Thomson Retort" (letter to the editor). *London Free Press* (Ont.), 13 December 1938.

Arbec, Jules
1972. "Rétrospective Tom Thomson." *Le Devoir* (Montreal), 19 May 1972.

Armstrong, John
1997. "A Rec Room Requiem." *C Magazine* 56 (November 1997– January 1998): 18–22.

Art Gallery of Hamilton
1989. *The Art Gallery of Hamilton: Seventy-Five Years (1914–1989)*. Hamilton: Art Gallery of Hamilton, 1989.

Art Gallery of Ontario
See under AGO.

Art Gallery of Toronto
See under AGT.

Atherton, Ray
1947. "The Man in a Canoe." *Canadian Art* 5, no. 2 (Christmas 1947): 56–58. Reprinted in *Canadian Art* 15, no. 1 (January 1958): 20–21.

Ayre, Robert
1941. "Toronto Honors Memory of Artist; Exhibition of Thomson Paintings Includes Loans of Principal Work." *Montreal Standard*, 1 February 1941.
1969. "The Thomson Mystery as Puzzling as Ever." *Montreal Daily Star*, 15 February 1969.
1972. "Thomson's Vision." *Montreal Daily Star*, 6 May 1972.

Baldwin, Warren
1956a. "Tom Thomson Murdered? Experts Scoff." *Winnipeg Tribune*, 11 October 1956.

1956b. "'Who-dun-it' Fans Face Busy Times.'" *Province* (Vancouver), 11 October 1956.

Bale, Doug
1980. "Thomson Deserved More Than Northern River Offers." *London Evening Free Press*, (Ont.), 17 October 1980.
1981. "U.S. Man Laying Claim to Tom Thomson Paintings." *London Evening Free Press* (Ont.), 27 May 1981.

Ball, Helen
1916. "Trying to Understand Artists and Their Arts." *Toronto Daily News*, 11 March 1916.

Bantey, Bill
1972. "Tom Thomson a Brace of Fine Art Exhibitions." *Current Events* (Montreal), May 1972.

Barbeau, Marius
1932a. "Tells Remarkable Story of Progress and Achievement." *Ottawa Evening Citizen*, 27 July 1932.
1932b. "Morrice and Thomson." *New Outlook* (Toronto) 8, no. 3 (August 1932): 764.
1932c. "Canada Sets a Banquet of Art for the Imperial Conference." *Art Digest* 6, no. 19 (1 August 1932): 3–4.
1932d. "Distinctive Canadian Art: National Gallery Organizes Characteristic Show for Conference." *Saturday Night* 47, no. 39 (6 August 1932): 3.
1932e. "L'Art au Canada: Les Progrès." *La Revue Moderne* 13, no. 11 (September 1932): 5, 9.
1932f. "Exotic Leanings of Art In Canada Was Handicap." *Ottawa Morning Citizen*, 1 October 1932.

1942. "A quoi bon les arts?" *Revue de l'Université d'Ottawa* 12, no. 2 (April–June 1942): 172–83.

Barker, Hazel

1967. "Artists Says Tom Thomson Was a Kind, Helpful Man." *Barrie Examiner*, 30 March 1967.

1971. "Tom Thomson's Famous Works Shown At Toronto Gallery." *Barrie Examiner*, 2 November 1971.

Barkley, Frank

1964. "Preparing to Mark 96th Birthday, George Thomson Is Oldest Active Artist." *SunTimes* (Owen Sound), 8 February 1964.

Baskin, Bernard

1968. "Master of Canada's Autumn and Winter Moods." *Hamilton Spectator*, 17 February 1968.

Baxter, Arthur Beverley

1919. "The Members Who Served." In *The Lamps*, 16–24. Toronto: Arts and Letters Club, 1919.

Bayer, Fern

1981. "The 'Ontario Collection' and the Ontario Society of Artists Policy and Purchases, 1873–1914." *RACAR* 8, no. 1 (1981): 32–54.

Benedetti, Paul

1989. "Beckett Gallery Painting Believed to Be a Tom Thomson." *Hamilton Spectator*, 13 October 1989.

1990. "Picture Worth More Than a Thousand Words." *Hamilton Spectator*, 5 July 1990.

Berton, Pierre

1961. "Robert McMichael and His Remarkable Obsession." *Toronto Daily Star*, 8 May 1961.

Bertram, Anthony

1924. "The Palace of Arts, Wembley." *London Saturday Review*, 7 June 1924.

Betts, Jim

1990. *Colours in the Storm*. Play performed at the Muskoka Festival Theatre, 17 July–7 August 1990 (co-production with Arbour Theatre Company, Peterborough) and Theatre Orangeville, Orangeville Town Hall Opera House, 16–30 September 1997.

Bice, Megan

1988. *Thomas John (Tom) Thomson: Six Sketches* (exhibition catalogue). Kleinburg: McMichael Canadian Art Collection, 1988.

Bice, Ralph

1977a. "Along the Trail/About Tom Thomson." *Almaguin News* (Burk's Falls, Ont.), 20 July 1977.

1977b. "Along the Trail/About Tom Thomson." *Almaguin News* (Burk's Falls, Ont.), 27 July 1977.

Bishop, Hunter

1979. *J.E.H. MacDonald: Sketchbook, 1915–1922*. Facsimile edition. Moonbeam, Ont.: Penumbra Press, 1979.

Bisson, Bruno

1988. "Une toile de Thomson dérobée au musée de Joliette." *La Presse* (Montreal), 5 July 1988.

Bogardi, Georges

1977. "Town Book Fails to Solve Enigma of Tom Thomson." *Montreal Daily Star*, 26 October 1977.

Boggs, Jean Sutherland

1969. "The National Gallery of Canada." *Canadian Art* 26, no. 1 (February 1969): 2–7.

1971. *The National Gallery of Canada*. Toronto: Oxford University Press, 1971.

Booth, David

1995. *Images of Nature: Canadian Poets and The Group of Seven*. Toronto: Kids Can Press, 1995.

Booth, Godfrey

1979. "Claremont Cottage Artist's Birthplace." *Toronto Star*, 10 July 1979.

Bordo, Jonathan

1992. "Jack Pine — Wilderness Sublime or the Erasure of the Aboriginal Presence from the Landscape." *Journal of Canadian Studies* 27, no. 4 (winter 1992–93): 98–128.

Boswell, Randy

1998. "Thomson's Algonquin." *Ottawa Citizen*, 16 August 1998.

Boulet, Roger

1982. *The Canadian Earth: Landscape Paintings by the Group of Seven*. Foreward by

A.J. Casson, biographies by Paul Duval. Toronto: Prentice-Hall, 1982.

Bourinot, Arthur S.

1954. *Tom Thomson and Other Poems*. Toronto: Ryerson Press, 1954.

Bradfield, Helen

1970. *Art Gallery of Ontario: The Canadian Collection*. Toronto: McGraw-Hill Company of Canada Limited, 1970.

Bridle, Augustus

1926. "Six Varieties of Canadian Pictures at Art Gallery." *Toronto Star Weekly*, 6 February 1926.

1934. "Massey's Canadiana Feature at Gallery." *Toronto Daily Star*, 7 December 1934.

1937a. "Thomson Paintings Here Next Week." *Toronto Daily Star*, 6 March 1937.

1937b. "Tom Thomson Show Attracts Hundreds." *Toronto Daily Star*, 15 March 1937.

1943. "Art Folk at Dinner Honor Trail Artist." *Toronto Daily Star*, 25 November 1943.

1947. "Music, Art, Drama." *Toronto Daily Star*, 12 July 1947.

Brieger, Peter G., Stephen Vickers and Frederick E. Winter

1964. *Art and Man: The Modern World*. Vol. 3. Toronto: Holt, Rinehart and Winston, 1964.

Brink, Andrew

1977. "Tom Thomson and the Personal Meaning of Landscape." *Copperfield: An Independent Canadian Literary Magazine of the Land and of the North* 6 (1977): 29–35.

Broomfield, George

1928. "Tom Thomson's Studio." *Saturday Night* 43, no. 34 (7 July 1928): 5.

Brown, Bill

1964. "This Art Was a Crime: Innocent Buyers Paid Thousands for Paintings They Thought Were the Work of Canada's Greats." *Weekend Magazine* 30 May 1964.

Brown, Eric

1917. "Landscape Art in Canada." In *Art of the British Empire Overseas*, ed. by Charles Holme, 3–38. London, Paris, New York: The Studio Ltd., 1917.

1922a. "The National Gallery of Canada: A Story of Struggle and Achievement in Establishing a Little-known Institution." *Arts & Decoration* (New York) 17, no. 1 (May 1922): 28–29, 62, 66.

1922b. "Tom Thomson." In *Special Exhibitions: Pictures and Sketches by Tom Thomson* (exhibition catalogue). Ottawa: National Gallery of Canada, 1922.

1926. With Fred R. Jacob. *A Portfolio of Canadian Art Reproducing Important Canadian Paintings by Cornelius Kreighoff, Otto R. Jacobi, Paul Kane, Daniel Fowler, William Brymner, Paul Peel, Blair Bruce, Frederick M. Bell-Smith, James Wilson Morrice and Tom Thomson*. Vol. 1. Toronto: Rous and Mann, Ltd., 1926.

1927a. "La jeune peinture canadienne." *L'Art et les artistes*, 21, no. 75 (March 1927): 181–95.

1927b. "Canadian Art in Paris." *Canadian Forum* 8, no. 84 (September 1927): 360–61.

1932. "Canada's National Painters." *Studio* 103, no. 471 (June 1932): 311–23.

Brown, Joy

1962. "Shack Full of Memories." *Weekend Magazine* 12, no. 30 (28 July 1962): 12–15.

Brown, Maud

1927. "Canadian Art in Paris." *Canadian Homes and Gardens* 4, no. 8 (August 1927): 20, 56.

1964. *Breaking Barriers: Eric Brown and the National Gallery*. Ottawa: Society for Art Publications, 1964.

Buchanan, Donald W.

1938. "The Story of Canadian Art." *Canadian Geographical Journal* 17, no. 6 (December 1938): 273–93.

1945. *Canadian Painters from Paul Kane to the Group of Seven*. Oxford & London: Phaidon Press, 1945.

1946. "Tom Thomson — Painter of the True North." *Canadian Geographical Journal* 33, no. 2 (August 1946): 98–100.

1947. "The Hart House Collection." *Canadian Art* 5, no. 2 (Christmas 1947): 63–67.

1950. *The Growth of Canadian Painting.* London and Toronto: Collins, 1950.

1951. "Canadian Painting Finds an Appreciative Public." *Culture* 12, no. 1 (1951): 51–55.

Buchholz, Garth

1998. "Curator's Novel Inspires Exhibit." *Winnipeg Free Press*, 20 June 1998.

Buckman, Edward

1937. "With Canadian Pioneers." *Magazine of Art* 30, no. 9 (September 1937): 568–71, 586–88.

Burant, Jim

1998. "Peleg Franklin Brownell and the Fine Arts in Ottawa." In *North by South: The Art of Peleg Franklin Brownell (1851–1946)*, (exhibition catalogue), 17–38. Ottawa: Ottawa Art Gallery, 1998.

Burgoyne, St. George

1937a. "Tom Thomson, Painter of the Wilds, Lost to Canadian Art 20 Years Ago." *Gazette* (Montreal), 25 September 1937.

1937b. "Late Tom Thomson and His Art Theme of Volume by A.H. Robson." *Gazette* (Montreal), 25 September 1937.

Burnett, David

1990. *Masterpieces of Canadian Art from the National Gallery of Canada.* Edmonton: Hurtig, 1990.

Burnside, Sharon

1976. "Book First on Thomson's Art." *Sun Times* (Owen Sound), 24 December 1976.

1977a. "Owen Sound Gallery Re-issues Stamps Designed by Thomson." *Sun Times* (Owen Sound), 7 April 1977.

1977b. "Gallery Ready for Dual Celebration." *Sun Times* (Owen Sound), 19 April 1977.

1977c. "Exhibit a Glowing Tribute." *Sun Times* (Owen Sound), 5 May 1977.

Burtch, Michael

1982. "At the Gallery." *Sault Star* (Sault Ste. Marie, Ont.) 10 July 1982.

Cameron, Ross Douglas

1998. " 'Our Ideal of an Artist': Tom Thomson, the Ideal of Manhood and the Creation of a National Icon

(1917–1947)." Master's thesis, Queen's University, Kingston, 1998.

Canada Business College

[1903]. *Canada's Greatest School of Business.* Chatham: Canada Business College, [1903].

Canadian Pulp and Paper Association

1954. *With Palette and Brush.* Montreal: Canadian Pulp and Paper Association, 1954.

Chadwick, Phil

1994. "Tom Thomson, Weatherman." *Outdoor Canada* 22, no. 5 (May 1994): 11.

Charlesworth, Hector

1914. "The R.C.A. Exhibition." *Saturday Night* 28, no. 7 (28 November 1914): 4.

1915. "O.S.A.'s Exhibition, 1915." *Saturday Night* 28, no. 23 (20 March 1915): 4.

1916. "Pictures That Can Be Heard: A Survey of the Ontario Society of Artists' Exhibition." *Saturday Night* 29, no. 23 (18 March 1916): 5, 11.

1922. "The National Gallery a National Reproach." *Saturday Night* 38, no. 6 (9 December 1922): 3.

Chassé, Charles

1927. "L'Exposition Canadienne à Paris." *Le Figaro Hebdomadaire* (Paris), 13 April 1927.

Chauvin, Jean

1929. "L'Atelier du célèbre peintre canadien Tom Thomson." *La revue populaire* 22, no. 1 (January 1929): 28.

Chavance, René

1927. "Une exposition d'art canadien s'ouvre demain au Jeu de Paume." *Liberté* (Paris), 11 April 1927.

Cherry, Zena

1969. "Out of a Jumble of Unsigned Prints, a Tom Thomson Appears." *Globe and Mail* (Toronto), 11 August 1969.

Cline, Beverly Fink

1980. "Novelist's Ideas on Tom Thomson's Last Years." *London Free Press* (Ont.), 14 June 1980.

Cohen, Matt

1980. "The Daughter Tom Thomson Never Had." *Saturday Night* 95, no. 6 (July/August 1980): 57–58.

Cole, Douglas

1978. "Artists, Patrons and the Public: An Enquiry into the Success of the Group of Seven." *Journal of Canadian Studies* 13, no. 2 (summer 1978): 69–78.

Colgate, William

1943. *Canadian Art: Its Origin and Development.* Toronto: Ryerson Press, 1943. Reprint Toronto: Ryerson Press, 1967.

1945. "Tom Thomson, Artist, Knew Wind Direction." *Globe and Mail* (Toronto), 24 April 1945.

1946a. "Tom Thomson Writes to His Artist Friends." *Saturday Night* 62, no. 10 (9 November 1946): 20.

1946b. *Two Letters of Tom Thomson, 1915 & 1916.* Weston, Ont.: The Old Rectory Press, 1946.

Collins, Larry

1964. "3 Years' Total for Two in Art Fraud." *Telegram* (Toronto), 5 March 1964.

Comfort, Charles

1951a. "Georgian Bay Legacy." *Canadian Art* 8, no. 3 (spring 1951): 106–109.

1951b. "Canadian Art on an Island in Georgian Bay." *Ottawa Journal*, 25 April 1951.

Conoley, Ken

1977. "Canada Salutes Artist." *Montreal Daily Star*, 14 May 1977.

Cook, Ramsay

1974. "Landscape Painting and National Sentiment in Canada." *Historical Reflections* 1, no. 2 (winter 1974): 263–83.

Corbeil, Marie-Claude, Elizabeth A. Moffatt, P. Jane Sirois and Kris M. Legate

2000. "The Materials and Techniques of Tom Thomson." *Journal of the Canadian Association for Conservation* 25 (2000): 3–10

Couëlle, Jennifer

1996. "Le précurseur du Groupe des Sept." *Le Devoir* (Montreal), 22 June 1996.

Crawford, Lenore

1963. "16 Canadian Paintings Out of 75 Termed Fakes." *London Free Press* (Ont.), 1 February 1963.

1970. "Looking at Art: Individualistic

Tribute to Tom Thomson." *London Free Press* (Ont.), 28 February 1970.

Crew, Robert

1990. "Series of Sketches Fail to Form Picture of Thomson's Life." *Toronto Star*, 22 July 1990.

Cummings, A.C.

1938. "What Britain's Critics Think of Canada's Art." *Ottawa Evening Citizen*, 29 October 1938.

Curf, Rod

1980. "On the Trail of Tom Thomson." *Kingston Whig-Standard*, 16 May 1980.

Currie, Rod

1980. "Thomson Still a Mystery." *Record* (Kitchener-Waterloo), 17 May 1980.

Dalrymple, A.J.

1928. "Tom Thompson [sic] Treasures Discovered." *Toronto Star Weekly*, 11 May 1928.

Dane, William

1956. "Jaycees Plan Living Memorial to Honor Artist Tom Thomson." *Victoria Times*, 10 March 1956.

Davidson, Margaret F.

1969. "A New Approach to the Group of Seven." *Journal of Canadian Studies* 4, no. 4 (November 1969): 9–16.

Davidson, T. Arthur

1956. "Tom Thomson Grew to Manhood in Leith Area and Later Became Canada's Best Known Painter." *Sun Times* (Owen Sound), 21 January 1956.

1971a. "Out of the past . . . " *Sun Times* (Owen Sound), 17 May 1971.

1971b. "Out of the past . . . " *Sun Times* (Owen Sound), 22 May 1971.

Davies, Blodwen

1930a. *Paddle and Palette: The Story of Tom Thomson.* With Notes on Pictures by Arthur Lismer. Toronto: Ryerson Press, 1930.

1930b. "Canoe of Birch Bark to Carry Rare Tribute." *Toronto Star Weekly*, 26 July 1930.

1930c. "Young Pirates Hunt Late Artist's Canoe." *Toronto Star Weekly*, 9 August 1930.

1930d. "Tom Thomson and the Canadian Mood." *New Outlook* 6, no. 35

(27 August 1930): 826, 836. Reprinted in *Collingwood News*, 11 October 1930.

1935. *A Study of Tom Thomson: The Story of a Man Who Looked for Beauty and for Truth in the Wilderness*. Toronto: The Discus Press, 1935.

1937. "Art and Esotericism in Canada." *Canadian Theosophist* 18, no. 2 (April 1937): 57–58.

1949. "Tom Thomson's Farm Homes." *Farmer's Magazine* April 1949: 20–21, 33.

1967. *Tom Thomson: The Story of a Man Who Looked for Beauty and for Truth in the Wilderness*. Foreword by A.Y. Jackson; sketches by Arthur Lismer. Vancouver: Mitchell Press Limited, 1967.

Davis, Ann

1971. *A Study of the Group of Seven*. Ottawa: National Historic Sites Service, 1971.

1973a. "An Apprehended Vision: The Philosophy of the Group of Seven." Ph.D. diss., York University, 1973.

1973b. "The Wembley Controversy in Canadian Art." *Canadian Historical Review* 54, no. 1 (March 1973): 48–74.

1998. "Thomson, Thomas John (Tom)." In *Dictionary of Canadian Biography: Vol. 14, 1911–1920*, 995–1000. Toronto: University of Toronto Press, 1998.

Davis, Mary Elizabeth

1939. "Tom Thomson." *Ottawa Citizen*, 8 July 1939.

Deacon, William Arthur

1936a. "Famed Canvases Found in Cabin." *Mail and Empire* (Toronto) 9 November 1936.

1936b. "Biography Hints Artist Murdered." *Globe and Mail* (Toronto), 1 December 1936.

Delaplante, Don

1956. "Body May End Riddle of Tom Thomson Death." *Globe and Mail* (Toronto), 10 October 1956.

Dempsey, Lotta

1971. "About Town." *Toronto Star*, 9 November 1971.

1972. "Tom Thomson Actor's Life Study/ TV Series Probes Artist's Strange Death." *Toronto Star*, 24 November 1972.

Denoinville, G.

1927. "Exposition d'art canadien." *Le Journal des Arts* (Paris), 30 April 1927.

Department of Citizenship and Immigration

1957. *The Arts in Canada*. Canadian Citizenship Series Pamphlet No. 6. Ottawa: Department of Citizenship and Immigration, 1957.

Devorski, Lorraine

1986. *Tom Thomson: The Man and His Legend*. Ottawa: Canadian Library Association, 1986.

Dexter, Gail

1967. "Record Price Paid Here for Tom Thomson Sketch." *Toronto Daily Star*, 18 May 1967.

1968. "Tom Thomson's Dollar-a-Month Shack Becomes a Group of Seven Shrine." *Toronto Daily Star*, 1 June 1968.

Dick, Stewart

1928. "The National Gallery of Canada: Tom Thomson." *Saturday Night* 43, no. 42 (1 September 1928): 5.

1929. "East and West." *Saturday Night* 44, no. 12 (2 February 1929): 5.

1932. "Canadian Landscape of To-Day." *Apollo* 15, no. 90 (June 1932): 279–82.

Dixon, M.R.

1956. "Buried Tom Thomson at Boat Lake in 1917 Denies Sign of Foul Play'" *Sun Times* (Owen Sound), 17 October 1956.

Dolenc, Rafaela

1971. "The Tom Thomson Mystery: An Interview with the Author." *Time*, 22 January 1971: 72–73.

Drysdale, Susan

1972. "Canadian Landscape Artists." *Christian Science Monitor*, 24 August 1972.

D.S.M.

1932. "All Canadian Artists' Pictures on Exhibition." *Vancouver Sun*, 11 May 1932.

Duchesne, André

1996. "Le paradis, selon Tom Thomson." *La Presse* (Montreal), 22 April 1996.

Dulmage, Paul

1963. "Toronto Shrine to Receive Donation." *Swift Current Sun* (Sask.), 6 September 1963.

Dumas, Paul

1972. "Exposition rétrospective de Tom Thomson." *L'Information medicale et paramedicale* (Montreal), (6 June 1972): 48–49.

Dunn, Scott

1996a. "Digging Up a Mystery." *Sun Times* (Owen Sound), 20 August 1996.

1996b. "Thomson Investigation Up in the Air." *Sun Times* (Owen Sound), 21 August 1996.

Duval, Paul

1954. "Tom Thomson's Cabin-by-the-Subway." *Mayfair* 28, no. 12 (December 1954): 51.

1961. "Tumbledown Shack — Or Art Shrine?" *Telegram* (Toronto), 6 May 1961.

1967. *The McMichael Conservation Collection: A Catalogue of Outstanding Work by Tom Thomson and the Group of Seven*. Toronto: Clarke, Irwin, 1967.

1970. *Canadian Art: Vital Decades, McMichael Conservation Collection*. Toronto, Vancouver: Clarke, Irwin & Company Limited, 1970.

1973. *A Vision of Canada: McMichael Canadian Collection*. Toronto: Sampson Matthews Limited, 1973.

1990. *Canadian Impressionism*. Toronto, London: McClelland and Stewart, 1990.

Edinborough, Arnold

1976a. "Want to (Help) Buy a Tom Thomson? Here's Your Chance." *Financial Post*, 10 April 1976.

1976b. "Garfield Weston Makes Gift of 'Waterfall' to Gallery." *Financial Post*, 19 June 1976.

Edmison, Alex

1964. "Interview with Mark Robinson." Transcript from a 1952 tape recording at Canoe Lake, 11 September 1964, NGC Library.

E.H.L.

1977. "The Life of Canadian Painter Recounted in Handsome Book." *Standard* (St. Catharines), 19 December 1977.

Elder, R. Bruce

1995. "The Canadian Æsthetic." *Literary Review of Canada* 4, no. 3 (March 1995): 13–16.

Emery, Tony

1967. "Group Needs Thomson Nearby to Shed Light on Energies." *Victoria Times*, 13 May 1967.

Engel, Marian

1980. "Shorelines." *Globe and Mail* (Toronto), 10 May 1980.

Engel, Walter

1972. "The Art of Tom Thomson." *Art Magazine* 3, no. 10 (winter 1972): 8–9.

Fairbairn, Margaret L.

1913. "Younger Painters Dominate this Time at O.S.A. Exhibition" (signed M.L.A.F.). *Toronto Daily Star*, 12 April 1913.

1916. "Some Pictures at the Art Gallery" (signed M.L.A.F.). *Toronto Daily Star*, 11 March 1916.

1920. "Memorial Exhibition to Artist of North" (signed M.L.F.). *Toronto Daily Star*, 18 February 1920.

1921. "Tom Thomson Pleases with Canadian Scenes" (signed M.L.F.). *Toronto Daily Star*, 22 January 1921.

Fairley, Barker

1919a. "Algonquin and Algoma" (signed B.F.). *Rebel* 3, no. 6 (April 1919): 279–82.

1919b. "Canadian War Pictures." *Canadian Magazine* 54, no. 1 (November 1919): 3–11.

1920. "Tom Thomson and Others" (signed B.F.). *Rebel* 6, no. 6 (March 1920): 244–48.

1944. "Canadian Artists." *Canadian Affairs* 1, no. 22 (1 December 1944): 10–11.

1968. "Reviews." In *Review Canadian Books for Children* 2, no. 2 (spring 1968): 20.

1971. "Tom Thomson" (letter to the editor). *Globe and Mail* (Toronto), 11 November 1971.

Farr, Dorothy M.

1977. "Reproductions Outstanding." *Kingston Whig-Standard*, 17 December 1977.

1981. *J.W. Beatty, 1869–1941* (exhibition catalogue). Kingston: Agnes Etherington Art Centre, 1981.

Fegdal, Charles

1929. "Exposition Art Canadien — Musée

du Jeu de Paume." *Le Jour* (Paris), 29 May 1929.

Fenton, Terry

1978. "The Group of Seven." In *Modern Painting in Canada: A Survey of Major Movements in Twentieth Century Canadian Art* (exhibition catalogue), 15–21. Edmonton: Edmonton Art Gallery, 1978.

Fenton, Terry and Karen Wilkin

1978. *Modern Painting in Canada: Major Movements in Twentieth-Century Canadian Art*. Edmonton: Hurtig Publishers and Edmonton Art Gallery, 1978.

F. F.

1956. "Thomson Paintings on View." *Canadian Observer* (Sarnia, Ont.), 3 August 1956.

Ford, Arthur R.

1955. "Tom Thomson Fund Started." *London Free Press* (Ont.), 15 February, 1955.

1956a. "London Free Press Editor Writes of Tom Thomson." *Sun Times* (Owen Sound), 17 February 1956.

1956b. "The Fame of Tom Thomson." *Hamilton News*, 21 February 1956.

Forester Subscriber

1948. "Tom Thompson [sic] and One-Tree Island" (letter to the editor). *Huntsville Forester* (Ont.), 18 November 1948.

Forsey, William C.

1975. *The Ontario Community Collects: A Survey of Canadian Painting from 1766 to the Present* (exhibition catalogue). Toronto: Art Gallery of Ontario, 1975.

Francis, Daniel

1997. *National Dreams: Myth, Memory and Canadian History*. Vancouver: Arsenal Pulp Press, 1997.

Frank, Marion

1956. "Reminiscences of Tom Thomson." *New Frontiers* 5, no. 1 (spring 1956): 22–24.

Franklin, J.D.

1970. "How Did Thomson Die?" *Vancouver Sun*, 16 October 1970.

Frayne, Trent

1953. "The Rebel Painter of the Pine Woods." *Maclean's* 66, no. 13 (1 July 1953): 16–17, 30–33.

Frye, Northrop

1941. "Canadian and Colonial Painting." *Canadian Forum* 20, no. 242 (March 1941): 377–78.

Fulford, Robert

1962. "Canadian Art's Biggest Mystery: Where Do All Those Fakes Come From?" *Maclean's* 75, no. 25 (15 December 1962): 69–70.

1964. "On Art Frauds: What a Smart Cop Found Out about Some Odd 'Group of Seven.'" *Maclean's* 77, no. 7 (4 April 1964): 49.

1971. "Giving Us a Sense of Ourselves." *Toronto Daily Star*. 10 July 1971.

1997. "Tom Thomson Film a Canvas for Beliefs, Ideas of the 1970s." *Globe and Mail* (Toronto), 30 July 1997.

Gadsby, H.F.

1913. "The Hot Mush School." *Toronto Daily Star*, 12 December 1913.

Gamester, George

1983. "Secret Thomson Sketch Is Revealed." *Toronto Daily Star*, 22 March 1983.

Gauslin, Lillian M.

1974. *From Paths to Planes: A Story of the Claremont Area*. Claremont, Ont.: Published by the author, 1974.

Ghent, Percy

1939. "Tom Thomson Gave Canada New Vision of Lakeland Glory." *Evening Telegram* (Toronto), 25 July 1939.

1940. "In the Spotlight: Some Memories of Tom Thomson's Art in Algonquin Park." *Evening Telegram* (Toronto), 20 August 1940.

1942. "Tom Thomson Sketch in Kitchener Home." *Evening Telegram* (Toronto), 20 June 1942.

1949. "Tom Thomson at Island Camp, Round Lake, November 1915." *Evening Telegram* (Toronto), 8 November 1949.

Gill, Audrey

1966. "Canada's Fake-Art Detectives Are as Busy as Ever." *Financial Post*, 23 April 1966.

Godsell, Patricia

1976. *Enjoying Canadian Painting*. Don Mills: General Publishing Co. Ltd., 1976.

Gosling, Mike

1970. "Judge Little's Book Explores Riddle Behind Artist's Death." *Brampton Daily Times and Conservator*, 5 September 1970.

Graham, Colin

1956. "Thomson Made Us See Nature of Our Land." *Victoria Times*, 17 March 1956.

Graham, John, W.

1971. "Thomson Exhibit a Rare Event." *Winnipeg Free Press*, 17 March 1971.

Graham, June

1969. "The Mystery of Tom Thomson." *C.B.C. Times* 21, no. 32 (1–7 February 1969): 2–3.

Grande, John K.

1981. "Tom McLean: A Canadian Art Enigma." *Antiques and Art* 7, no, 6 (June 1981): 32–34.

1999. "Tom Thomson." *Vie des Arts* 44, no. 176 (Autumn 1999): 69.

Grant, Judith

1970. "Tom Thomson: The Algonquin Years." *Canadian Forum* 49, no. 590 (March 1970): 296

Grantham, Ronald G.

1968. "Artist Suddenly Saw What Canada Is Like." *Ottawa Citizen*, 13 January 1968.

1969. "New Material Fills Out Life of Great Canadian Painter" (signed R.G.). *Ottawa Citizen*, 22 November 1969.

Grayson, E.V.K

1929. *Picture Appreciation for the Elementary School*. Toronto: J.M. Dent and Sons Ltd., 1929.

1932. *Picture Appreciation for the High School*. Toronto: J.M. Dent and Sons Ltd., 1932.

Grier, Edmund Wyly

1926. With A.Y. Jackson. "Two Views of Canadian Art: Addresses by Mr. Wyly Grier, R.C.A. O.S.A. and A.Y. Jackson, R.C.A., O.S.A. before the Empire Club of Toronto, February 25, 1925." In *Empire Club of Canada — Addresses Delivered to the Members during the Year 1925*, 97–113. Toronto: McCoomb Press, 1926.

Groves, Naomi Jackson

1968. *AY's Canada*. Toronto and Vancouver: Clarke, Irwin & Company Ltd., 1968.

Gubasta, Dolores

1991. "He Kept Those Home Fires Burning." *Cottage Life* 4, no. 1 (March 1991): 17.

Guillet, Edwin C.

1944. "The Death of Tom Thomson, Canadian Artist: A Study of the Evidence at the Coroner's Inquest, 1917." *Famous Canadian Trials*. vol. 10, 1944, typescript in Library of Parliament, Ottawa.

Haines, Max

1975. "Where Is Tom Thomson's Body?" *Toronto Sunday Sun*, 18 May 1975.

Hale, Barrie

1967. "Thomson Fetches $15,250 at Auction." *Telegram* (Toronto), 18 May 1967.

1969. "After 50 years, the First Public Showing of the Group of Seven's Earliest Work." *Canadian Magazine*, 18 January 1969.

Hamilton, Velma

1971. "Tom Thomson 1877–1917." *Haliburton County Echo*, 25 November 1971.

Hamilton Club

[1973]. *100th Anniversary of the Hamilton Club, 1873–1973*. Hamilton: [The Club, 1973.]

Hammond, M.O.

1930a. "Leading Canadian Artists: J.W. Beatty, R.C.A." *Globe* (Toronto), 2 August 1930.

1930b. "Leading Canadian Artists: A.Y. Jackson." *Globe* (Toronto), 23 August 1930.

Harper, J. Russell

1955. *Canadian Paintings in Hart House*. Toronto: University of Toronto Press, 1955.

1962. "Three Centuries of Canadian Painting." *Canadian Art* 19, no. 6 (November/December 1962): 405–52.

1966. *Painting in Canada: A History*. Toronto: University of Toronto Press, 1966. 2nd Edition, Toronto: University of Toronto Press, 1977.

Harris, Frank Mann

1926. "Feeding Our Artistic Soul." *Toronto Star Weekly*, 13 February 1926.

Harris, Lawren

1926. "Review of the Toronto Art Gallery Opening." *Canadian Bookman* 8, no. 2 (February 1926): 46–47.

1948. "The Group of Seven in Canadian History." In *The Canadian Historical Society, Report of the Annual Meeting Held at Victoria and Vancouver June 16–19, 1948*, ed. R.A. Preston, 28–38. Toronto: University of Toronto Press,1948.

1954. "The Story of the Group of Seven." In *Group of Seven* (exhibition catalogue), 9–12. Vancouver: Vancouver Art Gallery, 1954.

1964. *The Story of the Group of Seven*. Toronto: Rous & Mann, 1964.

Harris, William G.

1964. *The Group of Seven and Lake Superior* (exhibition catalogue). With comments by A.Y. Jackson. Port Arthur, Ont.: Lakehead College, University Centre, 1964.

Harrison, S. Frances

1920. "A Little of Everything: The Tom Thomson Exhibition" (signed Seranus). *Toronto Daily Star*, 26 February 1920.

1923. "To Tom Thomson." *Saturday Night* 38, no. 13 (3 February 1923): 35.

Harvey, Eleanor Jones

1999. "The Artistic Conquest of the Far North." In *Cosmos: From Romanticism to Avant-garde* (exhibition catalogue), 108–13. Montreal: The Montreal Museum of Fine Arts, 1999.

2000. "The Artistic Conquest of the Far North." In *Cosmos: From Goya to de Chirico, from Friedrich to Kiefer: Art in Pursuit of the Infinite* (exhibition catalogue), 65–71. Milan: Bompiani, 2000.

Hedley, Dr. R.W.

1955. "Canadian Masterpieces by Thomson on Display." *Edmonton Journal*, 10 November 1955.

Henry, Bill

1996. "Art Gallery to Unveil New Thomson Acquisitions." *Sun Times* (Owen Sound), 4 October 1996.

Henry, Lorne James

1950. *Canadians: A Book of Biographies*. Toronto: Longmans, Green, 1950.

Heward, Burt

1980. "Curious Novel Deepens Tom Thomson Mystery." *Ottawa Citizen*, 19 April 1980.

Hill, Charles C.

1995. *The Group of Seven: Art for a Nation* (exhibition catalogue). Ottawa: National Gallery of Canada, Toronto: McClelland and Stewart Inc., 1995.

Hind, C. Lewis

1924. "Art and Artists: Canadian Landscape Painters at Wembley." *The International Interpreter* (New York) 3, no. 8 (24 May 1924): 249–50.

Holubizky, Ihor

1998. "Up North." *Art/Text* 61 (May–July 1998): 83–84.

Hoover, Dorothy

1948. *J.W. Beatty*. Toronto: Ryerson, 1948.

Hossack, Lesma

1970. "Algonquin Park Cruise Following Tom Thomson Recalls Artist's Mysterious Death." *Globe and Mail* (Toronto), 23 May 1970.

Housser, Bess

1924. "In the Realm of Art." *Canadian Bookman* 6, no. 8 (August 1924): 185.

1926. In the Realm of Art." *Canadian Bookman* 8, no. 1 (January 1926): 33.

Housser, Frederick Broughton

1926. *A Canadian Art Movement: The Story of the Group of Seven*. Toronto: The Macmillan Company of Canada Limited, 1926.

Hubbard, R.H.

1954 "The National Movement in Canadian Painting". In *Group of Seven* (exhibition catalogue), 13–17. Vancouver: Vancouver Art Gallery, 1954.

1960a. *An Anthology of Canadian Art*. Toronto: Oxford University Press, 1960.

1960b. *National Gallery of Canada, Catalogue of Paintings and Sculpture, Vol. III: Canadian School*. Ottawa, Toronto: University of Toronto Press, 1960.

1962. *The Gallery of Canadian Art: 2 Tom Thomson*. [Toronto]: Society For Art Publications/McClelland and Stewart Limited, 1962.

1963. *The Development of Canadian Art*. Ottawa: The National Gallery of Canada, 1963.

1968. *Vincent Massey Bequest: The Canadian Paintings* (exhibition catalogue). Ottawa: National Gallery of Canada, 1968.

1973. "Landscape Painting in Canada." In *Canadian Landscape Painting 1670–1930: The Artist and The Land* (exhibition catalogue), 5–32. Madison, Wisconsin: University of Wisconsin Press, 1973.

Hubbard, R.H. and J.R. Ostiguy

1967. *Three Hundred Years of Canadian Art* (exhibition catalogue). Ottawa: National Gallery of Canada, 1967.

Hunkin, Harry

1971. *There Is No Finality . . . A Story of the Group of Seven*. Toronto: Burns & MacEachern, 1971. 2nd ed. *A Story of the Group of Seven*. Toronto: McGraw-Hill Ryerson, 1976. 3rd ed., *The Group of Seven: Canada's Great Landscape Painters*. Edinburgh: P. Harris Publishing, 1979.

Hunter, Andrew

1997. *Up North: A Northern Ontario Tragedy*. Owen Sound: Thomson Books, 1997.

2001. *Stand by Your Man or Anne Crawford Hurn: My Life with Tom Thomson* (exhibition catalogue). Edmonton: Edmonton Art Gallery and Art Gallery of Hamilton, 2001.

Hunter, Martin

1987. "Decking the Halls." *Canadian Art* 4, no. 3 (September 1987): 78–85.

Inglis, Grace

1987. "Tom Thomson Sketch a Christmas Highlight." *Hamilton Spectator*, 12 December 1987.

Israel, Callie

1971. "Riverside Public Library." *Riverside News* (Ont.), 27 January 1971.

J.A.A.

1927. "Art." *Canadian Bookman* 9, no. 6 (June 1927): 184.

Jackson, A.Y.

1919. "Foreword. " In *Catalogue of an Exhibition of Paintings by the Late Tom Thomson* (exhibition catalogue). Montreal: The Arts Club, 1919.

1926. "Art in Toronto." *Canadian Forum* 6, no. 66 (February 1926): 180–81.

1933. "J.E.H. MacDonald." *The Canadian Forum* 13, no. 148 (January 1933): 136–38.

1943. "Dr. MacCallum, Loyal Friend of Art." *Saturday Night* 59, no. 14 (11 December 1943): 19.

1951. "The Origin of the Group of Seven." In *Highflight*, ed. J.R. McIntosh, 154–66. Toronto: Copp Clark, 1951.

1954. With Leslie F. Hannon. "From Rebel Dauber to Renowned Painter: A Self-portrait of A.Y. Jackson." *Mayfair* 28, no. 9 (September 1954): 27–29, 58, 61–63.

1958. *A Painter's Country: The Autobiography of A.Y. Jackson*. Toronto: Clarke, Irwin & Co., 1958. Revised edition, 1967.

Jackson, H.B.

1912. "A Camping Trip in the Algonquin National Park" (unsigned). *Toronto Sunday World* , 11 August 1912.

Jacob, Fred R.

1922. "How Canadian Art Got Its Real Start." *Toronto Sunday World*, 9 April 1922.

1927. "Christmas Cards with Canadian Atmosphere." *Canadian Homes and Gardens* 14, no. 12 (December 1927): 34–35, 64.

J.E.S.

1914. "Studio-Talk: Toronto." *The Studio* 62, no. 255 (July 1914): 146–47.

Johnson, Pat

1968. "Unravelling the 50-Year Mystery of Tom's death." *Telegram* (Toronto), 9 November 1968.

1969. "Was Tom Thomson Murdered?" *Telegram TV Weekly* (Toronto), 31 January 1969.

Jones, Arnie

1957. "Time Out: A Tribute to Thomson." *Sun Times* (Owen Sound), 21 June 1957.

Jones, Donald

1985. "One Doctor with the Saving Grace." *Toronto Star*, 21 December 1985.

Kahn, Gustave

1927a. "Les Beaux-Arts." *Le Quotidien* (Paris?), 14 April 1927.

1927b. "L'Exposition de l'art Canadien,

Musée du Jeu de Paume." *Mercure de France*, 1 May 1927.

Kamienski, Jan
1972. "A Grandstand View of the Old Canadian North." *Winnipeg Tribune*, 26 February 1972.

Kates, Joanne
1986. "Painting the Wilderness." *New York Times*, 14 December 1986.

Kell, J.A.
1977. "Local Historian Gives Thomson Death Theory." *Sun Times* (Owen Sound), 16 July 1977.

Kelly, Ann
1975. "Ann Kelly." *Sun Times* (Owen Sound), 15 March 1975.
1977. "'Officially' Retired Organist Wilson Buzza, 74, a Storehouse of History." *Sun Times* (Owen Sound), 12 January 1977.

Kemsley, William Sr.
1979. "Elder of the Tribe: Tom Thomson." *Backpacker* 7, no. 5 (October/November 1979): 56–61.

Kent, Norman
1960. "Help Wanted." *American Artist* 24, no. 6 (June 1960): 10, 12.
1964. "Footnotes: The Cover" (signed N.K.). *American Artist* 28, no. 4 (April 1964): 4.

Kent, Peter
1964. "Big Art Swindle Involved Innocent Oakville Artist." *Oakville Daily Journal-Record*, 3 June 1964.

Kerr, Estelle M.
1916a. "At the Sign of the Maple." *Canadian Courier* 19, no. 17 (25 March 1916): 13.
1916b. "Bilingualism in Art." *Canadian Courier* 21, no. 3 (16 December 1916): 15.
1917. "French Impressionists and Others Seen at the Canadian National Exhibition." *Canadian Courier* 22, no. 16 (15 September 1917): 19, 26.

Kilbourn, Elizabeth
1966. *Great Canadian Painting: A Century of Art*. Toronto: Canadian Centennial Publishing Company, 1966.

King, Alan
1994. "Tom Thomson's Mysterious Death." *Ottawa Citizen*, 20 November 1994.

Kiyooka, Roy K.
1972. "Letters Purporting to Be about Tom Thomson." *artscanada* 29, no. 1 (February 1972): 25–34.

Konody, P.G.
1927. "Art and Artists." *Observer* (London), 24 April 1927.

Konrad, Don
1996. "Valley Sketches." *Pembroke Observer* (Ont.), 26 January 1996.

Kritzwiser, Kay
1965. "Get Advice, Collectors Urged." *Globe and Mail* (Toronto), 21 January 1965.
1967. "A Tribute to Thomson." *Globe and Mail* (Toronto), 12 August 1967.
1968. "A Weathered Shack with Memories of a Great Painter." *Globe and Mail* (Toronto), 3 June 1968.
1971. "Thomson: Myth Dispelled, Man Emerges." *Globe and Mail* (Toronto), 7 November 1971.
1977. "The Essential Tom Thomson." *Globe and Mail* (Toronto), 11 May 1977.

Kyle, Fergus
1913. "The Ontario Society of Artists." In *The Year Book of Canadian Art, 1913*, 183–89. Toronto: The Arts and Letters Club, 1913.

Lacroix, Laurier
1990. "Ombres Portées: Notes sur le paysage canadien avant le Groupe des Sept." *Journal of Canadian Art History* 13, no. 1 (1990): 7–24.

Laing, G. Blair
1979. *Memoirs of an Art Dealer. Vol. 1*. Toronto: McClelland and Stewart, 1979.
1982. *Memoirs of an Art Dealer. Vol. 2*. Toronto: McClelland and Stewart, 1982.

Lambert, Richard S.
1947. *The Adventure of Canadian Painting*. Toronto: McClelland and Stewart, 1947.

Landry, Pierre
1990. *The MacCallum-Jackman Cottage Mural Paintings*. Ottawa: National Gallery of Canada, 1990.

LaRue, Gilbert
1916. "Au salon de peinture." *L'Autorité* (Montreal), 25 November 1916.

Laverty, Kathleen
1998. "Every Picture Tells a (Canadian) Story/The Jack Pine by Tom Thomson." *Vancouver Sun*, 5 September 1998.

Le Butt, Paul
1970. "Book Column." *Daily Gleaner* (Fredericton), 3 October 1970.

Lee, Rupert
1924. "Canadian Pictures at Wembley." *The Canadian Forum* 4, no. 47 (August 1924): 338–39.

Leech, Maggie
1977. "Thomson Book Records Artist's Unique Talent." *Columbian* (New Westminster, B.C.), 12 December 1977.

Legris, Marianne
1986. "Featured in Two Paintings by Thomson: Cockburn Family Pointer Boat City's Claim to Fame." *Pembroke Observer* (Ont.), 23 April 1986.

Lehmann, Joe
1974. "Tom Thomson Will Be Subject of Play by Toronto Group." *Sun Times* (Owen Sound), 8 January 1974.

Lewis, Wyndham
1946. "Canadian Nature and Its Painters." *The Listener* 36 (August 1946): 267–68. Reprinted in *Wyndham Lewis on Art: Collected Writings 1913–1956*. New York: Funk & Wagnalls, 1969.

Lince, Pat
1967. "Great Canucks: Tom Thomson Inspiration for Canada's Group of 7." *Georgetown Herald* (Ont.), 20 April 1967.

Lismer, Arthur
1926a. *A Short History of Painting: With a Note of Canadian Art*. Toronto: Art Gallery of Toronto, 1926.
1926b. "The Art Gallery of Toronto." *The Journal, Royal Architectural Institute of Canada* 3, no. 2 (March/April 1926): 65–72.
1929. "Art Appreciation." In *Year Book of the Arts in Canada, 1928–1929*, ed. Bertram Brooker, 57–71. Toronto: Macmillan, 1929.

1930. *Canadian Picture Study*. Toronto: Art Gallery of Toronto, 1930.
[1932]a. *Outline for Picture Study: The Jack Pine*. Series I, no. 1. Ottawa: National Gallery of Canada, [1932].
[1932]b. *Outline for Picture Study: The Northern River*. Series I, no. 2. Ottawa: National Gallery of Canada, [1932].
[1932]c. *Outline for Picture Study: Spring Ice*. Series I, no. 3. Ottawa: National Gallery of Canada, [1932].
1934. "The West Wind." *McMaster Monthly* 43, no. 4 (January 1934): 163–64.
1940. *Canadian Picture Study*. Toronto: Art Gallery of Toronto, 1940.
1947. "Tom Thomson 1877–1917: A Tribute to a Canadian Painter." *Canadian Art* 5, no. 2 (Christmas 1947): 59–62. Reprinted in *Canadian Art* 38, no. 3–4 (March 1982): 31–33.
1954. "Tom Thomson (1877–1917): Canadian Painter." *The Education Record of the Province of Quebec* 80, no. 3 (July–September 1954): 170–75.

Lister, A.
1976. "Joyce Wieland." *Criteria* 2, no. 1 (February 1976): 15–17.

Little, Dr. R.P.
1955. "Some Recollections of Tom Thomson and Canoe Lake." *Culture* 16, no. 2 (June 1955): 200–208. Reprinted in William T. Little, *The Tom Thomson Mystery*. Toronto: McGraw-Hill, 1970.

Little, William T.
1970. *The Tom Thomson Mystery*. Toronto: McGraw-Hill, 1970.

Locke, George
1926. "Tribute to Tom Thomson, Artist." *Collingwood News* (Ont.), 20 February 1926.

Lockwood, Peggy
1970. "Claremont Past and Present." *The Bay News* (Pickering, Ont.), 25 November 1970.

Long, Charles
1999. "The Natural Gallery of Canada." *Cottage Life*, April/May 1999: 44–53, 114.

Lord, Barry
1974. *Painting in Canada: Towards a People's Art*. Toronto: NC Press, 1974.

Luppino, Tony
1999. "The Influence of Tom Thomson." *Globe and Mail* (Toronto), 1 September 1999.

Macbeth, Madge
1926. "The All-Canadian Exhibition of Paintings at Ottawa." *Saturday Night* 41, no. 17 (13 March 1926): 25.

MacCallum, H.R.
1933. "The Group of Seven: A Retrospect." *Queen's Quarterly* 40, no. 2 (May 1933): 242–52. Reprinted in *Imitation and Design and Other Essays by Reid MacCallum*, ed. William Bissett, 162–69. Toronto: University of Toronto Press, 1953.

MacCallum, J.M.
1918. "Tom Thomson: Painter of the North." *Canadian Magazine* 50, no. 5 (March 1918): 375–85. Reprinted in part in *Loan Exhibition of Works by Tom Thomson* (exhibition catalogue). Toronto: Mellors Galleries, 1937.

MacDonald, J.E.H.
1913. "The Hot Mush School in Rebuttal of H.F.G." *Toronto Daily Star*, 20 December 1913.
1917. "Landmark of Canadian Art." *Rebel* 2, no. 2 (November 1917): 45–50.
1919. "Below the Rapid" (signed J.M.). *Rebel* 4, no. 2 (November 1919): 66.

MacDonald, Thoreau
1944. *The Group of Seven*. Canadian Art Series. Toronto: Ryerson Press, 1944.

MacFarlane, M.A.
1948. "'West Wind' Approved for Thomson's Picture" (letter to the editor). *Globe and Mail* (Toronto), 28 April 1948.

MacGregor, Ron
1987. *Canadian Art: Building a Heritage*. Scarborough: Prentice-Hall Canada Inc., 1987.

MacGregor, Roy
1973. "The Great Canoe Lake Mystery." *Maclean's* 86, no. 9 (September 1973): 30–31, 44, 48–50.
1977. "The Legend: New Revelations on Tom Thomson's Art — And on His Mysterious Death." *The Canadian* (Toronto), 15 October 1977: 2–5, 7.
1980. *Shorelines: A Novel*. Toronto: McClelland and Stewart, 1980.
2000. "Thomson Would Still Be Impressed." *National Post* (Toronto), 22 February 2000.

MacHardy, Carolyn Wynne
1978. "The West Wind by Tom Thomson, 1877–1917." Master's thesis. University of British Columbia, 1978.
1999. "Inquiry into the Success of Tom Thomson's *The West Wind*." *University of Toronto Quarterly* 68, no. 3 (summer 1999): 768–89.

MacKay, Roderick, and William Reynolds
1993. *Algonquin*. Toronto: Stoddart, 1993.

MacLennan, Hugh
1949. "The Ten Greatest Canadians." *New Liberty* 26, no. 9 (November 1949): 7–13.

MacTavish, Newton
1925. *The Fine Arts in Canada*. Toronto: The MacMillan Company of Canada Limited, 1925. Reprinted Toronto: Coles Publishing Company, 1973.
1938. *Ars Longa*. Toronto: Ontario Publishing Co., 1938.

Madawaska Club
1923. *The Madawaska Club, Go-Home Bay, 1898–1923*. Toronto, 1923.

Mahoney, Jeff
1998. "Two Northern Deaths Transmuted into Art." *Hamilton Spectator*, 6 February 1998.

Malone, Judy
1977. "Tom Thomson Tribute Great, But Spoiled by Rhetoric." *London Free Press* (Ont.), 15 October 1977.

Marshall, John
1963. "Second Arrest in Metro Art Fraud Probe." *Telegram* (Toronto), 9 October 1963.

Martinsen, Hanna
1984. "The Scandinavian Impact on the Group of Seven's Vision of the Canadian Landscape." *Konsthistorisk Tidskrift* 53 (1984): 1–17.

Masse, Denis
1977. "Les timbres et leur histoire — Deux nouvelles esquisses de Thomson sur timbres." *La Presse* (Montreal), 21 May 1977.

Mathews, Robin
1977. "A Big Book on Tom Thomson." *Revue* (Ottawa), 20–26 October 1977.

Mathias, Philip
1989. "Is It or Isn't It an Authentic Thomson?" *Financial Post*, 10 October 1989.

Matthews, Ross M.
1976. "James Metcalfe MacCallum, BA, MD, CM (1860–1943)." *CMA Journal* 114, no. 3 (April 1976): 621–24.

Mays, John Bentley
1987. "What You Get Is Not Always What You See." *Globe and Mail* (Toronto), 22 August 1987.
1996a. "The Remains of the Day." *Globe and Mail* (Toronto), 24 August 1996.
1996b. "Body of Evidence Is on the Walls." *Globe and Mail* (Toronto), 23 November 1996.

McAree, J.V.
1947. "Happy Retirement Wished Dr. Mason." *Globe and Mail* (Toronto), 8 March 1947.

McCabe, Nora
1971. "3,000 at Tom Thomson Opening." *Toronto Daily Star*, 30 October 1971.

McCarthy, Pearl
1937a. "Art and Artists." *Globe and Mail* (Toronto), 15 March 1937.
1937b. "Throngs See Thomson Art." *Globe and Mail* (Toronto), 16 March 1937.
1941. "Art and Artists." *Globe and Mail* (Toronto). 4 January 1941.
1943a. "Gallery Dinner Honors Early Admirer of 'Group.'" *Globe and Mail* (Toronto), 25 November 1943.
1943b. "Thomson's Method Shown on Screen." *Globe and Mail* (Toronto), 27 November 1943.
1956. "Tom Thomson Memorial Planned." *Globe and Mail* (Toronto), 27 February 1956.

1962. "Young Couple Bequeath Art to Foundation." *Globe and Mail* (Toronto), 20 June 1962.

McCartney, Rob
1992. "Gallery Director Says Artist Was an Angry Man." *Sun Times* (Owen Sound), 20 March 1992.

McInnes, G.C.
1937a. "Art World." *Saturday Night* 52, no. 20 (20 March 1937): 9.
1937b. "Art of Canada." *Studio* 114, no. 533 (August 1937): 55–75.
1938. "Canadian Panorama in London." *Art News* 38, no. 2 (8 October 1938): 7–8, 20.
1939a. "World of Art: Thomson, MacDonald and Others." *Saturday Night* 54, no. 15 (11 February 1939): 24.
1939b. *A Short History of Canadian Art*. Toronto: MacMillan Company of Canada Limited, 1939.
1940. "Tom Thomson." *New World Illustrated* 1, no. 1 (March 1940): 27–28. Reprinted in *Owen Sound Times*, 1 March 1940.
1941. "Two Local Boys Made Good." *Saturday Night* 56, no. 18 (11 January 1941): 25.
1943. "The Canadian Artist and His Country." *Geographical Magazine* 16, no. 8 (December 1943): 396–407.
1950. *Canadian Art*. Toronto: MacMillan Company of Canada Ltd., 1950.

McInnes, Jacquie
1996. "The Mystery of Tom Thomson." *This Week*, 23 August 1996.

McLean, J.S.
1952. "On the Pleasures of Collecting Paintings." *Canadian Art* 10, no. 1 (autumn 1952): 3–7.

McLennan, Mary Louise
1931. *Children's Artist Friends*. Toronto: J.M. Dent & Sons, 1931.

McMichael Canadian Collection of Art
1978. *The Group of Seven and Tom Thomson: The McMichael Canadian Collection, Kleinburg, Ontario*. Kleinburg: McMichael Canadian Collection, 1978.

1989. *McMichael Canadian Art Collection, Twenty-fifth Anniversary Edition, 1965–1990.* Kleinburg: McMichael Canadian Art Collection; Toronto: McGraw-Hill Ryerson, 1989.

McMichael, Robert

1977. "But Sensationalism . . . Has Flawed It: New Book Written as Tribute to Thomson." *Midland Free Press* (Ont.), 11 November 1977.

1986. *One Man's Obsession.* Scarborough: Prentice-Hall Canada Inc., 1986.

McPherson, Hugo

1964. "The Resonance of Batterwood House." *Canadian Art* 21, no. 2 (March–April 1964): 96–103.

McRae, D.G.W.

1944. *The Arts and Crafts of Canada.* Toronto: MacMillan Company of Canada Ltd., 1944.

Meehan, Brian

1996. *George Thomson: Retrospective* (exhibition catalogue). Owen Sound: Tom Thomson Memorial Art Gallery, 1996.

Mellen, Peter

1970. *The Group of Seven.* Toronto, Montreal: McClelland and Stewart Ltd., 1970.

1978. *The Landmarks of Canadian Art.* Toronto: McClelland and Stewart Ltd., 1978.

1979. "Canada's Group of Seven." *Americas* 31, no. 10 (1979): 38–44.

Millard, Laura

1998. *Algonquin Memories: Tom Thomson in Algonquin Park* (exhibition catalogue). Owen Sound: Thomson Books, 1998.

Mitchell, Maggie

1987. *Tom Thomson (1877–1917)* (exhibition catalogue). Owen Sound: Tom Thomson Memorial Gallery and Museum of Fine Art, 1987.

Montagnes, Ian

1963. "The Hart House Collection of Canadian Art." *Canadian Art* 20, no. 4 (July–August 1963): 218–20.

Morriset, Gérard

1947. "L'influence française sur le goût au Canada." *Monde français* (Montreal, Paris) 5, no. 17 (February 1947): 233–41.

Morrison, A.

1977. "A Sense of Place." *Vanguard* 6, no. 9 (December 1977): 17–18.

Mortimer-Lamb, Harold

1915. "Canadian Artists and the War." *The Studio* 65, no. 270 (September 1915): 259–64.

1917. "The Thirty-eighth Exhibition of the Royal Canadian Academy of Arts." *The Studio* 70, no. 287 (February 1917): 30–39.

1919. "Studio Talk: Montreal." *The Studio* 77, no. 316 (July 1919): 119–26.

Moss, Kathleen H.

1947. "Painter of the Northland." *Ottawa Evening Citizen,* 17 July 1947.

Mulligan, H.A.

1937. "Canada's National Painter." *Canadian Comment* 6, no. 4 (April 1937): 18.

Munnings, Gladys

1987. *Seven Plus One: Tom Thomson and the Group of Seven.* Newmarket, Ont.: Quaker Press, 1987.

Murray, Joan

1971. *The Art of Tom Thomson* (exhibition catalogue). Toronto: Art Gallery of Ontario, 1971.

1972. "A Thomson Retrospective." *Winnipeg Free Press,* 29 January 1972.

1978. "The Artist's View: The Tom Thomson Mystique." *artfocus* in *artmagazine* 37, no. 9 (March–April 1978): 2–5.

1984. *The Best of the Group of Seven.* Essay by Lawren Harris. Edmonton: Hurtig, 1984. Reprinted Toronto: McClelland & Stewart, 1993. Reprinted in 1994.

1985. "Another Connection" (letter to the editor). *Oshawa Times,* 20 March 1985.

1986a. *The Best of Tom Thomson.* Edmonton: Hurtig, 1986.

1986b. "Tom Thomson." In *The Advent of Modernism: Post-Impressionism and North American Art, 1900–1918* (exhibition catalogue), 166–69. Atlanta: High Museum of Art, 1986.

1989. "The Mysteries of The West Wind.'" *Art Impressions* 5, no. 1 (spring 1989): 22–24, 26.

1990. "Following the Arts: Carmichael's Triumph?" *Journal of Canadian Studies* 25, no. 2 (summer 1990): 155–59.

1991. "The World of Tom Thomson." *Journal of Canadian Studies* 26, no. 3 (fall 1991): 5–15.

1994a. *Tom Thomson: The Last Spring.* Toronto, Oxford: Dundurn Press, 1994.

1994b. *Northern Lights: Masterpieces of Tom Thomson and the Group of Seven.* Toronto: Key Porter Books Limited, 1994.

1995. "The Many Trees of 'The West Wind.'" *Art Impressions* 2 (summer 1995): 50–52, 62.

1996a. *Confessions of a Curator: Adventures in Canadian Art.* Toronto, Oxford: Dundurn Press, 1996.

1996b. *Tom Thomson: A Sketchbook.* Brampton, Ont.: Art Gallery of Peel, 1996.

1998. *Tom Thomson: Design for a Canadian Hero.* Toronto, Oxford: Dundurn Press, 1998.

1999a. *Canadian Art in the Twentieth Century.* Toronto, Oxford: Dundurn Press, 1999.

1999b. *Tom Thomson: Trees.* Toronto: McArthur & Company, 1999.

1999c. "Tom Thomson: Naturalist-Artist." *The Naturalist* (Durham, Ont.) 45, no. 5 (fall 1999), n.p.

2001. *The Birth of the Modern: Post Impressionism in Canadian Art, c. 1900–1920* (exhibition catalogue). Oshawa: Robert McLaughlin Gallery, 2001.

Nasby, Judith M.

1980. *The University of Guelph Art Collection: A Catalogue of Paintings, Drawings, Prints and Sculpture.* Guelph: University of Guelph, 1980.

Nasgaard, Roald

1984. *The Mystic North: Symbolist Landscape Painting in Northern Europe and North America 1890–1940* (exhibition catalogue). Toronto, Buffalo, London: Art Gallery of Ontario and University of Toronto Press, 1984.

National Gallery of Canada

See under NGC.

Newlands, Anne

1995. *The Group of Seven and Tom Thomson: An Introduction.* Willowdale, Ont., Buffalo, New York: Firefly Books, 1995.

Newton, Eric

1939. "Canadian Art through English Eyes." *The Canadian Forum* 18, no. 217 (February 1939): 344–45.

NGC (National Gallery of Canada)

[1924]a. *A Portfolio of Pictures from the Canadian Section of Fine Arts, British Empire Exhibition, London, 1924.* [Ottawa: National Gallery of Canada, 1924.]

1924b. *Press Comments on the Canadian Section of Fine Arts, British Empire Exhibition.* [Ottawa: National Gallery of Canada], 1924.

[1926]. *Press Comments on the Canadian Section of Fine Arts, British Empire Exhibition, 1924–1925.* [Ottawa: National Gallery of Canada: 1926].

Northway, Mary L.

[1970]a. With J. Alex Edmison, J. Harry Ebbs and John W. Ebbs. *Nominigan: A Casual History.* [Toronto, 1970].

1970b. *Nominigan: The Early Years.* Toronto: University of Toronto, 1970.

Ontario Agricultural College

1926. *Unveiling of "The Drive," a Northern Ontario Landscape Painting by Tom Thomson in the War Memorial Hall, Friday Evening, January 8th, 1926.* Guelph: The College, 1926.

Ontario Society of Artists

See under OSA.

Oppé, Paul

1938. "Art-Canada Hits Back." *London Mercury* (Ont.), (Christmas 1938): 199–200.

Orton, Marlene

1977. "Thomson Tale Tops Despite Doomsayers." *Expositor* (Brantford), 10 December 1977.

OSA (Ontario Society of Artists)

Annual reports for the years 1914 to 1918.

Ostiguy, Jean-René

1971. *Un siècle de peinture canadienne, 1870–1970.* Quebec: Les Presses de l'Université Laval, 1971.

Oswald, Brad

2000. "WAG Raises $1.15 Million for Early Snow." *Winnipeg Free Press,* 25 May 2000.

Oughton, John
1987. "The Best of Tom Thomson." *Books in Canada* 16, no. 3 (April 1987): 23.

Owen Sound Junior Chamber of Commerce
1956. *Tom Thomson, 1877–1917.* Owen Sound: Tom Thomson Memorial Gallery and Museum of Fine Art, 1956.

Oxorn, Pearl
1977. "Cutting Through Myths Surrounding Tom Thomson." *Ottawa Journal,* 8 October 1977.

Palette (see Parker, J. Delisle)

Paillard, Louis
1927. "La peinture canadienne aux Tuileries." *Petit Journal* (Paris?), 10 April 1927.

Palk, Helen
1951. *The Book of Canadian Achievement.* Toronto: J.M. Dent & Sons, 1951.

Parker, J. Delisle
1956. "Tom Thomson Sketches, Pottery at UBC Gallery" (signed Palette). *Province* (Vancouver), 9 April 1956.

Pearce, Helen
1948. "Unique in Canada's Art Annals Are Owen Sound's Two Families, the Painting Thomsons, Johnsons." *Sun Times* (Owen Sound), 5 June 1948.

Peck, Robert McCracken
1989. "Seasons of the Canadian Soul." *International Wildlife* 19, no. 3 (May–June 1989): 44–51.

Perry, S.W.
1928. "Studies in Canadian Art: The West Wind by Tom Thomson." *School* 17, no. 3 (November 1928): 226–28.

Petrie, W.
1963. *Keoeeit.* New York: MacMillan, 1963.

Phillips, Walter J.
1982. "Tom Thompson [sic]," *Winnipeg Evening Tribune,* 25 May 1929. Reprinted in *Phillips in Print: The Selected Writings of Walter J. Phillips on Canadian Nature and Art,* ed. Maria Tippett and Douglas Cole, 72–73. Winnipeg: The Manitoba Record Society, 1982.

Pierens, Paul
1927. "L'exposition d'art canadien." *Journal des débats* (Paris), 11 April 1927.

Plewman, Charles F.
1972. "Reflections on the Passing of Tom Thomson." *Canadian Camping* 24, no. 2 (winter 1972): 6–9.

Poirier, Patricia
1988. "Art Thefts in Quebec Leave Police Baffled." *Globe and Mail* (Toronto), 1 July 1988.

Pollack, Jill
1990. "Canadian Art for the Tourist." *Vancouver Courier,* 27 June 1990.

Poulton, Ron
1976. A Sherlock Holmes of the Space Age." *Toronto Sun,* 22 February 1976.

Pratt, Florence
1968. "Thomson Sketch Highlight." *StarPhoenix* (Saskatoon), 4 May 1968.

Pringle, Gertrude
1926. "Tom Thomson, the Man, Painter of the Wilds, Was a Very Unique Individuality." *Saturday Night* 41, no. 21 (10 April 1926): 5.

Prokosh, Kevin
1989. "Rare Paintings to Make Debut in City." *Winnipeg Free Press,* 19 March 1989.

Purdie, James
1975. "The Best Tom Thomson Faker in the Whole World." *Globe and Mail* (Toronto), 12 July 1975.
1976. "Gallery Gets Major Thomson Work." *Globe and Mail* (Toronto), 17 June 1976.

Putman, Joyce
1991. *Seven Years with the Group of Seven.* Kingston: Quarry Press, 1991.

Pyper, C.B.
1937. "Master Painter Discovered 20 Years After His Death." *Evening Telegram* (Toronto), 13 March 1937.

Rainey, Ada
1930. "Art and Artists in Capital." *Washington Post,* 9 March 1930.

R.B.
1927. "Chronique des Arts." *L'Action française* (Paris), 14 April 1927.

R.B.M.
1926. "Local Artists Have Pictures Purchased to Be Hung in Canadian National Gallery." *Ottawa Journal,* 22 January 1926.

Reid, Dennis
1969. *The MacCallum Bequest of Paintings by Tom Thomson and Other Canadian Painters & the Mr. and Mrs. H.R. Jackman Gift of the Murals from the Late Dr. MacCallum's Cottage Painted by Some Members of the Group of Seven* (exhibition catalogue). Ottawa: The National Gallery of Canada, 1969.
1970. *The Group of Seven* (exhibition catalogue). Ottawa: The National Gallery of Canada, 1970.
1971. "Photographs by Tom Thomson." *Bulletin* 16 (1970). Ottawa: National Gallery of Canada for the Corporation of the National Museums of Canada, 1971.
1973. *A Concise History of Canadian Painting.* Toronto: Oxford University Press, 1973. 2nd ed. Toronto: Oxford University Press, 1988.
1975. *Tom Thomson: The Jack Pine.* Masterpieces in the National Gallery of Canada, 5. Ottawa: The Gallery for the Corporation of the National Museums of Canada, 1975.
1976. *The Jack Pine* (exhibition catalogue). Exploring the Collections Series. Ottawa: The National Gallery of Canada, 1976.
1985. With David Burnett. *Painting in Canada.* Ottawa: Secretary of State for External Affairs, Government of Canada, 1985.
1988. *Collector's Canada: Selections from a Toronto Private Collection* (exhibition catalogue). Toronto: Art Gallery of Ontario, 1988.

Reid, Robert
1994. "Innovative Musical Celebrates Life and Work of Tom Thomson," *Record* (Kitchener-Waterloo), 7 April 1994.

René-Jean
1927. "Devant l'exposition canadienne." *Comœdia* (Paris), 14 April 1927.

Reynolds, Nila
1979. "Blanche Linton Remembers Tom Thomson." *Early Canadian Life* (Milton, Ont.) 3, no. 1 (February 1979): 18–19.

Rhenish, Harold
2000. *Tom Thomson's Shack.* Vancouver: New Star Books, 2000.

Rhodes, Richard
1996. "Paddle: The Letter." *Canadian Art* 13, no. 3 (fall 1996): 106–107.

Richardson, Linda
1977. "Thomson Misconceptions Cleared." *Sault Star* (Sault Ste. Marie, Ont.), 10 December 1977.

Richmond, Leonard
1925. "Canadian Art at Wembley." *Studio* 89, no. 182 (January 1925): 16–24.

Ridley, Hilda
1934. "Art and Canadian Life." *Dalhousie Review* 14, no. 2 (July 1934): 214–20.

Robertson, John K.B.
1949. "Canadian Geography and Canadian Painting." *Canadian Geographic Journal* 39, no. 6 (December 1949): 262–73.

Robson, Albert H.
1932. *Canadian Landscape Painters.* Toronto: Ryerson Press, 1932.
1937. *Tom Thomson.* Canadian Art Series. Toronto: Ryerson Press, 1937.

Rodgers, Margaret
1995. "Touched by Sadness." *Art Impressions* 11, no. 2 (spring 1995): 62.

Rodgers, Philip
1972. "Summer Exhibition Opens at Confederation Centre." *Guardian* (Charlottetown), 3 July 1972.

Ross, Alan Henderson
1924. *Reminiscences of North Sydenham: A Retrospective Sketch of the Villages of Leith and Annan, Grey County, Ontario.* Owen Sound: Richardson, Bond & Wright, 1924. Reprinted *Reminiscences of North Sydenham: An Historical Sketch of Annan and Leith,* Owen Sound: [1991].

Ross, Val
1996. "Thomson Mystery Rekindled." *Globe and Mail* (Toronto), 22 August 1996.

Rossell, Leonard
19—. "Reminiscences of Grip, Members of the Group of Seven and Tom Thomson." Ottawa, [19–]. Typescript in the NGC Library.

Rowe, Mrs. John
1968. "At the Art Gallery: Tribute to Tom

Thomson." *Sun Times* (Owen Sound), 27 September 1968.

1969a. "At the Gallery: Was Thomson Murdered?" *Sun Times* (Owen Sound), 6 February 1969.

1969b. "At the Gallery: Thomson Film Innuendos." *Sun Times* (Owen Sound), 17 February 1969.

1969c. "At the Gallery: Private Fund." *Sun Times* (Owen Sound), 17 May 1969.

Russell, Francis

1946. "Canadian Wilderness Artist." *Christian Science Monitor*, 22 October 1946.

Rutter, Frank

1926. "Canadian Art at Manchester, England." *Christian Science Monitor*, 20 September 1926.

Sabean, John W.

1998. "The Thomson Family." *Pathmaster* (Pickering, Ont.) 1, no. 3 (spring 1998): 23.

St. Germain, Pat

2000. "Gallery Unveils Tom Thomson Prize After Pricey Tug-of-War." *Winnipeg Sun*, 25 May 2000.

Salinger, Jehanne Bietry

1930a. "Canadian Paintings in U.S. Earn Critics High Praise." *Province* (Vancouver), 10 March 1930.

1930b. "Canadian Art Is Applauded by United States Experts." *Toronto Star Weekly*, 15 March 1930.

1930c. "Peinture et littérature: L'exposition d'art canadien aux États-Unis." *La revue populaire* 23, no. 5 (May 1930): 6–9.

Saltmarche, Kenneth

1957. "Thomson Art in Willistead Show." *Windsor Star*, 5 October 1957.

1968. "Tom Thomson-Painter." *Windsor Star*, 6 January 1968.

1971. "Thomson: Great as His Legend." *Windsor Star*, 6 November 1971.

Saunders, Audrey

1947. *Algonquin Story*. Toronto: Department of Lands and Forest, 1947. Reprint, 1963.

Scott, Ian

1971. "Thomson at AGO." *The Varsity* (University of Toronto) 7, 12 November 1971.

Seranus (see Harrison, S. Frances)

Sharpe, Dr. Noble

1970. "The Canoe Lake Mystery." *Journal, Canadian Society of Forensic Science* 3, no. 2 (June 1970): 34–40.

Shaw, S. Bernard

1996. *Canoe Lake Algonquin Park: Tom Thomson and Other Mysteries*. Burnstown, Ont.: General Store Publishing House, 1996.

Shields, Alexis

1975. "Untitled Thomson Work Comes Home to Gallery." *Sun Times* (Owen Sound), 9 January 1975.

Shields, Roy

1964. "The Canadian Art Fraud." *Canadian Weekly* (Toronto), 16 May 1964.

Shuttleworth, Donald W.

1986. "Memories of Tom Thomson." *Insight on Collectables*, March 1986: 15–17.

Siddall, Catherine D.

1987. *The Prevailing Influence: Hart House and the Group of Seven, 1919–1953* (exhibition catalogue). Oakville, Ont.: Oakville Galleries, 1987.

Simmons, Richard

1956. "Major Work by Thomson Now on Display at Library." *LeaderPost* (Regina), 10 May 1956.

Siskind, Jacob

1977. "Tom Thomson: A Re-evaluation . . . Clearing the Cobwebs." *Ottawa Today*, 18 October 1977.

Smith, George L.

1974. *Norman Gurd and the Group of 7: A History of the Sarnia Art Movement*. [Brights Grove, Ont.: G.L. Smith], 1974.

Smith, Martin

1988. "Vol d'un tableau de plus de $200,000." *Le Journal de Montréal*, 27 June 1988.

Smith, Stephen

1991. "Canadian Heroes." *Globe and Mail* (Toronto), 29 June 1991.

Smyth, Michael

1990. "Colors in the Storm—Musical Honors Painter." *Toronto Sun*, 19 July 1990.

Somerville, Henry

1924a. "British Critics Say Canada Devel-oping Own Virile Art." *Toronto Daily Star*, 27 May 1924.

1924b. "British Art Critics Laud Vigor of Canadian Painting." *Toronto Daily Star*, 4 July 1924.

Stacey, Robert

1982. "Tom Thomson: 'Tiefer in den Wald.'" In *Okanada* (exhibition catalogue), 70–79. Berlin: Akademie der Künste, 1982. Original text "Tom Thomson: 'Deeper into the Forest.'" In *Okanada*, 63–69. Ottawa: Canada Council, 1982.

1987. "Reviews." *Canadian Art* 4, no. 1 (spring 1987): 103.

1991. "The Myth—and Truth—of the True North." In *The True North: Canadian Landscape Painting 1896–1939* (exhibition catalogue), 36–63. London, England: Lund Humphries and Barbican Art Gallery, 1991.

1996. *J.E.H. MacDonald, Designer: An Anthology of Graphic Design, Illustration and Lettering*. Ottawa: Archives of Canadian Art, an imprint of Carleton University Press, 1996.

1998. "Making Us See the Light: Franklin Brownell's 'Middle Passage.'" In *North by South: The Art of Peleg Franklin Brownell (1857–1946)* (exhibition catalogue), 64–99. Ottawa: Ottawa Art Gallery, 1998.

Steegman, John H.

1960. *Catalogue of Paintings*. Montreal: Montreal Museum of Fine Arts, 1960.

Stevenson, Orlando John

1927. *A People's Best: Out of the North Country*. Toronto: The Musson Book Company Ltd., 1927.

Stewart, Dick

1928. "The National Gallery of Canada: Tom Thomson." *Saturday Night* 43, no. 42 (1 September 1928), p. 5.

Storm, Rev. H.J.

1938. "Depth of Feeling in Thompson [*sic*] Art." *Windsor Star*, 17 September 1938.

Swinton, George

1956. "Tom Thomson Exhibit." *Winnipeg Tribune*, 7 February 1956.

Syphowich, P.

1970. "Was Tom Thomson Murdered?" *Toronto Daily Star*, 29 August 1970.

Taylor, David

1984. "Sketch for the Jack Pine by Tom Thomson—The Samuel E. Weir Collection." *Niagara Arts Journal* 1, no. 7 (15 April–15 May 1984): 5.

Taylor, Irene

1948. "Canada's Early Artists Inspired 'Revolution'." *London Free Press* (Ont.), 24 January 1948.

Taylor, John

1969. "Tom Thomson." *Cult* (Ontario College of Art) 2 (November 1969): 12–13, 18.

Teitelbaum, Matthew

1991. "Sighting the Single Tree, Sighting the New Found Land." In *Eye of Nature*, 71–88. Banff: Walter Phillips Gallery, 1991.

Tesher, Ellie

1996a. "Lake Mystery of an Artist's Death," *Toronto Star*, 12 August 1996.

1996b. "Experts Offer to Re-examine Artist's Death." *Toronto Star*, 19 August 1996.

1996c. "Skull May Hold Clue to Artist's Death." *Toronto Star*, 23 August 1996.

1996d. "Artist's Death: Offers of Help Pour In. *Toronto Star*, 26 August 1996.

1997. "Still Seeking Clues to Painter's Death." *Toronto Star*, 28 July 1997.

Thiébault-Sisson

1927a. "Une exposition d'art canadien au Jeu-de-Paume." *Le Temps* (Paris), 25 March 1927.

1927b. "Art et curiosité." *Le Temps* (Paris), 12 April 1927.

Thom, Ian M.

1990. *Tom Thomson* (exhibition catalogue). Vancouver: Vancouver Art Gallery, 1990.

Tom Thomson Memorial Gallery and Museum of Fine Art

1978. *The Permanent Collection, 1978*. Owen Sound: The Gallery, 1978.

1984. *The Tom Thomson Memorial Gallery and Museum of Fine Art: Catalogue Addendum,*

Acquisitions from 1978 to June 1984. Owen Sound: The Gallery, 1984.

[1988]. *The Collective Achievement: Selections from the Permanent Collection* (exhibition catalogue). Owen Sound: The Gallery, [1988].

Tonnancour, Jacques de

1940. "Exposition de la 'Contemporary Artist Society'." *Le Quartier Latin* 23, no. 9 (29 November 1940): 5.

Tooby, Michael

1991a. "Orienting the True North." In *The True North: Canadian Landscape Painting 1896–1939* (exhibition catalogue), 10–35. London, England: Lund Humphries and Barbican Art Gallery, 1991.

1991b. *Our Home and Native Land: Sheffield's Canadian Artists* (exhibition catalogue). Sheffield: Mappin Art Gallery, 1991.

Thorbjornsen, Lise

1992a. "Leith, Art Gallery Celebrating." *Sun Times* (Owen Sound), 29 July 1992.

1992b. "Church, Early Cemetery Remembered." *Sun Times* (Owen Sound), 4 August 1992

1995. "Thomson's Photographs Portray Love of Nature." *Sun Times* (Owen Sound), 11 March 1995.

Toronto City Directory

The Toronto City Directory. Vols. 29–40. Toronto: Might Directories Ltd., 1904–15.

Totzke, Carl

1956. "Thomson Caught Colors, Atmosphere of Northland." *Record* (Kitchener-Waterloo), 22 September 1956.

Town, Harold

1965. "The Pathfinder." Selected by Vincent Massey and others; illustrated by Franklin Arbuckle. *Great Canadians.* Canadian Centennial Library. Toronto: McClelland and Stewart Ltd., 1965.

1977a. "Tom's Work." *Toronto Life*, September 1977: 43–45, 174–75, 178–79.

1977b. "Master of Color and Light." *Reader's Digest* 111 (November 1977): 134–40.

1985. "Thomson, Thomas John." In *The Canadian Encyclopedia*, 1817–18, vol. 3. Edmonton: Hurtig, 1985.

Town, Harold, and David P. Silcox

1977. *Tom Thomson: The Silence and the Storm.* Toronto: McClelland and Stewart, 1977.

Troupe, Edwin

1945. "East or West?" (letter to editor). *Globe and Mail* (Toronto), 20 April 1945.

Trowell, Ian

1985. "Loyal to Algonquin Park." *The Christian Science Monitor*, 17 September 1985.

1986. "An Enthusiastic Examination of Tom Thomson." *London Free Press* (Ont.), 19 December 1986.

Turnbull, Joan

1957. "Brothers Together First Time." *Globe and Mail* (Toronto), 6 July 1957.

Turner, Evan H.

1963. "A Current General Problem . . . and a Specific Issue." *Canadian Art* 20, no. 2 (March–April 1963): 108–11.

Uhthoff, Ina D.D.

1967. "Did Famous Artist Tom Thomson Die This Way?" *Victoria Colonist*, 9 May 1967.

Varley, Christopher

1978. *Lake in Algonquin Park: An Examination of an Early Painting by Tom Thomson,* (exhibition catalogue). Stratford: The Gallery Stratford, 1978.

Wadden, Dianne

1991. "California Home Gets Painting Sought by Art Gallery of Algoma." *Sault Star* (Sault Ste. Marie, Ont.), 4 December 1991.

Wainwright, Ian N.M.

1991. "A Double-sided Panel Attributed to Tom Thomson." *CCI Newsletter* 7 (March 1991): 10–12.

Walker, Bill

1990. "Analysis Shows Work Likely Thomson's." *Sun Times* (Owen Sound), 12 July 1990.

Walker, Harold C., A.J. Casson, Martin Baldwin and Sydney J. Key

1950. "Fifty Years of Collecting." *Journal, Royal Architectural Institute of Canada* 27, no. 1 (January 1950): 3–31.

Walker, Kathleen

1977. "Tom Thomson Legacy Is Brilliantly Reflected." *Ottawa Citizen*, 11 November 1977.

Walker, Susan

2000. "$135,000 That's What this Painting Fetched at Auction Yesterday. (Unfortunately, the Seller Had Paid $165,000 for It.)". *Toronto Star*, 21 February 2000.

Walton, Paul H.

1990. "The Group of Seven and Northern Development." *RACAR* 17, no. 2 (1990): 171–208.

Weiers, Margaret

1964. "Tom Thomson's Sister Still Does Two Sketches on 'Good' Day." *Toronto Daily Star*, 14 March 1964.

Wells, Kenneth

1934. "Art and Artists." *Evening Telegram* (Toronto), 3 February 1934.

Wice, Aubrey

1964. "The Picturesque Parish." *Telegram* (Toronto), 25 July 1964.

Wilson, Peter

1971. "Tom Thomson Art Show an Exciting Spectacle." *Toronto Daily Star*, 5 November 1971.

Wilson, Trish

1977. "Thomson's Work Shocked Public." *Sun Times* (Owen Sound), 5 May 1977.

Winter, Brian

1985. "Whitby's 'Most Famous' Artist Gave Pointers to Tom Thomson." *Oshawa Times*, 16 February 1985.

Wistow, David

1982. *Tom Thomson and the Group of Seven: Selected Works from the Collection of the Art Gallery of Ontario.* Toronto: Art Gallery of Ontario, 1982.

Worthington, Helen

1974. "Artist Sees Tom Thompson [sic] as Romantic Hero." *Toronto Star*, 12 June 1974.

Wrenshall, A.S.

1916. "Toronto." *American Art News* 14, no. 16 (22 January 1916): 9.

Wrenshall, H.E.

1920. "A Northland Painter." *Toronto Sunday World*, 22 February 1920.

Wrenshall, Irene B.

1914a. "The Field of Art." *Toronto Sunday World*, 22 March 1914.

1914b. "The Field of Art." *Toronto Sunday World*, 26 April 1914.

1914c. "The Field of Art." *Toronto Sunday World*, 26 July 1914.

Yanovsky, Avrom

1971. "Tom Thomson: Canadian Realist." *Vancouver Pacific Tribune*, 12 November 1971.

Zaritsky, John

1966. "He Had Real Love for North." *Record* (Kitchener-Waterloo), 12 November 1966.

1968. "Tom Thomson: A False Image." *Record* (Kitchener-Waterloo), 6 January 1968.

Zemans, Joyce

1977. "A Celebration of Tom Thomson." *Artmagazine* 9, no. 36 (December 1977): 6–11.

1995. "Establishing the Canon: Nationhood, Identity and the National Gallery's First Reproduction Programme of Canadian Art." *Journal of Canadian Art* 16, no. 2 (1995): 6–35.

Unattributed Articles

1904

Toronto Daily Star. "Neil McKechnie, Toronto, Drowned." 28 June 1904.

Globe (Toronto). "Drowned in New Ontario." 29 June 1904.

Toronto Daily Star. "M'Kechnie's [sic] Death." 29 June 1904.

Toronto Daily Star. "The Drowning of Neil McKechnie." 30 June 1904.

1912

Owen Sound Sun. "Local Man's Experience in Northern Wilds." 27 September 1912. Reprinted in Arthur Davidson, "Out of the Past." *Sun Times* (Owen Sound), 17 May 1971.

1913

Mail and Empire (Toronto). "Fine Paintings Placed on View." 5 April 1913.

Globe (Toronto). "Buy Pictures for the Normal Schools." 23 April 1913.

1914

Globe (Toronto). "Art and Artists." 21 November 1914.

1915

Globe (Toronto). "Colour and Originality at the O.S.A. Exhibition." 13 March 1915.

1916

Globe (Toronto). "Extremes Meet at OSA Show." 11 March 1916.

Mail and Empire (Toronto). "Ontario Artists Do Daring Work." 11 March 1916.

1917

Owen Sound Sun. "Pictures by Sydenham Boy Worth Seeing." 10 April 1917.

Owen Sound Sun. "Tom Thomson's Canoe Found on Canoe Lake." 13 July 1917.

Globe (Toronto). "Toronto Artist Missing in North." 13 July 1917.

Owen Sound Sun. "Tom Thomson Likely Drowned." 17 July 1917.

Globe (Toronto). "Toronto Artist Drowns in North." 18 July 1917.

Owen Sound Times. "Tom Thomson, Artist, Drowned." 20 July 1917.

Owen Sound Sun. "Tom Thomson's Body Found, Was Missing More than a Week." 20 July 1917.

Owen Sound Times. "Toronto Artist Missing." 20 July 1917.

Globe (Toronto). "French, Italian and Canadian Paintings at the Exhibition." 27 August 1917.

Owen Sound Sun. "Late Mr. Thomson's Sketches at Exhibition." 28 August 1917.

Globe (Toronto). "Erect Cairn to Artist's Memory." 3 October 1917.

1919

Gazette (Montreal). "A Painter of the Wilds." 28 March 1919.

Shawville Equity (Que.). "Canadian Art." 29 May 1919.

1920

Globe (Toronto). "Art and Artists." 14 February 1920.

Mail and Empire (Toronto). "Beauty of North Shown in Color." 14 February 1920.

Toronto Daily Star. "Memorial Exhibition to Artist of North." 18 February 1920.

Mail and Empire (Toronto). "Thomson and the Algonquin School." 21 February 1920.

Toronto Daily Star. "The Tom Thomson Exhibition." 26 February 1920.

Sarnia Observer. "'Canadian Art' An Instructive Talk is Heard Here." 20 November 1920.

1921

Winnipeg Tribune. "Leader of 'Free' Artists Exhibits Painting in Winnipeg Gallery." 15 October 1921.

1922

Mail and Empire (Toronto). "Ontario Art Shown in the Making." 11 February 1922.

Globe (Toronto). "Retrospective Exhibition of Ontario Artists." 13 February 1922.

Ottawa Journal. "Fine Pictures Added to National Gallery." 18 February 1922.

Ottawa Citizen. "A Canadian Artist." 22 February 1922.

Evening Telegram (Toronto). "Says Schools of Art Are but an Abomination." 11 March 1922.

Montreal Herald. "Canadian School is Well Represented at the Art Exhibition." 25 March 1922.

1923

Sarnia Observer. "Art Exhibition Opens Tomorrow Public Library." 22 March 1923.

Victoria Colonist. "A Canadian Artist." 29 May 1923.

Varsity (University of Toronto). "Address Delights Sketch Club." 21 November 1923.

Varsity (University of Toronto). "Art, Music and Drama." 21 November 1923.

1924

Toronto Star Weekly. "Canada Has Given Birth To a New and National Art." 26 January 1924.

Art News. "The Triumph of Wembley." 22, no. 34 (31 May 1924): 7–11.

Canadian Forum. Editorial. 4, no. 45 (June 1924): 260–61.

Canadian Magazine. "Fine Arts from Canada." 63, no. 3 (July 1924): 132–44.

Toronto Daily Star. "Says Paintings from Canada Are Most Vital of Century." 5 July 1924.

Toronto Daily Star. "Canadian Art." 20 August 1924.

Toronto Sunday World. "Canada Rightly Proud of Her Younger Artists." 31 August 1924.

Winnipeg Free Press. "The Art of Canada." 20 November 1924.

1925

Canadian Annual Review of Public Affairs, 1924–1925. "Canadian Art at Wembley; Other Exhibitions," 485–86. Toronto: The Canadian Review Company, 1925.

Sarnia Observer. "Famous Picture Owned in Sarnia Goes to England." 31 January 1925.

London Advertiser (Ont.). "62 Canvases by 20 Canadian Painters Displayed in the Public Library." 4 April 1925.

Toronto Daily Star. "The Late Tom Tomson [sic]." 30 May 1925.

1926

Quality Street (Toronto). "Honor for Tom Thomson." January 1926.

Guelph Mercury. "Fine Painting is Unveiled at O.A. College." 9 January 1926.

Toronto Daily Star. "Variety Marks Display of Canadian Paintings." 21 January 1926.

Canadian Bookman. "A Great Show." 6, no. 65 (February 1926): 137.

Evening Telegram (Toronto). "Painting Purchased by Canadian Club for New Galleries." 4 February 1926.

Toronto Daily Star. "Tom Thomson's Aged Father Typifies Son's Rugged Scenes." 4 February 1926.

Ottawa Morning Journal. "Contemporary Canadian Art." 9 February 1926.

Mail and Empire (Toronto). "Fine Canadian Canvas for the Art Gallery." 10 February 1926.

Canadian Forum. "Decorative Pen Drawing." 6, no. 66 (March 1926): 181.

Canadian Bookman. "Activities in the Art Gallery of Toronto." 8, no. 3 (March 1926): 92.

Canadian Homes and Gardens. "A Group From Toronto's New Art Gallery." 3, no. 3 (March 1926): 23–25.

Christian Science Monitor. "Inaugural Exhibition at the Art Gallery of Toronto." 8 March 1926.

Canadian Forum. "Books." 6, no. 70 (July 1926): 312–313.

1927

The Times (London). "Canadian Art." 12 April 1927.

Daily Telegraph (London). "Canadian Artists." 13 April 1927.

Comœdia (Paris). "À propos de l'exposition des Canadiens." 16 April 1927.

1928

Chatelaine. "The West Wind by Tom Thomson." 1, no. 8 (October, 1928): 15.

1929

Mail and Empire (Toronto). "Hart House Acquires Tom Thomson Painting." 18 April 1929.

Regina Leader. "Noted Work at Art Exhibit at City Hall." 29 October 1929.

1930

Toronto Daily Star. "Tom Thomson Memoir to Come Out Soon." 31 May 1930.

Ottawa Citizen. "Tom Thomson Will Be Honored Aug. 1." 19 July 1930.

Evening Telegram (Toronto). "Remember Woods Artist." 19 July 1930.

Gazette (Montreal). "Will Pay Tribute to Tom Thomson." 21 July 1930.

Gazette (Montreal). "Canoe Found By Lad." 8 August 1930.

Mail and Empire. (Toronto). "Canoe Discovered by Boy on Lake Is Believed to Be Tom Thomson's." 9 August 1930.

Mail and Empire (Toronto). "Totem Pole Honors Tom Thomson's Ideal." 18 August 1930.

Globe (Toronto). "Bark Canoe Carries Memorial Flowers." 19 August 1930.

Toronto Daily Star. "Camp Ahmek Rangers Honor Artist." 23 August 1930.

Mail and Empire (Toronto). "Father of Famous Painter Dies in Ninety-first Year." 3 September 1930.

Globe (Toronto). "John Thomson." 5 September 1930.

London Free Press (Ont.). "Tom Thomson." 12 December 1930.

1931

Onward (Toronto). "Famous Canadian Pictures: The Jack Pine by Tom Thomson." 41, no. 36 (5 September 1931): 288.

1932

Canadian Bookman. "Children's Artist Friends." 14, no. 1 (January 1932): 11.

1933

Toronto Daily Star. "'Bean's Play Parallels Life of Ontario Artist." 11 November 1933.

1934

Peterboro Examiner. "Canadian Art Is Something to be Proud Of." 14 April 1934.

1935

Canadian Homes and Gardens. "Around the Galleries." 12, no. 12 (December 1935): 22, 44.

1936

Chatelaine. "In the Northland by Tom Thomson." 9, no. 2 (February 1936): 22.

1937

Globe and Mail (Toronto). "Holstein Art Club Leads Way to Culture." 15 January 1937.

Curtain Call (Toronto). "Tom Thomson Memorial Exhibition." 8, no. 6 (March 1937): 11.

Saturday Night. "Tom Thomson's Art." 52, no. 19 (13 March 1937): 3.

Saturday Night. "A Tom Thomson 'Waterfall.'" 52, no. 36 (10 July 1937): 12.

1938

Times Weekly Edition (London). "Canadian Season by Canadian Artists." 7 July 1938.

Sarnia Observer. "'Chill November' Is Sent to Tate Gallery." 25 August 1938.

United Empire (London). "Recent Canadian Art." September 1938: 402–411.

Montreal Standard. "To Be Exhibited in London." 10 September 1938.

1939

Evening Telegram (Toronto). "Two Painters Represented at Art Show." 8 February 1939.

1941

Curtain Call (Toronto). "Art Notes." 12, no. 4, January 1941, 2.

Evening Telegram (Toronto). "At the Galleries: Artist's Sketches Reveal Progress of Paintings." 3 January 1941.

Evening Telegram (Toronto). "Lismer Talks of Fine Artist Tom Thomson." 11 January 1941.

New World Illustrated (Toronto). "The Crown of the Year: Tom Thomson." 11, no. 11 (December 1941): 50–51.

1943

Gazette (Montreal). "Film on Tom Thomson Will Be Screened Here." 3 April 1943.

London Free Press (Ont.). "'Tom Thomson Film Shown Here'." 20 May 1943.

Sun Times (Owen Sound). "Represents the Artist." 20 May 1943.

Montreal Star. "Tom Thomson." 20 October 1943.

Evening Telegram (Toronto). "Tributes Paid Tom Thomson by Admirers." 25 November 1943.

Evening Telegram (Toronto). "Group of Seven Inspired by Dr. James MacCallum." 11 December 1943.

1944

Evening Telegram (Toronto). "Pictures Willed to Art Gallery." 18 April 1944.

Ottawa Evening Citizen. "Notable Gift of Paintings to National Gallery." 14 September 1944.

Evening Telegram (Toronto). "Ottawa Gallery Left 70 Thomson Paintings." 14 September 1944.

Canadian Art. "A Gift to the Nation." 2, no. 1 (October–November 1944): 2.

1945

Gazette (Montreal). "Fine Arts, Crafts and Decoration." 9 June 1945.

1946

Maclean's. "Tom Thomson Master of Color." 59, no. 19 (1 October 1946): 17–18.

1947

Gazette (Montreal) "Tells Maritime Club of Canadian Painters." 12 February 1947.

Galt Daily Reporter (Ont.). "School Students Hear Broadcast by Painter." 29 March 1947.

Mayfair. "Canadian Landscape Painting Through the Years." 21, no. 5 (May 1947): 30.

Globe and Mail (Toronto). "Envoy Says Canadian Painter True Prophet of Continent." 31 May 1947.

Ottawa Citizen. "Canada's Artist Of The Canoe." 2 June 1947.

Gazette (Montreal). "Tom Thomson's Work For Art Association." 28 June 1947.

Gazette (Montreal). "Displays Small Oils by late Tom Thomson." 5 July 1947.

Evening Telegram (Toronto). Tom Thomson Painter Died 30 Years Ago." 8 July 1947.

1948

Kingston Whig-Standard. "Tom Thomson Pictures Collected In One Room." 14 July 1948.

1950

Sun Times (Owen Sound). "Tom Thomson Leads Artists in 'Famous Canadians' Poll." 16 January 1950.

Windsor Daily Star. "Tom Thomson Painting Presented to Association." 25 April 1950.

London Free Press (Ont.). "Thomson Work Displayed Here." 26 May 1950.

Globe and Mail (Toronto). "Canadian Painter Lived In The Rugged Northland." 30 September 1950.

Telegram (Toronto). "Maple Leaf." 7 October 1950.

1951

Sudbury Daily Star. "Canadian Painting Shown in Sudbury." 9 November 1951.

1956

Victoria Colonist. "Famed Canada Artist to Brighten Gallery." 1 January 1956.

Ottawa Citizen. "A Tom Thomson Memorial." 11 February 1956.

Gazette (Montreal). "He Made Canadians See Their Own Land." 18 February 1956.

Ottawa Citizen. "Was Thomson Slain in Algonquin Forest?" 10 October 1956.

Toronto Daily Star. "Canoe Lake Bones Revive Rumors Tom Thomson's Body Never Brought Here." 10 October 1956.

Telegram (Toronto). "Skeleton Revives Artist Mystery." 10 October 1956.

Regina Leader-Post. "Artist's Death Said Not Premeditated." 11 October 1956.

Sun Times (Owen Sound). "Wherever Tom Thomson Lies, He Was Greatest Canadian Painter." 11 October 1956.

Regina Leader-Post. "Ex-undertaker Says He Exhumed Artist's Body." 12 October 1956.

Ottawa Journal. "Tom Thomson's Death Violent, Not planned." 13 October 1956.

Globe and Mail (Toronto). "Thomson Body Reburied in 1917, Undertaker Says." 13 October 1956.

Regina Leader-Post. "Author Did Not Know Artist." 16 October 1956.

Telegram (Toronto). "Artist 'Mystery' Angers Mortician." 18 October 1956.

Globe and Mail (Toronto). "Bones at Canoe

Lake Not Those of Artist." 19 October 1956.

Ottawa Citizen. "The Mysterious Death of Tom Thomson." 24 October 1956.

1957

Globe and Mail (Toronto). "Memorial Fund for Noted Artist May Be Closed." 15 February 1957.

London Evening Free Press (Ont.). "Two Thomson Brothers, Each in His Own Way Capture Some of the Wildness of the North." 13 July 1957.

Windsor Daily Star. "Pay Tribute to Painter." 7 October 1957.

1959

CBC Times. "'Portrait from Memory': Tom Thomson." 11, no. 51 (27 June – 3 July 1959): 8, 16.

1961

Sun Times (Owen Sound). "To Commemorate Painter by Unveiling of Plaque at Leith on Sunday." 17 August 1961.

Sun Times (Owen Sound). "Creates Great Heritage of Enjoyment." 14 September 1961.

1962

Toronto Daily Star. "Gallery to Honor Tom Thomson." 12 March 1962.

Toronto Daily Star. "Group of Seven Art Inspires 'Place of Joy'." 3 April 1962.

Victoria Colonist. "Tom Thomson's Clear Oils on Display at Arts Centre." 6 April 1962.

Telegram (Toronto). "Bogus Art Floods Metro." 18 December 1962.

Hamilton Spectator. "Fakes and Forgers and All That." 21 December 1962.

1963

Telegram (Toronto). "Tely Art Clinic Has a $10,000-Plus Windfall." 1 February 1963.

Telegram (Toronto). "Leading Dealer Arrested." 23 May 1963.

Toronto Daily Star. "Jackson Labels 14 Paintings as Crude Fakes." 4 November 1963.

Telegram (Toronto). "Trial Over Paintings Told: 'Oils Sold for Thousands'." 5 November 1963.

Telegram (Toronto). "'Dear Old Lady' Art in Court." 6 November 1963.

Globe and Mail (Toronto). "Was Paid $4 to $10 to Copy Valuable Art, Painter, 74, Testifies." 7 November 1963.

Telegram (Toronto). "Painter, 67, Tells Court of Copying." 7 November 1963.

Toronto Daily Star. "Auctioneer Tells Fraud Trial: Never Guarantee Paintings." 8 November 1963.

1964

Toronto Daily Star. "2 Admit Selling Fake Art." 4 March 1964.

Telegram (Toronto). ". . . Bogus Art Goes Back." 5 March 1964.

Sun Times (Owen Sound). "Two Thomson Originals For Art Gallery." 24 March 1964.

Sun Times (Owen Sound). "Tom Thomson Enshrined In McMichael Home." 4 April 1964.

Brantford Expositor. "Glenhyrst Art With Difference, Thomson Family Exhibit Opens." 1 October 1964.

Sun Times (Owen Sound). "Museum, Gallery Filled For Opening of Annual Lyceum Club Exhibition." 26 October 1964.

Saskatoon Star Phoenix. "'Snow in October' Painting Displayed at Mendel Gallery." 18 December 1964.

1965

Telegram (Toronto). "$1,200 Thomson Painting Theft in Vancouver." 7 January 1965.

Hamilton Spectator. "Tom Thomson's Art." 19 June 1965.

Sun Times (Owen Sound). "Fraser Thomson Pictures Hang in Lobby Show." 5 October 1965.

Toronto Daily Star. "Gift to Ontario, Valued at $830,000 Includes Art, Tom Thomson's Shack." 18 November 1965.

Flin Flon Reminder (Manitoba). "The Giants: Tom Thomson." 6 December 1965.

1966

Famous Ontarians, A Series of Six Portraits: Tom Thomson. [Toronto]: Brewers Warehousing Co., Ltd., 1966.

1967

Sun Times (Owen Sound). "Mayor to Officially Open Tom Thomson Gallery." 25 May 1967.

Sun Times (Owen Sound). "Tom Thomson Gallery Is Officially Opened." 29 May 1967.

Sun Times (Owen Sound). "Tom Thomson Memorial Art Gallery." 30 May 1967.

Sun Times (Owen Sound). "Fraser Thomson Dies In Toronto." 10 August 1967.

Halifax Mail-Star. "Citadel 'Guards' Art Exhibits." 18 October 1967.

Sun Times (Owen Sound). "Valuable Tom Thomson Works Are Presented to Gallery by His Sister." 23 October 1967.

Markham Economist & Sun. "Blodwen Davies' Book Tribute to Artist." 21 December 1967.

1968

Sun Times (Owen Sound). "Thomson 'West Wind, Jack Pine' Feature Gallery Anniversary." 13 May 1968.

London Free Press (Ont.). "Tom Thomson's Old Shack Reopened." 1 June 1968.

Gravenhurst News (Ont.). "Friend of Famous Painter Opens Series at Art Yard." 26 September 1968.

Sun Times (Owen Sound). "CBC Doing Film on Tom Thomson's Boyhood in District." 27 September 1968.

Sun Times (Owen Sound). "CBC Crew in Area to Film Life and Art of Tom Thomson." 30 September 1968.

1969

Sun Times (Owen Sound). "Morbid Curiosity Should Not Be Satisfied." 4 February 1969.

Midland & Penetang Free Press Herald (Ont.). "Was Tom Thomson Murdered." 5 February 1969.

Sun Times (Owen Sound). "Tom Thomson Family Will Bar Exhumation of Body." 8 February 1969.

Sun Times (Owen Sound). "Recall Identifying of Tom Thomson Body Prior to Burial Here." 10 February 1969.

University of Guelph News Bulletin. "Tom Thomson Painting Owned by University." 13, no. 7 (13 February 1969): 1.

Brampton Daily Times and Conservator. "Artist's Death Baffles." 13 February 1969.

Huntsville Forester (Ont.). "Undertaker's Letter Refers to Mystery." 13 February 1969.

Collingwood Enterprise-Bulletin (Ont.). "The Painter of Algonquin." 13 November 1969.

London Free Press (Ont.). "Book on Canadian Painter Success for Two Housewives." 16 December 1969.

Fergus News Record (Ont.). "Books to Enjoy at Fergus Public Library." 17 December 1969.

Oakville Daily Journal Record (Ont.). "Mystical Thomson Oil Painting Now On View at House of Art." 18 December 1969.

1970

Toronto Life. "Was it Murder? 'Men Have Hanged for Less'." (April 1970).

Arnprior Chronicle (Ont.). "Tom Thomson's Works Added to Group Display." 22 July 1970.

Le Droit (Ottawa). "Son influence sur le Groupe des Sept." 22 July 1970.

Sun Times (Owen Sound). "Thomson Death Perennial Show?" 28 August 1970.

Town Talk About Toronto. "Mystery in Algonquin Park?" (Autumn 1970).

1971

Sun Times (Owen Sound). "Local audience Hears of Life of Thomson." 24 April 1971.

Canadian Magazine. "You Asked Us: About Painter Tom Thomson." 16 October 1971.

Sun Times (Owen Sound). "Favorable

Reviews for Thomson Show." 1 November 1971.

1972

Sun Times (Owen Sound). "Tom Thomson 'Revelation' Pointless, Unkind." 15 February 1972.

Saskatoon Western Producer. "Not Suicide Author Says." 9 March 1972.

Winnipeg Tribune. "Thomson Painting Termed 'Best Known'." 13 March 1972.

Toronto Star. "Airport May Pose Threat to Home of Tom Thomson." 3 April 1972.

Sun Times (Owen Sound). "Symbol Identifies City With Artist Thomson." 4 April 1972.

Charlottetown Patriot. "Thomson Exhibition Really Drew Crowds." 18 August 1972.

1973

Oshawa Times. "Tom Thomson's Birthplace Will Survive Pickering Airport." 1 October 1973.

1974

Guelph Mercury. "Money in Moonlight." 10 August 1974.

1975

Sun Times (Owen Sound). "Good Buy." 17 January 1975.

Peterborough Examiner. "Was He Murdered or Did He Drown Accidentally?: 58 Years Ago Tommy Thomson Became a Legend." 11 July 1975.

Kingston Whig Standard. "Movie Shot at Skootamata." 5 September 1975.

Globe and Mail (Toronto). "Thomson Work Exhibit Highlight." 8 September 1975.

1976

Toronto Star. "Tom Thomson Painting Fetches Record $285,000." 17 June 1976.

1977

Sun Times (Owen Sound). "Women's Committee Buys Thomson Painting." 26 April 1977.

Maclean's. "Portrait." 90 (25 July 1977): 13.

1979

Toronto Star. "Margaret Tweedale Artist's Last Relative." 19 January 1979.

Toronto Star. "Thomson Painting Fetches $56,000." 31 March 1979.

Province (Vancouver). "Canada Venture— Tom Thomson." 4 October 1979.

1981

Toronto Star. "Thomson Art Withdrawn as Ownership Is Disputed." 3 June 1981.

1989

Saint John Evening Times-Globe. "Opinion Is Split on Whether Work Is True Thomson." 12 October 1989.

1990

Globe and Mail (Toronto). "Tests Suggest Landscape Is Genuine." 12 July 1990.

1996

Globe and Mail (Toronto). "Artist's View of a Tree Turned Eyes Toward Canada." 20 March 1996.

Globe and Mail (Toronto). "Thomson Oils Double Sotheby's Estimates." 28 November 1996.

1998

National Post (Don Mills, Ont.). "Tom Thomson's Nocturne Gets Record Price." 9 November 1998.

Manuscript Sources

AGO Arch. (Edward P. Taylor Research Library and Archives, Art Gallery of Ontario Archives, Toronto)
Tom Thomson papers.

Albright Arch. (Albright-Knox Art Gallery Archives, Buffalo, N.Y.)
Exhibition Records.

Arch. of Ont. (Archives of Ontario, Toronto)
E. Wyly Grier papers (F1108).
H.A. Callighen papers (F1039).
Ontario Society of Artists papers (F1140).
William Colgate papers (F1066).

B.C. Arch. (British Columbia Provincial Archives and Records Service, Victoria)
Harold Mortimer-Lamb papers (MS 2834).

CMC (Canadian Museum of Civilization, Hull, Que.)
Marius Barbeau collection.

Lambton Arch. (Lambton County Library Headquarters, Lambton Room Wyoming, Ont.)
Norman Gurd correspondence (Box 24, JA-DA).

McMichael Coll. (The Michael Canadian Art Collection Library, Kleinburg, Ont.) Arthur Lismer papers. Tom Thomson papers.

NAC (National Archives of Canada, Ottawa)
Charles Comfort fonds (MG30 D81).
Blodwen Davies fonds (MG30 D38).
J. Russell Harper fonds (MG30 D352).
Lawren S. Harris fonds (MG30 D208).
R.H. Hubbard fonds (MG31 E76).
Arthur Lismer fonds (MG30 D184).
J.E.H. MacDonald fonds (MG30 D111).
Norah de Pencier fonds (MG30 D322).
Tom Thomson fonds (MG30 D284).
Harold Town fonds (MG30 D404).
F.H. Varley fonds (MG30 D401).

NGC Arch. (Archives of the National Gallery of Canada, Ottawa)
Curatorial files.
Dr. James MacCallum papers.
MacCallum Collector's file.
Dennis Reid Scholar file.
7.1–Thomson correspondence.
7.4–Film-Thomson.
1.7–MacCallum Bequest.
1.12–Thomson oils purchased.
5.4–Century of Canadian Art, 1938.
7.1–Carmichael correspondence.

Nutana Arch. (Nutana collegiate Institute, Saskatoon)
Memorial Gallery correspondence.

Queen's Arch. (Queen's University Archives, Kingston, Ont.)
Lorne Pierce papers (coll. 2001a).

Trent Arch. (Trent University Archives, Peterborough)
Mark Robinson diary.

UTA (University of Toronto Archives)
Hart House papers (A73-0050).

UTL (University of Toronto, Thomas Fisher Rare Book Library)
Sir Edmund Walker papers (ms coll. 1).

Exhibition History

compiled by Beth Greenhorn

1913

OSA 1913. *Ontario Society of Artists Forty-first Annual Exhibition*, Art Museum of Toronto, 5–26 April 1913 (exhibition catalogue).

1914

Little Pictures 1914. Second *Annual Exhibition of Little Pictures by Canadian Artists*, Art Museum of Toronto, 7–28 Feb. 1914 (exhibition catalogue).

OSA 1914. *Ontario Society of Artists Forty-second Annual Exhibition*, Art Museum of Toronto, 14 March–11 April 1914 (exhibition catalogue).

RCA 1914. *Royal Canadian Academy of Arts Thirty-sixth Annual Exhibition*, Art Museum, Public Library Building, Toronto, from 19 Nov. 1914 (exhibition catalogue).

Patriotic Fund 1914. *Pictures and Sculpture Given by Canadian Artists in Aid of the Patriotic Fund Sale*, under the Auspices of the Royal Canadian Academy, Art Museum, Public Library Building, Toronto, from 13 Dec. 1914 (exhibition catalogue). Exhibition shown in Winnipeg, Halifax, Saint John, Quebec, Montreal, Ottawa, London and Hamilton.

1915

OSA 1915. *Ontario Society of Artists Forty-third Annual Exhibition*, Art Museum of Toronto, 13 March–10 April 1915 (exhibition catalogue).

CNE 1915. *Canadian National Exhibition: Department of Fine Arts*, Toronto, 28 Aug.–13 Sept. 1915 (exhibition catalogue).

Halifax 1915. Nova Scotia Provincial Exhibition, Fine Arts Building, Halifax, 8–16 Sept. 1915 (exhibition catalogue).

Thomson 1915. Arts and Letters Club, Toronto, Dec. 1915.

1916

Thomson 1916. Heliconian Club, Toronto, March 1916.

OSA 1916. *Ontario Society of Artists Forty-fourth Annual Exhibition*, Art Museum of Toronto, 11 March–15 April 1916 (exhibition catalogue).

CNE 1916. *Canadian National Exhibition: Department of Fine Arts*, Toronto, 26 Aug.–11 Sept. 1916 (exhibition catalogue).

Halifax 1916. *Nova Scotia Provincial Exhibition*, Fine Arts Gallery, Halifax, 13–21 Sept. 1916 (exhibition catalogue).

RCA 1916. *Royal Canadian Academy of Arts: Thirty-eighth Annual Exhibition*, Art Association of Montreal, 16 Nov.–16 Dec. 1916 (exhibition catalogue).

1917

CCE 1917. *Central Canada Exhibition: Fine Arts*, Ottawa, [Aug.] 1917 (exhibition catalogue).

CNE 1917. *Canadian National Exhibition Department of Fine Arts*, Toronto, 25 Aug.–10 Sept. 1917 (exhibition catalogue).

Halifax 1917. *Exhibitions of Lithographs Loaned by the National Gallery of Canada, Ottawa, and Little Pictures and Sketches by Members of the Ontario Society of Artists*, Nova Scotia Museum of Fine Arts, Halifax, from 30 Nov. 1917 (exhibition catalogue).

Thomson 1917. Arts and Letters Club, Toronto, Dec. 1917.

1918

Halifax–Saint John 1918. *Paintings by Canadian Artists, Loaned by the National Gallery of Canada, Ottawa*, Nova Scotia Museum of Fine Arts, Halifax, 26 Feb.–Dec. 1917 (exhibition catalogue) / Saint John Art Club Studio, Saint John, N.B., from 30 Jan. 1918.

St. Louis 1918. *Exhibition of Paintings by Canadian Artists*, City Art Museum, St. Louis, Mo. from 8 Nov. 1918 (exhibition catalogue) / Hackley Gallery, Muskegon, Mich. / Minneapolis Institute of Art, from 15 Feb. 1919 / Art Institute of Chicago, 4 April–1 May 1919 (exhibition catalogue) / Milwaukee Art Institute, Wisconsin, 17 May–17 June 1919.

1919

Thomson 1919. *Exhibition of Paintings by the Late Tom Thomson*, Arts Club, Montreal, 1–21 March 1919 (exhibition catalogue) / Art Association of Montreal, 25 March–12 April 1919.

1920

Thomson 1920. *Memorial Exhibition of Paintings by Tom Thomson*, Art Gallery of Toronto, 13–29 Feb. 1920 (exhibition catalogue).

Sarnia 1920(1). *Canadian Pictures*, Sarnia Conservation Committee, March 1920.

Sarnia 1920(2). *Canadian Paintings*, Sarnia Art Gallery, Nov. 1920 [ms. list in MacCallum to Gurd 1 Nov. 1920 in Lambton County Library Headquarters, Lambton Room Wyoming, Ont., Box 24, JA-DA].

Worcester 1920. *Paintings by the "Group of Seven" Canadian Artists*, Worcester Art Museum, Mass., 7–28 Nov. 1920 (exhibition catalogue) / Boston Museum of Fine Arts, 1–31 Dec. 1920 (exhibition catalogue) / *A Collection of Oil Paintings by the Canadian "Group of Seven" and Water Colors by Nine American Artists*, Memorial Art Gallery, Rochester, N.Y., 1 Jan.–15 Feb. 1921 (exhibition catalogue) / *Oil Paintings by "Group of Seven" Canadian Artists: Work of Mahoning Society of Painters, Youngstown, Ohio; Pictorial Photographs of Greece*, Toledo Museum of Art, Ohio, March 1921 (exhibition catalogue) / *Exhibition of Paintings by Canadian Artists*, Art Association of Indianapolis, April 1921 (exhibition catalogue) / Detroit Museum of Arts, June 1921 / Cleveland Museum of Art, 8 July–29 Aug. 1921 / *Three Special Exhibitions: Paintings of China by Frederick Clay Bartlett; Paintings of Louise Upton Brumback; Paintings by the "Group of Seven" Canadian Artists*, Buffalo Fine Arts Academy, Albright Art Gallery, 10 Sept.–3 Oct. 1921 (exhibition catalogue) / *Paintings by the "Group of Seven" Canadian Artists*, Columbus Art Association, Ohio, Oct. 1921 (exhibition catalogue) / Minneapolis Institute of Arts, Dec. 1921 / Hackley Gallery of Art, Muskegon, Mich., Jan. 1922. [Catalogue numbers refer to the Worcester Art Museum catalogue.]

1921

Thomson 1921. Women's Art Association, Toronto, January 1921.

Winnipeg 1921. *Canadian Art of Today*, Winnipeg Gallery of Art, 15 Oct.–10 Dec. 1921 (exhibition catalogue).

1922

Thomson NGC 1922. *Special Exhibitions: Pictures and Sketches by Tom Thomson; Illustrations to the "Book of Job" and Dante's "Inferno" by William Blake*, National Gallery of Canada, Ottawa, 11 Feb.–31 March 1922 (exhibition catalogue).

OSA Retrospective 1922. *Retrospective Loan Exhibition of the Works of Members of the Ontario Society of Artists Covering the First Half-Century of the Society's History*, Art Gallery of Toronto, 11 Feb.–12 March 1922 (exhibition catalogue).

AAM 1922 *Art Association of Montreal: Thirty-ninth Spring Exhibition*, Montreal, 21 March–15 April 1922 (exhibition catalogue).

Thomson Owen Sound 1922. *The Women's Art Association Exhibit of Paintings by Tom Thomson*, Owen Sound, 1–6 May 1922 (exhibition list).

1923

Sarnia 1923. *Little Picture Show*, Sarnia Conservation Committee, from 23 March 1923.

Thomson 1923. [*Exhibition of Tom Thomson Sketches*], Hart House, University of Toronto, from c. 21 Nov. 1923.

1924

Wembley 1924. *British Empire Exhibition, Canadian Section of Fine Arts*, Palace of Fine Arts, Wembley Park, London, England, 23 April–31 Oct. 1924 (exhibition catalogue) / Leicester Museum and Art Gallery, 12 Nov.–12 Dec. 1924 / Kelvingrove Art Galleries, Glasgow, Scotland, late Dec. 1924–17 Jan. 1925 / City of Birmingham Municipal Art Gallery, England, 30 Jan.–31 March 1925. [Catalogue numbers refer to the Wembley Park catalogue.]

AGT 1924. *Summer Exhibition of Canadian Art*, Art Gallery of Toronto, 24 May–16 Aug. 1924 (exhibition catalogue).

1925

Sarnia 1925(1). *Little Pictures Exhibition*, Women's Conservation Art Committee, Sarnia, Feb. 1925.

Thomson 1925. [*Exhibition of Tom Thomson Sketches*], [some works identified in UTA, A73-0050-161, Tom Thomson exhibition, Hart House], Hart House, University of Toronto, 16–28 Feb. 1925.

London 1925. *Contemporary Canadian Art*, Public Library, London, Ont., 3–29 April 1925.

Wembley 1925. *British Empire Exhibition, Canadian Section of Fine Arts*, Fine Arts Galleries, Wembley Park, London, England, 9 May–Oct. 1925 (exhibition catalogue) and *British Empire Exhibition (1925) Palace of Arts* (exhibition catalogue) / *Exhibition of Canadian Art*, Whitechapel Art Gallery, London, 26 Nov.–23 Dec. 1925 (exhibition catalogue) / York City Art Gallery, 16 Jan.–13 Feb. 1926 / *Exhibition of Canadian Art*, Corporation Art Gallery, Bury, 20 Feb.–20 March 1926 (exhibition catalogue) / Blackpool, 27 March–24 April 1926 / *Exhibition of Canadian Art*, Corporation Art Gallery, Rochdale, 1–29 May 1926 / *Exhibition of Canadian Art*, Corporation Art Gallery, Oldham, 12 June–10 July 1926 (exhibition catalogue) / Cartwright Memorial Hall, Bradford, 17 July–14 Aug. 1926 / *Exhibition of Canadian Pictures*, Queen's Park Branch Art Gallery, Manchester, 28 Aug.–9 Oct. 1926 (exhibition catalogue) / Sheffield, 15 Oct.–11 Dec. 1926 / Municipal Museum and Art Gallery, Plymouth, 12 Jan.–12 Feb. 1927 (exhibition catalogue).

Ghent 1925. *Exposition Triennale de Gand*, Palais des Fêtes, Parc de la Citadelle, Ghent, Belgium, 7 June–2 Aug. 1925 (exhibition catalogue).

Sarnia 1925(2). *Little Pictures Exhibition*, Women's Conservation Art Committee, Sarnia, Nov. 1925.

1926

NGC 1926. *Special Exhibition of Canadian Art*, National Gallery of Canada, Ottawa, 21 Jan.–28 Feb. 1926 (exhibition catalogue).

AGT Inaugural 1926. *Inaugural Exhibition*, Art Gallery of Toronto, 29 Jan.–28 Feb. 1926 (exhibition catalogue).

Kitchener 1926. *Exhibition of Paintings*, Schreiters Exhibition Annex, Kitchener, Ont., 25 May–5 June 1926 (exhibition catalogue).

Philadelphia 1926. *Paintings, Sculpture and Prints in the Department of Fine Arts, Sesquicentennial International Exposition*, Philadelphia, from 24 July 1926 (exhibition catalogue).

AGT Canadian 1926. *Exhibition of Canadian Paintings*, Art Gallery of Toronto, 9 Aug.–30 Sept. 1926 (exhibition catalogue).

1927

Paris 1927. *Exposition d'art canadien*, Musée du Jeu de Paume, Paris, 10 April–10 May 1927 (exhibition catalogue).

AGT 1927. *Paintings by Contemporary Canadian Artists*, Art Gallery of Toronto, 30 June–2 Oct. 1927 (exhibition list).

Saskatoon 1927. Nutana Collegiate Institute, Saskatoon, 11–12 Nov. 1927 (exhibition list).

1930

AFA 1930. *Exhibition of Paintings by Contemporary Canadian Artists under the Auspices of the American Federation of Arts*, Corcoran Gallery of Art, Washington, D.C., 9–30 March 1930 (exhibition list) / Rhode Island School of Design, Providence, April 1930 / Baltimore Museum of Art, 4–28 May 1930 (exhibition catalogue) / Grand Central Art Galleries, New York, June 1930 / Minneapolis Institute of Arts, July 1930 / City Art Museum, St. Louis, Mo., August 1930 (exhibition catalogue).

Canoe Lake 1930. *Tom Thomson*, Camp Ahmek, Canoe Lake, Ont., c. 13 Aug. 1930.

CNE 1930. *Canadian National Exhibition: Canadian Paintings, Sculpture, Water Colours, Graphic and Applied Art; Architectural Exhibit and Salon of Photography*, Toronto, 22 Aug.–6 Sept. 1930 (exhibition catalogue).

1932

VAG 1932. *All-Canadian Exhibition*, Vancouver Art Gallery, May–July 1932 (exhibition catalogue).

Thomson 1932. *Imperial Economic Conference*, National Gallery of Canada, Ottawa, 18 July 1932–28 Jan. 1933 (exhibition catalogue).

1934

Massey 1934. *Contemporary Paintings by Artists of the United States, Canadian Paintings, the Collection of Hon. Vincent and Mrs. Massey, and in the Print Room Scissor Cuts by René Kulbach*, Art Gallery of Toronto, December 1934 (exhibition catalogue).

1935

AGT 1935. *The Permanent Collection of Oil and Water Colour Paintings as Arranged for Exhibition, Summer, 1935*, Art Gallery of Toronto, from 6 July 1935 (exhibition catalogue).

AGT Margaret Eaton 1935. *Loan Exhibition of Paintings Celebrating the Opening of the Margaret Eaton Gallery and the East Gallery*, Art Gallery of Toronto, from 8 Nov. 1935 (exhibition catalogue).

1937

Thomson 1937. *Loan Exhibition of Works by Tom Thomson*, Mellors Galleries, Toronto, March 1937 (exhibition catalogue).

1938

Tate 1938. *A Century of Canadian Art*, Tate

Gallery, London, 15 Oct.–15 Dec. 1938 (exhibition catalogue).

1939

San Francisco 1939. *Contemporary Art*, Gold Gate International Exposition, San Francisco, [1939] (exhibition catalogue).

Thomson 1939. *Exhibition of the Work of Tom Thomson and J.E.H. MacDonald*, Mellors Galleries, Toronto, 1–18 Feb. 1939 (exhibition list).

CNE 1939. *Canadian Painting and Sculpture, Canadian Water Colours, Canadian Graphic Art, British and Canadian Applied Art, Canadian Photography*, Canadian National Exhibition, Toronto, 25 Aug.–9 Sept. 1939 (exhibition catalogue).

1941

Thomson 1941. *Horatio Walker — Tom Thomson*, Art Gallery of Toronto, January 1941 (exhibition list).

1942

London 1942. *Milestones of Canadian Art: A Retrospective Exhibition of Canadian Art from Paul Kane and Kreighoff to the Contemporary Painters*, Elsie Perrin Williams Memorial Public Library & Art Museum, London, Ont., from 9 Jan. 1942 (exhibition catalogue).

New York 1942. *Canadiana: An Exhibition of Historical Prints, Water-Colour Drawings, Oil Paintings and Maps*, Grand Central Art Galleries, New York, 6–18 April 1942 (exhibition catalogue).

San Francisco 1942. *Canadian Paintings*, San Francisco Museum of Art, from 1 July 1942.

1944

AGT 1944. *Loan Exhibition of Great Paintings in Aid of Allied Merchant Seamen*, organized with the Navy League of Canada (Ontario Division), Art Gallery of Toronto, 4 Feb.–5 March 1944 (exhibition catalogue).

New Haven 1944. *Canadian Art, 1760–1943*, Yale University Art Gallery, New Haven, Conn., 11 March–16 April 1944 (exhibition catalogue).

Southam 1944. *Paintings Lent by H.S. Southam*, National Gallery of Canada, Ottawa, 27 May–2 July 1944 (exhibition list).

Rio de Janeiro 1944. *Pintura Canadense Contemporanea*, Rio de Janerio, Brazil, November 1944 (exhibition catalogue).

Chicago 1944. *Art of the United Nations*, Art Institute of Chicago, 16 Nov. 1944–1 Jan. 1945 (exhibition catalogue).

1945

DPC 1945. *The Development of Painting in Canada, 1665–1945*, Art Gallery of Toronto, 10–28 Jan. 1945 (exhibition catalogue) / Art Association of Montreal, Feb.–21 March 1945 / Le Musée de la province du Québec, 26 Mar.–April 1945 / National Gallery of Canada, Ottawa, 8 June–14 July 1945.

Housser 1945. *F.B. Housser Memorial Collection*, London Public Library and Art Museum, London, Ont., 6–24 Feb. 1945 (exhibition list).

1946

Albany 1946. *Painting in Canada: A Selective Historical Survey*, Albany Institute of History and Art, 10 Jan.–10 March 1946 (exhibition catalogue).

1947

AGT 1947. *Pictures Purchased by the Albert H. Robson Fund*, Art Gallery of Toronto, October 1947 (exhibition list).

McLaughlin 1947. *Pictures from the Collection of Col. and Mrs. R.S. McLaughlin*, Art Gallery of Toronto, Oct.–Nov. 1947 (exhibition list).

1948

CNE 1948. *Canadian Painting and Sculpture Owned by Canadians*, Canadian National Exhibition, Toronto, 27 Aug.–11 Sept. 1948 (exhibition catalogue).

Windsor 1948. *Tom Thomson and The Group of Seven*, Willistead Art Gallery, Windsor, Nov. 1948 (exhibition catalogue).

1949

Richmond 1949. *Exhibition of Canadian Painting, 1668–1948*, Virginia Museum

of Fine Arts, Richmond, 16 Feb.–20 March 1949 (exhibition catalogue).

Boston 1949. *Forty Years of Canadian Painting: From Tom Thomson and the Group of Seven to the Present Day*, Museum of Fine Arts, Boston, 14 July–25 Sept. 1949 (exhibition catalogue).

CNE 1949. *An Exhibition of Paintings and Sculpture Arranged by the Canadian National Exhibition Association and the Art Gallery of Toronto*, Canadian National Exhibition, Toronto, 26 Aug.–10 Sept. 1949 (exhibition catalogue).

Laidlaw 1949. *List of R.A. and W.L. Laidlaw Sketches on Exhibition at the Art Gallery of Toronto*, Art Gallery of Toronto, Oct.–Nov. 1949 (exhibition list).

AGT 1949. *Fifty Years of Painting in Canada*, Art Gallery of Toronto, Oct.–Nov. 1949 (exhibition catalogue).

1950

London 1950. [*3 Sketches by Tom Thomson*], London Public Library, London, Ont., May 1950.

CNE 1950. *Exhibition of Paintings and Sculpture Arranged by the Canadian National Exhibition Association and the Art Gallery of Toronto*, Canadian National Exhibition, Toronto, 25 Aug.–9 Sept. 1950 (exhibition catalogue).

Washington 1950. *Canadian Painting: An Exhibition Arranged by the National Gallery of Canada*, National Gallery of Art, Washington, D.C., 29 Oct.–10 Dec. 1950 (exhibition catalogue) / California Palace of the Legion of Honor, San Francisco, 5–30 Jan. 1951 / Fine Arts Society of San Diego, Feb. 1951 / Santa Barbara Museum of Art, March 1951 / Seattle Art Museum, 4 Apr.–6 May 1951 / Vancouver Art Gallery, 15 May–11 June 1951.

1951

Halifax 1951. *The Development of Canadian Painting*, Halifax Memorial Library, from 12 Nov. 1951 (exhibition catalogue).

1952

McLean 1952. *Paintings and Drawings from*

the Collection of J.S. McLean, National Gallery of Canada, Ottawa, 23 Feb.–24 March 1952, (exhibition catalogue).

CNE 1952. *Exhibition of Paintings and Sculpture Arranged by the Canadian National Exhibition Association and the Art Gallery of Toronto*, Canadian National Exhibition, Toronto, 22 Aug.–6 Sept. 1952 (exhibition catalogue).

1953

NGC 1953. *Exhibition of Canadian Painting to Celebrate the Coronation of Her Majesty Queen Elizabeth II*, National Gallery of Canada, Ottawa, 2 June–13 Sept. 1953 (exhibition catalogue).

Hamilton 1953. *Inaugural Exhibition*, Art Gallery of Hamilton, Dec. 1953–Jan. 1954 (exhibition catalogue).

1954

Brandon 1954. *Fine Arts Collections*, [Exhibition at the homes of Mr. and Mrs. D.R. Doig and Professor and Mrs. Edward Perry, Brandon, Manitoba], March 1954 (exhibition catalogue).

VAG 1954. *Group of Seven*, Vancouver Art Gallery, 29 March–25 April 1954 (exhibition catalogue).

MacAulay 1954. *Paintings from the Collection of John A. MacAulay, Q.C.*, National Gallery of Canada, Ottawa, 15 April–20 May, 1954 (exhibition catalogue) / Art Gallery of Toronto, 28 May–13 June 1954.

1955

Victoria 1955. *The Group of Seven*, Arts Centre of Greater Victoria, 15–27 Feb. 1955 (exhibition catalogue).

Thomson 1955. *Tom Thomson Travelling Exhibition: Sketches and Painting from the National Gallery of Canada Collection*, Edmonton Museum of Arts, 10 Nov.–6 Dec. 1955 / Calgary Allied Arts Centre, 13 Dec. 1955–1 Jan. 1956 / University of Manitoba, Winnipeg, 2–22 Feb. 1956 / Lethbridge, Ab., 1–8 March 1956 / Art Gallery of Greater Victoria, 13–25 March 1956 /

University of British Columbia, Fine Arts Gallery, Vancouver, 3–28 April 1956 / Regina Public Library, 5–25 May 1956 / Saskatoon Art Centre, 1–21 June 1956 / Winnipeg Art Gallery, 1–30 July 1956 / Sarnia Public Library, August 1956 / Kitchener-Waterloo Art Association, 21 Sept.–8 Oct. 1956 / Yarmouth Art Society, N.S., 31 Oct.–12 Nov. 1956 / Colchester Chapter of the I.O.D.E., Truro, N.S., 15–24 Nov. 1956 / Louisburg Chapter of the I.O.D.E., Louisburg, N.S., 27 Nov.–6 Dec. 1956 / Amherst Art Association, N.S., 10–24 Dec. 1956 / Moncton Society of Art, 24 Jan.–2 Feb. 1957 / Fredericton Art Club, 6–20 Feb. 1957 / University of New Brunswick, Fredericton, 20 Feb.–6 March 1957 / [Art Centre], Saint John, N.B., 9–20 March 1957 / Dalhousie University, Halifax, 4–18 April 1957 / Nova Scotia College of Art, Halifax, 18 April–1 May 1957 / Glenhyrst Gardens, Brantford, Ont., 22 June–2 July 1957 / London Public Library and Art Museum, July–Sept. 1957 / Willistead Library and Art Gallery, Windsor, 1 Oct.–5 Nov. 1957 / Winnipeg Art Gallery, 15 Nov.–15 Dec. 1957.

1956

CNE 1956. *Exhibition of Paintings and Sculpture Arranged by the Fine Arts Committee of the Canadian National Exhibition Association and a Showing of Amateur Paintings from Across Canada*, Canadian National Exhibition, Toronto, 24 Aug.–8 Sept. 1956 (exhibition catalogue).

Thomson 1956. *Tom Thomson Exhibition, 1877–1917*, Kitchener-Waterloo Art Gallery, Sept.–Oct. 1956 (exhibition catalogue).

1957

AGT 1957. *Comparisons: An Exhibition Organized by the Art Gallery of Toronto*, Art Gallery of Toronto, 11 Jan.–3 Feb. 1957 (exhibition catalogue).

Thomson London 1957. *Tom Thomson 1877–1917, George Thomson 1868–*, London Art Gallery, 6 July–6 Sept. 1957 (exhibition catalogue).

Thomson Windsor 1957. *Tom Thomson 1877–1917*, Willistead Art Gallery, 6 Oct.–2 Nov. 1957 (exhibition catalogue).

1958

Los Angeles 1958. *Tom Thomson* (Thomson 1955 with additions from the collection of the National Gallery of Canada), Canadian Cultural Exhibition, Los Angeles County Museum, Jan.–March 1958.

Winnipeg 1958. *Children and Flowers*, Winnipeg Art Gallery, 6 April–12 May 1958 (exhibition catalogue).

1959

Laing 1959. *A Loan Exhibition: One Hundred Years of Canadian Painting*, Laing Galleries, Toronto, 27 Jan.–8 Feb. 1959 (exhibition catalogue).

NGC 1959. *Ottawa Collects*, National Gallery of Canada, Ottawa, April 1959 (exhibition list).

Poole 1959. *Paintings from the Collection of Ernest E. Poole and Family*, Art Gallery of Greater Victoria, 4 Aug.–13 Sept. 1959 (exhibition catalogue) / Fine Arts Gallery, University of British Columbia, Vancouver, 1–18 Nov. 1959.

CNE 1959. *Private Collectors' Choice in Canadian Art Sponsored by the Canadian Cancer Society*, Canadian National Exhibition Art Gallery, Toronto, August 1959 (exhibition catalogue).

AGT 1959. *Loans From Private Toronto Collections*, Art Gallery of Toronto, 2–18 Oct. 1959 (exhibition catalogue).

1960

Mexico 1960. *Arte Canadiense*, Museo Nacional de Arte Moderno, Instituto Nacional de Bellas Artes, Mexico City, 22 Nov. 1960–Feb. 1961 (exhibition catalogue).

1961

London 1961. *The Face of Early Canada: Milestones of Canadian Paintings*, London Public Library and Art Museum, February 1961 (exhibition catalogue).

NGC 1961. *150 Years of Canadian Painting*, Memorial University of Newfoundland, St. John's, 8–28 Oct. 1961 (exhibition catalogue) / City Hall Gallery, Bermuda Society of Arts, Hamilton, Bermuda, 25 Nov.–Dec. 1961 (exhibition catalogue) / Fort William Public Library, Fort William, Ont., 24 Feb.–4 March 1962 (exhibition catalogue).

1962

Bordeaux 1962. *L'art au Canada*, Musée de Bordeaux, 11 May–31 July 1962 (exhibition catalogue).

1963

Stratford 1963. *Canada on Canvas*, The Stratford Shakespearean Festival, Stratford, Ont., 22 June–14 Sept. 1963 (exhibition catalogue).

Chautauqua 1963. *Canadian Group of Seven and Eskimo Folk Art*, Chautauqua Art Association and Chautauqua Institution, Chautauqua, N.Y., August 1963 (exhibition catalogue).

1964

Edmonton 1964. *Permanent Collection Exhibition of the Edmonton Art Gallery*, Jubilee Auditorium, Edmonton, April 1964 (exhibition catalogue).

Thomson 1964. *Thomson Family Exhibition*, Glenhyrst Gardens Galleries, Brantford, Ont., Sept.–20 Oct. 1964 / Tom Thomson Memorial Art Gallery, Owen Sound, 23 Oct.–14 Nov. 1964.

Port Arthur 1964. *The Group of Seven and Lake Superior*, Lakehead College, University Centre, Port Arthur, 19 Nov.–12 Dec. 1964 (exhibition catalogue).

1965

London 1965. *Canadian Impressionists, 1895–1965*, London Public Library and Art Museum, London, Ont., 7 April–2 May 1965 (exhibition catalogue).

Poole 1965. *The Poole Collection*, Confederation Art Gallery and Museum, Charlottetown, P.E.I., 1 June–6 Sept. 1965, (exhibition catalogue).

London Eng. 1965. *Commonwealth Arts Festival: Treasures from the Commonwealth*, Royal Academy of Arts, London, England, 17 Sept.–13 Nov. 1965 (exhibition catalogue).

1966

Poole (1) 1966. *The Ernest E. Poole Foundation Collection: An Exhibition of Canadian Paintings*, Northern Alberta Jubilee Auditorium, Edmonton, 24–29 April–2–6 May 1966 (exhibition catalogue).

Vancouver 1966. *Images for a Canadian Heritage*, Vancouver Art Gallery, Sept. 1966 (exhibition catalogue).

Thomson 1966. *Tom Thomson: Sketches*, Travelling exhibition organized and circulated by the National Gallery of Canada, New Brunswick Museum, Saint John, 2–25 Sept. 1966 (exhibition catalogue) / Memorial Art Gallery, St. John's, Nfld., 7–30 Oct. 1966 / Kitchener-Waterloo Gallery, 10 Nov.–4 Dec. 1966 / Agnes Etherington Art Centre, Queen's University, Kingston, 16 Dec. 1966–8 Jan. 1967 / Sir George Williams University, Montreal, 20 Jan.–12 Feb. 1967 / London Art Museum, London, Ont., 24 Feb.–19 March 1967 / Edmonton Art Gallery, 31 March–23 April 1967 / Art Gallery of Greater Victoria, 5–28 May 1967 / *Dartmouth's Canadian Year*, Hopkins Center Art Galleries, Dartmouth College, Hanover, N.H., 6–30 June 1967 (separate exhibition catalogue) / Confederation Centenary Celebration, Halifax, 15 Oct.–5 Nov. 1967 / Université de Sherbrooke, 19 Nov.–10 Dec. 1967 / Willistead Art Gallery, Windsor, 4–28 Jan. 1968 / Winnipeg Art Gallery, 11 Feb.–3 March 1968 / Calgary Allied Arts

Council, 17 March – 7 April 1968 / Mendel Art Centre, Saskatoon, 21 April – 12 May 1968 / Brandon Allied Arts Centre, Brandon, Man., 26 May – 16 June 1968.

Poole (2) 1966. *Twenty Selected Works from the Ernest E. Poole Foundation Collection: An Exhibition of Canadian Painting*, Regina Public Library Art Gallery, Saskatchewan Festival of the Arts 1966, 10 – 24 Sept. 1966 (exhibition catalogue).

1967

Expo 1967. *Painting in Canada*, Canadian Government Pavilion, Expo 67, Montreal, 1967 (exhibition catalogue).

Stratford 1967. *Ten Decades 1867 – 1967 Ten Painters*, Rothman's Art Gallery of Stratford, [4 Aug.] – 3 Sept. 1967 (exhibition catalogue) / New Brunswick Museum, Saint John, N.B., fall 1967.

NGC (1) 1967. *Canadian Painting 1850 – 1950*, travelling exhibition organized and circulated by the National Gallery of Canada, Willistead Art Gallery, Windsor, 8 Jan. – 12 Feb. 1967 (exhibition catalogue) / London Art Gallery, London, Ont., 17 Feb. – 26 March 1967 / Art Gallery of Hamilton, 1 April – 7 May 1967 / Agnes Etherington Art Centre, Queen's University, Kingston, 12 May – 10 June 1967 / Rothmans Art Gallery of Stratford, 16 June – 30 July 1967 / Mendel Art Gallery, Saskatoon, 9 Aug. – 9 Sept. 1967 / Edmonton Art Gallery, 15 Sept. – 10 Oct. 1967 / Art Gallery of Greater Victoria, 20 Oct. – 18 Nov. 1967 / Confederation Art Centre, Charlottetown, 30 Nov. – 30 Dec. 1967 / The New Brunswick Museum, Saint John, 15 Jan. – 15 Feb. 1968 / Beaverbrook Art Gallery, Fredericton, [Feb. – March] 1968; Musée du Québec, Quebec, 15 March – 14 April 1968.

NGC (2) 1967. *Three Hundred Years of Canadian Art*, National Gallery of Canada, Ottawa, 12 May – 17 Sept. 1967 (exhibition catalogue) / Art Gallery of

Ontario, Toronto, 20 Oct. – 26 Nov. 1967.

Thomson 1967. *Tom Thomson and the Group of Seven*, Tom Thomson Memorial Gallery and Museum of Art, Owen Sound, 27 May – 11 June 1967 (exhibition catalogue).

New York 1967. *Artists of the Western Hemisphere, Precursors of Modernism: 1860 – 1930*, Inaugural Loan Exhibition, Center for Inter-American Relations, Art Gallery, New York, 19 Sept. – 12 Nov. 1967 (exhibition catalogue).

1968

Brandon 1968. *Doig Collection of Canadian Paintings Featuring the Group of Seven*, Brandon University, Music Building Foyer, 17 – 28 May 1968 (exhibition catalogue).

Owen Sound 1968. *First Anniversary Exhibition*, Tom Thomson Memorial Art Gallery and Museum of Fine Art, Owen Sound, 24 May – 9 June 1968 (exhibition catalogue).

NGC 1968. *Traditional Landscape Painting in Canada*, travelling exhibition organized by the National Gallery of Canada, Saskatoon Art Centre, 5 – 29 Sept. 1968 (exhibition catalogue) / Sir George Williams University, Montreal, 11 Oct. – 3 Nov. 1968 / Agnes Etherington Art Centre, Queen's University, Kingston, 15 Nov. – 8 Dec. 1968 / St. Catharines & District Arts Council, 20 Dec. 1968 – 15 Jan. 1969 / Dalhousie Art Gallery, Dalhousie University, Halifax, 29 Jan. – 23 Feb. 1969 / Université de Sherbrooke, 7 – 30 March 1969 / Memorial University, St. John's, Nfld., 11 April – 4 May 1969 / Confederation Art Gallery and Museum, Charlottetown, 16 May – 8 June 1969 / London Public Library and Art Museum, London, Ont., 28 Oct. – 23 Nov. 1969 / Students' Union, University of Alberta, Edmonton, 21 Jan. – 15 Feb. 1970 / Glenbow Foundation, Calgary, 6 – 29 Mar. 1970 /

Beaverbrook Art Gallery, Fredericton, N.B., 17 Apr. – 10 May 1970.

McLean 1968. *The J.S. McLean Collection of Canadian Painting*, Art Gallery of Ontario, Toronto, 19 Sept. – 20 Oct. 1968 (exhibition catalogue) / Confederation Centre, Art Gallery and Museum, Charlottetown, 1 Nov. – 1 Dec. 1968 / Beaverbrook Art Gallery, Fredericton, 13 Dec. 1968 – 12 Jan. 1969 / London Public Library and Art Museum, London, Ont., 24 Jan. – 23 Feb. 1969 / Winnipeg Art Gallery, 7 March – 6 April 1969 / Mendel Art Gallery, Saskatoon, 18 April – 18 May 1969 / Norman Mackenzie Art Gallery, Regina, 30 May – 29 June 1969 / Edmonton Art Gallery, 5 July – 13 Sept. 1969 / Vancouver Art Gallery, 23 Sept. – 26 Oct. 1969.

Massey 1968. *Vincent Massey Bequest: The Canadian Paintings*, National Gallery of Canada, Ottawa, 20 Sept. – 20 Oct. 1968 (exhibition catalogue).

1969

MacCallum 1969. *The MacCallum Bequest of Paintings by Tom Thomson and Other Canadian Painters & the Mr. and Mrs. H.R. Jackman Gift of Murals from the Late Dr. MacCallum's Cottage Painted by Some of the Members of the Group of Seven*, National Gallery of Canada, Ottawa, 25 Jan. – 23 Feb. 1969 (exhibition catalogue).

Thomson 1969. *Paintings by Tom Thomson: The Second Anniversary Exhibition*, Tom Thomson Memorial Gallery and Museum of Fine Art, Owen Sound, 23 May – 15 June 1969.

1970

NGC 1970. *The Group of Seven*, National Gallery of Canada, Ottawa, 19 June – 8 Sept. 1970 (exhibition catalogue) / Montreal Museum of Fine Arts, 22 Sept. – 31 Oct. 1970.

1971

Thomson 1971. *The Art of Tom Thomson*,

Art Gallery of Ontario, Toronto, 30 Oct. – 12 Dec. 1971 (exhibition catalogue) / Norman Mackenzie Art Gallery, Regina, 15 Jan. – 13 Feb. 1972 / Winnipeg Art Gallery, 25 Feb. – 31 March 1972 / Montreal Museum of Fine Arts, 14 April – 28 May 1972 / Confederation Art Gallery and Museum, Charlottetown, 2 July – 5 Sept. 1972.

1972

Ottawa 1972. *Progress in Conservation*, travelling exhibition organized by the National Gallery of Canada / National Gallery of Canada, Ottawa, 14 Jan. – 13 Feb. 1972 (exhibition catalogue).

1973

Edmonton 1973. *Edmonton Collects: 1*, Edmonton Art Gallery, 25 Jan. – 25 Feb. 1973 (exhibition catalogue).

Madison 1973. *Canadian Landscape Painting 1670 – 1930: The Artist and the Land*, Elvehjem Art Centre, University of Wisconsin, Madison, 11 April – 23 May 1973 (exhibition catalogue) / Hopkins Center Art Galleries, Dartmouth College, Hanover, N.H., 15 June – 1 Aug. 1973 / University Art Museum, University of Texas, Austin, 20 Aug. – 7 Oct. 1973.

1974

AGO 1974. *Impressionism in Canada, 1895 – 1935*, Vancouver Art Gallery, 16 Jan. – 24 Feb. 1974 (exhibition catalogue) / Edmonton Art Gallery, 8 March – 21 April 1974 / Saskatoon Gallery and Conservatory Corporation, 4 May – 10 June 1974 / Confederation Art Gallery and Museum, Charlottetown, 22 June – 1 Sept. 1974 / Robert McLaughlin Gallery, Oshawa, 19 Sept. – 3 Nov. 1974 / Art Gallery of Ontario, Toronto, 17 Nov. 1974 – 5 Jan. 1975.

Guelph 1974. *19th and 20th Century Paintings from the Art Gallery of Hamilton*, McLaughlin Library, University of Guelph, 28 April – 30 May 1974 (exhibition catalogue).

Spokane 1974. *Our Land, Our Sky, Our Water: An Exhibition of American and Canadian Art, Organized by Alfred Frankenstein on the Occasion of the International Exposition*, Bureau international des expositions, Spokane, Wash., 4 May – 3 Nov. 1974 (exhibition catalogue).

1975

Peking 1975. *The Canadian Landscape in Painting: An exhibition of Canadian Landscape Paintings of the Nineteenth and Early Twentieth Centuries*, organized by the National Gallery of Canada / National Gallery of Chinese Art, Peking, 16–29 Apr. 1975 (exhibition list) / Shanghai Art Gallery, 13–27 May 1975.

Sarnia 1975. *Group of 7 and Friends*, Sarnia Public Library and Art Gallery, 3 Sept. – 1 Oct. 1975 (exhibition catalogue).

Thomson 1975. *Tom Thomson: The Jack Pine*, organized and circulated by the National Gallery of Canada, Rodman Hall Arts Centre, St. Catharines, 12 Sept.–5 Oct. 1975 (exhibition catalogue) / Nova Scotia Museum of Fine Arts, Halifax, 20 Oct.–2 Nov. 1975 / Art Gallery of Greater Victoria, 31 March–25 April 1976 / Art Gallery of Windsor, 28 May–20 June 1976 / National Gallery of Canada, Ottawa, 5 Oct.–5 Dec. 1976.

AGO 1975. *The Ontario Community Collects: A Survey of Canadian Painting from 1766 to the Present*, Art Gallery of Ontario, Toronto, 12 Dec. 1975 – 1 Feb. 1976 (exhibition catalogue).

1976

Saint John 1976. *Seven Plus: A Selection of Work by the Group of Seven Arranged by the Department of New Brunswick Museum*, Saint John, June 5 – July 30, 1976 (exhibition catalogue) / *The Group of Seven and Tom Thomson*, The Art Gallery, Memorial University of Newfoundland, St. John's, 15 Aug.–12 Sept. 1976 / Owen's Art Gallery, Mount Allison University, Sackville, N.B., 20 Sept. –

17 Oct. 1976 / The Gallery Stratford, Stratford, Ont., 3 Dec. 1976 – 2 Jan. 1977.

Sarnia 1976. *Treasures from Local Collections*, Sarnia Public Library and Art Museum, 16 June – 6 July 1976.

McMichael 1976. *Group of Seven: Canadian Landscape Painters*, travelling exhibition organized by the McMichael Canadian Collection, Kleinburg, Ont. (exhibition catalogue) / Kelvingrove Art Gallery, Glasgow, Scotland, 25 Aug. – 18 Sept. 1976 / Talbot Rice Centre, Edinburgh, Scotland, 29 Sept.–20 Oct. 1976 / Aberdeen Art Gallery, Aberdeen, Scotland, 27 Nov. – 18 Dec. 1976 / Canada House Gallery, London, England, 12 Jan.–23 Feb. 1977 / The Royal Residence, Munich, Germany, 15 March – 30 April 1977 (exhibition catalogue in German) / The Provincial Museum, Bonn, West Germany, 1–18 May 1977 / The Hermitage, Leningrad, Russia, 7 June–2 July 1977 / Museum of Western and Eastern Art, Kiev, Russia, 11–31 July 1977 (exhibition catalogue in Russian) / Pushkin Museum, Moscow, Russia, 10–27 Aug. 1977 / Ernst Barlach Haus, Hamburg, Germany, 23 Sept. – 15 Oct. 1977 / Oslo Kunstforeningen, Oslo, Norway, 16 March – 10 April 1978 (exhibition catalogue in Norwegian) / National Gallery of Ireland, Dublin, Ireland, 20 April–14 May, 1978 / Castle Gallery, Kilkenny, Ireland, 18 May – 4 June 1978 / National Exhibition Centre, Thunder Bay, 1–16 July 1978 / Thames Art Centre, Chatham, Ont., 21 July – 13 Aug. 1978 / National Exhibition Centre, Timmins Museum, 23 Aug. – 17 Sept. 1978 / Northern Studio du Nord, Kapuskasing, Ont., 22 Sept. – 9 Oct. 1978.

Calgary 1976. *Through Canadian Eyes: Trends and Influences in Canadian Art*, Glenbow-Alberta Institute, Calgary, 22 Sept. – 24 Oct. 1976 (exhibition catalogue).

1977

McMichael 1977. *Group of Seven: Canadian Landscape Painters*, The Phillips Collection, Washington, D.C., 22 Jan. – 20 Feb. 1977.

Thomson 1977. *The Tom Thomson Memorial Exhibition*, Tom Thomson Memorial Gallery and Museum of Fine Art, Owen Sound, 4 May – 1 June 1977 (exhibition catalogue).

David Mirvish Gallery 1977. *Tom Thomson Exhibition*, David Mirvish Gallery, Toronto, 15 Oct. – 14 Nov. 1977.

AGO 1977. *Canadian Paintings in the University of Toronto: An Exhibition in Celebration of the Sesquicentennial of the University of Toronto*, Art Gallery of Ontario with the support of the University of Toronto Sesquicentennial Celebrations Council, Toronto, 1977 / Circulated in the Province of Ontario by AGO Extension Services, 1977–78.

1978

Thomson 1978. *Lake in Algonquin Park: An Examination of an Early Painting by Tom Thomson*, The Gallery Stratford, Stratford, 10 Feb. – 12 March 1978 (exhibition catalogue).

McMichael 1978. *Group of Seven: Canadian Landscape Painters*, Organized by the McMichael Canadian Art Collection, Kleinburg, Ont. (exhibition catalogue) / Thunder Bay, National Exhibition Centre, 1–16 July 1978 / Thames Art Centre, Chatham, Ont., 21 July – 13 Aug. 1978 / Timmins Museum: National Exhibition Centre, 23 Aug. – 17 Sept. 1978 / Northern Studio du Nord, Kapuskasing, Ont., 22 Sept. – 9 Oct. 1978.

Edmonton 1978. *Modern Painting in Canada: A Survey of Major Movements in Twentieth Century Canadian Art*, Edmonton Art Gallery, 7 July – 30 Aug. 1978 (exhibition catalogue).

Lethbridge 1978. *Group of Seven / Selections*, Southern Alberta Art Gallery, Lethbridge, 7–29 Oct. 1978 (exhibition list).

1979

Victoria 1979. *Nationalism in Canadian Art*, Art Gallery of Greater Victoria, 31 Jan. – 30 March 1979 (exhibition catalogue).

1980

Heffel 1980. *The Group of Seven and Their Contemporaries*, Kenneth G. Heffel Fine Art Inc., Vancouver, 29 Feb. – 22 March 1980 (exhibition catalogue).

Owen Sound 1980. *Sixty Years of the Group of Seven*, 13th Anniversary Exhibition, Tom Thomson Memorial Art Gallery, Owen Sound, 10 May – 1 June 1980 (exhibition catalogue).

Sault Ste. Marie 1980. *Painters of the Shield*, Inaugural Exhibition of the Gallery, Art Gallery of Algoma, Sault Ste. Marie, 6 Sept. – 5 Nov. 1980 (exhibition catalogue).

1981

Charleston 1981. *Wilderness Canada: Canadian Landscape Paintings from the McMichael Canadian Collection*, The Gibbes Art Gallery, The Spoleto Festival U.S.A., Charleston, South Carolina, 20 May – 22 June 1981.

Tokyo 1981. *Twentieth Century Canadian Painting*, organized by the National Gallery of Canada / National Museum of Art, Tokyo, Japan, 9 July – 2 Aug. 1981 (exhibition catalogue) / Museum of Modern Art, Hokkaido, Sapporo, 29 Aug. – 20 Sept. 1981 / Oita Prefectural Art Centre, 1–28 October 1981.

Kitchener 1981. *Canadian Treasures: 25 Artists, 25 Paintings, 25 Years*, Kitchener-Waterloo Art Gallery, 8 Oct. – 1 Nov. 1981 (exhibition catalogue).

1982

AGO 1982. *The Canada Packers Collection*, Art Gallery of Ontario, Toronto, 27 Feb. – 11 Apr. 1982 (exhibition catalogue).

Sault Ste. Marie 1982. *Tom Thomson and the Group of Seven*, Art Gallery of Algoma, Sault Ste. Marie, July 1982.

Berlin 1982. *OKANADA*, Akademie der Künste, Berlin, 5 Dec. 1982–30 Jan. 1983 / Institut für Auslandsbeziehungen, Stuttgart, 8 Feb.–20 March 1983 (exhibition catalogue) (original texts in French and English published by the Canada Council, 1982).

McMichael 1982. *Selections from the McMichael Canadian Collection*, Leigh Yawkey Woodson Art Museum, Wausau, Wisc., Dec. 1982–Dec. 1984 (exhibition catalogue) / Charles H. MacNider Museum, Mason City, Iowa / Neville Public Museum, Green Bay, Wisc. / Bergstrom Mahler Museum, Neenah, Wisc. / The Fine Arts Center, Cheekwood, Nashville, Tenn. / Albrecht Art Museum, St. Joseph, Mo. / Midland Art Council of the Midland Center for the Arts, Inc., Midland, Mich. / South Dakota Memorial Art Center, Brookings, S.D. / North Dakota State University Art Gallery, Fargo, N.D. / University Gallery, University of Minnesota, Minneapolis, Minn. / Davenport Art Gallery, Davenport, Iowa / The Tweed Museum of Art, Duluth, Minn. / Rahr-West Museum, Manitowoc, Wisc.

1983

Sobey 1983. *Selections from the Sobey Collections Part III: Tom Thomson, J.E.H. MacDonald, A.Y. Jackson and Frank H. Johnston*, Dalhousie Art Gallery, Dalhousie University, Halifax, 16 Dec. 1983–29 Jan. 1984 (exhibition catalogue).

1984

AGO 1984. *The Mystic North: Symbolist Landscape Painting in Northern Europe and North America, 1890–1940*, Art Gallery of Ontario, Toronto, 13 Jan.–11 March 1984 (exhibition catalogue) / Cincinnati Art Museum, 31 March–13 May 1984.

Bennett 1984. *The Ontario Heritage Foundation, Stewart and Letty Bennett Collection*, Macdonald Stewart Art Centre, Guelph, Ont., 2 March–29 May 1984 (exhibition catalogue) / Tom Thomson

Memorial Gallery, Owen Sound, 8–24 June 1984 / Lynnwood Arts Centre, Simcoe, Ont., 6–29 July 1984 / Laurentian University Museum and Arts Centre, Sudbury, 29 Aug.–23 Sept. 1984 / Art Gallery of Algoma, Sault Ste. Marie, 25 Oct.–18 Nov. 1984 / Sarnia Public Library and Art Gallery, 7 Dec. 1984–8 Jan. 1985 / Art Gallery of Peterborough, 24 Jan.–17 Feb. 1985 / Rodman Hall Arts Centre, St. Catharines, 7–30 March 1985.

West Palm Beach 1984. *Masterpieces of Twentieth-Century Canadian Painting*, Norton Gallery and School of Art, West Palm Beach, Florida, 18 March–29 April 1984 (exhibition catalogue).

1986

Atlanta 1986. *The Advent of Modernism: Post-Impressionism and North American Art, 1900–1918*, High Museum of Art, Atlanta, Georgia, 5 March–11 May 1986 (exhibition catalogue) / Center for the Fine Arts, Miami, Florida / Brooklyn Museum, N.Y. / Glenbow Museum, Calgary.

1987

New York 1987. *Fifty Years of Canadian Landscape Painting: A Selection*, Grace Borgenicht Gallery, New York, 3 April–2 May 1987 (exhibition catalogue).

McMichael 1987. *The Group of Seven: Masterpieces from Toronto Collections*, McMichael Canadian Art Collection, Kleinburg, 25 June–3 Sept. 1987.

Hart House 1987. *The Prevailing Influence: Hart House and the Group of Seven, 1919–1953*, The Justina M. Barnicke Gallery, Hart House, University of Toronto, 8 Sept.–9 Oct. 1987 (exhibition catalogue) / Centennial Gallery, Oakville Galleries, Ont., 29 Oct.–13 Dec. 1987 / University Art Gallery, Mount St. Vincent, Halifax, 8 Jan.–7 Feb. 1988 / Agnes Etherington Art Centre, Queen's University, Kingston, 5 March–3 April 1988 / Winnipeg

Art Gallery, 23 April–5 June 1988 / Musée d'art de Joliette, Joliette, Que., 25 June–2 Sept. 1988.

1988

McMichael 1988. *Six Sketches: Thomas John (Tom) Thomson*, Landmarks Series VII, McMichael Canadian Art Collection, Kleinburg, 16 Oct. 1988–22 Jan. 1989 (exhibition catalogue) / Woodstock Public Art Gallery, Woodstock, Ont., 20 July–20 Aug. 1989 / Chatham Cultural Centre, Chatham, Ont., 26 Aug.–1 Oct. 1989 / Sarnia Public Library and Art Gallery, Ont., 24 Nov. 1989–8 Jan. 1990 / Lindsay Gallery, Ont., 2–24 Feb. 1990 / Laurentian University Museum and Arts Centre, Sudbury, Ont., 28 Mar.–22 April 1990.

AGO 1988 *Collector's Canada: Selections from a Toronto Private Collection*, Art Gallery of Ontario, Toronto, 14 May–10 July 1988 (exhibition catalogue) / Musée du Québec, Quebec, 21 Sept.–30 Oct. 1988 / Vancouver Art Gallery, 20 Jan.–5 March 1989 / Mendel Art Gallery, Saskatoon, 23 March–7 May 1989.

1989

Simcoe 1989. *Tom Thomson and the Group of Seven*, Lynnwood Arts Centre, Simcoe, Ont., 5 Oct.–5 Nov. 1989.

1990

Thomson 1990. *Tom Thomson*, Vancouver Art Gallery, 16 June–16 Sept. 1990 (exhibition catalogue).

McMichael 1990. *Selections from the McMichael Canadian Art Collection*, Mendel Art Gallery, Saskatoon, 5 Oct.–18 Nov. 1990 (exhibition catalogue).

Hart House 1990. *The Canadian Landscape: An Exhibition of Canadian Landscape Paintings, 1915–1939, Selected from the Hart House Collection*, Art Gallery of the Canadian Embassy, Washington, D.C., 8 Nov. 1990–16 March 1991 (exhibition catalogue).

1991

Barbican 1991. *The True North: Canadian Landscape Painting 1896–1939*, Barbican Art Gallery, London, England, 19 April–16 June 1991 (exhibition catalogue).

1993

Dallas 1993. *Museum of the Americas*, Dallas Museum of Art, 26 Sept. 1993–26 Sept. 1994.

1995

Thomson 1995. *Tom Thomson: The Last Spring*, Robert McLaughlin Gallery, Oshawa, 4 May 1995–7 Jan. 1996 / McCord Museum of Canadian History, Montreal, 11 April–21 July 1996 / Glenbow Museum, Calgary, 17 Aug.–13 Oct. 1996 / McMichael Canadian Art Collection, Kleinburg, 16 Nov. 1996–26 Jan. 1997.

New York 1995. *Visions of Light and Air: Canadian Impressionism, 1885–1920*, Musée du Québec, Quebec, 14 June–4 Sept. 1995 (exhibition catalogue) / Americas Society Art Gallery, New York, 27 Sept.–17 Dec. 1995 / Dixon Gallery and Gardens, Memphis, 18 Feb.–14 April 1996 / Frick Art Museum, Pittsburgh, 12 June–11 Aug. 1996 / Art Gallery of Hamilton, 12 Sept.–8 Dec. 1996.

1997

Hunter 1997. *Up North: A Northern Ontario Tragedy*, Tom Thomson Memorial Art Gallery, Owen Sound, June–Aug. 1977 (exhibition catalogue) / McMaster Museum of Art, Hamilton, Jan.–March 1998 / Winnipeg Art Gallery, June–Aug. 1998 / Kamloops Art Gallery, Oct. 1998.

1998

Algonquin 1998. *Algonquin Memories: Tom Thomson in Algonquin Park*, Algonquin Gallery, Algonquin Park, Ont., organized by the Tom Thomson

Memorial Art Gallery, Owen Sound, 26 June – 25 Oct. 1998 (exhibition catalogue).

McMichael 1998. *In the Wilds: Canoeing and Canadian Art*, McMichael Canadian Art Collection, Kleinburg, 27 June – 5 Nov. 1998 (exhibition catalogue).

1999

Montreal 1999. *Cosmos: From Romanticism to the Avant-garde*, Montreal Museum of Fine Arts, 17 June – 17 October 1999 (exhibition catalogue) / Centre de Cultura Contemporània de Barcelona, 23 Nov. 1999 – 20 Feb. 2000 / *Cosmos: From Goya to de Chirico, from Friedrich to Kiefer, Art in Pursuit of the Infinite*, Palazzo Grassi, Venice, 2000 (exhibition catalogue).

Algonquin 1999. *Wilderness Reunion: Art in the Park '99: Featuring Tom Thomson, Members of the Group of Seven and Masters of Wildlife Art*, Algonquin Gallery, Algonquin Park, from 25 June 1999.

Mexico City 1999. *Tierra salvaje: La pintura paisajistica canadiense y el Grupo de los Siete*, Museo de Arte Moderno de México, Mexico City, 26 Aug. – 31 Oct. 1999 (exhibition catalogue) / *Terre sauvage: Kanadensiskt landskapmaleri och Group of Seven*, Prins Eugens Waldemarsudde, Stockholm, 10 Feb. – 2 April 2000 (exhibition catalogue) / *Terre sauvage: Canadisk landskapsmaleri og The Group of Seven*, Kunstforeningen, Copenhagen (exhibition catalogue) / *Terre sauvage: Canadisk landskapsmaleri og Group of Seven*,

Lillehammer Kunstmuseum, Lillehammer, Norway, 29 July – 23 Sept. 2000 (exhibition catalogue) / Göteborgs Konstmuseum, Göteborg, Sweden, 14 Oct. – 3 Dec. 2000.

2000

Sarnia 2000. *The First Exhibition of "The Sarnia Art Movement" March 1920*, Gallery Lambton, Sarnia, 12 Feb. – April 2000 (exhibition catalogue).

Winnipeg 2000. *The View from Here: Selections from the Canadian Historical Collection*, Winnipeg Art Gallery, 28 May – 31 Dec. 2000 (exhibition catalogue).

2001

Beijing 2001. *Terre sauvage: The Canadian Landscape and the Group of Seven*, Yan-Huang Museum of Art, Beijing, 19 April – 20 May 2001 (exhibition catalogue in Chinese) / Shanghai Museum of Art, 2–24 June 2001 / Guangdong Museum of Art, Guangzhou, 10 July – 10 Aug. 2001 / Guanshanyue Art Gallery, Shenzhen, 20 Aug. – 23 Sept. 2001.

Hunter 2001. *Stand by Your Man or Annie Crawford Hurn: My Life with Tom Thomson*, Art Gallery of Hamilton, 17 March – 27 May 2001 (exhibition catalogue) / Confederation Centre Art Gallery and Museum, Charlottetown, 24 June – 27 Aug. 2001 / Edmonton Art Gallery, 22 Sept. 2001 – 2 Feb. 2002.

Photo Credits

Index